Digital Imaging
for Visual Artists

Digital Imaging for Visual Artists

Sally Wiener Grotta

Daniel Grotta

Windcrest®/ McGraw-Hill

New York San Francisco Washington, D.C. Auckland Bogotá
Caracas Lisbon London Madrid Mexico City Milan
Montreal New Delhi San Juan Singapore
Sydney Tokyo Toronto

 This book is printed on recycled, acid-free paper containing a minimum
of 50% total recycled fiber with 10% post-consumer de-inked fiber.

2 3 4 5 6 7 8 9 10 11 MAL/MAL 9 9 8 7 6 5 4

Library of Congress Cataloging-in-Publication Data
Grotta, Sally Wiener, 1949-
 Digital imaging for visual artists / by Sally Wiener Grotta and
Daniel Grotta.
 p. cm.
 Includes index.
 ISBN 0-8306-4442-3 (paper)
 1. Image processing—Digital techniques. 2. Computer art.
3. Computer input-output equipment. I. Grotta, Daniel, 1944-
II. Title.
TA1637.G76 1993 93-17754
006.6—dc20 CIP

Acquisitions editor: Brad Schepp
Editorial team: Robert E. Ostrander, Executive Editor
 David M. McCandless, Book Editor
Production team: Katherine G. Brown, Director
 Ollie Harmon, Coding
 Wanda S. Ditch, Layout
 Nancy K. Mickley, Proofreading
 Linda L. King, Proofreading
 Jodi L. Tyler, Indexer
Design team: Jaclyn J. Boone, Designer
 Brian Allison, Associate Designer
Cover design: Peter J. Rozek WK1
 4420

To Jonathan Sosnov & Elizabeth Sosnov

Contents

Part four:
The difficult question of color

Acknowledgments

The density of research that is required by a book such as this could never be done without the assistance and support of many people.

For their generosity of time, information, and advice, we want to thank numerous people, including various imaging experts and gurus, such as: Jim Merrikam at Agfa; Bob McKeever of Kodak; Robert Schwarzbach of The ArtLab (San Francisco); Kevin O'Neall of Image Axis (New York); Joe & Lisa McClain of McClain Imaging (San Jose, CA); Gregg Truemann of Neographic (New York); Wayne Breisch of WEB Associates (Pennsylvania); Scott Geffert of Ken Hansen (New York); Katrin Eismann of the Center for Creative Imaging (Maine), Maureen Stuart of Preality (Philadelphia); Jim Dunn, Rick Roberts and others at Leaf Systems; Tara Griffin of The Apple Center (New York); Charles Altschul of Yale University; and Steve Puntolillo of Zenographics.

Thanks also to Peter Treiber of Treiber Photography (Bethlehem, PA) and Via Wynroth of the International Center of Photography (New York).

And to Brad Schepp, David M. McCandless, Jackie Boone, Sandra J. Bottomley, and the rest of the team at Windcrest/McGraw-Hill for their patience, support, and faith.

For permitting us to use photographs, screen captures, and other visual material related to their products, we want to thank Adobe, Agfa, Aldus, Corel, ColorAge, Dantz, EFI, Fractal Design, Inset Systems, Leaf Systems, Micrografx, TruMatch, Ventura and ZSoft.

Thanks, also, to the companies that loaned us test equipment: Agfa, Apple Computer, Canon, Comtrade, Kodak, Kurta, Lasergraphics, Leaf Systems, Matrox, MicroNet Technology, MicroExpress, NEC, Nikon, Polaroid, Procom Technology, Tektronix, and Wacom.

Our gratitude, also, to all those other individuals and companies who helped us, but who we, in our human frailty, failed to mention.

While we are greatly indebted to all of these people and companies for their assistance, any opinions we have expressed or inadvertent mistakes we have made in this book are our own.

Preface
Confessions of a digital artist

by Sally Wiener Grotta

I hate computers. They are dumb, humorless, literal machines that have the annoying habit of doing exactly what I *tell* them to do and not what I *want* them to do. They have no soul, no sense of aesthetics, or fair play. Invariably, the frequency of computer failure or foul-up is in direct proportion to the proximity of an impending project deadline. And that's only the beginning. Working with just a computer and a laser printer in a typical office is problematical enough. But now, we've added scanners and recorders, color printers and calibrators—all the paraphernalia of digital imaging—and the frustration level has soared into the stratosphere.

But I love computers—or at least what they enable me to do as an artist. All the reasons I first became a photographer have been reborn in the unlimited creative possibilities that I have discovered in the jumble of silicon, metal, and cables that now fill my office. No more am I confined by the physics of optics or the chemistry of film. Nor am I professionally pigeonholed any longer, having the freedom to work in illustration and fine art as well as with photographic images. With digital imaging, the only restrictions to creativity is the digital artist's imagination.

So, I have come to an accommodation with the dumb machines that, despite my innate distrust of them, have become essential not only to my income, but also to my art. It is true that the transition to accepting computers was made easier for me because I live and work

with my own personal computer guru—Daniel. So, that's a major reason behind this book—to provide other photographers, artists, illustrators, designers, and art directors with access to an in-house expert who has had to respond, on an everyday, working basis, to the questions and problems of a digital imager. But Daniel's technical guidance will be seasoned with my perspective of what it all means for the created picture and the creative businessperson.

My first piece of advice is to not let the computer intimidate you. After all, it's just a tool. It's no more than an electronic easel that holds your canvas, as well as your palette and brushes, filters and lights, lenses and templates, charcoal and paper, etc. An artist's workplace has never been so clean and environmentally correct.

Like any other tool of our craft, it must be used, experimented with, pushed beyond its established parameters to break the rules and thereby establish new artistic expressions. Is there an innate contradiction to merging technology with art? Sometimes, yes. But most of the time, I find that the technology becomes a boon that is somewhat transparent to what I am doing. To me, it's like driving a car along a beautiful country road. The driving is instinctive, because I have been doing it for years. I don't bother to worry about what is happening under the hood. Instead, I open the windows to listen to the birds and enjoy the landscape. Of course, I believe in being an intelligent consumer. So, when we go to buy a car, I have enough knowledge to ask the right questions and to recognize when a salesperson is laying on the spiel. I can read the gauges and not only know when the car needs oil or if I'm about to run out of fuel, but also how to pump the gas myself. And, if it were absolutely necessary, I could probably change a tire, though I'd rather call the AAA emergency line or Daniel. Still, I don't bother to think about all that when I am driving from point A to point B.

So, it has become with computers. I ignore the technology, except to use it to my best ability and to be able to choose the right piece of equipment or software to do the job. Because I don't live in an artistic utopia in which I could turn my back on such considerations, I've learned what is under the hood, to know what my next purchase should be, how much it should cost, and how to make my work easier, better, or smoother. And I have discovered what the machines' real or possible limitations are as a means to increase my productivity, recognize why things go wrong (when they do go wrong), properly plan out my projects, and challenge my inventiveness.

But, when it comes to imaging, I simply enjoy sitting back, taking untried paths just to see where they'll lead, trying a new brush stroke or filter. Metaphorically speaking, I revel in opening the windows of my mind to see what might fly in. If all the exciting, inventive, experimental work that I now do must be dependent on a dumb, hateful computer, so be it. I've never had so much fun or felt so creative.

Introduction

Make no mistake about it: digital imaging is here, today. It's not something that is looming on the near horizon. Already, digital imaging is beginning to create a profound and permanent change in the very nature of photography and illustration, and it will impact upon almost every professional in the visual arts field in the near future.

So today is a good time to learn what digital imaging is, something about the hardware and software, how it will affect your career, and what you can and should do about it.

Remarkably, only a handful of photographers, artists, designers, illustrators, and art directors have a clear understanding of digital imaging. And among those who do know, because they are actively making a very good living as imagers, few are willing to share their knowledge with others. Why? Because they're afraid that the more people who know how to do digital imaging, the greater the competition will become. Their fear is not without some justification. As the technology and the software that makes digital imaging possible becomes more affordable and accessible, a once rare and, therefore, highly paid skill will eventually become a more common ability. So, in the end, it won't be the ones who have the computers who will get the best jobs and money. It will be talent, artistic ability, technological sophistication, and good business sense that will determine the big players—just as it always has been. And, of course, the ones who get into the field earlier than others will have a major head start. That's why so many of those who are successfully imaging aren't talking.

Not surprisingly, a surfeit of confusion and misinformation runs rampant throughout the industry. Accurate knowledge about digital imaging knocking about the visual arts community is on the level of adolescent rumors about sex overheard in junior high locker rooms.

Therefore, the *raison d'être* of this book is to introduce digital imaging to visual professionals who need to know:

➤ Exactly what digital imaging is.

➤ How it will impact on their careers and business.

➤ Details about the kinds of equipment needed to do successful digital imaging.

➤ What all the jargon and technical terms mean.

➤ Insider's tricks and tips to putting together an effective and affordable system.

➤ How to go about using specific software or hardware.

➤ The truth behind the salesperson's spiel.

➤ Shortcuts on how to master any imaging program easily and creatively.

➤ Dealing with service bureaus and print shops.

➤ What prepress is and how to master its various aspects.

➤ How to adapt to changing client needs.

➤ Perspectives on inherent imaging problems and controversies, such as image copyright and ownership, the pros and cons of putting your images on CD-ROMs, the dilemma of color, etc.

We recognize that you might not yet be ready to put together a system for your studio, or may not yet want to learn how to use imaging software that allows one to manipulate and create pictures electronically. Even so, if you want to stay contemporary and competitive, and if you want to be able to respond intelligently to your clients' inevitable questions and queries, it will be necessary to acquire as soon as possible a good working knowledge of digital imaging.

Even if you aren't ready to go head first into imaging, we firmly believe that the more questions you ask, as a visual arts professional, the healthier our industry will be. Among the questions most professionals start out asking are very fundamental ones, requiring thoughtful answers. "What kind of equipment and software will I need?" "How will I use them?" "How will my business practices have to change?" "Will my relationship with my clients change?" "How much will it cost me, and how much can I charge?" But, as you begin to understand the complexity of this change in our industry, you will probably ask even more searching questions of yourself and the rest of us. "What are the ethical implications of imaging?" "Will our world change so much that there won't be a place for darn good professional photographers and artists who do things the traditional way" Finally, most return to the most basic questions of them all— "What, actually, is digital imaging?" Or, "Am I an imager?"

What we find most disconcerting about imaging is that many highly respected professional visual artists are so intimidated by the new technology and the uncertainty they perceive it represents, that they aren't asking the right kinds of questions that will get them the answers they want and need. For instance, when someone asks what kind of computer should I buy, he should instead be asking "What do I want to do with the computer?" Instead of wondering whether he should install *Photoshop*, *QuarkXPress*, or some other software, he should first determine in his own mind whether he will be working primarily with photographic images or illustrations or other forms of original art. Or, does he expect to become more involved in the production end of the process? What exactly does he want to do with those digital images he plans to create or manipulate? Are they going to be used for reproduction in a magazine, or as a print to be hung in an exhibition or to appear on the side of a cereal box?

Similarly, the question isn't "Must I buy a film scanner or film recorder?" It's "Who are my clients and what kind of final output will they require?"

We have made an effort to answer the questions that will have the most direct impact on your decision making process and your creativity. When we look at a potential purchase of a piece of equipment or software, we define "best" as the item that is required to do the job, with an eye to purpose, appropriateness and compatibility. In addition to answering the questions that we feel will set you off in the right direction, we have designed this book to provide you with the knowledge and understanding that will help you formulate your own questions—ones you will ask salespeople and your clients, and, finally, questions that you will continue to ask yourself about your place in this new and exciting industry.

Don't worry if you are not a "techie." We aren't techies either. Also, don't search for specific brand-name recommendations for digital imaging products. The market changes so fast that what's hot today may be obsolete tomorrow. Instead, we try to provide guidelines for evaluating for yourself any piece of equipment or program, even ones yet to be invented. Nor should you be intimidated by computers and software. They're tools, just like cameras and T-squares. As Sally said in her preface, we view computers and electronic gadgets merely as a technology that ultimately gets us to a creative destination. How it does that, we don't care.

All a digital imager really needs to know about technology is how to operate his or her computer, how to choose the right equipment and software for the job, and how to use it creatively and profitably. We hope this book will be a useful guide for you as you develop those skills and knowledge.

Like any other authors, we would enjoy hearing from you—hopefully about how our book has helped you, or, if not, why not. Please feel free to write to us about your imaging adventures and misadventures. Send us your questions, so that we may try to incorporate and answer them in future publications. You may contact us either through our publisher at

Windcrest/McGraw-Hill
13311 Monterey Lane
Blue Ridge Summit, PA 17294-0850

or leave us a note on MCI electronic mail to *DGROTTA*.

Thank you, and happy imaging....

Sally Wiener Grotta & Daniel Grotta

D IGITAL IMAGING has quietly become the nearly universal industry standard in the high-end, glossy quality segment of commercial arts and advertising. Here's a telling fact: Virtually all advertising photographs presently appearing in large circulation national magazines have been digitally edited, enhanced, or altered in some way. Until very recently, most of this work was achieved on multi-million dollar systems. Today, it's possible to produce the same effects on off-the-shelf Macintoshes (Macs) and IBM-type personal computers (PCs) at a fraction of the cost. In fact, professional-looking digital images can be created on a bare bones basic computer system priced at under $2000, though the ideal setup will probably cost somewhere between $15,000 and $50,000.

Traditionally, producing commercial images for advertising and other purposes has involved a sharply segmented chain of creative responsibilities. First, the client hires an advertising agency to produce and place its advertisements. The agency's creative director appoints an art director to create the image concept, which is then handed over to an illustrator to develop a working layout. After being fine-tuned and approved by the client, either a photographer or an artist translates that layout into an actual photograph or illustration. Next, that picture goes to a production manager, who shepherds it through a series of technical processes—retouching, type specing, stripping, color corrections—which are collectively known as *prepress*, and which are done by highly skilled professionals. The penultimate result of the prepress process is usually a set of color separations or master positives that will be used to make plates for a printing press. Finally, either a printer runs off thousands or millions of copies of the finished advertisement, or the color separations are integrated into a page in a newspaper, magazine, or book.

At least, that's the way it has been done until recently. But changing market pressures (reduced budgets, accelerated production schedules, demands for more novelty, etc.) coupled with professional realities (static income, greater competition, fewer clients, more productive use of time and equipment) and, of course, more affordable and easier to use digital imaging hardware and software have coalesced in such a way that the traditional delineation of creative responsibility is beginning to blur. For the first time, visual professionals have the means, as well as the motivation, to do everything from conceptualizing and developing dramatic, seemingly impossible pictures, to handling most or even all prepress processes. More and more, clients are asking visual artists to apply their creative skills with digital technology to produce new and novel images. Increasingly, art directors are expected to deliver their finished images in an electronic format. And, as is happening right now, clients are turning to those professionals who can provide a wider array of services that include computer manipulation, assistance in layout, and some or even all prepress responsibilities.

In other words, it is becoming an accepted fact of doing business that a visual professional should not only produce a good picture for a job but should have the ability to manipulate it according to the client's needs, do whatever color correction is necessary, and assist in placing it within the page. At the very least, today's photographers, artists, and illustrators might be expected, within a very short time, to be able to deliver their images electronically, on such media as a SyQuest cartridge or a magneto-optical disc. Remember, it was a few years ago that clients asked whether or not you happened to have a fax machine. Today, all they ask for is your fax number because it is generally assumed that anyone in business must use one as a matter of course. Technology has a way of being so integrated into the process of doing business that it's only a matter of time when clients will take for granted that a visual professional is digitized.

Bert Monroy, a photographer who now does all his work digitally, feels that "the creative process is greatly enhanced. In the old days, many times ideas couldn't be done because they weren't within the budget. Nowadays, you go as wild as you can." Creating or enhancing a photograph, drawing, painting or illustration can be a relatively quick and simple process. Even a neophyte can effect subtle or dramatic changes in a comparatively short space of time. Experts are creating incredible, sometimes mind-boggling images.

Retouching, spotting, or cleaning up an image in order to make a final good copy is far easier electronically than with a traditional brush or knife. Digital imaging confers upon the artist far more control over his picture. But with that control comes more responsibility, since he will no longer be able to point a finger of blame at the airbrush artist or color separator if the image is less than satisfactory.

By being able to provide retouching, type specing, and other services once farmed out to outside specialists, the visual professional has the potential for generating additional profits. Many art directors, given the choice of piecemealing and parceling out the various tasks that must be done to transform a visual idea into a finished image, would prefer to turn it over to one or two individuals only. Most clients feel the same about the art director they hire. There's less of a chance for mistakes and misunderstandings, and it could save time and money.

That a steadily increasing number of visual professionals are and will be using digital imaging technology to extend the range of the services that they can offer doesn't mean there won't always be demand for traditional visual artists who can provide darn good pictures and do nothing else. It's just that given images of comparable quality, and all other things being equal, those who are able to offer more services and assume greater responsibilities will probably be able to make more money per project. As clients become more savvy about what is possible with digital imaging, a greater percentage of their budgets will be going to the individuals and companies that can deliver digitized work.

How you position yourself in this reorganization of our industry involves re-examining your definition of yourself as a professional. Are you a photographer, artist, illustrator, art director or designer—or are you a provider of finished images?

According to Charles Altschul, a respected imaging educator and former director of the Center for Creative Imaging in Maine, "The potential is there to take more control over the production process, and with that comes the question of whether you want to become more involved in production issues or stick more with creative issues." Individual artists and photographers who develop digital skills are finding that they're being hired for their new abilities as much as for their primary crafts. Photo studios that invest in equipment to do digital operations find themselves becoming de facto design studios. Traditional design studios are getting involved in prepress for the first time, even becoming service bureaus.

If you are an art director, you, too, will find your workstyle drastically changed. You will have to become thoroughly (though not so intimately) familiar with virtually all aspects of digital imaging, from scans to color separations, from software capability to design possibilities. In addition, you will have to know something about the computers, peripherals, and accessories that will be used to create, manipulate, or process your project. You might not have the equipment or software yourself; you might be farming all the work out. But the more you know, the more specific your direction and control over the process will be, no matter who does it for you. In other words, you need to know what can and can't be done with this new technology. So, even though much of what we write here is focused on what the artist will be doing, it will have important implications for you as an art director.

There are four key ways that digital imaging can change the way you do business. Here are the processes that many visual professionals might find themselves involved in:

➤ The digital creation or electronic capture of images.

➤ The electronic delivery of images to the client.

➤ The digital manipulation of images.

➤ The digital design studio.

The electronic capture or digital creation of images

All commercial and fine art starts with one thing—the picture. Traditionally, the picture may be drawn, sketched, painted or photographed. However, in digital imaging, there are three choices:

❶ The image may be captured electronically by a filmless camera.

❷ The image may be created within the computer using various paint and illustration programs.

❸ The image may be created traditionally then scanned into digital form.

⇨ Electronic capture

Undoubtedly you have seen, read about, or even played with the new generation of filmless cameras (also called *digital cameras* or *still video cameras*). You might have dismissed them out of hand because they are considered far inferior to film in resolution and dynamic range. Yet, in many shooting situations—specifically, newspaper photography and catalog production—filmless cameras and conventional cameras equipped with electronic or scanner backs are equal or even superior to film-based cameras.

Take note: that's here and now, and not months or years away.

Filmless cameras capture pictures on photo-sensitive electronic chips (called CCDs) instead of silver-based film, and in a way that the information can be transported directly into a computer, even over phone lines. That's why newspapers are using them for fast-breaking stories, making it possible to get the images to the presses within minutes of shooting them, regardless of how far away the subject of the story is.

Commercial photographers who do a notable percentage of their business shooting pictures for catalogs are discovering that an increasing number of their competitors are switching over to filmless cameras and scanner backs. Because catalog pictures are relatively small and don't require a high degree of resolution, they are well suited to the capabilities of this technology. A single catalog can contain scores or hundreds of pictures, which means that even the initial higher cost of the camera will eventually translate into a dollar savings. (You will never need to pay for film or processing again.) If you do catalogs for a living, now is the time to rent a filmless camera or an electronic or scanner back in order to become familiar with how they work and what they do. Don't wait until a job comes through before learning how to use a filmless camera. There are a few significant shooting differences that must be learned, or else the image quality may be disappointing. Also, correctly interfacing the camera with the computer will take some trial and error. It's far better to experiment on your own, make mistakes, and learn from them, rather than go through on-the-job training with the client looking over your shoulder.

Filmless cameras are also excellent for quickly capturing elements that you want to incorporate in a computer-generated image. It could be done more cheaply with film but not as quickly, because that would require processing. Also, you would need to buy a film scanner or have a service bureau scan the traditional photograph for you in order to convert it into the digital data that a computer understands. For instance, suppose you are using your computer to create a fantasy scene of a woodland glade. In your kitchen, you notice that the water streaming out of your vegetable colander produces exactly the effect you want for a waterfall. You would just grab your filmless camera, capture the falling water, and transfer the picture to your computer—all in a matter of minutes.

If you are a newspaper or wire service photojournalist, you already have or will soon be required to use a filmless camera. If you are a commercial photographer specializing in catalogs or similar projects that involve small multiple pictures, get going or get behind the competition. But if you are just interested in capturing portions of the real world for digital imaging, wait out the technology a little longer, unless you have a rich uncle. As we speak, prices are going down while overall quality is improving. That's the nature of computer technology, including filmless cameras.

⇨ Digital creation of images

Artists and illustrators can achieve anything on a computer that they can on an easel or drawing board. What's more, they can do things with a click of a button that might have taken them days or weeks if they tried it the traditional way. The biggest difference is the limited, flat textures of the two-dimensional digital print, but that, too, is being improved with the use of some new, expensive specialty printers that can work with unusual kinds of paper and other textiles.

What can you do with a computer that you are now doing with a paintbrush, charcoal stick, or colored pen? Well, you can control your brush stroke with absolute precision, choosing between brush types, media (pastels, acrylics, charcoal, etc.) and surface reactions. What's more, you can combine media that just would never mix in the real world (like water color on concrete)—creating a rather dramatic effect. And these are just a *few* of many, many different possibilities.

Then there are the special effects of the type that were accessible only to a very few, technically adept artists before the advent of the computer. We're talking about computerized filters, scores of different textures, color inversions, and other techniques that usually take many months to master. Mastering them on a computer can be done in hours or even minutes.

Because the computer allows the artist to paint, draw, or sketch in many different mediums and in a fraction of the time that it would take to do by hand, it's not surprising that computer-generated art has already achieved a major foothold in magazine illustration. Children's books are being revolutionized by it. Art galleries and museums are beginning to display noteworthy digital images. And, as we mentioned earlier, advertising illustration has wholeheartedly embraced digital as its production standard.

It's not a matter of *if* the computer will become the universal creative tool for artists and illustrators—especially those involved in commercial or editorial art. It's merely a matter of *when*. So the sooner one gets involved in computer-related art, the better.

An illustrator's new competitors

It's not just your fellow artists and illustrators with whom you will have to compete for assignments, but with photographers and designers who are using computers to create images that cross over all the old boundaries. The delineation between illustration and photography is blurring as all computer creativity begins to take advantage of electronic montages, digitized textures, software paintbrushes and palettes, and photographic elements.

As digital imaging begins to snowball in popularity among visual professionals, we expect that a new generation of luminaries and superstars will emerge. Some of them will be newcomers to the field, but most will be traditional artists and illustrators who have embraced the new technology. In fact, fractal artists—those who use the random beauty of numbers to program computers for unusual, dramatic, futuristic designs—have already received a certain amount of acclaim. If you have aspirations for this kind of recognition, you'll need to start developing your imaging skills now because others are already well ahead of you.

Scanning traditional pictures into digital form

Photographs, illustrations, and paintings continue to be made the old-fashioned way, even by visual artists who are otherwise immersed in digital imaging technology. In fact, Sally uses her Leicas, Hasselblads, and Nikons rather than a filmless camera to capture most of her real-world images. They not only produce much higher quality images, but it's equipment that's already bought and paid for. A state-of-the-art Kodak DCS 200 filmless camera body costs $8000-$9000.

So don't throw away your cameras or sketch pad (at least, not yet).

Traditional photographs, illustrations, and paintings are easily imported into computers through the use of a device called a scanner.

In fact, if your work is headed for advertising or magazine layouts, it will be scanned at some point in the process. Scanning is a meticulous and time-consuming process that requires a moderate degree of skill coupled with expensive equipment. Someone will always be paid to do professional quality scans. It is possible that you might want that someone to be you or, at least, will want to retain control over who scans your pictures so you can profit from the service.

Most advertising agencies expect a quality of scan that is usually available only from a good service bureau. Top quality scans can cost from $75 to $300, and up, for each single image, and are done on equipment that can cost a quarter million dollars or more. Typically, the kind of desktop film or flatbed scanner that a visual artist would have in his studio for inputting pictures into his computer is generally not on the level of a service bureau's drum scanner. However, some jobs might be done perfectly well on a desktop film or flatbed scanner, which are getting better even as we write.

The problem is that scanning is still looked upon as something of a black art, requiring skill, finesse, and experience. Damon Torres of Nomad (a multi-media consulting firm), who was brought on-staff at *Spy* magazine to help them digitize their operations, said "The quality issues that I see mean a lot to me. I have seen fantastic and terrible scans from a wide variety of scanners that make me question the cost versus value and quality issues."

Here's how scanning will affect the way you do business. One, you could buy or lease a scanner and go into the business of providing high quality scans to other artists and photographers. The down side is that you might be heading for a creative dead end. Do you really want to become a scanning technician? True, it tends to be a remunerative position that helps to pay for the equipment you want to buy, but it's as far removed from being an artist as a builder of ovens is from being a gourmet chef.

Two, you could establish a working rapport with a service bureau that will make scans to your exact specifications. For your time and effort in overseeing the scan's quality and consistency, you might bill your clients the cost of the scan and add an appropriate markup for your services.

Three, you could do your own scanning, realizing that the quality of the scans you produce might not be equal in quality to service bureau scans made on hideously expensive equipment. However, your particular needs might not require high-end scans, and a desktop scanner may give you a convenient cost-effective means to get your traditional photographs and illustrations into the computer.

One way or another, you will probably have to become acquainted with the scanning process and the equipment used to accomplish it.

Not to do so will put you at the mercy of others who took the time and bother to learn about scanning.

⇨ The electronic delivery of images to the client

The scanning issue takes us right into the question of whether you should offer the option of delivering your images to your client on electronic media.

Right now, if you are an artist, illustrator, or photographer, you probably hand over original transparencies or artwork to a client when you have completed a job. Whenever you relinquish physical possession of an original to a client, you are entrusting a valuable, possibly irreplaceable composition that is about to undergo a complex production process. Besides going through the hands of more than a half-dozen people, it might have to be physically transported to several studios, production houses, or printing plants. That puts your original at risk, with the possibility of its being lost, stolen, misplaced, or damaged increasing every time it passes to another set of hands.

A better alternative is to deliver your work as digital data. You don't even have to own a computer or a scanner. What is necessary is to develop a professional relationship with a service bureau that has the means to take your photo, drawing, etc., scan it into the computer and then output it to a transportable storage medium, like a SyQuest cartridge.

The SyQuest cartridge

The SyQuest is a plastic-encased removable hard drive about the size of a small ceramic tile, which can hold digital data, just like a cassette recorder tape. SyQuest cartridges are a convenient means of transporting data from one computer to another, or from one location to another. In fact, the 44Mb SyQuest cartridge is so ubiquitous that it is considered the lingua franca *of digital imaging.*

If you have a SyQuest drive attached to your computer and use a service bureau, you don't even need to invest in equipment like a scanner, film recorder, or color printer. All you have to do is take your photograph or art to the service bureau to be scanned. They return it and a digital file on a SyQuest cartridge to you. Once you have finished editing or manipulating the image in your computer, you then save it to the SyQuest cartridge and send it to the service bureau or your print shop. Depending upon what you specify, they can output it to a color printer, imagesetter, film recorder, or even make color separations.

What is a service bureau?

A service bureau is the electronic equivalent of a photo lab, but instead of processing tanks and enlargers, it has scanners, computers, film recorders, and color printers. There are literally thousands of service bureaus throughout the country, most situated in cities and larger towns, that offer a variety of digital imaging services. Most can be reached overnight by Federal Express, or even instantly contacted by transmitting computer image files over the telephone. The term service bureau is interpreted in many ways, so know with whom you are working and what they can achieve before entrusting them with your precious images. See Chapter 33 about service bureaus and print shops.

Unlike slide duplication, digital copying to a SyQuest cartridge or some other media involves no degradation of the image when compared to the original digital image. (There are some technical and artistic limitations in transferring an original slide, print, or illustration to electronic form that we discuss later in this book. However, such limitations are already a part of the prepress process and have been out of your hands until now.)

From that perspective, electronic delivery makes sense, especially to clients who prefer a cartridge of data to an original. They might appreciate, and even pay extra, for electronic delivery.

However, don't think that you can simply dump all digital responsibilities onto your service bureau. In order for you to be able to distinguish scan quality, electronic color corrections and the all-important issue of compatibility with your clients' specific computer configurations, you must learn the lingo and have a thorough understanding of how the technology works. Luckily, any good service bureau can help you navigate this uncertain territory and hand hold you through the learning curve.

The two biggest questions about whether electronic delivery is a good career move are these:

➤ Do your clients want electronic delivery?

➤ Are your clients prepared to pay a premium price that would cover your service bureau costs and the added time you would spend providing electronic delivery?

Electronic delivery of your images might eventually become the industry standard, but that won't happen for many months. In the meantime, it makes sense for you to offer that option if your clients want it and if it is more profitable or more convenient for you.

→ The digital manipulation of the image

There is no limit to what you can do to a picture in a computer. It is possible to retouch a photograph or illustration so that it becomes quite perfect and the manipulation is not noticeable. Or you can change the original picture so drastically that you would never recognize it. Or, you may introduce unreal or surreal effects that make the picture more dramatic and dynamic and mark it as digitized.

If your work is commercially oriented—especially if it is directed toward high-end advertising or glossy magazines—as we have said before, someone is going to be paid to alter, edit, or manipulate your image. It might as well be you. Why let someone else change, retouch, enhance, or rework your images digitally—with or without your knowledge or approval? Why not assume more creative control over the way your images will appear in final form? And why not learn this skill so you can increase your income? Besides, it can be very satisfying, even great fun.

Getting directly involved in digital imaging does not mean that you must completely change the way you do business in one fell swoop. We suggest continuing to do business with your clients in the same way, but little by little, let them know that you can provide additional services for a bit more money. Offer to scan one of their pictures into your computer and change this or that. Once you have learned the basics and feel comfortable with the equipment, invite your clients in—one at a time—and give them a demonstration of what you can do.

As your imaging ability and access to the equipment increases, begin bidding for jobs that require digital manipulations of your own images. Then, finally, as you feel more comfortable and capable, develop a portfolio and marketing strategy based entirely on the digital manipulation of your own images.

The digital imaging field is wide open, and offers unprecedented ground floor opportunities for establishing yourself professionally. Like computer art itself, there really are no limits to where such a career move might take you.

→ The digital design studio

The final possible career move that we'll briefly discuss involves making a decision that could affect your very essence as a visual artist. Once you have an imaging system and the skill to use it for editing your pictures, you will also have the potential for controlling all the

processes involved in graphic arts—from design conception to delivery of color separations to the printer. All of it can be done quite masterfully by computer, by one person or one studio. The profit potential is very high.

Of course, such a move does require a considerable investment in equipment, software, training and staff. In the end, you will no longer be an artist, a photographer, or an illustrator. Instead, you will be a manager, an administrator, a technician. Expanding your job description also means taking on a huge burden of responsibility with each job. Unlike before, your work doesn't end with the creation and delivery of a picture. Rather, you'll have to shepherd those images through a complex series of steps, any of which could go wrong and foul everything up.

The more one gets involved in digital imaging, the greater the temptation to become a we-do-everything electronic design studio. If you are among the first, you will be able to carve out a chunk of this growing industry, which could mean big money, indeed. On the flip side, it could also mean big headaches, all-night sessions, a large capital investment, and the ulcers that come from so much responsibility.

Interestingly, electronic design studios will become major buyers of photography and illustrations because they will need new and novel raw material to work with. They will probably have openings on their staffs for those digital artists who aren't suited for management, don't have the capital for equipment, or don't want the ulcers.

There's a Darwinian process at work here as design studios start taking more responsibilities for the creation and production of finished digital images. How will this affect advertising agency art directors and account executives? As budgets shrink and clients start looking for more bang for their buck, they might go directly to the design studios and bypass traditional Madison Avenue companies completely. In the meantime, many advertising agencies will learn to depend upon electronic design studios as a means of cutting their costs, increasing their profits and streamlining their operations.

The bottom line

We recognize that there will always be a significant number of creative professionals who cannot or do not want to be involved in any aspect of digital imaging. This is because either they are temperamentally unsuited for mastering a new technology, or artistically disinterested in the medium.

If history is a good indicator, there will continue to be a commercial demand, albeit a steadily diminishing one, for traditional, well-produced photographs and illustrations. The invention of photography in the mid-19th century didn't make the fine artist completely obsolete, although the family portrait painter virtually disappeared as a staple of American life. And representative art (which could be achieved so superbly by photography) was overshadowed and eventually eclipsed by newer, increasing abstract styles.

Similarly, the photographer, artist, or illustrator who refuses to get involved with digital imaging on any level might continue for a time to enjoy a successful career, especially if she is well-known for specializing in a specific creative aspect. If she is able to redefine her medium in such a way that can't be easily mimicked on a computer, perhaps she'll even develop some renown. But there is a finite limit to how much market there will be for such people, and those who are only moderately talented will probably not survive the winnowing-out process.

We are not saying that traditional artists are a dying breed. In fact, the determining factor for success in computer art, as in any art form, will continue to be very traditional talents in design and composition. A good design and an artistic execution of that design is still what matters most; all the rest is just logistics. What is changing is that there is now a new medium for those talents.

Probably in the coming decades, art galleries, museums and collectors will become the ultimate outlet for those few remaining traditional fine artists and illustrators, as computers decimate their ranks in the commercial realm. Just as hand-tailored clothing and handmade furniture are highly prized and priced today, a select minority of traditional artists will attain a new position and rank within the community.

It's just that eventually, ultimately, commercial clients will choose to employ professionals able and willing to use digital imaging technology, because it is more cost-effective and because it speeds up and streamlines the creative process.

How quickly will this happen? It has already begun. As long as there are influential art directors who made their success the old-fashioned way, they will continue to assign commercial projects according to that pattern. But they, too, will have to watch out for the "youngsters," the new art directors who were raised and weaned on PCs and Macs and who will, naturally and instinctively, move to the sleeker digital milieu.

Among photographers, the deciding factor will be how quickly filmless cameras can attain a quality comparable and then equal to film. For illustrators, the changeover will be limited only by inertia. Digital is

here, now. But soon, even the original picture will be created or captured digitally.

(We hated writing that last sentence. For Sally, there's still nothing that can replace the joy of working simply, in the field, with her beautifully compact, almost perfect Leica M4. Her preferred method of work is to shoot on film, then to scan her pictures into one of our computers for manipulation. But she, too, will shoot with a Kodak DCS 200 or a Hasselblad with a Leaf back when clients need the speed and convenience of filmless photography.)

What kind of time frame can we predict, given the state of our industry and the projected growth of the technology? Over the next five years, the most innovative advertising campaigns will be digital. Within ten years, it will be the norm. In twenty years, it will be big news when a major ad is created by a traditional visual artist.

So the great majority of us have some important decisions to make, changes to accept, new equipment to obtain, and skills to learn, if we wish to remain commercially competitive. Those of us who get into digital imaging early, rather than later, will have an important lead on others who enter the field at a later date. But even the holdouts— unless they plan to retire by the turn of the century—will eventually have to accept reality and become part of the digital process to one degree or another.

But don't make that move to the computer desk, if that isn't where you belong. As we said before, there will always be a need for a superb picture. You just might be capturing and/or delivering it in a new way.

2

Profile of an imager

What does it take to be a successful imager?

A FRIEND of Daniel's used to be a successful freelance writer. Then, suddenly, one day he could no longer write. The problem was that he had a very established daily ritual that culminated in reading his morning mail, in preparation for getting down to work. When the local post office changed its route schedules, his mail started arriving in the late afternoon. He tried to change his daily ritual, but nothing would work for him. Every time he sat down at his typewriter (this was in the dark ages, before computers), his mind was unsettled, wondering what the mail might bring. Was there a letter from one of his editors or a check for the last piece or a response to his query to that new magazine? He just couldn't concentrate on his work until the mail came. And, by then, it was too late in the day to get anything done. Eventually, he quit writing and became a teacher.

Obviously, Daniel's friend didn't have the temperament to be a freelance writer because he required consistency and predictability—two factors that are in short supply in the freelance life. Luckily, he recognized this and made a career change while there was still time. Unfortunately, that meant that the world lost a talented writer.

We are frequently asked what it takes to be a successful digital imager. Like freelance writing, it requires tolerance to inconsistency and unpredictability. Imaging is just as uncertain as any other artistic lifestyle. But there is something you can depend upon: the same ingredients for success remain constant and apply to all creative businesses. Success will be based on a combination of talent, ability, technological sophistication, business sense, and that other, special, unidentifiable ingredient that gives a personality pizzazz. But a new dimension has been added with the computer, because technological sophistication means something quite different in digital imaging.

While there is a wide variety of personality types that have been and will be successful in this new field, people with certain temperaments generally have an easier time with it. Key elements include flexibility, patience, precision, and a sense of innovation. It also requires discipline, tenacity and stick-to-it-ness.

Computer heads

First and foremost, an imager is someone who can sit and work at a computer for long periods of time. The tunnel vision that develops is not unlike the concentrated intensity of closing yourself up in a darkroom to perfect a series of prints, only to emerge and find out, to your amazement, that the sun had set hours ago. Or it could be compared to sitting at an easel, so intent on getting the right colors and shapes for your composition that you don't realize that you have missed both lunch and dinner and have been hungry for hours.

This single mindedness that can focus on an artistic project until it is finished is a common trait among talented imagers. As one was heard to say recently, "Time flies when you're obsessed."

If you haven't worked on one of your own digital pictures yet, then you might not understand how or why anyone would be happy doodling away on (out of all things) a computer. Well, the fact is, if you have the right temperament for it, working on one of your own pictures on a computer can be an entrancing, hypnotic, often frustrating, but usually very satisfying experience.

The computer provides immediate feedback on everything you do, which means that you don't have to wait around for reinforcement or reassurance from a friend, colleague, or client. You know almost at once when you have done something very right. And, when you make a mistake, there are very specific and immediate ways to try to rectify it. In this increasingly uncertain world, such responsiveness and sense of being effective can be very rewarding indeed.

You can work with as much precision or as much flamboyance as you wish. Paint on the pixel level, exploring the colors and textures of the individual dots that make up your picture. Then zoom out to full size and splash wild effects on your image, just to see what will happen. Work as a pointillist or as a realist or just throw an electronic paint bucket to see how it will land.

Digital imaging allows the artist to follow through on a variety of "what-ifs." With the ability to immediately correct less-than-pleasing results, she tries alternative design options that would normally never be attempted for the lack of time.

Digital imaging can take you into a fantasy realm in which almost anything is possible—if only visually. You can position a downhill skier on the crest of a Hawaiian wave, a rhinoceros in a tuxedo sipping champagne at a gallery opening, or any other impossible reality, and make it look natural, almost believable.

On the down side, it is possible to lose yourself in the computer and let the world pass you by. Sally often is so intent on perfecting an image that she works through the night, never going to sleep.

After a few hours of staring at individual pixels, painting on them with such precision that each dot takes on a life of its own, your eyes can begin to cross and your back ache. Occasionally, when extremely fatigued, one reaches a creative plateau in which you can't decide what to do next. That's when it's time for a break.

Actually doing digital imaging is frequently frustrating. While the computer is so very fast, working as it does at millions of instructions per second, it never seems fast enough. It could take you 5–10

minutes to try a single effect, or 15–30 minutes to make a single color print. Some effects can take hours to execute. Also, computers are very dumb machines. They respond only to what you tell it to do, rather than what you want it to do.

Successful imagers are not only willing to put up with all the absurd time distortions, system limitations, and artistic obsessions that sitting for hours at a computer can involve. They are actually inspired by such an environment, and their creativity flourishes at a computer screen.

Digital creativity

The fundamentals of what it takes to be successful as a creative individual are the same regardless of the media you use. You will need to demonstrate innovation, reliability, control over the technology, and predictability. All that must somehow be combined with the ability to surprise, a sense of style, knowing how to finesse a composition, and enough familiarity with the classic conventions to know when to be devoted to them and when to ignore them. Plus, you should have an innate understanding of the power and psychology of color. Computer design requires the same artistic mastery as any other visual art.

Without such talent and skill, imaging is no more than a technology and much less than an art form. So, to be successful as an imager—if success is defined as being good at what you do and creating works of intrinsic value that are pleasing to others—you must have a gift for creative composition.

There is a strong tendency to confuse the medium with the message, to become overly enchanted with what the technology can do. We often see very clever but almost meaningless images that reflect excitement over what the electronic tools can achieve, rather than what the artist's vision is. The trick to being an effective imager, creatively speaking, is to use the technology, become so familiar with it that it is native to your work, without losing sight of who you are as an artist. As Gregg Truemann of Neographic (an electronic design studio in New York) admits, "I don't care how a picture was created. I just want a great picture that will fit the job."

Generally speaking, there are two schools of thought about digital design:

> ➤ Beauty is something that transcends media. Any picture should stand on its own, aesthetically speaking, with no reference to how it was created.

> ➤ The special effects potential of digital imaging are so spectacular that pictures created or manipulated on a computer should stand out as something different from anything you've ever seen before.

Both attitudes may be evinced by the same imager in different pictures. The important thing is to know when to use one over the other.

⇨ Business sense

Our industry is in such turmoil and transition that even those individuals making a living with computerized art are uncertain about what the keys are to running a successful imaging business. The first problem is that everyone has a different viewpoint of the nature of the imaging business. What's more, most have not clearly identified what their product is.

If you don't know what you are selling, how can clients be convinced to buy from you? Depending upon what you want to do with imaging, your product may be one of two things:

➤ A service that defines itself by the technology available.

➤ Works of art that happen to be created or manipulated electronically.

⇨ Imaging as a service business

Affordable digital technology has made it possible for many individuals and companies to take over the roles, responsibilities, and income potential that once were reserved to layout specialists, prepress houses, printers, and others who convert a picture into something that can be used commercially.

Electronic design studios (as described in Chapter 1) provide comprehensive services that can take a project from concept to development, execution, layout, color separation—all the way to the final display, advertisement, catalog or whatever it is intended to be.

Similarly, photographers, artists, and illustrators might discover that they can make inroads into otherwise difficult-to-crack markets or improve their positions with current clients, by offering digital services such as scanning, manipulation, electronic delivery, etc. Greg Truemann, who buys a considerable amount of visuals, acknowledged that given two artists of equal talent, he would tend to choose the one who could deliver his pictures electronically on a SyQuest cartridge or optical disc.

Others might find themselves providing digital services to former (and current) competitors. For instance, when a visual artist has invested a considerable amount of money to purchase an expensive slide scanner, should he consider providing a scanning service to his fellow artists in

order to help pay for the equipment? If so, should he continue to offer a scanning service once all the bills have been paid, or if it becomes a lucrative portion of his income, even if it means doing less and less of his own art?

Many photo labs, desktop publishing firms, printers and, yes, digital artists will try to become service bureaus. As we will explain in greater detail in Chapter 33, the term service bureau has become an ambiguous term that is loosely used to describe a wide array of companies offering various digital services (scanning, color separations, etc.)—many of which are defined situationally, as they go. Their uncertainty of what their niche will be is symptomatic of an industry-wide confusion. How can they decide what services they will be offering, if their potential clients don't know what services they will be needing?

Those who define themselves and their services clearly from the start will undoubtedly be the most successful—if the services they offer are ones that clients are willing to pay for.

When the product is the image

Here we are on more solid footing. Visual artists have been selling their pictures (or the right to use their pictures) for many centuries. So, if you intend to sell computerized images in a similar fashion to how you marketed your photographs or illustrations, it is just a question of revamping your marketing skills and letting potential clients know what kinds of pictures you can create.

We suggest that one of the first things you do is put together a new portfolio that focuses on your electronic images rather than your traditional ones. Then start hitting the pavement, making phone calls, and sending out your promotional mailings. Re-invent your professional persona to include your imaging skills. Make certain that you clearly communicate exactly the kind of jobs you can do and the type of assignments you are interested in obtaining.

To sum up, success in this kind of imaging business is based on talent and marketing *savoir-faire*, as well as knowing exactly what it is that you want to do and going after it.

Inventive portfolios

Every art director and picture buyer is besieged with picture postcards, mini-portfolios, promo sheets, and other paraphernalia that visual artists use in an attempt to catch his attention. Unfortunately, there's more than a kernel of truth to the saying that if you don't "Wow!" an art director during the first 2 seconds of his seeing your promotional piece, he will never remember it or you.

Digital technology offers a number of new techniques that might help your presentation or mailing stand out among the masses. If you are selling yourself as a digital artist, your portfolio or other promotional material should reflect your technological prowess, innovation, and know-how, as well as include several superb images.

Here are some ideas that we are providing, not as blueprints to be imitated but to point you in the right direction for developing your own unique high-tech self-advertisements:

- *Use electronic media, such as CD-ROMs, floppy disks or videotapes to give a lively presentation. (If you use background music, please stay away from the electronic stuff that's all beginning to sound alike.)*

- *Personalize a poster or picture with the likeness of the person whom you are trying to reach. (Try to get a publicity photo or some other snap of him from his secretary.) For instance, position him somewhere fantastic, such as in the middle of a rain forest, a Hobbit village, or talking to Godzilla. If you can't get a photo to work with, use their name, company building, or some other point of reference in the image. The idea is to make them want to keep the piece and even put it up on their wall. (Don't forget to have your name, address, and phone number on it, so that too would be displayed prominently in their office.)*

- *Rent a filmless camera to take with you on an interview with the potential client. (Be sure you do some test shoots first so you know how to handle it properly.) You might want to bring along a portable computer with a paint program to immediately demonstrate what you can do with your just-shot image right then and there. When you send a follow-up letter, include some printed manipulated images that put the person or her office in humorous, romantic, absurd, or otherwise intellectually intriguing locales or situations.*

The idea is to impress the potential client with your digital imaging savvy, so that he will always remember you and what you are able to do when he considers commissioning something that would require digital imaging.

⇨ Making the sale

The old saying that "talent will always win out" doesn't apply any more, if it ever did. We know many very talented people who will never get very far, at least not in terms of modern standards for success. They might be geniuses, but unless a client knows who they are and what they are capable of doing, they might as well live on the far side of the moon.

Unless you can actually make the sale, land the job, and get the return business, financial success will remain an elusive goal.

There are several steps to consider in your marketing strategy:

➤ Know what it is that you have to offer that is unique or exceptional.

➤ Zero in on how the product or skill that you have to offer would benefit the potential client.

➤ Discover what the potential client's own goals are and clearly explain to him how using your services or buying your images will help him attain those goals. Always describe what you have to offer in terms of those objectives.

➤ Don't beat around the bush. Tell the potential client what it is you want. If you want to stop by next Tuesday to discuss how you might fit into his future projects, say so. If you want a specific assignment, ask what it is that they are looking for in the person to whom they will award that job, and be certain to tell him that you would like to be considered for it.

➤ Follow through, be consistent and reliable. Always do what you say you will do, and when you will do it.

➤ Leave something for the client to respond to or do that requires more of a commitment to the relationship than just saying yes or no. (When given a choice, most will automatically say "no" simply because it requires less effort.) For instance, don't ask if they are looking at portfolios; ask what would be the best time for Mr. Jones to see your portfolio.

➤ Make the contact a relationship. Be personable without becoming invasive. Recognize the potential client's problems and provide solutions to them, whether or not they relate to the service or the product you have to offer.

➤ Ask for the job.

➤ Thank the client for the job.

➤ Ask the client if he was satisfied with the job. And if not, don't leave until whatever problem or conflict existed has been resolved.

➤ Ask the client what new projects he is planning and to consider you for that assignment, too.

The common thread running through all those steps is for you to demonstrate clear, articulate, unambiguous communication skills. Of course, the other side of the equation requires grace, good will, and keeping a human face to all business transactions so that the client enjoys hearing from you and working with you.

If you follow through with personable interaction and a clearly defined purpose, coupled with talent and ability, then you have boosted your chances for success.

⇨ Element X

But we all know that there is some other ingredient to success that no one has yet defined clearly. It's that something extra that sets one person apart from the crowd. It might be visual art's equivalent to Hollywood's star quality. Conventional wisdom is that you either have it or you don't. We wonder if it can't be developed.

This element X appears to have something to do with a person's self-esteem, which is not to be confused with arrogance. In some individuals, it is also expressed as a sense of joy that seems to be contagious. Or you might recognize an aura of liveliness or creative energy, the feeling that she is destined for success.

Even if others have more talent, greater business savvy, a higher degree of technical sophistication, the person with element X will be the one to get the job. The client trusts, respects, and feels safe around people with it. He knows that the job will be done with flair, intelligence, and style. Besides, everyone prefers working with a "star," with that individual whom everyone else recognizes as the artist who shines brighter than the others.

So, what is element X? It's an ephemeral, almost transcendental quality that makes the person scintillate. We have a suspicion that it's really only being yourself, if yourself is a great person to be.

If you don't have it right now, don't be fatalistic about your potential for success. Study the people who got the job you tried for and missed out on. Try to understand what it is that they have and you don't. And, if possible and desirable, develop those qualities in yourself. Eventually, you might be the person others will be studying to understand what element X is.

3

Common-sense tips for closet computer phobiacs & others new to computers

C OMPUTERS have become an essential part of our world. They are everywhere, making life more productive, making life more complex, measuring the value of human endeavor by bits and bytes, and making demands of us as though they were the intelligent beings and we only the automatons. No wonder there are millions of capable, accomplished individuals who fear, hate, or otherwise find it difficult to function with computers.

The thing is that computers are merely dumb machines that exist only to be told what to do. They don't merit such an emotional reaction. We're not saying that the discomfort that is often felt the first time a person sits at a monitor and keyboard isn't valid. Of course, it is. Any adult who is used to being adept and knowledgeable will feel uneasy about his lack of ability to conquer—immediately—something that has become (literally!) child's play in our society.

Starting from scratch

If you have decided that you really do want to get involved in digital imaging, the first thing you must achieve is a comfortable working relationship with the technology. This is really much easier than it may sound; it just requires some patience and letting go of old fears and prejudices.

First, it is necessary to accept the situation as it currently stands. You might not know anything about the computer, or what you know might not be enough. Okay, that can be corrected.

The most brilliant geniuses we know are the ones who are always ready to learn something new. Put yourself in their league. Enroll in a class that will take you away from your everyday distractions and immerse you in a one-on-one relationship with a computer. (See Chapter 19 on learning imaging.)

The best classes are those that are concentrated, last several days (in a row), and relate directly to what you want to do on the computer—i.e., imaging. (Forget about the many courses offered on computers in general, programming, or other subjects that have nothing to do with imaging.) Of course, these courses require an investment in time and money: such seminars typically run between one and three days, and cost, on average, $300–$500 per day. For your money, you usually get exclusive use of a computer, instructional materials, sometimes a major piece of software, and the advantage of a low teacher-to-student ratio. Because you concentrate on learning only one thing, your chances of developing a working familiarity with it in that brief period are probably better than trying to learn it on your own over a period of weeks or even months.

The down side to these seminars-in-a-hotel is that you might not be able to afford the money or the time, at least for now. There are evening classes at local schools, as well as free (or nearly free) seminars sponsored by manufacturers and stores that will take only a few hours out of one day. Look in the business section of your newspaper for computer or graphics trade shows that might be coming to your area, which often offer hands-on workshops. Whatever instructional program you choose, make sure that it will allow you to sit at your own computer for the entire class, actually working with the machine as you listen to the instructor. That will provide a decent start to help you get over the initial sense of unfamiliarity.

If you can't get to a class, things might be a bit difficult but not impossible. Unless you are a particularly strong-willed individual, we suggest that you not try to do it all on your own, at least in the beginning.

Go to a friend's studio or office and ask her to show you how her computer works. If she's a really good friend, she might let you experiment with the computer. Perhaps, you could offer to input some data for her, if she would show you how to do it. (Everybody who has a computer is always behind in keying data into their mailing list, spreadsheet, database, etc.)

Stop in at a computer store—not to buy, but to just sit down at a computer and have someone show you how to make it do whatever it is that it does.

Don't just watch demonstrations. Whenever you can, get your hands on a computer, watch what happens when you move a mouse around, or type in a few words. Ask to see some imaging software, such as *Photoshop* or *IntelliDraw*. Play with it to get a feeling for what imaging is really all about.

When you are just starting out with learning how to function with a computer, your best bet is to relax and let things happen. Don't try to take control right away and don't expect to make everything perfect on your first try.

 When first approaching a computer, be patient, take it easy and have some fun with the learning process. You might even want to play some computer games before moving on to more serious applications—just to get a feeling for the cause and effect relationship between working the keyboard or mouse and what happens on the monitor.

How long will it take before I feel comfortable with a computer?

At the Center for Creative Imaging in Camden, Maine, which is presently the Harvard and Oxford of digital imaging, they teach a pre-course evening class about how to work with a Macintosh computer. It usually takes them only three hours to get absolute novices ready for serious imaging. You can expect that any good class will have you comfortable with a Mac in a similar length of time, because it is the easiest computer to learn.

It will probably take a little longer to learn how to use a PC, although the *Windows* environment (which is what runs most imaging programs) has so much in common with the Mac that most people respond favorably to a well-structured class of three or four hours. However, going from novice to intermediate user will require more time and experience on a PC.

HINT Without question, the most "user-friendly" computer system is the Macintosh. Keep in mind that being an *easy* computer to learn and master isn't the only criteria for an imaging system. But if you are uncomfortable with technology, it makes sense to consider buying the machine that is easier to learn and use. (Please see Chapter 7 for a comparison of Macs and PCs.)

Making friends with a computer

Sally anthropomorphizes machines; it's how she makes friends with the inanimate objects that rule our lives. Thus, our car is "Butter," her Leica M4 is "Baby," her Comtrade 486 WinStation is "GIGO" (computerese for "Garbage-In, Garbage-Out"), and our Macintosh Quadra 700 is "Max," for some reason that not even she understands. The point is, she has turned all of these machines into characters with whom she has a personal (if occasionally rocky) relationship. For her, if a *thing* can be perceived as having a personality, then, even if it doesn't always behave as she expected or needed, it isn't because it's a cold, inanimate object. Besides, if she has a relationship or a rapport with the equipment, then she feels that she can create with it. Unfeeling, uncaring things just don't inspire her to artistic heights.

Sally's solution might seem silly to some, but it works for her. Others who work daily with computers find it reassuring to remember that the machine is nothing more than a dumb, stupid box with no ulterior motive, no soul, no purpose but to respond to their commands.

Each person has to come to his own accommodation with computers and other equipment. How you achieve this is mostly a question of pragmatics, of what works for you.

When you sit down at the keyboard

The first time you approach a computer—face-to-face—don't expect too much of yourself or of it. As with any initial meeting, it is normal to feel uncertain. It's like meeting strangers from a different culture. The language might be different, almost foreign, and you don't quite know what is expected of you. Don't recoil in a corner, like a Colonel Blimp-type party-goer who is annoyed that nobody speaks English and that the food doesn't look like anything he has ever seen. Dive right in and see what happens.

The following is a quick overview of what you will see in front of you. We are keeping it as simple as possible to make it obvious how easy it is to understand a computer. Of course, you probably already know all the very basics, but it doesn't hurt to review them before moving on to more complicated aspects of working with a computer.

➤ The *monitor* or *screen* is the TV set-like contraption that shows you what is going on in the computer.

➤ The *keyboard* is where you type in commands (like a typewriter) to make things happen in the computer.

➤ The *pointing device* is a *mouse*, a *stylus* or a *puck* which sits on your desk, next to the keyboard. When you move the pointing device, it causes the *cursor* to move around on the screen. (The cursor is an arrow, blinking line, or other symbol that indicates where you are on the screen and where any command you type or choose will take effect.) Generally speaking, you choose or activate an object on the screen by putting the cursor on it and clicking a button on your pointing device once. Clicking twice might reveal options associated with the object.

➤ None of the above is the computer. They just allow you to communicate with the computer, which is a metal box that holds the CPU (its "brains"), the memory and disk drives. The computer is also what connects to any accessories or peripherals that you may use, such as a printer, scanner, film recorder, etc.

All you have to do is watch the monitor, as you use the keyboard or pointing device, and see what happens.

Remember, the cursor is where any command will take action or any words will be typed, so keep an eye out for where the cursor is at all

times. Practice controlling it with your pointing device or with the arrow keys on your keyboard. And read all messages on the monitor to understand what the computer wants you to do next.

Of course, when all else fails, read the documentation, which is the book of instructions that comes with every computer, accessory and software program.

Take a clue from the way computers function. They are just machines that can do one thing at a time—albeit very quickly. When you are learning how to use a computer, and even after you are very familiar with it, break up each job into its various steps. Do one thing at a time, and, before you know it, you will have control over the entire process.

Many of the chapters in this book, especially those in Part Two (Imaging Hardware) and Part Three (Imaging Software), go into much more detail about how to interact productively with computers, programs, and all the other paraphernalia that comprises an imaging system. This is just a quick, superficial overview of the fundamentals.

Home alone

The worst mistake anyone can make would be to buy a computer before they have actually used one. But, eventually, at the end of the odyssey of trying out the technology, of learning to feel comfortable with it and then either buying or leasing it, there will be that moment of truth—when you are home alone with your new machine.

Of course, you can pay a technician to come to your home, office, or studio and set it up for you. (Some vendors include equipment set-up in the cost of the system. If not, look up consultants or repair under the computer section of the Yellow Pages.) He will make all the connections and assure you that, when you turn on the power, everything works. But what do you do next, after that person leaves, and you are staring at the blank screen of your expensive new investment?

Hopefully, you already know how to start it up and get into a particular program. If you don't know those kinds of basics, you weren't ready to purchase the computer in the first place. No matter. Either grit your teeth, put the instruction manual between your knees, and try to learn on your own (not recommended), or get to a class or a seminar. Back in 1980, when we got our first computer and faced the same dilemma, we called the computer teacher at the local high school and asked him to recommend his brightest student to help us get started. Obviously, it worked, which is why we suggest checking with a nearby high school or college and offer to pay a computer

wunderkind to come into your studio and teach you. (You might even catch the interest of the computer teacher himself, if he is looking for moonlighting work.)

Once you have the machine turned on, it's time to learn how to use a particular program. (Please see Chapter 19, "Beating The Steep Learning Curve.") The most important hint we can offer you is to set aside a specific time in your day—or, better yet, an entire weekend—that you are willing to give completely to practicing with the computer. Trying to fit learning the computer into your normal, everyday, busy schedule is self-defeating, because other things will always take precedent—an urgent phone call, a crisis in the darkroom, bills to be paid, a client to be won, etc. Distractions can be fatal, because they prevent you from concentrating on the matter at hand. That in turn will increase your sense of frustration when you perceive that you haven't gotten a handle on the damn thing-a-ma-jig yet. Take our advice. Don't put yourself into a hard-to-succeed situation. In fact, whenever Sally has to learn a new program, she closes the door to her office and turns off the phone's ringer.

Take the program's tutorials, experiment with its tools and the possibilities that it offers. When you get into difficulties, get on the phone to ask the advice of friends, salespeople, etc. (Please see Chapter 36 on getting technical help.) If possible, take a few more seminars on specific programs. Also, get into the habit of dropping in at computer stores during your lunch breaks and asking all sorts of questions. Eventually you'll find a semi-expert willing and able to answer most of your more pressing questions.

Before you are aware of it, you will have developed a comfortable familiarity with the machine, using it to create images and manage your business. Pretty soon, you will be the one who is helping other friends get over their uncertainty about computers, when they come over to your studio to try their hands at it.

4

The question of copyright

Does computerized art compromise ownership rights to intellectual & creative property?

CHAPTER 4

I T IS SAID that one of the first cases of copyright infringement was in sixth century Ireland. St. Colmcille, while visiting Finnian of Moville, discovered that his host had a copy of a rare book. Colmcille coveted the book, but Finnian declined to give it to him. When Colmcille was caught secretly copying the book in the dead of night, Finnian took the case to the High King. The High King decreed that since the copy was made without Finnian's knowledge or permission, Colmcille would have to turn over his copy to Finnian. Colmcille was so outraged that he rallied the countryside to civil war, actually inciting some battles, which led to his excommunication and exile. (Colmcille was eventually reinstated to grace, or we wouldn't have started this tale by calling him St. Colmcille. But he never got the book.)

Copyright remains an emotionally charged matter, although in this day we stop short of literally going to war over it. (International trade sanctions may be imposed, however, which is the commercial equivalent of war.) As in the sixth century, modern law remains strongly on the side of the holder of the copyright (which is usually the creator). However, some unenlightened business practices, aided and abetted by advanced technology, are constantly eating away at those rights.

Now, digital imaging has arrived and, with it, the ability to perfectly duplicate pictures without the artist ever finding out about it. With digital duplication, there is no degradation of quality, even if you are looking at the fifth or the five-thousandth copy. Knowing this, a number of visual artists are concerned that digital imaging might be a threat to their rights of intellectual property and—more to the point— a danger to their future income.

Let's put this into perspective. Artists and photographers have been sending *originals* to clients through the mail for years. The trust that implies is considerable. If the original were lost, damaged, or stolen, it would be gone forever. Such a loss is measurable in the time, talent, energy, and expense it took to create the picture, plus the potential income it represented. For that reason, originals are probably an artist's most valuable assets. Although it would be far easier and safer for artists to send copies, no client who is doing high-caliber reproduction for slick ads or glossy magazines wants to work from anything other than the original. That's because, with conventional duplications, the quality just wouldn't be the best. So, most of us have accepted the risk involved in sending out originals by Federal Express or UPS as part of the cost of doing business.

Some visual professionals perceive digital imaging as a greater risk than even sending out originals. Yes, the potential for problems is there. However, while the nature of the technology has made it inherently easier to have one's work pirated, don't blame it on the machines. The problem now, as it has always been, is with people.

And it's the same kind of people we have been dealing with for years. Some are honest; some will try to get away with whatever you let them; some will out-and-out cheat you, if they think they can get away with it. Of course, there are few black and white absolutes in business, so you are likely to encounter individuals who have some of the characteristics of all those types, depending upon the circumstances and the state of the negotiations. Also, the new temptations made possible by digital technology might cause some clients who have previously honored the artist's ownership rights to consider new, less respectful practices.

We can't stop the flow of time or the advent of digital imaging. It is here to stay and is opening exciting creative and financial doors to those of us who are ready to take advantage of them. Instead of flailing at what cannot be changed, we must take the opportunity to help shape the future of our industry (during this period of change, when it will be most malleable), so that it will be healthy, energetic, and innovative. That way, it will endure as a source of income and satisfaction for both the artist and the client for years to come.

The client's vested self-interest in our creativity

The most central question to this whole discussion is whether or not our society wants to continue to benefit from the advantages of creativity. For most of the twentieth century, we have witnessed a glaring example of what happens to an ideologically-blinded country or bloc of nations when creative people cannot reap the rewards of their efforts. If artists, writers, and other innovators can't make a living out of developing new images, new ideas, new challenges, they very quickly learn to stop trying. Their society becomes a place where the status quo is enshrined, and mediocrity is rewarded over genius. Progress grinds to a screeching halt because there is no incentive for change, and the economy heads toward collapse. How else could one interpret what happened to the Soviet Union and communism?

When creative individuals can no longer make a living doing what they do best, it is society, and especially the commercial realm, that suffers. Do we really want our best and brightest to be pushed so far that they won't be available when we need them?

Let's bring the case closer to home to help make our point. Our clients' own income depends on their ability to obtain evocative images that will get their message across to the public. If clients insist upon paying as little as possible for an image, as well as reducing the artist's potential for income from future sales of that picture, then, they are in effect, diminishing the viability of the creative marketplace.

As the dollar squeeze becomes more severe, more and more artists will change careers. The net result would be that it will be more difficult and, therefore, probably more expensive, to obtain quality images in the future. That's because fewer working professional visual artists with the experience, skills, and talent required to do the job will be left in the field.

We are not arguing against a free market, competition, or shrewd negotiations. Quite the contrary. In fact, we believe that creative professionals should arrive at the bargaining table with as much ammunition as they can muster. This includes the recognition that we are all in the same industry—client, art director, and artist. Our survival is inexorably intertwined, which gives us all the more reason to be pragmatic when necessary and to leave some meat on the bone when negotiating.

Keep the long-range goal in front at all times, so everyone can see it: an industry that continues to support its own future by maintaining the viability of the creative marketplace. Then come to some neutral ground compromise that will make all parties pleased that they will be working together on the project at hand (and, hopefully, on future projects). The client's vested self-interest is to ensure that creativity not just survives but thrives, both financially and aesthetically. It is in our vested self-interest to help them and our fellow visual professionals realize this. If we achieve that, then no technology, no matter how sophisticated, will be a threat to copyright.

Who owns the copyright to your image?

We do not claim to be attorneys and would never give advice about legal matters. However, we will pass on to you what we have been told by people whose expertise we respect. Of course, check with your own attorney or professional association representative, if you are choosing among various options that might affect your legal standing.

When an image (called "the work" in legalese) is created, the assumption is that it is automatically the copyrighted property of the creator—if you're an independent creator working on your own initiative. It becomes much murkier if you are creating on commission from a client, especially if you are working from a preliminary sketch or illustration. Then it's best to establish the copyright and other concerns in writing before you take the commission.

Many agencies now demand that their creative providers sign "standard form" contracts, memos, purchase orders, etc. that have terms transferring ownership of the copyright or other control over your intellectual property to them. They do this as a matter of policy, just to see if you will accept the terms. It's okay to argue the small points, but watch out for the big clauses.

For example, be wary of phrases in the fine print that say something like "work for hire" or "all rights." These are becoming increasingly

common, not only as an attempt to wrestle ownership of an image away from its creator but as a means to avoid the potential tax implications of having you on the books as an employee rather than an independent contractor. However, the implication of being a "work for hire" producer might mean that whatever images you produce could become the company's property.

Read the small print carefully, before you sign any contracts, accept any purchase orders, cash any checks, or allow any of their paperwork to stand as delivered. We rarely accept any contract as it comes from the client. Instead, we read every word and paragraph, cross out or append where appropriate and, even, tear up that contract, substituting one of our own design. For the most part, doing this has not hurt the artist/client relationship. In fact, it probably has made them respect our professionalism even more. The only problem we've had is getting the contracted terms honored afterward (i.e., getting paid), but that happens in every field.

If you want the ultimate legal protection, you might wish to register the copyright of your images with the U.S. government. To save money, you can copyright as many images at a time as you like, so long as they are in a single document (like a sheaf of your images informally bound into book). At present, you can't use a Photo CD to register your images with the government; that will probably change. There's even a movement afoot that will automatically grant copyright protection to an artist or a writer at the moment of creation without having to register it first in Washington.

Forms and information may be obtained from the Register of Copyrights, Library of Congress, Washington, DC, 20559, (202) 707-3000.

⇨ The creative business

We can hear the comments now. We're artists, not CPAs or lawyers. That is one of our chronic conundrums: the creative life isn't what we expected it to be, and we weren't properly prepared for it. If we had known, perhaps we would have gone to business school instead of art academy.

All we ever wanted was to make beautiful pictures and let the business end take care of itself. Unfortunately, that's not a realistic option. Even in Michelangelo's day, an artist needed patrons or clients to pay for paints, models, and household expenses. The only difference is that, today, everything is more complex, and modern commercialism has provided us with a wider array of possible clients, as well as a multitude of competitors for their patronage.

The creative life, if it is done right, is a business in which the end result is beauty—but not beauty without respect and income. So if there is a threat to our copyright, to our reaping the benefits of our

intellectual property, we need to accept our responsibilities as astute businesspeople. That's because such a threat will cut directly into our ability to make a living, pay our bills, maintain a home, keep a car, put food on the table, and maybe even have enough to help the kids through college. Copyright and intellectual property are not some highfalutin, esoteric concepts. They are the foundation blocks on which we build our business.

So we are not only artists, but businesspeople who have a responsibility to ourselves, our families, our clients, and our industry. In the question of whether digital imaging threatens copyright, our responsibilities are threefold:

➢ To become familiar with what can be done with digital technologies.

➢ To protect ourselves to the full extent that the law provides, while maintaining friendly relations with our clients.

➢ To promote and participate in education and increased general awareness among clients and the public as to the value of and need for respecting intellectual property.

A quick CD-ROM glossary

A CD-ROM (Compact Disc Read Only Memory) is a compact disc that can hold prodigious amounts of digital information, which might be images, an encyclopedia, or any other data destined for a computer. Identical in appearance to audio CDs, the difference is in the kind of information that they store. CD-ROMs are written to once, by the manufacturer. The end user can read from this disc but not write to it.

Photo CD is the Kodak system of storing photographic images that are scanned with Kodak's equipment. Just as the Xerox name should not be used when you are talking about generic photocopies, Kodak is attempting to maintain trademark integrity with their Photo CD name.

CD-WORM and magneto-optical (MO) discs can be written to, once for a WORM disc and as frequently as the user wants on MO discs.

By the way, a disc (with a "c") always refers to the plastic media that is read (and sometimes written to) by a laser, such as CDs, CD-ROMs, and Photo CDs. A disk (with a "k") is media that is read (and written to) by a magnetic coil, such as floppy disks, diskettes and hard drives.

See Chapters 12 and 15.

CD-ROMs: Marketing advantage or copyright black hole?

Probably the most feared and least understood imaging technology is the CD-ROM. We've all heard the horror stories—which, unfortunately, are based in truth—about CD-ROM publishers buying *all* rights, including world rights, to photographic images for as low as $25-$50 each. There's even a company that buys non-exclusive rights to reproduce your photos in any computer-based glossy or electronic magazine for a measly $2 each. Talk about devaluing the currency; they are forcing the value of images, yours and ours, to plummet through the basement. The problem is that many of the publishers of these CD-ROMs originate from the computer world, not the graphic arts world, so they themselves don't understand and seemingly don't care about the true value of professionally created pictures.

It's easy to protect your images from those lowball schemers; don't let them get their hands on your pictures. If your clients suggest using images from these high-volume, low-priced CD-ROMs instead of commissioning you to produce original art or buying from your stock library, just smile and help them to understand that even if the quality is good and the resolution high enough (both of which is often doubtful), the pictures are so non-exclusive that they will appear *everywhere*. Ask them: Do you *really* want to have your product, service, or company represented by the same image that everyone, including your competitors, could also be using? Does a corporation want to publish the same picture to sell a deodorant soap that a mail-order condom vendor could use to hawk French ticklers, just to save a few dollars on original art?

CD-ROMs are simply digital storage media, just like floppy disks or SyQuest cartridges. What makes them unique is that they are very inexpensive to produce in large quantities (about $2 each) and can store staggering amounts of information. How large? The entire text of the Encyclopedia Britannica could be stored—twice!—on a single 4.75" CD-ROM.

Images put on CD-ROMs can be of any resolution. When a stock photo agency produces its catalog on a CD-ROM for distribution to its present and prospective clients (something that is happening throughout the industry), all the pictures on the disc will be low-resolution images. Low-resolution images are well suited for fast viewing on a computer, and it's possible to stuff hundreds or *even* thousands on a single CD-ROM. (High-resolution images take up more space.) While a client could, if they wished, appropriate images from the CD-ROM for use without paying for them, the reproduction quality is too low for most commercial applications.

What the client does with these CD-ROMs is peruse the images on a computer screen, select the picture or pictures they want to buy, and then arrange to purchase those images in a format that can be used commercially—a transparency, print, or high resolution file on a cartridge.

It should be pointed out that there is some controversy associated with low-resolution image files. Their actual usability will depend upon how large the final printout will be and just how critical (or particular) the user is about image quality. Some skeptics feel that low-resolution files might be made better by using imaging software's ability to interpolate—duplicate existing data, so the picture appears as though it is better than it really is. Interpolated images are not considered fine quality, but a client who doesn't care about the ethics of stealing a picture might not care too much about the quality of the picture. Also, what is low resolution when printed at a size of 8"×10" could be very acceptable resolution when used in a 2"×2.5" ad.

Other digital media

Recognizing that CD-ROMs are just another storage media for digital images—albeit one that will be proliferating at an incredible rate within a short time—let's look at other digital media before going further into the question of the potential for copyright infringement.

The biggest difference between CD-ROMs and other media is that, generally speaking, you can only read CD-ROMs, not write (save files) to them. That's why the storage media that the vast majority of computer artists will be using to deliver pictures will be SyQuest cartridges, tape cassettes, or magneto-optical discs. Floppy disks are impractical because any one image file would fill several, if not dozens, of floppies. (See Chapter 12 for a discussion of storage devices and media.) As with CD-ROMs, there is nothing inherently risky about using these technologies. The deciding factor of whether an image can be used for anything other than viewing on a computer monitor is the quality and resolution of the image, and the size of the image file. So, when you ship an image file, you can control just how usable it will be.

A calculated risk

Once you begin delivering your work electronically, you will be shipping high-resolution image files to numerous people and companies—just as we have always sent out original transparencies and illustrations. The only way you can avoid sending out your images—putting them at risk—is if you never sell any publication rights to your pictures. In other words, you can guarantee your images

will always be safe and never used in an unauthorized manner, only if you stop being a commercial artist. Letting someone else have possession of your digital images is the kind of calculated risk that one must accept as a cost of doing business.

However, you can protect yourself against theft of your images by using several different approaches:

➤ High-tech protection schemes.

➤ Intelligent negotiating, contractual and licensing practices.

➤ Develop a relationship with your clients based on mutual self-interest, respect and trust.

➤ Using a safe delivery service (which has nothing to do with copyright but a great deal to do with security).

 # High-tech copy protection schemes

Software manufacturers have long had a similar, if not more rampant problem. The computer programs that they sell are like digital images—intangible products that are nothing more than data on storage media. But the effort, time, and money that it took to develop the data were extensive, and it has value to users. Yet, when some people buy the programs, they feel that they own not only the copy that they purchased, but the right to duplicate the programs and hand them out indiscriminately to their friends. After all, why pay $500 for a second copy of a program for your secretary when all it takes is five bucks' worth of blank floppy diskettes to make a copy?

Illegally copying and distributing software is as much an infringement of copyright and an assault on the concept of intellectual property as the unauthorized use of one of your pictures. (If you are a visual artist who cares about his own intellectual property, remember your concerns when a "friend" offers you an unlicensed copy of some software he purchased or otherwise obtained.)

To counter software piracy, manufacturers developed a variety of copy protection schemes. One of the least popular is a hardware lock, a small "black box" that must be attached to a computer. Without it, the software won't run and the computer might lock up. The problem is that these locks are devilishly inconvenient to install (especially if you have more than one program that demands its own lock) and sometimes conflict with other software or hardware on the computer, causing problems for the users. Few manufacturers use them, and they tend to be only on the most expensive (over $1000) programs.

Other copy protection techniques include encryption, passwords, software locks, etc. All are intended to prevent the actual copying of the software onto floppy disks. Without the right code, password, or other gimmick, the program won't copy or would copy as unusable garbage. The danger in this type of copy protection is that authorized owners could be stranded if the original floppies were lost or destroyed. (It's standard operating procedure to make backup copies of the master floppies for security.) Also, making a tape backup of the entire hard drive could be difficult or even impossible.

Whatever copy protection schemes manufacturers came up with were eventually discarded by most companies, because they were so unpopular with authorized owners that they began switching to programs without copy protection. (Besides, copy protection didn't bother software pirates, who considered them challenges to be defeated.) When industry polls showed their widespread unpopularity, and that the overwhelming majority of people will buy software rather than steal it (not only because they are honest, but because the manufacturers provided support, newsletters, help phone lines, and upgrades to registered owners), most manufacturers removed their copy protection schemes. In the final analysis, when the accountants looked over the numbers, most manufacturers realized that it really was a relatively small percentage of computer buyers that pirated software. (Software piracy is still rampant outside the U.S. and Canada, especially throughout the Orient and South America.) Today, most software manufacturers depend upon their reputation for service and quality products rather than high-tech protection schemes to ensure that people buy instead of steal from them.

That's why we do not recommend using any of these schemes for protecting your images. They would be more annoying to your clients than to potential thieves.

⇨ High-tech copyright labeling

On the other hand, there's technology available that could be used to identify your images as your copyrighted property.

As everyone who does business in commercial arts knows, you should put a copyright notice on all your prints or photographs. You can do the same with digital images by creating a copyright notice file and placing it within the image file (usually on a border that doesn't interfere with the composition). Thus, whenever one of your images is read off of a disc or cartridge, it would carry a very short message in small print that contains a copyright symbol, your name, and some phrase that tells the viewer that to use the image he must purchase appropriate rights to it. This is a formal statement of ownership. Of course, when the art director uses your image in her layout, she will

remove (crop out) the message. That is to be expected. It's similar to removing a 35mm transparency from its mount when it is used. Cutting the copyright notice off the picture does not change the fact of its ownership. It does require that the art director see the notice and therefore acknowledge that it exists.

Okay, so your image is out there on some storage medium with a removable copyright label. What about the apocryphal art director or assistant who takes your picture, cuts off the label, and then manipulates it until it would be hard to prove that it was originally your image? That's a tough question with uncertain parameters that will be tested over the next few years in a variety of situations. You could embed something deep within the image that can't be easily spotted but that you can point to as definitive proof that you originally created all or part of the disputed image. When you edit down to the pixel level, you could use your mouse or stylus to draw your name in letters a thousandth of an inch high, much too small to be seen by the unaided eye.

Or if you think that too obvious and likely to be spotted, weave in a tiny but distinctive pattern, such as a seven-pointed star or a six-rung ladder. For better protection, embed a half-dozen, a dozen, or even more patterns or logos throughout the image. These additions won't in any way depreciate the image quality, nor will they protect you against unauthorized use. But if you ever have to hire a lawyer to prove that you created a particular image—something that will become a much more common dispute as the number of digital imagers mushrooms—you'll be able to provide excellent evidence to help your case.

Another scheme is to create what is called software "wallpaper" made up of small repeating lines of copyright notices. Wallpaper functions as a background to an image. (Your image file would be pasted over the wallpaper file.) One could create such a file so that the copyright lines are so tiny that they are almost imperceptible—at least on the computer monitor. But it could be noticeable whenever that image is printed.

Of course, hackers would have little difficulty removing your notices or logos. (But not too many actual image buyers are hackers.) The main objective in creating and using wallpaper is to make it inconvenient to use the image commercially without authorization, and to ensure that parts of your image aren't appropriated as an element into someone else's image.

Remember, though, that all embedded copyright notices, wallpaper, logos, or distinctive patterns should be removed before making a high-quality print from the file. One should use embedded notices only on files that would be going out to potential clients who say they just want to see what you have. Then, if they want to use the image, you would

send them the version without the wallpaper, after you have negotiated the price, terms, and rights.

Setting the ground rules

Daniel has been a freelancer for over twenty-five years. (Sally is the younger, both in age and in professional experience: she has been at it only fifteen years.) In that time, we have agreed to all kinds of terms, signed all sorts of contracts. Some were mistakes, others were slanted in favor of the client, and a few were so enlightened that we still fondly and wistfully remember them whenever we are about to sign another contract. Yes, we have been cheated and lied to, as all businesspeople have. But all in all, we have been fortunate in our relationships with our clients and editors. In fact, at this point in our careers, we prefer to not work with anyone who has proven unreliable, unprofessional or, most important to us, not nice.

Over the years, the great majority of the problems we have encountered have been from misunderstandings. For that reason, we try to set the ground rules with a client before proceeding with a project or assignment. The fax machine has been a boon in this because so many of our assignments are negotiated over the phone. After accepting an assignment from a client over the phone, we write out a quick memo that describes our understanding of the assignment. We include the specifics: project description, logistics, terms, deadline, price, payment schedule, expenses and, if relevant, what exact result the client has asked us to obtain. We ask the client to sign the memo, if he feels we have described the assignment correctly, and then fax it back to us. If he feels that we missed on some points, then we ask him to please call us, so that we can clarify everything before we proceed with the project. Sometimes we must rewrite the memo several times until the client or the editor agrees with the wording and is willing to sign it.

Both sides prefer knowing where they stand and what they can depend upon, so no client has ever objected to this. Even a number of our clients who, as a practice, refuse to use contracts are willing to sign and abide by these memos. Though the signed fax is legally binding, it doesn't look like a contract, so it isn't intimidating. (If you don't have a plain paper fax, be sure to make a regular photocopy for your files. The slippery, shiny kind of fax paper fades very quickly, and you want a permanent copy.) Because the party who first writes an agreement is usually the one who has the advantage, this method provides us with a way of establishing the ground rules by which we are willing to work before we can be asked to accept less.

When copyright ownership doesn't really matter

We believe in the legal and moral right of an artist to own and control his image. However, we interpret that right of control to include selling our copyright or allowing the property to be copyrighted by the company paying our fee. That's what is known as work for hire, and it isn't something we do frequently. In fact, we always approach negotiations with the attitude that it would take a substantial extra sum to persuade us to sign our copyright away. When the client comes up with the right incentive, it becomes worth our while to let him have the copyright.

We have retained copyright ownership of most of our creative efforts because we wish to control how and where our work appears, as well as receive payment when it is used. The problem is that copyright ownership does not necessarily guarantee either benefit. *It is possible to maintain copyright ownership and still lose legal, financial, and/or physical control over the image.* That is why our assignment memos and other related paperwork usually include certain phrases. Of course, we pick and choose the correct phrase for the situation and never use all the following in a single project description.

> ➤ *These images are provided for the following purpose.* A description of how the images may be used by the client is necessary. This is also known as the usage statement or license.

> ➤ *The copyright of all images remains the property of the artist. No payment of any fees implies the transfer of copyright.* Of course, first, we establish the basics.

> ➤ *The cartridges and other media on which images are delivered and stored remain the property of the artist and must be returned at the end of the project.* Just because you own the copyright doesn't necessarily mean that you own the SyQuest cartridge, disc, slide, or other media on which the image is stored. Unless told otherwise, most clients will keep the media (which itself can cost $50, $75, or even $120). At some future time, someone in the client's office might come across the image in their files and mistakenly believe they have the right to use it. On the other hand, a client (or his service bureau) may prefer to retain a copy of your image in his files. This is a valid request. They have already color corrected and otherwise worked the file according to their needs, and it would be a waste of time and effort for them to lose this version. If this is the case, you will have to come to some agreement about the status of that file, how it may be used in the future, and when fees would have to be renegotiated and paid. Be sure to include a statement of this agreement in your paperwork.

➤ *The image may be manipulated by computer or by other means only for the purpose stated above. Any other use or manipulation of the image is not allowed unless and until permission for the specific purpose is obtained from the artist and fees have been pre-negotiated and paid.* If you want to do business in today's marketplace, you cannot forbid the manipulation of your pictures. Almost all commercial images will go through some computerized alterations in the layout and prepress steps. However, you do have the right to require a client to conform to the agreed usage of your picture. Thus, they are not permitted to use your picture as the basis of another image unless they obtain your permission and pay you for that right—if you state (and they agree to) that provision in writing, before the fact.

➤ *The license to use images will not be transferred to the client until all agreed upon fees and authorized expenses have been paid.* In other words, the client has no right to use your picture until you have been paid. No, it doesn't always work that way; artists are usually the last people to receive their checks on a project. However, by including the phrase, it gives the client incentive to pay you as quickly as he can, so he'll have the legal right to use the image.

➤ *The image may not be used unless and until fees for usage have been pre-negotiated and paid.* While this statement is similar to the one above, it is more appropriate when an image has been requested for viewing without any agreed upon usage or terms being established.

➤ *No further use of this image may be made after* (insert a specific date here). When appropriate, set a time limit during which the client may continue to use the image at an agreed upon price. After that date, all rights and total control revert to you, or you might renegotiate further use at a different (hopefully, higher) price.

Of course, there are other variations on these concepts. The idea is to provide the client with all the rights they need and are willing to pay for, without signing away the control you wish to retain.

By the way, our actual memos tend to be written less formally than the phrases above because we don't want a client to be intimidated or confused by legalese. We use names rather than "the artist," "the client," and "the image" to personalize the situation. And we make our statements as direct and unambiguous as possible.

Standing up for your rights

It is difficult to go head-to-head with a client. So much of an artist's life is based on supplication and pacification, a result of the innate uncertainty of our profession. But there are those clients who just aren't worth placating. Either they are out to cheat you or they are so poorly managed that the way they do business puts you at the sharp end of the stick.

There's a nationally published magazine for which we used to be regular contributors and whose management is so chaotic that it is a liability to work for them. We have heard that we got a reputation in their offices for being "troublemakers," because we insisted upon being paid the money they owed us and for sticking to the contracts they signed with us. In that kind of situation, standing up for your rights can help you winnow out troublesome clients. No longer will you have to deal with the ones that will take your time, energy, and creative effort and give you nothing but misery in return.

The point is that you should be businesslike and stand up for your rights. By doing so, it will help create a professional milieu in which both the client and the artist can function better, by knowing what is expected by both from both.

License vs. usage statements

Peter Treiber, a well-known commercial photographer and former president of Sally's ASMP (American Society of Media Photographers) chapter, has devoted a considerable amount of his energy, time, and income to a crusade that could benefit all visual artists. Treiber says that what we are really selling our clients is the license to use our images—not the images themselves. But we seldom provide that license in written form. In other words, we are not delivering the product that we are selling. So, what proof does the client have when a printer or other associate asks if the client has the permission of the copyright owner to reproduce a picture? (The other side of this equation is to get printers to ask that question more often.)

Treiber's aim is to get clients to recognize their need for a written document that clearly outlines the extent (and the limit) of their rights to reproduce and otherwise use the picture.

Opponents to this concept might contend that the usage statements on an invoice provide this information. But the invoice usually goes to the accounting department. A license stays in the client's own files, to be referred to and used whenever necessary. Besides, by the time you submit an invoice, the job has been done. All terms of the project should be agreed to well before the work begins.

Treiber's license agreement is a common-sense, businesslike solution that speaks to the client's own need to make sure that everything will run smoothly and correctly. We recommend it as a more formal alternative to the faxed assignment memos we described earlier. The printed form that Treiber sells is inexpensive ($20 for 50 forms at the time of this writing), looks professional, and sounds impressively legal, all of which can help convince clients to accept them as the industry standard. For a sample, send $1 with a self-addressed envelope to

Copyright Assistance Co.
P.O. Box 21521
Lehigh Valley, Pa 18002-1521

For some clients, the relaxed, personal attitude of the memos we discussed is more appropriate. They might be put off by a contract like Treiber's. Others will feel more comfortable with the license, because it looks and feels more like a contract (which, in fact, they both are). The point is to use at least one of these methods or some variation of either.

Your images will be stolen, lost, & manipulated

Unfortunately, we do not live in an ideal world. There might come a time when you will discover that one of your images has been used incorrectly, without payment to you or without your permission. You do have legal recourse if you have registered your copyright correctly (we have been told that it's not necessary to formally register them with the government, until and unless you want to take legal action, though doing so beforehand does add considerable weight) and have laid the groundwork to establish your rights to control the image. Go ahead and pursue your rights if the situation warrants the time, expense, and emotional cost. Take advantage of the support and aid that are available to you through trade organizations, such as ASMP, AIGA (American Institute of Graphics Arts), or PPA (Professional Photographers of America). Ethics and the law are behind you.

The good news is that this will happen very infrequently, probably not much more often than what the industry rate has been up to now. Buyers of pictures are seldom hackers. And hackers generally do not have the connections or the means to exploit and profit from your images in ways that would compete with your market. Besides, we have found that buyers are generally too scared or too honest or too involved with their own problems to overstep their boundaries—once you have defined those limits clearly.

It is in clearly defining the limits—before misunderstandings occur—that we have the most power. Imaging is a comparatively new field that is still being shaped by what is happening in the marketplace. As individuals, we can work with our clients to help them understand what would be the enlightened way to proceed for the sake of our mutual future. Each of us needs to develop and maintain a friendly but thoroughly professional relationship with our clients, so that we can work in an environment of mutual trust, good faith, and respect. As a group, organized within a variety of trade associations, we can work together to establish a general awareness and acceptance of basic ground rules that will strengthen our position.

But remember, it isn't the technology that threatens our rights of intellectual property. Nor is there really any malice out there that is conspiring to rob us of the fruits of our labor. The real potential danger to our copyright is our own passivity in allowing our industry to set new standards that are less than we deserve and far less than our industry needs to survive as a viable profession.

5

Altered reality

Ethical & legal questions sparked by digital imaging

I N STALINIST RUSSIA, when an *apparachnik* (government functionary) was purged from the Communist Party, he was shot in the back of the head and erased from official photographs. The first clue that outsiders received that someone had been liquidated by Stalin was that the Party pictures were changed, scrunching everybody closer together to get rid of the space where the disappeared person used to be. The darkroom and retouching techniques were coarse and obvious, but no one in the Soviet Union was willing to risk his neck to comment on it. Imagine what the NKVD and the old Kremlin could have done with digital imaging.

The Soviet Union wasn't the only organization to change photographs to propagandize or control public reaction. Ever since photography was invented, darkroom wizardry and camera trickery have been used to alter the perception of reality. Often it was merely for artistic reasons. Sometimes it was to promote political, commercial, or social agendas.

Do you want to prove that a skin cream will make years vanish from your face? Just airbrush away a model's wrinkles, circles, and age spots. Want to show President Clinton having tea with Amelia Earhardt and Elvis Presley in the middle of the Bermuda Triangle? Do some double exposures or some cutting and pasting. How about pictures that prove a competitor has connections with a crime syndicate, or photos of a fast food meal that includes a plump, juicy, appetizing hamburger? The same traditional techniques can and have been used to blackmail, entice, cajole, sell to, or convince people into believing something is that isn't, or happened when it did not.

There's nothing new in the idea of image manipulation. But when it was done in the chemically-based darkroom or on the layout table, it was almost always detectable by experts, if not by the unsuspecting public. Now the computer allows us to alter photographs so thoroughly that even experts have difficulty determining their authenticity.

Because we are the people who are creating the pictures that the public will see and which could possibly be used to convince people to think, act, or feel a certain way, what, if any, are our ethical or legal responsibilities when we use a computer to manipulate an image?

Do people believe what they see?

Our society has become increasingly cynical and jaded. Not even children are as naive as their grandparents or parents were at the same age. The Saturday matinee horror films that used to scare the pants off us are laughed at for their crude special effects by the generation that has been raised on the glitzy, almost perfect terror of

today's Hollywood. Still, when the movie is over and the house lights come up, the kids already know how the magic was done—with computers, of course. If a society's youngsters are so wise in the ways of picture manipulation, can it be that easy to deceive that society with an altered image? *Yes!*

Madison Avenue has proven time and again, if you keep repeating a message, eventually it will sink in, even if the listener is a skeptic. That's the same tactic Josef Goebbels used to seduce an entire nation when the Nazis came to power in Germany. Combine the message with a visually exciting picture and the impact is even more immediate. Some might say that we, as a society, don't really believe commercials. But if we didn't, they wouldn't be so effective. A product with a multi-million dollar ad budget will always outsell a better product that has little to spend on advertising. What's more, the way we elect the leaders to run our government, the people who will make important decisions about our future, is by reacting to political campaigns designed by Madison Avenue.

So, even if we don't quite believe that a picture is the truth (as most people don't when they see an ad), on an emotional, subliminal level, it can still affect us very deeply.

It could be argued that advertising is an unfair example because everyone expects a company to show only the most positive views of their products. But what about magazines, newspapers, and television news programs? These are the sources we rely upon to learn what is happening in our world. We form our opinions, make our investments, decide how to plan our lives based upon what these "sentinels of public truth" tell us. Without question, if a picture is published in a respected newspaper, we believe its veracity. If a television news program shows a GM pickup truck bursting into flames upon impact, we accept it as gospel truth (though it later turned out to be staged reality).

Then there is the question of photographic evidence. Until recently, the courts actually institutionalized the power of a photo to be the bearer of truth. If a prosecuting attorney could show a picture of the defendant holding a gun pointed at the deceased's head, then the defendant was proven guilty. If a defense attorney had a picture of his client in another city on the same day—proving the day and time by the fact that there are a parade and a clock tower in the image—then the verdict would be innocent. Those pictures could always be faked; you didn't need a computer to do it. But the attorneys and the people who provided the pictures were entrusted to not manipulate the evidence. To do so would be a prosecutable crime.

Often, in today's high-tech courtrooms, photographic evidence is allowed to be clarified by whatever technical means is available, enhanced to show more detail. Computer-generated animations are

even allowed into court to visually demonstrate what the attorney is saying as he reconstructs the scene of the crime. While the judge will warn the jury that the image has been changed or the cartoons show only one possible explanation, not evidence of definite proof, the persuasive power of the picture is so strong that one wonders if it isn't often the lawyer with the best computer artist who wins the case.

 NOTE Will the maxim "A picture is worth a thousand words" become "A picture is worth a thousand lies?"

⇨ Why do you think they call it manipulation?

Everybody does it. There's not one photographer who hasn't changed the camera's angle to make the viewer see what is important to the shooter. For instance, she could move her camera so that the picture doesn't reveal a garbage dump next to a resort hotel. Or, by selecting a certain lens or tilting the camera at a dramatic angle, she could force the lines of perspective to increase the impact of an image of, say, a child playing in a sandbox in the shadow of a nuclear reactor. What darkroom technician hasn't cropped pictures to make the composition zero in on the action that he wants you to focus on? And what about dodging or burning a picture as it is being printed, to alter the relative importance of various elements in the composition? Illustrators and other traditional artists don't even pretend that what they have created is absolute truth. Rather, it is their attempt to influence the viewer to consider an idea that the artist (or the client) wants to portray.

What is the purpose behind making these subtle or dramatic changes, if not to manipulate the viewer's reaction? Why would we do it otherwise? Is not all our work done with the express idea that art in its highest (and lowest) form evokes a response? Sometimes we seek to affect the viewers' emotions. Other times his intellect is our target. But the purpose is manipulation—both of the picture and of the public.

That's not to say there is anything inherently wrong in doing it. We're just trying to put what is now possible in perspective. If Aaron Copland could be praised for making us feel proud with his "Fanfare for the Common Man," if Picasso could be honored for inspiring anger in us with his "Guernica," what is the fuss about continuing in that tradition? It is art's place within our civilization to move us, make us think, cause us to care and, perhaps, even act.

Does the introduction of the computer—an essentially unfeeling, inhuman machine—change the rules? By drastically improving the technology that we use to manipulate, are we increasing our accountability? Or are we just now being convinced to look more

closely at what we have been doing all along and to assume personal responsibility for it?

⇨ Where is the fine line?

Let's take a look at a typical news magazine like *Newsweek* or *Time*.

The cover might be a photographic portrait of a world leader that has been cut out of its original environment and put into an illustration or a composite photo. That context might make him look statesman-like, or sly and devious, or overwhelmed by circumstances. Everyone seems to recognize that the cover isn't so much an accurate portrayal as a visual description of what the magazine has to say about that person.

Inside the magazine are news stories with pictures that supposedly prove or, at least, reinforce what the writers are saying. We depend upon the unimpeachable accuracy of those photos, because, after all, it's the news.

Interspersed among the news stories and photographs are advertisements that use blatantly manipulated pictures, because that's the purpose of advertising.

Viewing it from that perspective, it seems that limits and rules are already in place and well respected.

However, these examples are merely a handful of easy to distinguish, clear-cut cases. What about those in which the fine line between creative interpretation and truth is not so well defined?

Let's consider a picture that a computer artist manipulates. Suppose it's a photograph of a man walking down the street, and the artist cuts him out and puts him on an entirely different street. (This is a relatively easy thing to do with a good digital imaging program.) If the image is destined for an ad, no one will complain. After all, it's done all the time. But if the altered image goes next to a news story about that man and is used to "prove" that he was where he wasn't—such as putting him in the middle of a red light district—then it is a lie and potentially damaging. But what if the changes done to the street were just to make it brighter, sunnier, or less crowded? Is it still a lie, or only a justifiable attempt to make it more attractive? Or what if an editor decides to crop the picture, to make it fit in the column space, but it also makes it appear that the only person on the street is that man? Does that constitute a breach of editorial ethics?

If the article about the man states that he is suspected of being a sexual pervert who lurks in lonely places, and the picture is used to imply his preference for deserted streets, are the art director and

photographer liable for a legal suit? Perhaps the caption doesn't even indicate that you are supposed to make that conclusion about the picture. It's only a photo of him alongside a story. But doesn't the picture lend an aura of truth to the story? What if, before it was cropped, it was just a photo of the man Christmas shopping with his wife and child and, by cutting it ostensibly to make it fit the space, the photo now gives him a sinister aura?

When the *National Geographic* magazine digitally moved a pyramid in order to make a better balanced picture, there was a general outrage because readers thought they had been visually duped.

But when *Newsweek* magazine created a technically brilliant composite picture of Hillary Clinton and Eleanor Roosevelt sitting side by side on lawn chairs, it was acknowledged as tasteful use of artistic license to make the point that they were spiritual sisters.

Spy magazine does it all the time, putting celebrities' heads on compromisingly posed bodies. They pasticed Hillary Clinton's face to the nearly naked body of a leather-clad, sado-masochistic bondage queen brandishing a whip in her hand. *Spy* not only gets away with it, they have established an enthusiastic and loyal following that applauds their outrageous composite images.

Apparently, the fine line that defines and determines the ethics of image manipulation has something to do with the circumstances of how the picture is to be used, by whom, where, and for what purpose.

Advertisements are required only to not make any outrageous or untrue claims about their products that they can't prove; otherwise, anything goes. The root of this seems to be that the viewer doesn't depend upon or expect the ads to have truthful pictures. But if an image is to be used to change opinion, make a statement, illustrate a presumed fact, etc., in such a way that it could affect public opinion, then altering the picture might cause problems.

Where the picture is published appears to matter. The photographs in *National Geographic* are expected to be pure, inviolate photography that transcends our daily grind. The front page of *The New York Times* is also considered a sacred public trust. But the reader's opinion of the lifestyles section of the same newspaper seems to be more accommodating, allowing for the presence of digitally altered images. (No, we don't know if the *Times* has ever used a manipulated image. This is a philosophical discussion, not a report card on the media.)

Also, there appears to be a rule of believability that governs these matters. If a manipulated image is simply not possible and the general public would know it (for instance putting the Leaning Tower of Pisa in the middle of downtown Los Angeles), then, apparently, it is acceptable. Everyone who reads *Newsweek* realizes that Eleanor

Roosevelt is dead and couldn't possibly have ever met an adult Hillary Clinton. Similarly, the readers of *Spy* magazine enjoy its satire and humorous irreverence; no sane and intelligent person would consider any composite picture appearing in that publication as fact.

Then there are the questions of purpose and impact. If an image is altered for malicious reasons or to make a point that could harm the subject or lie to society, there is no doubt that a breach of goodwill has occurred. Such behavior is generally considered unethical. If the reason for the image manipulation is quite innocuous, but the picture is used in a harmful way not ever intended by the artist, is it the artist's fault? Can she (or should she) be held accountable? Are good intentions an adequate moral or legal defense when a manipulation causes injury?

If the purpose is humor, the fine line can become microscopic. When it works, even the subject of the joke might enjoy a good laugh. When it fails, it can be cruel, damaging, and the source of a legal suit. If ridicule is intended, because the photographer, art director, or editor believe that the subject deserves to be "shown up" or stopped or is simply, in their minds, ridiculous, then they will have to accept the possible repercussions—both moral and legal—of their actions.

Satire, certainly, has a long tradition that is respected in a free society. It can be very effective in making the public more closely examine (and possibly change) the status quo. In fact, satire is one of the first art forms to be crushed by a repressive government or an iron-fisted corporation. It is also one of the most effective forms of computer art humor. But is there a greater potential for going too far when you are working with a computer and the satirically manipulated image can look absolutely real?

Why is there sometimes such an uproar when both the purpose and the impact is beauty, pure and simple? Did the misplaced pyramid picture published in the *National Geographic* actually hurt anyone? What difference did it make? No opinion was being manipulated. No damage was inflicted on Egypt's national monuments. Are there situations in which the manipulation of a photograph is considered such a physical assault on perceived reality that, even when no one is affected by the change, the viewer has a right to know that the photo has been altered? Do we have a responsibility to not only provide exciting, inspiring, effective, and beautiful pictures, but to also keep faith with the public trust? Should images that have been substantially manipulated be labeled as such?

What does ethics have to do with art?

Visual artists have long played with truth, twisting it this way and that. Often it was just a visual experiment to see what worked, creatively speaking. None of Picasso's women were really shaped like vases or had eyes in the middle of their foreheads. Other times, art has been used to effect political or social change. Hogarth's illustrations influenced Victorians to acknowledge the plight of the wretched. Today, the most obvious incentive is the commercial value of our work. When the client wants a wart removed from the model in his ad, it gets removed because he's paying the bills.

So why should we now be burdened with ethical considerations about something we and our forerunners have always done?

The biggest difference between today's artistic interpretation of truth and the stuff that was being done less than a decade ago is the potential perfection of our computerized manipulations. Digital imaging techniques are so good that the viewer has little hope of detecting that reality has been somehow changed, that what he is seeing is not the unblemished truth.

Artists have always been the guardians of how society sees itself and others. As such, shouldn't these questions have been part of the artistic experience all along? Now that the modern world has become more visually oriented than any time in history, does that not imply that the public is even more dependent on us to be responsible artists?

As we've pointed out earlier, it was the Nazi propaganda machine that demonstrated so devastatingly the effectiveness of "The Big Lie" that proved that repetition and reinforcement is all that is needed to convince a person or group of people that black is white. The most powerful tool Dr. Goebbels had at his disposal was pictures.

No, we are not saying if an artist doesn't take responsibility for the effect that his pictures create, then *ipso facto*, he is a Nazi. But no artist can ignore the fact that the source of evil is often merely the relinquishing of your own ethical responsibilities to what is expedient or what is popular. To be passive, not think, or not care about the effect one's actions have, but to just do whatever is pleasant, attractive, or profitable is just as morally wrong as deliberately and purposely acting as an accomplice to wrong-doing. As Kevin O'Neall of New York's Image Axis says, "There are ethical requirements placed on every human being that is alive to be a decent human being."

If moral imperatives are not enough incentive, consider practical motivations. The computerized manipulation of pictures will be getting

more and more press over the next few years. Someday soon, a *cause célèbre* will catch the public's attention. It will involve a picture that captures their imagination and makes them care, worry or send money. It might be a provocative image of abused animals at a famous zoo, a politician accepting a bribe, policemen beating a hapless motorist, or even a particular manufacturer's tire coming apart at the seams. When it is discovered that the picture was altered, all hell will break loose. One of the repercussions could very possibly be a movement to restrict by law or otherwise control how pictures might be manipulated or how altered images may be used.

This is not as farfetched as it might sound right now. Remember the Robert Mapplethorpe exhibit? As a photographer, Mapplethorpe was magnificent, but he photographed homosexuals in very expressive and controversial ways, which was a threat to a very vocal part of the population. This lead to further erosion of the grant system of the National Endowment for the Arts. Under attack and chained with new restrictions that makes it difficult to get grants, the artistic community has all but lost one of the last noncommercial supporters for continuing experimentation. Without the opportunity to explore new avenues of expression—which almost by their very nature will be controversial—art can lose its creative edge. This is not only unhealthy for artists but also for the community that depends upon us to keep fresh ideas always in the forefront and to stimulate change rather than support the status quo. (In a capitalistic society, status quo is the antithesis of economic growth.)

We mention the Mapplethorpe/NEA case, not to argue that matter but to show how easily the public (or at least a segment of the public that has developed very effective means for advancing their political, moral, or religious agendas) can place limitations upon what an artist can or cannot create.

Let's consider an altered picture that might capture—big time—the public's attention. Perhaps it is of Vietnam-era MIAs still incarcerated in a secret jungle prison camp. Or it might be a handicapped child being molested by a famous actor. Even more likely, it could be a household product being shown to be something it isn't. Whatever it is, in our information hungry world, it will become the focus of news stories and angry editorials that will then start people talking and thinking about how artists are altering the general view of reality. While the blame might be properly placed on the heads of the specific imager and picture editor, it will also tar the process they used and, by extension, blacken the reputations of other digital imagers. Remember the outcry when Volvo's advertising agency faked a shot of that sturdy Swedish car's roof remaining intact when a truck was driven over it? Similarly, would there then be a public and, finally, a government backlash against digital imaging that could possibly end up placing limits on how we use computers? It certainly makes more sense to be

aware of how our artistic actions impact on others than to wait for someone else to force us to do it.

Recognizing our responsibilities as ethical artists and acting accordingly will not only help our standing within the community and make us feel proud as individuals, but it will help us to avoid any future movement to curtail our freedom of expression because of a perceived breach of public trust.

The sign of change

Many involved in imaging have proposed that the caption to a manipulated photo should always have an easy-to-recognize emblem. The most popular sign, which appears to be attaining a level of international acceptance, is the universal mathematical symbol for not equal: ≠.

 # Is it okay to manipulate someone else's picture?

A discussion of the ethics of computer manipulation would not be complete without exploring the question of whether or not it is acceptable to take another artist's picture and change it until it becomes your own. This is an undefined realm that will be tested and debated considerably over the next few years, both in the court of public opinion and the courts of law. While we could argue either side with academic objectivity, our own personal belief is that the original creator of the picture still retains rights when part of his image is used as the basis for someone else's image. This isn't only because we are creators ourselves, but because we believe it is the most ethical position.

The central question is: Does anyone have the right to take someone else's intellectual or artistic endeavors and use them for profit or other purposes without the creator's explicit (and written) permission?

Consider a writer taking another author's lost manuscript, changing the names of the characters and places, then submitting it to a publisher as his own. Literary plagiarism is not only wrong but can also bring a lawsuit. Yet, if a writer takes the *idea* for a story from another and rewrites it so that it is more fully his own, that is considered acceptable. Stephen Sondheim and Leonard Bernstein, the creators of "West Side Story," certainly didn't have to pay royalties to Shakespeare's heirs for stealing the plot line of "Romeo and Juliet." In fact, borrowing plots, themes, and characters is an ancient literary tradition, and its practitioners are said to be playing homage to the original author.

Borrowing passages and melodies from earlier compositions is part and parcel of our classical music heritage. Haydn, Mozart, Beethoven, Respighi, Brahms—the list is long and distinguished—all borrowed from other composers, even creating and naming compositions as variations on their predecessors' themes.

However, the one thing all these composers have in common is, as Bob Dylan once so aptly pointed out, they're dead. Dead men, at least those who passed away long before the modern copyright conventions, can't collect royalties. (The rights of heirs of more recent artists is another situation entirely.)

More often than not, when a modern musician tries to weave in just a few bars of another composer's music or lyrics, that incorporation isn't considered an homage but piracy. In today's competitive, supercharged music world, borrowing anything remotely identifiable as someone else's work is automatic grounds for an expensive lawsuit.

Another example of how jealously intellectual property is guarded—as well as how valuable a tiny excerpt can be—is in the computer world. Did you ever wonder why there are hundreds of manufacturers making IBM clones and compatibles but virtually no one knocking off imitation Macintoshes? That's because the basic code that gives the Macintosh its instructions is copyrighted. (So is IBM's code, but it was easily circumvented by writing new code that did the same things.) We're talking about a few dozen lines of very critical programming that, if pirated, would allow a manufacturer to build and sell 100% compatible Macintosh clones, thus threatening Apple's very existence. That's why Apple jealously protects its source code and sues anyone who appropriates even the smallest kernel. To date, only one Mac clone has appeared, and it's not 100% compatible, because the company wrote its own code rather than trigger a massive lawsuit.

Let's look at the issue of borrowing from yet another perspective. Suppose you found a competitor's design for an ad campaign and presented it as your own, with just a few alterations. That might make economic sense, if you get the job, but is it right? Is it legal?

We can understand the temptation to cut a picture out of a magazine or a stock photo catalog, scan it into your computer, and use it as the basis of a computer manipulation. After all, who is to know? It's certainly cheaper than buying the rights to the picture. We have even heard one art director claim that it's acceptable if a picture is so altered that it constitutes only 20% of the final image. Another professional said that he doesn't consider it pirating if the final image uses 10% or less of someone else's image. Both formulae are gossip, not generally accepted.

So what is right, and what is legal?

61

We wish we could give you absolute, black and white laws and rules that govern every case, but they just don't exist. At least, not yet. But here's the working premise we use: don't borrow anything from anyone else's images or picture elements unless you have written permission from the copyright holder. It will save you a lot of grief later on, and, possibly, a lot of money too. If you are a truly creative artist, designer, or art director, you don't need to borrow someone else's pictures. Besides, there's a profusion of inexpensive, unencumbered clip art available that you are given free license to use however you wish. These include inexpensive diskettes and CD-ROMs that are brimming with different patterns, textures, shapes, backgrounds, and other visual elements that you can incorporate in your images without worrying about copyright infringement.

Realistically speaking, chances are that you would be able to borrow from someone else's photographs or images with impunity; the probability of getting caught is very small. But that's not the point. Since the beginning of the Reagan era, our society lost sight of some moral fundamentals in the rush to get ahead and make money. But the eighties are gone, and, in their wake, we have been left with a bankruptcy of our innate sense of what is right and wrong. Back then, inside trading, backstabbing your coworker to get ahead, stealing another person's ideas or work, and other such practices might have been acceptable, even admired. But that was then, and this is now. It is generally acknowledged that that kind of behavior was a temporary aberration with unhealthy repercussions. Just as it is no longer acceptable to litter the highways or destroy rain forests, it is no longer considered civilized or moral to dirty up your working environment with attitudes or actions that could be destructive or harmful to others. In a Darwinian sense, the reverberations we are now experiencing from the eighties' reckless disregard for ethics in the pursuit of the almighty dollar might be taken to be proof that ethical behavior is an attribute of the fittest, who are the ones who will survive in the long run.

Clip art

Clip art is the term used to describe images, icons, illustrations, and photographs that are sold in quantity on diskettes and CD-ROMs. Some CD-ROMs contain literally thousands of different images, ranging from traffic lights to post boxes, computer terminals to children playing. Some are low-resolution line drawings, while others are high-resolution 24-bit color photos with considerable detail. What most of them have in common is that, when you buy the diskette or CD-ROM, you are also buying a license to use or incorporate the images in your own work. Thus, you can use any or all of the image elements as you see fit, without worrying about paying an additional royalty or inviting a lawsuit. Some clip art packages have more restrictive licenses in that they may be used for company newsletters and other publications with limited circulation, but not for commercial applications.

Clip art is advertised and sold in computer and graphics arts publications, and may be available at your local computer store. Before buying, ask to see a printout of the images so that you know if there are any that you might want to use. Also, always read the terms of any clip art package, to be sure there are no restrictions on usage.

Using clip art as the basis of manipulated images is a generally accepted and rather inexpensive alternative to the ethically tenuous and legally precarious practice of "borrowing" elements from an artist's copyrighted pictures. That's why clip art exists and sells so well. It's particularly valuable as the basis for backgrounds, textures, patterns and shapes, the very components of an original, copyrighted picture that are most susceptible to unauthorized use. With so much clip art available, why bother with practices that could get you in trouble?

⇨ To be an ethical imager

We do not presume to know all the answers to the many questions we have posed in this chapter, or to the ethical questions that we will be asked as the computerized manipulation of pictures proliferates. Somewhere along the way, guidelines will be developed by various organizations that will help us understand and define precisely what is an ethical artist. While we support any movement towards developing ethical guidelines and standards, we feel that they should not be written into stone. For every rule there are exceptions, and, often, those exceptions evolve into new rules.

The ethical person is one who tries her best to recognize the right thing to do in each unique circumstance, not someone who necessarily obeys inflexible rules as laid out by someone else. So what follows are not ethical guidelines, but our suggestions of the kind of questions you might ask yourself and your client to determine the proper course of action, in each individual case.

➤ What is the purpose of the manipulation?

➤ Will it cause any harm to another person or organization?

➤ Can I trust the client to use the manipulated image as it was intended to be used?

➤ What will the impact of my image be?

➤ Where will it be used?

➤ How believable is it? Is it obviously an altered picture? If not, should a symbol be printed with it to indicate that it has been changed?

➤ Could the manipulated image be construed as proof of something that is not true?

➢ Why am I being asked to manipulate this picture?

➢ Is there artistic merit to the proposed manipulation?

➢ Is the manipulation libelous or otherwise a potential legal headache?

➢ If the image to be manipulated is not my own, do I have the written permission of the creator to do what is planned?

➢ Will I be proud of the effect the manipulated image will have?

Part 2

Imaging hardware

6

Blueprint of an imaging system

IN TERMS OF THE hardware decisions that the computer artist must make, digital imaging is very similar to photography. That's because you must assemble a system made up of a variety of different kinds of components, and the choices you make will directly affect your final image. But instead of having to choose among cameras, lenses, lights, and film, the digital artist must commit to the most appropriate computer system, software, scanner, printer, film recorder, and other accessories and peripherals.

Unfortunately, choosing the right digital equipment is a far more difficult task than selecting which camera system or accessories to buy. For instance, the kind of equipment needed for producing digitally edited 35mm slides for audio-visual presentations is far different from creating perfect images ultimately destined to be printed as full page 4- or 8-color advertisements in slick national magazines like *Vogue* or *Esquire*. Or two products might have what seems like identical technical specifications, such as 24-bit film recorders with a rated resolution of 4000 lines. In reality, the image recorded by one may be significantly superior to the other because of various other technological factors. But you might never know about these vital differences if you depend solely upon information from sources that may have a vested self-interest in steering you towards a particular device, or upon single reviews in which no context, comparison, or real-life test is presented. Product advertisements are obviously going to be slanted, as are salespeople's pitches. Nor should one rely heavily upon the advice of friends or colleagues, no matter how technologically sophisticated or well-intentioned, since their particular needs and solutions may be very different from yours.

Separating the hype and hyperbole from the truth is a time-consuming, trial-and-error process best left to disinterested experts who are not trying to sell anything to you.

Which brings us to this section of our book: what sort of equipment is needed for digital imaging, and which components may be best for your specific needs. While we're not going to recommend one particular brand-name product over another—an elusive and ephemeral task, because equipment specs and prices change more frequently than April weather—what we will try to do is give you the information you'll need to evaluate and compare most types of hardware.

Incidentally, in surveying the currently available equipment, we have set an admittedly arbitrary limit that no single piece of hardware that we recommend as possible purchases should cost more than $20,000. Certainly, there are excellent digital imaging devices with price tags that top more than a quarter-million dollars. And in establishing this limit, we must overlook very important and very good equipment, such as the $32,000 Rollei Scanback. But we believe that few individual professionals, studios or reasonably-sized companies can afford these

over-$20,000 devices. Nor do we feel that most professionals will need such equipment on a full-time basis. Of course, there are always places where one can go to rent time on the big machines, should a project warrant it. We'll cover them when that's a sensible alternative, too.

By the way, don't be concerned if we throw some new and unfamiliar terms and names at you without defining them in detail in this chapter. While it's not our style to use any language that our readers would not know, this chapter is just an introductory overview. From the context, you'll be able to easily figure out what they are, or at least what they do. We promise to explain all terms in greater detail when we explore each kind of component in its own chapter.

Some basic definitions

Hardware *are the tangible, physical components and peripherals that you can touch, hold in your hand, etc. Computers, scanners, printers, monitors, and keyboards are all examples of hardware.*

In contrast, software *is defined as the information or program that instructs a computer what to do. Software is also the data you create, whether it's a letter to a supplier or a file that contains the information needed to reproduce a digital image. Although software is often sold or transferred on tangible media, such as floppy disks, it's not considered hardware because what's important is the electronic data and not the disks themselves. (We'll talk about software in a later section.)*

Firmware *is a cross between hardware and software in that programmed instructions are permanently encoded not on a floppy disk or some other standard media, but in the hardware, such as in a semiconductor chip (called a ROM, or Read Only Memory), or a credit-card-sized memory card (called PCMCIA cards) that plugs into devices such as scanners or printers in order to update (provide the latest version) that equipment's operating instructions.*

To use a photographic analogy, hardware would be equivalent to your camera, lens, and lights, while software is the image that you capture on that film.

⇨ Imaging hardware

Almost without exception, there are always four fundamental hardware components to every digital imaging system:

➢ A computer system to create, alter, manipulate, edit, or fine-tune an image.

➢ A means to insert a preexisting image into the computer.

➤ Some sort of output device that will display or reproduce the completed image.

➤ Permanent storage to keep your images safe and accessible.

See Fig. 6-1.

Figure 6-1

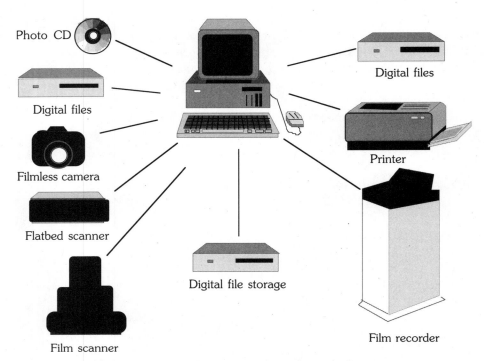

Photo CD

Digital files

Digital files

Filmless camera

Printer

Flatbed scanner

Digital file storage

Film recorder

Film scanner

The relationship of input, output, and storage devices in a digital imaging system. Sally Wiener Grotta

The computer

Unless you have been hibernating in a cave for the past 20 years, you know what a computer is. Perhaps you use a computer already in your work or have one sitting on a desk at home, but even if you don't, you've seen them in offices and studios, at banks and airport check-in counters. Computers are ubiquitous, and with good reason: they can help you do things once thought impossible, and at warp speeds that seem miraculous.

What, exactly, is a computer? Basically, it's only a box filled with electronics that can make super-fast calculations. With a computer, you can balance your budget, write the great American novel, manage your stock portfolio, control the climate in your studio or accomplish hundreds of other tasks. Or—and this is the reason that you have bought our book—you can use a computer to create or edit visual images.

Of course, to use the computer, you'll need the following things:

➤ A *monitor* (a souped-up television screen, also called a CRT—Cathode Ray Tube, a VDU—Video Display Unit, or simply a screen) to view your work.

➤ A *keyboard* to type instructions (input) to your computer.

➤ *Disk drives*: a *hard disk drive* to store your programs and the files you generate (most hard disk drives are hidden away inside the computer box), and a *floppy disk drive* for loading software onto your hard drive.

➤ A *pointing device*—an electronic gizmo (such as a mouse, trackball or, preferably, a pen-like stylus) often attached by a cord to the computer that you move about with your hand in order to produce a corresponding change of direction on whatever's showing on the computer monitor. See Fig. 6-2.

Figure 6-2

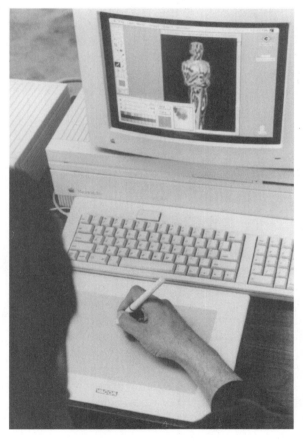

Digitizing tablets are the imager's preferred pointing device. Wacom

Naturally, there are other hardware add-ons, called *peripherals*. Peripherals are devices that attach to a computer—such as printers, scanners, modems, filmless cameras, CD-ROM drives, film recorders, etc. In other words, they are accessories that might boost speed, increase efficiency, make working easier or safer, or extend the computer's abilities and functions. We'll cover them a little later.

You have probably read or heard that computers will simplify and streamline your life and make work flow much easier. To that, we say hogwash. What these marvelous machines will do is extend your abilities, your productivity, and, hopefully, your net income. They allow you to do things in seconds that previously could have taken hours or even months. And, more importantly, they provide access to capabilities, functions, and achievements that were not humanly possible before the advent of this technology. But it won't happen overnight, or without some pain.

Learning to use any computer properly is a skill that will ultimately take time. The more time you invest in the learning, the more skillful you will become. Although you can be up and running within an hour of first plugging in your computer, to be comfortable and familiar with it will take many, many hours. Achieving true expert status will usually take months and years. No matter what your level of expertise, working with a computer will sometimes be a frustrating, anxiety-ridden experience. This is especially true when things don't go as expected or equipment fails to work properly, and we guarantee that there will be times that this will happen (especially if you are working on a PC rather than a Mac). Why? Because computers are very literal, dumb devices that do exactly what you tell them to do, not what you meant to tell them to do. (Later in this book we will provide guidelines on how to deal with computer crises.)

We're not trying to scare you away from computers but instead prepare you for the reality of working with them. They are not the perfect productivity buddies that manufacturers would have you believe. However, it is important to recognize that, although they can be frustrating machines, they are incredible devices that give us the power to do things we only dreamed of achieving previously.

By the way, if you plan to use your computer for managing your business as well as for imaging, you should know that, before a computer will be of any appreciable use, you first must input all the data the computer will need to make its computations. For instance, you might have heard that the computer is a wizard at managing your bank accounts. Yes, it is. But before you can use the computer to balance your checkbook in under 15 minutes a month, you must spend hours installing and learning a money management program and then keying in all previous transactions for the fiscal year in order to bring your accounts up to date. (The worst thing about balancing a checkbook—whether on a computer or the old-fashioned way—is that you must start your calculations from a point in your far history when it was balanced. For many people, that only existed when they first opened the account. We actually closed out a checking account when we changed money management programs because the two were hopelessly irreconcilable.)

So if anyone tells you that computers will save time, money, and anxiety for you from day one, just smile. What computers will do is expand your vision, open new doors to your imagination, create opportunities for greater productivity and profitability, and—depending upon how much information you are willing to input into them—help you to better manage your business. (See Chapters 7, 8, and 9 for a full discussion of computers.)

Input devices

Some digital artists create all their images in the computer from scratch. But the overwhelming majority of us will base our work on already existing photographs or other kinds of artwork, all of which must somehow be transferred directly into the computer. In either case, you'll need some sort of input device.

As its name implies, an input device is a peripheral, gadget, or gizmo that can get that information into a computer.

The keyboard is the most widely used computer input device, just as a punch card was a quarter-century ago in dinosaur-sized IBM mainframes. The mouse, a small palm-sized device with one or more buttons tethered on a cord that one pushes around on the desk with the palm of the hand, is the best-known example of another common means of input, called a *pointing device*. Another frequently used input device is a modem, which allows computers to talk to each other over the phone lines. A video capture or "frame grabber" is a board that plugs into the computer that can suck off *freeze-frame* still shots from television signals, such as from a VCR or a camcorder.

But the most critical input device for digital imagers is a scanner, which translates prints and transparencies, illustrations, and drawings into the kind of data a computer can use. Originally invented for scientific and medical use, the scanner is much like a slow-motion camera that captures an image, not on film but on a light-sensitive computer chip, and then converts it to electronic impulses that the computer can recognize and reconstruct as a digital image. There are a variety of different kinds of scanners that the digital artist may use. What they do and the quality of the scan created varies considerably, as do the prices: scanners can range from a couple hundred dollars to over two million dollars.

Then there are filmless cameras. Also called electronic cameras, still-video, or digital cameras, these devices capture their images on a silicon CCD chip (as do most desktop scanners), but one that is much more light-sensitive. The camera is then plugged directly or indirectly into the computer in order to transfer image data.

See Chapters 10 and 11 for a full discussion of input devices.

 # Output devices

Once you have scanned in an image and performed your artistic magic in the computer by creating a fabulous picture, you will need some way to show it to the world. This is done via an output device, the most important of which are printers, imagesetters, or film recorders.

A film recorder is the exact opposite of a scanner in that it electronically translates your computer's digital image directly onto film. Of course, a printer is an output device that attaches to the computer and draws pictures or places type directly onto paper, acetate sheets, or other two-dimensional media. Imagesetters produce high-quality camera-ready copy or color separation positives, and are usually found only in print shops and service bureaus. (See Chapters 13 and 14 for a full discussion of recorders and printers.)

Storage

A successful and productive imaging artist will, over the course of a career, make scores, hundreds, or even thousands of different digital images. Generally, the file size for each image is far larger than typical word processing or spreadsheet files. Therefore, a library of digital images will take up far more storage space than any computer hard disk drive can hold. For this reason, your computer system must have some sort of built-in or add-on high capacity storage medium that will easily archive electronic pictures for future use. Some kinds of high capacity storage media used by computers in digital imaging include tape drives, optical drives, Photo CDs, and data cartridges.

In addition to archival storage, certain media—such as 44Mb or 88Mb cartridges—are used for exchanging image data with clients and service bureaus. (See Chapter 12 for a full discussion of storage devices.)

Systems, workstations, & solutions

Walk into any computer store, and the salesperson will immediately start talking about which system is best for you. From that context, it would seem reasonable to conclude that a computer and a computer system are one and the same, but actually they're not—just as a stereo receiver and a stereo system are similar but not quite identical.

As we mentioned earlier, the computer is a box filled with various electronic components. But the computer by itself is quite useless

unless it has attached to it a monitor, keyboard, and, with digital imaging, some sort of pointing device. Collectively, these components are called a computer *system*.

The important thing to keep in mind about most computer systems is that each component may be selected and purchased independently. You don't have to buy an all-in-one package deal if you don't want to. For instance, one can buy a Compaq computer, a Northgate keyboard, an NEC monitor, and a Microsoft mouse, and expect that they will all work together as if they were manufactured by the same company. We'll discuss later why you might want to buy individual components rather than a complete system, or vice versa, and why some components won't work with others, no matter how hard you try.

A computer *workstation* is a higher performance computer system that's usually configured with a large amount of electronic memory and a high capacity hard disk. Typically, workstations also sport large, high-resolution monitors and specialized pointing devices like a drawing tablet. Workstations are usually, but not always, more expensive than comparable computer systems. While many workstations are essentially souped-up IBM-compatible or Apple desktop systems that will operate (in addition to digital imaging programs) standard PC or Macintosh software, others incorporate different hardware that makes them incompatible for general use. Many brands of workstations use a high-powered but more difficult-to-use operating system called Unix (found on many minicomputers and even some mainframes), which requires special Unix-compatible versions of software.

The term *solution* is an industry buzz word that applies to well-equipped computer or workstation systems. As its name implies, a solution is a total approach in which a single vendor—known as a systems integrator—selects, matches, configures, and installs a particular digital imaging computer system. Usually, a solution also includes training the purchaser how to use the equipment and software, as well as troubleshooting and servicing any and all problems relating to the system. About the only thing that the user has to do is turn the key on, which is why a solution is often referred to as a *turnkey system*.

Micros, minis, mainframes, supermicros, & supercomputers

So far, all the computers, systems, workstations, and solutions we have been discussing are desktop-based units, which are also known as *microcomputers*. We won't be covering larger systems in this book because the vast expense and panoply of technical considerations puts

them well beyond the pale of the typical digital artist. (A single supercomputer can cost over $30 million and requires a sterile, chilled operating environment, plus a battery of highly paid full-time technicians to keep the sucker running.) The only people who can afford to do digital imaging on minicomputers, mainframes, supermicros, and supercomputers are scientists on grants, medical researchers, industrial designers, big-budget film makers, and (of course) military planners.

That you will be using a desktop microcomputer system of one sort or another instead of "big iron" should in no way make you feel inferior. After all, micros, minis, mainframes, supercomputers, and supermicros are all capable of creating identical imaging effects.

In 1983, Disney Studios generated nearly 20 minutes of ground-breaking high-resolution animation of its imaginative science fiction film *Tron* on an $8 million Cray supercomputer. (The film was an artistic and commercial flop, however.) In contrast, Steven Spielberg produced all the dinosaur special effects for his 1993 blockbuster film, *Jurassic Park*, on a battery of $50,000 Silicon Graphics workstations.

The major difference between a mainframe or mini and a PC or Mac is processing speed. An executed digital imaging command (giving the computer a specific instruction, such as applying a filter to an image) that might take 30 seconds on a micro would appear to be almost instantaneous on a supercomputer. Because a single finished image might require several hundred or more commands, what might take 10 hours of work on the PC or the Mac could be completed in less than half or even a third that time on a supercomputer. That's a two- or threefold increase in productivity at a price tag of 10–1,000 times as much money, which isn't very cost-effective for anyone on a real-world budget. However, given the fact that microcomputer processing power tends to double every 18 months (while the price drops about 50%), the performance gap between desktops and large systems should continue to narrow, while the price gap will continue to expand.

⇨ Necessaries

Just as virtually no one buys a stripped-down, no-options automobile off the showroom floor, there's hardly a computer owner who does not buy various devices, accessories, and enhancements that might not be absolutely necessary but are unarguably indispensable. Some are obvious, like ergonomically-designed desks and printer stands. Others might be known only to those who already have a familiarity with computers, such as surge suppressors, uninterruptible power supplies, disk storage systems, monitor filters, anti-static mats, mouse pads, copy easels, keyboard drawers, dust precipitators, cleaning kits, etc.

Forty-five minutes in a computer superstore or a two-hour cover-to-cover read of a major computer magazine (especially the advertisements) will give you an excellent idea of the kind of secondary support products you might want to add to your working environment. We'll talk about some of these accessories in Chapter 15, as they relate to making work easier or safer.

➡ Making choices

That's the basic blueprint for every imaging system, whether it's a modest entry-level unit or a high-end workstation. The following chapters will go into detail about the many choices you will have to make in selecting the right components for the kind of work you intend to do. Even if you decide to go the route of a workstation or a solution, you should know about the components to make sure that whatever you buy will be the best for your needs and budget.

7

Mac or PC, or what?

IN THE computer world, most users are divided into two separate, distinct, and competitive camps: PC and Macintosh owners. (Yes, there are other tribes, such as Amiga, Sun, or Silicon Graphics users. We'll discuss them later in this chapter.) Like Bosnians and Serbians, each group is fiercely loyal to their particular platform. PC users contemptuously dismiss Macintosh computers as "yuppie trash," while Mac users look at PCs as "grey-flannel technology."

We're members of the PC bloc . . .

For the past decade, we have been stalwart PC people. (PC stands for Personal Computer, but is generally taken to refer to that family of IBM-compatibles that are powered by Intel or Intel-clone microprocessors.) We bought our first IBM clones in 1984, to replace a battery of once state-of-the-art and, by then, obsolete Radio Shack TRS-80 and LNW (TRS-80 compatibles) computers. Abandoning our TRS-80s/LNWs was an expensive decision; we had money invested in hardware and software that we'd never recoup. (We eventually donated our Radio Shack stuff to the local high school.) But more than that, we had established a rapport, an emotional bond with those sometimes temperamental machines, so much so that we anthropomorphized them with names and personalities. (Sally's first TRS-80 Model I was called GIGO, which is computerese for Garbage In/Garbage Out—a name she has affectionately resurrected recently for her Comtrade WinStation.)

But it was past time to move on. After months of careful research, we took the plunge and invested in two IBM-XTs. Actually, they were Beltron XTs, 100% IBM-compatible clones that were cheaper and faster than official Big Blue machines. Quality-wise, Beltron wasn't the best, and certainly not the worst, clone manufacturer; but for the price, it was practically unbeatable.

Yes, we had briefly considered switching over to the just-launched Macintosh computer instead of going the IBM route. But at the time, not only was the original Mac half again as expensive as the Beltron, but it wasn't even comparably equipped. The Mac had a tiny 9" screen, a single floppy disk drive, and a very modest 128K of Random Access Memory (RAM). Our less expensive Beltron-XTs had much larger 12" monochrome monitors, floppy disk drives, and a 32Mb hard disk drive, and 640K of RAM. Besides, there was virtually no serious Mac software, and it wouldn't work with our daisywheel printers.

As the saying goes: in for a penny, in for a pound. Over the past 10 years, we upgraded our machines regularly for faster, more powerful, and versatile PC systems. (Our older but never quite obsolete machines were either sold through the local *Penny Saver* or given to family

youngsters.) We're still using some of the original programs that we bought for our early PCs—WordPerfect, Lotus 1-2-3, The Norton Utilities, etc.—albeit in upgraded, modern versions. At present, the majority of our PC software is specifically written to run under Windows 3.1. We expect that as they become available, we'll be gradually getting software that is written to take advantage of the new Windows NT operating environment.

Incidentally, our present 486s each have 32Mb of RAM, 50 times more memory than our original Beltrons and 2,000 times more than our first TRS-80 Model I. And by the time this book appears, we will have upgraded one PC to either 64Mb or 128Mb of RAM, depending upon our budget.

. . . but we've learned to love the Mac

The Chinese have always had a very pragmatic approach towards religion. It's not unusual for a born-and-bred Buddhist to also be a Christian, a Taoist, and an animist. Not that they're hypocritical or confused about doctrines and dogmas. To the contrary, they see all religions as pathways to immortality, so the more of them they practice and believe in, the greater their chances of getting into heaven.

While we're hardcore PC users, we're also recent converts to Macintosh computers. The most significant and telling conclusion we've reached in the seven months that we've been working with our Quadra 700 is that, except for a bad piece of software that wiped out most of the files on the hard drive (which we eventually restored from the backup tape), the Mac has not given us a lick of trouble. There's something to be said about paying extra for that kind of reliability.

PC virtues

One of the beauties of the PC is that, while the pace of innovation is so rapid that there will always be a newer, better, faster, and cheaper system, its backwards compatibility ensures that our older peripherals and software will always remain useful. Other PC advantages include:

> ➤ With over 100 million PCs in the U.S. alone, it's the most widely used type of computer. So, the PC has the greatest support network—supplies, repair facilities, accessories, training, users' groups, etc.—of any platform.

> ➤ PCs are priced less expensively than comparably powered and equipped Macs. It's the cheapest digital imaging platform.

➤ There are over 60,000 commercially available PC programs—far more than for every other platform combined. Also, the number and quality of digital imaging programs easily equals and may even exceed those available for the Mac.

➤ There are more peripherals and accessories made for the PC. The larger market, more intense competition, and greater volume translates into lower prices.

➤ Most PCs offer greater expandability and upgradability than most Macs, at significantly cheaper prices.

➤ The PC can be configured, altered, and tweaked far more, providing greater accessibility and individual customization.

➤ The Mac is produced by a single company, Apple, while PC compatibles are manufactured by hundreds of different companies. This creates an intense competitive spirit, which means changes and innovations appear more often for the PC.

➤ PC components are cheaper to repair or replace.

➤ The PC's operating systems and environments—DOS, OS/2, and Windows—are directly accessible by the user, which means more control and faster operating times.

⇨ PC shortcomings

However, there's a down side to the PC:

➤ PCs are much harder than Macs to set up, configure, and initialize.

➤ Adding peripherals or making system changes can cause problems; some are solvable only by a trained technician.

➤ The PC suffers from either too many or not enough standards. So some software and some devices might never work with your PC or will take an expert to get them working properly.

➤ Quality control among the manufacturers who make IBM compatibles and parts for the computer can vary considerably. Off-brand PCs are likely to require more service than those manufactured by major companies.

➤ Upgrading to a new system, adding memory, etc., can be problematical on a PC. Unlike the Mac, in which the computer automatically detects and adjusts to changes, the PC must be told whenever there are hardware changes (which is usually not an easy task). Otherwise, it won't work properly.

➤ The PC's operating system and environment are inherently more difficult to use and master than the Mac's. Windows, the PC's main operating environment for digital imaging programs, is

sometimes unstable and can cause seemingly random errors that turn into hours of grief.

➤ PC software is often harder to learn and run than Mac software and takes longer to master because the command conventions aren't terribly standardized. (However, imaging programs under Windows have become quite well standardized.)

➤ When something goes wrong, PCs are harder to diagnose, troubleshoot, and repair because there are more variables.

➤ While PCs cost less to buy, they generally depreciate more rapidly and command a significantly lower resale value.

The PC is a machine that you either love or hate, or both love and hate at the same time. But on the whole, its virtues and advantages more than outweigh its shortcomings and annoyances. PC users put up with and learn to handle the problems that are inherent in their computers, in exchange for the power and cost edge.

Macintosh virtues

All the things that we hate about the PC, we love about the Mac:

➤ There is but one Apple, which makes for greater consistency, uniformity, quality control, and compatibility.

➤ Because there's only one manufacturer, there's no problem with establishing hardware and software standards. So there are no nasty surprises or oddball ways of doing things.

➤ The Mac is probably the easiest computer in the solar system to set up and operate. To attach a peripheral or install a program, just hook it up to the computer or put in the program diskette and follow standard Mac setup procedures.

➤ Because the command structure is standardized and identical in all Mac software, learning to use the Mac, as well as learning any Macintosh program, is far easier.

➤ Apple provides 1 year free technical support for its computer, including a toll-free number.

➤ The Mac's GUI—graphical user interface—is a visually logical, intuitive way of organizing files and commands, and can be quickly mastered, even by a computer novice.

➤ The Macintosh's simple design makes it both more reliable than the PC, as well as easier to troubleshoot and repair.

➤ Hundreds of manufacturers sell thousands of products specifically designed for the Macintosh.

➤ Almost all service bureaus and most computerized print shops (as well as most digital artists and their clients) use Macs, so your image files will be compatible.

➤ Because of standardization, Mac software tends to be more compact and efficient than programs written for the PC. So they run faster and take up less hard drive space.

➤ Although we don't yet network our computers, the Mac is far easier and less expensive to link to other systems.

➤ Macs depreciate at a slower rate and hold a better resale value. Many banks accept Macintosh computers (but not PCs) as collateral on loans.

Macintosh clone?

Until recently, Apple seemingly had all the patents and copyrights tied up on Macintosh technology, inhibiting any potential clone manufacturers. But NuTek U.S.A. is now selling a "functionally compatible" Macintosh clone. While it is not a 100% compatible machine, NuTek claims that it will run most Macintosh software right out of the box. The company is also developing a more expensive model, the Duet, that will supposedly function as both a Mac and a PC compatible machine.

Although the prospect of a less expensive Mac "work-alike" (it can't be called a true clone) and a machine that will run both Mac and PC software might appeal to many, apparently, the reality falls somewhat short of the mark. The initial NuTek pseudo-Mac uses a less powerful CPU than the Mac Quadras or Centris and will therefore operate at slower speeds. Nor does it have a 24-bit color card, requiring adding a board to display true color. Also, there's no guarantee that it will run imaging programs like Photoshop or Color Studio. Besides, it's only slightly less expensive than a comparably equipped Mac. The dollar saving isn't great enough to entice users to make the switch.

At least for the present, buy only genuine Apple computers.

Macintosh shortcomings

Like the PC, the Mac is not a perfect machine. It has its faults, deficiencies, and eccentricities. Here are some of the things we don't like about the Mac:

➤ Although prices fell significantly between 1992 and mid-1993, Macs are still more expensive than comparably equipped PCs.

➤ There are far fewer Macs than PCs, so the user, products, and support bases are correspondingly smaller. (But proportionately, many more Macs are used for digital imaging than PCs.)

➤ Software and peripherals tend to be more expensive for the Mac. There's far less choice of Mac products.

➤ In its quest for simplicity and sophistication, the Mac often operates at slower speeds than the PC.

➤ While the GUI interface is easy to use, it can be significantly slower than DOS to operate. In comparison, the PC has the ability to accept and immediately execute direct, typed-in commands.

➤ Most Mac models have limited expandability and upgradability. Our Quadra 700 has only 2 NuBus slots. (We can add only 2 boards to that system.) However, Macs come equipped with ports and interfaces (such as SCSI and sound) built-in that are usually add-ons to the PC.

➤ Apple has released so many new models it's difficult to keep up with all the changes. Some models are being mass marketed in department and discount stores, so purchase advice may be spotty, and on-site technical support might be more limited and less competent (at least, on those models).

➤ So far as absolute performance goes, the Mac's top-of-the-line Motorola CPUs are significantly slower than top-of-the-line Intel microprocessors. Motorola's development schedule for introducing new generation CPUs is slower than Intel's.

Choosing a Mac or a PC

So which should you choose, a Mac or a PC? Here's some important factors that might help tip the scales one way or the other. You might want to number them in importance to you, and even give them a weighted value. For instance, ease of use may be number one to you, while cost and resale value are at the bottom of the list. Then compare and see which platform offers the edge.

➤ Convenience. How easy or time-consuming is it to set up and configure the system, to add or remove peripherals, etc.? (Mac by a mile)

➤ Ease of use. How difficult or how simple is it to operate the system and the software? (Mac uber alles)

➤ Learning curve. How long will it take to become familiar with the system and the software? (Mac in a walk)

➤ Power. How quickly does it perform frequent digital imaging functions, such as screen redraws and filter commands? Does the system have enough memory or the right coprocessors to avoid bottlenecks on large files? (PC has more muscle)

➤ The ability to run certain software. If you have decided that a specific digital imaging program is of primary importance over any hardware considerations, will it run on the platform that you will be using? If there are both Mac and PC versions, are they absolutely equal, or does one offer superior features or speed? (Either)

➤ Compatibility. Does the system you are considering successfully interface with specific peripherals that you already own or want to add? Will it create problems or conflicts with other devices or peripherals? Are there "built-in" software drivers that will add on to your favorite digital imaging programs, and are they affordable? (Mac puts PC to shame)

➤ Familiarity. With which platform are your employees or associates most familiar? Which do your clients use or does your service bureau have? (Though Mac has ruled the digital imaging roost for a long while now, PCs are catching up.)

➤ Service and support. How easy or difficult is it to get a service contract, hire a local consultant, buy supplies and accessories, etc.? Is there a user group nearby? (PC by a slight margin)

➤ Ergonomics. Which system "feels" better, fits your desk or studio environment, etc.? (Too personal for us to say)

➤ Display fidelity. Which system offers truer representation of your images, in terms of colors, sharpness, accurate display of circles and straight lines, etc.? (Depends upon the monitor and the graphics board)

➤ Expandability, trade-up. How easy, expensive, or important will it be to upgrade to a newer CPU, install extra memory boards, change the motherboard, etc.? Which one has a faster development cycle that will ensure that you stay at the cutting edge? (PC, but with certain qualifications)

➤ Resale value. Which platform commands a higher trade-in or resale value? (Mac can be taken to the bank)

➤ After system expenses. Computer prices aside, what will the software, peripherals, supplies, electricity, etc., cost for your particular platform over the long haul? (PC is usually cheaper)

And finally, but certainly not least, is the matter of cost. In absolute terms, what sort of budget do you have? Now, and over the next few years? If you incline towards the Mac platform, be prepared to pay a premium of roughly 20%–35% above comparable PC hardware and software. Will you be able to afford to upgrade your platform with more memory or a faster CPU? Do you project that the increased income or funds that you generate or save by selecting the more expensive but more convenient platform (Mac), as opposed to the cheaper but more powerful platform (PC), will justify the decision? How long is the payoff or break-even point? One year? If it's longer

than 12–18 months, then perhaps you should seriously consider lowering your sights.

So that brings us back to the same basic question: Which is the better platform for you, the Mac or the PC?

When selecting the better computer platform for digital imaging, there are no correct answers, no absolute rights or wrongs. The Mac might better fit your personality, the PC your pocketbook. You might tilt towards the Mac because of its vaunted ease of use, or incline towards the PC for its raw power. Everybody you know in the same line of business might use a Mac . . . or they might all have PCs. The salesperson for the PC might have a little more enthusiasm and knowledge or be ready to cut a better deal than the salesperson hawking Macs. Conversely, you might be turned off from one or the other by scare stories, true or not, of computer crashes, built-in bugs, missed upgrade deadlines, or other alleged design or manufacturing flaws.

Why one favors a Mac or a PC can be emotional, arbitrary, or simply irrational. We know one illustrator who bought a Mac, not because she knew anything about it but because it was the computer her son used in school and raved about at home. Our former accountant bought a PC for his office simply by the numbers: he read that PCs dominated the domestic desktop microcomputer market, so he was going with the system that seemed to be the overwhelming favorite of corporate America. (Actually, no one knows exactly how many desktop computers there are. Industry experts estimate that there are about 120 million microcomputers used in America, of which better than 90% are PCs. Apple reports that its 10-millionth Macintosh rolled off the assembly lines in Cupertino sometime during the winter of 1993, so Mac commands roughly 7%–10% of the microcomputer market.)

Obviously, what we're saying is that there's no simple or correct answer to which platform to embrace. Going Mac or PC is probably one of the more serious decisions you will have to make during your career, because you'll be completely committed to that particular platform for at least the next few years. So read the following two chapters on both Macs and PCs in this book. That way, you will get a much better idea of what you'll be getting, and getting into.

Is there an Apple/IBM synthesis in the future?

IBM (the ailing giant desperately trying to hold onto its market share) and Apple (the brash upstart perennially afraid that its complete dependence upon producing non-IBM-compatible technology could in

the long run prove to be a disastrous mistake) have joined forces in a cross-platform project named Taligent. Code named Pink, Taligent is an entirely new generation operating system (like DOS, Windows, or System 7) that supposedly will run the same applications software, regardless of the platform. Whether or not Taligent will run existing PC and Mac software is not clear. If not, then it might be many months or years before your favorite digital imaging software is available for the new operating system.

Also, IBM's future flagship platform might actually abandon Intel-based PCs and instead manufacture its own low-end RISC machines that would compete with high-performance PCs. (RISC machines are faster, more powerful and, usually, more expensive than PCs or Macs, but are often the choice of those who can afford workstations.) IBM has joined forces with Intel's arch-rival Motorola to produce the next generation of RISC-type CPUs, called the PowerPC. (Motorola makes the CPUs used in all Macintoshes, and Intel or Intel clones power all PCs.) IBM is scheduled to release its first PowerPC system by the end of 1993. It will initially be a PC-compatible, although it will use IBM's OS/2 operating system rather than Microsoft's DOS or Windows. IBM has not revealed if or how the Taligent operating system will fit in with its PowerPC plans.

Some high-end Macs—scheduled for release sometime in 1994—will reportedly incorporate the PowerPC chip.

The upshot of all this is that the inherent hardware differences between IBMs and Macs might become meaningless, since the Taligent operating system will likely allow both platforms to run the same software, and both platforms might begin using the same PowerPC chip. It's conceivable that this joint IBM-Apple standard will compete head-on with the PC, which is a risky business. (There are quite a few, well-entrenched PC manufacturers that will fight it.) Whether it will have the clout to dominate the microcomputer market as we reach towards the year 2000 is anyone's guess. Given the multi-billion-dollar incentive to be the dominant platform and system, it is possible that Apple and IBM could jointly announce other, equally revolutionary products soon after this book is published.

Or it could all fall apart. Both companies have a spotty history of joint ventures, and Taligent might turn out to be so much vaporware. So commit now to a platform. Get started in digital imaging, but stay informed about what the next generation of IBMs and Macs will offer.

What about the Amiga?

The Amiga is an excellent system for multimedia development and animated digital presentation. However, although it uses the same family of Motorola CPUs as Apple, we can't recommend it as a digital imaging platform. It's possible for an Amiga to mimic a Mac, and even a PC, with emulator software and hardware, but the price one pays for this hybrid system is speed. In digital imaging, speed might not be everything, but it's far ahead of everything else. Nor is the Amiga in its native environment really a suitable platform for serious digital imaging. Without going into the technical reasons, let's just say that the design differences hinder high-speed, top-quality operations. Also, while a handful of users are creating serious images on the Amiga, there are precious few professional-quality digital imaging programs or support products for it right now.

What about the Silicon Graphics, Sun, Hewlett-Packard, etc.?

No Mac or PC can match the raw processing power of an RISC-equipped workstation. These high-end, super-fast micros are the greyhounds of the microcomputer world. The graphics produced on them are nothing less than spectacular. With recent price breaks, entry-level workstations are selling as low as $5,000. So, why shouldn't you consider moving up to a big league platform?

There are two factors that will probably keep most digital imagers in the Mac/PC world: cost and practicality. Although it's possible to buy a basic high-powered graphics RISC workstation for about the same price as a Quadra 950 or a well-equipped 486 system, going beyond the basic configuration—adding more RAM, getting a larger hard drive, installing an optical drive, etc.—may be significantly more expensive than adding the same items to a Mac or PC. More to the point, your hardware costs will be eclipsed by the price of the software. Digital imaging programs written for workstations will be 2–10 times more expensive as those available for Macs or PCs. By the time you have brought your workstation up to speed and installed all the software you need, you probably will have spent several times more than you would with a comparably equipped PC or Mac. If you want a faster model, you can easily spend $100,000 or more just for the computer alone. Also, having a workstation is like owning a rare and exotic sports car. Even the smallest repair or part will be expensive and require the services of a specialist.

The other reservation we have about going the workstation route is the time and trouble it will take you to get up and running, as well as to become familiar with using the software. Most workstations use a powerful, complex, and user-hostile operating system called Unix. Because of their relative scarcity, the aid and comfort of a users' group or other sources of support and assistance is not as easily available.

These are machines only for the very successful, very profitable imagers who have the cash reserves and specific needs for them. Of course, if we had very deep pockets, we would buy such a workstation, because they are state-of-the-art for digital imaging. Only, we would buy a package "turnkey solution" from a company that will, for a price, take care of everything—installation, training, technical support, etc. Only a computer genius would simply get the machine and hope to start producing within a short time. But we can't afford such a step, and Sally is doing very exciting work on our PCs and Quadra.

Should I buy now, when exciting changes are on the horizon?

Some people buy a new car every other year. We personally don't understand it, because it seems to be just a status-hungry, "keeping-up-with-the-Joneses" attitude. Our Mercedes (which we bought used) is over 10 years old. It's solid, drives like butter, and has given us fewer problems than any newer car we've ever owned. When we do finally trade it in (years from now), we will most certainly buy another used car, and probably another Mercedes at that.

But when it comes to computers, we tend to trade in systems every 24 to 30 months. We get the next to the newest model. For instance, when the Pentium (aka 586) was first announced, we bought our 486s. The 486 had gone through its trial period and software had been upgraded to take advantage of its power. Besides, the prices went down then because the 486 was no longer the very newest model.

Why do we constantly upgrade our computers when we are rather conservative about things like cars? We have found that problems with our computers begin to become more frequent after two years of constant use. (That's why we never buy used computers.) In addition, we watch the resale value of our machines. As long as they are only one level below the state of the art, we can get a decent return (albeit one that is much less than what we paid). When yet another new model is announced, our computers begin to lose most of their value.

All that is why we recommend jumping into the field right away. You will probably be upgrading to the new exciting machines every two years anyway. In the meantime, you would be working and producing both art and income. The only proviso is to recognize that any platform (PC, Mac, or whatever) commitment you make now will influence your future purchases. That's because all your software, accessories, and peripherals will be geared to that platform. For a more specific discussion about buying and upgrading, see Chapter 32.

8

Putting together a PC system

I F ALL YOU WANT are specific hardware recommendations, use the chart in Table 8-1 as your shopping list. Any computer store or mail-order company will be more than happy to build a system for you, based upon these recommendations. But if you want to understand why we suggest a certain PC configuration and discourage the use of certain popular peripherals or components, please read the entire chapter. It'll help give you a better perspective of what's involved in selecting the best possible PC configuration for your digital imaging needs and budget.

Table 8-1 **Shopping list for a PC computer system for digital imaging**

	Ideal	Average & Practical	Minimum
Processor	66MHz 80486DX2	33MHz 80486DX	16MHz 80386SX
CPU cache	256K	128K	none
Architecture	EISA/VESA/ISA	ISA or ISA/VESA	ISA
Case	Full-size tower model	Mini-tower	Baby AT
Power supply	250–300 Watts	200 Watts	200 Watts
RAM memory	128 (or 256)	32Mb	8Mb
Hard disk	2.2Gb	540Mb	80Mb
Floppy drives	1.44Mb 3.5" & 1.2Mb 5.25"	1.44Mb 3.5" & 1.2Mb 5.25"	1.44Mb 3.5"
Controller	EISA SCSI	IDE or SCSI	MFM, RLL, IDE, or SCSI
Video board	24-bit EISA or VL-bus	24-bit accelerator	24-bit generic
Monitor	20" or 21" SVGA 1600 × 1280	17" SVGA 1024 × 786	14" VGA
Point. device	12"×12" LCD tablet with pressure sensitive stylus	6"×9" Tablet with pressure sensitive stylus	Mouse
Other	128Mb opto-magneto drive	44/88Mb removable drive	44Mb removable drive
	Multisession CD-ROM drive	2.2Gb 4mm DAT drive	SCSI board
	8Gb 8mm DAT tape drive	Multisession CD-ROM drive	
	44/88Mb removable drive	2400/9600 fax/modem board	
	14,400/9600 intelligent fax/modem board	SCSI board	
	16Mb cached parallel board		

Okay, you think you want to buy or lease a PC system to do some serious digital imaging. Unfortunately, you can't simply order an off-the-shelf PC suitable for imaging. It's like asking a supermarket employee to load up a cart with a hundred dollars' worth of food that you like, when he has no idea of your culinary preferences.

Just a few years ago, most PCs were sold like off-the-rack clothing. You shopped until you found a brand or a model that was most closely configured to your needs and pocketbook. If, for instance, it didn't come with a big enough hard drive, you either learned to live with what you got or bought a second drive.

Nowadays, it's the rule rather than the exception for a manufacturer or a dealer to build a PC according to the customer's specification. Computers have become modular commodities, with different components being almost completely interchangeable. All of the components can be assembled and attached in 15–20 minutes by an expert, and the only tool needed is a screwdriver. Most manufacturers and dealers, including leaders like IBM and Compaq, will have their technicians custom-build you a computer from whatever off-the-shelf components you specify, sometimes even while you wait. Want a 1Gb hard drive instead of the advertised 270Mb drive? No problem. Do you wish 32Mb of RAM instead of the usual 8Mb? It will take almost no time to install. All you have to do is tell your dealer or vendor what you want, and he'll configure it for you.

In other words, there is no such thing as a standard PC. Unless you are buying an expensive "turnkey" or "solution" system (which a VAR, or value-added reseller, configures specifically for digital imaging), almost no off-the-shelf PC will have everything you want and need. You'll have to ask for it. So, before you even talk to a salesperson, you should have already decided exactly what components you want in your system.

Don't worry if you don't understand what all the terms in Table 8-1 mean. We'll give you a crash course on what choices you have, as well as some recommendations on which to incorporate in your PC.

⇨ **The motherboard**

The motherboard, like the mother of all rivers and the mother of all battles, is the greatest, most important board in the entire system. It's that large, usually green epoxy board bolted to the bottom of the case that looks like a complicated railroad freight yard. Everything on your computer plugs into it: the CPU, memory chips, and peripheral boards. The motherboard is also referred to as the bus because, like a bus route, it picks up and drives the data from one point to another,

along a predefined route. Your computer's motherboard type is often called the computer's architecture.

All motherboards have expansion slots for peripheral boards or cards. The typical motherboard will have 8 slots, although the so-called "baby" (small-sized) boards might have only 4 to 7 slots, to better fit in small or slimline cases. A number of manufacturers have taken to consolidating into the motherboard itself functions and peripherals that are traditionally handled by plug-in boards. Thus, the motherboard might include the disk controller, video controller, and serial and parallel interfaces (the communications ports to which are attached printers, pointing devices, modems, etc.), and even a SCSI port (where many digital imaging peripherals will be plugged in). These integrated motherboards sound attractive, especially because the price is often less than you would pay for each separate item. Also, your video and hard drive might actually run faster because things attached directly to the motherboard (rather than plugged into it) will almost always communicate faster with the CPU.

The tradeoffs, however, are considerable. First, you won't get as many expansion slots—but then, with all those functions built in, you won't need as many either. Also, if anything malfunctions, you can't simply remove the bad peripheral board and replace it with another; the entire motherboard would have to be repaired or replaced and, besides being much more expensive, that's more inconvenient. However, the biggest drawback is that you're stuck with the manufacturer's choices of drive and video controllers. The probability is high they won't be the type that you want. (We'll discuss those particulars later.) Our advice is to forget about these integrated motherboards.

But assuming that you won't be shortchanged on the number of slots (7 or 8), by all means get the motherboards that offer built-in mouse port or SCSI port. Just be sure that any SCSI interface is for the newer SCSI-2 and will work with industry-standard SCSI drivers.

Incidentally, there are a handful of more expensive motherboards that have 10 or 12 slots. These models are used primarily as network file servers because they can be loaded up with all sorts of devices and peripherals that everybody in the office or studio can share.

The advantage of a 10- or 12-slot motherboard is maximum expandability. The cons are higher price, greater heat (the more boards, the hotter the interior of the computer becomes, and heat can cause failures), larger and bulkier case, the more difficult the computer is to configure, and the greater the chances for hardware conflicts. How many slots you tell the dealer you want in your computer is a matter of personal preference. Eight is quite enough for us, but six is too few.

What is a backplane?

One variation of the motherboard is called the backplane—a so-called daughter board that holds the CPU and memory and plugs into the motherboard. The advantage is quick upgradability for a newer CPU or more memory. The main disadvantages are space and speed: the daughter board takes up an extra expansion slot, and communication between the CPU and everything else on the bus is slower. Backplane computers tend to be moderately more expensive, both initially and for the upgrade board. So far as we know, they plug into only ISA-type motherboards, not the newer, faster EISA and VL bus-equipped motherboards. We have no personal experience with backplane design computers. However, we prefer the speed, extra slot, and savings that a non-backplane motherboard features.

 # Different kinds of motherboard architectures

There are four different kinds of PC motherboards on the market, and it's very important for you to know what they are.

> ➤ ISA (Industry Standard Architecture), also called the AT bus, is the slowest of the four but the easiest to build. Buy an ISA bus if you want low price, proven reliability, and strong compatibility.

> ➤ MCA (Micro Channel Architecture) is IBM's proprietary bus. Despite its being easy to configure and its inherent speed, avoid MCA-based computers like the plague. It's a non-standard, almost obsolete technology (used by IBM's PS/2 systems) that few peripherals manufacturers support.

> ➤ EISA (Extended Industry Standard Architecture) can communicate with EISA-specific peripherals at nearly 4 times the speed of the ISA bus. EISA boards are $100–$500 more expensive than ISA, and EISA-specific peripherals cost 25%–50% more than their ISA counterparts. There's a super-EISA on the way that's much faster, but it won't be available until sometime in 1994.

> ➤ VESA (Video Electronics Standards Association) is not really a separate motherboard but a new type of bus that is piggybacked on an ISA or EISA board. Also called a local bus or VL-bus, VESA is engineered to communicate directly with the CPU and is, therefore, faster than ISA or EISA architecture. However, there's usually a maximum of only 2 VESA slots on a motherboard.

A recent innovation, especially among high-powered motherboards, is to combine ISA, EISA, and VESA on the same board. Typically, such motherboards have 2 VESA, 2 EISA, and 4 ISA slots. It makes great sense, since this arrangement allows the user to have the best of all possible worlds: power, speed, and backwards compatibility.

Incidentally, just about the only VESA peripherals available at this time are video and hard drive controllers. If you have a VESA-compliant motherboard, you'll be able to gain a significant speed boost by installing VESA video and disk drive controller boards. They're slightly more expensive than non-VESA boards, and the specific type or brand you want might not be available.

 SUGGESTION Get a motherboard that combines VESA, EISA, and ISA. Our second choice would be EISA, and the last choice is ISA.

⇨ CPUs

As we've discussed elsewhere, the brains of every computer is a chip: the CPU (aka central processing unit or microprocessor). Every PC (at least for the present) is powered by Intel or Intel-compatible CPUs. The CPUs that digital imagers should consider as part of their PCs are (in descending order of desirability):

❶ 66MHz 80486DX2

❷ 50MHz 80486DX

❸ 33MHz 80486DX

❹ 25MHz 80486DX

❺ Any 80486SX

❻ 40MHz 80386DX

❼ 33MHz 80386DX

❽ Any 80386DX or 80386SX

How's that for a jumble of technobabble? Before we proceed any further, let's explain them.

First of all, the 80486 and the 80386 are just model names. You may even see them written with a small "i" (for Intel) in place of the 80-, such as i486DX2. The 486 is faster and newer than the 386.

Look at your car's speedometer; it gauges your forward speed. Many cars also have a tachometer, which shows you how fast the engine is revving. The speedometer and the tachometer are similar in that they both measure speed, but two different kinds of speed.

One of the ways computer CPU speed is rated is in megahertz, or MHz (that's engineering talk for units of 1 million). MHz is sometimes referred to as clock speed, because that's how fast the computer's internal clock is working. The higher the number, the faster the CPU. Typically, PCs run at 25MHz, 33MHz, 50MHz, and 66MHz. The next generation of super-fast CPUs might run at 100MHz or even more.

Returning to the speedometer/tachometer analogy, a high number on the tachometer means that the engine is racing at or near its maximum. But if the car is still in first gear, the speedometer will register only a modest speed. Put the car in 5th gear, and you're in Le Mans or Indianapolis 500 territory.

Computers are also rated by how many bits of information the CPU can process. 80386 and 80486 computers are 32-bit systems, while the Pentium is a 64-bit CPU. That means they can process 32 or 64 bits of information at one time. The higher the number of bits, the faster the computer will operate.

Here's where you need to understand a little about the philosophy behind CPU price/performance specs. Intel—the company that designed and manufactured the 386, 486, and Pentium microprocessors—markets and prices different versions of essentially the same chips. The CPUs with the suffix DX or DX2 are always faster, more powerful, and more expensive than those with SX designations. Technically, the 386SX is a 32-bit chip that can process data 32 bits at a time (that's good), but it can transfer it to and from the rest of the computer at only 16 bits at a time (that's bad). It's like having a 32-lane highway that must squeeze down to 16 lanes in order to cross over a bridge. The 486SX has several other performance-crippling features, such as no memory cache and no math coprocessor (both of which the DX and DX2 have). In other words, Intel deliberately engineered its SX CPUs so it wouldn't siphon off sales from its more expensive DX and DX2 models.

Incidentally, the new Pentium CPU is technically an SX CPU because, although it processes information 64 bits at a time, its data path is 32 bits wide. Intel plans to produce a hotter version of the Pentium that will be a true 64-bit chip.

Speed is also the difference between a DX and a DX2. The DX2 indicates that the regular operating clock speed of the CPU (such as 33MHz) has been doubled (to 66MHz). At the time of this writing, only the 25MHz and the 33MHz CPU can be doubled; the latter chip gives the 66MHz a marginal speed advantage over an undoubled 50MHz 486. That's because, like the SX having 32-bit processing powering but a 16-bit data path, some of the DX2's internal functions still run at 33MHz, not 66MHz. Intel plans to market other DX2 chips, the next probably being a 100MHz DX2, doubling the 50MHz CPU.

In a smart marketing move, Intel created a way that users who bought a computer with an SX CPU could easily upgrade to the more expensive DX or DX2 version. If your computer boasts that it has Overdrive capability, there's an empty socket on the motherboard into which you can plug in a DX CPU when you can afford it. In effect, it renders the slower SX CPU inoperative, replacing it with the faster chip. Intel makes it easy for even a bumbler to replace the SX chip

with what it calls ZIF (zero insertion force). It's a snap-in socket that requires a user to simply drop the CPU in and push down a lever.

So here's what you have to keep in mind:

> The faster the clock speed (MHz rating), the faster the computer.

> DX will always be faster and more expensive than SX CPUs with the same clock speed.

> DX2 performance gains are more incremental than dramatic, so don't assume that you'll get significantly more speed out of a 66MHz DX2 than a 50MHz DX CPU.

> When given a choice, and the price difference isn't significant, buy the computer with Overdrive capability (for easier upgrade).

> When given a choice, and the price difference isn't significant, buy the PC that has a ZIF socket, for painless CPU replacement.

⇨ Memory cache

For imaging, you want a PC with a 486DX CPU. Whether it's a 66MHz 486DX2, a 50MHz 486DX, or a 33MHz 486DX depends upon your budget. When choosing among the various CPUs, make sure it has a built-in memory cache of at least 8K. A memory cache is where information about the last command executed is stored. The probability is high (90–95%) that you'll ask the computer to do the same command again, or at least something very similar to that last command. If you get that information from the hard disk, where it's normally stored, it might take hundreds of milliseconds (thousandths of a second) to find, retrieve, and execute the command. But if, instead, that same code is stored in a special high-speed memory (the cache) that can be accessed in nanoseconds (billionths of a second), you'll retrieve it almost instantaneously. The effect is a great increase in speed because electronic (chip) memory is always many times faster than disk-based memory.

Some 486s can store 8,000 (8K) bits of information about your last command. That's good, but it won't save you much time if you ask it to execute a command that is 50K in size. Only the first 8K would be covered. That's why many manufacturers add a set of external high-speed memory chips to the built-in 486 memory cache.

When shopping for your PC, ask what the size of the memory cache is. If you're told that it's 8K, that means that the manufacturer has opted to not include an external memory cache in order to reduce costs. (It doesn't mean that the computer is crippled, only that it won't give you the top performance possible.) Memory cache sizes range from 32K to 1,024K, although for the 486, 128K and 256K are most typical. Daniel's 386 PC has a relatively modest memory cache of

64K, while Sally's 486 PCs both have 256K. If you can afford it (high-speed memory chips are expensive), and if your computer will support it, you might be able to squeeze out a little extra performance with 256K, 512K, or even 1024K.

 # What about the Pentium?

The Pentium, also referred to as the 586, is currently the state-of-the-art Intel CPU. Although expensive (the price to computer manufacturers is $1,000–$1,200 each, at the time of this writing), it is also the fastest CPU Intel makes for the PC.

But there's a saying in the computer industry: you can always tell the pioneers by the number of arrows in their backs. Almost every new technological advance has been accompanied by an uncertain period plagued by bugs, glitches, and other problems. Eventually, the manufacturer produces a patch or redesigns the chip in order to overcome or eliminate early problems, but the damage has been done to those users who bought when new products first hit the market.

The Pentium is new technology, no question about that. Whether or not it will create problems for its early purchasers we can't say because, as of this writing, it has just hit the marketplace. But to fully utilize its advances, computer manufacturers have had to redesign the basic computer architecture. Yes, the Pentium can be easily inserted in empty Intel Overdrive sockets prepared for its introduction. And yes, there will be a number of manufacturers that, in order to save retooling costs, will simply substitute a Pentium for the originally intended 486 CPU (they're both pin-compatible). But in both instances, these 486s turned into Pentium machines won't run as fast or have the capabilities as ones designed for the 586.

Also, the trade press reports that the Pentium is, literally, a hot chip, requiring a heat sink or a fan to be glued right on it. If you buy a Pentium-based PC, make certain that it's in a large tower-style case, which allows better air circulation and cooling.

We're going to wait until at least late autumn 1994 before shopping for a Pentium-based PC. By then, any bugs or problems will probably have been worked out, and the inventories of leftover 486 motherboards sporting Pentium CPUs will have diminished considerably. Also, the industry's biggest trade show, Fall Comdex, will have come and gone. Usually, that's when prices begin to drop, especially because Intel's next CPU (the Sextium?) might have been announced by then.

 # What about the Alpha & the PowerPC?

Digital, as well as IBM in partnership with Motorola, are both offering their versions of 64-bit CPUs to compete with Intel's Pentium. All three CPUs are powerful state-of-the-art chips that will control the next generation of PCs. The Alpha is slightly less expensive than the Pentium, the PowerPC less than half the price. Each CPU has some engineering feature that puts it one up over the competition; but for the present, if you want a 64-bit CPU, get only the Pentium. The main problem with the Alpha and the PowerPC is compatibility. Neither is 100% Pentium-compatible, and it's not certain how well (if at all) they will run DOS and Windows programs.

Until and unless the manufacturers can issue an absolute guarantee of 100% compatibility, we suggest avoiding machines that are powered with Alpha or PowerPC chips.

CPU recommendations

Buy or lease a 50MHz 486DX or a 66MHz 486DX2-based PC system for serious digital imaging (and the 100MHz 486DX2, when it comes out). It's fast, and, more importantly, it's proven technology. (When the Pentium chip becomes more affordable—probably in late 1994— we will begin recommending it over the 486.)

Computer design and manufacture is such a fast-moving field that today's top-of-the-line model can be tomorrow's technological orphan, so be guided by performance specs rather than brand names. (In addition to Intel, PC CPUs are made by other manufacturers, such as Cyrix, AMD, IBM, and Texas Instruments.) What you are looking for is 100% Intel compatibility, the same "mps" rating (millions of instructions per second), the same instruction cycles, a true 32-bit (or 64-bit) system, a built-in math coprocessor, and a built-in memory cache of at least 8K.

Memory

Every computer has two kinds of memory. One is permanent memory, as found on a floppy diskette, hard drive, tape backup, etc. The other is the electronic memory (Random Access Memory or RAM) that allows you to do literally everything. You need RAM to hold the part of the software you're currently using (like Photoshop), part of your operating system, and whatever data you generate or call up from the hard drive.

To better understand the difference between RAM and the computer's storage devices, think of cooking a meal in your kitchen. The refrigerator (hard drive and other storage devices) is where you keep the food (software). You actually prepare the meal with the food processor and the oven (RAM). But if the fuse blows (the power turns off) on the processor or the stove, you can't leave the food out or it will spoil; it has to be put back into the refrigerator. (Actually, when you turn off your computer, anything in RAM disappears forever—unless it is saved to permanent memory.)

Today's average PC comes equipped with at least 4Mb of RAM, which is scarcely enough to run Windows 3.1. Microsoft recommends at least 16Mb of RAM for Windows NT. We strongly suggest that anyone doing serious digital imaging should have a PC with at least 32Mb. 64Mb is much better, especially for those who will be outputting their work to film recorders or to prints at least 8"×10". If you are going for maximum resolution or plan to produce large-size images (such as posters), you will want 128Mb or even 256Mb of RAM.

Most RAM chips for today's computers are soldered onto SIMM (Single In-line Memory Module) boards. These small boards—which are about the size of a thick stick of chewing gum—plug into slots on the motherboard. They're available in various densities, from 256K to 32Mb for each SIMM. Some motherboards can accommodate only 2 SIMM, while others have slots for 16 SIMM. They're very easy to plug in (assuming that the slots aren't physically blocked by the power supply or drive bays, in which case something has to be disassembled), though you have to be very careful not to accidently generate static electricity (which can destroy a memory board in an instant).

RAM is rated according to how fast it works, which is measured in nanoseconds (billionths of a second). That might sound like so much science fiction to us real-time creatures who can take 10 minutes to order lunch from a short menu, but in computerese, it's half a lifetime. Typically, today's RAM chips range in speed from 60ns to 80ns (nanoseconds). Of course, the faster the RAM, the better. However, faster RAM carries a 10%–25% premium, which can amount to hundreds of extra dollars. In addition, your computer CPU must be able to make use of the RAM's speed, or else you'll just be wasting money on faster RAM chips that the computer will slow down anyway. Also, the practical performance difference between a 60ns and 80ns memory chip usually ranges from infinitesimal to negligible. But if you are doing memory-intensive work with large image files (such as applying a filter in a paint program to a 40Mb file) those seconds can add up. Personally, we opted for mid-speed, slightly less expensive 70ns RAM.

The other thing to keep in mind is that the more RAM you have, the more it costs. Currently, RAM is selling at $40–$50 per megabyte, although it can fluctuate according to the market price or whatever

anti-dumping tariffs Washington decides to impose on memory chips. (95% of all memory chips are foreign-made, and the small American RAM industry periodically protests that they're being driven out of business by lower-priced Pacific Rim chips that are sold below cost in order to destroy their companies.) Maxing out your RAM could cost you more than your computer and hard drive combined.

Your motherboard might restrict the total amount of RAM you can add. Most 386 and 486 machines allow up to 32Mb and no more. That's because your computer might not have any instructions on recognizing and handling the relatively new (and expensive) 16Mb SIMMs. Those instructions are contained in a chip that comes with your motherboard, called the BIOS (Basic In/Out System). On many computers, a new BIOS may be purchased and installed (about $40–$50) that will recognize 16Mb SIMM. Thus, a particular brand of computer that is advertised as having a maximum memory capacity of 32Mb might actually be able to accommodate 128Mb.(However, don't take such upgradability for granted. Get it in writing.)

SIMM engineering is such that you can't add a single board whenever you're flush or the mood hits you. Usually, they must be added in groups of 4. Some motherboards permit one or two SIMMs to be initially installed, while others allow mix-and-match densities (such as a combination of 4-1Mb and 4-4Mb SIMMs). One shouldn't try to mix SIMMs with different speeds, however, because it might mess up the computer's timing and slow things down. And if you decide to install 16Mb SIMMs, they can't be mixed with any other kind of SIMMs on most motherboards.

SUGGESTION Imagers measure wealth by how much RAM they have. Load up your motherboard with as much RAM as you can afford. When you buy your computer, make sure the motherboard will be upgradable to at least 64Mb, if not 128–256Mb of RAM. Eventually, you'll want and need that much memory.

⇨ Drives & drive controllers

Every PC has at least one hard drive and one floppy drive; most have two floppy drives. The hard drive is the primary means for storing programs (the software you buy), and data (the information, files or images you create). Hard drives come in various capacities, interfaces and speeds. Floppy drives are used for installing programs, and for downloading—taking off the computer or the hard drive—individual files (for backup, or to transfer to another computer). We'll cover both floppy and hard drives in greater detail in Chapter 12.

To attach a hard drive and floppy drives to your PC requires what is called a drive controller. It's a peripheral board that plugs into an expansion slot (some controllers are built into the motherboard) and is

connected to the drives with flat ribbon cables. For better or worse, there are dozens of different drive controllers on the market.

We could go into long-winded, technical explanations of what they are and how they work, but let's just cut to the chase and mention only those that are suited for digital imaging. Here they are, in order of preference:

➤ SCSI (Small Computer Systems Interface)

➤ IDE (Integrated Drive Electronics)

➤ ESDI (Enhanced Small Device Interface)

We describe the various kinds of controllers in some detail in Chapter 12.

 SCSI is the drive controller of choice for imaging. Most computer systems are sold with the hard drive already installed, formatted, and connected to the controller board that you specified. Unless you are computer sophisticated and have some spare time, don't try to save money by getting a computer in which you will have to add and configure a hard drive by yourself.

⇨ Video controller

What you see on the monitor is directly related to the type of video controller board you have inside your PC. Over the years, PC owners have had to contend with a host of different video controllers: MDA, CGA, Hercules, EGA, PGA, 8514/A, just to name a few. The one that has endured the longest is called VGA, or Video Graphics Array, although it's been split into sub-categories, such as SVGA or EVGA.

Rather than bore you with the technical details, let's simply declare that you will need a 24-bit VGA board that comes with Windows drivers. That means that your computer monitor will be capable of displaying up to 16.7 million colors at a minimum resolution of 640 dots by 480 dots per square inch (dpi), and that it will do this for any Windows-compatible program (such as PhotoStyler). There are literally scores of different 24-bit VGA boards that fit this bill, ranging in price from under $100 to well over $4,000. Why the big difference in cost? As usual, power and performance.

Depending upon the board and the type monitor you have, VGA is capable of displaying at different resolutions. 640×480 dpi is the minimum resolution possible. At that resolution, only a portion of your image will fill most of the screen, and it will be partially obscured by menu bars, tool boxes, and color palettes. If you want to display the entire image, you must reduce its magnification, and/or temporarily hide any command boxes, bars, or palettes.

But if you have a more expensive video controller board capable of displaying 24-bit color at higher resolutions, such as 800×600 dpi, 1024×768 dpi, or 1280×1024 dpi, your image would be relatively smaller but denser, giving you more detail with which to work. There would be more open space on the monitor, and therefore, some of the tool boxes, palettes, etc. could be put to the side without intruding on the image. With a large monitor set at the maximum resolution, there would be space for an entire image displayed at 100% size, plus all your boxes, bars, and palettes. Depending upon the software, some monitors and video boards will even allow you to display two side-by-side pages.

There's a tradeoff for having greater resolution on the monitor. The higher the resolution, the smaller the image will appear. If you don't have 20/20 eyesight, or you prefer working a few feet away from the monitor, you might not be able to read small text or see minute details. There are several solutions to this problem. The most obvious one is to move closer to the monitor, but because this might increase radiation exposure, we do not recommend it. Another approach is to buy a large-sized monitor. Sally has a 20" Mitsubishi monitor, which, although it is far from the best available (it was a discontinued model at a closeout price of $799), is large enough to be able to see every character, line, and detail. Daniel's solution is even easier, and far less expensive. He uses a $10, off-the-shelf pair of 1.25-magnification reading eyeglasses to do detailed work on his 14" monitor. It's very low-tech, but it works.

HINT

Just because you have a 24-bit VGA video controller does not necessarily mean that you will see 24-bit color. You must set your Windows, or other video drivers, for 24-bit color. VGA allows the user to specify different resolutions and color modes. Some boards can display only 16 or 256 different colors at maximum resolution. So set your software to 24-bits rather than selecting the highest resolution, except on expensive boards that will give you both at the same time.

Another critical advantage of more expensive boards is greater speed. Running graphics under the Windows environment is much slower than operating in the DOS environment. To overcome these programming limitations, engineers have created elaborate and exotic coprocessor and accelerator chips that can speed up what you see on the monitor. While many relatively inexpensive video controller boards have some acceleration hardware built into them, the better boards use state-of-the-art acceleration techniques, more advanced software drivers, more and faster video memory, etc. Also, inexpensive boards might run very fast in the 8-bit or 16-bit mode, but not in 24-bit color.

SUGGESTION

If you are on a tight budget, almost any 24-bit video controller board will do, but get a guarantee of 24-bit compatibility with your programs. If you want significantly better video performance and

higher resolution, consider paying more for a high-end video controller from a company like Matrox, Targa or SuperMac.

Sally uses a Matrox Impression 1024 board that gives her 24-bit color at resolutions up to 1024×768. For even better performance, get the EISA version of the board (if you have an EISA-type motherboard), though it is expensive. The first Matrox we got worked terribly with Windows, but virtually all our problems disappeared as soon as Sally installed a new driver. It has been a steady, stable, and fast performer ever since. (However, it was recently discontinued and replaced by a much faster board that plugs into a VESA-bus slot.) Daniel uses a much more modest Genoa board, which, although much slower and with far less resolution, has the virtue of costing ⅕ that of Sally's Matrox.

What about VL-Bus video?

Many recent PCs come equipped with 1 or 2 VESA slots that can accommodate VESA video controller boards. Getting both a VESA-equipped computer and a VESA video controller board doesn't cost much more, but VESA will work several to many times faster than comparable ISA-type video controller boards. The only problem is there are few inexpensive 24-bit medium- or high-resolution VESA video controller boards on the market, at least, not right now. If you want VESA performance, you'll be limited to 640×480 dpi or 800×600 dpi in the 24-bit mode, or must be prepared to fork out lots of money. This situation could change at any time. So keep an eye out for affordable, high-resolution 24-bit VESA boards.

⇨ Monitors

Paradoxically, your monitor is both the least and most important component of your computer system. It's the least significant because it doesn't do anything. Whether you have a $50 12" monochrome or a $4000 21" color monitor won't improve or denigrate your images or other files one iota. All it is is a window onto your files. On the other hand, your monitor is vital to digital imaging. You have to see what you're doing, or you can't do it. Try to picture a blind person doing imaging; it's just not possible, even with a seeing eye dog.

There's a school of thought that has it that the bigger the monitor, the better. While we don't subscribe to that theory, we do admit that Sally's system has a 20" color Mitsubishi monitor. No, a bigger monitor won't assist you in creating better images, but it will allow you to see everything in greater detail, and all at one time. A smaller monitor displays very small images or can show only portions of the image at any one time. As we mentioned in the previous section, a larger monitor provides more visual real estate when running in the

Windows environment, so you can more easily access toolboxes, pull-down menus, and color palettes without obscuring part of the image.

Here's what you should consider when buying a color monitor for your PC:

> Screen size

> Screen resolution

> Dot size

> Anti-glare surface

> MPR compliance

> Interface

> Built-in intelligence

For serious digital imaging, we suggest at least a 17" color monitor. NEC, SuperMac, Samsung, ViewSonic, and others sell 17" monitors, which range in price from $800–$1,300. 20" monitors are better but more expensive, costing between $1,200 and $3,000. 21" and larger screens are preferred but can run $3,000–$10,000.

HINT If all your work will be black & white, save money by getting a high quality greyscale monitor.

One of the major criteria of quality is the screen resolution. It used to be that a good color monitor was defined as one that could display 640×480 dpi. That number has now increased to the point that 1024×768 is considered average. Better screens can resolve at 1280×1024 or even 1600×1200. But don't get into a numbers game by purchasing the highest resolution screen you can afford. Remember, it has to match your video controller board output. If your video controller board is capable of displaying 24-bit color at only 640×480 dpi, then it doesn't matter if your monitor has a resolution of 1280×1024; you will get true color only at 640×480 dpi. Look for a monitor whose resolution is the same as, or slightly greater than, your video controller board's resolution in the 24-bit mode.

Dot size is one of those figures that means everything and nothing. It refers to the diameter, in millimeters, of the actual dots that are projected on the screen. The smaller the dot, the tighter and sharper the image. An inexpensive color monitor might have a dot size of .51mm, while an average screen is .31mm. More expensive monitors have dot sizes of .28mm, .26mm and even .25mm. The problem, however, is that as the dots become smaller and sharper, they are also spaced further apart. So, while a .31mm dot gives the visual illusion of a continuous, unbroken line (the phosphors tend to mush and overlap into each other at that size), a pitch of .25mm might look like a finely dotted line. Which you prefer is a matter of personal preference.

Sally's monitor has a dot pitch of .31mm, Daniel's is .28mm. Frankly, we don't see any significant difference between the two, and we have no compelling need to buy a more expensive monitor just to have a finer dot pitch.

If you've ever tried to watch television with sunlight streaming in the windows, you know what glare can do to a screen. Many manufacturers add a special anti-glare coating to their screens that will reflect light out at an oblique angle, away from your eyes. All other things being equal, buy the monitor with an anti-glare coating. But be aware that even the best anti-glare coatings will only cut down, not completely eliminate, glare. Another solution is to buy an external anti-glare mesh or a polarizing filter. They might be more expensive, but they also cut the glare down much more. (A good polarizing filter might also have a built-in anti-static lead that will help reduce the amount of dust that screens attract.) The down side is that a filter may change the color values. But the best solution is also the cheapest: move the monitor away from the glare. By slightly rotating the screen, you can eliminate most glare.

You've heard the scare stories and health warnings. Color computer monitors can cause cataracts, induce miscarriages, and even lead to cancer. Maybe yes, maybe no . . . the jury's still out on that controversy. Until we know definitely, it's best to use a monitor that complies with safety standards. No, not the EPA's Reagan-era standards (which were business-friendly and user-hostile), but the much tougher Swedish government's MPR-2 standards. Buy only those monitors that state that they meet or exceed Swedish MPR-2 standards. After all, it's your life we're talking about; why take any unnecessary risks with it?

Most color monitors have a standard VGA port or cable that plugs directly into your video controller board. Higher quality monitors might have, in addition to or in place of the VGA port, a 5-pin BNC connector. Although needing a special cable, a BNC-capable monitor usually can separate the color channels more accurately, producing a slightly superior and faithful color image. (Of course, the quality of your image will only be as good as the quality of your video controller board.) Also, some monitors are convertibles in that they may be attached to either a PC or a Mac, some even at the same time.

Recently, manufacturers such as NEC and Philips have been slowly releasing a new generation of "smart" monitors that are very suited for digital imaging. They are different from earlier monitors in that they have a built-in microprocessor that allows them to be fine-tuned and calibrated to various established color standards, and then saves those settings so you only have to push a button to recall them. The major advantage of having a smart monitor is that one can adjust the colors to more closely conform to actual printed pages. (However, an electronically transmitted color image will always look different than

one printed on paper. See Chapter 29.) Also, they allow you to customize your colors, as related to a specific program. For instance, you can have one setting for *Photoshop*, another for *Painter*, etc. Most monitor manufacturers advertise that it's easy to calibrate their monitors—some include color swatches and software for that purpose—but quite honestly, true calibration requires the use of a densitometer that attaches directly to the screen.(See Chapter 29.)

SUGGESTION Smart monitors cost the same as or only slightly more than regular monitors, so you would do well to buy the smart variety. Whatever monitor you get, be sure it is compatible with your 24-bit video controller. A 17" monitor would be our minimum preference. 20-21" monitors are more expensive but extremely desirable.

Communications board

Also known as the I/O board, this small, very inexpensive, usually generic peripheral contains the computer's serial and parallel ports, where you plug in things like a mouse or printer. Some computers have serial and parallel capabilities built into the motherboard, so an extra card is unnecessary. Many I/O boards also have a game port built in, though we have yet to find a practical use for the game port (unless you have an alien-zapping teenager).

For years, an I/O board was an I/O board; but with demands for higher performance and faster data transfers, there are now super serial and faster parallel ports. They're considerably more expensive relative to the price of a generic I/O board, but at $35–$500 each, they're still affordable. The main difference is that whereas the old style I/O cards usually combined 2 serial, 1 parallel, and even 1 game port on a single board, the new serial and parallel ports may be separate and will therefore take up two slots. We haven't had any experience with these new I/O cards, but because of the increased performance specs, we will probably incorporate them into our next computer.

SUGGESTION Make certain that your PC will have at least 2 serial ports and 1 parallel port. (Two parallel ports are even better.)

You'll need 1 serial port for your mouse or pointing device and 1 parallel port for attaching your printer. The second serial port can be quite useful for adding a modem, a serial printer, a calibrator, or any other device. If possible, try to get an I/O board with a second parallel port as well. We have both a Hewlett-Packard LaserJet II office laser printer and a Tektronix Phaser IISDX dye sublimation printer that are parallel devices, and we must turn off the computer and switch cables when we want to change printers. (The Tektronix won't allow you to use what is called an AB or switcher box for selecting printers.) Having an I/O board with two parallel ports would make life a lot easier.

 # Pointing devices

A pointing device allows you to draw on your monitor and to choose from among icons, commands, pull-down menus, etc. In other words, it provides a means of immediate and direct interaction with whatever is on your screen.

There are various kinds of pointing devices:

➢ Mouse

➢ Trackball

➢ Stylus

➢ Puck

The most ubiquitous pointing device is a mouse. It's that palm-sized, plastic contraption that you see people pushing about on their desk to make things happen on their screen. The mouse has a ball and gears inside, and when it moves about on the desk (or a mouse pad), it tells the cursor where to go on the screen. The mouse's biggest advantage is that it is universally available, and prices begin as low as $9.95. But a mouse just isn't accurate enough for the kind of precision work you will need to do in imaging.

The only pointing device worse than a mouse for precision work is the trackball. Basically, a trackball is a mouse that has been turned upside down. With a trackball, you push a ball around with your fingertips and the cursor makes corresponding moves. It's great for zipping about a word processor or spreadsheet but terrible for drawing and tracing.

A stylus—also called a digitizer, digitizing pad, or tablet—is the most natural pointing device to use for drawing because it works and feels like a pen or pencil. The stylus is attached (either by cable or wireless magnetic control) to a special drawing pad. More expensive styluses have sensitive tips that allow them to control the degree of pressure of the line being drawn, just like pressing down hard on a paintbrush will "mush" the line's appearance. The user has many options on speed and sensitivity and can easily customize the stylus' touch and feel. Depending upon the manufacturer and the model, the pad or tablet can range in size from a modest 5"×5" up to 12"×18" and even larger. The larger the tablet, the more detailed and precise the drawing or tracing can be.

Most digitizers can also be outfitted with a mouse-like device that fits in the palm, called a puck. It's pushed around like a mouse, but at the front is a clear round circle with cross hairs that mark exactly where the cursor is at, providing greater precision than a mouse. Sally uses

the stylus for paint and illustration programs and switches to the puck for almost *everything* else.

SUGGESTION
If you can afford it, get a cordless 12"×12" Wacom, Kurta, or Summagraphics tablet with touch-sensitivity capability, with both a stylus and a puck. If that's too expensive, buy a smaller, wired model (8"×12" or 8"×8") without sensitivity levels, or get something like the inexpensive 5"×5" Acecat Tablet with both a pen and a puck.

Keyboard

We've paid as little as $10 and as much as $129 for a keyboard. Computer salespersons will talk about such things as capacitors, impedance, tactile pressure, programmability, etc. in explaining the difference between no-name generic and brand-name quality keyboards. But what matters most is how it feels to your fingertips.

Keyboards are very personal items, like toothbrushes and underwear. You want one that feels comfortable to the touch and has keys arranged for maximum convenience. Most keyboards are pretty much standard, with a row of F (function) keys along the top, a numeric keypad on the right side, and a second, directional keypad in between. Some have built-in trackballs, which Daniel would like, if he weren't left-handed. (Sally hates trackballs.) We've found even the cheap keyboards pretty durable. The only problem we've had with the many keyboards we've owned was one that we accidently dropped, breaking several keys. Chances are your keyboard, no matter how little or much it costs, will outlive you if you take care of it.

However, there are several styles you should consider. Do you want a hard or soft touch; do you like a clicking sound every time a key is depressed, or do you want silent keys? Do you prefer sculpted keys (such as was made famous on the IBM Selectric typewriter), or wide, flat-topped keys? Try out as many different keyboards as you can and get the one that feels the best to you.

Our personal preference is for the OmniKey series of keyboards made by Northgate. They're moderately expensive, but we like their weight and feel. What's more, they have a second set of F keys along the left side, for those of us who grew up on the older PC models (the top row of F keys came out with later models). But as we said, it's a matter of personal taste, and what we feel is wonderful might be too harsh and noisy for someone else.

SUGGESTION
Go into as many computer stores as you can and try out the keyboards. Write down the names and model numbers of the ones that feel good to you. Then buy your very favorite from that list.

Case & power supply

Computer cases come in all sizes and shapes, from the familiar AT-style box that sits on the desk under the monitor to a large tower case that stands beside the desk like an electronic pillar. In between are mini-towers, slimlines, and exotic-shaped cases. The case houses the motherboard and peripheral boards, disk drives, and a power supply to provide the right kind of electricity.

For serious digital imaging, a large tower case is the best choice.

> ➤ It will have more bays for disk drives, hard drives, DAT drive, SyQuest drive, CD-ROM drive, etc.

> ➤ It will be easier to install or work on the motherboard, memory boards, peripheral boards, etc.

> ➤ Being large and spacious means greater air circulation, which in turn will allow the system to run cooler and safer.

> ➤ The power supply will be beefier, providing safer, more consistent power, and a lower operating temperature.

> ➤ The tower case itself will be heavier, more stable, and less prone to knocks or vibration.

> ➤ Tower cases usually have thicker steel covers, shielding them better against radio frequency interference (which can produce snow or static on nearby TV or radio sets).

> ➤ Sally's new tower case has, in addition to a fan on her 250W power supply, a second fan in the front for sending a stream of cool air directly onto the motherboard and the peripheral boards. The cooler the computer, the less problems it will give you.

 Spend the extra $50–$150 to have your system housed inside the biggest, most expandable tower case your dealer has to offer. If he can't sell you a tower case, consider buying your system from someone else who can.

Do it yourself?

Finally, should you consider building your own PC? After all, if a college freshman named Michael Dell can do it in his dormitory room with only a screwdriver (thus launching a billion-dollar mail-order empire, the Dell Computer Corporation), you should be able to assemble off-the-shelf components and put your own system together, right?

Daniel is by no means an active do-it-yourselfer, but he has built four PCs by himself over the last two years, saving many hundreds of dollars. The first took four hours, the second two hours, and the others less than an hour to assemble, troubleshoot and get working.

On the other hand, you must know which components to use and where to buy them. You also must be prepared for the mistakes and problems that inevitably occur. If something does go wrong, you might not have anyone to help bail you out, especially because each component manufacturer or vendor will blame the other for the problem.

Our advice, based upon lots of experience: Unless you really know what you're doing, pay the extra few hundred to have someone else build your PC. It's an interesting and fun project if you have a spare Saturday afternoon and wouldn't be terribly disappointed if you're not up and running by evening, but a very serious problem if your livelihood depends upon having a working system almost immediately. Our next PC will be built by our technician, who will take all responsibilities.

9

Putting together
a Mac system

IF YOU don't have the time or the temperament to read completely through this chapter, look at Table 9-1. It lists three Mac configurations that are appropriate for serious digital imaging: the cheapest, the top-of-the-line, and the best compromise between price and practicality. You may use it as your shopping list. If you want to understand why we make these recommendations, read on.

Table 9-1 **Shopping list for a Mac computer system for digital imaging**

	Ideal	**Practical & Average**	**Minimum**
Model	Quadra 950 33MHz	Quadra 840AV 40MHz	IIsi 20MHz
Processor	68040	68040	68020
Memory	256 Megabytes	32 Megabytes	9 Megabytes
Hard disk drive	2.2 Gigabytes	400 Megabytes	80 Megabytes
Video board	24-bit built-in color	24-bit built-in color	16-bit display board
Monitor	20" or 21" 1,152 × 870	16" 832 × 624	14" 640 × 480
Pointing device	12"×12" tablet with pressure sensitivity	6"×9" tablet with pressure sensitivity	Mouse
Other peripherals	44/88Mb removable drive	Multisession CD-ROM drive	44Mb removable drive
	8Gb 8MM DAT drive	44/88Mb removable drive	
	Multisession CD-ROM drive Accelerator board		
	14,400/9600 fax/modem		

Shopping for a Mac involves making fewer decisions than are required of you if you get a PC. It's the inherent difference between buying a machine that is made by only one company (Apple) and selecting from among those that are made by hundreds of companies using a variety of similar components (PCs). Therefore, this chapter will be much shorter than the previous one on PCs.

NOTE

While the Mac and PC are quite different, much of what we said in the PC chapter applies to Macs, such as definitions of CPU, motherboard, MHz etc., as well as recommendations for universal components such as the pointing device or monitor. Please refer to the previous chapter for this information.

Since the first Macintosh was introduced in a spectacular, surrealistic television commercial broadcast during the 1984 Superbowl, Apple has produced about three dozen models of its best-selling computer. Most, however, are not suitable for digital imaging, because they lack the processing power, can't be expanded with enough memory, can't be equipped with 24-bit color, or are in some important way hardware deficient. Selecting the right Mac for the kind of digital imaging you want to do is, paradoxically, far easier and yet almost as perplexing as selecting a comparably equipped PC. It's easy because most of what you will need will either be built into the Mac or be very simple to add on. It's confusing because there are so many different Mac models out there, many of which appear to fit within imaging specifications. Don't worry: we'll talk you through it all in this chapter.

The biggest decision you will have to make about your Mac isn't what components you want, but which particular model to get. Many of the basic components are fixed and not interchangeable on the Mac, so you won't have any choice regarding motherboard, CPU, case and power supply, floppy disk drive, disk drive controller, and I/O ports. Also, although the keyboard is listed and sold as optional, the majority of buyers opt for the standard Mac keyboard. (Apple recently brought out a futuristic break-apart keyboard that allows a user to customize where and how her left and right hands will rest on the keys. But besides being expensive, it's designed primarily for fast touch-typing and won't help you very much with digital imaging. So, don't bother wasting your money on a keyboard that will offer you no usable advantages.) That leaves you with the following choices of components that you must make:

➢ The manufacturer and size of the hard drive.

➢ What 24-bit graphics controller board to add (except for the Quadra 950, which has 24-bit color for monitors up to 20" built in, and the Quadra 840AV and 700, which offer 24-bit color with monitors 16" or smaller).

➢ A monitor.

➢ Any peripheral boards, such as an accelerator board.

➢ Pointing devices, though a mouse comes with every Mac (see the previous chapter).

⇨ Which Mac?

All other things being equal, and money being no object, we would have, until very recently, confidently recommended that the ideal Mac for imaging is a fully equipped, take-no-prisoners high-end Quadra 950. After all, the 950 had been Apple's flagship system for several years because it was faster and more expandable than any other model. Not any longer, because Apple has just introduced a new

model specifically built for digital imaging, full motion video, and multimedia applications, the Quadra 840AV. In raw computing power, the 840AV is currently the fastest, most powerful computer Apple has ever built. Its 40MHz 88040 CPU will not only outperform the top-of-the-line Quadra 950, but built right onto the motherboard are chips that will significantly speed up applying specific Photoshop filters (which are used by other imaging programs). This hardware boost supposedly eliminates the need to add expensive accelerator or coprocessor boards in order to obtain optimum performance.

At first glance, the Quadra 840AV seems significantly cheaper than a Quadra 950. Not only is the initial list price less (despite Apple's dramatic drop in prices), but because of its built-in Photoshop-specific chips, the 840AV generally requires less RAM for serious digital imaging. Therefore, it needs only half the amount of RAM as the Quadra 950, or a maximum of 128 megabytes of RAM. That's the good news. The bad news is that fully equipping an 840AV with 128 megabytes of RAM requires four of the new, ultra-expensive 32 megabyte SIMMs (single in-line memory modules, or memory chips on a board), which are currently selling for $2,000–$2,200 each. That's over eight grand. The 950 uses much less expensive 16 megabyte SIMMs, which go for $500–$600 each. So, for the same eight grand, you get a full 256 megabytes of RAM with the 950.

The average street price for a stripped-down, entry-level Quadra 840AV is about $4,500, and that includes 8 megabytes of RAM, keyboard, a 14" color monitor and a 230 megabyte hard drive. But to buy a no-holds-barred, fully-equipped system (128 megabytes of RAM, 20" color monitor, 24-bit accelerator board, 2 gigabyte hard drive, CD-ROM drive) will set you back $12,000–$15,000, even if you get a good deal from a discounter.

However, the 840AV comes with an impressive number of other advanced features, that are either unavailable on other Macs or would cost an arm and a leg to add. For instance, it has built-in video capability, rudimentary speech recognition, full stereo, etc. For the most part, these state-of-the-art bells & whistles are, at least for the present, of little use to the digital imager. (What they may offer in future upgrades and incarnations is anyone's guess. For instance, there may be a real advantage in convenience and time savings by being able to speak a command, such as "apply unsharpen filter," instead of having to click on the screen or push a key.) Of more interest is the computer's fast SCSI interface, three NuBus expansion slots, and the ability to accommodate up to five internal drives and devices.

Until and unless Apple decides to bring out an even more powerful machine, the 840AV is far and away the Mac of preference for digital imaging.

Of course, most of us have kids, mortages and doctors' bills, so coughing up the money for a fully equipped Quadra 840AV is probably not in the cards. Most digital imagers will be looking for a more modest, but still powerful Mac that will do everything the Quadra 840AV or 950 does, albeit on a somewhat slower level. It is possible to do imaging on such systems as a IIci, IIvx, the Centris 650, or Quadra 800.

By the time this book appears in print, Apple might have discontinued some models and introduced others. So when you go shopping for a Mac, don't search by specific models, but by what you need your computer to have:

> ➤ A Motorola 68030 or 68040 CPU. If its speed is rated at 25MHz, that's good; 33MHz is better, and 40MHz is the best that you can presently get. Although it's not out yet, Apple might have a Macintosh or as-yet-unnamed machine in the near future with a PowerPC CPU. All higher-end Macs have CPUs with built-in memory cache. If the model you're interested in doesn't, several companies sell cache boards for the Mac. (Check the technical specifications to see what is and isn't included in the machine.)

> ➤ Make certain that it will run under the System 7.x operating system. (The x indicates which revision you have, such as 7.0 or 7.1. Right now, 7.1 is the newest.)

> ➤ It should have at least 8Mb of RAM, and be able to accommodate 4Mb, 16Mb, or 32Mb SIMMs, for a total expansion of at least 20Mb. Some Macs can be packed with as many as 256Mb of RAM. (That amount of memory will cost twice as much as the price of a Quadra 950!)

> ➤ Among the built-in ports and interfaces, it should have a SCSI-2 interface, either built-in or on a peripheral board.

> ➤ At least 2 empty NuBus slots.

> ➤ A color monitor.

⇨ A little about the Macintosh

Macs are manufactured in highly automated factories situated around the world. They're sleek and sophisticated machines that were once touted as "the computer for the rest of us." But the bottom line with the Mac is that it is perceived as the ultimate user-friendly machine.

The original Macintosh that Steve Jobs and his design team created might have been an incredible piece of technology, but it was badly underpowered and therefore virtually useless for most serious business-related applications. That turned off most of corporate America to the

Mac's amazing possibilities (which is why we didn't get into using Macs until recently). Also, unlike IBM, which had inadvertently loosened the PC into a quasi-public domain status that allowed almost anybody to clone its designs and pay little or no royalties—thus making for greater innovation and cheaper PCs—Apple is the sole manufacturer of the Macintosh. In the short run, this corporate policy of maintaining a single-sourcing monopoly kept prices artificially high and made the Mac somewhat uncompetitive (a situation that Apple has been trying to correct by routinely lowering its list prices to come more in line with PC prices).

But, in the long run, doing this helped Apple maintain total control over their products and created an enviable consistency and quality control in every Mac manufactured. Thus, Apple was able to establish iron-clad standards for hardware and software developed by third-party (non-Apple) companies. These not-to-be-violated standards are what makes all the programs and peripherals behave well, individually and interactively, with each other. It ensured that the Mac would continue to be the easiest-to-use computer, from installation and setup to learning and expansion. All those virtues more than made up for the computer's deficiencies and annoyances.

The Mac is a radically different computer than the PC in one very important respect: graphics. Most business computers, including the PC, are what are called text-based systems. The Mac, however, is a graphics-based machine in which the screen is in effect a blank canvas. This makes the Mac a WYSIWYG (pronounced Wizzy-wig) machine, which stands for "What You See Is What You Get."

Here's an analogy that might help you better understand the difference between a text-based and a graphics-based platform. Suppose you hand the Declaration of Independence out to two different people and ask them to copy it, word for word. The first person uses a typewriter, and in 10–15 minutes, he's produced a faithful and flawless copy of this marvelous document. The second person has a sketch pad and a calligrapher's pen, and copies the Declaration, not only word for word, but also tries to capture the striking, flowing script, including John Hancock's unmistakably bold and provocative signature. Both copyists completed the assignment as requested, but the means by which they accomplished that task were quite different. The one using the typewriter was able to do it with great speed, the person with the pen with a high degree of faithfulness but at the price of speed.

That the PC is a text-based machine means that it has traditionally appealed primarily to verbally-oriented users. Conversely, it's true to say that the Mac, as a graphics-based WYSIWYG platform, has been the computer of choice for visually oriented individuals. It's a classic conflict of left-brained/right-brained people. Of course, Windows has brought the graphics orientation to the PC. But because the Mac

started life as a graphics machine, it's got a years-long head start on the PC as the platform of choice for digital imaging.

Is 24-bit color absolutely necessary?

In the Mac world, the price difference between 16-bit and 24-bit color is hundreds of dollars. (With PCs, it's a matter of about $50–$100, and some entry-level 24-bit boards actually cost less than brand-name VGA boards.) At what point is a 16-bit board adequate, and when, if ever, does the digital imager require a 24-bit board?

The 16.7 million that a 24-bit board is capable of displaying refers to the total palette available, and not how many colors you will see, at one time, on your monitor or will actually produce on your final print or transparency. In fact, most color prints contain an average of only 5,000 different colors.

Also, although you might be able to view only 16-bit color on your screen, the image you are editing or creating may be configured to output at a full 24 bits. That's analogous to videotaping in full color, even though the image you see through the viewfinder is only black & white. What you see in 16-bits will give you a good, but not necessarily exact, representation of what will ultimately be output.

Having said that, we still strongly recommend using a 24-bit board when the output device will be a dye sub printer, a high-end imagesetter, or a film recorder, or if you intend to produce color separations for quality printing. We're told that few serious digital imagers use 16-bit boards, anyway.

Just as auto manufacturers introduce models every year in order to capture consumer excitement (as well as create instant obsolescence for current year models), Apple seems to be premiering new computers at an ever-accelerating pace. Of course, some new models reflect cutting-edge technology, but the majority of new models seem to be market-driven rather than technology-oriented, appealing to new buyers with lower prices, built-in features like CD-ROM drives, or by selling through electronics and general merchandise stores rather than traditional computer outlets. The reason isn't hard to fathom: Apple is going all-out after the low-end PC clone market.

The first Mac we ever used for digital imaging was a now-discontinued Mac IIfx. It was equipped with 8Mb of RAM and a 24-bit Radius graphics board. Needless to say, the kind of digital imaging it could do was limited by the speed of the processor and the amount of memory. Just because a Mac is an older model, or isn't fully equipped with the hottest processor and a huge amount of memory, doesn't mean that it can't be used for serious professional digital imaging. The IIx, IIcx, IIci, IIfx, IIsi, IIvx, SE/30, and LC II can all be equipped for digital imaging. So, too, can the latest Performa 600 and 600CD. These systems are certainly cheaper than top-of-the-line Quadras, but they are also limited by their technologies.

One may always upgrade most Macs for greater performance. Apple offers a factory service that, for a rather hefty price, will swap an older, less powerful motherboard for a newer, better one. For instance, it's possible to transform a IIcx or IIci into a Quadra 700, complete with an 88040 CPU and 24-bit color interface, for $3499. But because the price for a Quadra 840AV with 4Mb of RAM and a 400Mb hard drive is about $4,000, it probably makes better sense to sell your old Mac and buy a brand-spanking-new Quadra.

There are other ways to boost your Mac's performance and capabilities so that it would be suitable for digital imaging. Scores of companies that advertise in magazines like *MacUser* and *Macworld* sell coprocessors, cache boards, accelerator boards, or motherboard swaps that will increase your present Mac's speed or abilities. While most are not cheap, they're usually lower-priced than buying a new Quadra.

Practically speaking, if you want to do serious imaging on a Mac, you'll want to have a Quadra. The Quadras are powered by a 68040 CPU with a built-in high-speed cache, and feature a SCSI port and 24-bit color graphics. At present, Apple offers two different models: the 840AV and 950. The Quadra 800, 700 and 900 are discontinued models, though the 700 and 800 are still sometimes available at close-outs.

Our own bottom-of-the-line Quadra 700 is a lightweight, compact computer. It has a single slot in the front for floppy disks and can accommodate two additional internal hard drives. The 700's CPU has a clock speed of 25MHz, which is about 25% slower than the 950's 33MHz CPU. However, the 700 is about twice as fast as the next lower model (also discontinued), the IIfx. The 700 comes with 4Mb of RAM soldered on the motherboard and can accommodate 4 additional SIMM boards. Our Quadra 700 has four 4Mb SIMM boards, giving it a total of 20Mb of memory. Officially, Apple lists the 700's maximum memory capability at 20Mb, but if four 16Mb SIMM are installed instead of the 4Mb SIMM (a highly recommended upgrade), that will boost the machine's total RAM capacity to a comfortable 68Mb.

Unfortunately, the 700 comes with only two expansion slots, so the maximum number of boards it can hold are either two NuBus cards or one NuBus and one PDS card. (NuBus and PDS are the standards for Mac expansion or peripheral boards.) That's a major disadvantage to those who plan to load up their systems with accelerator cards, fax/modem boards, high-speed network cards (though the Quadras have an Ethernet interface built in), higher resolution 24-bit video cards, or other boards that will increase performance or productivity.

The 800 was introduced in early 1993 as a replacement for the Quadra 700. It's cheaper, faster, and more expandable than the 700,

and, by some technical measures, even exceeds the Quadra 950 in raw power and processing speed. (They both use the same 33MHz 68040 CPU.) Unlike the 700, which can accommodate only one floppy drive and one hard drive, the 800 has bays for 4 additional devices, such as a CD-ROM and a SyQuest drive. It can be expanded up to 72Mb RAM (Apple specs it out at 136Mb, since it can accommodate 4 of the new, but ultra-expensive 32Mb SIMM memory boards), and has three NuBus slots. The only thing that the 800 lacks is built-in 24-bit color, a deficiency easily remedied by adding a video controller board.

The 840AV debuted in August, 1993, to replace the short-lived 800. As we've said, it is fast and powerful, but memory is expensive. It also must be equipped with an extra 1Mb of expensive video RAM in order to use a 16" color monitor in the 24-bit mode.

At present, the 950 is Apple's top-of-the-line model, though technologically speaking, it is getting a little long of tooth. What differentiates it from the 700, 800, and 840AV is its five expansion slots, which allows it to accommodate 5 NuBus cards and 1 PDS card. Also, it supports 4 internal devices, like a hard drive, CD-ROM drive, etc. Unlike the 700 and 800, the 840AV and the 950 do not have any RAM soldered to the motherboard. The 950 features 16 slots for accommodating SIMM boards, which when fully populated with 16Mb SIMM, equips the system with 256Mb of memory—an expensive option of incredible power and speed. Apple does not officially say whether the 950 can be upgraded to accept 32 megabyte SIMM, but if so, that would raise its memory capacity to 512 megabytes—more than most computer's hard drives. The 95016 SCSI-2 interface is the fastest SCSI interface Apple builds.

Obviously, selecting an 840AV or 950 is mostly a matter of money. The 840AV and 950 are expandable and upgradable, and can accommodate large amounts of RAM. You might not think you need that much memory right now, but someday you probably will want to expand. It's an immutable law of nature that need expands to the maximum available memory capacity.

SUGGESTION: Get the most powerful Quadra you can afford.

Many vendors prefer to sell Macintoshes exactly as they come from the factory. Not only is it less work for them, but there usually is more profit in selling Apple-brand components and memory chips. But don't let them sell you an off-the-shelf machine.

We strongly suggest passing up Apple's memory boards, hard drives and monitors. Instead, buy them from a third-party (non-Apple) dealer. There are several very good reasons for this piece of advice:

> If you are buying the Quadra 840AV or 950, you won't have to pay for (and subsequently throw out) the four 1Mb SIMM boards

that usually come installed. To make the computer usable for digital imaging, you'll have to upgrade immediately by adding either four 4Mb, 16Mb, or 32Mb SIMMs (we recommend the latter, if you can afford it), which means that the 1Mb SIMM boards may be useless (though you can keep them in to supplement whatever 4Mb or 16Mb chips you add, if there are enough slots available).

➤ Apple hard disk drives have traditionally been more expensive than brand-name drives provided by other companies. Save some money, and buy your drive from someone else. Apple monitors, too, were more expensive than comparable or even identical non-Apple monitors. Do some comparison shopping first before deciding whether to buy from Apple or some other dealer.

➤ Apple offers 1-year warranties on most components. Many third-party manufacturers routinely offer 2-year or even longer warranties on their products.

Macs are so easy to configure that putting in most of these third-party components will represent no hardship whatever. Some peripherals and upgrades must be installed by an official Apple technician. The best course is to get your machine from a dealer who will configure it according to your specifications rather than Apple's.

For information about pointing devices and monitors for your Mac, see the previous chapter.

10
Scanners
Getting your pictures into the computer

UNLESS all your digital imaging will be based on drawings that you will do in your computer, you will have to find some way to get pictures into the machine. The most commonly used device for inputting (or porting) film transparencies, photographic prints, paintings, statues, *objets d'art*, or illustrations—all 2- or 3-dimensional visuals—into a computer is with a scanner. Scanning is the electronic process of examining and converting real-world images and objects to digital data that a computer can recognize and manipulate.

There are five basic kinds of scanners that are relevant to digital imaging:

> ➤ A *film scanner* "reads" transparencies and negatives, much like an enlarger in reverse. It works only with film and can't be used with any other kind of material. This is the preferred desktop device for scans of slides or negatives. See Fig.10-1.

Figure **10-1**

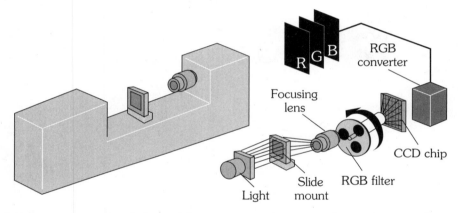

Array scanners record data without moving the original transparency, by using an array rather than a single row of CCDs. Agfa Digital Color Prepress publications

> ➤ *Flatbed scanners* input photographic prints, illustrations, etc. A similar type is the sheet feeder scanner, but it can't accommodate books, magazines, or anything with depth or height. These devices are used by those who need to input flat visual material into their computers.

> ➤ A *handheld scanner* does the same, except that you run the device over the page or paper like a lint brush. As a rule, this is not a device for professional-quality imaging.

> ➤ *3-D scanners* scan objects with depth, height, and width. Most often, they are set up on vertical copy stands, though some are meant to be positioned on a tripod. Depending upon the hardware, 3-D scanners can digitize objects with a depth of a few inches to panoramas of the great outdoors. Used primarily by studios that have a high-volume need for inputting 3-dimensional items, they're not usually considered the first choice for an imager's primary scanner.

> *Drum scanners* are expensive devices (from $13,000 to several million bucks) that are used for the highest quality scans of both transparencies and prints. Unlike the other scanners just mentioned, they utilize an older but much more precise technology called a *photomultiplier tube*, which tends to capture greater dynamic range (a wider scope of brightness and darkness). Drum scanners are usually found only in service bureaus and other large companies.

Other devices that also capture and upload visual data into the computer include filmless cameras, scanner backs, off-the-shelf camcorders, and video capture ("frame grabber") boards.

Frame grabber boards (which plug into a slot in your computer) accept standard TV signals through a connector and convert them into the digital data with which a computer can work. Generally, the quality of the image is limited by the quality of the feed. TV has a relatively low resolution when compared to a purpose-built scanner, so the image will not be as clear or crisp. The rule of thumb is the more expensive the frame grabber (and they can cost thousands) and the higher resolution the signal feed, the better the image quality.

While camcorders and frame grabbers might be less expensive or more versatile, the bottom line is they generally do not produce the same level of image quality as a dedicated, purpose-built scanner.

Please see Chapter 11 for a further discussion of filmless cameras and scanner backs.

⇨ Basic scanner technology

At the heart of most scanners is a light-sensitive silicon chip called a Charge Couple Device (CCD) (see Fig. 10-2). Small, wafer-thin, and about the size of a dime, every CCD is literally covered with hundreds of thousands of capacitors that measure electrical activity. (Capacitors are, in effect, sampling points or pixels.) Because light is energy, where light strikes a specific spot, the capacitor registers the intensity of that energy. That datum from each individual capacitor is then collected and combined with adjacent capacitor data, and when reconstructed in the computer, pixel by pixel, presents an image almost identical to the object scanned.

Here's the problem. Capacitors are like old-fashioned radio knobs. The light they register is infinitely adjustable, just as turning a radio knob adjusts the volume in a smooth, fluid way so that there are no discernible jumps in the sound. That's what we call analog (any value that is continuously variable). However, as we've pointed out,

Figure 10-2

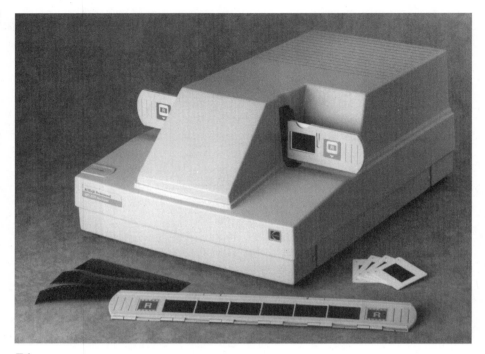

Film scanner. Kodak

microcomputers are digital devices that work only in sharply delineated steps, and not in one smooth, continuous flow.

The difference between analog & digital

Here are some clear-cut analogies to help you better understand the difference between analog and digital data. Analog is a ramp, while digital is a set of stairs. Analog is the dial on an older style rotary phone, while digital is the push buttons on contemporary telephones.

In other words, analog changes continuously with no discernible steps, stops or stages anywhere; digital moves or changes in steps, stages, or increments. Analog is everything you see in the real world, including photographic prints, drawings, oil paintings, film, statues, etc.; digital is what you get inside a computer.

What's required, then, is to somehow convert real world pictures from analog to digital, and yet trick the eye into believing that the image shown on the monitor or produced by a printer is, and always has been, analog. Here's how it's done.

When the CCD in the scanner passes over a drawing, photograph, transparency, printed page, or whatever, each tiny pixel on that silicon wafer senses light or dark and transfers the information to the computer. It's converted to digital data and reconstructed on the screen. The more detail scanned in, the better the image will look. Eventually, if enough pixels are recorded, it will cease looking like a

pointillist's painting and more like a seamless—yes, analog!—photograph. (However, that is its appearance, not its reality.)

What is a pixel?

The word pixel *is short for picture element. Pixels have no size or shape because they're merely data points, electronic blips, numbers. What looks like a square or a dot on your monitor or your printed sheet isn't really the pixel—it's only how that pixel is represented or displayed on a particular device. Its shape depends on the screen or the masking technology used by the monitor's manufacturer.*

The shape displayed or printed isn't as important as how many pixels are in a given area, how closely packed together they are, and how many bits of data—the information about color and greyscale—are associated with each and every pixel. The original Macintosh displayed a total of 72 pixels per inch, though high-resolution monitors are capable of showing two or more times that number.

Since printers represent pixels with dots, we talk of resolution of printers, not in pixels, but in dots per inch (dpi). A standard office laser printer has a resolution of 300 dpi (300×300), which translates into 90,000 dots per square inch. Current generation laser printers have boosted resolution up to 600 dpi, or 360,000 dots per square inch. Some film recorders support resolutions of over 5,000 dpi.

⇨ Image depth

Pixels never travel alone. Every pixel has a satellite of data bits pertaining to color and greyscale. The more bits associated with each pixel, the greater the depth and detail of the image. Most scanners used in digital imaging are 24-bit devices in that they have 8 bits associated with each of the primary colors of red, green, and blue (RGB). Some scanners are 30-bit, 33-bit, 36-bit, or even 48-bit devices, which of course provide correspondingly higher quality scans, simply because they pack in more information per pixel.

To translate this into down-to-earth terms of how it will relate to your specific computer system, adding extra data bits per pixel increases the file size. A 5"×7" monochromatic (1-bit) black-&-white image with a resolution of 600 dots per inch might create a file of about 12 megabytes (Mb). But that same file scanned as 24-bit color expands to 36Mb. Obviously, anyone working with images that are scanned in at a greater data depth will need lots of hard disk space for storing image files, as well as lots of RAM for working with and manipulating those images.

NOTE

If you want to be exact about your nomenclature, pixels are the data points associated with computer images, while dots are similar

information in the non-digital real world. However, by common usage, dpi (dots per inch) and ppi (pixels per inch) have become frequently interchangeable. It's not really 100% accurate, but it's the way you will hear artists, clients, and salespeople talk. We do it too.

Putting the cart before the horse

Sally is preparing for an exhibit of her digital art. But until she decides what kinds of prints she will actually be producing for each image, she can't even begin to scan in the photographic elements she will want to use in her designs.

In any digital imaging project, the first decision that must be made is what kind of output you'll be using. What size and resolution will you need for the final print, transparency or separation negatives? Until you know that, you can't begin to scan for it.

Similarly, until you understand the kind of digital imaging work you will probably be doing and how it will typically be output—as small images in a catalog, as medium prints in an ad campaign, as large prints in a gallery exhibition, or as film transparencies to be used by art directors for a variety of print sizes—you can't begin to decide what kind of scanner you should obtain or use.

One of the primary rules of intelligent imaging is to scan for the optimum output quality. Therefore, an important rule of choosing a scanner is to pick one that will provide the quality and amount of data you will need for the kind of output you will be using.

Essentially, there are four types of output that a professional visual artist will be using:

➢ Film recorders
➢ Desktop printers
➢ Print shop or service bureau output
➢ Digital files

The determining factors for an optimum scan

Each kind of output requires handling the scanning process somewhat differently. However, the two critical factors that you will have to know for any scan will always be your projected output resolution and dimensions.

The *dimensions* of an image are the physical size of its output—whether it is to be a 35mm slide (1"×1.5"), a 5"×7" print or whatever.

Resolution is a measure of how many pixels will be recorded by the scanner, worked on by the computer and used by the output device. The higher the resolution (the more pixels per inch), the better quality image you will have.

If you scan in more data than your output device can use, it will indiscriminately throw away pixels, making automatic choices with which you might not agree.

If you scan in less data than your output device needs to make the best reproduction possible, then one of two things will happen (depending upon your software and the options you choose): the computer software will *interpolate* (interpret and create) new data, which can lead to the degradation of the quality of the image; or the output will contain less information than the device can use and your image will come out less than the best. Neither result is really acceptable in top professional-quality work.

The size of the scanned-in image file is directly proportional to these two factors. The higher the resolution and/or the larger the dimensions, the larger the image file.

For instance, an image scanned in at 1.5"×1" and 2,750 pixels per inch (ppi) will be approximately 33Mb. Another scanned in at 8"×10" at 400 ppi will be about the same size—36.6Mb—because the dimensions were increased, even though the resolution was lessened. On the other hand, a 4"×5" 400 dpi image would be only about 9Mb.

In practical terms, the larger the image file, the more space it will take up on your hard disk and other storage media, the longer it will take to apply filters or other commands to it, and the more cumbersome it will be to work on. When you deliver a large image file to a service bureau or a print shop, they might charge you a premium for the extra time it requires for processing. Another way to look at it is that the larger your image file, the greater its cost will be to you in time, money, and computer memory requirements. Yet, for all that extra space and cost, your image may not print one iota better with a larger file if the numbers don't relate accurately to what your output device will be able to handle.

On the other hand, to not have the highest resolution image appropriate to the intended output device would be counterproductive. Therefore, time and money are often balanced against the need for quality, when determining the optimum scan for a project.

 # Scanning for output to film recorders

Film recorders are devices that take digital image files and put them onto film. (See Chapter 13 on film recorders.) Most studio-size (desktop or floor models) recorders use 35mm film, though some might also output to 4"×5" film. The way they work is that the image is projected on a small but very high quality monitor inside the recorder and a camera shoots that image.

Film is a very high-resolution media because it might have to be enlarged quite a bit to become anything usable. For instance, for a 35mm slide to be used for an 8"×10" print, it will have to be enlarged as much as 800%. That requires a density of image data, if you don't want the picture to become an inexact blur of sparsely placed dots. For that reason, scans that are intended for output to film recorders are the highest resolution scans generally done. (Audiovisual and multi-media slides do not necessarily require the highest possible resolution, because there is no need to eventually print them.)

Suppose your film recorder is rated for 4K resolution. That means that its internal monitor is capable of displaying 4,096 pixels across its widest dimension (which is described as 4,096 lines). That is *not* the same as 4,096 ppi.

The 4,096 pixels are spread across the widest dimension of the internal monitor and are picked up by the widest dimension of the film. If the film at its widest is 5", then the 4,096 pixels are spread across those 5". In other words, it becomes not 4,096 pixels per inch, but 4,096 pixels per 5 inches, which is 819 ppi. Therefore, this is probably one of the only situations in which the smaller size film actually has a higher resolution than the larger format, because the same number of pixels are spread out over a smaller area. (On the other hand, the larger film will not have to be enlarged as much as the smaller when prints are made, so the apparent loss of quality is relative, not absolute.)

This leads us to a very simple formula that is used to calculate optimum scan resolution when your intended output is a film recorder:

Film recorder resolution divided by the *largest film dimension* = *scanning resolution*

For instance, in the previous example, in which you plan to use a 4K film recorder for a 1.5"×1" slide, the formula would be: 4,096÷1.5 = 2,731 ppi. So you'd scan the image in at 2,731 ppi and 1.5"×1".

Calculating optimum scanning resolution
for film recorder output

Table 10-1

Recorder	Recorder resolution	Film size	Scanning resolution (ppi)	File size (Mb)
2k	2,048	35mm	1,365	8
4k	4,096	35mm	2,731	32
8k	8,192	35mm	5,461	128
2k	2,048	4"×5"	410	9.6
4k	4,096	4"×5"	819	38.6
8k	8,192	4"×5"	1,639	153

Remember, these are just working guidelines that follow conventional wisdom. Use them as points of reference as you run tests through your own equipment. Each imager will have to work out, through trial and error, the best scan resolution for their specific recorder.

HINT If you plan to use an unsharp filter or any other potential pixel-destroying process on a scanned image, consider overscanning (scanning at a slightly higher resolution) by about 1–5%. It's controversial whether or not this is of value, but it works for us.

SUGGESTION What all this means is that if your intended output is to be film, you will need a high-resolution scanner.

 # Scanning for output to desktop printers

When you intend to output your images to a digital printer, the matter is quite straightforward. Somewhere in the specifications about your printer will be an indication of its resolution and the size image it prints. Then, all you do is scan your image at that resolution and at those dimensions.

For instance, the Tektronix Phaser IISDX dye-sublimation printer we are currently using outputs at 300 dpi. Depending upon the paper we use, the image area on the paper may be 8.1"×8.6", 8.1"×10.8" or various other dimensions. So, when we scan for output to that printer, we simply scan at 300 ppi and for the dimensions of the printing area of the paper we plan to use.

However, most desktop printers won't make a print that is suitable for reproduction. Therefore, scanning your images only for that purpose might not be a commercially viable option. (Please see Chapter 14 about printers.)

SUGGESTION When your intended output is a desktop printer, the scanning can be handled by a relatively low-resolution scanner.

Scanning for service bureau or print shop output

When you are working with a service bureau or print shop for your output, all you have to do is talk to them. Describe the kind of output you will be needing, and they will tell you what kind of scan would best support it. (Please see Chapter 32.)

HINT One reason often argued for not doing your own scanning is the expertise and assurance available to you when you use a good service bureau. Many of them will guarantee the quality and accuracy of their color output only when they did the original scanning for you. Others will work with you to develop your scanning skills so that your files will be compatible with their output devices.

SUGGESTION If you expect to be using a service bureau or print shop for your image output, talk to them before you buy or lease a scanner. Look at the kinds of output they can provide, consider how you might use those methods and find out from them what resolution scan you will need for each type of output.

Scanning for output to digital files

More and more clients will be accepting digital files that you will deliver on SyQuest cartridges or other storage media. It's necessary for the client to tell you exactly how the images will be used so that you can determine the appropriate scan for it. Otherwise, you won't be able to guarantee the quality of the final print. (This will also help you in your negotiations with them, because no client can afford to not tell you, for instance, about a potential large poster from an image file they commissioned for a magazine ad.)

The art director in charge of the project will usually know only some aspects of the intended output. For instance, he'll know the dimensions, because that is part of his design. But he might not know what resolution he needs. On the other hand, he may know what line screen will be used in the printing.

In traditional printing, resolution is calculated in lines per inch (lpi) and typically varies from about 65–85 lpi (for very coarse black-&-white images printed on newsprint) to over 200 lpi (for high-quality slick magazine color graphics). The generally accepted rule of thumb is that you should scan in at a resolution at least twice that of the intended

line screen. For example, if a print will be done at 150 lpi, you should scan in at 300 ppi or more.

If he doesn't even know his line screen, ask to talk to the prepress operator, print shop or service bureau that will be in charge of his output.

Whatever scanning specifications are determined for the job, be sure to put them in writing. Also, make certain that you have the art director (or whomever is in charge of such aspects in the project) sign off on them (give written approval). That way, if the scan is done correctly, according to the specifications that are in writing, you can't be blamed if those specs turn out to be wrong. (See Chapter 34 about working digitally with your clients.)

SUGGESTION If you will be using your scanner for various kinds of projects, be sure the one you get is capable of the highest resolution you will need. You can always step it down for less demanding jobs. But if such high-resolution projects won't be that frequent, consider buying a lower-priced, lower-resolution scanner and using a service bureau for the few high-resolution scans you will need.

⇨ Types of scanners

⇨ Flatbed or sheet-fed scanners

Almost everyone feels comfortable with flatbed scanners because they look and function familiarly—like a small desktop photocopy machine. Pages or prints to be scanned are placed face downward on a glass platen, the cover is closed, and the user starts the scan. The unit and the page remain stationary as a CCD-tipped arm steadily moves down the platen and systematically "reads" every square inch, simultaneously transferring the data to the computer, where it is converted from analog to digital information.

Most flatbed scanners can accommodate papers or pages up to 8.5"×14" in size. Although they can scan only 2-dimensional sheets, sometimes, they can handle pages from an open book or magazine.

A sheet-fed scanner is similar to a flatbed scanner, except that individual pages are fed into a thin slot and then pulled along past a stationary CCD by a system of rollers, gears and stepper motors. A sheet-fed scanner can accommodate only single sheets of paper as wide as the carriage slot. Mechanically, sheet-fed scanners are less complicated than flatbed scanners.

Most experts feel that flatbed scanners give more accurate scans than sheet-fed scanners because the flatbeds don't have to deal with variable factors, like whether or not the paper is coated or wrinkled, is pulled through evenly, might be too thick for the rollers, etc. Some models of flatbed scanners can scan at high resolutions of 1,200 dpi to 2,000 dpi (though the latter machines almost always list for over $20,000). The best sheet-fed scanners rarely exceed a physical resolution of 600 dpi. Sheet-fed scanners will almost always be less expensive than flatbed scanners having the same technical specifications.

Some flatbed scanner models can accommodate accessories, such as a motor-driven sheet feeder device or an attachment for copying transparencies. The only accessory that some sheet-fed models can accept is a sheet feeder. Automatic sheet feeders are designed primarily for offices that require high-volume document imaging, not for digital artists who want and need optimum scan quality. You might lose some image quality if you try to scan in more than one document at a time. Similarly, the slide scanning attachments usually won't provide quality data on the level professional imagers usually need.

Incidentally, beware of how a flatbed or sheet-fed scanner's resolution is measured. You want to know its *optical* resolution, not its *interpolated* resolution. Software sold or bundled with some scanners can interpolate up to two to four times the actual optical resolution. However, such interpolation is nothing but computer guesswork, based upon analyzing the data and calculating what additional data might be appropriate. Optical resolution is the true measure of a scanner's real resolution.

SUGGESTION Buy a flatbed color scanner over a sheet-fed color scanner. Don't bother with an automatic sheet feeder or an attachment for copying transparencies or negatives if you want top-quality results.

OCR

Most flatbed, sheet-fed, and even many handheld scanners are capable of Optical Character Recognition (OCR). OCR allows you to scan a page, such as from a manuscript, and then edit that page in your word processor. Without the OCR software, your computer would not recognize the shapes on the page as words.

OCR software is particularly useful for offices that have a lot of text (such as legal briefs, contracts, etc.) that has to be entered into the computer but don't want to take the time or expense of having a typist do the job. They simply scan a page at a time (that's why many scanners can be fitted with sheet-feeders), and, in practically no time, it's in the computer. What takes the computer less than 100 seconds might take the average typist 10 minutes.

OCR software used to have a 99% accuracy rate, which meant one wasted time trying to find and correct that last 1%. But with higher-resolution scanners and greatly improved software, the accuracy rate is now closer to 99.9%. We use OCR occasionally to scan in printed notes.

At least twice, while writing this book, our OCR software has saved the day when a chapter file was corrupted. Because we print out our chapters as we work on them, we were able to scan in the lost pages and proceed with our writing.

Just about any flatbed, sheet-fed, or handheld scanner suitable for digital imaging can do OCR; some bundle an OCR program when you buy their product. If you hate to retype stuff into the computer, or if you combine text with images, you might appreciate the value of a good OCR program. However, if OCR is a real need for you, then it should be considered before you buy your scanner. OCR generally has different requirements than image/color scanning, but it is more suitable for line art and black-&-white scanning. Unless you want to buy two scanners, check to see what devices can give you the best color scans, while being able to work with good OCR software.

⇨ Handheld scanners

Handheld scanners are used to import 2-dimensional papers, photos, prints, illustrations or anything flat into a computer. The user carefully pushes the handheld scanner down the page as if he were painting a wall in slow motion.

Most handheld scanners have a 4" swathe only, which is fine if you need to scan in papers or illustrations of 4" or less across. For anything larger, a user must "stitch" together with software two, three or more segments. The software that controls the handheld scanner can guess where the sections must be joined to create one page. Some handheld scanners come with or can be adapted to work with an inexpensive frame-like accessory that helps guide the scans in straight lines.

The advantages of a handheld scanner are that it's one of the least expensive and fastest ways to scan in visuals, especially small photographs or illustrations. When not in use, it's small enough to be hung up on the side of a monitor or stuffed into a drawer.

The downside of handheld scanners is quality. Resolution and color rendition are generally less than one can obtain with a flatbed or sheet-fed scanner. How fast or how slow you push the scanner can affect the integrity of the image. Too fast, and you might miss data or elongate the image; too slow, and you might squash the image. Even with a perfect scan, the software may not automatically align the panels together accurately during the stitching process.

We don't recommend handheld scanners for most digital imaging purposes. They are too difficult and inaccurate for scanning in anything larger than 4" in diameter, and cannot provide the resolution and color accuracy that other devices are capable of doing. Nor are they in any way suitable for scanning in negatives or transparencies.

Having said that, we should balance it off by pointing out that handheld scanners may be useful to digital artists and photographers who have an occasional or infrequent use for small-sized scans and can't justify the added expense of buying a flatbed or sheet-fed color scanner. Handheld scanners can produce reasonably good images when restricted to a one-to-one reproduction, but any further magnification may expose quality weaknesses and problems of the scanning device.

 Handheld scanners do not have the level of resolution or reproduction quality that is required by professional digital imagers. Bypass them, unless you need only a quick way to scan in small, low-resolution material.

Film scanners

Flatbed, sheet-fed, and handheld scanners are all designed to read reflected light off an opaque page or paper. They are inappropriate for transparencies or negatives, which require a much higher resolution and must be scanned by reading light through them.

A desktop film scanner shines light directly through a stationary negative or transparency onto a slow-moving slit that contains a CCD. Line by line, the image is digitized and fed into the computer. The physical movement of the CCD is much more precise than that of a flatbed scanner, and the scan far more detailed. Desktop film scanners typically feature maximum resolutions of 1,700–4,096 dpi.

They also can vary in the kind of image depth they will capture. For instance, Nikon makes two models of its very popular LS-3510AF scanner—an $8000 8-bit (24-bit) model and a $12,000 12-bit (36-bit) one. Some computer artists (including Sally) believe that having the greater number of bits per pixel is a key to producing high-quality images. Basically, more color information will be captured in the original scan, rendering a more accurate representation of the image. Having a larger base of data, the imager can then "downsample" the file. Other artists will dispute this opinion, since most of those extra bits will be thrown away anyway during the final output. Make your own decision by inspecting the printed results from different kinds of scans with a high-powered magnifying loupe. If you can't see any qualitative difference, or, if the difference is not significant for your particular needs, then buy the less expensive model. A 24-bit film scanner is more than adequate for many professional needs, but when

you want (and can afford) the very best, by all means buy a scanner that offers greater image depth.

While some desktop film scanners can accommodate up to 4"×5" film, most work only with 35mm film. The price for these devices seems to increase exponentially as the image surface area increases. Film scanners are generally much more expensive than flatbed or sheet-fed scanners, ranging from a street price of $1400 to about $22,000.

SUGGESTION If you want to input slides or film negatives into your computer, you will need a film scanner. Get the best film scanner for your needs, but try to stay within your budget.

⇨ 3-D scanners

So far, all the scanners we've discussed can scan in flat objects only. A 3-D scanner (which is sometimes also called an *array scanner*) is specifically designed to image a three-dimensional object. (See Fig. 10-3.)

Figure 10-3

Sally scans a stuffed bunny with a 3-D (or array) scanner.
Sally Wiener Grotta

Most 3-D scanners look like miniature television security cameras and use a lens that resembles a high-quality camera lens. Some 3-D scanners are fixed copy stand devices designed to scan objects with limited depth or height (some inches or a foot at most), such as small

industrial parts, consumer products or other props. Others, which may be mounted on a tripod or camera stand, will scan objects or scenes of any size or perspective, such as automobiles, buildings, panoramic vistas or whatever. 3-D scanners run from $3500 to $15,000 and up, depending upon resolution and lens quality.

SUGGESTION

3-D scanners are generally considered specialty items. Get one only if the volume of 3-D work you are doing justifies the purchase. The fixed stand device is probably superior for users who scan in small items or products, and who wish to do double duty by using it as a 2-dimensional scanner for flat art, photos, illustrations, etc. If you want to scan in large products or outdoor scenes, you might consider buying or renting a filmless camera instead.

⇨ Drum scanners

Drum scanners are expensive, costing from tens of thousands to millions of dollars. Not surprisingly, relatively few photographers, artists, or small digital studios own or lease drum scanners. However, almost all service bureaus use drum scanners for their more demanding, discriminating clients.

Instead of using a CCD (as desktop scanners do), at the heart of every drum scanner is an older but still exotic technology called the *photomultiplier tube*, or PMT. Although established in the late 1940's and early 1950's by scientists and astronomers needing to measure extremely low levels of light (such as those from distant stars or planets), PMTs first really came into their own as a versatile technology when they were used by the military during the Vietnam War era, to allow snipers to fire at Viet Cong in almost total darkness. The PMTs work by enhancing the illumination from the sky, hence their more common name—"star scopes." For years, photomultiplier tubes were high on the Pentagon's list of restricted and secret technology, although today anyone can buy a star scope at an army surplus store.

The other component that makes a drum scanner different from all other scanners is its glass drum. A print, negative, or transparency is fastened with tape and a film of oil directly on a high-quality hollow glass drum and then spun at several thousand revolutions per minute. (Unlike most film scanners that have carriers for mounted transparencies, a drum scanner requires that all slides be removed from their mounts.) Most drum scanners can accommodate film or prints up to 8"×10" in size; some can handle even larger sheets. A light is directed on the print or through the transparency or negative, where it's recorded by a photomultiplier tube that moves a minuscule distance with every revolution. Then that data are digitized and uploaded to a computer. Drum scanners can record between 8 and 16 bits of data for each primary color.

A scan made on a drum scanner is more precise and has greater detail than with any other method. Every CCD scanner uses a series of gears and stepper motors, and their speed and flow can be affected by minute voltage fluctuations, vibrations, micro misalignments, uneven lubrication, and other almost absurd factors. Drum scanners are much less subject to the same problems, due in large part to the fact that their rate of speed is more accurately controlled by a highly precise screw instead of gears and inertia. Also, most are deliberately large and heavy instruments, for maximum stability.

Do you really need a drum scan?

There is a certain snobbishness about drum scanners that makes many art directors and clients sneer at any other type of scan. We've seen experts scrutinize every aspect of images with an 8X magnifier, checking such things as pixelation, color and edge sharpness. And yes, they usually can tell minute differences between an image scanned on a desktop film scanner and one scanned in with a very expensive drum scanner. But how do those differences affect the final image?

Very recently, Sally was attending the monthly board meeting of her chapter of the American Society of Media Photographers (ASMP). She pulled out three comparison color prints that a Kodak representative had sent us and invited her fellow officers to give their professional opinions. Each print had three identical images, but with one critical difference: the left one was made with a Leafscan 45 film scanner, the next with Kodak's Professional Photo CD scanner, and the right print with Kodak's Premier scanner. We covered up the captions with white tape, so the officers wouldn't know which one was scanned with which machine.

Depending upon the subject, the photographers preferred a different scanner over the others. So, each type of scanner got the nod over the others once but wasn't the preferred device two out of three times. The photographers making this evaluation are respected and experienced pros, all with a good eye and a sophisticated sense of image quality. While they could distinguish very minute differences, the consensus was that overall quality differences were really quite negligible. Any one of the scans would have been quite acceptable.

What they did question is whether the images would still hold up with the same quality when blown up to 8"×10" or larger, and at what point qualitative differences would begin to become significant. But for their money, the scans made on the (relatively) inexpensive $22,000 Leafscan 45 were every bit as good as the $250,000 Premier, and the scans made on the new $100,000 Pro Photo CD system (which will cost less than having a service bureau make a drum scan) were, in their opinion, just as good as the high-priced, high-end scans.

So, do you really need a drum scan? If your intended output is a rather small print, probably no. However, for large format output, such as posters or even billboards, it is almost mandatory. Of course, if you need and want optimum quality, regardless of size, you will use a drum scanner.

⇨ Other devices that act like scanners

Any device that can target something in the real world and transfer its image into a computer is worth considering, if only to compare and reject it. For instance, Tamron, a well known manufacturer of photographic products such as lenses, makes several models of a relatively inexpensive device they call a Fotovix. The Fotovix is a miniature television camera with a zoom lens specifically designed to project 35mm and 2¼" slides and negatives onto a television set. Depending upon the model and accessories, it can interface with a frame grabber board and be uploaded to a computer in digital form. The Fotovix cannot produce very good image quality. Such a device may be used for quick, inexpensive low-resolution scans of slides or negatives for small files or clip art, if that's all you need.

At the other end of the spectrum are filmless cameras like the Sony Mavica 5000 or the Kodak DCS 200. Some of these devices actually offer better resolution and superior optics than 3-D scanners and might be easier to operate, especially outdoors or for large subjects. But because of their expense, it would be foolish to buy one simply as a substitute for a 3-D scanner, something on the order of driving a Porsche on a paper route. (See the next chapter on filmless cameras.)

Some digital imagers find use for low-end, fixed focus filmless cameras, like the Canon Zapshot or the Logitech FotoMan, for taking snaps of real world objects in order to quickly import them into the computer. The images they will capture will be of low resolution, which limits their size and usefulness. They're good if all you want is an image element to paste in a larger picture, or to use as a point of reference for an image that you expect to manipulate extensively and which, when finished, will look less like a photograph and more like an illustration.

Similarly, any standard camcorder can be used, in conjunction with a frame grabber board, to scan in 3-dimensional objects or as a copy camera for flat art, photos, prints, etc. The quality is dependent upon how good the camcorder's CCD and optics are, but unless you are using top-of-the-line equipment, don't be too hopeful.

Last, and quite least, in this lineup of alternative scanning devices and techniques is to simply lift an image right off the TV. Television signals, whether from a network broadcast, a cable station, a closed circuit relay, or a videotape, all use the same industry standard NTSC signal. Any frame grabber can interpret and digitize NTSC signals, and some can capture higher-resolution PAL signals. The quality will be from poor to fair. Also, you might be entering the realm of stealing copyrighted images.

Clip art

Why bother with a scanner if all you want to do with it is to capture background or peripheral elements, such as clouds, crashing waves, famous landmarks, or other visual icons? There are literally hundreds of companies selling diskettes or CD-ROMs filled with a huge variety of stock images, clip art, textures, etc. Chances are that someone has an image that you need or want. It's much faster and probably far cheaper than assigning a photographer to shoot it.

Of course, your selection might be more limited, the quality might not be as high, and you'll have to ensure that you have legal permission to reproduce or incorporate someone else's picture element into your image. But it does provide an economical and practical alternative to having to scan in yours or someone else's images in order to have something with which to work.

As a practical and an artistic matter, we do not recommend using clip art or clip photography as the primary element in your digital image. Since the publishers of clip images make their money by volume sales, the image you lift won't look very original. And you won't appear very creative or innovative to your colleagues or clients.

⇨ Should you buy a scanner?

The primary question about shopping for a scanner is do you really need one? Service bureaus do a very good job and they guarantee their work (or, at least, they should). Besides, Kodak's Photo CD is a less expensive alternative for digitizing a volume of your photos.

Having your own scanner offers some important advantages:

> ➤ It's immediate. You can scan any time you wish, even in the middle of the night.

> ➤ If you're not satisfied with the scan—it doesn't look right, the image size is too large or small, there are pre-scan adjustments that you want to make—you can do it over immediately, as many times as needed, until you are satisfied.

> ➤ It's convenient. You would be more inclined to scan in secondary picture elements as you need them.

> ➤ It's easier to accurately calibrate the scanner's colors to your color printer, film recorder, or other equipment.

> ➤ If you have a flatbed or sheet fed scanner, you can use it also for general business purposes, such as OCR scanning of letters and documents.

> ➤ Assuming that you do a moderate to high volume of scans, the cost savings of doing your own scanning could be significant.

➤ With your own film scanner and a high density storage device, you can eventually move your entire slide library onto electronic media. You can do the same with a flatbed scanner for drawings, illustrations, paintings, etc. This could very possibly save them from the ravages of time, which eventually deteriorates all film and printed material.

Having your own scanner attached to your computer system gives immediacy, convenience, and control. You do not have to wait a day or two, or more, for scans to come back from your service bureau. Nor must you trust your original transparencies to the tender mercies of an express delivery company. Given the moderately expensive price per scan that most service bureaus charge ($25 for a 35mm slide and $75 for a single 4"×5" transparency are average costs, although they can be even higher if more resolution is required), you may limit the number of images that you have scanned. That could conceivably lead to artistic compromises, because you won't be inclined to scan additional or alternative images and choose among them on the computer.

However, there are important reasons *not* to own a scanner:

➤ A scanner can be an expensive capital investment.

➤ You may never reach a payback point if the volume of slides or prints that you scan is below a certain threshold.

➤ Scanners can deteriorate with age and, for optimum performance, may need to be overhauled or replaced every 3 years.

➤ Most desktop film scanners are limited in size to 35mm negatives or transparencies. A few can accommodate up to 4"×5", but the good ones are relatively expensive.

➤ Getting top quality scans, or scanning in larger film formats, requires an expensive drum scanner.

The rule of thumb with any piece of digital imaging equipment is if you can't reach the payback time (how long it takes you to make or save enough money to pay off the device) within 12–18 months, don't buy it. Here are two other reasons when not to buy a scanner:

➤ If you don't have the temperament to develop proper scanning techniques or can't afford to hire an employee with scanning skills.

➤ If your monthly volume of scans is too low to keep the equipment in use or your scanning skills sharp.

Should either or both of these conditions be true, send your transparencies, drawings, illustrations, etc., to a service bureau for scanning. (We discuss working with a service bureau in Chapter 32.)

Another, relatively inexpensive alternative is to send your films (up to 4"×5") for scanning to Kodak Photo CD. (Kodak works only with film, not original art or prints.) The quality is comparable to some of the best desktop scans available and can even hold its own (at small print sizes) against some scans made on drum scanners.

We aren't following our own advice

In order to do the research for this book, we borrowed a number of scanners from manufacturers to test. They have come and gone through our front door, as though this were a Federal Express depot. But one has just stuck—the Leafscan 45. Sally began using it only as another test machine, but because of its obvious image superiority, she continues to use it to scan in as many of her own slides as she can before it must be returned to the manufacturer. In fact, it has become the standard against which we test all other scanners.

We are now living testimony to the fact that all the logical advice we have to offer about whether or not it is absolutely necessary to buy a scanner doesn't take into account the emotional creative process that flourishes when you have an immediacy of input. Sally will find it difficult to function when she has to wait days for a Photo CD or a service bureau scan—so much so that we will be doing some quick calculations to see if we can justify the expense of buying it rather than let the Leaf leave this house.

⇨ What kind of scanner should I get?

For scanning 2-dimensional visuals (in your studio or office) which will be used in professional-quality digital imaging, it all comes down to a choice between film scanners or flatbed scanners for your primary scanning device. The other options are either too expensive, too specialized, or too inadequate.

The most obvious consideration is what kind of material you will want to input into your computer. If it is flat—such as prints, sketches, etc.—then you want a flatbed scanner. If it is a slide or negative, then you will need a film scanner.

Some imagers feel that a good flatbed scanner with a transparency option will work perfectly well for occasional film scans. This is especially true if the final output is to print rather than film, or if the original transparency is large (4"×5" or bigger) and will be reproduced at or near a one-to-one size ratio. Other imagers, including us, are convinced that slides and negatives really require a separate film scanner.

⇨ Selecting a flatbed scanner

Agfa, Hewlett Packard, Plustek, Microtek, Sharp, Ricoh, and many other manufacturers make flatbed or sheet fed scanners, which range in price from about $500 (for discontinued models, some of which are excellent bargains), to over $20,000. Here's what you want in a flatbed scanner:

> ➤ 24-bit color capability.

> ➤ At least 600 dpi *optical* resolution and 256 greyscale capability. (Many scanners offer higher resolutions by using software to interpolate, or enhance the image. For instance, a scanner that boasts 850 dpi resolution through interpolation may have only 300 dpi optical resolution, so the quality of the images might not be as good. Beware of interpolation, if your images are intended for high-quality, large output.)

> ➤ A TWAIN-compliant device. (TWAIN devices use standardized plug-ins, add-ons, and other drivers.) This ensures that the scanner will work with most major imaging programs. Most 24-bit color scanners are TWAIN-compliant.

> ➤ The ability to interface with your computer system. Some scanners are designed for either the Mac or the PC, but not both. Make sure you have a guarantee of compatibility with your system.

> ➤ On the PC side, one that will interface easily with your computer's SCSI board.

> ➤ For surer, higher quality scans, select a flatbed model over a sheet fed model.

Some 24-bit scanners (both flatbed and film scanners) make three passes—one each for red, green, and blue—while others scan in one pass. There's some difference of opinion over which is better. Theoretically, the 3-pass device should create a slightly better color separation, for more depth and higher resolution. On the other hand, the scanning time is longer, which could conceivably reduce image quality through vibration or movement, less-than-perfect registration, etc. Personally, we haven't seen any difference between the two in flatbed scanners, when all other variables were equal.

HINT

Any scanner you get should be placed on a flat surface free from vibration. The more stable the device, the less problem with motion and registration. Given a choice between two otherwise equal scanners, choose the heavier model.

Selecting a film scanner

Much of what we said about flatbed scanners applies to film scanners. Here are some other things to consider when selecting a particular brand or model:

➤ Film scanners can be 24-bit, 30-bit, 33-bit, 36-bit, or even 48-bit devices. The reason for the extra bits is to give greater dimension and definition to the image. While no output device can possibly use those many bits, the extra bits ensure that you will always have the maximum number of usable bits in your scanned image file. The more you enlarge the image, the more useful oversampling will be.

➤ As a matter of practicality, the maximum resolution you will probably need for 35mm slides is 2750 dpi (in order to match the 4K output resolution of most under-$20,000 film recorders). A few film scanners offer resolutions up to 5000 dpi. Choose the film scanner based upon your projected output device.

➤ Can you focus the slide? Some film scanners allow auto or manual focus to compensate for slide mount diameter differences. Others use fixed-focus lenses.

➤ What is the light source? Most film scanners use color-corrected filament-type bulbs, which produce heat and can possibly buckle the film during the scanning process. Newer, less expensive models use cold light sources (fluorescent or LEDs).

➤ Is there an option for stacking and automatically scheduling more than one slide at a time? (We strongly recommend not using this particular feature—you'll have less control over positioning and making pre-scan corrections—so why bother paying extra for it?)

➤ How fast do you need? The speed of a scan can vary tremendously, with some devices taking as little as 2 minutes or as many as 25 minutes to produce the same size file. Usually, the faster the scan, the more expensive the device.

Pre-scan adjustments

Whatever scanner you obtain, you will also need software so that your computer will be able to connect with it and take in the scanned data. These are called *drivers*, or *plug-ins*, are usually sold to you with your scanner, and install as part of Photoshop, PhotoStyler, or other graphics applications programs.

Drivers do a pre-scan first, projecting a low resolution scan of the film or the drawing (sometimes in black & white instead of color) on the computer monitor. This allows you to see a representation of the final scan and aids in making adjustments and corrections.

Depending upon the particular software, a user can:

➢ Crop, rotate, or reverse the image

➢ Set the exact resolution in dots (or pixels) per inch

➢ Set the exact dimensions in inches, millimeters, or centimeters

➢ Adjust the gamma curve and dynamic range (greyscale values)

➢ Control the color balance

➢ Specify a fast or slow scan

➢ Choose the file image type and format

There are two different schools of thought regarding the value of pre-scan adjustments (other than cropping, sizing, and maximizing dynamic range, which everyone does). One is that they are extremely useful and greatly reduce the time and effort one would have to spend on the uncorrected image after it is scanned at the final resolution. The software that comes with some devices is outstanding, such as that bundled with the Nikon LS-3510AF, because it is specifically written to address the capabilities of a given scanner.

The other perspective is that the correction tools that are usually bundled into scanner software are crude, compared to the sophisticated tools available in many paint programs. Any data edited out before the scan—good or bad—is gone forever and cannot be manipulated.

Which one is the better approach? We can't rightly say, since we sometimes do relatively unedited scans and other times make a number of pre-scan adjustments. It's more a matter of style and preference, one that every user will have to decide for herself.

One adjustment that we always do in the scanner is to get the image right side up. This might sound silly, but it happens often that a slide or print is put into the device upside down or reversed. It is much easier and more time efficient to just take the film or print out of the scanner, put it back in correctly and rescan, than to use software to fix its orientation.

In all cases, experimentation is recommended. Scanners generally have an inclination towards a particular hue. Successful imagers would be well-served if they could discover that propensity in their equipment before accepting any time-critical jobs, and make the appropriate adjustments.

HINT

Dust is deadly if you want an accurate scan. Every particle can translate into an inaccurate pixel that must be fixed in your computer. Use a photographer's antistatic brush and canned air to clean your images before scanning them. And try to keep the area around your scanner comparatively dust-free.

11

Filmless cameras

A different kind of input device

THE IMPACT of the digital imaging revolution is represented most vividly by the staggering advent and exponential improvement in filmless photography. In 1981, Sony quietly introduced a revolutionary camera called the Mavica. Short for *MAgnetic VIdeo CAmera*, the Mavica recorded its images not on film, but on a tiny 2" video floppy diskette. Instead of ending up as a 35mm transparency or a color print, the pictures it captured could be displayed only on a TV.

While its debut excited a small audience of visually sophisticated professionals who could envision what its true significance would be as the technology matured, most photographers either completely ignored the Mavica or dismissed it out of hand as a curious anomaly that could never compete with film-based photography. Among the things photographers justifiably faulted it for was its high price, poor resolution, severely limited dynamic range, questionable color fidelity, and the need to buy an even more expensive computer system and software to process the images into anything usable.

But there were those pioneers and visionaries who could see, however faintly, the handwriting on the wall for conventional film-based cameras. News organizations saw a potential for virtually instantaneous transmission of photographs for fast-breaking or deadline-hugging stories. Mail-order houses considered it as a possible way to streamline and economize on producing catalog shots. And a handful of creative photographers recognized that, with all its faults and deficiencies, filmless cameras represented a wholly new art medium waiting to be explored.

Obviously, the technology got better, though it still has a long way to go before it reaches the quality level of film. Filmless cameras cannot match the color gamut, color accuracy, resolution, and dynamic range that film provides—at least, not yet.

Filmless cameras are still very much in their infancy. But the quality differences between them and film-based photography are now mainly incremental. As the technology improves and the prices fall, the chasm between the two media will narrow.

We have had industry experts, including Kodak executives, explain to us with complete conviction and absolute faith that filmless photography will never, ever catch up with film-based cameras. In a 1993 speech, Robert Hamilton, Kodak's vice-president and general manager for the U.S. and Canada, said "one of the recurring questions that we, as manufacturers, keep hearing from retailers is that electronic imaging will somehow displace traditional photography. That just isn't going to happen. Silver halide-based photography will continue to generate the lion's share of revenues and profits for our industry, well into the next century."

But the next century is only a few short years away. The real question is whether film's here to stay over the long run.

Compared to the film products of the early 80s, today's films are significantly faster but with much finer grain. Colors are more saturated and realistic, dyes are more stable and long-lived, and other technical areas have been expanded and improved so that film emulsions are unquestionably better than ever. In fact, it's fair to say that film technology has reached almost a pinnacle of perfection.

And that's the fallacy of believing that film will always be superior to silicon. Film is a mature technology that has been around for over a century and a half; it's approaching its zenith. In contrast, filmless cameras and the computer technology that supports them is new, dynamic, and improving by leaps and bounds. It's a safe bet predicting that filmless photography will become an important component in the capture of images, and will eventually overtake and even eclipse film as the medium of preference among professionals. But that is in the future. The only thing we can't answer right now is how far in the future it will be.

Regardless of whether or not filmless cameras will ever completely replace silver-halide photography, this new technology has already become (and will continue to grow as) important input devices for digital imaging.

What is a filmless camera?

A filmless camera is a synthesis of a conventional camera with a television mini-camera. At the front end is a lens, diaphragm, shutter, viewfinder, and the equivalent of a frame transport mechanism, just as in any camera system. The lens might be a zoom or autofocus, the viewfinder a single lens reflex or a rangefinder type, and the shutter a Copal Square, guillotine, or leaf shutter. In fact, two filmless cameras manufactured by Kodak use conventional off-the-shelf Nikon F3 and 8008s bodies as their front ends. The only real front end difference is that instead of an advance lever or a motor drive for advancing film sprockets a frame at a time, all filmless cameras use a motor only to reset (cock) the shutter. Depending upon the model, filmless cameras are capable of shooting between 1 and 5.7 frames per second—the DCS 200 has a hiatus, of 7 seconds between frames—a mechanical rather than electronic limitation. See Fig. 11-1.

It's the rear end that's radically different than film-based cameras. The image is focused not on a piece of film but on a light-sensitive CCD, similar to the chip used in most scanners but having greater sensitivity and resolution. Most filmless camera CCDs have a sensitivity equivalent to film with an exposure index of between 80 and 400 ISO; the precise CCD speed is adjustable on most filmless cameras, just as

Figure 11-1

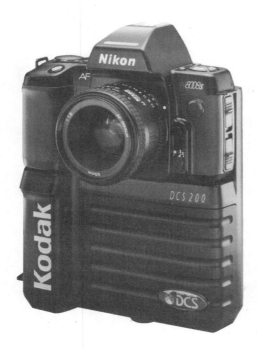

Kodak DCS 200 camera. Kodak

it is on conventional cameras, only it's much more accurate. This means that for most shooting situations, shutter speeds and f-stops will be set the same as they are for film.

In most analog-type filmless cameras, once the picture is registered on the CCD, the data are then electronically transferred and saved as analog information to a 2" video floppy disk or to a credit card-size memory card (called a PCMCIA). Registering and transferring the image takes only a fraction of a second.

⇨ Filmless cameras vs. conventional cameras

Put a Ferarri and a Volkswagen side by side on a drag strip or race track, and there will be no surprise regarding the outcome. Of course, the Ferarri will run rings around the Volkswagen. But suppose the criteria you are interested in aren't speed or style but economy and practicality. Suddenly, that Italian sports car seems like an overpriced, temperamental beast when compared to the economical, almost indestructible German sedan.

It all depends on what you want or need.

In similar fashion, conventional cameras and silver halide film outclass and outperform filmless cameras and electronic media when your criteria are resolution, color fidelity, and dynamic range (the ratio of

light to dark that the media can accurately capture). But once you start considering other factors, the playing field begins to level considerably. So, when do you stick with film, and for what uses are filmless cameras desirable, even superior? See Table 11-1 for some answers.

The pros & cons of film & filmless photography
Table 11-1

	Film	Filmless
Pro	Superior resolution Better color saturation Greater dynamic range of 8:1 Inexpensive media (36-exposure 35mm roll is $8–13 with processing) Cameras are cheaper, lighter, & easier to repair Self-contained, don't need a computer	Electronic media may be reused many times: the more often, the greater the savings per image Images may be viewed immediately on a TV or computer monitor Underexposure, overexposure, & other errors may be easily & quickly corrected on a computer Images may be transmitted immediately over phone lines, to any computer anywhere in the world Every copy will be an exact duplicate of the original, indistinguishable from the first generation
Con	Processing uses environmentally damaging chemicals that will become increasingly difficult & expensive to dispose of Film & processing are consumables that must be replaced with every shoot Processing is time-consuming—a minimum of 45 minutes for color slides Must process & then scan in any images you want to digitally edit or enhance All first-generation images are irreplaceable originals Duplicating originals diminishes the quality of the image with each succeeding generation Eventually, all film will decay with age	Most professional filmless cameras are heavier and bulkier than film cameras, so they are difficult to hand-hold Very limited dynamic range (usually no more than 1:2 or 1:3) Image resolution is $\frac{1}{10}$ to $\frac{1}{2}$ that of Kodachrome Uncorrected colors may be unrealistic and tinted with a strong monochromatic bias Number of exposures limited by filmless camera's or computer's storage capacity Many use built-in rechargeable batteries, which are useful for only a limited number of exposures at a time They're expensive Need a computer system to do anything with the images

Choosing between a filmless camera and a traditional one involves recognizing what factors are important to the project at hand. While filmless resolution, dynamic range, and color aren't as good, electronic images published at relatively small sizes or in newspapers, newsletters, and some catalogs or magazines are indistinguishable from those produced by film.

However, there's still the emotional value of film. As Baldev Duggal, of Duggal Labs in New York said to us, "Film is sexy." You can hold it in your hand, put it up to the light, relate to it as something real and tangible.

Operating differences between film & filmless cameras

Despite the technological differences, actually photographing with a film or a filmless camera is virtually the same. F-stops and shutter speeds have to be set according to the film's or the CCD's sensitivity to light. Lenses are focused the same way, too. Both daylight film and most CCDs are balanced for 5500 degrees K light, and each system requires the filters to compensate for tungsten or fluorescent lighting situations. Just like film-based cameras, some filmless cameras are of the point-and-shoot variety. Others are true systems with interchangeable lenses, finders, etc. A couple are even fixed-focus, nonadjustable electronic box cameras.

There are, however, a few real differences between the two systems that should be understood and factored into a professional photographer's working habits.

The first is dynamic range, or, how a particular shot should be lit. Filmless cameras work best in flat, low-contrast lighting, where the values between the darkest and the lightest parts of the image are not great. For instance, a high contrast scene, such as a subject half in bright sunlight and the other half in dark shadow, will not record well on a CCD. Details in the shadow and highlight areas will be lost.

While a conventional photographer might have to worry about grainy film, an electronic photographer must be aware of something engineers call *noise*. Noise—which might affect an image by making it appear grainy or creating unwanted spots or "snow"—is the unavoidable side-effect produced by almost *every* electrically-driven device, from a toaster to a lightbulb. On a filmless camera, it's usually produced by the CCD itself, the video floppy disk drive motor, etc. The better the camera, the less noise. Noise can also be created by shooting certain subjects, such as sunlight streaking through dark tree branches. The greater the contrast, the more noise in the image.

While there's little one can do about inherent noise, the photographer can minimize image noise by being judicious in choosing the subject and controlling the lighting.

Another peculiarity of filmless cameras, especially those that can accept interchangeable lenses from a conventional camera system, is that a traditional lens put on a filmless camera will capture an image ¼ and ½ as large than if the same lens were used on a film camera. For instance, depending upon the size of the CCD, a 50mm lens will produce a magnification equivalent of a 100mm, 150mm, or 200mm lens. That's why the standard lens on a filmless camera like the Kodak

DCS 200 is a 24mm lens, which captures approximately the same picture area as a traditional 50mm lens.

Being all-electronic devices, filmless cameras use up power more quickly than conventional cameras. The batteries must be replaced or recharged more often, which means the shooting sessions must be scheduled for a shorter period of time. One very effective way to conserve battery power is to simply turn off the device when it's not being used. It's a bit inconvenient to photographers used to having a camera always ready to shoot, but no more so than turning a strobe light on and off. A few filmless cameras have "sleep" modes that will allow the camera to remain on but will conserve battery life by turning off components that aren't being used; they turn on instantly when needed. Some filmless cameras can be directly attached to a small transformer, which can then be plugged into a wall outlet. Other cameras have battery compartments for quick-change rechargeables. Learning the rhythm and time cycle of a particular filmless camera is just a matter of practice and familiarity.

One tends to bracket much less on a filmless camera. (*Bracketing* is the process of taking the same picture at a variety of exposure settings to ensure one shot that is perfect.) First, the media is much more limited. A video floppy disk can store a maximum of 25 medium-resolution images (50 low-resolution images) and a PCMCIA memory card between 8 and 20 images. Of course, they can be quickly swapped for fresh video floppy disks or memory cards, but because filmless cameras drain electricity like there's no tomorrow, there's a practical limit on how many exposures can be made in a single shooting session. A camera like the Kodak DCS 200 with a built-in hard drive can store 60 images, although it can be plugged into an external, piggyback hard drive with a capacity of 200 more images.

But bracketing is not a shooting *modus operandi* in filmless cameras (except when first learning to use the device), primarily because overexposure and underexposure are not as critical as they are with color transparency film. Most exposure problems can be easily corrected once an image is in the computer, using editing software. We've tested systems with pictures that have been three or more stops off—an extreme that is usually fatal with color film—and managed to produce a near-perfect exposure in the computer within a matter of minutes. However, it's still preferable to capture as good an original image as is possible. The time spent correcting a bad image can be extensive and will not always produce the desired results.

Many traditional photographers will use bracketing not to assure optimum exposure but to record various depths of field. The filmless camera is not useful for this method of playing with the area of focus. Nor is there any advantage in varying the shutter speed to slow down or accelerate motion. Unlike film, which records everything, so long as there is still light (including blurred motion and trails of moving lights

caught in a time exposure or rear curtain sync flash shot), CCDs have no memory for holding an image past its initial exposure. All you'd get is an out-of-focus shot, not the effect of motion streaks. For these reasons, no filmless camera we're aware of has an automatic bracketing back. At least, not right now.

Finally, while many photographers will handhold their cameras, filmless ones are heavy and best used on a tripod.

Types of filmless cameras

The range and selection of filmless cameras is more limited than that of traditional cameras. Because of the engineering difficulties associated with designing and manufacturing CCDs, the largest filmless camera that shoots in real time is the equivalent of a half-frame 35mm conventional camera. (Scanner backs on medium or large format cameras don't work in real time, requiring time exposures for color shots.)

Therefore, what defines the different types of real time filmless cameras isn't the size of the CCD but instead the medium used to record images and the form in which those images are stored. At present, there are five different kinds of filmless cameras that are suitable for digital imaging:

➤ Video floppy disk cameras

➤ Digital cameras

➤ PCMCIA cameras

➤ Filmless camera backs

➤ Still video cameras

Data compression

In order to store many thousands, or even millions, of pixels that constitute each image, virtually all filmless cameras use some sort of compression scheme. The most commonly used one is called JPEG, and it's often built right into the filmless camera. Compression shrinks and squeezes the data down so it may be handled more quickly and efficiently.

Some data compression schemes work in real-time, which means that they compress and uncompress data on-the-fly, so quickly that any delay seems hardly noticeable. The data compression algorithm that most filmless cameras use is either lossless or might involve minimal image quality loss. The photographer is often given the option. Lossless data compression is more time-consuming and does not shrink the file down as much as the faster, more compact data loss compression methods. Data compression, either built into the filmless

camera or activated through the computers' software after the images have been uploaded, can shrink a file to ⅟₅₀ its original size. The quality loss for that amount of compression can be significant. (See Chapter 25.)

⇨ Video floppy disk cameras

This is the most popular type of filmless camera. The video floppy drives that are built into these cameras don't record data digitally like a computer disk, but more like the analog signal captured on a tape recorder. Spinning up to 360 revolutions per minute when the camera is turned on, they can record either 50 low-resolution or 25 medium-resolution color images at 1 to 5 images per second. See Fig. 11-2.

Figure 11-2

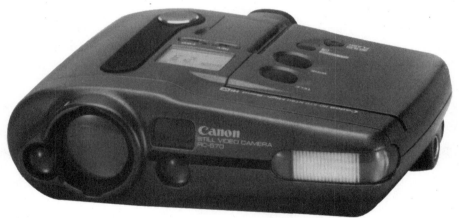

Canon RC-570, a video floppy disk camera. Canon

Like computer floppy disks and tape cassettes, video floppy disks can be reused many times by simply rerecording over the old images. They may also be wiped clean by passing a strong magnet over the video floppy disk, something that many users with an audiophile background do every so often as a matter of course. A magnetic field realigns the polarity of the video floppy disk, thereby eliminating any possible residual pattern of previously recorded images (which could conceivably produce "ghosting").

Filmless cameras that use video floppy disks range in price from under $500 for the Canon Xapshot (a discontinued model that is still a popular seller at discount electronics houses and camera stores), up to $7500 for the top-of-the-line Sony Pro Mavica 5000.

⇨ Digital cameras

One type of filmless camera is called a digital camera. While technically inaccurate (*all* cameras are always, without exception, analog devices because they capture continuous tone images), what differentiates digital cameras from other filmless cameras is they contain built-in circuitry that captures an analog image, immediately converts it to digital on-the-fly, and saves it to an internal or external hard drive in digital form. Logitech's FotoMan stores up to 32 low-resolution black-&-white images on a battery-protected memory chip. The Kodak DCS 200 camera instantly converts and downloads up to 60 images onto a built-in 3.5" hard drive, 200 images on an auxiliary battery-powered external 3.5" hard drive, or (via cable) directly into a Macintosh or PC computer.

Like video floppy disk cameras, digital cameras are among the cheapest and the most expensive. Logitech's FotoMan has a street price of under $500, including software and a computer interface. Kodak's DCS 200 camera tops $9000, not including lens.

⇨ PCMCIA cameras

One type of digital camera uses a more recent and convenient storage technology, the flash memory card (aka Type II PCMCIA cards). Memory cards contain tiny RAM chips, backed up by a button-sized lithium battery that protects the data content for 2–5 years. Depending upon the resolution of the image and the storage capacity of the memory chips, memory cards can store between 5 and 21 images. Memory cards are used like cartridges in that they can be quickly inserted or interchanged for fresh cards just by plugging and unplugging them into or out of PCMCIA slots. The only thing one really needs to know about such cards is how much memory they hold; the memory capacity ranges from 64K up to 20Mb, though larger capacity cards are supposedly in the works. See Fig. 11-3.

What's the difference between a memory card & a video floppy disk?

Video floppy disks record and store analog data only. Memory cards directly record digital data. Video floppy disks use a standard format that allows for either 50 low-resolution (called field mode) or 25 medium/high-resolution images (called frame mode). Memory cards have a lower overall capacity and can capture a maximum of 21 low-resolution or 5 high-resolution images. However, for reasons best understood by engineers, these digital images are (at least, theoretically) of a slightly higher quality than those captured on an analog video floppy disk.

Another important difference is that memory cards are solid state devices with no moving parts. Video floppy disks are made up of various components, some of which rotate at several hundred RPMs when the camera is turned on. Theoretically, it means that memory cards produce better images. Also, memory cards may be used over and over many thousands of times. While video floppy disks may be reused several hundred times, their moving parts eventually wear out and the entire video floppy disk must then be discarded.

No one really knows how long the data on the plastic-coated magnetic media used in video floppy disks will last. (Best estimates are at least 10 years and, then, the plastic becomes brittle.) Potentially, memory cards could outlive all of us, although the data will last only as long as the battery (3–5 years). But that's a moot point; most images are uploaded to a computer within minutes, hours, or days of being shot, in order to clear the video floppy disk or memory card so it may record new images. We know of no one who uses video floppy disks or memory cards as long-term data storage devices.

A significant tradeoff between video floppy disks and memory cards is one of cost. Video floppy disks generally cost about $6–$9 each, while memory cards cost $75–$150 per megabyte (at the time of this writing). It's likely that the PCMCIA card cost per megabyte will eventually drop to the $25–$35 range, but not for many months.

Figure 11-3

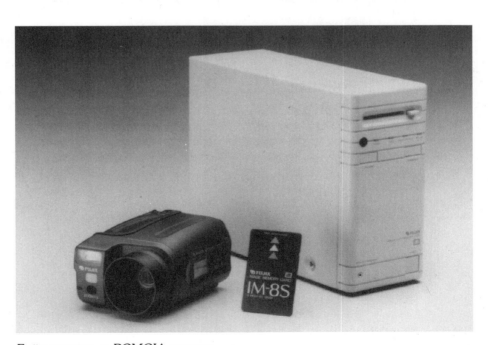

Fujix camera, a PCMCIA camera. Fuji

⇨ Scanner backs

Yes, we know we said that we wouldn't highlight digital equipment costing $20,000 or above. Most scanner backs range between $28,000 and $34,000, though by the time this book comes out there may well be significantly less expensive devices on the market. However, a scanner back is one product that many photographers might be tempted to buy or lease, since it could easily become their professional workhorse. That is because the image quality produced is virtually indistinguishable from film. See Fig. 11-4.

Figure 11-4

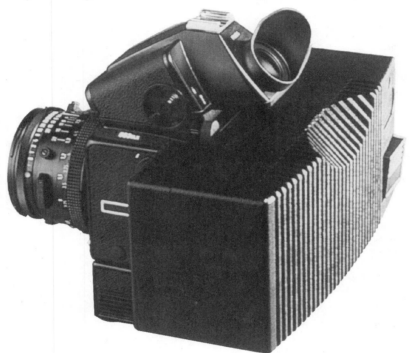

Hasselblad camera with a Leaf Systems back. Leaf Systems

Scanner backs are, literally, miniature scanning devices specifically designed to fit on certain medium and large format professional cameras, such as the Rollei, Hasselblad, Mamiya, etc. One type works in real-time (at least, in black & white), is able to take photos up to $\frac{1}{500}$ of a second. Color exposures, however, must be made by exposing the image three times through a motorized contraption that fits in front of the lens, and which, in turn, rotates a wheel with red, green, and blue filters. Obviously, the camera must be stationary on a tripod or stand, and the subject must not move during the three separate, successive exposures. By the time this book comes out, there may be filmless backs available that can shoot color in real-time, instead of using a color filter wheel.

The other type of scanner back is even slower. In fact, it's much less like an electronic camera than a scanner-on-a-lens. Unlike 35mm filmless

cameras, which have dime-sized CCDs upon which the entire image is focused simultaneously, these scanner backs have a CCD on a motorized arm that slowly passes over the entire camera area, whether it is 6×6cm, 6×9cm, or 4"×5". Because the arm moves mechanically in a systematic sweep over a much larger area, the overall quality and resolution will be significantly higher than anything that a 35mm filmless camera can capture. The average exposure time required for a complete scan at the highest resolution takes about two minutes, so it's not possible to use them handheld, or to shoot anything that involves motion.

Scanner backs are bulky, heavy and must be tethered by cable to a nearby computer. But the images they are capable of producing are almost equal to film. While the initial cost is quite high, the fact that they can work amazingly fast, as well as completely eliminate the need for film, processing and an expensive scanner, might make them very economical and quite practical in the long run.

⇨ Still video cameras

Take a standard, off-the-shelf camcorder and give it the ability to shoot a single frame at a time, and what you have is a still video camera. Some of the latest generation of sophisticated amateur camcorders have single frame capability built into the circuitry. The resolution and dynamic range are inferior to those obtainable with other filmless cameras because, technically, still video uses broadcast TV standards, which are inferior to those we use in digital imaging. Most are autofocus, autoexposure devices with limited or no manual control over shutter speed and f-stops. But the major drawback of a still video camera is that the images are saved on a strip of videotape from a standard VHS or Hi-8 cassette, a much less desirable and inexact storage medium. This almost guarantees lower resolution, more "noise," and the possibility of bands and stripes in the image.

Despite the drawbacks, still video cameras have one irresistible appeal: price. They are hundreds or even thousands of dollars cheaper than other types of filmless cameras. But the final image might not produce acceptable quality when it comes off a printing press.

Try before you buy

Most filmless cameras are far too expensive to buy in anticipation of some future commercial application. And yet, you may get a frantic call from a client tomorrow asking you to immediately shoot the spring catalog electronically to save time and money. (Don't laugh—it happened to a photographer friend of ours last fall. He had less than 24 hours to accept a lucrative job or pass it by.)

If you are in commercial photography and some of your clients are involved in catalog work, rent a filmless camera system before you get

that call. Learn how to use it by working on some self-promotion piece or personal project. Become its master, so that you will be able to tell a client (as our friend could not) that you are ready to shoot any medium she wishes, including filmless.

Then, continue to rent the equipment as you need it for jobs, until enough of your income is based on filmless shooting to justify buying or leasing a system.

Sally has been shooting with filmless cameras since she first tested a Kodak DCS prototype in 1991. But we don't own one; instead, we rent the equipment when she needs it. Just today, she accepted another assignment from InfoWorld to shoot Comdex (the huge semi-annual computer trade show) with a filmless camera, a first for that publication. So she called Scott Geffert, who manages the digital imaging department of Ken Hansen, a New York photo store nationally known for its digital imaging sales and rental departments. Scott is Federal Expressing down a prepackaged kit that includes a Mac PowerBook (portable computer) with Photoshop installed, plus a modem, so that she'll be able to edit whatever she shoots with the Kodak DCS 200 while on location and transmit, by telephone, the images to InfoWorld within minutes of shooting them.

Renting is a very viable, less expensive alternative to owning the equipment. What's more, it ensures that you can rent the most up-to-date version while letting someone else maintain it and absorb the capital costs. Besides, you can always charge the rental to the client. So we recommend establishing a working relationship not only with the equipment, but also with a shop like Ken Hansen that specializes in keeping a state-of-the-art inventory available for rent.

⇨ Getting the images into the computer

The fastest, easiest, and most convenient method of uploading data from a filmless camera to the computer is done with an analog-to-digital converter. Most are boxes about the size and shape of a slimline toaster that have slots in the front for video floppy disks or PCMCIA memory cards. They attach directly to a PC or Macintosh SCSI interface via a cable.

The computer treats the converter as if it were an external disk drive, but one that stores analog data and converts it to digital just before the data are copied over to the hard drive. The primary drawback is that most cost between $2000 and $3000.

Remember that we said most filmless cameras can display images on a regular TV set? A frame grabber board can intercept still images from any standard TV signal (from a filmless camera, camcorder, VCR or even directly from a broadcast program), process it into digital data,

and then upload it directly into the computer's hard disk drive. Most frame grabbers are significantly cheaper than analog-to-digital drives, but the quality probably won't be quite as good. Another disadvantage is that a frame grabber board takes up one of your computer's expansion slots. That may not matter much with a PC that has 8 slots, but it can be inconvenient with a Quadra 700 that has only 2 NuBus slots. The third drawback is reduced speed and convenience. It will almost always take longer to upload through a frame grabber than by using an analog-to-digital drive.

How important or critical are these differences and drawbacks? Not much, or else very, depending upon the level of quality you demand in your work. If you're shooting ads for a tabloid newspaper, it might not matter one iota whether one system will provide a marginal qualitative advantage. On the other hand, if your work will be going into *Vogue* or *Esquire*, you'll want all the resolution and dynamic range you can get, which generally means shooting with a high-quality filmless camera like the Kodak DCS 200 or a scanner back like the Leaf. If you're willing to spend a few extra minutes transferring images, have a slot to spare in your computer, and your work isn't intensely quality-dependent, then the dollar savings of buying a frame grabber board over an analog-to-digital drive can almost pay for a Caribbean vacation.

Filmless cameras & their uses

Like the day-and-night contrast between an Instamatic and a Hasselblad, the image quality among filmless cameras varies considerably. The factors that determine the quality, versatility, and price of a filmless camera are the lens, the degree of electronic sophistication, the number of controls and options, and most importantly, the CCD. Put simply, the better the CCD and the more pixels that a CCD can distinguish (which is based on the number of capacitors crammed onto the chip), the better the image. CCDs vary tremendously in density and quality control.

Low-end devices

Cameras with a street price of under $500, such as the Logitech FotoMan and the Canon Xapshot, are designed and targeted primarily towards amateurs who have discretionary money, want some novelty, and aren't particularly concerned about image quality. Most have fixed-focus lenses and a built-in flash and can shoot one to three photos per second. A video floppy disk is usually used to store either 50 low resolution or 25 higher resolution images, but others store up to 32 images on built-in memory chips. Most are capable of capturing color, but several are strictly black-&-white devices. They might or

might not have coupled exposure meters that adjust the shutter or the diaphragm according to light conditions. The image quality they produce ranges from something comparable to a disposable film-in-the-box camera to an inexpensive point-and-shoot camera.

Admittedly, these are severe restrictions of quality and flexibility. However, they are quite suitable for some of the tasks that now require the use of a Polaroid camera, such as positioning, checking lighting, continuity, etc. Other black-&-white digital camera applications include photo IDs, low-resolution photos for simple newsletters or, when put on a tripod and used with a close-up lens, low-resolution 3-dimensional scanning.

Inexpensive color filmless cameras are marginally more useful. For example, they might be suitable for artists and illustrators who need only a general low-resolution image to work with, or photographers who want to add a soft background or relatively unimportant image element as part of an overall digital picture.

Low-end still video cameras

Still video cameras are positioned between low- and mid-range devices, both in price and quality. They are frequently used in place of a 3-D scanner, to quickly and inexpensively capture an object for digital manipulation. Because they often lack f-stop and shutter speed options, still video cameras are very limited as a replacement for the types of photography ordinarily accomplished with a conventional professional-type camera. This type of device is most useful for those on a very limited budget and for whom the quality is sufficient.

Mid-range to high-end still video cameras

Middle-range to high-end still video cameras—such as the Mavica Pro 5000 or the Canon RC-570—typically produce near-photographic quality images, which, when displayed properly, are indistinguishable from film images. An increasing number of newspapers and wire services use them for fast-breaking, deadline-hugging news events. In conjunction with a companion device called a transceiver, images can be transmitted, via standard telephone lines, anywhere in the world in a matter of minutes.

The most important factors that determine these cameras' usefulness are the size and quality of the final output. Use them for pictures in which the actual printed size will be no larger than 5"×7", or the halftone screen will be no more than 150 lines. Mid-priced filmless

cameras are often used as a quick, inexpensive alternative to a film scanner or 3-D scanner.

Higher priced filmless cameras

High-end filmless cameras—which include the Fujix HC-1000 and the Kodak DCS 200—can be used almost as a one-to-one replacement for conventional film cameras. They exhibit a high enough resolution and dynamic range for many applications: photojournalism and editorial photography; sports and other action scenes; scientific/medical and commercial/industrial illustrations; catalog and brochure work; advertising and promotional scenes that will be printed no larger than 8"×10", at 150 lines. But they're still not the equal of film when it comes to high-quality color fidelity and reproduction.

Scanner backs

Because they cannot shoot color in real time (requiring from ⅕ of a second up to 5 minutes for each exposure), scanner backs are best suited for still-life, non-action photography. They work best for catalogs, product shots, architecture and design, scientific/medical shoots. With a resolution almost comparable to silver halide film, there are no practical limits regarding enlargement or the fineness of the printing process.

What's the real difference between a CCD & film?

Currently, the highest resolution filmless camera is the Kodak DCS 200. Its CCD can record 1.5 million pixels. In broadcast terms, that's over 1500 lines per inch resolution. Although film's grain structure is quite different from a CCD's pixels, each 35mm frame of Kodachrome contains a rough equivalent of 18 million pixels. That means Kodachrome is capable of recording approximately 2,500 lines per inch. Obviously, film has much better resolution, dynamic range, luminescence, color saturation, etc.—at least, for now.

As this book goes to press, we received what could very well be called earthshaking news. A Canadian company called Dalsa, Inc., has managed to create a CCD measuring 2.5"×2.5", which makes it the largest CCD in existence. (As a point of reference, most CCDs used in filmless cameras are about ½"×½".) What's more, it is reputed to have a resolution of 26.2 million pixels per frame. Compare that to Kodachrome's resolution equivalent of 18 million pixels. (For the time being, this CCD cannot come near Kodachrome's dynamic range.)

While we had predicted that digital technology would eventually reach, and possibly surpass, the quality of silver halide film, we had projected a time frame of 5–10 years. If the reports on Dalsa's revolutionary CCD are true, and if it ever goes into production (the

company says you'll be seeing products with its CCD as early as mid-1994), we will have reached the point where, qualitatively, film and electronics will be virtually equal and interchangeable.

Undoubtedly, the first filmless cameras using this new technology will be hideously expensive—Dalsa is talking about a price of $20,000–$50,000 for just the CCD. Most likely, its first applications will be primarily scientific, medical or industrial, for which price is not a particularly important factor. But if past history is any indication, the prices will begin to fall almost immediately while the technology will improve by leaps and bounds. Within five years, a filmless camera with better-than-Kodachrome resolution might cost approximately the same as a top-of-the-line Rollei or Hasselblad.

For the present, scanner backs provide the highest quality images that are possible electronically, and the next generation will rival film in all aspects except dynamic range. Also, look for scanner back prices to drop from stratospheric to merely outrageous by the end of 1994. But eventually, scanner backs could go the way of 8-track tape.

Within 10 years, most professional photography will be done with filmless cameras made by Nikon, Canon, Minolta, and other manufacturers now producing silver-based cameras. Adjusting for inflation, they will probably be more expensive than today's top-of-the-line pro models, but will actually save the photographer money because she will never have to pay for film and processing again.

We don't recommend waiting years for cameras based on these new CCDs to come onto the market. Technology will always be making leaps forward. Only the quick and the ready will be able to take advantage of it. That means learning as much as you can about what is available now, mastering filmless cameras and scanner backs if they are appropriate to your work, and preparing for the future.

Evaluating filmless cameras for yourself

Chances are that by the time you read this, several filmless camera models we've mentioned will have been discontinued and others will have been introduced. So, here are some guidelines on how to evaluate and select a filmless camera on your own.

First, establish exactly what you want to do with the camera. How will the electronic images you shoot be used? Are they going to end up as full-page color ads in major magazines? Will they become meat-and-potatoes catalog shots? Are they going to be used primarily for positioning or proofs, for fine art prints, or for photojournalism? Or do you just want them as input devices to capture raw material for your digital art? There's no sense looking at cameras that aren't

technologically capable of producing the level of quality you need, or in paying thousands more for features or quality you'll never need.

Here are some things to consider:

> *Storage medium.* How many images will you shoot during a single session? Does the camera you are thinking of buying have the capability of interchanging video disks or memory cards, or can it accommodate an external drive or some other auxiliary storage form?

> *Power.* Does it use built-in batteries, and if so, how long will they last and how quickly can they be recharged? Can an external battery or transformer be attached? Are the batteries replaceable?

> *Compatibility.* Will the camera interface with your particular computer? Will you need to buy additional, expensive peripherals in order to upload images?

> *Versatility.* Do you need a camera or a camera system with interchangeable lenses? Should the lenses and accessories be compatible with your existing conventional camera system?

> *Features.* Can it plug in directly to a computer, a portable image transceiver, a color printer, etc.?

> *Logistics.* Is the filmless camera you need truly portable, or will it require a nearby computer or power outlet? Does your style of photography allow for a lack of portability or demand a freedom of movement?

> *Speed.* Do you need real-time capability for shooting models, action, etc., or can most of your work be done with a scanner back that requires time exposures?

> *Quality.* How much resolution, color gamut, and dynamic range do you really need?

> *Warranties and service.* How long does the manufacturer guarantee the camera? Can it be repaired locally and quickly, or must it be sent back to the factory?

> *Life expectancy.* How long will the internal batteries last? How difficult or how expensive will they be to replace? What about the CCD or the disk drive?

Balance the answers to these questions with your budget, your income, your artistic requirements, and your clients' needs before you make your decision to buy or lease anything. And, as we stated earlier, try the camera out first. The commitment you will make with that purchase is one you will have to live with for a long while.

12

Storage
devices

EVERY PHOTOGRAPHER has his share of the-one-that-got-away stories. Daniel remembers the never-to-be-repeated shots he took during the 1969 siege of Umahaia in the Biafran-Nigerian Civil War, when he clicked off frame after frame of the panic of fleeing civilians, crashing artillery shells, and soldiers commandeering every lorry and car they could find to ferry them to the rapidly collapsing front. After the frame counter passed 40 with no sign of stopping, Daniel discovered, to his horror, that the film take-up claw on his Leica M4 hadn't properly caught. None of the roll had been exposed.

The point is if you don't have it in the can, you don't have it. That's true with computers, too. If it's not in a file on your hard disk drive, backup tape or floppy diskette, you just don't have a permanent record of the image. Even if it looks perfect on your monitor, what resides in the computer's electronic memory will disappear when you flick the off switch. Nothing will ever bring it back.

There are a number of devices used to store digital data, each with a specific purpose and advantages (as well as drawbacks or caveats). In addition to the ubiquitous floppy disk drives and hard drives, there are magneto-optical (MO) drives, high-density digital audio tape (DAT) drives, removable hard drives, CD-ROM drives, WORM drives, floptical drives, QIC, and 9-track tape drives. There are even solid state devices, like credit card-sized PCMCIA cards and exotic fail/safe technologies like redundant arrays of inexpensive drives (RAID). (Don't bother with those last two devices because, at present, they're not suited for digital imaging.) After listening to a salesperson talk about the many storage options he can sell you, you might begin to believe you are drowning in alphabet soup.

NOTE
You'll often hear storage devices, especially the kind that's portable and you can hold in your hand, referred to as media. Floppy diskettes and tape cassettes are media; floppy disk drives and tape drives are not. The media is the material that actually holds the data, not the drive that reads it.

Why do you need more than one type of storage device?

Why are there so many kinds of storage devices, and why will you need more than one kind in your digital imaging system? Computer storage devices are used for five main purposes:

> ➤ To keep your files, programs, images, and other data safe and immediately accessible while you work on your computer. (This is the job of the hard disk.)

➤ To back up the data on your computer's hard disk, because when technology fails, you can lose everything you have saved on your hard disk. Better to back up than be sorry.

➤ To archive your library of digital art.

➤ As a means of transferring data—especially image files—to and from your client, service bureau and print shop.

➤ To provide a means for getting programs into your computer.

Unfortunately, there isn't (as of yet) a single device that can do all of these functions well. Generally, an imaging system will have at least three or four storage devices. Invariably, that will include at least one floppy drive and one hard drive. You will also choose from among the following as input, backup, transfer and archival devices:

➤ Tape drive

➤ Fixed removable drive

➤ CD-ROM drive

➤ Magneto-optical drive

Let's take a more detailed look at these kinds of drives, as they relate to digital imaging.

What size memory storage?

Computer data—at least the stuff that is important enough to worry about storing—are measured in kilobytes, megabytes, and gigabytes. But it all starts with bits and bytes.

A bit is the smallest measure of digital information, in which the only options are on or off. These on/off states are actually the only information that a computer can process. But by combining a multitude of bits in a variety of mathematical juxtapositions, complex instructions can be issued to the computer.

- *A byte is equivalent to 8 bits.*
- *A kilobyte (K) is 1024 bytes.*
- *A megabyte (Mb) is 1024 kilobytes.*
- *A gigabyte (Gb) is 1024 megabytes (a billion bytes, or eight billion bits).*

What does all that mean to what kind of storage device or devices you may need?

A typical high-resolution digital image will be 13–90Mb. (The average is about 30Mb.) However, to create that single file, a computer artist will save several incremental, works-in-progress versions. It isn't unusual for Sally to have a folder on her computer of a few hundred megabytes of elements and versions of a single image on which she is working. In comparison, a typical word processing document—such as a two-page letter—is about 3–4K.

In other words, digital imaging requires an inordinate volume of storage. Trying to use the same amount of storage for digital imaging that one would use for word processing, databases, or other business software would be similar to keeping a research library in a hall closet. It just won't fit. To a computer artist, wealth is represented by having lots of computer storage space (as well as RAM).

Storage recommendations

This chapter goes into detail about various storage devices. The information will help you buy the best products and use them intelligently. If you don't want to read the entire chapter, peruse those sections on the storage options you think you want to use. The following are our recommendations for a digital imaging system. To better understand them, read the rest of this chapter.

You will need at least one hard disk drive with a minimum of 240–400Mb, with a relatively fast speed of 14ms or less. Ideally, it should be a SCSI drive, at least 1 gigabyte in size.

You will also need a 1.44Mb 3.5" floppy disk drive and, if you have a PC, a 1.2Mb 5.25" floppy drive.

For archival storage, the best devices to buy are tape drives—either a DAT drive of at least 2Gb or a QIC drive of 500Mb.

If you expect to submit your images electronically to a service bureau, print shop, or clients, ask what format they are using. Chances are it's a 44Mb SyQuest drive. You will need to be compatible with them; but, given a choice, and if they have it, opt for the 128Mb magneto-optical drive.

If you think you will need prodigious amounts of on-line hard drive storage and can't afford an array of expensive high capacity hard drives, consider a 600Mb or 1.3Gb magneto-optical drive. It's slower and has an initial high cost, but the cost per megabyte is much less.

If you will be doing anything with Photo CDs, you will need one of the latest generation of XA compatible, multisession CD-ROM drives. If you have the money and the need to master your own CD-ROMs, consider getting one of Kodak's or Philips' writable CD drives.

To save money and desk space, if your computer case has empty drive bays, buy your choice of drives without case and power supply and install them inside your computer.

Make certain that any drive you buy will be compatible with your computer's drive controller board, space constraints, and power

requirements. Better yet, have the drive installed, initialized, and formatted by a technician. Let him deal with compatibility headaches, and, if you can negotiate it, try to link his pay with the successful completion of the job, not a by-the-hour fee with no results guaranteed.

If you start to run out of storage space and can't afford to add another drive to your system, consider using a data compression program like *Stacker* or *Expanz!* They generally work well, and they're certainly a lot less expensive than another drive.

Establish a daily back-up schedule, without fail. And always copy your archived images to two separate tapes or cartridges, for safety's sake.

Now read on to better understand why we make these recommendations and how to use digital storage efficiently, cost-effectively, and with a high degree of security for your data.

Hard drive

Computers are almost useless without some sort of permanent storage, specifically a hard drive. Hard drives are the best devices for storing your programs and data files. Because of their size, delicateness, and the fact that most are permanently attached to the computer, hard drives are rarely used for exchanging data.

Hard drives are so named because the round disks (called *platters*) upon which the data are saved are made of hard, rigid aluminum or glass. These platters are stacked—2, 4, 8, or 16 disks, one on top of each other. One of the reasons why hard drives are able to pack many megabytes of storage is because the heads (the gadgets that read and write data to the platters) hover an astounding $\frac{1}{10,000}$ of an inch on a column of air above the platters, while they spin at about 3600 or 5200 rpms.

What is a hard disk crash?

Should the read/write head of a hard disk accidentally fail and actually touch the surface of the platter, it will gouge pieces out of the platter's magnetic coating, causing instant and irreparable damage. That's a hard disk crash, and, if it happens, you might lose some or all of your data and have to either repair or replace the entire drive. Fortunately, catastrophic hard disk crashes don't happen very often. Micro crashes (when very small areas of the drive are affected) are more common occurrences (and often can be repaired with software utilities like PCTools or MacTools). See Chapter 27 for repairing hard disk crashes and other maintenance or repair considerations.

 # Hard disk drive ratings

Hard drives are rated according to various criteria:

> *Size* or *capacity*, which measures the volume of data a drive can hold (usually expressed in megabytes or gigabytes).

> *MTBF*, or "mean time between failure," which is the average time between the drive's first use and its first failure.

> *Seek time*, which is a measure of how long it takes to move from sector to sector to locate a file on a hard drive.

> *Access time, throughput time, cache size, interleave factor, drive mechanism*, and interface requirements are all technical factors that will determine the drive's performance and suitability. They should be selected to match your specific computer configuration, something your salesperson or technician can assess.

 # What size hard disk should I buy?

Hard drives come in a wide variety of sizes 40Mb up to 4.5Gb. Practically speaking, you'll want a hard drive capable of storing at least 240–400Mb and, if you can afford it, at least 1Gb. In fact, buy the largest hard disk you can afford. Imaging programs, operating systems, and image files eat up many megabytes of space. Also, as you work on an image, you need empty space on your hard disk—in direct proportion to the file size—to perform the various tasks you'll do.

High capacity hard drives are much more cost effective than smaller ones. For instance, a computer magazine ad has a Conner 44Mb drive for $162, while a 1.2Gb Toshiba drive costs $1489. Yes, the Conner drive is much cheaper, but its per-megabyte cost is $3.68. The Toshiba drive works out to $1.24 per megabyte. Those prices are very typical, so it pays to start out with the largest hard drive possible.

 # Will you get the size hard drive you pay for?

When calculating the best cost-per-megabyte hard drive, be certain that you're comparing like to like. An unformatted drive will rate at slightly greater capacity than the same drive formatted. Formatting preps the disk in order to tell the computer where all the files are to be stored. It serves the same purpose as file cabinets' alphabetical dividers, which tell you where to find everything. Depending upon the operating system and the drive, prepping can occupy 5–10% of the

hard drive. An unformatted 1.1Gb drive might format to a little over 1 gigabyte or less. So check whether the advertised storage capacity of a hard drive is formatted or unformatted.

 # How good are today's hard disks?

Hard drive technology has improved dramatically, while the cost has declined precipitously. Ten years ago, a slow-as-molasses 10Mb hard drive cost over $1500. Today, a super-fast 1Gb drive costs about $1500. Or to put it another way, the cost per megabyte of storage has declined from about $150 to $1.50, a 1000% savings.

When hard drives first came out for the PC, they had a seek time of about 83ms (milliseconds): their recording heads took approximately 83 milliseconds to move from track to track, seeking the requested data. At the time, 20Mb hard drives had about 750 tracks on a single platter, so it could take up to 9 seconds to find the file you wanted. Most modern hard drives have seek times of 3–14ms and faster RPMs. While they have many more tracks, they're spread among two or more platters, so it rarely takes more than a few seconds to reach any file on the drive. What's more, the transfer time (how long it actually takes to load in or save data) has also been greatly reduced. So, what used to take seconds now seems to happen almost instantaneously.

Durability has also increased appreciably. The "mean time between failure" (MTBF) is a statistical average of when the components that make up a device can be expected to break down. The first hard drives we bought had an MTBF of approximately 8000 hours. Today's high density drives have typical MTBFs of 150,000–250,000 hours. In fact, IBM has a 1Gb drive with an MTBF of 800,000 hours, which is over 91 years of continuous non-stop use. Recognizing these hard drives' projected trouble-free life spans, some manufacturers have extended their warranties from 90 days to 5 years.

But remember, all these numbers are statistical averages. A drive that has an MTBF rating of decades could last longer or could die within weeks of being installed. But whenever we have had a drive fail within the warranty period, the manufacturers have repaired or replaced the drive rather quickly. They couldn't afford to do that if it weren't a rare occurrence.

 # Choosing among the many hard drive types

Buying a hard drive for the Mac is a relatively straightforward task. All hard drives for the Apple are SCSI (Small Computer System Interface)

or SCSI-2 devices. Besides matching up the correct SCSI type, the only thing you really must decide is how many megabytes you can afford. Of course, the shorter the seek time and the higher the MTBF, the better the drive's performance and longevity. And usually, the dearer the price.

Selecting the right hard drive for a PC is more difficult, because of the wider variety of types—MFM, RLL, IDE, ESDI, SCSI—some of which date back to microcomputing's early days. Hard drives are defined by the type of interface or drive controller board they use. The controller board plugs into the computer's motherboard, providing a communications link between the two components. (It might be built into some motherboards or even onto the hard drive itself.) Otherwise, the computer wouldn't know the hard disk drive was there or how to read and write data on it.

The most popular type of hard drive today is the IDE. It's also called an intelligent drive because all the basic circuitry is built into the drive itself, rather than coming from an IDE interface board (though a board is necessary for the drive to interface with the computer). IDE drives are popular because they're fast, reliable, and less expensive than other high performance drives.

But it is SCSI that is the drive of preference for digital imaging, because of its superior speed and capacity (some over 4Gb). Also, it's possible to daisy chain up to 7 separate devices (such as scanners, film recorders, CD-ROM drives and some color printers) on a single SCSI controller board. (See the last pages of this chapter on "SCSI Anarchy.")

What is a cache controller?

A cache controller is a drive controller board that has its own disk cache memory, from 512K to 16Mb of RAM. That RAM maintains a record of the last data that the hard disk was asked to load in or reference. Statistically, as you work, chances are 90–95% that, when you access the drive again, you'll ask for the same data as before, or data from a nearby sector. If you can pull it from RAM rather than the hard drive, you'll get it much quicker.

Theoretically, the more RAM you have on a board, the more likely you will be to have a "hit" (that the data you are seeking will be in the RAM). In practice, loading a controller board with a maximum amount of memory can actually slow things down, if you have other caches (such as a software cache program like PCKwik, or the 64K–256K high-speed cache chips that store last-accessed CPU commands). The computer can get confused and has to double-check everything that's in the cache before giving you access to the requested data. Use a hard disk cache or a software cache, but not both at the same time.

What do you do when your hard drive fills up?

Programs and files will always expand to fill up all available disk drive space. This was as true when we had our first PC clones with 20Mb hard drives as it is with our current Micro Express's 1.1Gb drive and our Quadra's 400Mb drive.

You have four choices when your hard drive fills up:

➤ Kill old files and programs to free up some space.

➤ Add a second, third, or fourth hard drive to your system.

➤ Replace your original hard drive with a larger one.

➤ Install a real-time compression utility like *Stacker* or the program that comes with *DOS 6.0*.

Deleting old or unnecessary files is something you should do periodically, whether or not you actually need the space. The more data you have on the hard drive, the slower and less efficiently it will operate. It also becomes more difficult to search through subdirectories or folders to find a particular file.

Adding a drive is very easy on the Mac and comparatively simple on the PC. If you're not sure what to do, any competent technician can install and initialize a hard drive within a half-hour to an hour, depending upon drive capacity. Of course, the original drive may also be replaced, either because it has stopped working or because its capacity is too small. Set aside a couple hours to replace the primary drive because you will probably want to reinstall all your old software from the most recent backup tape.

The third method is to use data compression (software that compacts image, data, and program files into smaller files). Someone once described data compression as the electronic equivalent of letting the air out of a tire. Although it's been used on mainframes for years, real-time data compression is relatively new to the microcomputer world. Data compression programs come in two versions: high compression and real-time compression.

High compression is when a file is shrunk down to a fraction of its original size (for instance, when a 5Mb image file is compressed down to 100K). However, this 50-to-1 downsize accomplishes its magic by literally throwing away data, and it takes time. High compression, especially in the JPEG format, is often used in digital imaging in order to make file sizes manageable, and it can be adjusted to minimize image quality degradation. (For a more detailed discussion on image compression, see Chapter 25.)

In contrast, real-time image compression, also called "lossless compression" (because supposedly no data are thrown away), operates so rapidly that one doesn't notice it working. A real-time data compression utility like Stac Industries' *Stacker* can effectively double your storage capacity. These programs work efficiently and transparently, so you never even know they're there. The only problem we have encountered in two years of using *Stacker* on all our PCs was that we couldn't run some of our normal hard drive utilities. But we took *Stacker* off the Mac when we discovered that we had to turn off virtual memory—a scheme for using the hard drive as a slow but inexpensive substitute for RAM—for it to work properly. (Unless you have at least 60Mb of RAM in your Mac, you will probably need to use virtual memory while imaging.) Resurrecting files after a hard drive crash can also be encumbered by compression. Whether or not to use this kind of compression, or which kinds of files to compress and which not to compress, will be a matter of personal preference. The only recommendation we make for the PC is to study the subject thoroughly before deciding upon using compression. Don't use compression on the Mac, if it means losing virtual memory.

⇨ Floppy disk drives

If you have been around computers at all, you've seen floppy diskettes. They're the thin squares that have been used for years to transfer data among computers and install software.

When you buy your computer, it will almost invariably come equipped with one or two floppy drives. All current model Macintosh computers have a 3.5" 1.44Mb floppy drive. Most new PCs have two floppy drives: a 3.5" 1.44Mb floppy drive and a 5.25" 1.2Mb floppy drive. The 3.5" 1.44Mb diskette is newer, more efficient, and a higher density than the 5.25" 1.2Mb diskette. However, the latter has been around longer, and many software manufacturers still sell their products on this media because it is cheaper than 3.5" diskettes.

Floppy drives, whether made by Sony, Chinon, Teac, Toshiba, or whatever, are considered commodities that are absolutely interchangeable. In fact, the same computer purchased from the same manufacturer a couple of months apart might have a different floppy drive. Virtually no one ever specifies one particular brand, and whatever technical differences and advantages one might have over another are quite negligible.

The only reason you might go shopping for a separate floppy drive is that they do wear out. While Mac drives are expensive ($200–$300) and tend to be cheaper to repair than replace, PC floppy drives are comparatively inexpensive (usually between $50 and $95), which makes them almost disposable when they break down.

If you do need to replace a PC floppy drive, the only things worth asking are:

> ➤ Price.

> ➤ Does the drive physically fit in my computer case?

> ➤ Will the power connector fit my system?

> ➤ Does the color of the front plate match my computer case?

How are floppies used in an imaging system?

A typical image file is about 12 to 20 times as large as the greatest floppy capacity, so they just aren't practical for working with professional quality pictures. However, an imaging system that didn't have a floppy drive would be impossibly crippled.

Primarily, floppy disks are most often used to install program files, and for transferring or saving relatively small amounts of data. Until recently, all software has come on floppy disks, which you then insert into your drive to upload the program to your hard drive. (With the popularization of CD-ROMS, an increasing number—though still a minority—of programs are delivered on that media.)

We use floppies daily, sometimes hourly, because it's easier for us to frisbee them to each other as a means of sharing data than to try to connect our various computers on a network. (No, we don't mean that we literally throw them around. They should be handled with some respect.) In addition to storing this book on our hard drive and making a daily tape backup of the hard drive's contents, we also save the chapters to a single 3.5" 1.44Mb floppy every day. We then remove that diskette from the computer at night, putting it in a safe place, as extra insurance against anything happening to the hard drive or the tape backup. That single floppy has saved us twice in the past few months, when we had a hard disk crash (and our last backup was a day old, not containing the previous night's work) and when several pages of a chapter somehow mysteriously disappeared from another hard disk (we probably inadvertently deleted them and then overwrote the older, more extensive file during a save).

Floppy disk drives are much faster and easier to access than tape drives, but significantly slower than hard drives. They work in conjunction with hard drives and tape drives, rather than compete with or replace them.

What about backing up my hard disk with floppies?

The process of backing up a hard disk is an absolute, imperatively necessary failsafe practice that stores your data on another, redundant

storage media. When a problem arises with your hard disk, you can recover your data from the backup set. Many computer users get complacent because they seldom have reason to access the data on the backups. Then disaster strikes, in the form of an overwritten file or an accidental delete or, in a true crisis, a hard disk crash, and you pray that your last backup was very recent. We'll go further into this subject later in this chapter and Chapter 27.

For many years, most desktop computers' hard disks have been routinely backed up onto floppies—they're certainly cheap enough. That might have been viable when hard drives were typically 10–40Mb, but most hard drives used for imaging range from 270Mb to over 2Gb (approximately 2000 megabytes). To back up a 2Gb drive with 5.25" 1.2Mb floppies could take up to 1667 diskettes, and assuming a data transfer rate that would fill up a floppy every 45 seconds, backing up would last almost 21 hours. Even with a backup program that uses data compression, you'd still use some 700 floppies and about 9 hours. Either way, it's just not practical or feasible to plan to do your backups of your imaging system's hard disk with floppies.

⇨ Old & new versions

Many earlier versions of the 3.5" and 5.25" floppy drives are not completely compatible with their contemporary counterparts, mostly because their capacity is not the same. While contemporary drives can read and write to these smaller capacity diskettes, the only reason to bother with that is to be able to exchange data with someone who has an older, lower capacity drive.

There are several other floppy disk drives that are just beginning to hit the market in substantial numbers. One that may become a new standard is a 2.88Mb drive that doubles the floppy disk capacity but without having to change any of the computer's settings. At present, the 2.88Mb drive costs 2–3 times what a 1.44Mb drive does, but the same high density diskettes may be used.

Another floppy drive gaining some popularity—especially as a backup medium—uses special ultra-high density diskettes that can store 20 megabytes of data. (That's twice what the first hard drives on the IBM-XT could hold.) They may be of some value for storing and exchanging digital image files, but only if the file size is 20 megabytes or less (or more with compression). However, they are much slower than hard drives and require a companion controller board to be plugged into one of the PC's expansion slots. 20Mb floppy drives sell between $350 and $500, and each diskette costs $20–$25.

Does it matter what sort of diskettes or tapes I buy?

The temptation is almost irresistible. You're at a computer show, a flea market or the closeout counter at your local store, and you spot a pile of 3.5" or 5.25" floppies shrink wrapped in lots of 25, 50, or 100. Instead of having to shell out eight bucks or so for a box of 10 brand-name floppies, here are 100 no-name high density 5.25" diskettes for $29 or 50 3.5" 1.44Mb generic floppies for $48. The seller might even throw in free colored labels and sleeves for the 5.25" diskettes. Is there anything wrong with them? Should you buy or not? Yes . . . and maybe.

We have often bought floppy disks in bulk, and we've found no qualitative differences between generic no-names and brand names like Memorex, Dysan, 3M, Maxell, and Sony. In fact, the no-name diskettes are often production overruns made by the manufacturers and are absolutely identical to their labeled products. On the other hand, such diskettes are sometimes production seconds that, for one reason or another, didn't pass the final quality control inspection. Perhaps they had blemishes on the sleeves or shells, or too little glue was used to seal the paper sleeves. Our experience is that almost-perfect is good enough for transferring data, making copies of files, sending electronic articles and columns to editors, etc.

Floppies are very forgiving. If a floppy will format, it will almost always work properly, so you needn't be concerned about it failing at a critical time.

The only difference between a high density 3.5" 1.44Mb diskette and a normal density 3.5" 720K diskette is a second hole in the plastic shell and about 50 cents. (The second hole allows data to be recorded on both sides of the diskette.) With high density diskettes, the manufacturer certifies that both sides can be used. Although the second side on a 720K diskette isn't officially certified, it will record data. The trick is to somehow add a second square hole.

We use an $18–$25 device called a DoubleDisk Convertor, available at most computer stores, that punches out that hole. Of the literally hundreds of normal density 720K diskettes that we've punched to convert to high density diskettes (saving us hundreds of dollars), only two didn't work—because the plastic shells cracked. Every other diskette formatted properly and accepted data perfectly, just as if it were a regular, expensive high density diskette.

Tapes are another matter. Don't try to save money by purchasing unheard-of brands or the manufacturer's economy line. When you're laying megabytes or even gigabytes on a small stretch of magnetic tape, every byte and bit has to be absolutely accurate. Backups and archival storage are too important to have a single mistake. We use several brands and don't recommend one over another. However, our experience is that a certain percentage of the tapes will fail, for whatever reason. DAT tapes pack an incredible amount of data in an

amazingly small space, so the slightest problems with the cassettes can render the entire tape useless. We suggest buying the best quality you can get and maintaining backups of redundant data.

Can Mac diskettes be read in a PC, & vice versa?

Because both the Mac and the PC have identical-looking 3.5" 1.44Mb drives and use the same exact diskettes, shouldn't they be completely interchangeable? Not really. Because the physical drive mechanisms are different, a Mac drive wouldn't fit in a PC computer and vice versa. And while you can use the exact same raw unformatted diskettes in either drive, once they are formatted, they become specifically designated as either a Mac or a PC disk.

Some utility programs, such as *Mac-in-DOS*, *PC Access*, or *Mac-to-DOS Mounter*, will convert any file so it can be read on either machine. *Mac-in-DOS* also allows a user to format a diskette in the PC for use in the Macintosh. Some file conversion programs will read and write to media other than floppies, such as SyQuest and MO cartridges.

File conversions have some limitations, however.

➤ The PC/Mac conversions work with high density 3.5" 1.44Mb diskettes only, not older 400K, 720K, or 800K drives or diskettes. (As mentioned, you can physically tell the difference because 3.5" 1.44Mb diskettes have square holes on both the left and right sides of the plastic shell.)

➤ File transfers are useful for data files only, not programs, drivers, utilities, etc. The Mac and PC are too different for a program designed to run on one system to work on the other (unless extra emulation hardware is added, something we do not recommend because it's inherently slow).

➤ The last problem is one of capacity size: a floppy disk holds only 1.44Mb each, and digital image files can be 25, 30, 50, or more megabytes. That would require spanning (recording portions of the file on many diskettes), a tedious process. Large file transfers are better accomplished by other means, such as via a network or with removable media (see later).

Random access vs. sequential storage

Hard, floppy, removable, CD and CD-ROM drives are all random access *devices. On the other hand, all tape drives—QIC, DAT, 9-track—are* sequential *or* discrete *devices.*

To better understand what random access memory is and how it works, think of the difference between a phonograph record and a cassette tape recorder. Suppose you have a record of Paul Simon's

Graceland and you want to listen to track 7, "Under African Skies." To get there, you simply lift up the phonograph arm and physically move it to the appropriate groove. That's "random access," or the ability to instantly move to wherever you need to on the record.

If you were listening to the same Graceland album on a cassette tape and wanted to listen to "Under African Skies," you would have to fast-forward to track 7, which might take a minute or two, even at high speed. While it takes longer to get from track to track, the advantages of the tape over the record are that tape isn't breakable or scratchable like the record, and it's far easier playing it on your car stereo system or in a Sony Walkman than trying to carry around a 12" lp.

Similarly, the primary advantage of disk/disc drives is that, because it's possible to position the read/write heads anywhere in an instant, you can quickly get to any point on the disk. Data can be stored randomly, almost any place where there's available space. It doesn't matter whether it's physically at the beginning, middle, or end. Also, a file might be segmented into many smaller files and at various locations on the disk. The computer keeps track of where data are stored on disks in a File Allocation Table (FAT).

Sequential drives operate in only two directions—backwards and forwards—and therefore cannot be accessed randomly. While saving or accessing data on tape is far slower than a random access drive, the advantage is price and convenience: tape cartridges or reels can hold as much or even more data as a hard drive, but at a fraction of the cost. (A single 4mm 90-meter tape cartridge for our Wangtek DAT drive can store up to 2.2 gigabytes, and depending upon the brand and the quantity we buy, they cost $15–$22 each. A 2Gb hard drive typically sells for $2400 or more.) This makes them a superior storage method for backing up or for archival storage.

Tape drives

Tape drives are for backup, pure and simple. They're too slow for real time use, and not being random access devices, they can't retrieve data from here, there, and everywhere. Tape drives are both your security blanket and your bank vault. They'll keep up-to-date carbon copy records of everything on your hard disk, just in case you accidentally delete a file or an entire subdirectory, if your machine has an electronic hiccup and eats some of your data, or if it has a full-blown bellyache and trashes everything that's on the hard drive.

It's one of the safest and the cheapest place to save, store, and archive your image files. If you're a serious digital imager intending to make a living at creating and manipulating computer art, you're going to quickly accumulate many megabytes and, eventually, gigabytes of visual data. Unless you're an artist who creates a single masterpiece and then throws away the mold (or a photographer who burns her

negatives after making that single perfect exhibition print), you'll want to keep at least one copy in your permanent files.

There are three different kinds of tape drives that are of interest to the digital imager. The most ubiquitous is QIC (Quarter Inch Tape), which comes in many models and incarnations, from 40 megabytes to 1.35 gigabytes. QIC drives are relatively inexpensive, and so are the tapes it uses.

DAT (Digital Audio Tape) records all its data digitally in a very accurate and precise manner. Unlike non-DAT drives, which are all analog devices, the tape is not affected by noise, static, or other electronic vagaries. DAT tapes come in two sizes—4mm and 8mm—and, depending upon the drive and the length of the tape, can record 1–8Gb. Virtually the only problem with DAT drives is their initial cost: they sell for 2–5 times more than QIC drives. However, the cost-per-megabyte for the cartridges is lower by a factor of 5–10. (We purchased our Wangtek DAT drive as a refurbished close-out from a mail-order company called Super Technologies for only $675, and it has worked perfectly for us. So bargains can be found.)

9-track ½" tape is an infrequently used medium in the microcomputer world. Remember the rapidly spinning reels of tape in cabinet-sized drives that you see in old movies showing huge mainframe computers at work? That's 9-track tape. However, some service bureaus, separation houses, trade shops, and commercial printers use it for archiving their customers' images, and a handful of high powered digital imaging workstations incorporate it as its archival storage medium. 9-track drives are expensive, and the cost per megabyte is comparable to that of a QIC drive.

Incidentally, the formats of each of the different types of drives are the same. So if you copy the contents of your hard drive on an Exabyte drive using a backup program called *SyTos Plus*, it can (theoretically) be read and used on a Cipher or a Manyard drive of the same capacity with another backup program called *Fastback*. Some service bureaus accept tape cartridges as a valid transfer medium, as long as the capacities are the same as their hardware. The caveat is that you must save all data in uncompressed form. (Most backup programs use data compression in order to save time and space. But it's usually possible to turn compression off from the program's main menu. As a rule, even if you use data compression for normal backups, don't use it for archival saves or whenever you might be using the tape in another computer that doesn't use the same backup program.)

We use a single Wangtek DAT 2.2Gb drive in its own case and power supply to back up our Mac and our PCs. It's not as convenient as having a separate backup device for each computer, but it is much more cost effective. Yes, we use data compression for the backups, since it's a lossless type of compression that won't degrade images.

That means that each of our 2.2Gb tapes can hold 3–3.5Gb of data, depending upon how compressed the files are. Compression ranges from zero, for files that are already stored in compression form, up to 55% for some image and word processing files.

However, we do not compress whenever we are permanently archiving image files. Why, we couldn't give a rational answer, except to say that we want absolute maximum protection. In fact, we save our images twice, on two different tapes, just in case one gets lost, corrupted, or eaten by the cat. (No, he hasn't destroyed a tape cartridge yet, but he has occasionally bitten through unguarded floppy diskettes and 35mm slide mounts.) And then we keep one set in our safe deposit box.

How often do we back up? That's something like asking if you should buckle your seatbelt whenever you get into a car. Computers are sturdy, but their data are ephemeral, just as Volvos are very safe cars that occasionally get involved in accidents. It might be infrequent, but power anomalies, hard disk crashes, accidental file overwrites, and other minor and major catastrophes do occur.

 There are three corollaries to Murphy's Law that you should always keep in mind:

❶ Your computer will fail only when you least expect it and can least afford it.

❷ Whatever files are lost or corrupted on your computer will be the ones that are the most valuable to you.

❸ The data you lose will invariably be files that were created or changed since your last backup.

We do a full backup of Sally's PC every day and—because we shift the DAT drive from computer to computer—about once a week for our other systems. (Quite frankly we have become complacent about our Quadra: it has proven to be so reliable that we back it up infrequently. We'll have to take our own advice and back up our Mac more often.)

Most high-powered backup programs like *SyTos Plus*, *Fastback*, *PCTools*, *MacTools*, and the *Norton Utilities* have provision for setting up daily automatic backups, which might work silently in the background while you continue your regular work. About the only difference you'll notice is a slight slowdown, because multitasking (doing two or more tasks simultaneously) siphons off some power from your computer's microprocessor. We don't do automatic backups, because imaging requires all the power reserves our systems have and we don't want any sudden drain going on in the background.

There are several backup strategies. One is to make full backups every time, so you can restore everything from a single file to the hard drive at one go. The other is to do incremental backups. Full backups take

much longer, and your cartridges will fill up very quickly. Intelligent backup programs can detect which files have been changed and copy only those files. That's a lot less time consuming and uses far less tape. However, it's less convenient to do a partial or full restore because you must keep track of where every tape segment is, get it, and stitch it together. We do full backups every time, scheduling them during lunchtime or other periods of the day, when that particular machine isn't being used.

We use a different tape for every day of the week and continue to add to it until it is filled up. We always keep one tape from that set in our safe deposit box, just for insurance. (Yes, we have a large vault-type box in a bank two blocks away, so it will take us only fifteen minutes or so to retrieve a tape if we really need it.)

Archival-type tapes are made much less frequently. Once Sally is done creating and perfecting a particular image, and it is output to film, a color printer or a file on removable media to go to the service bureau, print shop, or client, we then save it and all related files (masks, alternative versions, key design elements, etc.) to two uncompressed tapes, twice. One tape remains in her office, for quick reference, the other goes in our safe deposit box. Then, we delete the image and all associated files in order to free up space on the hard drive. (If an image is complicated, Sally will sometimes archive it and related files as she works on it.)

What brand do I buy?

Just as the auto industry has its Cadillacs, Mercedes, Buicks, and Toyotas, the computer drive industry has its Maxtors, Wangteks, Micropolises, Seagates, Conners, Fujitsus, and Quantums. Most drives are a hearty lot and will probably give faithful service for years.

Yes, there are differences, and probably one brand might be slightly superior to another. Here are some of the criteria that you can apply to compare one against another:

- *How fast is the drive? 3ms is faster than 18ms, 5200 rpm is faster than 3600 rpm, etc.*

- *How large is the drive? Be sure to get that figure in formatted and not unformatted megabytes.*

- *Is it the latest, fastest synchronous type with built-in buffering, or a simple drive with no speed enhancements?*

- *What's its "mean time between failure" (MTBF)? Don't settle for a hard drive rated less than 100,000 hours, a tape drive less than 8000 hours, or a CD-ROM drive less than 15,000 hours.*

- *How long is the warranty? Don't buy any drive with less than 1 year. Some drives are so reliable that they come with 5-year warranties.*

- *Does the drive come prepped and formatted? If a drive is for the PC, does it have DOS installed? Windows?*

- *Does it come with utilities for formatting, optimizing, etc.?*

- *Does it come with all cables, a mounting bracket, screws, etc., or are they extra?*

- *Does the drive type match your computer's interface? Don't buy an ESDI drive if you have an IDE controller board. (However, you can add a separate SCSI board, to which you may attach a tape drive, CD-ROM drive or other SCSI devices, if your drive controller isn't SCSI.)*

- *Are clear and thorough instructions included? Does the vendor provide over-the-phone technical support?*

- *How much does the drive cost per megabyte, after formatting?*

- *If it's a tape or a removable drive, does it include the initial tape or cartridge, or do they cost extra?*

Keep in mind that you might never know the exact brand of the drive that you're buying. But ask what kind of mechanism is used in the drive—that may help indicate who manufactured it. Many resellers buy "raw" drives, add their own case or faceplate, and silkscreen their name on the front. So don't worry if you don't recognize the brand. Chances are the drive itself is manufactured by one of the major companies, and not an obscure upstart of questionable quality.

⇨ Removable drives

If you plan to deliver images electronically to clients, work with a service bureau, need additional hard drive storage space, or want ultimate file security, then you should have a removable drive as part of your computer system. Some removable drives are, in fact, hard drive platters sealed in plastic or metal cartridges, which can be quickly and easily inserted or removed from the removable drive mechanism. Others are compact discs that, although using another kind of technology, act as if they are hard drives. Regardless of the type, the drive's electronics, interface, and motor are in the non-removable mechanism, which makes the interchangeable cartridges relatively inexpensive.

A variety of removable drives are used for digital imaging:

➤ At present, the most important kind is made by SyQuest. A close competitor is the Bernoulli system by Iomega.

➤ Gaining in popularity are magneto-optical (MO) drives, which range in storage capacity from 120Mb to 1.3Gb.

➤ A variation of the MO drive is the WORM (Write Once, Read Many) drive on which saved data absolutely, positively can't be deleted, changed, or overwritten. The most expensive, and potentially most useful, type of WORM is a CD writer drive that can create master CD-ROM discs.

(There are several other kinds of removable drives on the market, but for reasons of cost, convenience, limited capacity, or lack of compatibility, we don't recommend using them.)

SyQuest drives

A recent industry survey revealed that 95% of all digital imaging service bureaus have and use 44Mb SyQuest drives, establishing a near universal standard for compatibility. The formats used for the PC and the Mac are identical, so they can be read and written to by the other platform with the proper software utility. They're also inexpensive ($65 to $95 for each cartridge, $300 to $550 for the drive). The cartridges are easy to use, rugged, small, and light for shipping and carrying in a pocket or purse, and convenient to store or stack. For these reasons, 44Mb SyQuest cartridges are considered the exchange media's *lingua franca.*

The down side of the 44Mb cartridge is its relatively limited storage capacity. However, it is commonly used to transport or store files two to four times larger than 44Mb by using industry-standard JPEG data compression software. For still larger files, or for uncompressed files more than 44Mb, SyQuest manufactures an 88Mb cartridge. The drives and cartridges look identical in size and shape, and while the 44Mb drive can read and write only to a 44Mb cartridge, the newest 88Mb drive can read both sizes, as well as write to the 88Mb cartridge. Although initially more expensive ($90 to $120 for each cartridge, $500–$800 for the drive), the 88Mb cartridge itself is actually cheaper than the 44Mb when calculated on a cost per megabyte basis. The main disadvantages of the 88Mb are that it isn't as common as the 44Mb. Check with your service bureau or client to make sure that they support the removable drive format that you want to use.

SyQuest drives are sold either raw (to be inserted in an empty drive bay in your computer case), with an independent case and power supply or in a twin drive case. We can think of no compelling reason to buy 2 SyQuest drives, especially now that the new 88Mb drive can handle both media sizes.

Don't look for SyQuest brand drives at your computer store. SyQuest sells its drives to OEMs—Original Equipment Manufacturers—who put their names on the drive faceplates, add cases and power supplies, and write the software drivers for interfacing their devices with the Mac and/or the PC. But you can be confident that any 44Mb or 88Mb drive that accepts 5.25" cartridges—whether the name is Procom, Mass Microsystems, Eagle, etc.—is 100% SyQuest or SyQuest compatible. We use a Procom MRD 80C 88Mb drive for both our PC and our Mac, and it has worked well from the very beginning.

Incidentally, SyQuest has recently introduced 3.5" drives offering still higher capacity, but they are too new to be considered a standard. Avoid the temptation to buy one of these new drives.

Bernoulli Box

There's another common type of removable drive called the Bernoulli Box. Like SyQuest, Bernoulli reads and writes to plastic-encased hard disk cartridges, but the size, shape, and format are quite different and completely incompatible. Bernoulli is a decent technology, certainly comparable to SyQuest. And although it's been around longer, its initial high cost and relatively short cartridge MTBF rating kept it from becoming as popular as SyQuest. While both the cost and the longevity issues have been corrected, only a handful of service bureaus are equipped to handle Bernoulli technology. For this reason, we advise not buying a Bernoulli Box.

Magneto-optical drive

Gaining in popularity is the magneto-optical drive. MO drives are available in several different sizes and densities, though the two that are rapidly emerging as the universal standards are the 128Mb 3.5" and the 660Mb 5.25" formats. MO drives can read and write much more data than other removable media. While most brands of MO drives are slower in operation than SyQuest drives, they are about as fast as a hard drive from the mid-1980s. Some MO drives use an enhanced technology that doubles their previous speed, making them faster than a SyQuest drive and about the same speed as an average hard drive.

MO drives are relatively expensive, but only at the entry level. A basic 128Mb drive costs between $1000 and $2000, and a 600Mb drive ranges from $2000 to $4500. Offsetting these prices is the average price of the removable cartridges: a 128Mb cartridge costs $45–$60, and a 660Mb one goes for $100–$125. This makes it one of the cheapest cost per megabyte storage devices in use (only DAT and QIC tapes are cheaper, and they don't allow for random access). So cheap, in fact, that many PC and Mac owners use a MO drive in place of a second hard drive. Using MO drives for normal backups is a little more expensive, if you rotate the diskettes by dedicating one for each day. But it's much more economical than a SyQuest or Bernoulli cartridge.

We have a Procom 128Mb MO drive with its own case and power supply, which—like our Wangtek DAT and Procom 88Mb removable drives—we shift among our various computer systems. In addition to storing image files, we use MO cartridges to hold infrequently used programs that we may need from time to time, but with which we don't want to clutter up the hard drive. While it has not yet achieved the popularity of the SyQuest

44Mb, it is far more ubiquitous than the 88Mb SyQuest, and most service bureaus we have polled report that they have 120Mb or 128Mb MO drives. (It is the same drive, but formats as a 120Mb cartridge on the Mac and 128Mb on the PC.) Look for this format to eventually replace the 44Mb SyQuest as the medium of preference for file format exchange.

Double your storage capacity

SyQuest, Bernoulli, and CD cartridges can all be formatted with a data compression program like Stacker, which will effectively double their storage capacity. A 44Mb Syquest becomes an 88Mb cartridge, a 128Mb CD stretches to a 256Mb CD, etc. So far as we have been able to determine, there's no significant performance or safety penalty, on the PC (the Mac still can't use virtual memory) although formatting each cartridge will take additional time. Whether or not you choose to use data compression on removable drives is a matter of personal preference. But we strongly advise never using it when transferring files to a client or a service bureau, unless you are sure that they use the same software.

⇨ WORM drive

WORM stands for "Write Once, Read Many." Like a sculptor who has chiseled an image in marble, whatever data you put on the WORM's CD is totally, irrevocably permanent. It can't be changed, erased, overwritten, ever. So you might ask, what use is a drive that can save a file but once?

Most importantly, you never need fear accidentally wiping out a file. It's there, always, just as you saved it. A client might ask you for the exact copy of an image that you created a year or 10 years from now. Another reason is insurance. Suppose, as does happen, your client swears that the color separations that the printer used to make his press plates were not the match prints he saw. If you have it all down on a WORM-written CD, that might constitute irrefutable proof that it wasn't your fault.

The newest and most expensive type of WORM drive is the 660Mb CD writer drive. Priced at $3000–$6000, it differs from the MO drive in that it reads and writes data, once, to a standard-size blank 4.75" CD. What makes it unique is that it can write in native CD-ROM and Photo CD formats, which means that you can create your own master CD-ROMs and Photo CDs almost as easily as writing to a floppy disk drive.

The CD drive should be high up on most digital imagers' if-I-had-a-spare-million bucks list. It can turn every imager into her own CD-ROM publisher, able to produce single units or small runs at an extremely economical cost. The ability to create your own CD-ROMs means that you can market your illustrations or stock photographs,

make multi-media presentations, create incredible portfolio submissions, and archive your entire visual library on Photo CDs. Another important use is creating a master disc, which can then be sent to a recording company capable of pressing thousands or even millions of CD-ROMs or Photo CDs at a very low cost per unit.

Each blank disc costs about $25 (though the price will go down), but you will need special mastering software to use the CD writer most effectively.

Clearing the confusion of similar sounding names & technologies

CD drives, CD-ROMs, and CDs all use compact discs as their media. However, the different kinds of drives do represent different technologies. Here's some guidelines to help clear up the confusion nomenclature.

- *A disk drive (with a "k") is a device that uses a magnetic coil to read and write data. Floppy drives and hard drives are both examples of disk drives.*

- *A disc drive (with a "c") uses a combination of a laser and a magnetic coil to read and write data onto a plastic disc. CD-ROMs and MO drives are disc drives.*

- *A CD-ROM is a Compact Disc Read Only Memory disc that can be read—but not written to—by a CD-ROM drive.*

- *A CD Writer drive can write once to special blank CD-ROM discs (but not to the pre-recorded CD-ROMs on which you buy clip art, an encyclopedia, a library of fonts, etc.). Once written, those discs can then be read by any standard CD-ROM drive.*

- *A WORM (Write Once Read Many) is similar to the CD drive, but it writes once to a CD cartridge (a CD disc inside a plastic shell), which can never be erased. The cartridge is incompatible with CD-ROM drives.*

- *A magneto-optical drive can read and write many times to a specially formatted CD cartridge (similar to the WORM, but there is no limit to erasing or writing data with an MO drive). The cartridge is quite incompatible with both CD-ROM and CD drives.*

How long do tapes, floppy diskettes, & CDs last?

The practical useful life of DAT and QIC tapes is probably 5–8 years. Most floppy diskette manufacturers offer 5-year, 10-year, and even lifetime guarantees on their diskettes. (Mind you, they're not guaranteeing the data, just the medium. They'll replace the diskettes if they wear out or fall apart before the warranty expires.) As a point of reference, we have 5.25" floppies dating from 1981 that are still usable and readable, though we wouldn't want to stake our careers on the integrity of the data. Ten years seems to be the average life span

> *of how long a floppy diskette will hold data without the media itself deteriorating.*
>
> *No one can say for certain exactly how long CDs will last until their data cannot be read any longer. Some experts predict a relatively short life span of 10 years, at which time the plastic will begin to crack up into millions of tiny spider web-like fissures. Other experts don't see this happening at all for decades and suggest that CDs are the best long-range storage medium we presently have. But to be conservative, we're not going to count on CDs for more than 10 years.*
>
> *So what do you do when the media that contains your archive files are reaching their projected life span? Re-record them on new CDs, diskettes, tape, or whatever newer and better media happens along in the interim.*

CD-ROM drives

CD-ROM drives are play only devices, pure and simple. The CDs they play are all pre-recorded and can't be changed. But the drives are indispensable because many programs, typefaces, and clip art are now distributed on CD-ROMs. Also, Kodak's Photo CDs can be uploaded to the computer with an ordinary CD-ROM drive.

In its first incarnation, Kodak offered to amateurs a package deal where, for $20, a photo lab would process a 24-exposure roll of Kodak color negative film, produce a strip of negatives and set of prints, and scan all the images onto a single gold 4.75" Photo CD that could be hooked up to a CD player and displayed on any television set. Each photo would be automatically scanned in at five different resolutions. Although 24 images were initially written onto a Photo CD, more could be added at any time, up to a total of 100 photos onto a single disc.

In June 1993 (which is after these words are being written, but before the book will be published), Kodak will have introduced its professional Photo CD, which will have the capability of scanning in up to 4"×5" negatives or transparencies, and at higher resolutions. Time will tell whether this service catches on among professional photographers, but central to using this technology is having a CD-ROM drive.

If you think you might be using Photo CDs to input image elements into your computer, you will need to buy what is called an XA-compatible, multisession CD-ROM drive. Besides being slightly faster than older style drives, the multisession moniker refers to the fact that they are hardware equipped to read appended directories anywhere on the disc. In contrast, the older drives can read only the directory on the first, outside track. This is vital because, as we mentioned earlier,

one of the characteristics of Photo CDs is that they can be written to more than once, and more images can be added at any time.

CD-ROM drives are relatively slow devices, about one-third to one-half the speed of a floppy disk drive. Some drives have built-in buffers to help speed up operations. It's axiomatic that the faster the drive, the more buffers it has, the more expensive it will be.

There's a type of CD-ROM drive called a jukebox that can have at the ready a half-dozen CDs at a time. On paper, it's a good idea if you want to be able to quickly load from among your library of CD-ROMs, but in practice, it's often more trouble than it's worth. Jukeboxes are not only very slow, but your computer might have a difficult time keeping track which discs are loaded into what slots.

Much more expensive than a jukebox, but certainly faster and more convenient, is attaching two or more drives to your computer. Some manufacturers sell stackable CD-ROM drives in multiples of 2, 4, 6 or 8, for users who need to have gigabytes of reference data on line. Multiple CD-ROM drives might have varying degrees of value for libraries, schools, and certain kinds of businesses, but are too expensive and probably unnecessary for most imaging applications.

At present market prices, a CD-ROM drive with its own case and power supply that can read Kodak Photo CDs costs between $400 and $800. However, prices are slowly dropping as their popularity and, therefore, the volume of sales increases.

⇨ PC's SCSI anarchy

SCSI controller boards are used not only as the interface for the most advanced, highest capacity hard drives, but also for many of imaging's peripherals, such as tape drives, printers, film recorders, CD-ROM drives, etc. Supposedly, SCSI's introduction was to be an answer to the problems of getting so many different kinds of machines to talk to each other and your computer. Unfortunately, that isn't quite the way it works—at least not in the PC environment. Using SCSI—as almost all digital imagers will—can be particularly daunting on a PC. We've heard one computer executive describe SCSI as the standard from hell. Actually, there have been times that we thought that he was being kind.

NOTE Macintosh's built-in SCSI interfaces, software drivers, and devices are remarkably well behaved, which is one major reason that even die-hard PC users are now being won over by Apple.

There are two types of SCSI controller boards: the older, slower ones (simply called SCSI), and the more modern SCSI-2 drives. The newer

SCSI-2 hard drives can transfer data up to five times faster than older SCSI hard drives, though practically speaking, the overall speed gains really aren't that great most of the time.

SCSI and SCSI-2 are, in theory, standardized protocols. Supposedly, every SCSI device should work with *every* SCSI controller board and be recognized by *every* SCSI software driver. It should be possible to daisy chain (connect to a single controller board by a series of cables) up to 7 different SCSI devices from different manufacturers—such as a hard drive, flatbed scanner, film scanner, CD-ROM drive, DAT drive, film recorder, and color printer—and have them all behave perfectly and work without any problems or conflicts.

Unfortunately, that's rarely, if ever, the case on a PC.

The sad truth is that SCSI is *not* a standard, but more of an ideal. Almost *every* SCSI board manufacturer uses its own hardware and software standards. Over the past six months, we've had three different SCSI controllers in our 486 systems because each one lacked the correct hardware interface or device driver for specific SCSI peripherals we had to attach. An even worse scenario is that device manufacturers seem to be very egocentric and short-sighted, believing that theirs is the only SCSI device you will *ever* use. Many of them insist that you install their "proprietary" SCSI controller board. (A proprietary board is one that is made or adapted by a single manufacturer and will work only with his products.)

Configuring and initializing a SCSI controller board or device on a PC should be relatively simple and straightforward, but often as not, it isn't. Here are some of the things that can go wrong:

➢ The wrong device driver is being used. (A device driver is the software that allows the computer to recognize and use the peripheral that is being attached to it.)

➢ The device driver is being loaded into the computer in the wrong order in relationship to other drivers. (This is controlled by a file called CONFIG.SYS that automatically installs the software necessary to run a PC every time you start it up.)

➢ The dipswitches/jumpers on the board are set incorrectly. (Every board has a series of switches that must be configured on or off, according to what you want to do with the board.)

➢ The cable ends don't match (there are 3 different kinds of connectors that SCSI uses).

➢ The terminating resistors (chips that tell the controller board which device is the last one, so it won't endlessly look for more SCSI devices that aren't attached on the chain) are missing or plugged into the wrong device.

➤ Some SCSI devices operate only with their own dedicated SCSI controller boards, which can conflict with another installed SCSI board, locking up your computer.

➤ The wrong memory address (the part of the operating system that keeps track of every device that's attached to the computer) has been set.

While researching this book, we tested a wide variety of drives, scanners, film recorders, and color printers, most of which are SCSI devices. With the exception of the hard drives, almost all of them took considerable tweaking to get them to operate on the PC. Embarrassingly, there were a couple that we were never able to get working with that system, no matter how hard we tried and no matter how frequently we were on the phone to that particular manufacturer's technical support line.

On the other hand, we had virtually no difficulty initializing or working with the Macintosh's SCSI devices. The only exception was a just-released CD-ROM drive that was shipped with a defective diskette, which wiped out part of our hard drive when we tried to install it. But that was a fluke. The truth is that SCSI is well-behaved—a joy to work with on the Mac, and a nightmare on the PC.

Here's what we suggest, for those who will be using SCSI on the PC. Buy an Adaptec SCSI controller. It's not the universal standard, perhaps not even the best or fastest, but more SCSI devices will work with it than any other brand of SCSI controllers.

Buy a utility from Corel (the folks that make the illustration program *CorelDraw*) called *Corel SCSI*. Designed to work in conjunction with Adaptec, Future Domain, and a few other popular SCSI controllers, it contains a set of device drivers that will interface with a large number of different printers, scanners, recorders, drives, etc. You're much more likely to be able to match up and get working a SCSI device with this software/hardware combination.

Also, give some thought to the type and length of cable you will be using. Last autumn we had frequent, random, and unexplained errors with our scanner, DAT drive, film recorder, MO drive, etc., that we couldn't cure. We finally isolated the problem to the total length of our SCSI cables (each device was daisy chained into one another). Fifteen feet appears to be the collective practical limit of most SCSI cable connections—any longer, and the electrical signals might be too weak to fire consistently. And that means lost data and garbled commands. If your daisy chain is longer than 15', consider temporarily removing a device or two that you don't need for that session, just to shorten up the total length. The cable itself might create problems. We've had more SCSI cables stop working than any other sort of cables. Sometimes the thin strands just break inside their plastic sheath.

There's a reason why the superstore chain CompUSA sells two otherwise identical-looking SCSI cables for $16.99 and $29.95, and why we buy only the latter.

Instead of trying to daisy chain different devices by different manufacturers on the same controller board, consider adding a second or even third SCSI controller to your PC. That has the effect of reducing potential hardware conflicts and might in fact be the only possible way to simultaneously connect certain devices to your system. It's also possible that it might speed up data transfers.

Hire a technician to install, configure, and fine-tune any SCSI device that you want to add to your PC. He's an expert, he should know how to eliminate all hardware/software conflicts, and you will probably be up and running within an hour, regardless of whatever sort of device you are adding. Otherwise it could take you many hours of trial, error, cussing, and gnashing of teeth. Try to negotiate the price of his services based upon getting certain configurations done, rather than according to an hourly rate.

Fortunately, once you have set up your SCSI controller board, hard drive, and any other devices, that will be the end of your problems. Everything will work perfectly, until and unless you decide to add another SCSI device to a PC. Then you have to go through hell all over again, until everything is configured perfectly.

SCSI is one of the best arguments for paying extra for a Mac or for a PC-based digital imaging "solution," in which the vendor will take responsibility for all configurations.

13
Film
recorders

J UST AS THE introduction of greenbacks over gold during the Civil War era produced riots (many didn't consider it "real" money and steadfastly refused to accept it as legal tender), so too, many art directors and clients are loathe to accept any medium other than film.

You can't throw a SyQuest cartridge or a Photo CD onto a lightbox and instantly inspect it with a 4X loupe. To see an electronic image requires a compatible computer and storage system, a good color monitor, and the proper software. Depending upon the computer system and software, as well as file size and format, it might take minutes before the first image appears on the screen after powerup. Even then, what you see may be quite different than what is actually in the image file itself, as it would print out on an imagesetter, a desktop color printer, or a commercial printing press. (Please see Chapter 28.)

Besides, there's something intrinsically beautiful about film, above and beyond the image that's recorded on it. It has a higher resolution, greater dynamic range, more colors, and greater luminance than any other medium. Film resonates and scintillates with life.

Of course, there are many advantages of electronic image files over film. There's no fear about an original image being lost or damaged, since the smart digital imager has multiple copies of his electronic images. The fiftieth generation is every bit as good as the first generation. (As every photographer knows, each transparency copied will suffer some image degradation.) Any enhancements can be made without changing the original. (On film, once you've retouched the original transparency or negative, it's changed permanently.) Digital data don't deteriorate with age (though the media might), so the image will appear exactly as it did a decade earlier. (Color film is inherently unstable and the colors may begin to fade after 5–10 years, no matter how well it's stored.)

But when push comes to shove, many art directors, stock agencies, and other art buyers still prefer film to electronic images. Therefore, if you want to make the sale to these traditionalists, you'll have to output your images to film.

⇨ What is a film recorder?

Reduced to its bare essentials, a film recorder is a camera bolted in front of a computer monitor that takes a photograph of whatever's on the screen. But that's a little like saying the *Queen Elizabeth II* cruise ship is just another boat, since film recorders are very precise and usually very expensive devices capable of producing very high-resolution, photographic-quality transparencies or negatives from digital images that were created or edited on a computer. And the

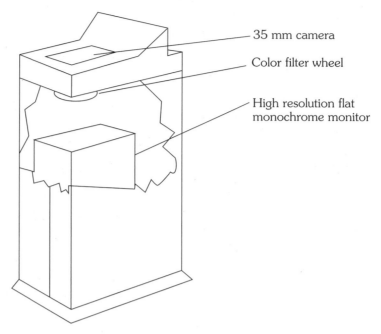

Figure 13-1

35 mm camera

Color filter wheel

High resolution flat
monochrome monitor

Inside a film recorder. Agfa

result will be, at least to the naked eye, indistinguishable from original film. See Fig. 13-1 for the inner workings of a film recorder.

The concept behind the film recorder is quite simple. After you have put the finishing touches onto an image with your computer, instead of pushing the Print button to send it to your desktop printer, you load in software that tells the computer to send the image to a monitor inside the film recorder. Mind you, this isn't like the 17" or 21" color monitor you use with your PC or Mac, but a much smaller (3" to 7"), substantially higher resolution black-&-white screen. Instead of having a resolution of 72 dpi (dots per inch) like a typical high-quality color monitor, it may have a resolution of 400–700 dpi. To achieve such high resolutions requires exotic circuitry and sophisticated engineering, which explains in part why film recorders are such expensive devices.

NOTE The process of sending an image file to a film recorder is called rasterization (or RIP for raster image processing), and it can be time-consuming. Most rasterizing for film recorders is done in software, either provided by the manufacturer or sold by a third-party vendor.

The image file to be sent to the film recorder monitor is automatically separated into three color channel files: red, green, and blue. Then each is painted onto the screen, one at a time, and photographed by the camera through a color wheel that is turned to the corresponding RGB filter. The camera shutter remains open during the separate RGB color channels, so all three are exposed on the same frame. Then the

195

shutter is closed and the film advanced. The result is an image on film that superimposes the primary colors to make all colors.

HINT There are actually two types of film recorders: analog and digital. An analog device displays a color image onto a screen. A digital device separates the color channels and displays them, one at a time, on a black-&-white screen and applies the corresponding filter. While an analog film recorder is usually much faster, it will produce, almost without exception, inferior images. For photo-quality slides, always use a digital film recorder.

⇨ What goes into a film recorder?

We recently gave our niece a Kodak autofocus 35mm camera for her birthday. That camera sells for about $75 in the stores. Sally also has various Leica cameras and lenses, but the cost is much higher: each would cost several thousand dollars to replace. Both the Kodak and the Leica camera will take essentially the same photographs, but even the untrained eye could see qualitative differences. Of course, that is to be expected from two very different devices that have such a wide disparity in monetary value.

Similarly, film recorders designed to be compatible with desktop computer systems range in price from about $4,000 to $50,000. The disparity in price is due to a number of factors:

> The size, resolution, and quality of the internal monitor.

> How many bits per color channel. Some film recorders are 8-bit (per channel) devices, while others are 10-, 11-, or 12-bit devices.

> The quality, type and size of the camera back, optics and transport system.

> The number of controls and the ease of use.

> The software used to interface the device with the computer.

> The number of built-in features, such as auto-calibration, self-diagnostics, auto-bracketing, pin registration, etc.

> How rapidly each exposure is made.

> Accessories are available, such as larger format film backs, etc. (Most studio-size film recorders output to 35mm, though some have optional 4"×5" or 8"×10" film backs.)

> The extensiveness and upgradability of LUTs, or "lookup tables." LUTs contain information about specific film emulsions, so that the recorder will automatically adjust to accommodate itself to the characteristics of the loaded film (such as Ektachrome or Agfachrome).

➤ The degree of service provided and the length and the extent of the warranty.

➤ The number of units manufactured and sold.

A general rule of thumb is the smaller the screen, the less expensive (and lesser quality) the film recorder. However, there are other criteria other than monitor size that define image quality:

➤ In MHz, what is the monitor's rated resolution? The larger the number, the higher its resolution.

➤ In dots per inch, how many can it resolve? The larger the number, the higher the resolution.

➤ How large are those dots? The smaller the dot pitch, the sharper the image.

➤ Monitor dpi, like a car's mileage ratings, is, at best, an optimum number that may be quite unobtainable under most circumstances. The best monitors display almost all dots, while less expensive monitors may lose up to 5% image fidelity.

➤ How flat is the monitor? Is there edge-to-edge sharpness, fall-off on the edges, barrel or pin cushion distortion, or any other inherent anomalies?

➤ How bright are the dots at the default settings? If the brightness must be turned up, the dots may mush together, thereby reducing sharpness.

➤ What is the practical operating life of the monitor? Depending upon how frequently the device is used, some monitors may begin to lose brightness and accuracy after 2–3 years.

⇨ What are the determining factors for choosing one film recorder over another?

To read the manufacturers' specifications, there aren't very many substantial differences among the various desktop film recorders currently on the market. One might have a slightly higher resolution, while another has a larger screen. Yet another may have a smaller dot pitch, or easier to use controls, or a better film transport system. So, which one do you choose?

It all depends upon what you intend doing with the recorder. If your primary objective is to make slides for audiovisual or multimedia presentations, then you probably do not require the image depth or resolution built into the more expensive film recorders. However, if you intend to film for stock photo sales, prepress preparation, or

similar quality-dependent reasons, you'll probably want the best available within your budget.

A quick way to determine the quality of a film recorder

Until a new generation of film recorders hits the market, price is probably the quickest way to determine the quality level. There's a definite threshold that divides the merely good film recorders from the superior ones. A general rule of thumb is that devices with a list price under $14,000 are best suited for audiovisual, multimedia, and business presentations. Products above that price are designed primarily for reproducing photographic-quality slides. Of course, the under $14,000 machines can be used for photographic images, but there may be a difference in resolution, dynamic range, etc., that can be discerned by the naked eye.

The best way to tell if a particular film recorder, regardless of price, will reproduce the quality level needed for your clients or purposes is to make a few test slides and loupe them carefully. Then take those slides to a lab or service bureau and have photographic prints made, to the largest size that most of your work would normally appear (such as 5"×11" or 8"×10"). If they look good to you, then the quality is acceptable; but if you are disappointed with any of the results, look for another product or unit.

Most desktop film recorders offer only two resolutions (usually switchable by pushing a button): 2K or 4K. (An exception is Management Graphic's Sapphire film recorder, which has a 3K option, to better match the resolution of Kodak's Photo CDs.) That refers to the number of lines that the recorder is capable of reproducing over the size of the entire image. Because most film recorders under $20,000 are 35mm devices—and a single 35mm frame is 1"×1.5"—that means that the highest possible resolution will be 4,000 (actually 4,096) lines over 1.5". Or, to put it another way, approximately 2,731 lines per inch. (That's 4,096 lines divided by 1.5".) Sounds familiar? It's no coincidence that most film scanners can capture at least 2,700 to 2,750 dpi. (Scanner resolution is measured in dots per inch, while that of film recorders is listed in lines per inch.) That allows them to match, dot for dot or line for line, the exact resolution of film recorders, so that, theoretically, there will be no degradation of quality as the image goes from film back out to film.

The reality, however, may be something slightly different. Remember, we said that a single 35mm frame is 1"×1.5". In actual fact, it might vary slightly, depending upon the recorder's camera brand and the type of slide mount being used. Then there's the question of image fall-off, or, how many dots are actually projected onto the monitor (and therefore recorded on film). In an ideal world, a monitor capable of resolving 2,731 dots per inch will always project that exact number. But in the real world, phosphors burn out, electron guns lose their

precise registration, the screen glass becomes clouded, etc., so what you actually get is less than perfect. Dropouts are almost impossible to avoid, but generally, the better the film recorder, the fewer the data dropouts.

Recognizing this reality, many experienced imagers scan at a slightly higher resolution, in the hope that the extra data bits may in part compensate for monitor dropouts. Sally typically scans her 35mm slides at 2,750 dpi instead of 2,731 dpi, and sometimes as high as 2,868 dpi. Avoid the temptation to overscan by a large amount. Not only will your file sizes swell to an unmanageable size, but when you send those files to the film recorder, the software will throw away whatever extra data it can't use. While it tries to do this according to various algorithms (such as looking for the sharpest edges), it can end up discarding vital, rather than superfluous data, the net effect of which is a less-than-optimum image.

The general rule of thumb is to not create an image file that will be larger than 105% of the size of the calculated ideal file for a film recorder. For instance, if you are sending a file to a film recorder with a rated resolution of 4,000 lines, the image should never be greater than 2,868 dpi. We usually scan in a transparency so its file will be no larger than 101% of the finished image that will go out to the film recorder, unless we expect to lose bits during the computer manipulation of the image.

HINT The monitor inside a film recorder can be affected by strong electro-magnetic fields, so that straight lines may become wavy lines, "noise" will appear, etc. Try to keep your film recorder physically isolated as much as possible, several inches from the computer, printer, photocopy machine, or any other device that emits a strong electrical signal. Also, because the image on the monitor is very sensitive and, therefore, susceptible to signal interference, plug it into its own dedicated UPS (uninterruptable power supply) that generates a true sine-wave, and not a pseudo sine-wave.

⇨ Calibration, adjustments, & testing

Remember when the first color televisions hit the market, and you had to adjust the colors almost every time you turned on the TV or changed the channel? Today, you might adjust the color once in a blue moon. Why? The technology got much better, and most modern TV sets automatically adjust the color at regular intervals.

Calibration is just a fancy way of saying that you're fine-tuning the monitor inside the film recorder. Since it's not a color monitor, what

you are adjusting are such things as the brightness level, contrast, image sharpness, etc., to bring them in line with preestablished standards. (Color adjustments are done by changing the length and/or repetition of exposure through each color filter.) Because the signal may drift slightly over the course of time, it becomes necessary to recalibrate the monitor in order to bring it back to its optimum level.

Fortunately, that is done automatically on many film recorders: you don't have to set values, change parameters, or make any calculations. Depending upon the particular manufacturer and how you configure the device, recalibration can occur when you first power up, every few frames, every time you change the film, or at preset intervals. Or it can be done manually by flicking a software or hardware button. It generally takes 2 to 5 minutes to recalibrate.

Some film recorders are capable of generating internal test patterns. When you have the test film developed and mounted, you compare it to a factory-provided reference slide, either by looking at it with a loupe, or putting the slides under a densitometer. (If your recorder doesn't have a test image built into its circuits, you can generate one.) After looking at the test results, you may change the color values, contrast, brightness, etc. to bring the film recorder closer to the theoretical ideal.

HINT

Keep all test slides on file, labeled with dates and adjustment information, so you can compare them to future tests.

Some of the adjustments that may (or may not) be available (depending upon the film recorder) include:

> ➤ Changing the LUT (lookup table), so that the film recorder automatically adjusts itself according to the brand and type of film you are using.

> ➤ Adding new film LUTs to the film recorder's software or firmware, as they become available.

> ➤ Varying the exposure times for each color independent of each other (to change color balance).

> ➤ Adjusting the brightness of the monitor (usually in direct proportion to an exposure time adjustment).

> ➤ Choosing between high or low resolution, many or less colors.

Most of the time, you'll probably do little or even nothing to adjust the film recorder, other than periodically calibrate it and check the test slides. But you will want to fine-tune it occasionally, which will require a familiarity with the theory and practical reality of how the equipment works. If you feel that you don't quite know what you are doing, hire a technician to come out to optimize your film recorder's performance.

HINT Don't buy a film recorder (or a film scanner) from a discount house that won't give you a high degree of quality technical support; get it from a full-service imaging specialist. Some of the most important advice and guidance we have received in the past year were from our on-tap Agfa film recorder (and Leaf scanner) experts. When it comes to adjusting and fine-tuning your film recorder (and scanner), you'll want to be able to call the company where you bought it for knowledgeable assistance.

⇨ When to buy or not buy a film recorder

If money were no object, you would quite naturally want to have a film recorder permanently attached to your computer. Any time you wanted a transparency of a just-edited, just-saved electronic image, all you would have to do is load in the driver or program, push a button or two, and out it goes to film. It's there, it's done, and it's immediate. You can make as many duplicates as you want, or bracket your exposure, gamma values, color corrections, etc. You also have the luxury of trying different crops, alternate versions, or other variations, and then selecting the best from the series. If you have a color darkroom, you can rewind the film and soup it directly in E-6 chemicals. Or you can messenger it to your local lab. Or, as we sometimes do when we're on a particularly tight deadline, we shoot with Polaroid's instant PolaChrome film so we can have usable mounted slides within 5–10 minutes. (However, that film is not generally recommended for top-quality reproduction.)

Owning or leasing your own film recorder gives you much more freedom and latitude. If you're paying $5–$50 (or more) per slide to your service bureau, you're far less likely to do any experimentation. Mistakes or less-than-optimum slides can become very expensive and time-consuming. Sending out to a service bureau means that you won't enjoy the immediacy of having your slides in hand within minutes or hours. Or, if you insist on same-day or even next-day service, you may pay a very high premium for that quick response.

To help you determine whether you have a sufficient volume to justify the purchase or lease of a film recorder, let's look at some comparative costs. Most service bureaus have tiered pricing, depending upon the size of the image file. Low-resolution files (usually 2 megabytes or under) typically cost between $2 and $5 per slide. A very high-resolution file (44 megabytes or larger) can cost $75 to $150 or even more, depending upon the size of the output—35mm, 8"×10", etc.

Let's look at a hypothetical photographer who needs medium resolution slide output at the rate of about 5 a week. We'll assume that his lab charges the public $25 per slide at the resolution he requires. However, he's able to negotiate a better price, of, say, $20 per slide, because he's a regular client. (Most service bureaus offer discounts to their better clients.) During an average week, he needs a total of 5 slides. Therefore, those 5 slides will cost him $100 a week from his service bureau (not including delivery or messenger service charges).

On the other hand, suppose that he's considering buying a $15,000 film recorder. He may be able to haggle a small discount from his dealer (though slide recorders, being specialty items, are usually sold at or near list), but he may have to add to that basic cost such things as the interface board, software, cable, an accessory camera back, etc. The photographer would also be well advised to take out an on-site service contract, since repairs can be very expensive and time-consuming once the device is out of warranty. Of course, he may also have to pay for shipping costs, setup fees, LUT upgrades, state sales or use taxes, and, perhaps, interest on a bank loan.

When all the extras are added in, his total cost is likely to be closer to $20,000. And that doesn't include consumables and normal operating expenses like film, processing, electricity, and periodic software and LUT upgrades.

What happens to old film recorders?

We're told that most film recorders have a useful life cycle of 3–5 years. As they age or undergo heavy use, the high-resolution monitor begins to lose some of its integrity, the LUTs may become outdated, the rigid alignment could become less precise, etc. This may ultimately be reflected in lower quality slides. Whether or not that definition loss is significant or not depends upon the individual user's definition of acceptable quality.

Various companies maintain a service that will rebuild and refurbish older film recorders. They'll replace the CRT, update the LUTs, and repair, replace, or service any other parts to bring the device up to current factory specifications. However, this can cost up to 70% of the price of a brand new film recorder.

Let's make a few projections based on the previous scenario. Let's say that the hypothetical photographer works 50 weeks a year, and needs 5 slides a week. If he uses a service bureau, that would come to $5,000 a year. But if he uses his own film recorder—and assuming a 3-year life span—the cost averages over $26.65 per slide. Clearly, buying or leasing with that volume of work is not nearly as cost-effective as using a service bureau.

But while the price per slide will remain relatively stable when using a service bureau, no matter how great the volume (they will discount

only to a point), it will decline dramatically with the more slides he makes on his own machine. For instance, let's assume that he pumps out 50 slides in an average week. (We know one photographer who specializes in audiovisual presentations and generates 300 or more slides every week.) The cost per slide from a service bureau will still be $20 each, but the price of doing it on his own equipment declines to $2.67 per slide.

Large format film

While all under $25,000 film recorders are primarily 35mm devices, several models are capable of outputting to Polaroid pack, 4"×5" or even 8"×10" sheet film. This can be useful if you want to produce larger transparencies for display or your portfolio. However, there's no qualitative advantage in outputting to a larger format if you want the transparency for prepress purposes, since the overall resolution will be exactly the same, whether it's on a 35mm slide or a sheet of 8"×10" film. In fact, you might lose image quality when you go to a larger film format.

How so?

Inexpensive film recorders are able to switch from 35mm to larger formats by simply removing the 35mm camera back and substituting an accessory back. The only compensation you must make—which the software does automatically, when you tell it that you've put on another back—is an increased exposure factor. (The distance from the lens to the film plane is increased.) It will take 2–5 times longer to output to a larger format. The disadvantage of this approach is that the flat field lens built into the film recorder is designed primarily to cover a 1"×1.5" film plane. Larger sizes may cause falloff, vignetting, soft edges, or other forms of distortion.

Better film recorders capable of producing larger film sizes incorporate supplementary lenses in the film backs. This helps correct most of the optical problems, but it also increases the expense of the back. Like the lensless backs, exposure times must be increased, but the software does it automatically. While the image will be superior to one created with a lensless back, it will still fall short of what a more expensive film recorder can produce.

Here's why. Remember, we said that most of these under $25,000 film recorders are capable of a maximum resolution of 4,000 lines. That's 4,000 lines for the entire image, whether it's a 35mm frame (1"×1.5"), a 2¼" transparency or an 8"×10" piece of film. At 4,000 lines, the 35mm has a resolution of 2,731 dpi, the 2¼" transparency is 1,778 dpi, and the 8"×10" sheet is 400 dpi. (However, when the film is finally printed, the larger format needs to be enlarged by a

smaller percentage for the same size print. So, the resolution in a final print from each of these formats may be somewhat equivalent.)

The only advantage to the larger size is for display purposes. In fact, outputting to a larger film size may be counterproductive. While a client may be impressed with the sharpness and depth of an image by louping a 35mm slide, she may be disappointed in seeing the same image on a larger-sized film, where it won't appear as sharp and crisp. Although you can intellectually explain why they are really the same, the client's visual expectations and realizations may be visceral, and the advantage lost.

HINT

If you want to output to larger film *and* increase resolution, send your images to a service bureau equipped with a film recorder capable of at least 8K resolution and specifically designed to output to larger film formats.

Will that be SCSI, parallel, or GPIB?

Many film recorders have built into them a variety of interfaces (the circuitry that allows them to be connected to the computer). Inexpensive devices for the PC may attach only to a parallel port. This is the slowest interface option available, the tradeoff being the relatively low cost of the film recorder and the fact that the user does not have to purchase an additional board. Using a GPIB (General Purpose Interface Board) interface will allow you to produce slides much faster, but GPIB boards are also much more expensive. We've found that when given a choice (as many film recorders feature) SCSI is the best interface for both the Mac and the PC. You probably already have a SCSI board or port (saving both money and freeing up an expansion slot), and SCSI will transfer data more quickly than GPIB or the parallel port.

There's one exception to this rule. Since many film recorders have both GPIB and SCSI built in, we can simultaneously attach our Agfa PCR II to our Mac, via the SCSI port, and to our PC, via the GPIB board. All we have to do is change the interface default on the film recorder's front panel when we want to switch from one computer to another.

The question of PostScript

For some reason lost in antiquity, no film recorder we're aware of has PostScript built in to its circuitry. (We're told that since early film recorders predated the invention of PostScript, no one has bothered changing the basic design to incorporate this ubiquitous and useful page description language.) This doesn't mean that you can't produce superb slides from EPS files, or use PostScript fonts in your PICT or TIFF files.

All film recorders require drivers—rasterization programs—to work. A few operate as plug-ins to such programs as Photoshop or PhotoStyler,

but most are designed as stand-alone programs. That is, you get into the program, bring up the image file, make whatever adjustments you require, and then hit a button to begin outputting to the film recorder. Some of these programs are proprietary, designed by the manufacturer, and are not PostScript compatible.

However, there are at least two companies that produce excellent PostScript-compatible software interpreters—SuperPrint and Freedom of Press—for various film recorders. Because they have a limited market (film recorders aren't exactly mass-produced consumer items with low per-unit pricing), these drivers tend to be very expensive (over $1,000), and may work only with a specific device. Other software interpreters are device-independent and will work with any printer or film recorder. However, they may lack important features that the dedicated software RIPs offer.

Incidentally, there are also hardware RIPs available for some film recorders. These are essentially computers with lots of fast RAM that will rasterize the image much quicker than a software RIP. As might be expected, they are expensive, and only available for specific models.

However, there are at least two companies that produce PostScript-compatible drivers—SuperPrint and Freedom of Press—for various film recorders. Because they have a limited market, these drivers tend to be very expensive (over $1,000), and work only with a specific device.

If PostScript is important to you (which it could be, if you produce slides that frequently incorporate type and other design elements), make certain that there is a PostScript driver available for the film recorder you are thinking of buying or leasing. Or, ask your service bureau if they can produce slides from PostScript files. (See Chapters 14 & 25 for more information on PostScript.)

⇨ The bottom line

Whether or not a client prefers film to an electronic file is, in part, a generational thing. Older, well-established art directors and other buyers were brought up around darkrooms and drawing boards, and many are hesitant to adapt to or wholeheartedly embrace the computer age. They want to see traditional film, pure and simple, which is why film recorders will continue to be important devices for at least the next few years.

On the other hand, the new crop of graduates from universities and art schools grew up in the Nintendo era and are very high-tech oriented. To them, digital imaging is simply another medium, just as valid as silver-based film. As this new generation grows in experience and responsibility and, eventually, replaces older, more established art

directors, the need for film output will probably diminish dramatically. It won't happen overnight, but the long-range trend is clear.

So what do you do right now?

Our reading of the market is that film will continue to be a vital component for the present—certainly longer than the average 3–5 year useful life cycle of most film recorders. So, if you must output to film, the question is whether to buy or lease one for your studio, or use a service bureau.

Consider buying or leasing if:

➤ You need the immediacy of having such a device as part of your imaging system.

➤ Your volume of work justifies the expense.

➤ You want (and can afford) the option of creative experimentation.

➤ Your clients require a volume of multimedia or presentation slides.

➤ Stock photo sales are a significant part of your income.

However, you may be well advised to use a service bureau for producing your computer images to film when:

➤ Your work requires top quality output, regardless of cost.

➤ Your volume of work is modest.

➤ You need larger-sized film for prepress or other purposes.

➤ You need resolutions of higher than 4k.

➤ You can't afford the considerable capital investment that may be required.

HINT

Remember, film that you shoot with a film recorder will have to be developed and mounted. If you use 'chrome (and most professionals will), that probably means using E-6 chemicals. A few years ago, that presented no particular problem to anyone having a well-equipped darkroom. But now that the EPA requires permits, silver recovery devices, and other environmental safeguards, processing your own film may turn out to be very expensive, or at least involve a lot of time-consuming paperwork. That's why we use a professional lab to process all our slides.

Which particular model or brand should you buy? Because they are such specialty items, film recorders are hard to comparison shop. Most VARs and specialty stores that sell film recorders usually carry only one or two manufacturers' products. Here are a few ways that you can find out more about film recorders:

> Ask your service bureau for recommendations.

> Visit a photography, graphics arts or computer exposition or trade show, and talk to the company representatives.

> Look at the ads in imaging magazines and call the manufacturers for information. Request sample slides.

> Check in the yellow pages or B-to-B directories for companies that sell digital imaging products. Ask them to bring a film recorder out to your studio or office so you can test it using your own system.

The ultimate litmus test of whether or not a particular film recorder is the best for your needs and price range is image quality. Whenever you are considering a film recorder, either in a computer store, at your service bureau, as a loaner, or during a trade show, carry a SyQuest cartridge on which you have saved a test image file. Ask them to load it into their computer and output it to their film recorder. When the film is processed and the company sends the test slides to you, loupe the results and see if they are acceptable to you. Compare the same test image on various recorders.

When selecting a film recorder, here are a few other points to keep in mind:

> Will it accommodate the accessories you want and need? For instance, will it take a 100' roll of 35mm film, or a 4"×5" film back?

> Does it have a LUT for the type film that you prefer? Can the LUTs be easily updated?

> How many seconds or minutes does it take to capture an image from the size files that you typically work with?

> Is the device's size and shape compatible with your workspace and computer configuration?

> Is a PostScript driver available for it? Does it really matter to you?

> Does it offer the type interface that you want to use?

14
Printers

DIGITAL images are just so many electronic blips until they can be transformed into something tangible. True, we are just entering the electronic era, in which most of our contemporary information comes to us visually and audibly through television or radio. But at the same time, we are still very much a print-and-paper society. Our books, newspapers, magazines, photographs, fine arts, posters, billboards, and even shopping lists are, for the most part, reproduced on touchable, tangible media like paper, canvas, stone, etc. Perhaps in another decade or two, all of us will routinely read our newspapers and books directly off a wall-sized computer monitor, but, for the present, we're still dealing with physical media.

The device that most computers use to output their data to the real world of paper and ink is a printer. Depending upon the system and the purpose, that printer may sit on a desktop attached to your computer, or it could be a floor model at a service bureau, or a pickup truck-sized press in a print shop.

Over the past 15 years, we've gone through a remarkable evolution of computer-directed printers, all the way from automated electric typewriters that could produce 10 characters per second (cps) to Star Wars-like laser printers that can generate several pages of typeset-quality output every second. Color printers, once hideously expensive and therefore available only to a few, are becoming increasingly common and affordable. Two very nice industry-wide trends predominate: prices continue to fall, and the technology improves. In fact, color printers are so affordable and accessible that we feel every serious digital imager who works in color should have one attached to her desktop system, even if she normally outputs to a film recorder or sends her files out on a cartridge or via modem to a service bureau.

Here's why you will want a desktop color printer (or better yet, a color printer plus a black-&-white laser printer):

➢ To produce "comps" that give immediate visual feedback about the images you're currently working on.

➢ To provide your clients with FPO (For Position Only) proofs or match proofs.

➢ For public or private display, exhibition, or portfolio.

➢ For normal business purposes, such as writing letters, generating invoices, etc.

➢ For actual camera-ready typesetting and page production.

Just as there are many different kinds of motor vehicles (cars, motorcycles, pickup trucks, etc.), the digital imager will encounter a variety of different printers and printing technologies. All computer printers will reproduce either text or images, and most will do both. But the appearance and quality can be quite different. As with most

other digital equipment hardware, what kind of printer you select mainly depends upon what you intend using it for, and the amount of money you can afford to spend. In this chapter, we'll briefly describe the different printer technologies and the sort of output they produce, how to maximize your desktop printer for superior quality and productivity, and some tips, hints and snippets of information that may make your work a little easier or your printing a bit surer.

PostScript printers

There are two classes of desktop color printers: those with PostScript built in, and all the others. PostScript is Adobe's page description language that tells the printers where each dot is to be placed, and what colors are to be used where. It's generally acknowledged to be better than anyone else's page description language. That's why almost all paint and illustration programs have provision for outputting to PostScript printers, and most can save files in a special PostScript-compatible format (Encapsulated PostScript, or EPS).

One of PostScript's chief virtues is that it's a device-independent format. That is, the image resolution depends, not on the file, but on the printer. If you have a PostScript printer capable of producing 300 dots per inch, it will print out at 300 dpi. But if you output that same exact EPS file on a high resolution PostScript-equipped imagesetter, it will print at 1,200 dpi, 2,750 dpi, or whatever resolution the device is capable of producing. The other important advantage is appearance: a printed image or text will almost always look better when printed on a PostScript-equipped device than on a non-PostScript device, especially if type or other design elements are overlaid.

For these reasons, we strongly suggest selecting a PostScript-equipped printer over a non-PostScript device. Most moderate-to-expensive desktop printers come equipped with PostScript, and the latest generation have a more advanced version, PostScript Level 2. Other printers can be retrofitted with PostScript whenever you have the need and the money, at an additional cost of between $400 and $1,500.

If your printer doesn't have PostScript, don't despair. Some printers come equipped with a PostScript clone (emulator) built in, which acts just like the real thing. Also available for many non-PostScript printers are relatively inexpensive software emulators like SuperPrint *and* Freedom of Press *that will make your printer behave as if it were PostScript-equipped. The downside to software emulators is that they are usually much slower than true PostScript-equipped printers.*

Printer technologies

There are essentially six different kinds of computer printer technologies that are relevant to digital imaging, each of which creates a different kind of image. They are:

> *Inkjet*. Tiny ink droplets are sprayed out of a cluster of nozzles, which are deposited on paper as instantly dried dots that form characters or shapes. Some inkjets work at room temperatures, while others (thermal, or bubble inkjets) must be heated for maximum image quality.

> *Thermal wax transfer*. These printers position thin colored ribbons of wax over the page, and then heat embosses them directly onto the paper.

> *Phase-change*. Also known as phaser devices, this hybrid technology is a cross between a thermal wax and an inkjet printer. It works by using solid sticks of wax that are then melted and sprayed like an inkjet printer.

> *Dye sublimation*. Also known as gas diffusion printers, they work by heating up colored ribbons until the pigments turn into gas, which is then absorbed by the polyester coating on the paper.

> *Electrostatic*. These use the same technology as photocopy machines: iron filings are deposited onto paper via a photosensitive drum, and then transferred and "fixed" onto the page with heat. The laser printer is the most common type of electrostatic printer.

> *Imagesetter*. A cross between a computer printer and a traditional commercial photographic printer, imagesetters expose their images onto photo-sensitive paper or film that is then chemically developed. Imagesetters are usually large and expensive high-resolution devices, found mostly in service bureaus and print shops.

Depending upon the specific configuration, all of these mentioned devices may be a monochrome (black-&-white), greyscale (halftone-like), or a color printer, or all three in one. Some will print on plain paper, while others require special (usually expensive) coated stock for optimum quality. Most work with paper 8.5"×11" or smaller, while some are designed to accommodate sizes up to 11"×17", or even larger (suitable for newsletters and tabloids).

What do DPI, PPI, & LPI mean?

One of the measures of desktop print quality is the number of dots per inch, or dpi, that a device is capable of laying down. The typical office laser printer is capable of producing 600 dpi, a high-quality laser printer 1,200 dpi, and an imagesetter up to 3,600 dpi or even higher. By contrast, a typical inkjet or thermal wax unit is capable of 300 to 400 dpi, and a dye sub printer 200 to 400 dpi.

However, don't measure desktop printer quality by dpi alone. How those dots are laid onto the paper is as important as how many dots there are. For instance, a 300 dpi dye sublimation printer will almost

always produce a better quality image than, for example, a 400 dpi inkjet printer.

Ppi, pixels per inch, is the measure of resolution of digital images in your computer. Ppi is equivalent numerically to dpi and many people will use the terms interchangeably. It's an inexact misuse of terms that is prevalent throughout the industry and does no one any harm.

Lpi, or lines per inch, is a graphics art term that refers to the resolution of a page produced by a printing press, as determined by the line screens used. (See Chapter 30 about line screens and prepress.) The higher the number, the finer the resolution and the more detailed and photo-like the page.

How many colors do you actually print?

As you should be aware by now, 24-bit color means that the digital artist may select from a palette of up to 16.7 million different colors.

On the other hand, except for dye sublimation printers, all other types of desktop color printers are capable of creating only 3 or 4 different colors, period. But out of those 3 or 4, up to 5,000 different colors can be created for photographic-quality desktop output. (Illustrations created by desktop printers often have no more than 256 colors.)

This seeming contradiction is very simple to understand. Most color printers work, not by mixing colors, but by laying down the primary colors of cyan, magenta, yellow, and black (some less expensive color printers use only CMY, not CMYK, primary colors) in such a way that creates the appearance of many more colors. This process is called dithering, and you will often hear the term dithered images used when discussing desktop printers.

You can easily see how dithering works by louping any image produced by an inkjet, thermal wax, or electrostatic printer. Instead of seeing many different and distinct colors, you will instead see a mosaic of four (or three) tiny primary colored dots clustered closely together in such a way that one or more colors will predominate (like two cyan and two magenta for every yellow and every black). Although the printed image consists solely of primary colors, dithering tricks the eye and the brain into believing that there are many thousands of different colors.

Incidentally, this is the same principle by which offset printing presses work (though they may have up to eight primary colors for greater reproduction quality). However, the dot sizes on true halftone images will vary, while desktop printers tend to produce uniform sized dots.

The notable exception to this process of dithering is the dye sub printer, which actually mixes (overlays) transparent primary colors to form all other colors. This is why dye sub printers are said to produce photo-quality prints. Imagesetters also produce true photo-quality images, but they are not really desktop devices and will usually be found only in a service bureau.

213

⇨ Inkjet printers

Generally the least expensive color printers, costing typically between $400 and $6,000, most inkjets also have the virtue of being small, quiet, efficient, and using relatively inexpensive consumables. Some inkjet printers are capable of producing 11"×17", or even larger-sized prints. The majority of lower-cost color inkjets are not PostScript devices. However, some of the new generation—such as Hewlett Packard's DeskJet 1200 series—can be ordered with PostScript built in.

Depending upon the particular inkjet printer, colored ink is sprayed out from 24, 48, or up to 128 separate nozzles. (Generally, the more nozzles, the better the resolution.) The speed varies according to how much memory the device has, the number of nozzles, and the printer's internal processor (though the least expensive inkjets are "dumb" devices that rely on your computer's CPU for all its instructions and RAM for speed). On average, an inkjet can produce a full color page every 2–5 minutes. A single page showing a photo-like image will cost between $1–$3 in consumables, depending upon the brand and whether or not it requires plain or specially coated paper stock.

HINT Your inkjet printer's ink reservoirs may be refillable. There are kits available for certain models that allow the user to refill the color reservoirs at a fraction of the cost of a new cartridge, with no color degradation. If done properly, there *should* be no mess.

There are, however, several significant drawbacks and disadvantages to using an inkjet printer. Some less expensive color inkjets are only CMY devices, and cannot be equipped to produce true CMYK prints. Avoid these printers, if you want more realistic color output. On the other hand, if your particular purpose doesn't require accurate, photo-quality color, the inkjet printer may be the best, most economical device for you.

Here are a few other problems that should be taken into account. The ink tends to dry up, clogging the nozzles. This problem can be minimized by not subjecting the printer to long periods of inactivity (like more than a couple of weeks) and by cleaning the nozzles regularly (be sure to follow the manufacturer's instructions to the letter).

Another common problem particular to inkjet printers (as well as offset presses and other print shop presses) is color saturation, or how much ink is used to produce a particular image. Color saturation is often described as a percentage of ink to paper. For instance, double-spaced text usually has a saturation of less than 10%. That is, one-tenth of the page is covered with color, and the rest is left blank. A business chart may have a 25% saturation. Conversely, a photographic image or a

full-sized illustration will have a saturation of 95%–100%, with ink covering virtually every square inch of the page.

Some undesirable effects may occur when a high-percentage color saturation is applied. The ink may bleed together, be applied unevenly, or worse yet, begin to run off the paper. It all depends upon the particular printer, the type and brand of pigments being used, and the paper surface and composition. Some inkjet printers, especially inexpensive brands, are designed and suited primarily for business applications with relatively low-color saturation (text, charts and graphs, etc.) and not photo images or illustrations with high-color saturation.

The best way to avoid potential saturation problems is to make certain that you have selected a printer capable of producing trouble-free 100% saturation prints. You can do this by asking the salesperson or manufacturer's technical representative, before you buy, for a written guarantee that his particular device is suitable for photo- and illustration-type color prints. Also, look at actual print samples. If they don't look good enough to you (remember, the company will show you the best prints possible in order to put their product in a good light, so you probably won't be able to squeeze out higher quality than the samples, no matter what you do), start searching for another type of printer.

But if you already have an inkjet and saturation begins to become a problem, try using only the recommended dyes and paper stock. Generic supplies may perform poorly, as can a brand formulated for a specific printer or manufacturer and used on another device. Another way to lessen the saturation problem is to allow each individual print to dry for up to a half-hour. Yes, the ink is supposed to dry instantly, but we've found that it can remain tacky for some minutes, especially when the ambient temperature and humidity are high.

HINT

If the image smears, streaks, runs, or looks dull when you print using a particular brand or type of paper, try another paper stock until you find one that looks good.

But the main drawback to inkjet printers is that they produce a fair-to-good image quality that just may not be good enough for some users and applications. The inkjet's dots tend to be discernible to the untrained eye, even when the printer is working at its highest resolution. Colors appear less vibrant, and details may be lost in the highlights and shadow areas. If you show inkjet-generated prints to a client who is used to seeing true photographs, make sure that you educate her to expect that what she is seeing will be of a different (lesser) quality than the final image, as produced by a printing press, imagesetter, or other printer technology.

Inkjet printers make good affordable FPO and proofing devices. They're especially suitable when price is an important issue, and image quality is much less relevant than the information a print can provide. Another excellent use for inkjet printers is in producing overhead transparencies for audio-visual and multimedia presentations.

⇨ Phase change printers

There's a hybrid device called the phase change printer. Instead of liquid inks, the phase change printer uses solid sticks of colored wax that are melted, liquified, and then sprayed onto the page. The colors are more vibrant, the images usually more realistic. Technically, the phase change printer is a cross between an inkjet and a thermal wax printer. However, no special paper is needed, and the wax does not smear or streak. It does produce a slight 3-dimensional texture build-up of wax, which can crack when the paper is folded. The phase change printer is capable of producing a fairly high output near-photographic quality. Because some phase change printers are capable of producing 11"×17" color printers, they are often used for double page proofing. Some imagers actually use them for creating camera-ready copy for newsletters.

Banners & other large color prints

Until recently, almost all banner-sized color prints (at least 36" wide by up to 12' long) were produced on large pen-based plotters or on very expensive wide carriage inkjet printers. A company called LaserMaster has brought banner printers into the realm of the affordable—a list price of $20,000 (though we have seen them discounted between $16,000 and $18,000)—with its new 36" color DisplayMaker printer. At the time of this writing, that's about one-fifth the cost of its nearest competitor. It's a PostScript-equipped device capable of printing up to 300 dpi, and compatible with either the PC or the Macintosh. It comes with its own dedicated 48 megabyte hardware RIP (expandable to 256Mb), and can produce large-sized color prints up to 110" in length at the rate of 20 square inches per minute. (Read about RIP later in this chapter.) We're very impressed with the print quality this device is capable of producing, especially when viewed from a distance.

⇨ Thermal wax transfer printers

Thermal wax prints have unusually vibrant, saturated colors, and the image output can be very impressive. The devices themselves are priced between inkjet and dye sub printers—$4,000 to $9,000. The cost of the consumables is quite reasonable (about $.50–$1 per print), much less expensive than inkjet or dye sub prints. Usually, printing time is relatively fast; the average thermal wax printer can produce a

full-sized, maximum resolution color page every 2–3 minutes. Unlike inkjets, color saturation is usually not a problem. Most thermal wax printers have PostScript built in, and some can produce 11"×17" prints.

On the down side, most thermal printers are 4-pass devices that must physically move the paper under the colored ribbons 4 times. This can sometimes produce a registration problem, in which the outlines that delineate objects in the print don't coincide exactly and you can see separate colors. (Some thermal wax printers are 3-color, 3-pass devices, so what we said about 3-color inkjet printers also applies: they're not really suitable for photo-realistic images or high-quality illustrations.) While the printed images are reasonably stable (they won't smear or discolor), the inks may crack if the paper is folded.

Thermal wax prints are excellent for FPO prints and proofs, as well as individual presentation prints. They're also superb for producing audio-visuals, business and scientific graphics, and almost any other subject other than actual photographs. Non-photographic illustrations can look so good that they almost leap off the page. However, thermal wax devices are not the printers of choice for photographic-type images, because the print will have an unrealistic poster-like quality with almost surrealistic colors.

HINT When shopping for a printer, fill a SyQuest cartridge with image files similar to the kind you expect to be creating. If that's not practical, choose some samples from public domain Photo CDs. Then have them printed out on the machines you are considering. It's a much better gauge of whether a printer will give you the type of output that you will need than simply perusing the company's brochures or judging from their samples.

What is near-photographic quality?

Many printers are advertised as offering "near-photographic quality." That means that their output is good, but not quite as good as "photo-realistic quality."

With traditional chemistry-based photography, there's never been any question what a photograph is. It's a continuous-tone image from a negative or a transparency enlarged onto photo-sensitive paper and then developed, fixed, and dried. The colors, resolution, and overall representation of a good photographic print are about as close to reality as it's possible to get on paper. That's what we call photo-quality printing.

On the other hand, computer-generated photographic-type prints are made from a mosaic of tiny dots of color, squeezed or blended together to give the visual illusion of a continuous tone print. The more dots, the higher the resolution and the more photo-like the print's appearance. With inkjet, electrostatic, and thermal wax

printers, those dots are a tell-tale giveaway that the image was computer-generated. They can always be discerned, either by the naked eye or under slight magnification. Also, with those technologies, the colors are dithered rather than blended (packed close together to give the illusion of many different hues of color), so there can never be a true continuous tone.

For those reasons, we call the prints produced on these types of devices near-photographic quality. They may look excellent but, to the trained eye, could never be mistaken for a photograph.

Dye sublimation printers

The desktop device capable of producing a print most comparable to a silver halide-based photographic print is called a dye sublimation printer. It differs from other color printer technologies in that the output is continuous tone, just like a photograph. (However, you can usually tell the difference with a loupe, since dye sub prints are rarely as sharp as a well-printed true photograph.) Like Fuji's famed Velvia film, dye sub prints are unusually bright, brilliant, and vibrant, and are well suited for exhibition or fine art prints.

Most dye sub printers are relatively expensive devices. Typically, a good quality brand-name PostScript-equipped dye sub printer capable of producing full-sized prints lists from around $9,000 to $25,000. Because of the high cost of the technology, a number of mid-range dye sub printers are designed to produce smaller prints, such as 6"×8" or 4"×5". These devices usually range from $3,500 to $6,000. All these base prices may begin to drop by the time this book is published, however, because several manufacturers have recently announced or introduced full-sized dye sub printers for as low as $1,300. True, these low-priced dye subs are not PostScript-equipped, and the prototypes that we've seen produce notably inferior images. (One chronic problem seems to be their tendency to "band," which means that there will be pronounceable delineations between color and shading gradations, and not a smooth continuous tone.) But by the time they begin flooding the market, we're sure that there will be software PostScript drivers available and the image quality will probably be somewhat higher.

(Incidentally, a new sub-category of inexpensive (under $2,000) dye sub printers are the dual-technology devices capable of outputting both wax thermal and dye sub prints. The reason is cost: wax thermal consumables are much cheaper than dye sub consumables. This allows a user to output inexpensive proof and FPO prints for under a buck apiece, and then switch over to the more expensive $2.50 per print dye sub for higher quality desktop output. However, the samples we have seen have not been on the level we have learned to expect from dye subs.)

Dye sub printers work by passing a specially coated paper through 4 (or sometimes 3) separate color ribbons. A thermal head with 200 or 300 individual elements (that's where the 200 or 300 dpi comes from) then heats the ribbons hot enough that the color dye turns to gas (that's what sublimation means). The hotter the individual element—and there can be up to 256 different temperatures—the more gas is exposed to or laid on the paper. The gas from one element has the ability to blend with gases from other elements—just as an artist can mix colors on a palette—the net effect being that the dots vanish and the colors are mixed (rather than dithered). This dot blending also means that whether the printer is a 200 or 300 dpi device is relatively unimportant—print quality depends upon other technical factors. That's why a dye sub with 200 dpi can produce better looking prints than one with 300 dpi.

Like some wax thermal printers that are CMY rather than CMYK devices, some dye sublimation printers have the ability to reproduce either 3- or 4-color images. It depends upon how much memory is installed in a particular model, and whether the print ribbon has cyan, magenta, yellow, and black or just cyan, magenta, and yellow. The 3-color ribbons are less expensive, and suitable for graphs, charts and other non-photographic illustrations. If you want to print photographic-quality images, make certain that your dye sub printer is properly outfitted for 4-color processing.

As good as the print quality is, there are several drawbacks with dye sub technology. Like wax thermal printers, some dye sub printers require 3 or 4 passes in order to lay on all the colors. Potentially, this may cause registration problems. Although a just-introduced $15,000 Tektronix dye sub printer can produce 11"×17" prints, most cannot print on paper larger than 8.5"×11". That limits their exhibition use to small-sized prints only. Dye sub printers are slow-working devices. Typically, each print takes 4–7 minutes to output. Consumables are the most expensive of any desktop technology, costing on average $2.50–$5 per page. Nor can they print on plain paper; each company requires its own type of coated paper.

Ironically, the most potentially damaging problem, from the professional digital imager's point of view, is the print quality may actually be *too* good. Very often, the final product you are creating will be part of an advertisement or a document that will ultimately be output in large quantities on a commercial offset press. Offset is a 4-color or 8-color high fidelity process that uses halftones, rather than continuous tones. The inks used by printing presses are not as bright or as brilliant as the dyes used in the dye sublimation process. Also, the newspaper, magazine or report may not be printed on as good a quality of paper as the dye sub print. All this means that a dye sub print used as a proof, match print, or FPO will probably look better than the final product that rolls off a printing press.

And that could cause some confusion, disappointment, or even anger among clients who have not been prepared beforehand to understand that the dye sub proof they see is an approximate, rather than an exact representation of what the final product will be. It's up to you, the imager, to educate your clients about the qualitative differences between a dye sub print and an offset print. Also, the two technologies are really quite different, so any direct point-by-point comparison will only produce an approximation, rather than a close match.

HINT

The best way to educate your client about the relative qualities of different printing technologies is to prepare a set of samples for your working portfolio. For instance, if you use a dye sub printer for your presentation prints, you might put the alongside offset prints of the same images that we used in the actual job. Your client will then have a visual point of reference by which he can judge the relative qualities of the two technologies, providing him with a clearer idea what his final offset prints will probably look like.

RIPping

Whatever kind of image you produce on your computer, when you are ready to output it, the file must first be processed in such a way that the printer will have specific instructions on how and where to place every single dot on the page. This process is called RIPping, or raster image processing. Though time consuming, RIPping is fairly automatic and doesn't require the user to perform any complicated commands.

So far as the final image is concerned, it doesn't matter very much where, how, or by what method the RIPping is done: by your computer, in the printer's innards, or by a dedicated RIP computer or board. But it does matter to you, because it will greatly affect either your pocketbook or output speed, or both.

The least expensive way to RIP a print is with special RIP software installed into your computer. A RIP-type printer driver may be included with your imaging program, or can be purchased from a third party developer. SuperPrint and Freedom of Press are two widely used RIP programs. Your computer processes the image and, once completed, spools (sends) it out to the printer. This method can be very time-consuming, however. Not only are software RIPs slower than hardware ones, but the software RIPping ties up your computer so that you can't use it until it's finished and the image is finally sent to the printer. We've RIPped prints on our computer that have taken 45 minutes to complete. (Admittedly, they were output from very large and complicated image files.)

Some color printers have built-in RISC (high-speed) processors and lots of memory, and can do their own RIPping before starting the printing itself. This frees up your computer sooner and tends to be a more efficient solution. But installing additional RAM into a printer, so that it can do its own RIPping, can be relatively expensive, and, of

course, you have to first buy or lease a printer that has that capability for memory expansion.

The fastest—but by far the most expensive—way to RIP an image for printing is to install a dedicated RIP computer or board. A RIP computer is, in essence, a big and swift coprocessor that does but a single task: preparing your images at the fastest possible speed. It's generally a PC with a 486 CPU and lots of RAM (16Mb to 256Mb). Some RIPs come with a basic selection of fonts, which can be expanded, depending upon the size of the hard drive. Because of their expense (which may range from $8,000 to $27,000, depending upon the brand and amount of memory), RIP computers are often sold as an included accessory with expensive electrostatic color printers or imagesetters.

Much less expensive, but correspondingly less sophisticated and speedy, are special printer boards that install into your Mac or PC. Usually loaded with a memory buffer (4Mb to 16Mb, or more), they intercept and hold the image file when you invoke the Print command, and either RIP the image or spool it out to your printer (which does the RIPping).

Incidentally, hardware RIPs will not speed up your actual printing time. That's more or less fixed, according to the printer's inherent technical capabilities and the file size. What they do is return control of your computer to you much more quickly, so you can continue to work while the RIP device is preparing the file for the printer. Remember, the RIPping must happen before your printer can even begin to print. However, the overall time you spend waiting for a print—from the time you invoke the command to the time you hold a picture in your hand—will usually be cut significantly, if you use a hardware solution or add extra memory to your printer for that purpose. That's because the actual RIPping will consume far less time than if you had to do it with your computer alone.

⇨ Electrostatic or laser printers

⇨ Color laser printers

If money were no object, we'd dearly love to have a Canon 300 or 500 color laser printer with an Efi Fiery RIP computer sitting in the corner of our studio—similar to the configuration we've used at the Center for Creative Imaging in Camden, Maine. It's a digital imager's dream—a workhorse of a device than can crank out beautiful near-photographic quality images (at 400 dpi) onto plain photocopy paper at the rate of up to two per minute, and at a cost of about $.50 per print. There's no worry about pages cracking, dyes running, or having to use special coated stock. Besides, it's a clean and neat process, with no time needed for the pages to dry. And while the print appearance and quality doesn't quite match that of a true photographic print or a

dye sublimation print, it's extremely decent and could be shown to clients with no shame or hesitation. In fact, Sally uses several bound and laminated books of images made on the Canon 500 as part of her working portfolio.

The Canon 500, and its smaller, less expensive brother, the 300, are both electrostatic, or laser printers. Until recently, the price of color laser printers began at $22,000, and a high-speed unit with a RIP computer attached could easily exceed $100,000. Now that a company called QMS has introduced a desktop color laser printer in the $11,000–$13,000 range, this technology is in the realm of the affordable. We're sure that others will follow suit, and it won't be long before the $10,000 threshold is broken.

Most color laser printers are capable of outputting four colors at 400 dpi, by passing a paper through a mechanism with four separate toner cartridges. Depending upon the model and the file size, a color laser printer can output from 1–8 color pages per minute (and double or triple speed when monocolor pages, including black & white, are output). Characteristic of the technology is that the first original of any image will take a relatively long time to produce, while subsequent copies can be output at maximum speed.

Most color laser printers are also sophisticated flatbed copiers. Depending upon the model, they may come equipped with enlargement, reduction, and zoom capability, color balance controls, a special photo mode, memory mode (for storing settings for particular corrections), and the ability to make positive and negative prints. Some units can also accept a slide/film accessory for quick and dirty photocopy-quality prints. Others can be equipped with built-in editing tools so they can create or alter an image without even using a computer. (No, it's not a substitute for a medium to high resolution scanner and computer manipulation, but it's useful for quick, decent prints from film.)

A major virtue of most color laser printers is something known as duty cycle—the number of prints that can be made in a month without putting undue strain on the machinery. While the duty cycle of a dye sub or an inkjet printer may be limited to 1,000–1,500 prints per month, a typical color laser printer may be good for 20,000–30,000 copies. That makes it suitable for a high-volume design studio or service bureau.

There are very few disadvantages to a color laser printer, other than the initial high cost to buy or lease, and their relatively expensive maintenance costs. To maximize use and speed, you might have to add an expensive RIP computer. The near-photographic quality might be put off those used to the greater realism of dye sub output. And except for the new desktop units, most color laser printers are bulky, heavy floor models.

⇨ Black-&-white or greyscale laser printers

Black-&-white laser printers are ubiquitous. One finds them in offices, schools, and homes everywhere. Like color laser printers, they were once large and expensive devices. But now they are so common that good quality black-&-white laser printers sell for as little as $450. It's even possible to buy a PostScript-equipped laser printer for under $1,000.

Depending upon the model, laser printers can print from 4 to 17 pages of text per minute. Graphics are more time-consuming; depending upon the printer model, the amount of memory, and the file size and complexity, it can take 2–30 minutes to print a single page of graphics. All laser printers come equipped with built-in fonts. Several manufacturers feature as many as 135 scalable fonts, which is far more than the average imager may ever use. But if you do desktop publishing and need an even larger selection, it's also possible to buy literally thousands of "soft" fonts on disk or CD-ROMs and download them to your laser printer (as well as other types of printers). The average desktop laser printer can accommodate up to legal size (8.5"×14") paper, though larger machines are capable of using 11"×17" sheets.

The best way to visualize what a laser printer is and how it works is to think of it as a souped-up photocopy machine that connects to a computer. Laser printers work by using a laser beam to rapidly "paint" an image onto a photo-sensitive drum, which then attracts toner to those spots the beam hits. The toner is transferred and fixed by heat to a sheet of paper. The quality of the image is moderate to high, depending upon the resolution of the printer, the type of toner used, the grade of paper, and other factors. Consumables are quite inexpensive, and the average cost of printing a single page range from ½ cent to about 3 cents. Most laser printers print onto plain photocopy paper, though using better grades of paper may produce superior images.

 HINT If your laser printer is capable of producing 600 dpi or greater, don't use a standard toner cartridge that was designed for 300 or 400 dpi machines. Various companies market fine-grain toner for higher resolution laser printers that produces tighter, sharper images while leaving less residue on the page. They're slightly more expensive, but the quality difference can be significant.

The beauty of a laser printer is that there's very little that can go wrong. On most laser printers, the photosensitive drum and the toner (and with some, the developer) are in 1- or 2-piece disposable or refillable cartridges. When the copy gets light or something goes

wrong, you simply replace the cartridge. While an inexpensive laser printer may have an official duty cycle of 1,500 sheets per month, most industry experts acknowledge that those figures are wildly conservative and one could easily pump out 7,500 to 10,000 pages without doing any damage to most models.

Most contemporary desktop laser printers have a resolution of 300, 400, or 600 dpi, and use a dithering technique to mimic greyscale. However, some printers feature true 16 or 64 greyscales, as well as variable size dots, in a technology called *resolution enhancement*. This makes it possible to reproduce ersatz halftone photos with a fair degree of quality (so long as the image sizes are relatively small). These printers have limited digital imaging applications, such as low resolution black-&-white proofing and even meatball-quality desktop publishing.

There's another class of moderately priced ($2,000 to $10,000) laser printers, often deliberately mislabeled laser imagesetters, that are capable of reproducing 256 greyscales and which feature resolutions from 1,000 dpi and up. Those specs, at least theoretically, put them in the same class as true imagesetters.

However, the reality falls somewhat short of that mark, and the output can be disappointing—if you expect true imagesetter quality. While they are capable of producing high resolution greyscale copy, the image itself is frequently prone to banding, lines, and aliasing. (The latter refers to something commonly called "the jaggies"—when circles or oblique lines show stair-like step progressions instead of a smooth, unbroken line. Jaggies are characteristic of digital technology, but the better the printer and the finer the resolution, the more those stair-like lines appear like smooth lines.) The output may also appear flat and lifeless. Image quality is even worse if the laser printer is using interpolated resolution rather than true resolution (that's when software is used to fill in gaps between dots).

Mind you, the near-photographic quality greyscale print that a greyscale laser printer can create looks considerably better than anything produced by a dot matrix, inkjet, or black-&-white laser printer. Greyscale printers are very useful for producing camera-ready copy for newsletters, newspaper images, or black-&-white photos that are to be reproduced at relatively small sizes. But they would never replace true imagesetter output, at least at this level of technology.

Laser paper

Paper comes in many sizes, surfaces, and grades. For instance, most black-&-white laser printers work perfectly fine with standard 20-pound photocopy paper, the kind that you can get on sale at Staples or Office Max for as little as $16 a carton. (A carton is 10 reams, a ream is 500 pages, so you'll get 5,000 sheets of 8.5"×11" pages at

less than a third of a cent per sheet.) Photocopy paper is well suited for most office and even some digital imaging applications (mostly rough copies of black-&-white or greyscale prints, though we've used it successfully with color electrostatic printers, too).

However, if you want to produce the best possible images on plain paper, try using special extra bright white opaque paper instead of ordinary photocopy paper. It will cost between $5 and $15 a ream (that's 1 cent and 3 cents per sheet), but the results will probably be well worth the difference. We strongly recommend using this kind of stock if you are using your laser printer for final output or camera ready copy.

You might want to try using a coated stock, even if your laser printer's manufacturer doesn't specifically recommend it. It will tend to produce images that are a little sharper and brighter than those output onto plain paper.

Most laser paper, including extra bright opaque surfaces, is 20-pound stock—that's a printer's measure that refers to the weight and the density of each sheet. You might try 24- or even 28-pound paper for digital imaging, because the sheets will be less prone to foxing, bending, or curling. Don't buy any heavier paper, however, no matter what the salesperson recommends. Most laser printers are constructed in such a manner that they can't safely handle paper heavier (thicker) than 28 pounds. It may work for a while, but your machine may be prone to jamming, smearing, and could possibly do serious damage to the transport mechanism. However, a few laser printers are constructed to take heavier paper, so check with the manufacturer before buying if you think this might be an important consideration.

Yes, you can output to attractive stationery or special surface paper. Many paper manufacturers produce high-quality parchment, linen, embossed, etc. surfaces, often with envelopes to match. And they look gorgeous, too. Make certain, however, that whatever special stationery you buy is specifically formulated for a laser printer—that is, that the surface is fairly non-porous and hard, so it can take toner without mushing or spreading. Laser paper also produces less lint as it passes through the printer. Lint buildup can cause paper jams and streaks on the drum. If it doesn't say laser or photocopy paper on the box, don't buy it. You will be disappointed in the lack of sharpness and definition. Specialized laser-specific papers can be very expensive, ranging from $5 to $45 for 100 sheets (which translates to $.05 to $.45 per page).

⇨ Imagesetters

So far as we're aware, there are no desktop imagesetters on the market that cost $20,000 or less (though there's one that has a $22,000 price tag). It's doubtful that the average digital imager or design studio will be able to afford his own imagesetter. Nevertheless, chances are you'll be outputting to an imagesetter, either at your

service bureau or print shop, so you should at least know something about the technology.

Imagesetters are high-resolution (1,200 dpi to 4,000 dpi) electronic printers that output to film or photo-sensitive paper, which is then chemically developed. They're generally used to produce camera-ready copy, color separations, and proofs for clients who demand the highest quality. Most imagesetters are too expensive to operate as volume printers.

Depending upon the model, imagesetters use either a capstan or a drum drive. Capstan imagesetters are generally less precise and therefore less expensive, and are used primarily for setting type or outputting black & white. The more expensive and precise drum-type imagesetters feature better registration, which is a prerequisite for producing top-quality color separations. Either kind can output greyscale, color prints, or color separations. Because the paper, negatives, or transparencies output are usually spooled from a continuous roll, most service bureaus charge by the inch or foot, as well as by the minute. The last component is as an incentive for the client to produce correct sized, properly formatted files, since a problem file can take 2–10 times as long to print out as a perfect one. A typical 8.5"×11" color print generated by a computer file and produced on an imagesetter costs $18–$40. A Chromalin or MatchPrint produced from film negatives output by an imagesetter will cost about the same. (The same print output on a dye sub printer or an electrostatic printer will range from $15 to $35.) And a set of good color separations may run $75–$300.

Other technologies

Dot matrix printers

The least expensive color printers—as low as $200—use a relatively old technology called dot matrix. It's called an impact-type printer in that 9–24 rapidly moving, tiny electrically driven needles make physical contact with a colored ribbon, which then leaves an impression on the paper. Most color dot matrix printers use 3 separate ribbons or multiple ribbons—Cyan, Magenta, and Yellow—to create a color image. It's a very slow process, taking up to 5 or more minutes per print (depending upon the density and the speed of the machine). Unlike non-impact technologies (dye sub, thermal wax, inkjet), which are virtually noiseless, a dot matrix printer has a characteristic high-pitched whine that can be distracting or downright annoying.

Only a handful of dot matrix printers have PostScript built in, though third-party software drivers like *Freedom of Press* and *SuperPrint*, will work with most.

The main virtue of a color dot matrix printer is its initial low price. Most colored dot matrix printers work with reuseable colored ribbons, which like typewriter ribbons on a spool can be used over and over again. From an economic point of view, that's good, but from a quality perspective, every time the ribbon reverses, the images will look a little more faded and washed out. While it will print on plain paper, the price per page isn't appreciably cheaper than other technologies because the ribbons it uses wear out quickly.

Unfortunately, the print quality is fair to awful, certainly not suitable for professional imaging. For that reason, we do not recommend using a color dot matrix printer for proofs or FPO prints.

⇨ Video graphic printers

You've probably seen them in photographic or general electronics stores: a VCR-sized color printer that produces gorgeous, but small (3"×4" to 4"×5") prints, and cost between $1,300 and $2,200. What are video graphic printers, and more to the point, can they be of any use to the budget-minded digital imager?

Actually, most of these small-sized printers are in fact dye sublimation devices, capable of producing photographic quality output. Depending upon the manufacturer, they may work with either a Mac or PC, or both. Or maybe with no computer, period. The consumables are reasonably priced, averaging about a buck a print.

There are several significant, but not necessarily insurmountable problems with using a video graphic printer. These devices were designed primarily as a way to produce hardcopy off a broadcast signal from a camcorder, VCR, or other video source. But if they have a standard parallel or serial interface (some do), they may also be used for digital imaging. Even so, the manufacturer may not include a software driver that will allow you to print out directly from your favorite digital imaging program. If that's the case, the solution is to create and edit your file as you normally do, in a paint or illustration program (such as *PhotoStyler*), and then save it to a file format that the printer can handle. Exit that program, and then load in whatever software came with the printer that will output that file format.

No video graphic printer is PostScript-equipped. That would probably be a serious consideration if the print size were larger, but since it's only a proof or FPO print in which details probably won't be readily visible, don't worry about whether or not you can use PostScript.

Speed is another drawback. Depending upon the file size, it may take several minutes to produce a print. While that compares favorably to larger dye sub printers, remember, proportionately, the print is about one-quarter the size, so the actual printing speed on a square inch basis is about 25% that of the standard-sized machines.

But the biggest drawback—and why these devices are not well suited for serious digital imaging—is that the size of the print will probably not yield enough useful information. If your purpose in generating a print is as a proof or FPO, then you may be disappointed. Even viewed with a magnifying glass, you may not be able to read exact colors, whether a mask was drawn accurately, if there's a problem with design alignments, etc. Your client would have even more difficulty, not just in looking for technical information, but in conceptualizing what his final image will look like when it's published full-sized in a magazine or blown up to a poster. You may come across as being very amateurish or even parsimonious by giving him such a tiny proof.

Attaching more than one printer to your computer

Many digital imagers will have at least 2 desktop printers attached to their system: a laser printer for black-&-white proofs and standard business applications, and a color printer for exhibition, proof, and FPO prints. Usually, that's not a problem, because the different types of printers can use different interfaces. For instance, many printers have multiple ports in the back—serial, parallel, and AppleTalk—so you can configure it for whatever port happens to be available.

It becomes a problem when you have 2 or more printers that use the same interface. For instance, our Tektronix dye sub printer and Hewlett Packard LaserJet II are both parallel devices. (We could configure the HP as a serial device, but that would slow up printing by a factor of almost 10.) We thought we would solve that problem by installing what is known as an AB or "switcher" box, which allows you to dial the printer you want by flicking a switch. (Some do it electronically, an advantage because a mechanical AB box can conceivably zap the electronics in a laser printer.) Unfortunately, we've discovered that most color printers utilize, or "enable" all the pins on the cable to carry signals back and forth (most printers use only 4 or 5 of the 25 printer pins that the parallel cable is capable of transmitting), and most AB boxes, in order to cut down on costs, do not enable all the pins. Fully enabled AB boxes are expensive and hard to find.

So there are two solutions. One, buy and install a second I/O (In/Out) or parallel board in your PC, configuring your second printer as LPT2. It's cheap, but you will use up an extra expansion slot. Even cheaper is simply unplugging your parallel cable from one printer and installing the other every time you want to switch printers. The down side is it's both inconvenient and time-consuming, and eventually, you may screw up the cable or the I/O board, or both.

One note of warning, if you ever do find an AB box appropriate for color printers, or if you switch among printers by just physically pulling out and plugging in cables. *Always* turn off your computer and printers before doing either. Otherwise, you can destroy your equipment.

Printer speed

Printing is usually the biggest bottleneck in an imager's system. Some color printers have a normal operating speed of 5 minutes per print, and can take much longer than that to put out complicated or large-sized files. However, there are some ways that you can appreciably speed up your color printing:

➤ Tailor your file size to the printer's capabilities. For instance, if you insist on printing a 1,500 ppi file on a device that prints out at 400 dpi, you will waste an inordinate amount of time—it can easily be an hour or more—while the computer chooses the data and sends only the amount of data the printer can actually use. You may also sacrifice print quality by letting the computer choose what data to keep and what to throw away. Similarly, be certain that the image's dimensions correspond to the printer's output.

➤ Add more memory to your computer. The more image data you can process at the same time, the faster it will go out to the printer.

➤ Add more memory to your printer. The printer must interpret the data as it comes from your computer, and the more memory it has, the faster it will work.

➤ Install a hardware RIP (Raster Image Processor) to your system. This is a dedicated high-speed computer with lots of memory that does nothing but process your images, and then sends them out to the printer many times faster than your primary computer could do alone. The main drawback is that hardware RIPs can be very expensive.

➤ Install a high-speed coprocessor or printer board into your computer. Available from a variety of manufacturers, these so-called accelerator boards act as RIPs, rasterizing and

downloading your image files to the printer much faster than an unaided computer could do.

HINT

Since color printing can take a long time, wait to begin a major print until you are ready to take a break, make a phone call, or do some other non-imaging task.

What does memory have to do with printing?

Like your computer, the better color printers can have extra RAM memory added to boost performance and speed. Memory and resolution go hand in glove with color printers. The more dots, the larger the image and/or the greater the greyscale range, the more memory is needed. Some printers cannot output at full size at the highest resolution unless more memory is plugged in first. So, the imager may have a choice of a smaller image size (such as 5"×7") or a lesser resolution (such as 200 dpi instead of 300 dpi). Other printers may be able to output CMY only, and not CMYK, without extra memory. Also, memory is used to store downloaded software fonts, so a printer may not be able to load in a set of needed fonts without sufficient memory. (The print can still be made, but since each individual font would first have to be loaded, used, unloaded, and then replaced by the next font, it could slow up the overall printing process by 5–20 times.) More memory may also frequently speed up the print time, if RIPping is to be done in the printer rather than the computer.

Other printing hints

Color prints may be relatively soft and can be easily scratched or smeared. For greater permanency, laminate your prints. Some printer manufacturers recommend and sell expensive laminating machines, but we've found that our all-purpose business laminator (capable of taking prints up to 11" wide) is quite adequate—if it is used very carefully.

➤ Color prints are prone to curling. We deal with that problem by either storing prints under pressure (such as in a book or portfolio), or laminating the print.

➤ Another alternative is to protect your color prints in large-sized transparency glassine sleeves. They allow you to see the image while protecting the print.

➤ Don't buy printer paper and other consumables in very large quantities, if you don't plan to use them up within a year. Like darkroom paper and chemicals, many digital imaging supplies have a limited shelf life. While you will save money in the short run, you may end up either with lesser quality prints or may even have to throw the supplies out.

➤ The electrical signals that the computer sends to the printer are relatively weak and lose power as they travel over copper wires. If your cable to the printer is too long, you may experience frustrating intermittent errors, or not be able to print out at all. Make certain that you don't position your printer any further from your computer than: 15' for a parallel cable; 15' for a GPIB cable; 10' for a SCSI cable; 50' for an RS422 or RS232 cable.

➤ Buy a collator rack or a document divider (pigeon holes) for temporarily separating and storing your color prints. Often, color prints remain tacky for some minutes, and will stick to the backs of other prints if stacked together. Don't put anything on the surface of your color prints for at least a half-hour to an hour, depending upon the paper and inks you're using.

➤ Keep all prints away from excess heat, such as in a car trunk or a window on a hot day.

➤ Because coated paper can cost more than a dollar a sheet, try printing out your initial images on either plain paper or less expensive generic clay-coated stock. We've found that this substitution works with some machines, but not at all with others, so try a few test prints first. (It can be a disaster with some printers, causing inks to smear and requiring a cleaning of the machine's rollers.) The image quality will be significantly reduced, but it will be good enough to help you decide whether or not to make a print on coated stock or make further corrections first.

⇨ Printer recommendations

So, what kind of printer should you buy or lease? We personally use a Tektronix Phaser IISD dye sublimation printer as our main color output device, precisely because it is the closest thing we have to a color enlarger for the computer. It is not only a superb proofing and FPO machine, but Sally has produced a number of exhibition prints on it. We feel that the ability to produce photo-realistic prints from our desktop computer more than compensates for its high initial cost and expense of consumables. If you want and need the best photographic quality possible on a desktop, get a dye sub printer. Keep in mind that some dye sub printers will produce significantly higher quality prints than others.

But we also use a relatively inexpensive Hewlett Packard DeskJet 1200/PS inkjet printer for everyday works-in-progress and FPOs. Its price tag is far cheaper, the consumables cost less, and the print quality is quite acceptable for most applications. While it's supposed to use only coated paper for optimum quality, we save even more money by printing out first copies on plain paper. There are some inkjet models capable of outputting 11"×17" prints, which makes them

excellent devices for producing camera-ready newsletters. If you understand and can live with their limitations on image quality, inkjets are good all-around devices.

Wax thermal printers are better suited for original art, illustration, and the business world than photographic digital imaging. Sally uses a Tektronic Phaser III printer when she wants to make the image look like a brightly printed poster rather than a photo. The cheap consumables make them very affordable for moderate volume (1,000 to 2,500 sheets per month), proofing machines. The image quality they produce is excellent. But with the prices of entry level dye sub printers as low as they are—especially since several of those machines are capable of switching from dye sub to wax thermal technologies—we suggest looking at those machines too if you want a wax thermal printer.

If you have the big bucks and work with large volumes of prints (10,000 to 30,000 sheets per month), consider buying or leasing a color laser printer. They're fast, clean, and produce excellent quality prints, some up to 11"×17" in size. They can also double as color photocopy machines. Although we have no experience with the new, relatively inexpensive color laser printers, we think they may very well suit imagers who want electrostatic prints, but don't have the volume or the capital to justify the larger printers.

If your budget is limited, and you feel that a color printer, any color printer, is better than nothing, check out inexpensive color dot matrix or color video printers.

For normal everyday business needs, a black-&-white laser printer is an excellent investment. If you want to generate camera-ready black-&-white copy, consider getting a high resolution greyscale laser printer. But if you want optimum camera-ready copy, you'll need a true imagesetter (either in your studio or at a service bureau).

15

Useful or necessary accessories

MAYBE it's genetic, and maybe it's gender. Daniel, like most males we know, is an inveterate gadgeteer. He pours over every DAK, Comb, and Hammacher-Schlemmer catalog that arrives in the mail, spends one Saturday morning each month at the hardware store looking at tools, and regularly attends computer shows and photographic flea markets. Consequently, we have a houseful of electronic and photographic gadgets, gizmos, knick-knacks, and what-nots. Most are interesting, but nearly useless dust collectors or door stoppers; a few have become absolutely indispensable to our work; others we could live without, but we're glad that we don't have to.

It's these vital, useful and optional products related to digital imaging that we'll be covering in this chapter, including:

➤ Surge suppressor, line stabilizer, or UPS

➤ Cooling system

➤ Furniture

➤ Diskette and tape storage

➤ Cleaning kit

➤ Tools

➤ Safety items

➤ Cable extensions, connectors, gender changers

 # Surge suppressor, line stabilizer, or UPS

Look at the light on the ceiling or your desk. Does it always illuminate at a rock-steady level, or do you notice that it frequently dims, dips, grows brighter, wavers, or otherwise acts erratically? Unless you're in the rigidly controlled environment of a science lab or military facility, chances are that it's the latter, not only with your lights but your microwave oven, stereo, TV and, yes, your computer.

What you're experiencing is dirty power, or, to use its official names, power transients and anomalies.

The electricity that comes into your office or studio is affected by many external factors, ranging from far-off (or nearby) lightning strikes, to going on or off the national power grid. Nearer to home, it may be affected by such things as turning on an air conditioner, vacuum cleaner, or light switch. The power being fed into your computer fluctuates, on average, several times a minute. Computer equipment is especially sensitive to power anomalies, which manifests itself in erratic behavior (glitches, garbled files, freezes, etc.) or, even, permanent damage. It's been estimated that up to 95% of all unexplained

computer problems (hardware *and* software) are a result of dirty power. Also, the color you *see* on the computer monitor may or may not be adversely affected by power fluctuations, in the same way that they can cause color shift in a darkroom enlarger light bulb (depending upon how good your monitor's power protection circuitry is).

To keep your system running smoothly, and to avoid big repair bills, you'll need some device to help smooth out the power dips and surges. The best-known and least expensive remedy is a surge suppressor. Ranging in price from about $10 to $120, a surge suppressor will neutralize most power transients. Surge suppressors come in a variety of shapes and sizes, from the familiar rectangular power bar to a slim console that fits between your computer and monitor.

Usually, the more a surge suppressor costs, the better job it does. The better surge suppressors offer protection for your modem or facsimile machine, since they too can be damaged or destroyed by power surges. Some brands even bundle in a lifetime insurance policy. If a stray lightning bolt or a once-in-a-lifetime megasurge French-fries your system, they'll pay to repair or replace it (usually up to maximum of $5000). Because it won't cost much extra, we suggest buying a model that includes the insurance.

Next up from a surge suppressor is a line stabilizer, also called a voltage regulator. Usually, this $100–$200 device is a heavy breadbox-sized case that sits on the floor next to your computer. Besides featuring better circuitry for responding faster to surges and dips, they have large capacitors that soak up and store a certain amount of electricity, in the event of a brief reduction in power (a brownout). Brownouts are most common in the summer when air conditioning demands push the utility companies to their peak capacity. Sometimes, to keep the entire system from shutting down, the power is momentarily reduced. That's very bad for computers, and surge suppressors can't do a thing to prevent the damage brownouts can do. But a line stabilizer can. But neither a line stabilizer nor a surge suppressor can protect a computer user against a full-blown blackout, when all power is cut to the computer.

We use a line stabilizer on our Quadra 700, primarily because we bought it at a bargain basement price of $50 at a computer show. Line stabilizers were once much more popular, before UPS technology dropped to its present price level. But unless you can buy a line stabilizer at a tremendous discount, we suggest spending a few more dollars to get a UPS.

No, we're not referring to the shipping company when we say UPS; it stands for "uninterruptible power supply." As its name implies, a UPS ensures a steady flow of power to your computer, regardless of peaks, dips, brownouts or even blackouts. In the event of a total power loss,

your computer will continue to operate as if nothing happened, but only for 10–30 minutes, depending upon the UPS type and model.

Basically a UPS is a large lead acid battery that feeds clean power directly to the computer. Inexpensive UPSs are on standby mode, so when the power dips below a certain threshold, it'll automatically kick in, usually in 1–4 milliseconds. With better UPSs, the battery goes on permanent recharge, and the computer runs directly off the battery, not from a wall outlet. Thus, it is virtually impervious to every power anomaly.

A UPS provides only a few minutes of power before shutting down. What it does is warn you when you've lost power (by beeping or flashing). Then you're supposed to initiate an orderly shutdown of your system by immediately finishing whatever you're doing, saving the file, getting out of the program, and then turning off the computer. When the power is restored, you can begin working again.

How large a UPS do you need?

UPSs range in size from a brick to a refrigerator, and cost between $150 and $10,000. To calculate what size you need, add up the number of watts that your computer power supply and monitor use. (Typically, a tower case is rated at 200W–250W, and a color monitor at 75W to 150W.) Then double that number, and look for a unit that has an equivalent voltage rating. For instance, if your power supply and monitor total 300W, get a UPS that has a rating of at least 600V. Any less, and it may not adequately protect your system. Any more would be overkill.

Unless you can afford a large and expensive unit, your UPS won't protect your entire computer system. Don't try to attach a printer, scanner, second monitor, or any other power-hungry peripheral to the UPS, because the overload could damage the system or cause it to fail before you have a chance to shut down in an orderly fashion.

HINT

Most UPSs are designed to operate between 10 and 15 minutes only. However, many UPSs have supplementary power leads that allow the user to attach additional storage batteries. With extra batteries, it may be possible to continue working for a half-hour, an hour or longer. Check first with the UPS manufacturer about what types of batteries may be used.

Because of past power problems, Sally has a continuous UPS protecting her system. It's also a true sine wave unit, which is technical talk for meaning that the power is about as clean as it gets. Daniel uses a less expensive standby unit on his computer. It's what is called a pseudo-sine wave unit, not quite as good as a true sine wave but better than the cheapest UPSs that feature neither. What counts is both units work perfectly, a reassuring fact since we have mini-

brownouts at least once a week that would otherwise cause our computers to freeze or crash. So, if you can afford it, get a continuous power sine wave UPS. If you're on a tight budget, any UPS will be better than other types of protection.

Cooling system

If you have a Macintosh, you probably don't have to worry about temperature considerations. But if you're using a 486 or a Pentium-based PC, especially if it's loaded with lots of memory and peripheral boards, you may have problems that are directly related to the temperature inside the case. Semiconductors—memory chips, CPUs, ROMs, etc.—all consume electricity, and therefore generate heat. The denser (bigger) the chips, the more there are, and the closer together they are squeezed, the more heat. Intel's 486 CPU runs so hot that you can burn your hand by touching it. The Pentium runs even hotter, and if not properly cooled, can actually melt nearby chips and components.

What happens when a computer runs hot? Usually, in the short run, it simply stops running, at least until things cool down. In the long run, it may damage or destroy parts of the computer. A sure-fire tipoff that you have a heat problem is if your computer seems to operate normally when first turned on, but becomes erratic or crashes after a few minutes and, when it is turned off for a time, will again work perfectly.

Various companies sell products designed to cool down the computer interior or the CPU. The most effective product we know, and one which both of us use in our PCs, is called a FanCard II. Essentially, this $59–$99 device is a full-sized peripheral board with two thin muffin fans, which when plugged in and turned on, directs a steady flow of air over the other boards. The company claims that it cools the interior down an average of 20 degrees, something the army appreciated during Operation Desert Storm when 500 FanCards kept one combat division's computers from crashing. We used to have regular, unexplained crashes before we installed the FanCards, but they've since become fewer and farther apart.

An increasingly common solution to the hot CPU problem is to simply attach a $15 heat sink or even a miniature $39 fan right on top of the CPU with superglue. (Your computer manufacturer may have glued on a heat sink or fan when you bought your machine.) These gizmos are widely advertised in computer magazines, and are easily installable. Sally's 486s both have manufacturer-installed heat sinks.

HINT

Here are a few free ways you can cool your PC even further:

➤ Take off the cover, permanently. (But clean frequently to remove the accumulated dust.)

➤ Move the computer away from the sun, a radiator, etc. and keep it in a cooler spot.

➤ Direct the air from a fan or an air conditioner onto the computer.

➤ Don't put the computer under the monitor, but let it stand alone on the floor, at least a foot away from the desk or any other surface.

➤ If you have empty slots, stagger your peripheral boards so the boards are physically further apart.

Furniture & environment

The most unusual, stylish monitor stands we have ever seen were a pair of Doric columns standing behind two very plain desks at Image Axis, a digital retouching bureau in New York City. Our furniture is a combination of computer-specific desks and printer stands, and traditional office-style desks. Since we rarely, if ever, entertain clients in our combination house/office/studio, we're not particularly concerned about decor, color coordination, or other appearances and affectations.

But where we do consider furniture as part of the imaging system is in selecting desks and chairs that are strong, comfortable, and configured for maximum convenience and efficiency. Make certain that your desk or stand can support the size and weight of a particular printer or device. Daniel recently placed a color printer on a stand that nearly shook apart when the printer started spewing out pages. Another lightweight desk that was fine for holding a 12" monochrome monitor when we first bought it now sags dangerously under the weight of a 15" color monitor.

Select your furniture on functionality first and form last. Purpose-built computer furniture is designed for maximum efficiency. For instance, a desk may have a slide-out keyboard drawer, a platform for elevating your monitor, clips for organizing the tangle of cords that extrude from computer systems, a built-in swivel light or adjustable copy stand, and nooks and crannies for floppy disks, printer paper, etc. But they are short on drawer space, which every office needs.

Given a choice, try to select neutral colors rather than dark woods, to avoid introducing color influences into your monitor. Place desks and cabinets so you can easily snake cables and cords behind, and in such

a way that you can move or get behind them when necessary. By all means, get a comfortable chair, one that will give your back plenty of support.

 One of the biggest problems created by computer keyboards is repetitive stress disorder, or Carpel Tunnel Syndrome. It's the wrist's equivalent of tennis elbow, a painful and often permanently debilitating condition. The best way to avoid developing this common problem is to buy a wrist rest or perch that will force your hands into the proper position.

Most print shops and service bureaus, as well as many design studios and magazine offices have light shields for optimum viewing of color materials. These large, boxy contraptions that sit on top of a desk are closed on three sides, and everything inside is painted an 18% neutral grey and lit with a 5600° Kelvin color-balanced light source. The purpose is to create a viewing area whose illumination is close to sunlight at noon, so the colors of any printed material may be seen as accurately as possible. If you're involved with prepress and need a high degree of color fidelity, this is one piece of equipment you can't do without.

Diskette & tape storage

Eventually you will accumulate hundreds and, possibly, thousands of floppy diskettes, tapes and drive cartridges, all of which need to be stored in a safe, dust-free environment. Of course, you can stuff them into drawers or shoeboxes or even inexpensive disk file boxes. The problem is in creating a system that allows you to put your hands on a specific disk within seconds, if you ever need to reinstall or reference it. We suggest buying, not individual disk file boxes, but a modular system that allows each box to be attached to other boxes. Then put like with like: your master digital imaging diskettes in one drawer, working masters in another, system and utilities disks in a third drawer, other applications disks in a fourth, etc. Label everything clearly, and file them either alphabetically or some other logical order.

SyQuest cartridges are large enough to be stored in their own boxes on a bookshelf. Because we have so many SyQuests, we label each one numerically on the spine, as well as stick a label briefly describing what images are stored inside. We also maintain a detailed catalog on the computer, which we print out every time we add a cartridge. Those stapled sheets stay by the bookshelf, so we can quickly look up what's on which cartridge. We keep our MO cartridges in a plastic box originally designed for audio CDs, and label them the same as we do the SyQuests.

We keep our backup tapes in individual disk file boxes, one box for each computer. One set of tapes is labeled for the days the backups are made, such as Saturday, Monday, etc. Other tapes are simply labeled IMAGES 1, IMAGES 2, etc. As with the SyQuests and MO tapes, we keep a computer file and printout handy for quick reference.

We recommend using an image file database, which we will discuss more in detail in Chapter 27.

⇨ Cleaning kit

As every good photographer knows, dirt and dust are intractable enemies. A single speck of dust on a negative can create an ugly, unwanted white spot on a print. The more specs, the dirtier the prints, and the more spotting and retouching must be done to salvage the print. Dust is even a greater foe to the digital imager. It can mar scans, and, if a pervasive enough problem, it can cause serious computer errors. Too much dust on chips and boards can cause a heat build-up, which in turn can severely shorten the life of the computer, cause data losses on floppy disks, short out electrical contacts, and even start fires.

Almost all computer stores sell cleaning kits and products for computer monitors, disk drives, keyboards, tape drives and, of course, the computer itself. These include miniature vacuum cleaners, cans of pressurized air, chemically soaked cleaning pads, semi-abrasive cleaning floppy disks, cotton swabs, and cleaning tapes. We use a combination of canned air, a hand-held computer vacuum cleaner (the type that's acs powered, not battery powered), and specific solvents to keep our systems clean. Ideally, we should have plastic covers and shrouds to throw over all the equipment when we shut down in the evening, but besides being ugly, they tend to be a nuisance. We use floppy disk and tape drive cleaners about once a month, to wipe the heads of residual magnetism and gunk that inevitably accumulates. Just about the most useful tool we use to clean is an electrostatic camel's hair brush, bought at a camera store for cleaning negatives and transparencies. It wipes the dust off without building up an electrical charge that attracts even more dust.

We strongly advise buying an assortment of cleaning products and using them regularly. You may be tempted to use common household cleaners or standard office products rather than the more expensive computer cleaning products, but we have found that they simply aren't suited for the computer's more exacting needs. For instance, using anything but the fluid developed for cleaning monitors will streak and may even scratch the CRT's surface.

⇨ Tools

There are only a few tools that you need for working on your digital imaging system:

➤ Screwdrivers

➤ A pair of needle-nosed pliers

➤ A flashlight

➤ A magnifying glass

Daniel uses a $20 Black & Decker electric screwdriver as his main computer tool. It has just enough torque to tighten (but not overtighten) every computer screw. It's also fast, and comes with all the heads you will ever need. The pliers are useful for removing jumpers from boards, tightening nuts, crimping cables, and other minor tasks. The flashlight and the magnifier are necessary to see the markings on the boards. Any repair that requires other tools should probably be done by a technician.

⇨ Safety items

Sitting by each of our computers is a small Halon fire extinguisher. Fire is one of the possible disasters that can befall any piece of computer equipment. If you use water or a regular fire extinguisher to put out a smoldering circuit board in a computer, scanner, or whatever, you may as well throw out the device when the fire is extinguished, because it will be completely ruined. Halon, being an inert gas, won't short out electrical components, or leave a powdery residue that must be carefully cleaned away by hand. To save both your life and your computer, keep Halon extinguishers on hand.

Another product we use religiously in cold weather is an anti-static dissipator. Sally's is a large mat that sits beneath the keyboard and Daniel's is a little box that's situated under the monitor, but they work the same way. When approaching the computer, before we sit down, before we touch anything, we touch the mat or the box. Both have ground wires that are attached to nearby radiators, so any static charge we've built up by walking across the floor will be instantly dissipated. A single static spark has enough electricity to instantly destroy chips and boards. It's much safer and cheaper to install some sort of anti-static device before you do some real damage.

Many believe that monitors pump out harmful electromagnetic emissions that can cause cataracts, miscarriages, and perhaps even cancer. We don't know for certain, but we have Polaroid filters on several of our monitors, just in case. They not only cut down the glare

and filter out EM emissions, but by grounding them to a nearby pipe or radiator, they resist picking up the dust and fluff that all strong magnetic fields attract. If your monitor doesn't have an anti-glare coating or isn't MPR-2 compliant (the Swedish safety standard for EM emissions), we recommend adding a screen filter that will give you those attributes.

Because our offices and studio are part of our house, and since our only employees are family or people who have earned our trust, security isn't a problem. But if you have traffic coming in and out of your digital studio, or you live in a high-crime, high-risk area, you should consider installing any one of a number of security devices to your equipment. These include anchor chains, cables, and the like. They won't protect you from a vandal or a persistent burglar, but they can discourage thefts of convenience and opportunity.

How valuable are your images and designs? Important enough to be stolen or copied? If so, consider protecting yourself against industrial espionage or prying eyes. There are any number of hardware and software products for keeping your data secure, such as keyboard locks, data safes, data encryption, etc. Don't assume that simply because the studio door is closed, that your computer data will remain confidential. Make it so by making it difficult for any would-be idea burglar to see what's on your hard drive.

Cable extensions, connectors, gender changers

Ideally, you will never need these very inexpensive devices, if your computer, printer, keyboard, and other peripherals are clustered closely together. But if, like us, your digital imaging system is spread out over your office or studio, or if you add or daisy chain devices that don't come from the same vendor or manufacturer, you will probably need an assortment of cables and adapters.

Extension cables will allow you to stretch the distance between your computer, monitor, printer, keyboard, mouse or pointing device, film recorder, etc. Unlike regular extension cords, which can be added ad infinitum without experiencing any power loss, there's a practical limit on the length that you can stretch. Parallel printer cables should be no more than 15', and the total length of all SCSI cables must not be more than 15', though serial cables can stretch up to 52' or so. Any longer, and the electrical signals the wires carry might be too weak to fire correctly. Either the device won't work, or more likely, there will be maddening, sporadic errors that you won't be able to troubleshoot or correct. We sometimes have numerous devices (printer, SyQuest and MO drives, scanner, etc.) on our SCSI chain, which gives us a total length of more than 15'. Through experience, we've found it

easiest to disconnect one of the devices we're not currently using, in order to shorten the chain. You're only asking for trouble if you try to extend the length beyond its safety margin.

There's another solution, at least with parallel and serial cables. Several manufacturers sell relay boxes, which are $75–$100 cigarette pack-sized electrically powered devices that will intercept the weak signal, boost it to full power, and send it through an extension cord or cable. Typically, extenders will allow you to place your printer 75' to 100' away from the computer, and if that's not long enough, you can attach additional relay boxes and extension cables until you have the right length.

Another common problem, especially with SCSI cables, is when the cable itself, regardless of length, just won't work perfectly and consistently. Some are simply superior: the wires are thicker, the shielding better, the contacts are gold-plated, etc. If you are experiencing errors and problems and can't trace it to anything else, suspect the cable. As a rule of thumb, the thicker and more expensive the cable, the better its quality.

Cables and connectors come in two varieties: male and female. Sometimes there's no rhyme or reason which gender your computer has and what gender the device is, so you may find that the cable that you have simply won't connect. Rather than stop all work and rush out to the local computer store, we keep a shoebox filled with a variety of connectors and gender changers. It has been a lifesaver more times than we care to count.

⇨ Nonessential accessories

Walk into any computer superstore, and you will see shelf after shelf of interesting, appealing but quite unnecessary products. These include such things as swivel monitor stands, mouse holsters, copy stands, keyboard skins, disk organizer consoles, footrests, computer pedestals, diskette notchers, paste-on keyboard calculators, etc. There's even a miniature, hand-lacquered Corvette model that slips on top of the Macintosh mouse, just so the user can have fun pushing a car around and clicking on the hood.

What you buy or do not buy is strictly a matter of budget and personal preference. We own and use a fair number of these gadgets. Daniel uses the monitor stand to swivel his monitor about anywhere on the desk, or swing it out of harm's way. He uses a foam rubber platform, called a Lapcat, that allows him to put his keyboard in his lap and prop his feet up on the desk. Sally uses a ribbed footrest to soothe her stocking feet and a plastic file folder glued to the side of her monitor to hold papers and current documentation. And no, we don't have a Corvette cover on top of our Macintosh mouse.

WHATEVER dream machine you fantasize about—whether it's a Porsche 912 or Cadillac Seville—when you are finally able to purchase it, it will remain nothing more than a very large and rather expensive doorstop, unless you fuel it up. Computers, scanners, recorders, printers, etc. are lifeless, ineffective metal boxes filled with silicon and wire that are connected together with sophisticated circuitry. Nothing useful can happen until you fill them with their own special kind of fuel—software.

Imaging programs are the software that provide all the information that is necessary to transform your computer and other hardware into a powerful visual arts tool. Think of imaging programs as the high-tech equivalent of a pen and pad, paints and brushes, film and filters, drafting tools and rubber cement.

There are essentially six kinds of programs used in imaging:

➤ Illustration or draw programs

➤ Paint or photograph manipulation programs

➤ Desktop publishing programs

➤ Accessory programs

➤ CAD/CAM programs

➤ Multi-media programs

These six categories are somewhat arbitrary, though generally accepted within the digital imaging industry. A great deal of overlap exists, and it could be argued with validity that some of the programs that we put into one category could also fit into another. Our aim is to give our readers a handle on how to judge what a program does, and not to get into animated discussions over semantics.

⇨ Illustration programs

Illustration programs turn your computer monitor into a blank canvas on which you can place colors, shapes and figures, very precisely or with artistic splash. Even for those of us who have no talent for holding a brush, it's possible to create professional quality drawings, charts and other graphics, provided you have a sense of style, aesthetics, and composition.

The typical tools associated with illustration programs are those that emulate the functions of pencils and stencils and work with an electronic palette of colors and, sometimes, texture options. Components of images made with an illustration program are layered pieces (such as a circle, a square, a shape or a line) that are filled and outlined with colors and fitted together by design. The better

illustration programs have a great deal of finesse in working with type, providing a variety of very creative techniques for manipulating letters, numbers, symbols, and words as part of the composition.

Illustration programs can look deceptively simple, especially when compared to paint programs. But the more powerful ones can dramatically change the way visual artists tackle certain kinds of design projects. Some of the most popular illustration programs are *Aldus IntelliDraw*, *CorelDraw*, *Aldus FreeHand*, and *Adobe Illustrator*. With these programs, one can compose and execute—from scratch— glossy advertisements worthy of Madison Avenue, as well as fine art images that many galleries would be proud to exhibit.

Illustration programs are generally thought of as software for creating a picture entirely within the computer. But that doesn't mean you can't and won't incorporate photographs, sketches, shapes, or textures that are imported into the computer from the real world. One popular use of photographs in illustration programs is to trace their outlines and then fill them with color, turning them into cartoon-like images. However, these programs are not the ones to use for editing photographs. They don't interpret picture data in the way that is most conducive to working with the detail required by photographs. (See sidebar.)

Some programs that could be considered to fit into this category of illustration software include graphics programs like *Harvard Graphics*, which are best used for making charts and graphs. However, they are really business-oriented, somewhat limited, and of only marginal interest to the professional visual artist.

Object-oriented or bitmapped

The essential difference between paint programs and illustration software is in how the computer organizes the data that make up the pictures.

Object-oriented (also known as vector*) software creates images according to mathematical formulae that define the shape and color of their elements, such as a line, a circle, etc. This produces sharp delineations between elements and hard transitions between colors, such as that which is typical of poster-like illustrations.*

Bitmapped (also known as raster*) software creates images by organizing a collection of thousands or even millions of individual dots. Each dot, or pixel, has a defined value that identifies its precise color, size and placement within the image. This provides a more natural blend between components, as in a photographic image.*

It's an easy distinction to remember, with its own inherent mnemonic (memory aiding) names. Object-oriented *programs work with* objects; bitmapped *programs manipulate dots or individual bits of data.*

As a rule, illustration programs create object-oriented images, while paint programs work with bitmapped images. Object-oriented images can be scaled to any size without changing the amount of data associated with them. Bitmapped images will lose (actually throw away) data when they are made smaller and may lose some data integrity when made larger. There are other qualities about an image that change, depending upon how the data that define it are organized.

We will return to this concept frequently throughout this book, because it's a critical factor of how software tools will function, how output of the image is handled, what kind of file format is needed, etc.

Paint or photo manipulation programs

Paint programs are often called photo manipulation or editing programs because they have some very sophisticated tools for editing, perfecting, or otherwise extending the vision and appearance of a photograph.

Like human bodies, precious few photographs are perfect. A photograph might need retouching because the lighting was off, the sky not blue enough, the model may have circles under her eyes, or any other number of problems occurred in the shooting of the picture. Such corrections have always been possible with refined darkroom skills or highly talented airbrushing. Computer imaging only makes it easier and more precise (though not necessarily less expensive, when you calculate in the cost of equipment and training).

For instance, when Sally photographed sunset at Pemaquid Lighthouse in Maine, the light was perfect, no tourists got in the way, and the film's reciprocity factor (the tendency of film to change color during long exposures) gave the twilight a very appropriate pink tinge. The only problem was that because of restoration work being done on the lighthouse, there was scaffolding on one of the buildings. She removed the scaffolding by working on the picture for about a half-hour in a program called *Photoshop* on our Macintosh Quadra 700.

On the other hand, the real excitement (and the true financial value) in electronic photo manipulation is in using a photograph only as a starting point for a completely new picture. Full-blown paint programs such as *PhotoStyler*, *Picture Publisher*, *Color Studio* or *Photoshop* provide a remarkable array of tools and techniques, so that the variety of possibilities is limited only by your imagination. You can make fireworks form sparkling eyes, bring a statue to life with flesh tones, turn a summer day into a sci-fi nuclear winter, cross a dog with a flower . . . whatever.

Paint programs may also be used for some very creative illustration work that has no relationship to any photo, but is created completely within the computer.

The tools that tend to be associated with paint programs include pencils, paintbrushes, airbrushes, etc., plus those that allow you to cut and paste, copy (clone) or retouch. Special filters that come with the program (or are sold by other companies) will completely change the picture by sharpening, blurring, creating special effects, etc.

Compared to illustration software, paint tools and techniques are more complex and give greater flexibility. The brushes, pens, and other such tools usually have a wider variety of options associated with them. This diversity is inherent in the concept of working with individual dots, as opposed to fully formed objects. (See sidebar.) Think of how many more permutations are part of working on a circle that is made up of hundreds, thousands or millions of dots, as compared to one that is a single, defined shape.

Probably one of the most definitive aspects of paint programs is the masking tool. Masks allow you to limit, with great precision, exactly where you want a tool or filter to take effect, and where in your picture you want no change. For instance, suppose you have a photograph of a child but want to change the color of his shirt from blue to red. To do this, the digital artist draws a mask that isolates the shirt from the rest of the picture. He can then alter its color without affecting the colors in the rest of the image. Or suppose you want to create a stucco wall effect on part of a house, without adding the texture on the shed or the porch. You would draw a mask to delineate exactly where the stucco should go, and then activate the appropriate filters.

Those examples demonstrate the most obvious way to work with masks. You can also use them to define how two pictures will merge into a montage, as well as create unusual and spectacular special effects. If you can conquer the somewhat arduous techniques involved in drawing accurate masks, you will have developed the skills to be a superb imaging technician. (Please see Chapter 20.)

Illustration programs have no need for masks, because each shape in the illustrated image is already defined as an object that is separate from other shapes.

One particularly exciting paint program that stands apart from the rest is *Fractal Design Painter*. It provides tools that emulate fine art methods and techniques. For instance, one of the several options in the paintbrush menu converts your drawn line into a thick, almost multi-dimensional stroke that looks like something Van Gogh would have done in oils. Other options include textures and styles of watercolor, pointillism, charcoal, chalk, and many others. The

background will react to the stroke according to the characteristics of various paper textures, and you may choose from between wet paint or dry paint behavior. You may copy a scanned-in photograph with any of the paint tools, so that your picture will look like a painting done in any of a variety of media. Sally adores working with *Painter* and continues to discover new creative possibilities with it.

Paint programs tend to have higher resolution capabilities and the potential for greater subtlety than illustration programs. (However, the final resolution rests in the capacity of the output device. A high-resolution file printed on a medium-resolution color printer will produce a medium-resolution print.) In addition, because color is a much more sensitive issue with photographs than it is with illustrations (though some might argue with that statement), the color editing in photo manipulation programs tends to be much more sophisticated. In fact, just learning and using some programs, such as *Color Studio*, is an education in the theory and practice of color. You will find yourself editing, manipulating and otherwise working in new creative ways in a picture's various color channels. (See Chapter 26.)

⇨ Desktop publishing programs

Page layouts that used to be done on a drafting table with concentrated measuring, cutting, pasting, etc., are now done by computer. The programs that do the work of a typographer, typesetter, paste-up artist, stripper, and layout artist are desktop publishing software, or DTP for short. If you are using a computer to lay out a full page ad for a glossy magazine, produce a corporate newsletter, publish an entire book, or create anything with text and images that will be printed, you will need to know how to use DTP programs like *PageMaker* or *QuarkXpress*. These and similar programs will take type from word processing programs and pictures from imaging programs and combine them as a page or a document file that can be sent to a print shop or output to a desktop printer.

Most digital imagers don't use desktop publishing on a regular basis, but the images you create are likely to be exported to a DTP program for final page layout. In fact, the overall process of getting your image into print (prepress) will affect how your pictures are used and seen. So, it would be very useful to understand as much as you can about the electronic layout process.

On the other hand, if you want to extend your business into a design studio that provides a complete service from concept to output, then you will need to master desktop publishing and prepress.

Accessory programs

Accessory software are those programs that are important for imaging, but not central to it. In other words, none of them actually create images, but they do affect your imaging in some way. Examples of accessory programs are:

- ➤ Add-on filters
- ➤ Color management software
- ➤ Font utilities
- ➤ Device drivers

Add-on filters

Add-on filters provide a wider variety of special effects than the filters that are generally included as part of paint programs. The best known add-on filter program is *Aldus Gallery Effects*, which can plug into (be added on to) many of the better known programs, such as *Fractal Design Painter*, *PhotoStyler*, *Photoshop*, etc. Some of the *Gallery Effects* filters include mosaic, watercolor, emboss, chalk & charcoal, poster edges, fresco, etc. No serious computer artist that we know works without at least one package of supplementary filters installed on her computer. Yes, it is possible to work without them, but it's like cooking without access to spices and herbs. On the other hand, be careful not to get caught in the trap of allowing a very easy and recognizable filter effect to take the place of good design.

Color management software

All imagers are faced with a number of dilemmas centered on the fact that the color you see on your monitor will never exactly match the colors you'll get on your final print. The problem is so pervasive that a variety of hardware and software schemes have been designed to try to solve it, or, at least, to get the two color schemes close enough that you can make an intelligent choice for the best possible match.

Color management programs take several shapes, including color editing, color calibration, color coordination, color guides, etc.

At the time that we are writing this book, the one program that stands apart as a superb, intuitive, easy-to-use color editor is *Cachet*. It helps determine the correct color balance, saturation, hue, light, and shadow levels for any specific photo or image. And that it does with speed and simplicity. It also warns if colors you choose will not be printable by specific output devices. (However, the list of printers presently supported is limited.) If you are manipulating photographs with your

computer, you will find *Cachet* takes care of otherwise time-consuming tasks in the click of a mouse.

Color calibration programs may or may not include the use of a device called a densitometer or color calibrator. The densitometer is attached by a suction cup directly to the monitor and reads the colors that the software displays. The information it gathers from reading the colors is fed back to the computer (to which the densitometer is attached by cable) so that adjustments may be made to the way color is displayed when a particular paint or illustration program is loaded in. *Kodak ColorSense* is an excellent example of this kind of software/hardware product.

Agfa's *FotoFlow* system is currently the prime color coordination software. Rather than trying to make your monitor conform to some supposed ideal, as color calibration does, it attempts to keep track of the color characteristics of scanners, monitors, film recorders, and printers, as they influence an image. The idea is to keep the picture's colors as predictable and accurate as possible.

Color guides include the familiar color swatch books that printers use, such as *Trumatch* or *Pantone*. Those two (and others) have software equivalents, so that you can see the color on the monitor and relate it to how it prints out.

We will cover color management in Chapter 28.

Font utilities

At one time or another, almost every computer artist will want to put letters or words into an image. Perhaps it's to use type as part of the design, or maybe it's because the designer wants to convey written information within the picture. While most imaging programs have the ability to insert print into an image (illustration software does it with more finesse than paint programs), font generators and type design programs provide a wider array of possibilities.

Font generators, like *Fontographer* and *Typecase*, install onto your computer a variety of fonts, such as Baskerton, Manuscript, Art Deco, etc., as alternatives to the traditional Times Roman, Helvetica, or Courier. If you aren't satisfied with the fonts that you have, or if your service bureau recommends buying a particular manufacturer's typefaces in order to be compatible with the ones they use, you can purchase libraries of scalable fonts from many different sources. Some cost only a dollar or two a typeface, while others are much more expensive. There's no direct relationship between cost and quality. Some of our best-looking fonts were bought cheaply from a no-name source, and conversely, we are stuck with expensive and mediocre fonts created by a famous font manufacturer.

Don't give in to the temptation to install as many different fonts as you can lay your hands on. Not only do they take up inordinate amounts of space on your hard disk, but they can cheapen any image you use them on. There's a general rule of thumb that the sign of a poor designer is using too many kinds of fonts in a single image. In addition, too many fonts will slow up your computer, especially when you're using a PC running under Windows. Instead of going for quantity and variation, get to understand the attributes of individual fonts and the mood they will lend to the picture.

Adobe Type Manager, a font rasterizer, takes installed outline fonts and automatically builds them to the requested size, so that they may be displayed on your screen or output to your printer. (See Chapter 26 to learn about the varieties of fonts, including outline.)

The most important criterion about what fonts you should use in a design is whether or not your print shop (or your client's print shop) supports that font. If you provide a digital file to a printer that includes a specific type, that printer cannot reproduce it unless they also have their own copy of the software that created that typeface. An interesting utility is a font converter, like *Font Manager* or *Metamorphosis Pro*, which will change font formats and may help you deal with some compatibility problems.

A type design program specializes in type as an art form. For instance, *Pixar Typestry* and *Strata Type 3D* have special effects tools that are used in conjunction with a collection of font outlines to create dynamic and exciting letters, words and symbols. They may be incorporated into another image or stand on their own as a visually exciting picture.

⇨ Device drivers

Unlike most other accessory software, device drivers are absolutely necessary for your imaging system if you have a scanner, printer, film recorder, mouse, or other equipment connected to your basic computer. Device drivers are those programs that tell your computer what other hardware is attached and establishes lines of communication between all the components of your system. Every time you attach a scanner, film recorder, printer, mouse, stylus, etc., you will probably have to install software (which usually, but not always comes with the hardware) onto your hard drive. Without these drivers, your computer won't know what the other pieces of equipment are trying to say to it.

Multiple device drivers, especially on the PC, are often the source of incompatibility problems, which in turn can cause the computer to behave in strange ways or even freeze. The Macintosh device drivers are much better behaved, although they too can occasionally cause problems if not properly tweaked. Perhaps, some day in a future

better world, there will be a single standard for all device drivers. Until then, ask for a guarantee of compatibility among your drivers before purchasing a new device for your system.

⇨ CAD/CAM programs

CAD/CAM stands for "Computer-Aided Design and Computer-Aided Manufacturing." They're highly sophisticated and technical computerized design programs used in drafting, making blueprints, architectural drawings, renderings, and models. CAD/CAM creates templates that are used in the manufacturing process and for scientific modeling. Based on precise mathematical formulae, it's designed more for the engineer, architect and draftsperson than an artist or illustrator. You've seen CAD in those 3-D cutaway or wireframe representations of what a new car design might look like.

Traditionally, CAD/CAM programs have required very high powered machines, large monitors, lots of memory and co-processor boards, all of which translates into big bucks systems. Also, the software has tended to be very expensive, because it is highly specialized and sold to a limited market that has the funds to pay for premium-priced programs. But there are now numerous less expensive programs for both the Mac and the PC.

Advanced imagers are fascinated by certain powerful tools that come out of the CAD/CAM world, such as three-dimensional modeling and texturing (also known as texture mapping). That's why there is now a range of design programs that are addressing the interests of imagers, such as *Design CAD 2D/3D*, *Infini-D*, *Sculpt 3D* and *AutoDesk 3-D Studio*. Sally uses *3-D Studio*, which is expensive and cumbersome but offers fascinating modeling and mapping options. While we don't recommend CAD/CAM as a primary imaging tool, after you have mastered paint and illustration programs, you might want to experiment with incorporating 3-D effects into your pictures. In the meantime, keep an eye out for some of the new programs that will be coming out that use CAD/CAM-type effects with illustration and paint-generated images.

⇨ Multi-media programs

Digital imaging has blurred the lines between those artists who make a living creating still images and those involved in animation, presentation, and other various forms of computerized multi-media. While this book focuses on still imagery, there are quite a few programs that use the same or similar tools and skills for making slide shows, developing animated presentations and working with video. These include very business-like programs such as *WordPerfect*

Presentation or *Corel Show*, as well as much more fanciful programs such as *AutoDesk Animator Pro*. To see some of the cutting edge stuff that is coming out in multi-media, look at the more incredible music videos shown on MTV or check out some of the special effects in science fiction movies and TV series.

Much of what you will learn about illustration and paint programs in this book will start you off in developing the basic knowledge for multi-media. However, you might want to think your choices through very clearly, before you decide to diversify that widely. Yes, multi-media can be very profitable, but it also requires an even greater investment in equipment and education, as well as the development of new business skills, to help you succeed in an entirely new market.

⇨ Professional quality imaging programs

While there are scores of programs on the market, not all of them conform to the rigorous standards that are required by professional quality imaging for commercial or fine art. The following are the basic questions a computer artist will ask about a piece of software:

> ➤ What size file does the program support? Can it work with files at least as large as 30 megabytes? If it is a paint program, can it handle resolutions of at least 2750 to 4000 dpi?

> ➤ Will the program support 24-bit graphics, which will allow you to select from 16.7 million colors?

> ➤ Does the program provide a diversity of tools that can be customized by the artist according to varying design requirements? (See Chapters 18–24)

> ➤ Is the program compatible with a range of file formats, so that the user may import or export an image between it and other software? (See Chapter 25)

The answers to all these questions should be yes. Of course, there are exceptions. Sometimes, you'll want to work in fewer colors to force more severe transitions between shades. Or, you'll accept a program that is limited to 256 colors and has fewer tools, because that program (such as the fractal landscape program *VistaPro*) has some unique or interesting attributes. However, as a rule, professional quality imaging requires these listed minimum parameters. While that does limit the range of programs from which you'll want to choose, eliminating quite a few lightweight products, there are still dozens of top-notch professional-quality programs. We'll explore all these issues and how to judge a program's capabilities in the following chapters.

 # What program is right for your needs?

As is inevitable in a healthy and growing market, in which manufacturers are always trying to re-invent the wheel and package it more attractively, there is quite a bit of overlapping of attributes among professional-quality programs. Some are designed to do one thing, and one thing only, while others can blend elements of illustration, photo manipulation, desktop publishing, CAD/CAM, type design, font generation, color editing, add-on filters and multi-media in one package. However, no single program, no matter how comprehensive it is, will completely satisfy a serious imaging artist, even within each category of software.

As you begin imaging, you should focus on one program and master it, for the sake of your budget and your learning curve. That one program should address the specific kind of imaging you want to do. For instance, if you plan to work primarily with photo manipulation, *Photoshop* and *PhotoStyler* are the main contenders, though *Picture Publisher* has much to offer, and we're keeping an eye out for *Color Studio's* next release. If you want to do more illustration work, get *CorelDraw*, *Adobe Illustrator*, *Aldus Intellidraw*, or some other mainstream illustration software. An imager's preference among the top imaging programs is a very personal thing. Generally, we advise that once you have narrowed down your choices among the most powerful programs in each category, pick the one that has the most functions and attributes that you need for your work. (The following chapters will help you pinpoint the functions that are available and how you might use them.) You might also want to buy the program whose most recent version is the latest when compared to similar software, because each release is a leapfrog attempt to offer more than its nearest competitor.

Eventually, though, you'll probably want a library of programs, moving image files from one to the other and back again, or out to a third program to take advantage of different tools. For instance, among Macintosh paint programs, Sally currently feels that the brightness/contrast controls in *Color Studio* are more dynamic than those in *Photoshop*. She prefers using the automasking tool in *Picture Publisher* on the PC for isolating the fly-away tiny strands of hair that elude other programs. However, for defining masks for bigger areas and for sophisticated paste controls to be used with those masks, she prefers *PhotoStyler* or *Photoshop*.

As powerful and amazing as these heavyweight programs are, they have so many commands, tools, and special effects no one artist can know everything that they can do. Also, because needs and objectives change with every imaging project, and because she is constantly

learning new approaches with even her old standby programs, Sally's preferences among software are constantly changing. So we aren't about to presume to tell you what program is best for your needs. The purpose of this section is to provide you with the knowledge you will need to judge what imaging programs do, how well they do it, why you might need certain attributes over others, and how to develop the skills and knowledge necessary to take full advantage of all that they do offer.

17

Beating the steep learning curve

OKAY, you've decided that digital imaging is the shape of the future. Even so, you've heard about the steep learning curve that is involved, that it takes work, persistence, and—most significantly—time to become professionally proficient at it.

It's one thing to be prepared to invest tens of thousands of dollars in hardware and software. Money is not an irreplaceable resource. It's really no more than a measure of purchasing power that ebbs and flows with each new project or assignment. Hopefully, the new equipment and programs will increase your earning potential and the kinds of jobs you'll be able to take on.

But time is something else entirely. It's the most expensive commodity anyone can spend. Once it is expended, it is gone forever. You'll never see that day or week or month again. No, time is not money; it's much more valuable and far more precious.

The bad news is that we have no magic wand that you can wave to fashion an instant intelligent link between your new imaging system and your mind. You will have to make the commitment to spend the time to learn how to image well. But the good news is that we do have some tips on how to master an imaging program comparatively quickly, with greater success and a higher degree of creativity than is the norm.

The trick to learning imaging is to image

Recently, we heard a consultant tell a group of visual artists that they really don't need a computer to understand digital imaging. While it is true that you can read quite a bit about the subject, until you actually get your hands on a keyboard and a stylus, if only for a few hours at a seminar, digital imaging is no more than an abstract idea.

Think about finger painting. Could you learn how to do it without getting your hands dirty? The feel of the paint, the textures your fingerprints make, the effect on the composition caused by changing the pressure of your hands, how the colors mix when you swirl compared to when you dribble—in other words, the essence of what it is to finger paint . . . None of this can be learned by just reading about it. That's the real difference between art and technology. Art requires a direct and viscerally experienced connection between action and result.

For this reason, we strongly recommend that anyone seriously considering this medium for professional work get a hands-on experience on a digital imaging system. No, we are not suggesting that

you go out tomorrow and buy a system. In fact, we advise against making that kind of financial investment until you have a chance to try imaging for yourself. Who knows, you might not like it (though we have yet to meet any visual professional who has tried digital imaging for a few days that didn't become an enthusiastic convert). More importantly, until you actually experience imaging, you cannot possibly begin to plan how you will use it in your business. And until you gain that perspective, you can't know what kind of hardware and software you will want and need, or if you can realistically project an increase in income from it that would justify the purchase.

⇨ Imaging workshops, seminars, & schools

Our first, best advice is to get to a digital imaging seminar or workshop. There are dozens of companies and schools that conduct hundreds of classes, seminars, and workshops throughout the country, either at permanent locations or in hotels and motels. Chances are there will be one held near where you live within a few weeks or months. The number of organizations teaching digital imaging are proliferating at such a quick rate that it is literally impossible to name them all.

⇨ Free programs

If possible, start with a three-hour or one-day program, sponsored by a dealer, distributor or manufacturer of software or hardware. They're usually free; the price you pay for them is to make yourself accessible to salespeople (who can be very persuasive and pressuring). You'll be a captive audience in a lecture hall setting, probably in a hotel meeting room, where you will see demonstrations of programs or equipment. You can find out if any are being held soon and nearby, by checking the business section of your newspaper, looking in local trade journals, calling dealers who sell digital imaging equipment that are listed in the computer section of the Business-to-Business yellow pages, asking at a local service bureau or print shop, checking with the local graphics arts association or computer user groups, or calling the toll-free lines of companies that are prominent in the field (like Agfa, Aldus, Adobe, Apple, Nikon, EFI, Canon, Tektronix, Polaroid, Lasergraphics, etc.).

These programs can be useful introductions into what imaging looks like, what equipment is being used, how the software works, what some of the basic techniques are and a perspective on how much all this marvelous technology is going to cost you. Don't expect to get much direct hands-on experience. Usually, the manufacturers or dealers each bring one or two examples of what they're trying to sell and give group demonstrations with their equipment. Because there

may be several dozen or more people attending, you may get only a 5- or 10-minute opportunity to try the hardware or the software yourself, during breaks, before moving over and letting the next guy try it out.

Attending one of these mini-seminars is something like taking a glass-bottom boat ride in Florida, whereas full-blown imaging is more like scuba diving Australia's Great Barrier Reef. But if you haven't actually seen imaging, it's a good place to start. In fact, we continue to attend such seminars from time to time, just to see what new products are coming onto the market and to take advantage of the networking with other computer artists who often attend. Need we say it? Don't forget that the ultimate purpose of these seminars is to get you to buy something. Leave your checkbook or credit cards at home, until you know more about the subject and what you want to do with it.

⇨ Short workshops

The next level of workshops are tuition-based half- or full-day programs designed to teach you a specific skill, a particular program, or mastery of a certain piece of equipment. Depending on who is conducting them, the subject, and the length of the program, they can cost upwards of a few hundred dollars. The big advantage is that they guarantee that you will have your own computer on which to work throughout the class.

Like mini-seminars, workshops are held year-round at hotels, motels, and other meeting halls throughout the country, by several dozen national companies. They advertise extensively in the business pages of local newspapers. In addition, digital imaging workshops have become among the most popular sessions at national or regional trade shows, such as Viscomm, PhotoWest, Computer Graphics, etc. Some workshops are not transient or temporary. In larger cities, training organizations have established permanent facilities for teaching professionals various computer programs and skills, including digital imaging. They're listed in the yellow pages. Among the best known is The Apple Market Center in New York City, run by that computer company to promote imaging on the Macintosh platform. There are Apple Centers in nine other cities, which, at the time of this writing, are just beginning to offer imaging workshops.

Here's what to expect. In the classroom will be a dozen or more Macintosh computers, one for each student. At present, not many teach on PCs, because there are such a variety of makes and models, and because the students must have prior computer skills before beginning a course on PC digital imaging. In contrast, the basics of using a Macintosh can be taught in under an hour, even to those who have never touched a computer before. (What you learn on a Mac will help you image on a PC and vice versa.) You will have the exclusive

use of one of the computers for the entire seminar. Installed on that computer will be the imaging program you'll be learning—usually *Photoshop*—and your computer may be networked to a printer, scanner, or other devices. At the front of the classroom will be the instructor's system, usually hooked up to a large screen monitor or video projector, so that you can see what he is doing as he manipulates the computer. The students follow along on their own machines.

These short workshops are good, though limited, introductions, but they can be confusing for those who have little computer experience. You'll see and experience a little of what digital imaging is about, but it's still only a tantalizing hint of things to come. To use another scuba analogy, these short workshops allow you to get wet, but you're still only snorkeling, skimming the surface, unable to chase ideas to the full depth they can take you. That isn't to say you shouldn't enroll in one or more of these programs—quite the opposite. They offer informative, effective opportunities for you to try out the technology. That, in turn, may help you discover how it could affect your creativity, which might ultimately lead you to change the way you do business.

If your time is valuable and if you are uncertain whether you want to get involved in imaging, take one of these workshops before you invest the time and money to take a full-blown course.

⇨ Imaging courses

Eventually, you will want to jump head-first into imaging. That's when it's time to take a few days off and head to one of the numerous schools that teach the subject. The most famous school is the Center for Creative Imaging (CCI) in Camden, Maine. Conceived and originated by Kodak as a way to turn visual professionals to digital imaging (who would, hopefully, then become customers for Kodak's many digital imaging products), CCI was opened in the summer of 1991. For corporate reasons that had nothing to do with CCI's success or failure, Kodak sold the center to a private group of investors in January of 1993. It's too soon to tell whether the new owners will make major changes in its style of teaching and administration.

At present, CCI is probably the most important and influential mecca for would-be digital imagers. In its first two years, it attracted thousands of students, most of whom paid between $400 and $3000 in tuition (which doesn't include room & board) to take 3-, 4-, or 7-day courses on various aspects of digital imaging. (There are some 2-week and longer programs.) Taking a class at CCI has been compared to a religious experience, where acolytes come to be converted and indoctrinated. The facility remains open 24 hours a day to give

students access to their computers, so they can learn by experimenting, making mistakes, and following through on projects and techniques that were only hinted at in class. It is an intense, exhilarating, exhausting, mind-boggling experience that is now being imitated in many other schools with varying degrees of success.

An increasing number of prominent photographic schools, including the Santa Fe Photo Workshops and Palm Beach Photo Workshops, now offer digital imaging courses. The Apple Market Center in New York City has not only the single-session programs we just mentioned, but also 2–3 day abbreviated versions of those offered at CCI, taught by CCI instructors. The art, design, or computer departments at many colleges, traditional art schools, and other well-established schools (such as the New School for Social Research in New York City) have developed computer art laboratories and offer extensive courses in both their adult education and regular degree programs. In other words, unless you live in the wilderness, there's probably some imaging course near you.

Choosing your imaging course

With so many imaging courses now being offered, it may be difficult to discern which ones are the best for you. Here are a few questions you should ask before putting down your money and setting aside your time to attend:

➤ Is each student guaranteed his own computer with a stylus and enough hard disk space to save work in progress? Are the computers outfitted with SyQuest drives, so that you may save and take your images away with you in electronic form at the end of the course? (We suggest bringing your own SyQuest cartridges, because most schools will charge $75–$105 each, though you can get them from a computer superstore or by mail order for $65–$75.)

➤ Is the teacher's monitor projected onto a large screen for easy viewing by the class? When a student is sitting at her computer, is there a guaranteed clear view of the screen where the teacher's monitor is displayed?

➤ Will the student have access to her computer after classroom hours to pursue projects and experiment with what is learned during the class?

➤ What kind of prints will the student be able to make of her images? (Dye-sublimation, ink-jet, etc., see Chapter 14.) How many free prints will the student be able to make from images created during the class or in after hours projects? How much will the student be charged for additional prints?

> ➤ What is the teaching and imaging experience of the instructors? Will teaching assistants be available to answer questions and assist students with imaging experiments after classroom hours?

> ➤ How many students will be enrolled in the class? What is the ratio of students to teacher and teaching assistants?

> ➤ How much computer experience should you have to take the course? Is an introductory tutorial on the computer provided? (Typically, a computer basics class is offered the evening before the course starts for those students who have little or no experience on the system that will be used.)

> ➤ How long has the company or school been in business? How long have they been teaching imaging? Try to evaluate their reputation by contacting former students and asking established imaging professionals what they think of the program that you are considering. (Seminars and schools vary in quality considerably, but there are many good ones that are well known.)

> ➤ What is the object of the course? What can you expect to learn? What course materials will you be given to take home with you?

> ➤ What follow-through is offered? Will you receive a newsletter, discounts on future courses, membership in a local alumni group, etc.?

⇨ How to learn a new imaging program quickly

No matter what you do, how many classes you attend, how many books and magazines you read, eventually, it will all boil down to sitting at your own computer, staring at a blank monitor, and fondling a shrink-wrapped box containing that new imaging program you have just purchased. It's a moment charged with anticipation and, if you aren't prepared for it, fear. This is the crucial point for most future imagers, in which their success or failure in learning is rooted in their state of mind. If you can accept the inherent uncertainty, channel the excitement and anticipation you're sure to have, and if you are willing to recognize that, though you may not know what to do, you will be able to find out, then you will learn quickly.

Happily, even though you are alone in your studio or office, there are quite a few resources available at your fingertips. The very first is in the shrink-wrapped package itself. The documentation (the instructional booklets that come with a computer program) is usually divided into at least three categories: installation, tutorial, and reference. In addition, somewhere in the documentation, under technical support, troubleshooting, or, perhaps, on the copyright

information page, is a phone number to call for help. When you buy the program, you are also purchasing the right to call the company for help whenever you need it, though the quality and length of that support does vary considerably. (See Chapter 33 about how to work with a technician over the phone.)

The first step is to install the program onto your hard disk. Installation tends to follow one of only a handful of established formats, so it's relatively easy to do. We rarely have to consult the documentation during the installation process, though you may need to have certain information at the ready, like the kind of graphics board and printer that your computer system uses.

After you have successfully installed your first program, you will begin to recognize the method of subsequent installations. Almost every piece of imaging software has simple instructions somewhere in the documentation, often in a separate booklet or even on a one page card or flyer. Follow them exactly, step by step, and you will probably be up and running within five minutes to a half hour, depending upon the size and complexity of the program. It is usually very easy. (There are some few exceptions, usually with more complex programs like *AutoDesk 3-D Studio*. For these you will probably need help. But they tend to be expensive programs that often include installation in the price of purchase.)

Next, be sure to set aside an entire morning, afternoon, or evening to take the program's tutorials. Sally usually learns new programs in the evening or on weekends, when she won't be interrupted by important phone calls. On the other hand, Daniel feels that it is best to tackle learning on weekdays, especially during business hours when the company's support personnel would be more likely to be available over the phone.

Tutorials are usually broken up into several lessons, so that they can be taken one at a time. But we have found that such a shotgun approach is ineffective. By the time you get around to taking lesson two, you will probably have forgotten much of what you learned in lesson one. The problem compounds as the number of lessons increase. If possible, try to take all the lessons in one sitting.

The tutorials tend to be very basic, easy to follow, almost juvenilizing. Stick with it, even if it seems beneath your knowledge or skill level. In a very short time—sometimes less than an hour—you will develop the skills to function within the program.

That's when the fun begins. Get out the reference portion of the documentation, the part that goes into detail about all the known functions, tools, and techniques possible with the program. (Some

programs offer so many permutations and possibilities that not even the manufacturers can document them all.) If you are a linear thinker and work logically, you will want to start on page one, trying out the effects on your computer. Then, you would move on to page two, page three, and so on until you have gone through the entire book and tried all the techniques described. Time and again, Sally has tried to learn that way, but she is always distracted by "what-if" scenarios. For instance, while reading about a certain filter, she might become curious how it would work with color separations. So she'll experiment with the program until she hits a brick wall and doesn't know what to do next. Then she'll search out the color separation section in the reference index. That, in turn, might send her off in search of information about, say, how the program handles color balance. Such a serendipitous approach can pay big dividends in creativity.

Somewhere between starting the tutorial and browsing through the reference, you will have begun some of your own imaging. It just happens, because you get curious about how a command you discovered would affect one of your pictures. So, you pull in a file of one of your scanned-in photographs or open a new file in which you start painting on a blank screen. Then you get in trouble and have to check the reference to see what you did wrong—or, quite the contrary, what you did right, though it wasn't quite what you meant to do.

We heartily recommend this kind of improvisation and experimentation. The most successful imagers we know are constantly pushing programs beyond what the documentation says they can do. Some of the more interesting effects Sally has produced were the result of mistakes—incorrect commands initiated, the wrong button being pushed, the merging of two pictures with inaccurate parameters, etc. The problem is recalling, in correct order, how it happened, so you can reproduce the accident, with a measure of control when you want it again.

One piece of happy news: almost all imaging programs use similar tools, techniques, and conventions, regardless of whether you are using a Mac or a PC. That's why each program you learn will make the next that much easier to master. In the next few chapters, we will present an overview of typical imaging tools and techniques to help you develop an even better learning curve.

By the way, you never really stop learning about a program. Even after years of working with a specific piece of software, you'll discover new techniques, perhaps even develop ones that have never been documented by anyone else. With imaging software the variables are numerous, so the potential for new discoveries is almost inevitable.

 # Putting together an imaging library

Beyond the documentation that comes with a program, there are other learning aids, including books, videotapes, and magazines.

In all major bookstores and computer stores, you will find racks of what are called "third-party" manuals—instructional books that are published by companies other than the software manufacturer. They tend to be better written than the program's own documentation because the authors are usually professional writers, not technicians or engineers. Nor are they restrained by the manufacturer to not discuss critical or negative aspects about the program of which the user should be aware.

On our bookshelves, we maintain a library of as many third-party manuals as we can afford. For instance, we have five books on DOS, three on System 7, two on *Photoshop*, four on Windows 3.1, three on *QuarkXpress*, etc. Some we read from cover to cover (or at least Daniel does), while others are referred to only to solve a particular problem or to better understand a specific command. Third-party documentation is extremely useful—an invaluable resource of information, suggestions, and ideas. It's the second place we go to (after the official documentation) whenever we have a question about a function of the software.

We also read numerous magazines and newsletters on imaging that are published monthly or quarterly. Some are free, while most are not. We subscribe to more than a dozen of them; it helps us keep an eye on what other artists are doing, descriptions and reviews of new products, and whatever other tips and tricks we might be able to extract from them.

Although we continue to view them as they become available, we have yet to find an instructional videotape on imaging that we feel is worth buying and viewing. It's not only because we firmly believe that sitting in front of a TV is no way to learn how to image. Quite frankly, those that we have viewed have been dreadfully superficial and boring. Given that multi-media presentations are becoming excitingly innovative specifically due to digital imaging technology, we wouldn't be surprised to eventually see a new generation of truly useful, interesting and inspirational videotapes on learning digital imaging. But there's nothing worthwhile out there yet.

⇨ Users' groups

Back in the ancient pre-PC/Mac days, when TRS-80s, Apple IIs, Commodore Pets, and CP/M machines ruled the roost, getting computers to work properly—as well as learning how to use specific programs—was much more problematical than it is now. Documentation was far too technical and poorly written to be useful. Manufacturers didn't provide toll-free numbers by which one could speak to an army of technical support personnel. And the software, though much simpler, was hard to learn, full of bugs, and more limited. It was a difficult situation that most could not master.

Solutions were found or problems were ameliorated by checking with the local computer guru. Back then, a computer guru was defined as someone who had five minutes more experience than you did. Most were ready, willing, and sometimes able to assist their fellow users. In turn, some of those they helped became experts themselves to the next generation of computer neophytes. These self-made experts don't offer their time and talents to show off (although they certainly are not reluctant to boast of their technical prowess), but because they have a genuine spirit of openness and a desire to help.

Eventually, there were large numbers of hackers (expert computerists) and users, looking to compare notes and capitalize on the successes and solutions developed by their peers. Ad hoc groups spontaneously coalesced, usually by responding to an invitation posted at the local computer store or college bulletin board to attend an informal meeting at someone's house, office, or an empty classroom. To their delight and surprise, these meetings often brought out dozens or even hundreds of like-minded computer users.

That's a quick thumbnail sketch of how *users' groups* came into being. Users' groups are local collections of individuals who use computers, and who freely share advice, tips, and tricks that they have learned, based upon personal and professional experiences. Most users' groups have some central theme, whether it is that they all are users of a specific piece of software, a type of computer, involved in certain kinds of applications, etc. Others are just loose associations of people involved, one way or another, in computers. Our local computer club has about 200 members. (Some users' groups have thousands of dues-paying members.) It meets monthly in a nearby library and divides itself up into smaller special interest groups, such as Lotus 1-2-3 users, individuals involved in desktop publishing, WordPerfect users, etc. Another group we know of is made up of professional printers and typesetters.

The main purpose of a users' group is to provide a forum for getting together to talk about common computer problems and solutions,

having the opportunity to see product demonstrations, and, generally, helping each other as much as possible.

Users' groups can be a remarkable resource, if you can connect with the right one. Personal tutorials may be arranged with fellow members. You may also be able to network with technicians and other experts who can help you out in setting up, troubleshooting and maintaining your system.

To find a group near your office or home, ask at your public library if anyone is meeting there on a regular basis. Also, check for information in publications such as a local computer tabloid or national computer publications, like *Computer Shopper*. If there are universities in your area, the computer departments might know of a group or have notices up on their bulletin board. Computer stores often have lists as well. Commercial on-line services like CompuServe or Prodigy maintain national forums for exchanging information and often maintain lists of users' groups. Users' groups may set up booths at local computer shows. Also, contact major software and equipment manufacturers for referrals to groups that focus on their products. There's usually a nominal membership fee.

Once you get into the loop at a users' group, you will find that someone always knows someone else who has had a similar problem or has recently learned a certain program with the help of another person. It is a very valuable network of people who have varying degrees of experience. However, beware of the "know-it-alls," who really don't understand what digital imaging means to the visual professional, yet will still be very generous with inaccurate or unwarranted advice.

Find your fellow imagers

Of course, the ultimate resource for help in learning and mastering digital imaging is other imagers. By its very nature, imaging is something of an isolating experience. You sit alone at a computer for hours on end, manipulating the smallest of details. Yet, the healthiest thing to do is to get your head out of the monitor and see what is happening out in the world of imaging, what fellow artists are doing, how imaging is being used in the marketplace, etc.

Fraternizing with other artists is a time-honored creative tradition, whether it's in cafes, in studios, or at exhibitions. Traditionally, these were called salons, a word that has become outmoded but is still highly respected. Whatever you call it, it is a fertile playground of the mind, where conversations are exciting exercises in synthesizing new concepts from disparate individual ideas. Yes, in some manner of speaking we are all in competition with each other, but so were Van

Gogh and Gauguin. We have found that whenever we share our thoughts about an imaging program or process, we have learned much more. (That's one of the reasons we are writing this book and enjoy teaching and speaking about imaging so much.)

Seek out your fellow computer artists. They understand your problems and successes. They have struggled to learn the same programs you are now studying and may have suggestions that will carry you over the hard times. There are no better tutors or coaches. Besides, it's fun to talk with someone who is involved in the same kind of experimentation as you are.

We look for, and often find fellow imagers at computer support groups, product demonstrations, meetings of trade organizations such as ASMP (American Society of Media Photographers) or AIGA (American Institute of Graphic Artists), or at trade shows. We also eavesdrop on fellow customers at stores (like Ken Hansen in New York or Mid-City in Philadelphia) that specialize in digital imaging products, and then strike up conversations with anyone who exhibits interest or experience in the field. We hope that by the time this book is published that some national group of computer artists will have been formed. If it hasn't, it should be started soon, and we would be happy to work with the organizers. Once it exists, it will be a stronghold of advice and information for novices and experts alike to continue to learn new imaging programs and techniques.

18

How to navigate through almost any paint program

A FEW YEARS AGO, we got gloriously lost walking about Istanbul. We actually enjoy being lost in a new place, because that is how we learn about the area, meet people, discover the interesting nooks and crannies, and, generally, have something of an adventure. Of course, we always have a map in our pockets and enough local currency to be able to take a taxi back to our hotel. So, we feel comfortable about taking unexpected turns at unknown intersections and wandering down a promising path that might lead to a dead end. But this time in Istanbul, we had an appointment to meet a professor friend at 5:00 at the Blue Mosque. It was already 4:30, and, though we knew we were somewhere in the neighborhood, we had no idea which curving alley would get us there in time.

We stopped a man on the street, and, since we didn't speak the local lingo, pulled out our map, pointed to the Blue Mosque on it, said the name in various languages, and, with universal gestures, communicated to him that we didn't know where we were. Could he please show us our location on the map, so we could find the way to our meeting? He obviously wasn't an uneducated man, because he *could* read. But, apparently, he had no idea how to use a map and, therefore, could not show us where we were. The concept that an abstract two-dimensional graphic of squiggly lines and bright colors could represent the streets he knew so intimately was completely foreign to him. Fortunately, he was a gracious gentleman. So, he beckoned to us to follow him and escorted us the ten blocks or so to the Blue Mosque.

The imaging terrain is like navigating through Istanbul. All you need to get around is a sense of adventure, plus the ability to interpret the signposts. You simply have to learn how to read the map (or, in this case, your computer monitor) and understand the symbols it uses. Fortunately—and this is the key to mastering imaging quickly—the symbols, tools, and techniques of imaging programs are almost universal. Learn one program, and you'll have a headstart on learning others.

Identifying your neighborhood

There are essentially two kinds of imaging programs that you will probably use—paint (or photo manipulation) software and illustration software. Because there are important differences between the way these two types of programs handle graphics, it is necessary to recognize what type you are working with, before you can proceed.

As we discussed in Chapter 16, paint programs work with bitmapped images, while illustration programs are object-oriented. Bitmapped (or raster) refers to those images that are made by organizing individual

bits (or dots) of data. Object-oriented (or vector) software sees everything in your picture as a distinct and complete object.

Similar tools, icons, and techniques will behave differently, depending upon which kind of software is being used. In this chapter, we'll explore those that are usually identified with paint programs. The following chapter will cover additional ones that are associated with illustration software.

But remember, despite the essential differences between these two kinds of programs, there is a great deal of overlap. In fact, computer artists, who never use photos as the basis of their work, will still use bitmapped paint software to do very sophisticated illustration. And some new bitmapped software now offer some object manipulation tools.

Imaging's icons & the tools they represent

Start up almost any imaging program and much of what you will see on your screen will probably be similar to almost any other imaging program. Of course, the greatest similarities are among programs that fit into the same category of software: paint or illustration or whatever. They all have certain common features, the most familiar being icons (the various symbols in square blocks). These icons represent tools that emulate the properties of the item pictured. For instance, if you see an icon of a paintbrush, then, by clicking once on that icon, you'll be able to draw lines or shapes as you would with a real, physical paintbrush.

These icons are usually arranged in rectangular groupings (sometimes called *toolboxes*) on the side of the screen. Typically, double-clicking your mouse or stylus when the cursor is on a specific icon will give you access to various options associated with that tool. See Fig. 18-1 for a typical screen layout.

Not every paint program offers all the tools we describe below, and the sophistication of the options for each tool will vary, depending on the software. That's two of the major differences among programs. Let's look more closely at these icons.

 Whenever you encounter a new tool, double-click the icon or locate the options box elsewhere on the monitor. Then change one option at a time and try the adjusted tool on your picture to see what effect it has. When you become more sophisticated, you'll experiment with combining adjustments in numerous options to create a completely different look.

Figure 18-1

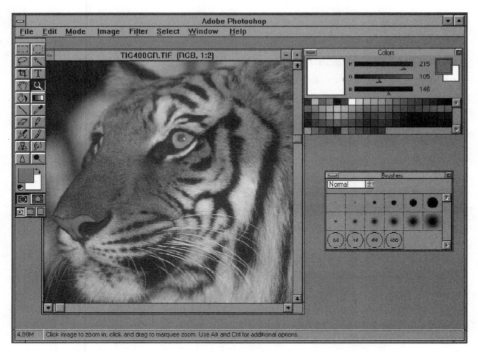

Adobe Photoshop screen with the toolbox of icons on the left, the color palette on the upper right, the brushes palette on the lower right, and a scanned-in photo (© Sally Wiener Grotta) ready to be manipulated.

Painting or drawing tools

Every paint program has a paintbrush; most also offer a pencil, pen, air brush and other typical artist tools. A few more elaborate programs, such as *Fractal Design Painter*, even have chalk, charcoal, and other painting tools. A few examples are

The options that may be available for these painting and drawing tools may include the shape and size of the brush, pencil, or whatever, as well as transparency, spacing, rate of flow, soft edge, density, feather, fade, pressure, etc. We have no intention of trying to be encyclopedic in explaining the many possible variations, but here are a few guidelines to keep in mind as you experiment and learn.

Most paint programs supply basic *brush shapes*, such as circles, ovals, squares, and lines, in a variety of sizes. You may choose from among

provided shapes and sizes for your drawing or painting tool, or create your own custom brushes. For instance, do you want to paint with five-pointed stars or the silhouette of a daffodil? Depending on the program, you may create brush shapes on a graph by drawing them freehand or by capturing them from an existing picture. The custom brush option can also create new sizes for the standard brush shapes. One paintbrush icon from Aldus PhotoStyler is

The *transparency* option defines how opaque or see-through your brush strokes will be. This is usually specified by a numerical percentage. Painting with a transparent tool is a very effective and creative technique, especially for mixing colors, blurring shapes, and making ghost images.

Spacing is a measure of which pixels will be changed when you draw. (Pixels are the tiny dots that make up the bitmapped picture paint programs create.) Sometimes, you want only every few pixels to be altered; usually, you want a continuous line. The default setting for spacing should be freehand, continuous, or zero, which will lay down paint according to the speed with which you move your stylus. For a steady, continuous line, don't move your stylus any faster than your computer can respond. You'll develop a feeling for this as you gain experience with each program.

When you paint in the real world, especially with wet paints or an airbrush, if you hold the tool still, the paint will continue to lay onto the canvas, spreading out from the point of contact. For instance, when an artist uses an airbrush, she may move slowly for a thicker application of paint or quickly for a thin one. In the computer world, you can mimic this effect with the *rate of flow* option. A rate of flow of zero will keep the color from spreading and give your stroke a hard edge. Choosing any number above zero will increase the rate of flow in direct proportion to the size of the number. So, at a rate of flow of 20, the paint would spread out more quickly than at one of 15.

Soft edge or *feather* (which sometimes is also called *fade*, but should not be confused with *fade-out*) allows the edge of your lines to either gradually bleed into the background or to be sharply delineated. The higher the number you choose as your soft edge or feather variable, the greater the amount of bleed. A soft edge setting of zero will create a hard edge. Your choice will depend upon the style of the picture and the design relationship of the image elements. Some items must have hard edges; others become disjunctive within the image unless they blend in smoothly. We'll encounter this concept again in Chapter 20 when we discuss masks.

Fade-out is an adjustment to make your stroke diminish in size as you apply it. The beginning of the stroke would have the appearance of

having been laid down with more pressure or more paint than the end of the stroke. A continuous level of *pressure* may be adjusted for the entire length of the stroke. (The higher the number, the harder the pressure.) Some programs also have a *density* option, which defines just how fine and soft a line the tool will create.

Of course, there are other options in various paint programs. The more tool options that a program offers, the more you will be able to customize your work.

HINT The trick to mastering any tool or option is to experiment with it on different kinds of pictures.

Tips on precise mouse control

Working with a pointing device on your desk to draw lines and shapes on your screen can initially feel like making love through asbestos gloves, at least for those artists who are used to the physical feel of drawing directly on paper or canvas. But if you keep working at it, it does become second nature rather quickly. Here's some tips that will increase your finesse and sensitivity with a pointing device.

- *Use the right pointing device for the job and your personality. Most artists prefer a stylus when doing the actual work on their pictures, because it handles like a pen. However, Sally often switches off from her stylus to a puck for a more positive reaction to selections when working with pull-down menus and other non-drawing functions.*

- *Don't rush ahead of your computer. How soon a line appears on your screen after you have drawn it with your pointing device will depend upon how powerful your computer is. On a fast machine that is loaded with memory, drawing a simple monochromatic line can be almost instantaneous. But regardless of what kind of computer you have, at some time or other, your hand will want to move faster than the computer. Then, there will be a delay of a second or so between moving the pointing device and the resulting effect appearing on the screen. That means you'll be making design choices based on what you think will shortly be happening on the monitor. That's when problems arise. Slow your hand down to the speed at which your computer can react.*

- *Take advantage of whatever constraining tools your software provides. Some software will help you maintain control by providing constraints. For instance, in Photoshop, if you hold down the Shift key while using any of the drawing tools, then whatever direction you draw, it will always produce a straight line. (Of course, keep the Shift key depressed through the whole procedure, releasing it only after you have released your stylus button.) Similarly, tools are available to constrain shapes and masks to exact squares or perfect circles. Seek out whatever techniques your program offers before you depend solely on freehand drawing.*

- *Use masks as valuable constraining tools. A mask will limit where you may paint on your picture, so that only certain areas will be affected by the movement of your stylus. (More about masks later.)*

- *Save your work to your hard disk often and in separately named files. If you save your picture each time it is changed dramatically, then it is easy to revert to that file should you make a mistake. For instance, suppose you invest two hours in perfecting a picture. Some of the steps might include creating a difficult to draw mask, using the paintbrush to create a translucent texture, sketching in some shapes with the pencil, etc. All these jobs are controlled with your pointing device. What if all the work is to your satisfaction, then suddenly you move the stylus incorrectly, giving the computer an inappropriate command and introducing a major flaw. If you haven't saved the other work you'd done, you'll have lost two hours. (Yes, there is usually an "Undo" command, but that does have its limits.) It's best to save separate files of the image in various stages of development, so you can always go back to any point and try some other variation.*

- *Be patient. The first time a novice picks up a pointing device can be intimidating. But keep at it and go slowly. Usually, artists find what is happening on the screen so exciting, that, within an hour or so, the use of the pointing device becomes a transparent, instinctive technique that gets only easier with practice.*

 # Current color boxes

Somewhere on the monitor, probably under the toolbox of icons, are two squares or rectangles that represent the current choice for foreground and background colors. In most programs, when you create a new image file it will be the color of the currently selected background color. When you use the drawing or painting tools, your strokes will be the current foreground color (unless you tell the program otherwise). When you cut out a portion of an image or use the eraser tool, the resulting color will be the current background color.

It is easy to change the background and foreground colors. Usually, all you have to do is double click on the relevant color square and then choose a color from the color dialogue box that comes up. In most professional programs, it's possible to display an abbreviated color palette on your monitor at all times, so that you may change your colors more quickly. The command for keeping the small color palette on your monitor is usually under "Window" or "View" in the pull-down menus at the top of the screen.

You can use the *eyedropper* tool to pick up a new foreground or background color from the palette or from an existing image. For

instance, if you like the richness of a blue in a field of flowers, use the eyedropper to select that blue from a picture of those flowers. Some examples of eyedropper icons are

The options involved in working with color are much more complex and will be described more fully in Chapter 22.

Use foreground color If . . .

In some paint programs, your options with the current color extend into other interesting possibilities. When you call up a tool, you may have the option of painting with the foreground color: always, if darker, if lighter, hue only, color only, brightness only, additive, subtractive, etc.

Always is the default, which means that the color your tool will use will be the foreground color.

When the *if darker* option is chosen, then, when you move your tool over the image, it will use the foreground color only if it is darker than what is already there. For instance, if the current foreground color is green, if it passes over any color lighter than the foreground color, it will change it to the current foreground color of green. But if it passes over a darker color, such as olive green or blood red, then nothing will be changed. The *if lighter* option reacts in the opposite manner, changing the colors of the image only if the foreground color is lighter than the existing ones.

A tool that is using the *hue* of the current foreground color as its paint, will change the hue of the image, but not its brightness or saturation. Similarly, you can paint with *brightness* or *saturation*.

Additive and *subtractive* simply add and subtract light from the colors over which the tool passes.

Other terms used to define how a painting or drawing tool will act on a picture include *luminosity* (increases the brightness of a color according to the brightness of the current foreground color), *multiple* (increases the darkness), *screen* (lightens the established color and introduces a tint of the foreground color over it), and *dissolve* (works with the density of the established color and replaces a random number of the existing pixels with the current color).

Different programs may use different words to describe similar color choices made by the painting or drawing tools. (And to make things difficult, some programs may use similar words to describe diverse functions.)

These tool options are used in other ways, such as when you "cut and paste" portions of images into a montage. (See Chapter 24.) Try each one of these options on a test picture to get a feeling of what it does and how you might use it.

⇨ The clone

The *Clone* tool replicates a section of a picture exactly, by picking up the color, texture, saturation, shapes, etc. and copying it either elsewhere on that image or onto another image. In effect, you are painting with a portion of a picture, rather than with the current foreground color.

For instance, suppose you have a portrait photo of a politician, and, being a member of her staff, you know you really should get rid of the age spots under her eyes. Use the clone tool to pick up the color and texture of her flesh from between the spots, to paint over those unwanted areas. Or, maybe you have a beautiful picture of a cuddly puppy, but one of his front teeth is broken. With the clone tool, you can rebuild the broken tooth with elements from the adjacent one.

There are two components to a clone, which is why many of the icons that represent it show twin symbols. (Other programs represent it as a rubber stamp.) When you use the tool, these two components are used on your picture in the following manner:

> ➤ You anchor the *source* point to an area in your image that you wish to copy. This source identifies the pixels or area of your picture with which you will be painting.

> ➤ You use the *clone* or duplicating point, moving it about over the area that you want to paint.

Think of the source point as your paint and the clone point as your paintbrush. You pick up your colors, brightness and shapes from the source and apply it with the clone. For instance, if you place your source point on a red rose, then the clone will paint a duplicate of that rose in another spot on that picture or on another picture.

 HINT Experiment combining cloning techniques with the additive, subtractive, hue only, if lighter and other color options (available in only some programs). It's an interesting use of the tool that can create unusual effects.

Two options available with the clone tool that are important to understand are aligned (aka rubber stamp) and unaligned. They relate to the positioning of the source point.

If the source point is *aligned*, then as you move the clone point (the point that is doing the actual painting), the source point will remain in the same relative position to the clone point; and when the clone or painting point is moved, say, a ¼ of an inch to the left, then the source point will also move a ¼ of an inch to the left of where you originally put it. For instance, suppose you anchor an aligned source at the corner of an eye. Then, as you move the painting point, it can create a duplicate of the whole eye.

If the source point is *unaligned*, it is supposed to stay where you put it, regardless of where the painting clone point goes. So, if that source point is still the corner of the eye, but it's unaligned, you'll keep painting the corner of the eye wherever you move the cloning point.

Often the artist will be confounded when an unaligned clone begins to behave as though it is aligned. That's because, in most programs, the source will move relative to the clone point's movement, as long as you keep the mouse button pressed when you paint. It's a useful option that can give you absolute control by being able to switch constantly between aligned and unaligned. However, if you forget, you'll end up with a mess and have to use the Undo command or revert to the last saved version of the picture to start all over.

Sometimes other options are available for the clone. For instance, a *revert* clone uses elements of the last saved version of an image to paint onto the current version. Suppose you've changed a picture's color balance to improve the flesh tones, but you preferred the red of the man's suspenders as they were. You would mask the suspenders (to assure they were the only portion to be affected) and use the revert clone to restore them to the original red.

Masking tools

Masking is an essential component of effective imaging with paint programs and one of the hardest to master, which is why we devote an entire chapter to it later in the book. Perhaps, it would be easier to understand the function of masking tools if we'd use their other name—*Selection Tools*. They allow you to select a specific portion of your picture, to separate it from the rest of the file, so that any effect, tool, or technique that you apply will change only that portion and

nothing else. For instance, if you select a beach ball in a picture of a backyard barbecue, by drawing around its edges with a masking tool, you can apply a filter to it or change its color or brighten it up, and the rest of the image will remain unchanged. You can also move that masked ball to any part of the picture, copy it, or cut it out of the image and paste it into another.

A masked item may be resized, skewed, rotated, and manipulated in various other ways. The power and control that masks give you is one of the most important aspects of the potency of paint programs. Some masking tools appear as

Please see Chapter 20 for a detailed discussion of masking techniques and options.

Bezier tool

Imagers either love or hate the *Bezier*; there's no halfway attitude about this tool. Essentially, it gives you the control to draw very straight lines or perfectly defined curves, even to the point of doing exact outlines of very irregular shapes. For this reason, it can be a valuable masking tool, a method which we will cover in the chapter on masks.

Available in only some paint programs, the icons for this tool tend to be confusing. It may be represented by a pen tip, but in other software a drawing pen can look very similar. Or, it may be represented by a line with dots, but so can a mask manipulation tool. Another icon may be a pencil or pen tip on a line with end dots. Look over the documentation to determine which icon is used to represent the Bezier curve, if the program has it at all. Here's a few visual examples:

Because the Bezier is used more in illustration programs, we'll discuss it in Chapter 19.

The fill tools

Don't be misled by the *bucket* icon that is part and parcel of most programs. The fill tools that bucket represents are much more diversified and more controllable than just spilling a bucket of paint onto a canvas, though you can do that too. They include smart fills, gradient fills, and texture fills.

A *smart fill* is controlled by a color similarity (or color tolerance) option, which is usually accessible by double-clicking on the icon or finding the option box elsewhere in the program. If you have a color similarity of 1, the fill tool will seek out those pixels that exactly match the one on which you clicked and change those pixels to the current foreground color. For instance, suppose the current foreground color is royal blue and you use the smart fill tool by clicking it inside your picture right on top of a pink pixel. If you choose a color similarity of 1, then only those dots in the picture that exactly match the pink one will be changed to royal blue. But if you choose a color similarity of 10, then the computer will be less literal, changing pixels that are almost the same color as that one pink pixel. A color similarity of 32 has even more leeway, and one of 64 can include some reds and mauves as well. In some programs, the smart fill will change the colors only of adjacent pixels that are within the designated color tolerance. Others will seek out all pixels within a picture that match. A really high color similarity can change the image to a blank canvas filled with the current foreground color.

A *gradient fill* is not only a useful tool, it's great fun to play with. Gradients are gradations of color that may be dramatic or subtle, depending upon what color model you use and which program is generating it. For instance, you could have a gradual shading between two colors, or you could create a rainbow. (The rainbow effect is generally created by using an HSB or HSL color model. See Chapter 22.) One effective use of gradients is to fashion a metallic or other reflective surface, by introducing highlights along the same hues as the rest of the object. (Some programs have gradient palettes available for gold, bronze, silver, and the like. But they aren't difficult to make yourself—try experimenting with the colors you think are in a gold or silver spectrum, ranging from an almost black to an almost white for the highlights and shadows.) Or, suppose you want to paint a realistic sky. A quick method would be to make a gradient of sky blues—no real sky is ever one single color.

The options for gradient fills may include shape or style, color model, repetitions or color sweeps, mixing control, transition, etc. Some of the icons look like this:

Gradient *shapes* or *styles* can be linear, circular, elliptical, rectangular, square, etc. These terms relate to how the colors change, not the final shape of the item being filled. For instance, you can have a circular gradient of colors radiating from a midpoint outward in concentric waves to fill a square space. See Fig. 18-2 for visual examples.

Figure 18-2

Linear horizontal fill

Circular fill from foreground to background

Square fill from foreground to background

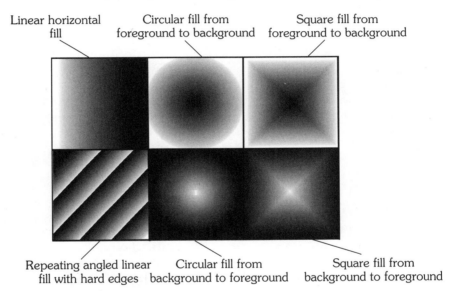

Repeating angled linear fill with hard edges

Circular fill from background to foreground

Square fill from background to foreground

Sample gradient fills. The foreground was defined as black, the background as white.

While the gradient always uses the established color palette, which is often taken from the current background and foreground colors from a user-designated palette, the *color model* of a gradient defines just how the colors will change. Depending upon the program in which you are working, if you chose an HSB (Hue/Saturation/Brightness) color model or an RGB (Red/Green/Blue) one, and if you decide that the gradient should be clockwise or counterclockwise around the spectrum of colors, you may end up with a very delicate transition between two colors, or a gaudy ribboning of several hues. (See Chapter 22 to learn more about the color models that govern how a gradient is made.) The best way to learn how to control gradients is to experiment with the tool.

The *repetitions* or *color sweep* option tells a gradient to repeat itself as many times as you wish. For instance, if you define a gradient from yellow to red and tell it to repeat three times, you'll end up with one that goes from yellow to orange to red to yellow to orange to red to yellow to orange to red. (In some programs, the gradient might go from yellow to orange to red to orange to yellow, etc., which is a more natural transition between the repetitions.)

Mixing control is usually a sliding scale that defines where the midpoint of the gradient will be—at half way along the continuum of color or at some other percentage point. This skews the gradient nicely, so that not all the colors are evenly represented.

The *transition* option allows for a soft or hard *edge* between colors or between repetitions, depending on the program. Sometimes the softness of the edge is a numerical figure, so that its amplitude— strength of effect—is adjustable.

In many programs, the gradient fill dialog box has a scratch pad, so you can test out any adjustments you make without affecting your picture. If there isn't a scratch pad, make a low-resolution empty image window to use as a test pad. The more you doodle on the computer, the more control you'll develop over the tools.

Drawing a gradient fill is a simple matter, after you have selected your options. Simply move your cursor to the point where you want the gradient to begin, hold down the left button of your mouse or push down the point of your stylus while you draw in the direction you want the color changes to go. Release the button at the point where you want the last color of the gradient to be. Unless you use a mask to define just where you want the gradient painted, it will, in most programs, fill your entire picture. In one exception—*Color Studio*— you can tell it to fill only that area defined by the "ramp," which is their word for the area between the user-defined starting and ending points of the gradient.

HINT Try using *Color Studio's* circular gradient fill, with the "fill ramp only" option in the four windows of a color separated file. Make a series of adjacent grey gradient circles in each of the four colors and then combine to the four-color image. It creates an interesting effect of bubbles.

Only some paint programs have *texture fills*. Instead of using the current foreground color, they paint with any one of a library of textures, such as brick, marble, glass block, basket weave, satin, etc. You can usually add to the library by creating new textures or taking some from your pictures. You may even be able to use that library of textures with your painting tools, so that a stroke is not a solid color, but is instead made up of grains, weaves, etc.

Many of the same options that are used with painting and drawing tools may be available with your fill tools. Remember to use masks and transparency options in conjunction with the fill tools for some interesting and creative effects.

 # The type tool

Invariably, you will want to add some type to one of your pictures. While there are some sophisticated specialty programs that will do this quite well (such as type design programs like *Pixar Typestry* or desktop publishing programs like *QuarkXpress* and *PageMaker*), most imaging programs have basic type capabilities that may be good enough for a few letters or words. If you want to use creative type as the centerpiece of an image, you'll find more and better options among illustration programs than in paint programs. The following discussion refers to type in paint software. (Illustration type options, which Sally prefers for the quality type they create, will be discussed in Chapter 19.)

The icons usually look like this:

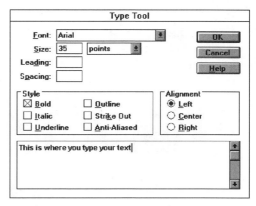

To use the *type* tool, you usually click on it once, then click inside your picture where you want the type to begin. That should open up the type options box, such as the one shown. (In some programs, you double-click on the type icon, make your choices among the options, then click on your picture where you want the type to go.) Depending on the program, you usually just type in your message or text, using the combination of two keys, such as Ctrl and Enter, to move your copy to the next line. You may also have the option of bolding, underlining, italicizing, etc. Imaging programs make use of whatever fonts or typefaces you have installed on your computer.

When done, press Enter, and you will usually see what are called "dancing ants" (the dotted lines that represent a masked area). These are temporary, and, as long as you see them, the letters you typed in can be moved, resized, skewed, rotated, or otherwise manipulated. The type can be filled with colors, gradients, textures, etc.—whatever

the program is capable of using. When you are done, choose the no mask option and the letters will be permanently set into the image.

 # The eraser

The *eraser* tool is used differently by different programs. In some programs, it is really just a painting tool (with all the painting tool options one expects, such as transparency, shape, size, etc.) that paints with the background color rather than the foreground color. In other programs, it is used to erase recent changes to the image, such as parts of a line you have just drawn. This is also known as a *local undo* tool. Some programs feature both eraser types, accessible through the options box of the tool or by holding down another key (such as Alt) while using the tool. Some eraser icons look like this:

 # Sharpening & softening tools

When working with real world charcoals, an artist will lay the color onto the paper and then use his finger to smear it into the picture. That is *exactly* what the computer's *smear* tool does. There are generally two different icons for smear or blur tools, which may behave differently. The finger is self-explanatory. Because you can't physically fingerpaint on a computer monitor, the software has to provide a tool that will do it for you. You can adjust the pressure of the finger smear through its options dialogue. (Some programs have a cotton swab smear, too.) The water drop tool tends to be more subtle, emulating water smears that cannot be increased with pressure. The icons for these tools often look like this:

The *sharpen* tool actually analyzes the differences between adjacent pixels and increases the contrast between them. So, if there is a red circle on a white background, and the edges of the circle are too soft for your composition, the sharpen tool applied along the edges will define them more fully. Use the sharpen tool sparingly. Because it changes the characteristics of the pixels in relationship to their surroundings, it can make small dots suddenly appear, where you once had a smooth surface.

If you don't see a softening tool icon on the monitor, look in the options for the sharpen tool, and vice versa.

The lighten & darken tools

The *lighten* and *darken* tools do just what their names imply to the areas over which they pass. (In *Photoshop*, they are known as a dodge and burn tool, taking their names from real world darkroom techniques. Burn will darken the image, while dodge is a lightening tool.) Essentially, they allow you to paint with light or shadows. It is possible to control the amount of lightening or darkening a single pass will do through a numerical option, with a higher number providing a greater change when you use the tool. (In some programs, the option is not numerical, but graphical or expressed in words, such as medium or heavy.) Many of the same painting tools options are also available, such as shape and size, spacing, feather, fade, transparency, etc., depending upon the program you are using.

Here's what these tools' icons normally look like:

The magnifier

When you are working on an image, sometimes you need to see it in greater detail. That's when you use the *magnifier* or zoom tool,

to enlarge portions of the picture. Usually, holding down the shift, alternate shift, alternate, or control key when using this tool will reverse the magnification, making it progressively smaller. In other programs, you might have to select the reverse magnifier tool, which will often be represented by a magnifying glass icon with a minus sign in it. Another magnification level may be shown as 1:1, which is supposed to represent real world size, displaying the picture in the physical size that you would see it on paper if the picture were printed out according to dimensions of the file (such as at 8"×10").

Imagers will often ratchet up the magnify tool so much that they end up editing the individual pixels that make up the picture. This is when digital imaging is its most meticulous, where a single dot out of millions can be created, changed, or deleted. Editing on this level can

be fastidious and time-consuming, and it's difficult to see what changes to individual pixels are doing to your image as a whole. That's why some programs have a windowing capability, so you can view the entire picture, while editing only a portion of it in another window (see Fig. 18-3). Whenever you work on the pixel level, either take advantage of these windows or frequently reverse the magnification to look at the results of your work on the unmagnified picture.

Figure 18-3

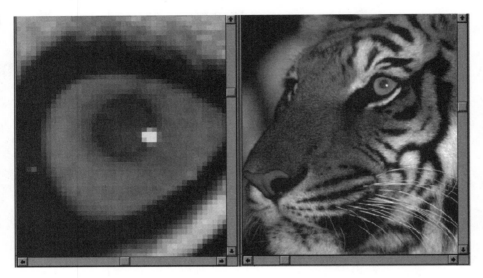

Tiger's eye magnified for editing on pixel level, with a normal size view in another window. © Sally Wiener Grotta

The moving hand

If your picture is larger than the screen, you can pull other portions into view using the *hand* tool, which resembles a hand:

It's a do-nothing tool that we often choose when we want to make sure that we don't accidentally call up any function that could change our image.

The cropping tool

Cropping is an easy procedure in computer art. This tool allows you to draw a perfect rectangle or square around the part of the image

that you wish to preserve. In some programs, click twice on the icon, which often appears like this:

to outline the entire image. Then, pull the corner or mid-line anchor points inward to put the outline exactly where it belongs. (In other programs, you click at one corner point where you want the rectangle to start and drag the cursor to the opposite diagonal corner to define your outline.) When you're happy with the crop lines, click anywhere inside them, and everything outside those lines will be deleted.

⇨ Pull-down menus

Across the top of your monitor will be a bar with words across it (see below). For instance, in *Color Studio*, they are "File," "Edit," "Scan," "Color," "Mask," "Effects," "View," and "Shapes." Every program uses different words, but you will quickly learn to discern where to find what. These are pull-down menus. To activate a pull-down menu, click your mouse or stylus on one of these words; a list of other options will appear below it (see Fig. 18-4 for an example). Click on the option you want, and it will either open up a dialogue box or offer yet another list of options in which you would click on the word that represents the option you want, etc.

File	**Edit**	**Mode**	**Image**	**Filter**	**Select**	**Window**	**Help**

File	**Edit**	**Mode**	**Image**	**Filter**	**Select**	**Window**	**Help**

Bitmap
Grayscale
Duotone
Indexed Color...
✓ **RGB Color**
CMYK Color
Lab Color
Multichannel

Color Table...

Figure 18-4

By clicking on "Mode," more options are revealed.

The pull-down menus hold almost all the commands, tools, and functions that aren't in the icons. These include color separations, filters, special effects, merge controls, tonal controls, etc.

If you're familiar with using a Mac or running Windows on a PC, there's really nothing new in how to navigate through pull-down menus. The difference is in the kinds of options that they offer. We will refer to only a handful here; more will be covered in other chapters.

If the rest of the screen is empty, click on "Windows" or "View." That's where you will usually find the command to show or hide the toolbox (the grouping of icons), the palette, and other command boxes.

In those programs in which the options associated with the icons can't be accessed by double-clicking the icon, you will probably find them in the pull-down menu. For instance, in *PhotoFinish*, you'll find them under "Options."

Under the "File" heading is where you will find the commands associated with importing and exporting data: scanning, printing, saving, loading, etc. Another useful file command is "restore" or "revert," which will return your image to the state it was in when you last saved it. This will negate recent editing changes, so you can start over again. Use restore as a last resort, when you really foul up. A better method is to make one change at a time on an image, and, if you don't like the effect, use the undo command. But at least this option is there, if you have to make wholesale changes. Remember, though, you can use it only if you have saved the file previously and recently enough to be useful. If your last save was two hours ago, all the work you did in those two hours will be lost if you use "revert."

Also under "File" is the command for creating or opening up a new image file. When you click on "New," an options box will ask you what size and resolution you wish the image to be. Change the numbers according to your needs and click on the OK button to make a new blank canvas. If the new canvas is intended only as a scratchpad for testing a tool or command, make the numbers defining it as small as you can (though not so small that it isn't usable). Then, any command you apply to it will be almost instantaneous. (The larger the file, the slower any effect will take place.) However, when you are creating a new canvas for working on an image, the numbers should relate to what you will need for your intended output.

Under "Edit" look for the "Undo" command. In most programs, this will allow you to wipe out the last thing you did to the image. For

instance, if you just applied a filter and don't like the effect, then selecting the Undo command will revert your image to what it was before you applied the filter. Usually, you can even Undo the Undo, such as reapplying that filter after you remove it. Many programs provide only a single-level Undo, which means that you can annul only the most recent command. Other programs have an option for multiple Undos that delete the effects of several consecutive commands. Not all commands can be undone.

The pull-down menus are jam-packed with tools and commands. Please refer to other chapters in this section for more extensive discussions of them. But as we have said and will continue to say, our most useful piece of advice is to just go ahead and browse through these menus, choose a command, play around with its options, and see what happens. When you make a mistake, browse through whatever books you have at hand, including this one, the documentation that came with the program, and any other volume on imaging to try to figure out what went wrong. That's the quickest way to learn how to image.

Conventions used in imaging programs

It's one thing to recognize what a symbol or command is. But you also have to know what the computer expects you to do to activate the function(s) of that symbol or command. In this, too, there are some standard conventions for interaction that make it easier for you to work with a new piece of software. The following are some of the symbols you'll encounter and what you should do with them. Many or all of them will be familiar to anyone who has used a Mac or Windows.

Cursor

A *cursor* is the graphical representation of where your mouse or stylus is positioned in relationship to the monitor. Whatever action you call up will take effect at the point of the cursor. Depending upon the program, the cursor may be represented as an arrow, a blinking dot, a solid square or a thin line. Its shape may change, depending upon what tool you have activated and where on the monitor it is. In some programs, you may also change the shape of the cursor under the *Preferences*, which is usually (but not always) under "File" or "Edit" in the pull-down menus at the top of the screen.

⇨ Icons

As we have stated previously, one of the first things you should try, when you want to access the options of an icon, is double-click on that icon. If nothing happens, then look in the pull-down menus for an options command.

If, when you open a program, it seems to have fewer tool icons than you expected, click on one of them and hold down the mouse button. That may reveal other related icons. Often, the symbol for hidden related icons is a small arrow or a cut corner on the icon square. Other times, there is no indication that they are under there. So, just click and hold to see what happens.

For instance, in *Picture Publisher*, when you click and hold on the painting icon, it will reveal icons for a paintbrush, airbrush, clone, texture painter, and finger smear (see Fig. 18-5 left). Without letting go of the mouse button, move your cursor to the tool you want. When you release the button, that tool will become the active one. (See Fig. 18-5 right.)

Figure 18-5

(Left) Picture Publisher Toolbox of icons.
(Right) Clicking on the painting icon reveals other icons for related tools.

Scroll bar

A *scroll bar* is a thin, long rectangle with a small box inside it that may be pushed the entire length of the rectangle by your cursor. At the extreme ends of the scroll bar are arrows that, when clicked, can also move the box in the direction toward that end.

There are two typical purposes of a scroll bar. If an image file (or any file) is larger than the space allowed it on the screen (i.e., if only a portion of the image can be viewed on the monitor at any one time), there will be an up and down scroll bar along one side and/or a side to side scroll bar along the bottom. Moving the box along the length of the bar will reveal new views of the file. The position of the box within the bar is directly proportional to the relationship of the part of your file that you can see and the whole file. For instance, if the box is at the very top of a vertical scroll bar, then you are viewing the top portion of the file or image. See Fig. 18-6.

Figure 18-6

Note the scroll bars that indicate that you're viewing only part of this image. © Sally Wiener Grotta

Scroll bars

Another purpose for this symbol is to portray a numerical continuum on which each end represents the farthest extreme of the scale, such as 0% and 100%. By pushing the small box along the scroll bar, you may choose the point along the scale that you want, such as 45%. (Scroll bars represent any kind of number, not just percentages.) This is one method by which you may be asked to input numbers that will define the controls of various filters, tools and other commands. See Fig. 18-7.

Figure 18-7

Scroll bars are used to define how Gallery Effect's Poster Edges filter will work.

 ## Scroll boxes & shadow pull-downs

Another method used for inputting numbers is very direct. There will be a box that either has a suggested number in it, or it may be blank. If there is already a number in it, and you want to change its value, you can delete it and type in the new number. Deleting can be achieved by either using the backspace or delete key (after you have clicked your cursor once in the box) or by double-clicking on the number until it is highlighted (which tells the computer you want to replace it) and then typing in your number.

To the right of these number boxes, you may find smaller *scroll boxes*, on which are up and down arrows, similar to those on the ends of the scroll bar. Click the up arrow to increase the number by an increment, usually 1. Click on the down arrow to decrease it by the same increment. The up and down arrows may be replaced in some programs with a plus or minus symbol, but what they do is identical.

You may encounter these up and down scroll boxes elsewhere. For instance, if there is some text representing a function inside a rectangular box and alongside it is a scroll box with a down arrow, click on the arrow. Other options for that function will be revealed in a pull-down menu. (See Fig. 18-8.) In a similar situation, a *shadow box* may replace the scroll box to indicate that options are available in a pull-down menu. Essentially, the text box will have a shadow or thicker lines on the right side and the bottom. This indicates that by clicking on the box, you will have access to a pull-down menu of options for that box.

Figure 18-8

Various scroll boxes are used to choose among options associated with Picture Publisher's airbrush.

Fold/Unfold arrows & other resizing techniques

Sometimes the screen can get a bit cluttered with boxes of brush shapes and sizes, color palette, tools, etc. One way some programs try to help you clean up your work space is to allow the boxes to remain on the screen, but in an abbreviated form, folding into themselves, in effect. If you see an arrow in a small thin rectangle at the end of one of these boxes, click on it to fold or unfold the box. For instance, in *PhotoFinish*, you will see one of these next to the current foreground/background squares (see Fig. 18-9). Click on it, and a palette will unfold (see Fig. 18-10). Click on it again, and the palette will be hidden, saving space but keeping it very accessible.

Figure 18-9

PhotoFinish's palette folded into itself, showing only the current foreground and background colors.

Figure 18-10

PhotoFinish's palette unfolded.

If a tool's option box (or, for that matter, any window or folder on a PC or Mac) has a small square in the upper left corner, double-clicking on it will close it (remove it from the screen). You can always bring it back when you need it again, from the pull-down menu. Small squares in the upper right corner are used to enlarge or shrink the box. Whenever you see the right corner squares on an option box, click on them to see if additional choices may be available.

Direction indicators

Yet another kind of arrow is used to indicate the direction in which you wish a command to act. You'll encounter *direction arrows* most commonly in certain filters that require you to tell the computer at what angle you want the light to come from, the stroke to be painted, the effect to push, etc. See Fig. 18-11.

Figure 18-11

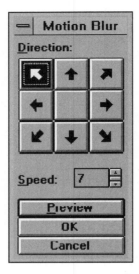

CorelPhoto-Paint's motion blur filter option box uses arrows to define the direction of the effect.

Another interactive control that does the same thing is a circle representing 360° of possible direction choices. Click on a space or a box along that circle to identify the direction or angle you want.

Alternately, you may instead be asked to input a number referring to the angle you wish, between 0 and 360. Of course, 90 degrees is the ever familiar right angle.

Multiple choice boxes

You may need to make a choice among a list of options, or you may want to activate a specific option. This is often achieved by clicking on an empty box or a circle (a *radio button*), next to the option. Suppose a filter has a heavy, medium, or light effect. You may make your choice by clicking on the circle next to heavy. A dot in the radio button indicates that the related option has been activated. If an option button or box will not accept a click, make sure that there are no contradictory options activated in the same dialogue box. See Fig. 18-12.

Greyed-out commands

If you can see a command or option that is grey rather than black and when you click on it nothing happens, then it's not accessible to you at that time. Why not? Sometimes, it's because the command requires some other process to be activated first. For instance, you must mask an area before you can cut or copy it. Other times, a command may be greyed out because it is not appropriate for the active image type. (See Chapter 22 for a discussion of image types.) Or it may refer to a

Figure 18-12

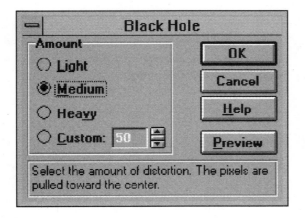

Some of PhotoFinish's Black Hole Filter's options may be activated with radio buttons.

device or a plug-in effect that you do not have attached or installed on your computer. For example, scanner controls may be greyed out if you do not have a scanner attached to your computer system, or if it is not properly installed and initialized.

19

Harnessing the power of illustration programs

REMEMBER playing in a sandbox with a plastic bucket? You could make a mound that represented an enchanted castle by just putting the bucket upside down on the sand. Or, you could make another mound of the exact same size and shape by packing sand into your bucket, turning it upside down and then pulling the bucket away. When you put the two castles—the one of plastic and the other of packed sand—side by side, they were almost the same, but not quite. You could move the plastic one around without changing its shape. But if you tried to move the one of sand, without putting the bucket back on, it would distort and, eventually, collapse. Conversely, you could poke holes into the one made of sand, so that your castle could have windows and doors and maybe even a garden on its roof. But the bucket was impervious to being reshaped (unless you broke it).

Think of imaging as a new kind of sandbox. Paint (also known as *photo manipulation*) programs are those that work with individual pixels—the grains of sand—that can be almost infinitely changed, moved about, and manipulated to make new designs. Illustration programs are those that work with specific shapes or objects—like the plastic bucket or a shovel or a piece of string—that are put into physical juxtaposition to each other to make a composition.

It's possible to use both kinds of programs to create a single image, but there are some limitations. The essential problem is that an image created by a paint program is made up of elements that aren't recognized by an illustration program, and vice versa. (We will explore some ways to get around this restraint later in this chapter.)

How do illustration programs differ from paint programs?

Illustration or drawing programs work with object-oriented data, while paint programs use bitmapped data. Remember the mnemonic names: *object-oriented* programs create images that are based on the mathematical definition of *objects*, while *bitmapped* programs create images that are collections of dots or *bits*. (See Chapters 20, 22, and 29 for additional discussions of the two kinds of images.)

Paint programs have many more sophisticated tools and techniques for working with photos, as well as a high level of editing and creative functions that are effective on all kinds of computer graphics. When you work with paint software, you're manipulating the tiny elements—the individual pixels—that make up a picture, which means more complex operations and greater detail are possible.

On the other hand, illustration programs provide more comprehensive and precise drawing facilities, as well as superior tools for the creative

handling of type. The components of an illustrated image are like building blocks made of malleable clay, which provides for smooth edges, easy manipulation and less eyestrain when you deal with the individual elements.

Of course, there are crossovers that exhibit some characteristics of both kinds of software in a single package. Some illustration programs have very effective facilities for detail work, and some paint programs have highly serviceable drawing and type tools.

ColorStudio has superb facilities that actually include being able to create and edit both bitmapped and object-oriented elements. (The illustration portion of *ColorStudio* is known as "Shapes.") Other paint programs are now beginning to introduce object editing into bitmapped pictures.

The names of the type of program do not limit the kind of computer art that is done with them. Illustrators will often use paint programs, such as *Photoshop* or *Picture Publisher*, to generate very creative digital drawings. And scanned-in photos may be played with to a certain extent and used as the basis of pictures created by illustration programs such as *CorelDraw* or *Adobe Illustrator*.

Another difference has to do with image resolution. In paint programs, it is necessary to define a high resolution—in the hundreds or thousands of pixels per inch—to assure a smooth, almost photographic quality print. A lower resolution would cause the image to break up into a tapestry of dots. In contrast, an illustration-generated image is not defined by dots but by shapes. Those shapes usually conform to the highest resolution possible on the output device—especially if the program saves its files in a format using a page description language called *PostScript*. (See Chapter 29.)

Many imagers limit themselves to just one kind of imaging program—either paint or illustration—simply because it is always easier to work with what is familiar to them. Besides, imaging programs can be expensive. But to limit yourself to a single type of imaging program, no matter how powerful, is to cut yourself off from important creative possibilities. In order to take full advantage of all that can be done with computer art, you need to understand what each kind of program is capable of doing, how each could affect your design, and then choose the right one according to the job you want to do.

Illustration's icons

On startup, the most visible attribute of any imaging program are its icons—pictures of available tools—that are usually arranged in a long rectangle on one side of your screen. When you open up an illustration program, the icons will look similar to those of a paint program, but there will be some important differences. See Fig. 19-1.

Figure 19-1

Adobe Illustrator screen.

While some of the tools described in the previous chapter have their equal, counterpart, or exact duplicate in illustration software, some just don't translate into the new environment. Also, other tools and options are specifically designed for work with object-oriented drawing. The rectangle, circle, and other polygon icons in an illustration program will be drawing tools, not masking tools, because illustration programs need no masks. (The objects that define your composition are already discrete and separate from the rest of the picture.) There are no paintbrush, airbrush, or clone icons, because those tools work on pixels, not shapes. However, the familiar fill tool gains importance as one of the two primary means of introducing color into a drawing. Other icons control selecting, moving, altering, outlining, or otherwise affecting the objects you draw.

This chapter will explore and explain those tools and techniques that are specific to illustration software. Not every illustration program has all the tools described here, and the sophistication of options for each tool will vary depending upon the software.

⇨ Drawing tools

Unlike paint programs, whose drawing tools create shapes by changing the attributes of individual adjacent pixels, illustration software defines lines and shapes as objects that conform to mathematical formulae. For instance, a line is a curve that goes from a specific starting point to a specific ending point and may bend as its direction is changed at any points in between. A circle is defined by its radius and center point, a rectangle by its corners, etc.

NOTE

When you draw an object, the *points* that define it will be shown as small squares, or *nodes*. Many of illustration's powerful techniques that alter shapes, lines, and curves will be enabled through clicking on or pulling at these points. The establishing node is often called the *anchor point*.

Freehand tool

There are generally two ways to draw a line—freehand or Bezier. The *freehand mode* is quite simple. As you move your mouse or stylus, it will draw the line, curve, or shape that you indicate by the way you move your mouse or stylus. It's a no-nonsense, no-frills tool that very closely resembles drawing with a pen or pencil on paper. The icon could possibly look like this:

Constraining drawing tools

When you draw a line, curve, ellipse, rectangle, or whatever, you don't need a steady hand to produce perfect shapes. All illustration software we have tested have constraining options or keys, which will guarantee a straight line, an exact square, a perfect circle, a designated angle, etc. These constraints are digital imaging's equivalent to working with a straight-edge ruler, compass, etc.

Constraints are activated either by pressing one of your computer's "Option," "Control," "Command," "Apple," "Shift," or "Alternate" keys while you use the mouse to activate a drawing command; or by clicking on the mouse (or stylus) button and releasing it before moving the mouse; or by clicking and dragging while keeping the button depressed.

For instance, to draw a straight line with the freehand tool in CorelDraw, click on the beginning point, release the mouse button and then click on the end point. Holding the mouse button down, as you draw, will make a squiggly line. Other programs may use the Bezier or polygon tool for straight lines—forcing the line to find the shortest (i.e., straightest) distance between two established points.

It's also possible to draw exact angles. Usually, you indicate the angle you want (7, 15, 32 degrees, etc.) in the preferences file. (The preferences file is found in the pull-down menus at the top of your screen, possibly under "Edit," "File," or "Special.") A negative angle will be measured counterclockwise from the anchor point. When you draw the line with your mouse or stylus, hold down the angle constraining key (it varies with each program), and you'll draw a line that is an exact increment of that number of degrees from the anchor. For instance, if the angle constraint is 15°, the line you draw may be 15°, 30°, 45°, 60°, and so on from the anchor.

There are constraining keys for drawing a perfect square with the rectangle tool, or a perfect circle with the ellipse tool, too.

Whenever you use a constraining key, be sure to release the mouse button before you let go of the key. Otherwise, you will lose the

> *constraint—the drawing will no longer conform to the particular angle, the circle will become an ellipse again, etc.*
>
> *Please remember that almost all generalizations that we make will have their exceptions. For example,* Adobe Illustrator *uses toggle keys as constraints, so that all you have to do is press the Shift key once and not hold it down to draw a perfect square or circle.*
>
> *Make maximum use of the constraints to all drawing tools, in order to make your work easier and more precise. We will approach this question of precision from another perspective later in this chapter, when we discuss grids, rulers, guidelines, etc.*

Bezier tool

The *Bezier* tool (which is also called the *pen* or *polygon* tool) uses directional lines or control points to define the slope, direction, and angle of a curve. If you ever used a French curve in drafting class, there will be a sense of familiarity about this tool. A French curve is a continuously changing angle of curvature defined by a logarithmic formula, as opposed to a linear progression (which is what defines a curve drawn by a compass). This translates into a softer, more gradual curve or a harder, faster curve than could be made by standard drawing tools. Electronically speaking, the Bezier tool establishes anchor points between which you want a curve to be defined. The definition of the curve is created by pulling directional leads or lines that approximate the angle of the curve that you want the next line to follow. The icon often suggests this idea of anchor points:

After creating an anchor point by clicking on your drawing with the Bezier, if you click and drag at that point, two dotted lines will appear with smaller squares on either end. (See Fig. 19-2.) These dotted lines are the controllers of the Bezier, and the end squares are the control points. As you pull on one control point, the other moves in the opposite direction, like a seesaw, with the established anchor point as a pivot. The direction that you pull the control point defines the direction the curve will move as it leaves the anchor point. The length of the controlling lines determines how sharp an angle the curve will have. (If you don't activate or pull on the control points, this tool will make perfectly straight lines.)

Writing about the Bezier is more complicated than actually using it. Imagine trying to explain how to ride a bicycle to someone who has never seen one. Even after that person sees a bike and understands intellectually how it works, it will probably take a bit of trial and error

Figure 19-2

The Bezier tool: Pull on the control points at either end of the seesawing dotted lines to determine the curve of the line.

before he is able to develop the necessary coordination between balance and speed that will get him anywhere. However, after some practice, it becomes as second nature as walking, with the added advantage of being faster and more fun.

The Bezier is like that bike. It's difficult to understand how it works without seeing it. And, even after you understand it and try it, you may feel clumsy, at first. But once you master the Bezier, there are few other tools that will give you as much control over drawing irregular shapes. In fact, it is one of the most valuable tools for precision drawing that imaging offers, which is why it crosses the barrier between illustration and paint programs. (See the following chapter on how it is used for making near perfect masks.)

As we have said and will continue to say, the only way to gain control over imaging's tools and techniques is to image. Practice with the Bezier. Bring up one of your pictures on the screen and try using the Bezier to outline some of the shapes in it. The more you use it, make mistakes with it, try to correct those mistakes, learn the cause-and-effect relationships, the sooner it will become second nature to you.

⇨ Rectangle & ellipse tools

Drawing a rectangle or ellipse is as simple as choosing the appropriate icon, which could resemble these:

clicking to establish the anchor point and, while continuing to hold down your mouse button, dragging diagonally away from the anchor. As you drag, the rectangular or elliptical shape is formed, so you can

see what you are creating. When the rectangle or ellipse is the size and shape you want, let go of the mouse button.

Both the rectangle and ellipse tools may be used in two ways. The first click of your mouse button may establish a corner (or cusp, in the case of the ellipse), or it may anchor the center point of the shape. The "draw from center" method is usually an option that's enabled by a constraining key. In *Adobe Illustrator*, it is accessed by toggling (clicking and letting go) the Option key.

Choose between drawing from a corner or drawing from the center, according to your design. Sometimes, you want to be sure that the center of your shape fits at a precise point. In other situations, the placement of the edge of your shape is more important to your design.

⇨ Other drawing tools

Many programs have other icons for drawing special shapes. For instance, *Aldus IntelliDraw* has a rectangle with curved corners (in which you can control the degree of curve at the corners), a *symmetrigon* tool that creates perfectly symmetrical objects, a *wedge* or arc tool that draws portions of a pie or a circle, etc.

Usually, drawing tool icons are shapes with solid lines. (There are exceptions, like the dotted line of the freehand tool in *Adobe Illustrator*.) When you encounter an icon that you don't recognize, click on it and try using it on a blank image page. When all else fails (or when you want to further your knowledge about it), look it up in the software manuals. Of course, we highly recommend taking the software tutorials that come with all programs. But once you understand the basics, experiment, play with the possibilities, allow yourself to make mistakes, so you can discover their solutions. That's how imaging becomes an instinctive, visceral, truly creative skill.

⇨ Drawing tools options

In some illustration programs (and most paint software), double clicking on an icon will bring up any options that are available for that icon. For instance, if you double click on the rounded corner rectangle icon in *Aldus IntelliDraw*, an options box will open that will allow you to define the corner radius and height by numerical values, and to choose the corner shape from among "round corner," "round end," or "oval corner."

Certain tools may be displayed as optional icons "hidden" under other icons. In *CorelDraw*, if you hold your mouse button down when you click once on the pencil (freehand) icon, out will scroll two icons—the pencil and the Bezier. If you click on the Bezier tool, in this instance, it

will replace the pencil icon on the screen's toolbox and become the active tool when you move your cursor over to your image.

There are two other places to look for drawing tool options:

> As functions in the pull-down menus at the top of your screen.

> As functions within additional windows (or palettes).

When you start a program, not all palettes or windows will necessarily be on view. These out-of-sight windows might include the icons toolbox, color or fill palette, lines options, and others. Look under "Window," "View," or "Display" in the pull-down menus to see what option palettes might be activated. Click on their names to "show" or "hide" them.

By the way, if you don't see all the options that you expect to see in the pull-down menus or on the various palettes, select "Full Menu" or "Long Menu" from the pull-down menus. To save screen space, some software may be run in two modes—with only the most essential options, tools and techniques available (short menu), or with everything showing and accessible (full or long menu).

HINT One of the more persuasive reasons for buying a large 20" or 21" monitor—as well as running in the highest resolution modes, such as 1280×1024 or 1024×768, is to provide enough empty space to display extra toolboxes and palettes without overlapping on the primary image. Physically, you can put more on a larger screen without having to hide portions.

The number of options associated with illustration drawing tools is much smaller than those associated with paint program tools. That's because the purpose of illustration drawing tools is to define a shape, not to manipulate pixels. It's a simpler operation with fewer variables.

NOTE Desktop publishing (DTP) programs are essentially object-oriented software, so much of what you learn in this chapter will help you with learning them. The following section on rulers and guidelines is especially relevant to DTP. See Chapter 30.

⇨ Tools & techniques for precision drawing

Where illustration programs shine is in precision drawing. Depending upon the software, a variety of techniques are available:

> Rulers

> Guidelines & grids

➢ Status & measurement information

➢ Alignment

➢ Smoothness tolerance

Rulers

All mainstream illustration programs can display a horizontal and a vertical ruler along your screen's edges. (Choose "Show rulers" in the "Display," "View," or "Window" pull-down menu at the top of the screen.) The rulers may be marked off in a variety of units of measurements, such as inches, millimeters, picas, points, etc., which you usually choose in the preferences file.

As you move about in the image, the exact location of the cursor is indicated by a dotted line on both the vertical and horizontal rulers. That way, you can know at all times the absolute and measurable placement within your image of your cursor and any object.

Look more closely at your rulers. Where the horizontal and vertical rulers meet, there's a square. Move your cursor to this square, click on it, keep your mouse button depressed, and drag your cursor to the closest corner of your image page. This sets that corner of your page as zero for both the horizontal and vertical rulers, which makes it easier to correlate your measurements.

Rulers give you an immediate ability to measure any and all work that you do. But they do require that you simultaneously keep an eye both on your work on the image page and on the rulers on the edge of your screen.

Guidelines & grids

Rather than try to correlate what the rulers on the edge of your screen say about the position of your cursor, it's possible to create non-printing guidelines right on the image page. Think of it as a background of customized graph paper to guide your hand to precise points on your page.

Different programs produce these guidelines in different ways.

For instance, in *CorelDraw*, the user clicks and drags on the ruler along the side of the screen, and a dotted line appears that is parallel to that ruler. Pull the dotted line along until it aligns with the other ruler at the measurement mark where you want it. Then, release the mouse button. To be more specific, let's imagine that you want a horizontal guideline that's one inch from the top of your image page. You would pull the line out from the horizontal ruler and drag it until

Figure 19-3

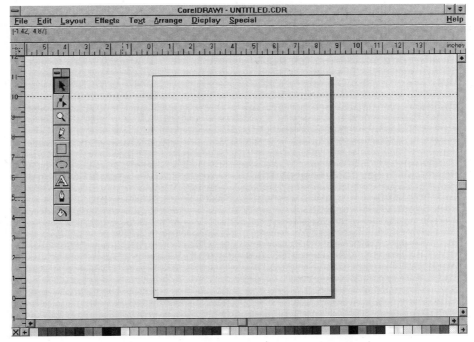

A guideline one inch from the top of a CorelDraw image page.

its end intersects with the one inch point on the vertical ruler (see Fig. 19-3). This is the most common method.

Similarly, *Adobe Illustrator* creates guidelines when the arrow icon is selected and the Shift key is toggled, so that the "move guide" legend is displayed in the screen's lower left corner.

On the other hand, *Aldus IntelliDraw* requires that you actually draw the guidelines, with a straight line tool, when the kind of line selected from the line palette is "guide."

CorelDraw uses yet another grid technique that overlays dotted measurement points onto your screen, in which the vertical and horizontal alignments are at specific intervals (such as 8 per inch).

However your program makes these guidelines, it's possible to lay down an exact grid, which will not print out or otherwise affect the composition of your image but which will assist with precise drawing.

HINT The "Snap To Grid" or "Snap To Point" option that many illustration programs offer will force any shape that you draw to be pulled to the nearest grid or guideline. Conversely, be sure that option is turned off if you want the curve to sit exactly where you put it, regardless of any grid or guideline.

Status & measurement information

Suppose you want to know the size of an object that you have drawn. You could lay down guidelines at its outermost edges, and calculate its size from the information the rulers provide. However, some illustration programs have tools for measuring shapes, lines and curves. For instance, in *Adobe Illustrator*, with the measuring tool activated, just click your cursor at the beginning point and then click on the end. An information box will open up that gives the relevant numerical values for the distance, angle, horizontal, and vertical placement for the shape between those two points.

Other programs will display information about drawings and other functions on a status line or area. In *CorelDraw*, the entire horizontal area between the pull-down menus at the top of the screen and the working area of the program is devoted to information, such as the physical position of the cursor, the type and size of the selected object, the number of defining points on that object, the fill and outline colors, the dimensions and angle of a line being drawn, etc.

These status lines and measuring tools are quite useful for artists used to working with drafting techniques who must know the size and placement of an object to be sure their drawing is accurate.

Alignment

Because images created by illustration software are made up of individually defined objects, it becomes both necessary and quite feasible to define their relationship to each other. Any object may be aligned to almost any point on another object. For instance, a small and a large rectangle may be aligned so they're right next to each other, with their sides touching and their tops at the exact same level. Or, they may be arranged, one inside of the other, so that they share a common center point, thus creating an equal distance between them on all sides. Distances, angles, and other relationships between objects may be exactly defined and maintained, even when the objects are moved or altered. When you are drawing a composition, alignment is a useful technique that makes sure all components of your design fit together.

In *CorelDraw*, one of the aligning tools is a "Snap To Object" option in the pull-down menu under "Display." This will cause a shape, line or curve to "snap" or be pulled into conjunction with a designated other object.

Similar tool is an "auto-join," which causes lines that come within a specific distance of each other to automatically connect. (That specific

distance is set by the user in an options dialog box, often in the preferences file.)

Other methods that are used to help align objects are menu driven options boxes that define the numerical values of placement and object relationships, icons that represent alignment tools, an "Auto Align" command, etc.

We will return to this concept of relating objects to each other from other perspectives in the section on "Organizing & Arranging Objects," later in this chapter.

Smoothness tolerance

Take out a pencil and start drawing on a piece of paper. Can you make a perfectly smooth line? Don't worry, almost no one can. It's the same for drawing freehand on a computer. Whenever you use a mouse or stylus, it's difficult to keep all your movements perfectly smooth. A tiny, almost imperceptible twitch of your hand can cause a curve you're drawing to have jagged edges or bumps.

Most illustration programs allow you to set the freehand tool's smoothness level, so that it will ignore the slight manual jitters and produce a smoother curve. In *Aldus IntelliDraw*, you access the smoothness option by double clicking on the freehand tool icon. *CorelDraw's* smoothness function is called "freehand tracking," and it is an option of the preferences file.

Generally, the level of smoothness is indicated by a numerical value. The higher the number, the smoother the line and the more it will ignore your hand's slight jitters. However, don't set it too high, or the tool will also ignore the small movements that you use to define slight but important changes in your line. Experiment with different smoothness settings to discover how each value affects your drawing.

⇨ Selecting, moving, transforming, & reshaping objects

One of the most telling differences between illustration and paint programs is in selecting specific elements of your design to make changes to them.

Let's return to the analogy of the plastic bucket and the sand shaped by the bucket that we described earlier. Shapes created by most paint programs are like that mound of grains of sand; they can't be moved or separated from the other elements of a picture unless a mask is drawn very precisely around them. The mask could be said to be

similar to putting the bucket back on the sand mound to move the mound intact. With a mask, the user selects the dots that make up a shape and distinguishes them from all the other dots in the image. The difficult process of creating an accurate selection mask is so intrinsic to working well with a paint program that we devote the entire next chapter to suggestions for conquering the masking process.

But you're not as dependent on masks in illustration programs as you are in paint programs. That's one of the major advantages of illustration over paint software. Every shape, curve, or line that is created by an illustration program is defined as a mathematical object. Selecting that object requires only that you point to it, so that the computer can identify which shape you mean.

The selection tool

Click on the outline of a shape, line or curve with the selection tool (also known as a pick tool),

and the object is automatically selected. Small solid squares will either surround it or appear on its circumference (depending upon the software you are using). Before you invoke any command, tool, or technique, look for these squares to make sure that the object you want to be affected is the one selected. See Fig. 19-4.

Figure 19-4

The nodes or black squares surrounding the rectangular figure (A—CorelDraw) or on its corners (B—IntelliDraw) indicate that the rectangle (and not the ellipse) is the selected (or active) object here.

To select more than one object, use the pick tool to draw a selection rectangle around all the objects you want included—so long as shapes that you don't want wouldn't also be captured by that rectangle. Just click on a corner spot where you want the rectangle to begin and, while continuing to hold down your mouse or stylus button, drag diagonally to include the entire area. As you draw, a rectangle of

dotted lines will appear. You will want to be sure that *every* object that you want selected is included in the rectangle. When you release your mouse button, the rectangle will disappear and be replaced by squares indicating which objects are selected.

Another method for selecting more than one object is to click on the first shape, then hold down a key (usually the Shift key) while clicking on all the other objects you want to select.

Selecting multiple objects at the same time is useful if you want to use a command on all of them. For instance, you might want to maintain specific spatial relationships between objects when you move them. (It is also possible to join or combine the objects into a single object. We'll cover that later in this chapter.)

To move an object, just click on it with the selection tool, keep the mouse (or stylus button) depressed, drag it to its new position, and then release the mouse button.

With most illustration programs, touching the delete key when an object or group of objects is selected will erase them.

Transforming objects

Those squares that appear around a shape when it is selected are determining points for reshaping, resizing, skewing (shearing), flipping, mirroring (reflecting), or otherwise transforming objects. Different programs use various ways to invoke these changes, but the essentials remain rather constant.

Generally speaking, there are three ways in which a program may work to transform an object:

> ➤ By using the pick tool to manipulate the squares or nodes that define the selected area.

> ➤ By activating a transforming tool through its icon.

> ➤ By accessing the process through the pull-down menus at the top of your screen.

CorelDraw uses the pick tool extensively in manipulating objects, which is why that program uses eight squares to define a selection area, whereas others may use fewer nodes. Pulling on any of these squares will stretch or shrink the object. (This is called *interactive manipulation*, in that you work on the object, until it looks right to your eye.) Pulling on any of the four corner squares in *CorelDraw* will maintain the aspect ratio (the proportions of its shape). For instance, if you pull on the corners of a 1"×2" rectangle, whatever size you make it, the two sides will continue to measure at a one-to-two ratio. Pulling

on any of the other four squares (which are placed between the corner squares) will also stretch or shrink the object, but the proportions may change. By the way, you can flip an object by pulling one of these selection squares all the way to the other side of the object, turning it inside out, in a manner of speaking.

Click twice on an object's outline in *CorelDraw*, and selection squares become eight double-headed arrows, and a bullet point is placed in the center. (See Fig. 19-5.) Dragging on the corner arrows will rotate the object around the bullet point, but that pivot bullet may also be moved, so the center of rotation can be varied. Pulling on the side arrows will skew the object at an angle.

Figure 19-5

CorelDraw's transforming arrows and bullet point.

Other programs have icons that are specifically designated for transforming objects. With the object selected, click on the appropriate tool for the job, then use it on the nodes to manipulate the image. These icons work pretty much the way we described above. Just click your mouse (or other pointing device) on the square that you want to affect. Hold the mouse button down for as long as you continue to move the object. Then, release the button when the shape is satisfactory to you.

These transforming techniques will work with constraining keys—such as the Shift, Option, Control, Alternate, or Command key—to limit the percentage size change, proportions, angles and other attributes of the transformed shape. Check your documentation to see what constraints and defining keys are available for each tool—or just try out all the possible keys with the tool to see what happens.

Sometimes, you won't want to make these kinds of transformations interactively (using a pointing device to shove and pull the object into shape). Perhaps you need greater precision of size or angle, or maybe you want a quicker, less involved way of doing things. That's when you'll choose the "Transform" (or other similar) command from the pull-down menus at the top of the screen. (Transform may be one of the menu headers or an option within another menu.)

The transform dialog box will give you access to mathematical determinants of whatever change you want. Each program has designed these dialog boxes differently, but they follow basic patterns. For instance, in *Aldus IntelliDraw*, there are several options under the "Object" pull-down menu. The "size and position" dialog allows you to input numerical values for the dimensions of the selected shape, as well as its exact placement on the page. This is used instead of moving and resizing it with the mouse. Another dialog box provides access to scaling the shape's vertical and horizontal dimensions as percentages of its current size. For instance, a polygon that is 2" high and 3" wide may be scaled by 150% horizontally and 200% vertically. The result would be a polygon shape that is 4" high and 4.5" wide. If you want to retain the shape's original proportions, the horizontal and vertical dimensions should be increased or decreased by the same percentage.

Other menu-driven transformations may include flipping horizontally or vertically, mirroring horizontally or vertically, rotating, etc. See Fig. 19-6.

Figure 19-6

Original

25° horizontal
skew

25° horizontal
skew

Some special effects.

Horizontal
mirror

Vertical
mirror

Some programs have the facility to perform transformations, both interactively and through menu options. Others offer only one of these choices.

⇨ Reshaping objects

While illustration programs define curves, lines and shapes according to mathematical formula, all the artist does is draw the object. So don't worry about trying to remember your high school math. The computer program does all the calculations, deciding what formula would best describe whatever you draw.

Should the artist draw a freehand curve, the computer would associate mathematical information that relates to the end points and to every intermediary point where the line changes. This information would include the direction and the angle of curvature of the line as it reaches each point and as it leaves that point. The Bezier tool takes advantage of this manner of defining shapes, because its specific function is to describe a curve in terms of its change of angle and direction of trajectory as it moves away from an established point. Of course, another important bit of data is the distance between defining points.

Thus, it can be said that the points where a shape bends, curves, or otherwise changes direction will establish the data that define that shape. These points are often called *nodes*.

If you took a long piece of string out to a nearby park, you would have a very graphic explanation of this. Two people holding the string at either end would make a straight line with it. Have a third person pull it in one direction from the middle. While the two segments are still straight lines, it could also be described as a curve with three defining points (the three people). A fourth person could pull the string from another midpoint, not with his hands but with a round object, such as a large pulley. Then you'd no longer have only straight lines making up the shape, but it would still be defined by what happens at the four points where the people are standing.

NOTE The defining points or *nodes* of a shape are shown on your computer screen as small squares, when the shape or segment is selected (see Fig. 19-7).

When you draw an object, these defining nodes are displayed until you begin to work on another object. In some programs, they are the same squares that are displayed when an object is selected with the pick tool. In others, a separate tool (sometimes called the reshape tool) must be invoked through an icon and clicked on the outline to redisplay the nodes.

Figure 19-7

The defining nodes of a line.

We have spent some time explaining what nodes are, because they are the handles by which an artist may interactively reshape an object. Clicking and dragging on one of the small squares allows you to pull at the object and change its shape. (Sometimes the node must be clicked on twice—once to activate it and the second to drag it.) It's a rather simple procedure, much like having one of those people who is holding the string pull it a few feet in another direction. Constraining keys may also apply to reshaping to help maintain proportions, angles, and other relationships.

Organizing & arranging shapes

Each illustrated object is defined as an independent component, separate from anything else in your image. It is your design that makes these individual elements coalesce into a picture. This lack of relatedness among shapes can be useful while drawing and editing your images, but it does cause some design management problems.

Illustration software provides several techniques for coordinating the various shapes, lines and curves. These techniques may be divided into two categories:

➢ Rearranging the order of object layers.

➢ Combining several objects into one, either temporarily or permanently.

Rearranging layers

Illustration programs work in layers, placing objects on your image like pieces of cut-out construction paper piled one on top of the other. The last one drawn sits on the uppermost layer, with the first one sometimes buried below all those that were created after it.

Suppose you drew the figure of a child first, and then the path on which you wanted him to be walking. If you made those objects in that order, the path would be on top of the child, obscuring part or all of him. It's an easy matter to rearrange the order of those layers, so that the child would be walking on the path and not hiding behind it. Look in the pull-down menus at the top of your screen under "Arrange," "Object," "Edit," or other similar heading. You'll find commands to position a selected object to the front or to the back. There may also

be a command to bring it forward one layer or put back one layer. Of course, be sure you have the correct object selected before you execute such a command. See Fig. 19-8 for an example.

Figure 19-8

On the left, the ellipse was drawn after the rectangle. On the right, the ellipse was selected, and, then, the command to "Move To Back" was invoked.

In this example, if you have the child selected, you would use the "bring to front" command to put him over the path. If you have the path selected, you would use "move to back" in order to create the same effect.

HINT When you prepare an illustration for output to your printer or to send to your print shop, remember to remove any hidden objects that aren't necessary to the design. Every shape on every layer, whether you can see them or not, will be processed. This is a waste of time, which will increase your costs. One printer described a simple ad that he was hired to output from a client's file. Because it had many hidden objects, it took a half-hour to process on the computer, rather than the 5 minutes he had estimated for the job. Of course, the client had to pay for the extra time.

⇨ Combining objects

It is in the nature of illustration that just about everything you could draw is a composite of several shapes. A flower is made up of petals, pistil, stem, leaves, etc., each of which is created on your monitor as a separate object, adjacent to the others. Similarly, the outline of an L-shaped room with a bow window could be drawn in increments of a small rectangle attached to a larger rectangle, with an arc (representing the bow window) placed along one side.

After these individual elements are drawn, you would probably want to combine them into a single object for various reasons:

➤ To maintain their spatial relationships as you edit your design.

➤ To cut down on the number of layers (and volume of data) defining the picture, which could reduce memory storage and printing costs.

➤ To put together individual components of a single object that were drawn separately only as a convenience (such as the L-shaped room described earlier).

➤ To be able to apply similar colors, outlines, and other style-defining commands equally over the entire group, without any transition between the elements.

After combining various shapes into one object, it's possible to separate them again. That allows you to work on a group of objects as a unit for awhile, then break them apart to refine details of the individual components.

The command to group/ungroup or combine/uncombine may be found in the pull-down menus at the top of your screen, probably under "Group" or "Arrange." Not all such commands are created equal, and some software will have more than one. For instance, in *CorelDraw*, when you *group* objects, each component retains its own identity within the group. But when you *combine* them, the components merge to make a single object, which may be manipulated in any manner. Be sure you understand the inherent limitations and abilities of these commands in your program before you execute them.

By the way, another version of the group or combine concept works to merge shapes into a single entity that is defined by the mathematical relationship of the component shapes. In *Aldus IntelliDraw*, these functions may be found under "Shapes" in the pull-down menus (see Fig. 19-9). Choose "Add" to have the final shape be

Figure 19-9

Original Add

Subtract

Intersect Slice

The mathematical combination of shapes in Aldus IntelliDraw.

the sum of all the selected shapes. Choose "Subtract" to have the final shape be similar to the primary shape, minus any area that was overlapped by the secondary shape. "Intersect" creates an object that is made up only of the overlapping area between the selected shapes.

Depending upon your program, there may be additional special commands that define how objects combine in relationship to each other. Make two very different shapes on a test image page, select both of them with your pick tool and, then, try out various commands that you find in the pull-down menu, to see what happens. When you're done (or when you get confused), look up the commands in your software manual to better understand the results of your experiments.

Copying, cutting, & pasting shapes

Working with illustration copy, cut, and paste techniques is so simple that it is almost redundant to discuss it. If you have any experience with Macintosh computers or the Windows environment, the process will be very familiar.

Select the object that you want to copy or cut and click on the "Copy" or "Cut" command in the "Edit" pull-down menu. Both commands will place a version of the selected object into a temporary file (called the "clipboard"). Copy will leave the original object in place where it was; cut will remove the original object. Then, click on "Paste" in the "Edit" menu to put the object in the active image page. (Be sure to open up the image page that you want the object pasted into, before you click on "Paste.")

If you paste into the same image page as where the original was, you may not see the copy. That's because it may be pasted right on top of the original. In that case, just use your mouse to select the copy and pull it off the original, dragging it to where you want it to be.

Many programs have a provision for triggering keyboard shortcuts, or macros, that will speed up or automate this process (as well as others). These shortcuts are accomplished by using what are called "hot keys" to invoke the various commands. For instance, in *Aldus IntelliDraw*, after an object is selected, simultaneously pressing the Control and C keys while moving the object with your mouse will create a copy of that object. In *Adobe Illustrator*, holding down the Option key while moving a shape will leave the original in place while moving a copy.

Another hot key available in many programs is one that duplicates an object repeatedly, at an interval that you define (usually in the

preferences file or elsewhere in the software). This creates a very interesting cascading effect, as is shown in Fig. 19-10. The hot key for duplicating a selected object is usually Ctrl-D.

Figure 19-10

Using Ctrl-D on a drawn circle can make a cascade of circles.

Another way to copy an object is to create a mirror, rather than a linear duplicate. For instance, suppose your object is a man's profile, with the nose toward the right. One kind of mirror of that profile would have the nose toward the left—as though the shape were being viewed through a mirror. Like many similar techniques, the mirror command (which may also be called "reflect") may be invoked through the pull-down menus or, in some cases, through the interactive use of your mouse and keyboard.

HINT

To make a shadow of an object, copy it with a mirror or flip command. Then skew the copy so that it looks like it is flat against the underlying surface. Finally, change its color according to the appropriate shadowy shade of the surface's hue. A similar process may be used to create a reflection.

Filling & outlining your objects with color & style

The greatest visual difference between illustration and paint programs is in how they put color into your image. Illustration software works with blocks or lines of color, filling or outlining shapes in such a manner that there is a clear and distinct transition between each color. In contrast, paint programs can apply color to individual pixels, which means that the transition can be smooth, almost imperceptible, photo-realistic quality.

While there are fewer color tools and techniques available with illustration software, there are still some interesting variations. Shapes may be filled with solid color, patterns, or gradients. Outlines may vary, not only in thickness and color, but in how the lines meet and end—in square, pointed, curved, or mitered joints or end points.

All color (other than outlines) applied by illustration programs is done so as a fill. Color elements are separated by breaking up a large object into smaller component objects and filling each with a slightly different shade. Or fill the object with a gradient or texture. It's difficult to develop a delicate touch with these color tools, but it is quite possible to be highly artistic with them.

Generally, an illustration program will have two similar color tools or palettes—one for filling objects and one for defining the color and width of the outline.

NOTE Please remember that all descriptions of commands, tools and techniques are generalizations. Programs will approach the same or similar aspects of imaging in individual ways. However, the theory and philosophy of creating effects tend to remain constant.

The line palette

The line palette defines how an outline, line or curve will be drawn and filled. It works with various aspects of that line:

➤ Thickness

➤ Style

➤ Color

➤ Shape of ends and corners

➤ Shape of the drawn line itself

➤ Its relationship to the object it is outlining

The *thickness* can be almost infinitely variable. You may choose from among a library of sizes or create your own.

The *style* of the line has to do with whether it is solid, dotted, or made up of dashes. A dotted or dash line can be defined by the frequency, size and regularity of those elements. For instance, you could have dots every .25mm, or two dashes close together alternating with three dashes further apart, or some other variation.

The *color* is chosen from a color dialog in which you may either mix your own by changing the relative values of the primary components (such as red, green, blue), or you may choose from a variety of palettes provided by the software, such as *Trumatch*, *Pantone*, or specialty palettes. (See Chapter 22 for more about the color dialog.)

The *shape of ends and corners* may be adjusted to mitered or rounded corners, arrow heads and end feathers, rounded or squared ends, etc.

The *shape of the drawn line* actually defines the form of the "pen nib" or point of the drawing utensil you want to emulate. In some programs, you can custom design the shape of your pen tip to be angled, rounded, squared, broken or whatever. Thus, your lines can look like they are calligraphic.

Finally, the *relationship of the outline to the object* has to do with whether it is behind or in front of the object. If it is in front, then it will appear larger than if it is in back.

 If you don't want your object to have a visible outline, you may choose to have no size and/or no color to the line.

⇨ The fill palette

An object may be filled with a solid color, gradient, or pattern.

The solid color fill is a simple procedure that requires only that you select which color you want. This is done by choosing a block of color within the fill palette or activating the color dialog box for more choices and customizing possibilities.

When defining a gradient (also called a *fountain fill)*, you must choose:

> ➤ The starting and ending colors.

> ➤ Whether it is to be a linear or radial gradient.

> ➤ If you want the center point of a radial gradient to be offset.

> ➤ If you want the linear gradient to be angled.

> ➤ At what percentage point in the gradient you wish the transition to be focused.

Generally, there is a preview of the gradient somewhere on the monitor, which displays the effects of your choices among the options. That makes the decision process easier and more intuitive. We'll not go into the gradient options here, because they are quite similar to those available in paint programs, which we discussed in the previous chapter.

Another method of producing color gradients over which you may have even greater control is discussed later in this chapter in the "Special Effects" section on "Blending."

Texture or pattern fills

The greatest variety available for applying color in illustration software is when you fill an object with a pattern. This pattern (which is called a texture by some programs) can be almost anything. It can be lifted out of a background library provided by the program you are in, from another program, from clip art or one of your own pictures. You can design a pattern and then save it to the program's library.

For instance, suppose you create an attractive beach ball. You can save that ball, with all its outline and fill information, to a file in your pattern library. Then, you can use it to fill another object anytime you want.

The options associated with pattern or texture fills include:

> ➤ Tile offset
> ➤ Tile size
> ➤ Color

The pattern is created in a single rectangle (or tile) that is repeated as often as it is necessary to fill the space. Suppose you have chosen a pattern of red dots on a white background. That pattern will fill your object in repeating squares, much as you would lay the bathroom floor tiles until the entire area is filled. That's why the tile size and the way the tiles are laid in relationship to each other are very important.

If the pattern tiles are laid side by side, corner to corner, you usually won't see the seams between them, nor can you distinguish where one tile begins and another ends. So, with the red dots on a white background, there would be no half dots not meeting and making a whole one, and spatial relationships would be maintained. However, the regularity of rows and columns in a pattern can be harmonious, or it can be boring. You can alter the relationship of the tiles to each other through a dialog box or interactively, using a mouse to move them around until they look just right. Either way, the pattern tiles can be offset to each other, so they no longer line up uniformly. See Fig. 19-11.

The tile size can usually be adjusted, either in a dialog box or interactively (pulling at a single tile with your mouse). As you increase the tile's size, it increases the size of the design elements within it, proportionately. Thus, in the above example, you would have larger and fewer red dots filling the same object.

In some patterns, especially ones composed of two colors, it may be possible to change those colors. For instance, if you have a clip art file of a black-&-white drawing of a bird in flight, you could import it as a fill pattern and change the black & white to pink and blue, or any other color combinations. Either choose your color from a small

Figure 19-11

The difference between a tile fill with no offset (left) and one with 50% column offset (right).

palette that may be displayed, or access the color dialog to choose from a wider array of colors or to create customized ones.

Letters, words, & symbols as design elements

The shape and form of letters and words have a life of their own, beyond their literal definition. Ever since humankind first learned to put the spoken word into written symbols, the visual effect of letters has given weight to their meaning and to the power they have to communicate.

The ancient illuminated manuscripts of the Middle Ages were more than collections of ideas; they were the glorification of The Word. Chinese calligraphers have long been (and still are) venerated for their beautifully expressive rendering of words into meaningful, evocative pictographs. With the invention of the printing press, the search escalated to almost a frenzied quest for the right shape and form—the most appealing and suggestive typeface—to better convey the essence of the text. That's why we have so many different type fonts today.

Modern art directors often lose sleep over the selection of the perfect type to convey what they need to say about their client's product. The wrong font might suggest flightiness rather than dependability, stodginess as opposed to youthful style, etc. An axiom of successful advertising is that how you say something is just as important (if not

more important) as what you say. A poorly chosen typeface can destroy an otherwise magnificently executed design.

But more than being a component of a composition, beautifully manipulated and decorated type can be the entire purpose and definition of an artistic rendition. Pictures made of letters and words in which the visual impact of the type augments and heightens the verbal message and vice versa has become known as concrete poetry.

Computers have a well-deserved reputation for providing sophisticated software tools for working with type in ways that were once reserved to print shops. Over the past decade, the proliferation of desktop publishing programs (and the introduction of inexpensive, high-quality laser printers) has turned almost every PC or Mac into a potential typesetter. (See Chapter 26.)

Another way that computers work with type is as artistic elements in a design. The more powerful illustration programs have some very exciting, creative, and fun-to-use tools for placing, altering, and manipulating letters, symbols, words, and even paragraphs.

The text tool

The most widely used icon for the text tool—in illustration, paint, and desktop publishing software—is a capital A. But in some programs, it might be ABC, or T.

In illustration programs, to put a few letters or words into your image, click on the text icon, then click on the place where you want your type to begin. And just type away, creating the letters or words that you want in that spot.

Use the pick tool to select the type. Then you can stretch it, shrink it, push it about, fill it with colors or patterns, define its outline, etc.

The type editing dialog box

For more extensive editing facilities, access the type editing dialog box, similar to that shown in Fig. 19-12. (After selecting the type on your image, the dialog can usually be found in the pull-down menu at the top of the screen, often under "Edit" or "Text.") There you can choose the typeface, size, justification (left, right, full, center, or none), style (bold, italic, normal, etc.), spacing (between letters, words, lines, and paragraphs), etc. You may also type in more letters or words that you want to place into your image in a rectangle in the dialog.

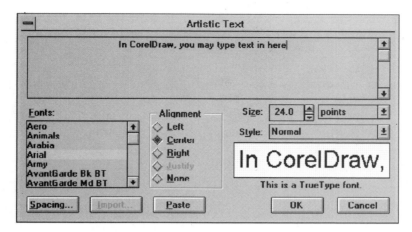

Figure 19-12

CorelDraw's Text Options dialog.

You'll have access to all the fonts that are active on your computer, but don't just use any that looks good. Your service bureau and print shop will have to have the same font software that you use in order to read any of your image files that contain type. Before you start a design, or, better yet, before you buy your font software, check with your service bureau and print shop to find out which specific fonts they can support.

Line justification is generally calculated from the point in your image page that you mark with a mouse click as your point of insertion. In other words, that click site is the center point, if you tell the software to center the text. Or it is the right margin for right-justified text, and the left margin for left-justified. Make certain to mark which you want.

Spacing is often measured as a percentage of letter size. Therefore, if the chosen font is 10 points, and the interletter spacing is set at 120%, then the space between letters within a word would be 12 points. An inter-word spacing of 150% would mean that there would be 36 points between words.

Manipulating individual letters

Many of the just-described text techniques are available in both paint and illustration software. Where illustration programs have the upper hand is in the manipulation of individual letters and the placing of text creatively.

Each letter may be moved about, rotated, skewed, distorted, given different colors, and otherwise played with, much as any other individual object on your image page can be. The method of selecting the individual letters or groups of letters may vary with each program. But the result is that each letter will have a small square (a node) at the bottom and (usually) to the left of it. Clicking on the node can indicate

that it is the letter you want to play with. In other cases, just clicking on the outline of the letter with the pick tool will do the same thing.

Just about anything that can be done to a word also can be done separately to the letters within that word. What's more, you can do everything with an individual letter that you can do to any shape or object, such as filling with patterns, changing outline and fill colors or styles, etc. But before you can make some manipulations, you may first have to translate that letter into a curve. For instance, if you are not satisfied with the typeface that you have used for a letter, and no other font on your hard drive is quite right, it's possible to convert the letter to a curve, so that its outline may be reshaped and molded according to the impression you want the letter to impart to your picture. You would then be creating your own individual type, based on the provided one.

Creating text that follows a path

A very useful (not to mention fun) text technique possible with most illustration software is to make text swirl and conform to whatever shape you create—a wave, a circle, a jagged line, etc. This is known as "fitting text to a path."

Usually, in order to activate this feature, you need to select both the text and a shape that represents the path. The shape can be just about anything: a curve, a profile of a face, a rectangle, etc. See Fig. 19-13.

Figure 19-13

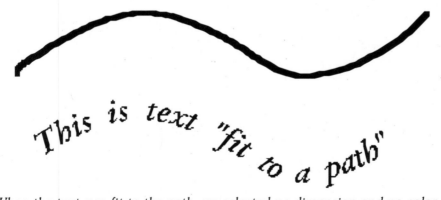

When the text was fit to the path, we selected no dimension and no color for the line, so that it wouldn't show in the final version.

HINT

Make a large letter that almost fills your image page, then convert it to a curve. That way, you can make your text run along the shape of that letter.

Some of the options available include:

➤ Which side of the path you want the text to fit. For instance, if you are putting type onto a circle, it can conform to the inside or outside of the circle outline.

➤ How the type should conform to the path. This is also called the orientation, which includes how the type shapes itself to the path, and whether the tops or bottoms of the letters are against the outline.

➤ How far from the path the type should be. This is an important design decision that must also consider what are called the "descenders"—those portions of letters that are usually below the line of text, such as the tail of a lowercase g or p.

➤ The alignment or justification of the text to the path. Where should the text start and end on the path?

➤ Whether or not you want the path to show. For instance, once you make your words curve along a wavy line, do you want the line to show, or to be invisible? (Generally, all you do is select "none" for the outline, and fill colors to make the line or any other shape invisible.) One may also completely remove the path and leave the text alignment intact. See Fig. 19-14.

Figure 19-14

Some variations on how text can orient to a circle.

One problem that can occur is when the tops or bottoms of letters overlap because they are trying to conform to shapes that set them against each other. Think about text on the bottom inside of a circle. Tall letters could end up with their tops overlapping, because of the inward curve of their base. This is corrected in one of two ways: through changing their orientation to the curve, or by altering their

spacing relative to each other. Orientation can determine if the letters lean away from each other, converge, remain straight, or skew at an angle. Spacing could just push the letters further apart.

Once you have set type onto its path, it is possible to manipulate it, as you would any text or object. However, be aware that, if you remove the path (rather than make it invisible), some editing procedures may distort the established curve of the text.

Other ways to manipulate type are covered later in the "Special Effects" section.

Paragraphs & other large blocks of type

So far, we have described working with individual or small groups of letters or words that are used as part of the design or for captioning purposes. But illustration software also has some sophisticated methods for working with paragraphs. The formatting facilities of paragraph text include word wrap (in which words will automatically wrap around to the next line), hyphenation and other methods with which you are probably familiar from your word processing software.

It's possible to import text from other programs, such as your word processor, in the paragraph mode. Often, paragraphs are placed in an object-oriented image by first creating a frame or bounding box; however, they may exist in the image without a box. Another possibility is to force the paragraph itself to conform to a shape. Therefore, a poem about a cat could be laid out so that the words create the shape of a cat.

If you are getting involved in importing large segments of text, you should consider using a desktop publishing (DTP) program like *PageMaker* or *QuarkXpress* instead of an illustration program. The difference is that illustration programs use text as design elements; desktop publishing (DTP) software creates layouts that integrate text and design. Please see Chapter 26 for more information on DTP.

Special effects

Both type and other illustration-created objects may be manipulated in interesting ways that add considerably to design possibilities. Depending upon the software you are using, you will have at your

command a variety of special effects techniques. We will cover three of the most popular:

➤ Blending or morphing

➤ Perspective and envelopes

➤ 3-D illusion or extruding

⇨ Blending or morphing

In the popular film "Terminator 2," the killer robot from the future had the ability to change shapes before your very eyes. That computerized effect, which has become popular in other science fiction films and TV series, is called *morphing*. Morphing is a powerful concept, not only of animation, but also of still digital imaging—so much so that *entire* programs are devoted to it. Illustration software provide some basic *blending* techniques that don't have the sophistication of morphing programs, but which can be used effectively to emulate it. (See Fig. 19-15.)

To blend one shape to another, select the two objects with your pick tool and then make the following decisions about the kind of blend you want:

➤ The number of steps

➤ The degree of rotation (if any)

➤ The relevant node for each object

➤ The method of color blend

The computer automatically calculates the steps of blend between the two objects that transform into each other. The artist defines how many steps there will be. At each step, the shape alters slightly, until it's quite similar to the object it is approaching. If you blend a square to a circle, the first step after the square would have slightly rounded corners, the next step would be curved even more, until the last step— just before the circle—would look more like a circle than a square. The more steps you designate, the more gradual the change will be per step.

Morphing from one object to the other can be very straightforward, or you can make it as complex as you like. One attractive option is to have the steps of the blend rotate. This rotation is usually described in terms of degrees, in which 360° is a complete circle. When rotation is added to the blend, the more steps you have the more a visual fanning will occur.

 When determining the rotation of your blend, be sure that it will give enough of a twist to the steps that the next to last one (the one

Figure 19-15

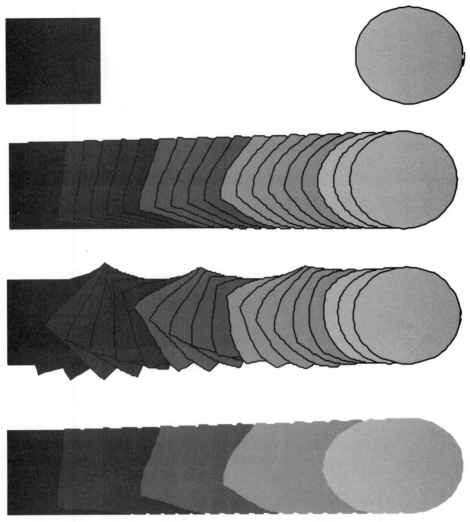

Blending a circle and a square. The first blend is without any rotation. The second has a 360° rotation. The final one has the outline removed from both the circle and the square to produce a color gradient. They all have 20 steps.

before the second object) will be oriented closely to the positioning of the final object. Otherwise, you'll lose the smoothness of the transition. Of course, you can always "Undo" your blend and enter in a new value for the rotation and the steps, if you don't like the result. Just remember to use "Undo" immediately after the blend, before you do anything else.

In some illustration programs, you can add even more control to your blend by defining which point of the first object will reach toward which point of the second object, as they morph toward each other. In *CorelDraw*, this is called "map nodes." (Nodes are the critical points that define a shape. For instance in a square, the nodes are the four corners.) You can tell the blend to go from the top left node of a

square to the bottom right node of a letter, and the appropriate rotation would be calculated by the computer to create that effect.

 Usually, a blend will follow the straightest line between the two objects. Rotation doesn't change this fact. However, it is possible to make a blend follow a curved path. (See earlier in this chapter in the section about "Creating Text That Follows A Path.") This is most often done by drawing the path, selecting both the path and the blend, then calling up the "fit blend to path" or similar command.

The blend applies, not only to the shapes of the two objects, but also to their colors. Generally, you will specify a direct blend between the two colors. In other words, if one object is red and the other is yellow, the blend's colors would go from red through various levels of orange and end up yellow. Some illustration software make it possible to have the blend go through the spectrum between the two colors, creating a rainbow effect.

A further option may be whether the blend would go clockwise or counterclockwise around the spectrum between the two colors. Let's go back to some basics to explain this concept. Think of a traditional color wheel, in which colors follow a continuum around a circle from green to yellow, red, magenta, blue, and back to green. Gradations between each of these colors are represented in that wheel. A clockwise blend between red and blue goes through the purples and magentas, with no other colors introduced into it. A counterclockwise blend would follow the longer route around the color wheel between red and blue, which would include oranges, yellows, and greens, but no purples or magentas. (See the color wheel in the color pages.)

Rather than memorize the color wheel, experiment with clockwise and counterclockwise color options. After some trial and error, you will remember the color wheel, not because you memorized it but because you have a working familiarity with it.

 When blending type or any other context sensitive elements, consider using a thin, strongly contrasting outline. The dynamics of color blending along the continuum can make it difficult to discern the individual elements, because there might not be any dramatic differentiation that the eye can easily discern. Conversely, if you want to create a seamless color gradient, be sure that your objects have no outline before you activate the blend.

An interesting use of blends is to make color gradients within objects. This method offers greater control over the process than the gradient fill that we discussed earlier in this chapter. Draw your object, then draw a smaller shape inside it. When you blend between the two of them, you will create a gradient which you have defined precisely, in regards to placement, orientation, steps, rotation, etc.

HINT

If a blend hasn't worked the way you intended, it might be because the objects aren't on the correct layer relative to each other. For instance, when using a blend to create a color gradient within an object, the smaller core object would have to be on the upper layer for you to see any effect. If your blend isn't correct, undo the blend, select the object that you want on top, and call up the "bring forward" command to put that object on the upper layer. Then, select the two objects and reinvoke the blend.

Perspective & envelopes

Points of perspective have been an important ingredient of art for centuries. The classical philosophy is that a picture should have one or two points toward which all other objects and lines of design reach. A graphic example of this is when you look at railroad tracks going off in the distance; they appear to merge together at a point on the far horizon. Whether or not you agree with this concept, the computer allows the artist to define perspective very accurately, either through the use of skew (or shearing) tools, or through interactively defining (with your mouse) points of perspective. (The same tools can be used to distort perspective and break with the classic rules.)

If your illustration software has a specific perspective command, it would probably be found in the pull-down menus. As a rule, it will create a rectangular bounding box around your selected object. You would pull on the corners of this box, reshaping both the box and the object inside it. *CorelDraw*'s perspective has the box plus two points—designated by X—that you push around to define the specific point of perspective you want. See Fig. 19-16.

Figure 19-16

A perspective envelope.

Given that a bounding box (which is also called an "envelope") can shape the object that it holds, some software will use a similar method to allow you to reshape objects in many other manners. Once the nonprinting envelope is formed around the selected object, you may use your mouse or stylus on its nodes to reshape it, according to whatever your fancy is. This is a very popular and creative method for placing type on the image page.

The perspective or other shape that you define for one object, set of objects or type can usually be copied to others within your image, by using a "Copy Style" or "Copy Perspective" command.

⇨ 3-D illusion or extruding

It is possible to build a design that gives the appearance of having depth, or of being 3-dimensional, by just drawing the appropriate shapes and curves together. We've all doodled these kinds of 3-D shapes during boring lectures or while on the phone. For instance, drawing a box is a process of combining a rectangle with two parallelograms. Once drawn, they may be permanently connected or grouped, so that the box may be moved and manipulated further.

However, such 3-dimensional drawings become much more difficult when the basic shape is more complex, such as type or an irregular polygon. That's why some illustration programs have tools for generating this effect. Quite frankly, they are not sophisticated, especially when compared to 3-D modelling that is possible in mapping programs, such as *AutoDesk 3-D Studio* (see sidebar). However, some good, basic 3-D drawings can be achieved very effectively with illustration programs. The 3-D technique in *CorelDraw* (which that software calls "extruding") is the most powerful of these commands among the various illustration programs we have tested. See Fig. 19-17.

Figure 19-17

3-D extrusion.

Beyond illustration:
3-D & animation software

Object-oriented software is a much wider subject than just illustration programs. In fact, learning illustration can be like letting the camel's nose into the tent. It's just one step from there to using 3-D (texture mapping) programs like AutoDesk 3-D Studio. While texture mapping will introduce some exciting effects into your images, it is incredibly time-consuming and skill intensive. We've heard of mapping commands that have taken 24 hours or longer for the computer to complete. Most pictures we have seen done with these programs has been more a demonstration of what is possible than a mature art, but we expect the work to become increasingly sophisticated over the next couple of years. If you have the budget and work on a PC, we highly recommend getting and trying to master 3-D Studio. (Be prepared for some difficult times and a tough learning curve though.)

Texture mapping is even closer to animation work than it is to illustration. In fact, many use 3-D Studio primarily for animation. So, before you know it, you'll be involved in a whole new career. Be careful of making such a move. Think it over first, and be sure it's what you want. Animation is harder, takes longer, requires very powerful workstations and is more expensive to produce. It's like the jump from being a still photographer to becoming a movie-maker. Sure, the potential for profit is much higher, but so are the risks.

⇨ Other special effects

It would be impossible to write about all the special effects that all illustration programs offer and still be able to lift this book up with one hand. We've mentioned only some of the more common tools and techniques. There are many more, and you should play with and try out all that you can.

Typically, when you call up a special effect, you will be asked to define a number of variables that will determine how the special effect will work. While the variables will be different for each effect, they do follow a pattern. For example, the variables for *CorelDraw's* extrude are:

➢ Horizontal and vertical orientation

➢ Depth

➢ Direction

➢ Lighting & shading

➢ Color

Special effect variables may be defined numerically (by inputting numbers into dialog boxes), interactively (by pushing on-screen objects

or controls about with your mouse) or by manipulating representative symbols (such as the globe described in the following list). Here's some hints on how to interact with various options and dialogs that are common among special effects.

➤ Be sure that you have the correct object or objects selected before you initialize a special effect.

➤ The interactive control points of a special effect are often represented by the nodes (control squares). However, other controls that may appear on your screen could include an X (such as one would see on a pirate's map, for "X marks the spot") and wireframes (shapes made up of dotted lines). If you see either, try pushing them around with your mouse to see what happens. As with objects, the control points of wireframes are most often corners, the nexus, or cusps. The X and wireframe tend to be preliminary controls that help you design the special effect. There's usually an activating command, such as clicking on an "OK" or "Apply" button.

➤ Whenever a dialog offers you a choice among options, try them out on your image to see what they do. (Of course, make sure you have saved the image first and that you use the "Undo" command immediately after invoking the effect, just in case.) That will teach you more about how to control any effect better than any printed words possibly could.

➤ When inputting numbers into dialogs, the larger the number, the greater the effect. Any negative number that you are able to input for an effect generally creates an opposite effect from a positive number.

➤ Whenever an effect asks that numbers be input for horizontal and/or vertical values, remember your junior high school math. Any 2-dimensional space may be defined by an x/y axis as shown in Fig. 19-18. Think of it this way: if your starting point (your object) is where the two lines cross, then a positive value for both the horizontal and vertical would push the effect upward and to the right. If you have a negative vertical and positive horizontal, it would push downward and to the right, etc. The numbers indicate how far from the starting point your effect will travel.

➤ A manipulatable graphic symbol that's not uncommon in special effects dialogs is a globe. For instance, it is often used to define the light source, which in turn creates natural highlights and shadows on your objects. Whenever you see such a globe, you can directly interact with it to place where you want your effects to be, and to specify the exact rotation of objects. Just click on the arrows or the intersections of the lines to move the effect or object about within a 3-dimensional space. See Fig. 19-19.

Figure 19-18

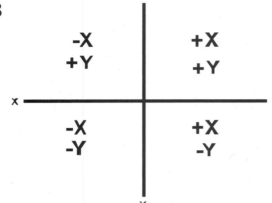

-X
+Y

+X
+Y

x

-X
-Y

+X
-Y

Y

When assigning the horizontal and vertical numbers to special effects, the positive and negatives usually refer to the direction in which the effect will go.

Figure 19-19

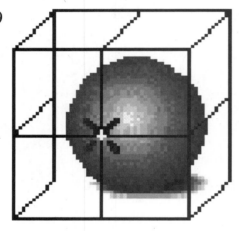

Two kinds of interactive globes (CorelDraw).

➤ Whenever an options dialog involves color, you will be able to click somewhere on the dialog or elsewhere on your screen to access the full range of possible colors available in the program. Look for a button or pull-down menu or other interactive path to the color dialog.

So go ahead and play with the special effects you discover in your software. Select an object or objects, open up the dialog box, and experiment with different values or choices among the options. When you get into trouble, or don't quite understand why something happened, look it up in the documentation. As we have said before, the best way to learn how to image is to image. Take chances, explore the nooks and crannies of your software, get in trouble and find out how to extract yourself. That's how you'll not only learn the program, but also learn how to be creative with it.

 # Working with bitmapped images in object-oriented programs

Fish can't breathe air; humans can't breathe water. So it is with images created in paint and illustration software. They don't function in their full glory, unless they are in their native environment. However, fish mounted on the wall can be beautiful (though lifeless), and people can don air tanks to go scuba diving.

Similarly, object-oriented images created by illustration programs can be converted to bitmapped images for use in paint (photo manipulation) software. This is achieved by an export/import facility or a file format conversion, as discussed in Chapter 26.

Bitmapped images created by paint programs (and scanned pictures) can be used in illustration software via one of three methods:

➢ Tracing

➢ Converting

➢ Embedding

 # Tracing

Available in only a few illustration programs, this technique allows the artist to view bitmapped images (including scanned in photos and art) through a translucent overlay. You can trace the shapes, lines and curves in the bitmapped image, creating an object-oriented outline that can be colored and manipulated by an illustration program.

Another method is to allow the program to make an "auto-trace." In this, the software makes the decisions of what constitutes the image's outline by analyzing areas of contrast.

Tracing by hand is much more difficult than letting the computer take over; however, many artists feel that it is necessary for maintaining complete control over the design process. That way, they make the decisions what lines are important and how to handle them.

If you trace by hand, remember to use the methods described earlier in this chapter for precision drawing. Try to attain mastery over the Bezier curve, since it is really the best tool for this purpose.

 HINT With either tracing process, increase the brightness and contrast of the bitmapped picture in a paint program, before you attempt to trace it, to make it easier to discern the details of the image.

⇨ Converting

Bitmapped images (or portions of them) may be actually converted to object-oriented images. Like the reverse process for converting object-oriented to bitmapped, this is achieved by the import/export facility that can change the file format of the image. We discuss this process in Chapter 26.

Remember, when you convert between bitmapped and object-oriented image formats, that you are actually changing the essence of the image. A previous bitmapped image will no longer be defined by thousands or millions of pixels of information. Instead, the software analyzes the shapes, lines, curves and colors, and will create the appropriate mathematical formulae to describe it. That means that you will no longer be able to edit the details of the image as you would in paint programs. Instead, it becomes an object that can be resized, reshaped, cropped, skewed, and otherwise manipulated in the same manner as any illustration-created object.

⇨ Embedding

If you don't want to change the essence of the bitmapped image—if you want to maintain its identity as something that's made of pixels and may be edited accordingly—you can still incorporate it into an object-oriented image. That's done by creating a link between a paint program and an illustration program that opens a window in your object-oriented image which can view the bitmapped image.

The embedded piece of bitmapped data may be resized and reshaped, but that is about all that can be done with it. To edit it, you have to go back to the paint program in which it resides. (Double-clicking on the bitmapped image within the illustration program will often switch you to the paint program automatically.)

Saving an object-oriented image that has a bitmapped image embedded in it may require some special considerations (depending upon the program in which you are working). Some illustration software require that the object-oriented image and its related bitmapped image be saved in the same subdirectory. There might also be a different save utility for this type of duplex image, which may be found under the "save as" command in the "File" pull-down menu. For instance, in *Adobe Illustrator*, you use the "save as" command and must check the box next to the "include placed images" option.

This type of embedding will become familiar to those who get involved in desktop publishing programs, as described in Chapter 27.

 Illustration programs are much more straightforward and less complex than paint programs. For that reason, several of the following chapters will go into greater depth about tools and techniques that are particular to paint software.

C-1 *Mask* When perfecting her selections, Sally always converts the mask to this form for more precise editing. When the mask is completed (and reverted to the "dancing ants" form), all imaging tools or commands applied to the picture will change only the area inside the mask (which is, in this case, the child's head). Sally Wiener Grotta

C-2 *Color wheel* A traditional color wheel shows the relationship of all colors, including those based on the RGB and CMY models. If it weren't necessary to add black (K) to CMY, it would be much easier to translate colors between those two models. Sally Wiener Grotta

C-3 *Indexed color* PhotoStyler's Index Color defaults of "Firelight" (left) and "Pseudocolor" (right). Both were created by converting a greyscale photo to index color. Sally Wiener Grotta

C-4 *Circus stamp* The bitmapped image (scanned photo) of Bucky the Clown was traced to convert it to an object-oriented format, so that it might be incorporated into this illustration. Sally Wiener Grotta

C-5 *Origin of the species* (a tribute to Alfred Eisenstadt) Elements from one color photo were manipulated in various copies of the same picture—changing a large part of it to a greyscale picture, using a "Find Edges & Invert" on background elements, converting Mr. Eisenstadt's head to "Tritone" to bring it closer to the tonality of his photographs, and fine-tuning in other ways. Then the diverse elements were montaged back together into their original relationship. Sally Wiener Grotta

C-6 *Storyteller* Several layers of color gradients make this object-oriented illustration somewhat complex, which means that screen redraws and printing can take longer. The words were shaped with the "Fit to Path" command; then the path was made invisible and the text converted to curves (to avoid font compatibility problems with the book's printer). Sally Wiener Grotta

C-7A *Four views of a lighthouse* The original photo. Sally Wiener Grotta

C-7B The photo was scanned into the computer, where the scaffolding was removed by using the cloning tool and then invoking the equalize tool to bring out details in the shadows. Sally Wiener Grotta

C-7C The number of colors was reduced with the posterize command. Sally Wiener Grotta

C-7D The equalized photo was embossed and saved as a separate file, then pasted over with "Colors Only" from the same equalized image. Sally Wiener Grotta

C-8 *Beyond Oz* This fantasy landscape was initially cropped out of a fractal generated by Kai's Power Tools, then a sphere filter was used to create the globe and a starry background montaged into the composition. Finally, the portrait of Elizabeth Sosnov was pasted in, using varying levels of translucency in the mask to retain the see-through effect of the organdy material. Sally Wiener Grotta

C-9 *Huli wigman* This portrait that Sally had taken of a native in Papua New Guinea, has been transformed by various tools in Fractal Design Painter to emulate an oil painting. Sally Wiener Grotta

C-10 *Dawn of a new era* In this object-oriented image (created in CorelDraw), extensive use was made of gradients to emulate natural transitions between colors. The bitmapped (photographic) images of the woman and the boy were imported in from Photoshop via Windows' clipboard. Here's a teaser... CorelDraw's perspective command won't work on bitmapped images. How did Sally create the illusion? Send us your ideas for a solution, and we'll send you our explanation. Sally Wiener Grotta

C-1

C-2

C-3

C-4

C-5

C-6

C-7A

C-7B

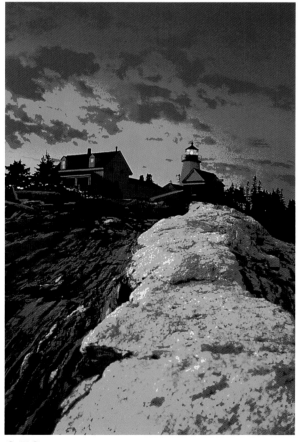

C-7C

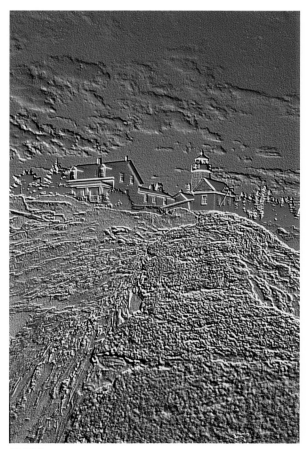

C-7D

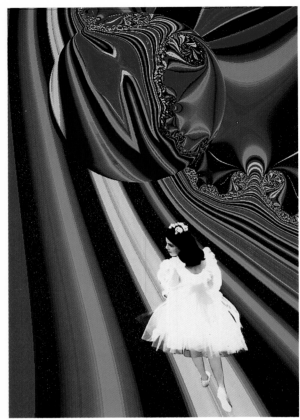

C-8

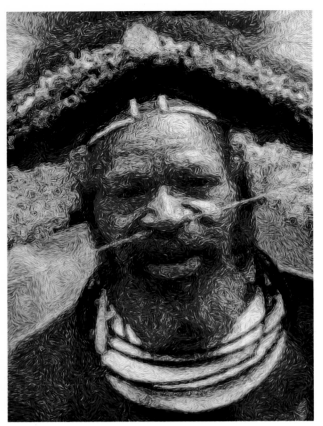

C-9

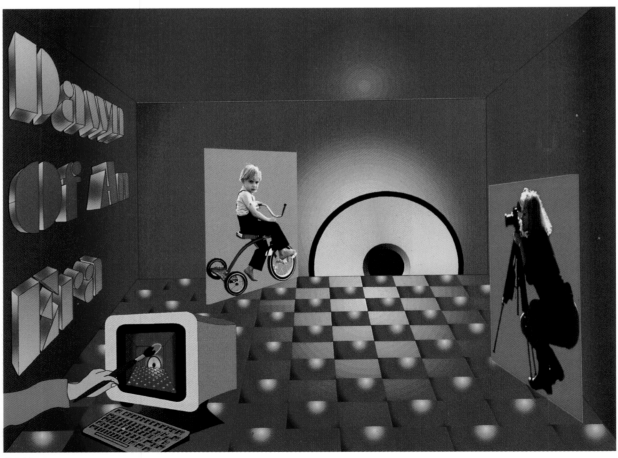

C-10

20
Conquering masking

C REATIVE digital imaging is not so much a function of how many diverse tools and commands you have available as it is a function of how well you can control them. Any child can throw paint on a canvas or scribble on a computer monitor; an artist is someone who dominates the process with her vision and technical expertise. The single most important tool available to computer artists for maintaining mastery over all the other tools that a paint program offers is masking.

A mask is a selection tool that defines exactly what area of your image will be affected by whatever other commands you use. Think of it as an electronic stencil or template. When you use a cardboard stencil in the real world, it limits your ability to paint on a canvas to just the area that the stencil doesn't cover. For instance, suppose you want to darken the color of a man's shirt without affecting the rest of the picture. Draw a mask around the edges of the shirt, then call up the brightness/contrast tool (usually found in a pull-down menu at the top of the screen under "Image," "Map," or "Tune"). While you are using the brightness command to darken the shirt, some programs might make it appear that the entire image is being darkened. However, when you are done and the mask is removed, only the shirt will have been changed.

NOTE Masking, as described in this chapter, is a technique used in paint (aka photo manipulation) programs, not in illustration software. (Please see the previous chapter to understand how illustrated objects are selected.)

The foibles & frustrations of masking

You can select an area to be masked by using a rectangular, circular or freehand tool (or a magic wand or a Bezier tool, both of which we will cover later in this chapter). The result is a blinking dotted outline that is called *dancing* or *marching ants* or, if you prefer a more urbane name, a *marquee*.

Since you are using the selection process to define exactly where various editing effects will take place, an inaccurately drawn mask can be a design disaster. Suppose the purpose of drawing the mask was to define a section of a picture—say, a woman's head—that you want to isolate and paste into another image. You certainly wouldn't want any of the wood grain wall behind her head to be imported into the new picture. Nor would you want to cut so closely that her hair looks like a plastic cap or wig. Therefore, the goal of all imagers who work in paint programs is to develop the skill and techniques required to draw a perfect mask.

If the item you need to mask is rectangular, square, oval, or circular, there's no problem. The rectangular and circular mask tools (some of which are shown here) are easy to use, individually or in concert.

For instance, suppose you need to draw a mask around a soup can, which is essentially only a rectangle and two ovals. Just use the rectangular mask tool to define the body of the can and then add to it by holding down the appropriate key (often the Shift key) while you draw the adjacent oval masks, which will become part of the entire selection. (See Fig. 20-1.)

Figure 20-1

The ellipse, circle, rectangular, and square masking tools have their limitations, as you can see from this selection made with the ellipse tool.
© Sally Wiener Grotta

NOTE Most masks will be drawn, or at least fine-tuned, by enlarging with the magnifier tool the section to be marked off. It's easier to draw the outline of the mask when you can better see where it and the background begin and end. In fact, the most meticulous mask editing often takes place on the pixel level.

Unfortunately, most objects are not made up of exact circles, ovals, or rectangles. The freehand or lasso tool (some examples being shown here) is what you will use to define most of your masks, and it can be a chore.

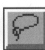

Using the tool requires intense hand-eye coordination; there's no getting around that problem. But it does help if you are using the appropriate

pointing device. We recommend using a stylus with a digitizing pad (rather than a mouse) to draw masks, because it feels like a pen.

NOTE In many of the following discussions, we use photographic images as examples. That is for the sake of simplicity. Artists who use paint programs to create original computer drawings will use masks extensively to create the outline of a shape they want to define with gradients, fills, or other colors and textures, to apply special effects to their pictures, to define montage elements, etc.

The most basic freehand mask will involve tracing a continuous line around the object to be selected, without letting up pressure or lifting the stylus from the pad. Even experts have difficulty with this task, though through experience they do develop a finer finesse with the stylus. One of the problems is that if you let up the pressure while drawing a freehand mask, you can end up with a partial outline that, in some programs, automatically closes between the starting and ending points. That's not so bad, since you can add to that partial outline.

A much worse scenario is spending twenty minutes or longer drawing a near perfect mask, only to accidentally lose it by clicking the stylus button at an inopportune moment or inadvertently calling up some other contradictory command and thereby erasing the entire mask. If the program doesn't have a multi-level "undo" command available, the only answer is to start all over again from the beginning.

NOTE Some digitizing tablets do not require the stylus to be always touching the pad to make a continuous line. The pen has a magnetic tip that will still affect the tablet, even when lifted ¼" above it. These devices are slightly more forgiving than tablets that require constant physical contact. On the other hand, when you have lifted the pen and think that it is no longer active, it might leave an unwanted line as you pull it away or move it to the next point. (See Fig. 20-2 for a bad mask.)

Figure **20-2**

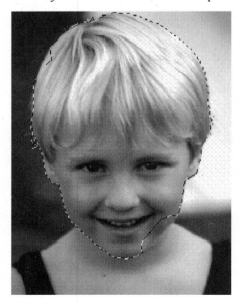

An imperfectly drawn freehand mask that cuts off the right chin and doesn't perfectly outline the rest of the head either. © Sally Wiener Grotta

⇨ To draw a perfect mask

Happily, using the freehand tool is not as difficult as it might seem. You don't have to draw the entire line completely freehand, without any assistance. Nor is it necessary to commit yourself to making one continuous stroke that can't be changed, erased, or edited.

In most programs, you can edit an existing mask. For example, in *Photoshop*, when you want to add to an existing mask, use the freehand or lasso tool while holding down the Shift key; anything that you encircle will be added to the defined mask. The Ctrl key used in conjunction with *Photoshop's* lasso will remove an encircled area from the mask. Similar key combinations are used in other software to allow you to include or exclude specific areas within the marquee. Another mask editing method used by other programs is to attach control points, or dots, to the mask and then tug at those dots in the direction you want the marquee to be moved. Usually, you may add a dot anywhere you wish, so this method is not as cumbersome as it sounds.

Nor do you have to draw the entire shape in one fell swoop. Most professional quality paint programs have some function that will help your hand navigate along the irregular contours. One common method is to break the curve into numerous straight segments that are very short, with their end points almost directly next to each other, in effect creating a curve out of a multitude of points. (If you remember your geometry, a curve is only a series of adjacent points.)

For instance, in *PhotoStyler*, when you're using the freehand tool, you must push down the stylus point or click on the mouse's left button to fix the outline to the image. Without the button depressed, the partially drawn marquee is a straight line anchored only at one point and waiting for another click to be told where to go next. The established method is to keep clicking along the edge of the irregular shape at intervals of about one-tenth of an inch. In that way you can rest between clicks and not be in danger of ruining a half-hour's labor when you put the stylus down in the middle of drawing the mask.

Before you start using the freehand or lasso tool in any program, look to see if there is another function that will allow you to emulate this method. For instance, in *Photoshop*, all you have to do is hold down the Option key while drawing with the freehand tool. (Just don't let go of the Option key, even when you put down the stylus.) In *Color Studio*, you can use the polygon tool instead of the freehand tool to make a curve by drawing a multitude of tiny straight segments.

Another tool that some programs offer, which uses a variation of this method of breaking an irregular mask into smaller, more controllable segments, is the *Bezier* curve tool. The Bezier tool (sometimes also

called a pen tool, but don't confuse it with a drawing pen tool) establishes anchor points between which a curve is to be defined. The definition of the curve is created by pulling directional leads, or lines that approximate the angle of the curve that you want the next line to follow. These directional leads may also be used to refine individual segments of a drawn Bezier curve. Although the tool might be confusing to use at first—it certainly is difficult to describe to anyone who has not actually used one—with a bit of practice, an imager can draw some very precise outlines with it.

After the curve is completed, call up the command (usually in the pull-down menu under Mask, Transform, or Select) to turn it into a selection marquee. (The Bezier is used more frequently in illustration programs, see Chapter 19.)

Once you've established your initial marquee, it's useful to magnify the image down to the pixel level so that you can see the individual dots that make up the picture. At this extreme magnification, you can perfect your mask, making sure that it includes all the right pixels, while keeping out any extraneous ones. Use the program's ability to subtract or add sections to the mask at this level, and you will get as good a selection as is humanly possible. (See Fig. 20-3.)

By the way, there is such a thing as an automask—a tool that analyzes the differences between the pixels along a curve and will automatically draw the curve accordingly. Few programs offer it. The automask in *Picture Publisher* is so superb that it can actually be used to capture the tiny wisps of hair that elude all other selection tools we have ever used. (*Picture Publisher's* automask is an option of its freehand mask tool.) To understand how it works, imagine a black ball on a white background. If you click on the edge of the black ball, the automask analyzes the differences between adjacent pixels (i.e., the black-&-white pixels that delineate the edge of the ball). Then you click on another point along the circumference of the ball, and the tool will draw the curve where it finds similar differences among the pixels that lie between the two click points.

With a black ball on a white background, it's rather easy to click around the ball and get a perfect automask. Problems arise when there are objects in the background that touch the ball (such as a dark telephone pole) and end up confusing the computer. Then, the automask might misdraw the curve, including parts of the pole. So even an automask will probably need to be edited on the pixel level to be perfected. Also, if the differences between pixels along the edge of the item to be masked are not severe—for instance, if you're masking a dark blue flower that's on a background of dark grey—then the automask is not the appropriate tool to use. Quite simply, it becomes confused about which pixels to choose.

Figure 20-3

Starting with (A) a quickly drawn freehand mask, Sally then (B) magnifies the picture to the pixel level to (C) edit it, using the program's tools for adding to and subtracting from an established mask. © Sally Wiener Grotta

Anti-aliasing & feathering your mask

The final step to perfecting your mask is to look not at the area being selected, but at the line defining the selection. Is it smooth? Will whatever you're planning to do to the selection create a sharp line along the masking line that would set that portion of your picture apart from the rest of your image? For instance, suppose you have masked a man's neck to smooth out some wrinkles. When you are done, will there be an unnatural line between the neck and the face?

Two techniques are used frequently to make the masked area blend in with the rest of the image: *anti-aliasing* and *feathering*. (Both are important tools in paint programs beyond how they are used with masks. They may be used to soften the edges of any painted or drawn

area, which is why they're often included in the options of painting tools.)

No matter how steady your hand is, the nature of a line created by paint software is to have "jaggies." That's because the dots displayed on the screen and printed out by most computer printers or imagesetters are square. So unless your line is exactly vertical or horizontal, it will look as though it's made up of incremental steps, like the steps of a very tiny staircase. Take the capital letter "M" as an example (see Fig. 20-4). It's composed of two vertical lines and two slanted lines. Without any manipulation, the slanted lines have jagged profiles, though the vertical lines are quite straight. When we apply anti-aliasing to the letter, the slanted lines appear smoother, blending into the background.

Figure 20-4

The M on the left has pronounced jaggies. In the center, anti-aliasing has smoothed them out somewhat. On the right, feathering has removed them completely, but it has also blurred everything. (Feathering is more useful with design components than with type.)

When anti-aliasing is applied to the outline of a mask, it reduces the differentiation between what is inside and what is outside the mask by graduating the greyscale of the pixels that make up that outline.

While the effect can be similar to anti-aliasing, feathering works to soften the line in a different manner. (In some programs, feathering is also called "soft edge" or another similar term. In other programs, there is no difference between feathering and anti-aliasing.) Feathering actually bleeds the color of the line into the surrounding background. The amount of bleed is controlled in the feather options box, in which you define the feather by the number of pixels you want it to radiate. So if you feather a mask by a radius of five pixels, then the colors or filters that you apply to that mask will bleed out into the surrounding area at a diminishing rate from the point of the mask's marquee to a depth of five pixels. (See Fig. 20-5.)

HINT

Do not overuse feathering or anti-aliasing because it does soften all edges within the selected area. Sometimes you will want a hard edge to an object.

A useful application of feathering is to smooth out the slight inconsistencies of an unevenly drawn freehand mask. Choose a very small feather radius for this purpose, such as 1 or 2. Then be certain to double-check your mask at pixel level after the procedure.

Figure 20-5

The inner slant of the letter M magnified. (A) Jaggies. (B) An anti-aliased edge. (C) An edge with a feather of 4.

Whenever you let a computer take over and automatically make choices between pixels, it can make the wrong choice. After all, it's only a dumb machine that knows nothing about esthetics and accuracy. When you tell it to feather a mask, it might cut out some critical pixels and include others that have no business being inside your mask.

HINT Feathering or anti-aliasing must be done before you call up any other command that will change the selected area.

By the way, *Photoshop* has a rather nice *defringe* command that removes extraneous pixels from a masked area that has been moved. For example, if you draw a marquee around a red apple that's on a blue background (maybe to cut and paste it onto a picture of a wooden fruit bowl), the defringe command will remove stray blue pixels that were accidentally transferred with the apple.

⇨ The magic wand

The areas that a computer artist wants to mask are sometimes not defined by their shape but by their color. The *magic wand* (see Fig. 20-6) makes selections based upon color similarities, as defined by the

Figure 20-6

Photoshop's magic wand options box.

Magic Wand Options

Tolerance: 32 pixels OK

☒ Anti-aliased Cancel

Help

color of the pixel on which the tool first clicks and the color tolerance designated in the magic tool options dialogue box. (As with almost any paint tool, the options box is usually found by double-clicking on the icon of the tool or in the pull-down menus at the top of the screen.)

If you click the magic wand on a pure white pixel in your image, and if the color tolerance is at 1, then all the pure white pixels in the image will be automatically masked. If the color tolerance is at 10, the selection will include some slightly off-white pixels. A tolerance of 20 will have a bit more leeway. One of 64 might include some light greys and beiges, and a very high tolerance of 255 (which is 100%) will select all the pixels in the image. (In some programs, the tolerance will select only those pixels that are near your original click.)

One way in which we use the magic wand tool is in the initial creation of montage elements, long before we even approach the computer. For instance, if we know that we will want to include the photograph of a violin in a picture, when we set up that photo, we shoot it against a background color that has no similarity to any of the colors in the violin—such as green or blue. Then the photo is scanned into the computer, and the image file is loaded into a paint program. To create the mask around the violin, all we do is use the magic wand on the background color of green or blue. The violin will be perfectly outlined, though in an inverse mask that is really defining the background. (All professional quality paint programs have a command that reverses masks, so that it will exclude the background and include the violin in the selection.)

Similarly, if a very irregular object that would be difficult to mask freehand happens to be made up of colors that can't be found elsewhere in your image, the magic wand becomes a shortcut to selecting that object. (That means the background doesn't have to be a uniform color for the magic wand to be effective; the selected item need only be made of colors that are drastically different from those of any other item in the picture.)

Various programs have tools that can refine the magic wand selection. For instance, in *Photoshop*, the "Grow" and "Similar" commands under the "Select" pull-down menu will add adjacent pixels or similar pixels to the area within the mask. Of course, other techniques for adding to or subtracting from a defined mask are also useful here, as they are whenever you create a selection area.

The magic wand can be used to alter a specific color. You can select all the reds and turn them into a particular yellow. Be careful with this use of the magic wand, and recognize its limitations and eccentricities. It can "dirty up" your picture with stray dots of yellow where you didn't mean for them to be. See Fig. 20-7.

Figure 20-7

Using the magic wand to select the hat in PhotoStyler. (A) A color tolerance of 90 leaves much of the hat unselected, especially inside the borders. (B) A color tolerance of 95 selects much more than the hat. (C) The solution: use a color tolerance of 90. Then, use the freehand masking tool with the Shift key to add to the mask. (Some subtractions—using the Ctrl key and freehand tool—were also needed.)
© Sally Wiener Grotta

Floating selections

A selected area of an image can be moved by clicking and dragging inside the marquee with one of the masking tools or the move mask tool. Depending upon what options or commands you use, you can create a variety of effects. (The commands vary with each piece of software, but the effects are available in almost all professional quality paint programs.)

What determines what will happen when you move a mask is whether or not the selection is *floating* (see Fig. 20-8). Imagine the mask as something that hovers above the picture. As long as it remains floating, then anything you do to the mask will have no permanent effect on the underlying pixels that make up the image—until the

Figure 20-8

If you move a mask that is not floating, then you will also be moving the pixels that make up that portion of the image. What will be left behind will be a hole in the picture, filled with the current background color (which, in this case, is black).
© Sally Wiener Grotta

selection is unfloated or deselected. However, a selected area is not always automatically a floating selection. So, before you call up any command, be sure to check the status of the mask by looking in the appropriate options box, which is often accessible from the "Edit" or "Mask" pull-down menu at the top of the screen. (In *PhotoStyler*, you will have to not only choose the make floating command, but also the preserve image command to guarantee that the underlying picture is not changed.) This is an important concept that will affect just about everything you do with masks, but it becomes most obvious when you go to move a selection marquee.

Another effect that's available when you move a mask will leave the original image intact while moving a copy of the selected portion. For instance, if the selected area is a rose, it would be possible to leave that rose where it is, as well as move an exact copy of it elsewhere in the picture.

A third move selection command will leave the picture intact and move only the outline that defines the mask. This allows you to make a shape that duplicates or approximates an object in the picture.

Look for these commands in whatever program you are using, so you can be certain to have the effect you want when you move a selected area.

HINT

To make a shadow of an object in a picture, mask that object. Then move only the marquee (leaving the image intact), flipping it so that it mirrors the original shape. Distort the selection so that it appears to be laying on the ground or against a nearby wall, as a natural shadow would. Then, finally, darken the area inside the marquee with the brightness/contrast command.

Manipulating masks

Once a mask has been defined, you can command the program to fill the selection with a color, gradient, texture or a cutout from another image. Anything that can be done to an entire image may also be done to a masked selection, such as applying a filter, playing around with color balance, sharpening the details, using the various paint or draw tools on it, etc. In addition, you can move it about or change the shape and size of the selected area with various *transform* tools. See Fig. 20-9.

Figure 20-9

Remember, the purpose of masks is to specify exactly where and how any effect or editing will take place on your image. If the hat weren't masked, this entire picture would have been covered by the radial gradient that was applied. © Sally Wiener Grotta

Usually, when a transform tool has been activated, small dots or corner squares—called *anchor points*—will be placed along the marquee. Use your cursor *interactively* to drag the dots until you have achieved the effect you want. (See Fig. 20-10A.) Other tools will have you input specific numbers or other commands to tell the software what you want done.

> ➤ To change the size of the selected area, you will choose *size, resize, free resize,* or *scale*. The difference between resize and free resize is that in the former you type in the numerical dimensions you wish the masked area to be. In free resize, you pull on the anchor points until the masked area is the size you need. See Fig. 20-10B and Fig. 20-10C.

> ➤ You can *rotate* a masked area in increments of 90 degrees, clockwise or counterclockwise. Or you may pull the selection to the angle that looks right and fits your image. See Fig. 20-10D.

Figure 20-10

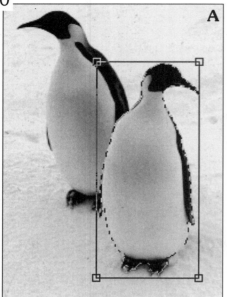

A

Pull on the corner squares of the
transforming bounding box to
interactively resize, angle, distort,
etc. a masked area. © Sally Wiener Grotta

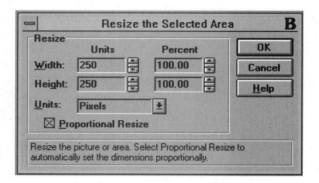

B

PhotoFinish's resize option box into which you
input numbers to change the size of a masked
area.

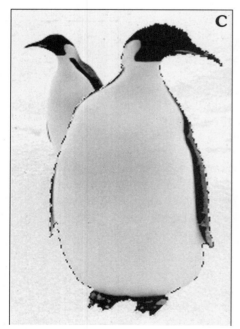

C

Masked area resized (or scaled)
larger. © Sally Wiener Grotta

D

Masked area rotated. (Current
background color is black, so that
"color" fills the space where the
penguin was.) © Sally Wiener Grotta

E

F

Masked area flipped horizontally and moved aside, to expose the black area that was left behind. Normally, the clone tool would be used to paint over the black area with elements of the picture.
© Sally Wiener Grotta

Masked area flipped vertically and moved aside. © Sally Wiener Grotta

G

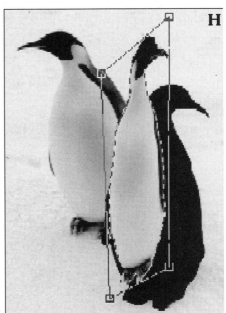

H

Masked area with perspective applied. © Sally Wiener Grotta

Masked area distorted or sheared.
© Sally Wiener Grotta

➤ *Flip* (or *mirror*) your masked area vertically or horizontally, so that it is a mirror image of the original. See Figs. 20-10E and 20-10F.

➤ *Perspective* locks corner anchor points to each other, so that if you pull one far into the background, the other will follow. Thus, a selection can be angled to look as though it is coming from the back to the front, following the rules of classic perspective drawing. See Fig. 20-10G.

➤ *Skew*, *distort*, or *shear* completely alters the original shape of your masked area, with each anchor point acting independently from the others. Sally recently used this method to place one of her photographs of a tiger into another of a computer monitor, though the monitor was angled away from the front perspective. In the end, it looked as though the tiger were displayed on the monitor. Skew may also be used to make strange shapes out of the original. See Fig. 20-10H.

Getting sophisticated with mask manipulation

The real excitement begins when you recognize that a mask is much more than a dotted line on your image (see Fig. 20-11A); it is a separate file that is temporarily associated with the image. And, as a separate file (which may be saved and loaded again to be re-associated with the same image or another), it may be manipulated to create powerful special effects.

When you view a mask file without its associated image, it is a black-&-white silhouette, such as in Fig. 20-11B. (Usually, the white is the area inside the selection, though it's possible to reverse that in some programs.) You can paint directly on a mask file, using not only white & black but also greys. And it's the greys that offer interesting creative possibilities.

Think of a mask as a window in front of your image. The white portion of the mask is like a perfectly clear glass pane that lets everything through to the image. So, whatever command, technique, or filter you apply through the white portion of the mask will get through to that part of the picture, just as sunlight can stream through a window. The black portion would then be similar to an opaque curtain that lets nothing through. Then, the greys are like a translucent screen that will let a controlled measure of light (or, in this case, commands, techniques or filters) through to the picture depending upon how dark the greys are. The darker the grey, the less effect any technique will have on the image.

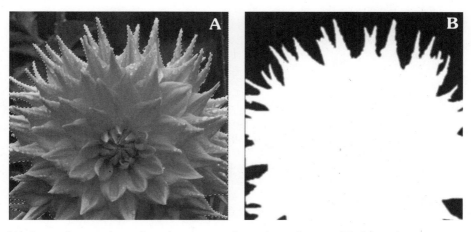

Figure 20-11

(A) A mask as a dotted outline around a selected area. (B) A mask as a black-&-white silhouette file. © Sally Wiener Grotta

The variable darkness of greys is a powerful tool well worth experimenting with (as shown in Fig. 20-12). For instance, if you fill the white portion of a mask with a grey gradient, then anything you apply to the picture through that mask will have the effect of fading away into the picture. (See Chapter 18 for a discussion of gradient fills.) Similarly, try using bands of different levels of grey, swirling greys, or checkerboard effects, or other combinations and permutations. You might even want to apply a filter to the greys in the mask to see what that will do when you then use the mask to define other commands on your picture. (See Fig. 20-13.)

Figure 20-12

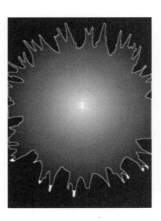

A circular gradient applied to the flower's mask, leaving a white edge for definition. Remember, the whiter the mask, the more effect will get through to the picture. The darker the grey, the less effect. The black areas won't be affected. © Sally Wiener Grotta

HINT One interesting effect is created by painting greys on the black-&-white mask file and then calling up a whirlpool filter. But first you must temporarily mask the mask file to make sure that your carefully defined silhouette isn't altered by the filter. This is easily achieved by using the magic wand on the white portion. Of course, don't forget to remove the secondary mask before you recombine the mask file with its associated image.

Figure 20-13

As you will see in the next chapter, pixelating filters can wipe out the entire underlying image (as in the center of this flower). But by applying it through the circular gradient mask, the individual petals remain distinct, with the definition increasing as it spreads out toward the outer edges. © Sally Wiener Grotta

Mask files, levels, & channels

One measure of the power of a paint program is how much control it gives the artist over the mask file. In some programs, all you can do is draw and perfect a marquee. This is the bare minimum requirement. But the truly sophisticated, highly professional programs treat a mask as a separate file that is temporarily or permanently associated with an image. The nomenclature and methods for working with the mask file may vary, but they tend to fall into two approaches.

➢ The mask is a separate file that is saved and loaded, usually through the pull-down menu on the top of the screen, under "Select" or "Masks."

➢ The mask is one of several levels or channels associated with the image that define various attributes of that image—much as color separation channels are—and may be saved and loaded through the channels or levels dialog that may be accessed through the "Window" or "View" pull-down menu or elsewhere on the screen. (Software developers like being original where they put the levels access, but it is usually rather easy to find.)

With either, the mask is accessible as a silhouette file that may be manipulated as much or as little as the artist wishes.

The essential difference between these two approaches (or even between these and the software that limits the artist to merely drawing a selection marquee on a picture) is not what the mask is, but how deeply into the workings of masking the program will allow the user to probe.

All images are made up of channels (including the color channels) or levels that merge one on top of the other to create the picture. When you draw a mask, you are establishing another level that is meant to control how the other levels react to commands, filters, tools, or other techniques. (The mask level is often called the "alpha channel," which

can be responsible for an additional 8 bits of information being associated with an otherwise 24-bit image.)

Think of a cardboard stencil laying over a blank canvas on to which a traditional artist will paint, first red, then blue, then green, changing the stencil with each paint pass to make new effects and combinations. Whether or not your imaging program allows you to see it, that's how a mask layer really works in digital imaging, except that with computers you can also change the mask itself to make it affect the quality and density of the paint being laid.

A few programs allow you to view the mask file not only as a black- &- white silhouette, but also as a translucent color overlay through which you can see the image. In that way, when you paint on the mask, you can see exactly where the stroke is being placed in relationship to the image. This is a powerful variation on which Sally depends extensively for perfecting her masks. (The name for this varies with each program that offers it. In *Photoshop*, it's called the "Quick Mask" mode.) See C-1 in the color pages.

For instance, if your overlay is red, then everything in the picture that isn't in the selected area would have a red tint to it. Painting with white will remove the red overlay (thereby adding that portion to the selected area). Painting with black will add red overlay (removing it from the selected area). And painting with greys will introduce varying levels of translucency to the mask. You can change the color of the overlay according to what will allow the most picture detail to show through.

21

Digital filters &
other special effects

PROBABLY the most popular imaging tools are the many software filters that can completely alter a bitmapped (paint-generated) image with a click of a mouse button. Digital filters are a type of computer macro (shortcut key) that calls up a predefined series of commands to produce a specific effect. Anyone who uses a computer on a regular basis has probably encountered macros. Perhaps you have made some in your word processor to insert your letterhead or today's date into a document.

Imagine the first person who worked out how to sharpen a photo's focus electronically. (It was probably someone working for—or co-opted by—the Jet Propulsion Lab in California, to clarify the deep space images that were being sent back by satellites.) The original process probably involved thousands of lines of computer code written so meticulously that a single misplaced digit might make the entire program fail. Rather than type in that code every time he wanted to invoke the command to sharpen, the programmer created a single key or menu option to access the file that contained all that code. Thus, a sharpening filter was born.

Filters automatically calculate the relative and/or absolute values and characteristics of every pixel in a picture (or a selected area of that picture). Then they alter those values and characteristics according to the command that has been invoked. For instance, a blur filter will analyze the relative traits of adjacent pixels and change them so that neighboring dots become more similar to each other. Often, this is done by decreasing the amount of contrast between pixels. (If a series of black dots making up the edge of an object were next to a series of white dots that made up another object, then the dots on the border area between the two objects would probably be made grey to blur the difference between them.)

All those calculations happen behind the scenes, out of sight and out of mind of the artist. It's like the chemical formulae that determine how different paints meld into each other on canvas. Few artists bother with *why* certain pigments and media blend one way or another. From experience, they simply recognize and use the paints' propensities to create a variety of effects.

Filters are a specialty of paint programs, working as they usually do on the individual dots that make up a bitmapped picture. All paint programs include some filters; the more sophisticated and more expensive programs often have an extensive library of them. There are also companies that produce collections of add-on filters that can be purchased and incorporated into your programs, or used separately. For instance, no serious digital artist would want to be without at least one package of *Aldus Gallery Effects*, which plugs in (integrates into) a number of other must-have software, such as *Photoshop*, *Fractal Design Painter*, *PhotoStyler*, etc. (There are currently two different

Gallery Effects packages—Classic Art, Volumes I and II.) Another powerful filter package that we use is *Kai's Power Tools* (*KPT*). KPT introduces the very creative, exciting, but difficult to understand fractal theory of chaos, as well as advanced color experimentation and other sophisticated techniques, into your *Photoshop* images. (*KPT* filters are quite unusual in many respects and break with most of the generalizations we use in this chapter.) Other special effect programs include morphing packages (such as *PhotoMorph*, *Morph*, and others), which synthesize a new object by combining the attributes of two others. (It's something like crossing a cat with an elephant to make a furry, bewhiskered pachyderm.) Another type of special effects involves introducing 3-D emulation, such as *Crystal 3D Designer*. Not all special effects programs are filters, in that they can stand alone rather than function only within another program. What all these programs have in common is that they somehow transform an image.

Roughly, filters, and similar programs can be divided into two categories—*editing tools* and *special effects*—though the two frequently overlap. The editing filters include those that blur, sharpen, smooth, lighten or darken, etc. Special effects are those that distort (such as whirlpool), change the texture (such as emboss), alter the composition of strokes (such as pixelate or add noise), add artistic effects or styles (such as impressionist, oil painting, watercolor), or introduce high-tech elements (such as fractals, morphs, 3-D), etc. In addition, some programs provide a comparatively easy-to-use option that allows the artist to create his own filter effect. (It will take about an hour to learn how to control the process of making your own filter, but the actual creation will take far less time. Of course, as with all imaging tools, the longer you spend experimenting with it, the more proficient you will become in designing your own filters.)

Increasingly sophisticated, intriguing, and sometimes useful filters and special effects are constantly coming onto the market. It's one of the major areas of growth for software developers, especially for the small companies who couldn't otherwise compete with the imaging software giants that are already so well established. Therefore, this chapter is not intended to be an encyclopedia of filters and special effects. Rather, use it to help you to understand almost any you encounter—to recognize what a filter or special effect package is capable of doing, how to choose among the options available, and to take control over them for more effective designs.

Dealing with the slow speed of filters

Filters work with complex mathematical formulae (called algorithms) that analyze every pixel in a paint-generated picture (or a selected area of the picture). Then they go to work on changing the appropriate pixels. Given that even a small image file can be made up of millions of pixels, invoking a filter will consume time, even on a powerful desktop computer loaded to the gills with memory. In

addition, the higher the resolution of a picture and/or the larger its dimensions (for instance, 8"×11" as opposed to 4"×5"), the larger the file will be and, therefore, the slower the filter applied to that file. What makes that most frustrating is that, while a filter is working, you can do practically nothing else on your computer.

Here are some suggestions on either speeding up the filter process or dealing with the passing of time.

- If you are not sure what filter you want to use on an image, try it out first on a low-resolution file of that picture, and then only on the critical parts of that picture. (Use a mask to define a small portion of the image.)

- When you have the money, add as much RAM memory as your computer can handle. (See Chapters 8 and 9.)

- Consider getting the Photoshop dedicated videocards (such as those from PhotoSpeed) which have high-speed co-processors built into the circuitry that will accelerate some of the filters by a factor of 5 to 20 times. (However, they're expensive and updating with new filters might be a problem.)

- Schedule your filters, if you can, to be applied at times during which you can make phone calls to clients or take care of other necessary chores. (Sally uses the time to catch up on slide labeling or to read about new techniques in documentation and imaging magazines.)

- Try to be patient and find something to take your mind off the filter until it is done. After all, the computer is doing the best it can for a dumb machine whose only virtue is being able to process information as fast as its engineering will allow.

- Okay, go ahead. Rant and rave. It won't speed up anything, but it might make you feel better.

⇨ Filter controls

Filters are generally located in the pull-down menus at the top of the screen under "Image," "Transform," "Effects," or "Filter." Some need only to be invoked by a mouse or stylus click to take action. Others require the user to make a few choices in an options box that pops up when the filter is selected.

Many filter options tend to be numerically designated. Don't be intimidated by their mathematical appearance. Once you understand what a filter does, it will become clear what the numbers represent. Here are some conventions that are generally used in filter options.

The *radius* option, which is usually expressed as a number of pixels, can relate to two different things, depending on the program and the filter invoked. It can be used to determine how wide a swathe the filter

will use to calculate its effect or to define how far the effect will spread. Let's explain those concepts more fully.

The typical filter first analyzes a group of pixels, then performs calculations based on that analysis, and finally makes the changes those calculations indicate. The radius you choose will tell the filter how many pixels to include in its calculations. Suppose the necessary calculations will determine just how different the contrast is along the designated swathe. If you use a wider radius, then you might introduce into the calculations a wider range of contrasts among the pixels. That would mean that the result of the calculations would not be the same as one that included fewer variables.

Mathematically, the average of a series of consecutive numbers will change each time you add another digit to the numbers to be averaged. Therefore, the average of 1, 2, 3, 4, and 5 equals 3, and the average of 1, 2, 3, 4, 5, and 6 equals 3.5. Increasing a filter's radius will increase the number of pixels that are introduced into the calculations and, therefore, usually will change the result of the calculations. How this translates into the effect on your image is something you can learn only from experimentation and experience.

On the other hand, if the radius indicator relates to how far the effect will spread, then it is like a blur tool or feathering technique that allows the effect to bleed into its surroundings—the larger the radius, the further it will bleed.

Experiment with different radius values on different kinds of pictures to get a feeling for what the numbers mean to your designs.

Sliding scales represent numerical filter options that range along a continuum. (Often, these are shown as scroll bars, a commonly used computer visual on which you use your mouse to push a box inside a thin rectangle along its length.) These allow the user to modify the strength or dimensions of various effects. For instance, Gallery Effect's fresco filter has three sliding scales. (See Fig. 21-1 and Fig. 21-2.) They allow you to define the amount of brush detail within a continuum between one to ten; choose a brush size between one and ten; and use a texture value between one and three. Usually, the lower the number chosen, the less detail or less drastic change in the image. In the fresco filter, the brush size indicates how wide the individual brush strokes will be; the brush detail determines how much variance you want between adjacent blocks of color; and the texture is a value of the smoothness or roughness of the resultant image.

The names of sliding scale options will vary according to what the filter does. If you don't understand the label of a sliding scale or any other filter option, you probably don't understand what the filter will be doing. Then you have two options: read the documentation, or just try out different values and see what happens. (Sally usually does the

Figure 21-1

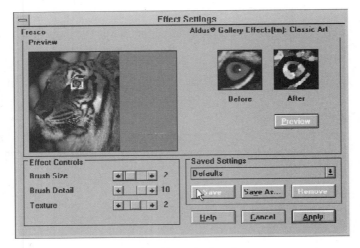

Gallery Effect's Fresco Filter dialog box.

Figure 21-2

The Fresco Filter applied on a photographic image with the brush size at 2, the brush detail 8, and the texture 3. © Sally Wiener Grotta

latter, turning to the documentation only if the result doesn't make everything patently clear to her.)

HINT Remember, you can use the *Undo* command immediately after applying a filter if you don't like what it does to your picture. But, in most programs, that won't work if you do something else to the image after you use the filter and before you use Undo. The ultimate safeguard is to save your image to your hard disk frequently, creating separate files (under different file names) for each significant stage of its development and keeping an original file intact and untouched. The tradeoffs for that protection are time and hard drive space. Saving a

large file can take many seconds, and, if you have limited available space on your hard drive, a few separate file saves can ultimately lead to the dreaded "Disk Full" message.

Incidentally, depending upon the program and the filter, numerical values may also be changed along the continuum by typing in a number or using *scroll boxes*. Scroll boxes are up and down arrows next to a number. Each time you click on an up arrow, it increases the number by an increment, such as 1. Each time you click on the down arrow, it decreases the number by the same increment. For instance, in *Corel PhotoPaint!*, the options box for the motion blur filter (see Fig. 21-3) has a scroll box option through which the user chooses how fast it wants the image to appear to be going. (Motion blur filters give an image an appearance of movement or speed.)

Figure 21-3

Corel PhotoPaint!'s Motion Blur dialog box.

You'll also notice in *Corel PhotoPaint!'s* motion blur options box another frequently used convention—*direction arrows*. In this case, they determine what angle the blur will be painted. Filter direction can also be represented by numerical values related to the 360 degrees of a circle. So you can tell the filter to make a 45 degree, a 175 degree, or whatever angle stroke you wish. Or, in other filters, you can tell them to affect the picture by changing the existing strokes according to a specified angle. Thus, a whirlpool filter of 90 degrees will make a right angle swirl of the existing colors.

Filter options may also be varied by clicking on *choice boxes* or *radio buttons*. Thus, you may indicate your preference among options or toggle an option on or off by clicking on a box or circle. *PhotoStyler's* ripple filter has three options from which a user may choose a high, low, or medium frequency to define how many ripples you want per area of image (see Fig. 21-4).

Figure 21-4

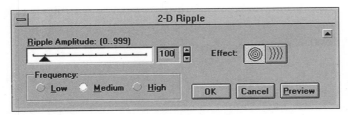

PhotoStyler's Ripple Filter dialog box.

Filter controls sound much more confusing than they really are. That's because you must use mathematical concepts to describe them. But to actually use filters, you just have to have a feeling for the aesthetic possibilities they offer. So just jump in, head first, into filters and enjoy playing with them. Recognize the many numerical choices as no more than dials which, like the ones on an old-fashioned radio, turn up or reduce the volume, modify the tonal balance, move the angle of reception, alter the depth of effect, etc.

By the way, whenever a program offers a preview button or window on the filter options box, use it—it will save time and help you make design decisions. Often, you can adjust that portion of your picture the preview window shows. In *Gallery Effects*, there's a square outline that you move around to pinpoint a small preview area, on which you wish to see the effect of the filter. In *Kai's Power Tools*, there is a box with arrows to the left of the preview; clicking on those arrows will adjust your view of the filter.

When you encounter a new filter, load in a low-resolution image file. Then mask a small portion of the picture and try the filter on that section. Select another portion of the picture to try another variation of the filter, and so on. Then try out the same options on a different kind of picture. (The same filter can have a very different effect when applied to another kind of image.) No documentation can give you as quick an understanding about what a filter can do as just experimenting with it.

⇨ Some examples of filters & how they work

Filters encompass an incredible array of possibilities. They can be subtle or dazzling, complicated or simple. They're capable of making delicate changes or completely transforming an image. Some filters will become second nature to you because of their universality. Others should be invoked occasionally or rarely because their visual effect can be severe, gaudy, or even bizarre. While you may use certain filters in conjunction with numerous others, there are those filters that should stand alone, to isolate and focus on the power they can impart to a

picture. What follows are just a few examples of what you can do with these dynamic tools.

HINT

If you find that you are unable to access a filter that is generally available in the paint program you are using (it might be greyed out on the pull-down menu or won't do anything when you click the mouse on it), check the data type of your image. Some will work only on 24-bit RGB images. (See Chapter 22 about data types.) Or the filter might need a mask to exist on the active picture before it can be invoked. In that case, if you want the filter to work on the entire picture, use the "Select All" command to mask the full image.

⇨ Focusing filters

Sharpening Filters work on the premise that the eye recognizes an object as well-focused when there are strong differences between pixels of varying contrast and/or color. Therefore, the mathematical purpose of these filters is to increase those differences. Most professional paint programs have more than one kind of sharpening filters, each of which produce slightly dissimilar results.

Sharpen, *Sharpen More*, *Sharpen Heavy*, and such names are easy to recognize and understand intuitively.

Sharpen Edges filters work only on those pixels where the differences between contrast and color are strongest (which is usually the definition of an object's edge).

An *Unsharp* filter also seeks out the edges within an image and increases the differentiations. In addition, it enhances contrast on either side of the edge. This strange name for a sharpening filter comes from the traditional prepress (graphics arts) world. Prepress operators discovered that when they applied masks to color separations, if the masks were slightly blurred, it had the contradictory effect of sharpening the edges of the composite picture. (No, it doesn't make sense to us either, but that is what we've been taught and how experts always explain it.) The unsharp filter is often the sharpening tool of choice because it gives more control over the process to the user through an options dialogue box.

Sharpening filters have a great deal in common with other edge altering filters. (See later comments.) See Fig. 21-5.

There's no free lunch

Be careful not to overuse sharpening filters. Because their purpose is to increase the contrast and color differentiation among pixels, using them too many times over the same area of an image can result in potential problems.

> - Aesthetically speaking, increasing the contrast of a picture too much can be unattractive and distracting.
>
> - Drop-outs of pixels can occur. That is, you can lose actual pieces of data related to your picture.
>
> - Your picture can end up covered in what looks like glittering speckles. It's the various pixels becoming so differentiated that they are no longer part of the composition. Of course, knowing this, you might want to use this effect for some new design possibilities. In fact, many programs have a noise filter to create this specific effect.
>
> Don't be fearful of applying this very useful group of filters. Just use them judiciously and be aware of the possible problems that could arise if you wield them indiscriminately.

Blur or Smooth Filters are exactly the opposite of sharpening filters in that they work to make adjacent pixels more similar to each other in contrast and color.

The common ones are *Blur*, *Blur More*, and *Blur Heavy*.

A *Gaussian Blur* gives the user more control over the process through an options box. The higher the number you input into the Gaussian options dialogue, the more it will smooth over the selected area of your picture. The highest numbers will remove all contrast from the image. (For those readers who are mathematically inclined, the Gaussian blur uses a bell curve for its calculations. The distribution of the effect of this filter falls off along the edges of the bell curve.)

A *Despeckle* filter blurs those pixels that stand out from their surroundings, such as a hard edge or the pixel glitter that can come from too much differentiation among adjacent pixels. (See sidebar.)

A *Motion Blur* filter makes an object appear to be moving and is best used as only part of a picture. For instance, you can apply it to make a trailing blur behind a running man or to create the sense of action in the background of a picture.

Similarly, a *Radial Blur* creates a circular burst, comparable to the technique used by photographers who adjust the focal length of a zoom lens while exposing a picture. See Fig. 21-6.

Edge-altering filters

The fact that digital imaging software can identify those pixels that make up the edges in an image according to where contrast is strongest has spawned a group of filters that identify and then alter those edges in interesting ways. In some programs, these may be found in the same pull-down menu as the sharpening filter, because they work on similar principles.

Figure 21-5

(A) The original photo. (B) The same photo with pixel dropouts and increased contrast from oversharpening. © Sally Wiener Grotta

Figure 21-6

A radial blur filter applied at maximum parameters on the same photo as Fig. 21-5. © Sally Wiener Grotta

An *Edge Enhancement* filter will increase the contrast of the pixels that make up the edges. This is very similar to the Sharpen Edges filter and may replace or supplement it, depending upon the program. Use this filter to heighten texture and dimensionality.

Find Edges, Trace Contours, or *Edge Detection* highlights all the edges and drops out the colors in the rest of the image. What you end up with is an outline of bright colors that sometimes can look almost fluorescent. (Be careful about outputting an image that has been altered by a Find Edge filter. The colors might not be within the reproducible range of your printer. See Chapters 28 and 29.) See Fig. 21-7.

The *Find Edge & Invert* filter is a variation of find edges, which, when it is finished with creating the outline, reverses the greyscale values of the rest of the image. What you end up with is a rather attractive sketchy outline on a light background. Similarly, the *Edge Detect* filter

Figure 21-7

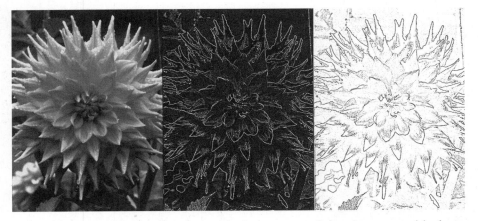

The original (left) was enhanced with the contrast & brightness tool before applying the Find Edges filter (middle) and the Find Edges & Invert filter (right). © Sally Wiener Grotta

in *Corel PhotoPaint!* highlights the edges and then lets the artist decide what color the background should be.

⇨ Color & greyscale altering filters

The *Posterize* command reduces the number of colors in an image or a section of an image. The result is a more dramatic, less subtle picture, in which transitions between colors are hardened. (See Fig.21-8). You may find posterize under the filter menu, but it is just as likely to be under "Tune," "Map," or "Color" in the pull-down menus.

Figure 21-8

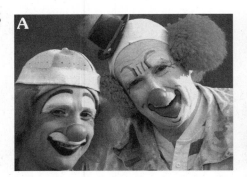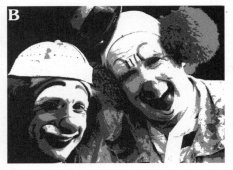

Posterization. (A) is the original, while (B) is the posterized image.
© Sally Wiener Grotta

A group of *Averaging* filters—called *Median, Maximum,* and *Minimum*—adjust the color and greyscale values of the pixels of a picture, according to how they relate to the other pixels in the picture. Thus, the maximum filter brightens a picture by increasing highlights to the level of the brightest pixels. The minimum filter has the overall effect of darkening a picture. The median filter balances the highlights and shadows relative to each other; it is also rather good at reducing the "noise" in an image. (Noise is the term for rogue pixels that

appear as speckles, because they don't quite fit in with the rest of the picture.)

The radius option that we discussed earlier in this chapter is critical in defining the result of these filters, because the more pixels used in calculating the average value in a picture, the greater variance there will be in the results of those calculations. This variance might mean a more accurate calculation or, conversely, one that is too extreme.

HINT Use the average filters to slightly increase or decrease a mask by, say, a pixel or two.

Read about other methods for changing greyscales and color, as well as about histograms (the graphical representation of those values) in Chapter 23.

Morphing & 3-D programs

Multimedia software has generated a number of interesting special effects that are now being used in still imagery. Among the most popular are programs that provide the tools for using morphing and 3-D effects in your images.

Morphing is familiar to anyone who watches science fiction movies or TV shows. It's the process of transforming an object into something else completely, such as the evil robot in the movie Terminator 2 that could instantly transform into anything or anybody before your eyes. In still imagery, morphing creates an intermediate synthesis of two objects that has characteristics of both of them. For instance, a morph between a man's face and a bowl of mercury would produce a luminous silver portrait. To use a morphing program, you will have to have two pictures in which the objects to be used are of the same size (in resolution and dimension). Then you indicate the areas of importance which you want the two objects to share—such as the eyes of a woman and the eyes of a cat which you are morphing. After that, the program takes over, creating the new type of creature.

3-D programs do just what their name suggests—make three-dimensional renderings of objects, so they appear to have height, depth, and width—in other words, actual substance. Some are quite complex, others rudimentary. Please see Chapter 19 on this subject.

Shapeshifting filters

Here are just a few of the wide variety of filters that will change the composite shapes that make up your images.

A *Sphere* filter curves an image as though it were wrapped around the face of a globe. This can be used very effectively to make multi-colored balls, especially when it is confined by a circular mask. See Fig. 21-9A.

A *Punch* filter pushes out the pixels in the center of the image, in a similar manner to the sphere, but with less uniformity. This has the effect of stretching the center of the picture, as though over a flat circular board. See Fig. 21-9B.

Pinch or *Black Hole* filters pull the pixels of the picture toward the center. See Fig. 21-9C.

Figure 21-9

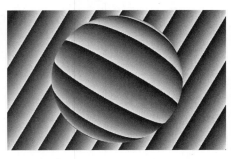

A

(A) On a background created by using a linear gradient with a repetition of 12 and hard edge transitions, Sally placed a circular mask. Then she used the Sphere filter (which affected only the selected area) and rotated it (with the mask still active) by 90°. (B) A punch filter applied to the same figure and with the same mask manipulation as A. (C) A pinch filter.

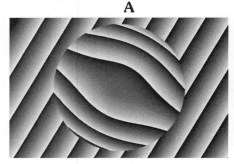

B

C

Pixelating filters are familiar to anyone who watches the news on TV. They create small squares out of the colors that make up the picture and are used by news shows to hide the identity of an anonymous informer or an innocent victim. Depending upon how large the squares are and if they are angled directly under each other or askew, it is possible to discern the underlying image or to completely break it up. (See Fig. 21-10.) In some programs, this may be called a *Pixelizing* filter or a *Mosaic* filter. However, *Gallery Effects* has another mosaic filter that is quite different—it turns the picture into a tiled image, with grout between each segment.

Crystallize or *Facet* filters are somewhat similar to pixelizing filters, but they break up the image into *irregular* shapes that look like crystals. The user defines the approximate size of these polygons, each of which tends to have a solid color taken from the picture. It's like viewing your image through a collection of gem stones. See Fig. 21-11.

HINT

Pixelating, crystallizing, and other differentiating filters will have little visible effect on an image in which there is no hard distinction among the colors. Try this experiment. Apply a pixelate filter on a linear gradient file. You might see some hard-to-discern ridges, but that's all.

Figure 21-10
Figure 21-11

A pixelating filter applied to the clowns of Fig. 21-8. (The cell size was kept small, so you could discern what lay underneath. If a larger cell were chosen in the filter's dialogue box, all you would see would be an abstract of colored squares.

A crystallizing filter, applied to the same clowns, at a similar cell size.

Now *undo* the pixelate filter and paint some dots on the gradient. (If you use the foreground color where the gradient used the background color and vice versa, your result will be rather attractive. Use the eyedropper tool on the gradient to pick up colors for your painting.) When you use the pixelate filter again, there will be a definite visible effect.

A *Whirlpool* filter twists the image through a specified angle, as though it were caught in a whirlpool at sea (see Fig. 21-12). One interesting use of this effect is to paint droppings of different colors inside a masked area of a picture and then whirlpool it through 360°. (For even more dramatic flair and more definition to the swirls, follow that effect up with the application of a sphere filter on the same area.)

Figure 21-12

Whirlpool filter followed up with a Sphere filter.

A *Ripple* filter makes waves in images, as though they were riding a rough sea (see Fig. 21-13). Or, when a high amplitude is chosen in the ripple options box, the effect is more of a zigzag. This is why it's sometimes called a *ZigZag* filter.

Polar Coordinates, *Polar to Rectangular*, or *Rectangular to Polar* are fascinating filters. Essentially, they bend images around the polar coordinates (as opposed to the traditional linear X,Y coordinates of two-dimensional geometry), establishing a very surrealistic and spectacular tunneling. The polar to rectangular pulls all the pixels of the image into what looks like an inverted globe that fills the center of

Figure 21-13

The clowns with a Ripple filter applied.

the picture. (See Fig. 21-14A.) The rectangular to polar splays all the pixels into a semblance of columns and arches. (See Fig. 21-14B.) In *Picture Publisher*, putting a picture through one and then the other will not return the image to its original form, and, with each pass of the filter, the picture will be distorted a bit more, creating wonderful variations on the theme of curved abstracts. But *Photoshop*'s newest version (2.5) no longer compounds the effect in this manner.

Figure 21-14

Polar Coordinates filters applied to the striped gradient background without the circular mask. (A) shows Rectangular to Polar, while (B) shows Polar to Rectangular.

Incidentally, according to Adobe, the creators of *Photoshop*, "This filter can create a cylinder anamorphosis, a type of art popular in the 18th century in which the distorted image is difficult to recognize unless viewed in the reflection of a mirrored cylinder." Sally uses polar coordinate filters very selectively, usually only on portions of an image or to create new textures. She especially likes them for making swirling borders around her pictures that use the colors and textures of the image in a disjunctive manner.

HINT

Steve Guttman of Adobe suggested the following application of polar filters for a spectacular effect. Pixelate an image or a portion of it (which is done in *Photoshop* by the mosaic filter). Then, use the polar to rectangular filter. You'll end up with a stained-glass abstract.

Kai's Power Tools

These filters from HSC software plug into Photoshop *and provide access to fascinating possibilities and areas of experimentation with fractals, the essence of color and other very advanced aspects of computer art. (Originally borrowed from advanced mathematics, fractals create fantastic patterns that fold in on themselves with mutating repetitions. The effect is intense, beautiful, organic, and almost alien.)*

While Sally does use Kai Power Tools *and enjoys the unusual creative potentialities of such a powerful program, we recommend that you first master the basics of digital imaging before venturing into this realm, then let* Kai's Power Tools *carry you further than you ever expected into creating new kinds of shapes, patterns and textures. By the way, KPT has the most sophisticated and satisfying color gradient tools we have found.*

Texture & artistic media filters

Remembering that digital imaging has its aesthetic origins in the traditional arts, realize that many filters emulate the media, textures, and styles of real world painting, drawing, and sketching.

So there are filters that mimic *Oil, Watercolor, Charcoal, Chalk, Pastels, Graphic Pen, Palette Knife,* etc. (See Fig. 21-15A.) There are other filters that can turn your image into something that looks like a *Fresco, Pointillist,* or *Impressionist* painting, or other styles and techniques. (See Fig. 21-15B.) Still other filters can alter your picture to make it look as though the paper were *Embossed,* the image *Engraved,* the canvas *Underpainted,* etc. Texture filters create the semblance of *Bas Relief, Chrome, Mosaic, Stucco,* etc. (See Fig. 21-15C.)

You can use more than one style or type of media in a single image, in ways that wouldn't be possible in the real world. Texturize various sections of your picture with different styles to give it a feeling of sculpture. Go a bit crazy every once in a while with your experiments, then step back and regroup. Remember, filters are like typefaces in a design. The use of too many on one page is often the sign of a novice—or of a genius, who knows when to break the rules and when to keep them.

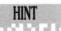 Try applying filters on one of the channels of a color separation, and then recombining those channels into the full image. More about using color separations as creative canvases in the next chapter.

Figure 21-15

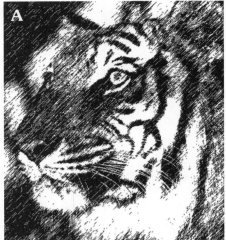

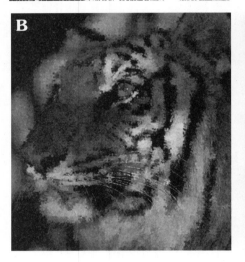

(A) A Graphic Pen filter applied to a photo of a tiger. (B) A Pointillist filter applied to the same photo. (C) A Bas Relief filter. © Sally Wiener Grotta

Fractal Design Painter

One very extraordinary imaging program—Fractal Design Painter— approaches the theme of simulating traditional artistic media and surfaces from a different direction, with great success.

By experimenting with the many choices of brush styles, papers and canvases, brush behavior, etc., you can create some amazing effects.

For instance, what might be just a single kind of paintbrush with different sizes and transparencies in any other program becomes in Painter *a variety of styles, such as a* Japanese brush, watercolor brush, hairy brush, graduated brush, *etc. In the fine artist options, you can emulate the thick oil strokes of a van Gogh, the pointillism of Seurat, etc. Pencils may be* sharp, thin *or* thick, *a* 2B pencil, colored, *or even a very heavy-handed* 500 pound pencil. *Water may be* frosty, tiny frosty, grainy, *or just* add water. *Felt pens options include* dirty marker, fine *or* medium tips, *etc.*

A clone tool will reproduce a portion of your image or your entire picture in the style of van Gogh, in pencil, as a sketch, in felt pen, hard oil, driving rain, etc. Or it will act as a typical cloner such as you are used to from other more mainstream paint programs.

Not only does Painter *provide a wide variety of brushes (many more than are listed here), but there is also a paper texture palette so you may choose your canvas and, thereby, change the way your brushes will behave. For example, there's* basic paper, cotton paper, *different* watercolor papers, rough, fine, medium *and other textures. You can also change the behavior of your brushes more directly from yet another palette that defines the type and degree raggedness or smoothness, dryness or wetness, etc. of your strokes and media.*

All in all, Painter *has achieved a high degree of creative impact in imaging, of the sort that one expects from filters. But there are no fine art emulating filters we're aware of that are quite as far reaching as* Painter.

Other filters

The diversity and number of filters and special effects programs is an indication of the ongoing growth of digital imaging, plus the demands that artists are making on the software. We've covered only some of those that are available today, recognizing that whole new libraries of transforming programs are probably on the drawing boards for future releases. In fact, new collections are introduced into the marketplace frequently.

If you don't want to depend on anonymous computer programmers for your library of filters, you can always create your own using the "Custom" filter tool that the better professional quality paint programs (such as *Photoshop* and *PhotoStyler*) offer. You don't have to understand mathematics or programming to use it; and no matter how sophisticated you get, you will always find ways to surprise yourself with it.

22
Playing with color

THE number one essential ingredient of all pictures—even black and whites—is color. It has the greatest and most immediate impact on the viewer, more so than any other element of a good design. In psychological testing, infants are drawn to the colors of an object before they even consider the shape or texture. We don't outgrow that simple truth, regardless of how old or urbane we get. For that reason, the digital artist reveals her expertise in her astute use of color.

The theoretical definitions of computer color can be confusing, involving some important concepts that are rooted in physics. We'll do our best to avoid scientific terms; they just obscure the basic fact that computer software has a wonderful array of color tools and techniques that have become a playground for artists.

NOTE Remember that the colors you see on your monitor are created with transmitted light, which means they might not translate exactly to what your printer (which works instead with reflected color) will make of the file. See Chapters 28 and 29 for a complete discussion of this problem and pragmatic solutions to it. This chapter will deal not with the output of color, but with how to manipulate and use it as a creative element within your computer.

⇨ Image data types

Every pixel of a picture generated by a paint program has information associated with it that defines its color. Computers organize information in bits, which are units of measure of digital data. The more information that is identified with each pixel, the finer the color detail of the bitmapped picture. For instance, an 8-bit image has a selection of up to 256 different colors, while a 24-bit image can work with 16.7 million colors. The more colors at a picture's disposal, the more subtle and natural the transitions, shadows and highlights are.

The computer identifies types of digital images according to the number of bits associated with each pixel. It becomes necessary to know what image type you are working with in order to recognize what kinds of colors (and other tools) you may use on it.

The data that defines an image will vary for a number of reasons. The original picture may have been digitized for use in the computer by a scanner that has limited capability. You may be given a file of an image created on a computer that doesn't have 24-bit color capability, so the file won't be saved in a 24-bit format. Also, the fewer the bits assigned to each pixel, the smaller the file size is. So, someone might have been trying to save disk space by using a lower-level data type (as described below).

NOTE
It should be noted that there is a difference between data types and file format types which will be discussed in Chapter 25. Data types refer to amount of information that is associated with each pixel in a bitmapped image. (This is also referred to as the *depth* of image information.) File formats (such as TIFF, BMP, PIC, etc.) define how the software saves, loads and otherwise handles the image file, and they are used by both paint (bitmapped) and illustration (object-oriented) programs.

Here are the key image data types you will encounter:

➤ *Black-&-white* images are the simplest type; they use one bit per pixel to define their composition. That single piece of information tells the computer whether the dot is black or white. Scanned-in line art may come into your computer in this form. The great majority of sophisticated paint program editing tools will not work on this image type. First, you'll have to convert it to a greyscale or color image. (See Fig. 22-1.)

Figure 22-1

When a greyscale image is converted to black & white, various schemes may be used to emulate the effect of greys using only black & white. (A) A greyscale picture. (B) The same photo reduced to b&w. (C) The same reduction to b&w using a pattern dither. (D) Using a diffusion dither. (E) Using a halftone screen with diamond-shaped dots. © Sally Wiener Grotta

➤ *Greyscale* pictures are 8-bit images that work with 256 different shades of grey, ranging from white (zero) to black (255). Many, though not all, paint editing tools are accessible for greyscale images. You can convert them to 24-bit color and still retain the black-&-white palette that defines them, though that will triple the image file size. Incidentally, these 8-bit grey values are also incorporated in all 24-bit color images, providing the greyscale values of the colors involved. (See the later explanation.)

➤ *Indexed color* images may be 4 bits (with 16 colors) or 8 bits (using 256 colors). The software creates a reference palette to which all colors used in the image are assigned. As a rule of thumb, the only reason a professional imaging artist will get involved in indexed color is if a computer on which he is working (or on which the picture will be viewed) can't display a 24-bit color image. Because, practically speaking, no individual picture uses all the 16.7 million colors available in a 24-bit environment, indexing the colors that the image does use is a very viable alternative. When you must import an indexed color picture from another source, convert it to 24-bit to have access to the full range of editing tools and techniques (including color separations, which can be done only to images with 24-bit data).

➤ *True color* 24-bit pictures may use up to 16.7 million colors and are usually discussed as being RGB 24-bit. (See the discussion on color models later in this chapter.) Actually, 24-bit RGB images are the combination of three greyscale (8-bit) channels, each of which represent the red, green, and blue (RGB) values of every pixel in the image. Think of what a greyscale picture is—it's an image in which every pixel has a value from 0 (white) to 255 (black). For the non-associated greyscale image, the colors in between 0 and 255 are varying levels of grey. However, the three channels of red, green, and blue are greyscales in which the pixels values between 0 and 255 are different levels of red, green, or blue, depending upon which channel you're working with. In some programs, these color channels appear grey on the screen; in others, they will be tinted according to the appropriate color. (We'll go into more detail about channels later in this chapter.) 24-bit true color is the native data type for professional quality desktop computer art, and all paint software tools and techniques will work with it. For this reason, it is the image type of preference.

Some paint software will also work with 32-bit pictures. For instance, *Color Studio* devotes 24 bits to the RGB color definition of each pixel, plus uses eight additional bits to describe the greyscale value of the mask layer associated with that picture. CMYK bitmapped images will also have 32-bits of information, 8 each for cyan, magenta, yellow, and black.

What about 24-bit illustration software or 32-bit computers?

Images generated by illustration software are not defined as having pixels, so the concept of image data type doesn't apply to them. However, illustration programs will be described as being 8-bit, 24-bit, etc. Let's go back to some basics to pull us out of this confusion of similar semantics which extends beyond programs and into hardware considerations.

A computer works with bits of information. Each bit is like an on/off switch. The more of these switches that a computer can process, the greater complexity that computer is capable of handling. All the computers that we recommend for digital imaging can process at least 32 bits of information at a time. (This is called throughput.*) These 32 bits have nothing to do with color, image types or software capacity. It's merely a determination of speed and power. The analogy we use to explain this is of a road congested with rush hour traffic. A 32-lane highway will allow cars to move more quickly than one with 16 lanes.*

In terms of color, the more bits that a piece of imaging software can support, the more colors that are available through that program. Thus, an 8-bit program can provide the artist with a palette of 256 different colors. A 24-bit program has 16.7 million possible colors from which you might choose.

Other components or aspects of an imaging system will use similar measurements. A video board—the piece of hardware that plugs into your computer and runs your monitor—can be rated at various bit levels for color. The only kind appropriate for professional imaging is 24-bit, because that gives you access to 16.7 million colors. But just because you have a 24-bit video board doesn't mean that your monitor will display all those colors, unless the monitor is similarly rated. (No monitor we're aware of can display more than 1.5 million colors at a time, but better quality 24-bit monitors can choose those 1.5 million out of 16.7 million possibilities.)

We have a friend who thought that his film recorder was capable of billions of colors because it has a 32-bit processor. However, the processor relates to its throughput (speed) rating, not its color rating, which is 24-bit. Yes, there are some high-powered workstations that are capable of 32-bit color, which would provide access to billions of colors. But, practically speaking, there isn't a printer or output device on the market that can reproduce more than a tiny fraction of that number of colors. Given the increased expense, complexity, and need for even more computing power and speed, there's currently no advantage to having a 32-bit color system (although you do want a 32-bit computer.)

The reason the same terms are used to describe very different aspects of imaging—from paint programs' data types to video boards, from film scanners to software color capability—is that you are dealing with the most basic components of computer language.

Think of it this way. You could write two very different sentences: one might be a declaration of love, while another might be an explanation of how a microwave oven works. Both sentences might share similar verbs and nouns. While the definitions of those verbs and nouns will remain somewhat constant, their context—the sentence in which they are used—will describe very different concepts.

So whenever you encounter the expressions 8 bit, 24 bit, 32 bit, etc., look to the context of the description to understand what is being said. Ask if the rating refers to throughput of data (the speed and power of the equipment) or to color capacity. If you are in a situation in which you will be basing a purchase on the promise of 24-bit or 32-bit capability, make sure you have no doubt about what that means for that specific product.

Changing an image's data type

All professional quality paint programs include a utility for converting image types. You'll probably find the "Convert" utility for changing image data type in the pull-down menus at the top of your screen, usually under "Image," "Effects," "Edit," or "Mode," depending on the program. While it is possible to convert images from one data type to another, there are practical limits to this process.

When you move an image down the scale, so that its new data type has less bits per pixel than it originally did (such as from 24-bit color to 8-bit greyscale), then you will permanently lose color data. Those extra bits are simply thrown away. Whenever bits are discarded, the image quality is reduced (although that quality loss might be negligible, depending upon the picture and how it will be used).

On the other hand, when you convert a picture to a more complex image type, such as from indexed color to 24-bit color, the number of colors in the image itself will not increase. What happens is that the software creates new bits of data that have the same value as original ones in an adjacent position. (This process is called *interpolation*.) In other words, no new color information is introduced into the picture. The advantage in doing it, though, is that you will then have access to millions of colors for editing the picture and a greater range of editing tools. As you edit, you will be working with the higher number of bits per pixel, thereby developing a finer quality.

The conversion of a greyscale image to indexed color can create some interesting special effects. Because indexed color is associated with specific palettes or color tables, you can tell the new type of image to retain its black, white & grey appearance, or to associate with a color table. The default color tables in *Photoshop* are "spectrum" (which makes a dazzling pastel picture) or "black body" (which is more subdued). In addition, you can create your own color table for the

indexed image. In *PhotoStyler* the defaults are "pseudocolor" and "firelight." See the illustration in the color pages. Some of the newer program updates are beginning to take advantage of this color table association in order to provide interesting alternative special effects. Try experimenting with establishing your own color table for a previous greyscale image.

HINT Sally will sometimes temporarily convert a greyscale picture to indexed color for a shortcut to unusual color effects. Then she'll convert the image directly to 24-bit for further editing.

Color models

As anyone who has taken elementary high school science classes knows, color is made up of components that, when combined in varying percentages, create other distinct and identifiable colors. Traditional artists know this almost instinctively, mixing pigments on their palettes while they paint—throwing a bit of yellow into blue to make green or a lot of blue into red to make royal purple.

However, the rules that govern the mixing of computer colors change, depending upon what color model you are using. Color models are the esoteric representations of how color is defined. If you think of image data types (as described earlier) as the individuals that populate computer art, then color models are the countries in which they live, where different languages are spoken. Of course, individuals might move from one country to another, and there are always translators nearby. But translations are never perfect—how do you say *savoir faire* in English?

RGB (red, green, blue) is the color model that relates to transmitted light as the source of color. CMYK (cyan, magenta, yellow, and black) is a printer's model, based as it is on inks and dyes. Others that you may encounter are HSL (hue, saturation, and lightness) and HSB (hue, saturation, and brightness). By the way, hue is a fascinating element in that it ranges the entire spectrum of available colors. Another model that is gaining in acceptance is the CIE or LAB model, which is an international attempt to create a universal standard for computer color. (We doubt that there will ever be a reliable, immutable universal standard.)

Think of each color model as just a different viewpoint of the same image. It's similar to looking at a young girl from various emotional and intellectual perspectives. She may be your brother's daughter, and her eyes might remind you of your grandmother. But she also has a lovely mulatto complexion that catches sunlight with such warmth. Sometimes you see her as an energetic and capable athlete whom you want to teach how to hit a baseball with more power. Other times, you recognize how graceful she is and seek a ballet teacher for her. Each

viewpoint is a valid perception of the child, a perception that attempts to define who she is. And while none of them capture all that she is and can be, each viewpoint provides you with a new approach to your relationship with her.

In the same way, you can work on the same image in different color models (though only one model can be the active one at any single time) using their very disparate viewpoints, of what makes up the color of the picture, to create distinctive effects.

Color models are often shown in books and documentation as three-dimensional polygons in which any position within that three-dimensional space represents a specific color or shade. Don't worry too much about those very scientific figures. Just recognize that you may be asked to make color choices and will have to use the terms related to the active color model.

As stated earlier, RGB is the data type and color model that is native to a computer monitor. But you will find yourself working with CMYK, LAB, HSB, or HSL at one time or other. For instance, when you do a gradient fill (see Chapter 18), if you have the option of HSB or HSL, you will then be able to paint with rainbow effects because the gradient will go through the entire spectrum between the foreground and background colors when you use those color models.

Experiment with changing color models when you make editing choices to see how each affects the result. Actually working with them will give you a much clearer feeling for them than any intellectual discussion ever could.

NOTE The *Data Type* of your image will determine what tools and techniques you will be able to apply to it (as well as the quality of your image). The *Color Model* that your software is working with determines how the computer creates the color that you will be applying to your image. Both variables may be changed in paint programs—usually in the pull-down menus at the top of your monitor. Image data types are a function of how much information is associated with each pixel. By definition, this means they are something you will work with only in paint programs, and not illustration software. Color models are a concept common to both paint and illustration programs.

Duotones, tritones, & quadtones

Greyscale images are pictures that are intended to be printed with one ink, which is traditionally black. However, there is no rule that says the ink must be black, and many very effective pictures are created using brown, blue, or some other pigment instead.

In a similar vein, greyscale images may be converted by software into pictures in which the varying values of grey may be created by combining two (duotone), three (tritone), or four (quadtone) colors. Using this method adds a richness of detail, dynamic range, and dimensionality not available with just black ink. In addition, the method can be used to give a warm or cool tint to the picture or to emulate tints that evoke certain moods. (You can make a sepia and other popular tones this way.) In addition, when you play with the values of the various colors, you can create some painterly or otherwise unusual effects, especially with tritones and quadtones.

Duotone, tritones, and quadtones have a long and well-respected tradition in printing that has translated very effectively into the world of paint software. We have found this ability especially satisfying when working with historical photographs or ones that we want to give the appearance of age without losing detail.

Selecting colors: The basics

The essentials of selecting and mixing colors are the same for both illustration and paint programs. But how you get to the color dialog box to work with it will be different, depending upon the kind of software.

Illustration programs

Fill or outline colors are displayed in illustration software in palettes of blocks and/or lines. (See Fig. 22-2.) If these palettes are not showing on your screen, look for them in pull-down menus at the top of your screen under "Window," "View," or other heading. Click on their names and they will be displayed.

Figure 22-2

Aldus IntelliDraw's fill palette.

To find the color dialog box, look in three places: on the fill or outline palettes under an edit or new command, in the pull-down menus, or in the icon toolbox (as a hidden icon that can be accessed by clicking and holding on the fill or outline icon).

 # Paint programs

Somewhere on the screen of any paint program, often below the icons that represent the various painting tools, are two boxes that represent the current foreground and background colors. (See Fig. 22-3.) Whatever painting tool you choose—paintbrush, pen, pencil, etc.—will draw with the current foreground color, unless you specify exceptions. The background color is what will fill the canvas of a new file, be used by the eraser, or replace a cut-out portion of the image. If you click on the current background or foreground color, you will probably bring up a box containing the many colors available for the image type of your current picture. (See Fig. 22-4.)

Figure 22-3

PhotoStyler's current foreground and background color boxes, which, as in many paint programs, may be found directly under the toolbox of icons.

Figure 22-4

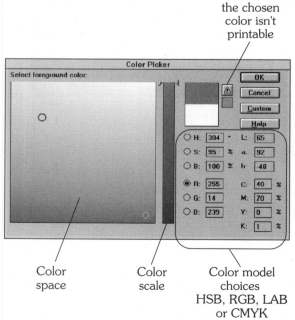

Photoshop's Color Picker (color dialog), which is opened by clicking on the foreground or background color boxes, provides access to all the colors possible in the system.

Incidentally, it can be cumbersome double-clicking on your current foreground color *every* time you want to change to a new color for painting on your picture. That's when you go to the "View" or "Window" pull-down menu at the top of your monitor and tell the software to "show color" or "show palette." (See Fig. 22-5.) The small rectangular palette that appears on your screen (and stays there throughout all your editing until you tell the program to "hide palette") is an abbreviated version of the color dialog box. If you think of the color dialog box as a paint store or warehouse where all possible colors are stored, then the color palette is your own personal selection or inventory of colors that you will be using to work on a particular picture.

Figure 22-5

Photoshop's Color Palette. The large box to the left of the color sliding scales is a scratch pad for mixing or testing colors.

Regardless of what tool is selected at the time, whenever your cursor moves over the palette, it will turn into an eyedropper (or similar icon), indicating that you can pick up color from the palette. In addition, some palettes might allow you to input numerical values to define specific colors. By keeping a color palette up on your screen at all times, you can choose a different color between every stroke, if you want, with as little bother as possible.

⇨ The color dialog

Depending upon the program, this box may be called the color palette, color dialog box, color options box, foreground/background selector, *etc.* Because its purpose is to provide the user control over color choices, through various options or dialogs, we will call it the *color dialog box* (just as we will assign logical names for the elements in it, because there is no universality among programs). Refer back to Fig. 22-4.

Fortunately, while the name changes, depending upon the software, its layout and how it works tends to be rather standard. The color dialog usually has the following elements:

➢ Somewhere in the dialog box, you can indicate what color model you want to be represented. (Though when the box first is opened, it will automatically go to the color model of the picture

you are working on.) Your choice is usually made on a small pull-down menu or by clicking on a circle (called a radio button) next to the color model's name.

➤ A *color space* is a large square or circle filled with colors of a certain range. This unmistakable shape is usually the most prominent part of the dialog box. The colors displayed in the color space will change depending upon what color model you choose and where the arrow is on the color scale (see last page). When the range of colors are approximately what you want, then select the exact dot of color by clicking your cursor on the point within the color space that shows that color. This will then replace the current foreground (or background) color.

➤ A *color scale* is a long, thin bar with an arrow next to it, which shows the entire range of colors available for the color model (or the color model component) involved. Slide the arrow to choose an area of values you want to be displayed on the color space. For instance, if you want to see a selection of pinks, then slide the arrow to that area on the color scale and a large range of pinks will be shown in the square or circular color space.

➤ Another manner in which you can pick your color in the dialog box is to input numerical color values for each of the components of the color model (RGB, HSB, etc.). This may be represented as percentages from 0 to 100 or greyscale values between 0 and 255. (HSB and HSL are usually represented as a number for the hue component and percentages for the other two.) This exact mathematical method of choosing a color provides you with the information you need to perfectly duplicate that color at any time, in any imaging program, on any computer. Thus, a red value of 148, green at 0, and blue at 188 will produce a specific medium purple every time. Or a hue at 200 with 84% saturation and 82% brightness will always make a certain sky blue.

➤ There may also be a box (sometimes labeled Custom) in the color dialog that will give you access to another set of color options, related to a library of brand-name color swatches, such as *Pantone* or *Trumatch*. These are established ink reference charts that a printer can recognize and try to reproduce. (Please see Chapters 28 and 29.)

HINT
Some programs will alert you with an exclamation mark or some other indication that the color you have chosen from the color dialog box won't be printable on your designated output device. That certain colors can't be reproduced in the printing process is because of the inherent differences between colors made from light (which is the source of your screen's colors) and those composed of inks (which is what any printer uses.) Pay attention to these warnings, if your final output is intended to be print. (See Chapters 28 and 29.)

HINT If there is a color in one of your pictures that you want to duplicate exactly at some future time, you may use the *eyedropper tool* (in paint programs) to pick up the color and make it the current foreground color. Then open the color dialog box by double-clicking on the foreground color. In the section where you would normally create a color by inputting mathematical values for the color model components will be the exact numbers that represent your color (such as 135 for red, 40 for green, and 75 for blue.) Write these down, and you will always be able to duplicate that color.

Using alternative color palettes

As useful as it is to use the default palette provided by imaging programs, not every picture is assembled from the same basic colors. In this, imaging is like music. Yes, as Igor Stravinsky said, there are still great symphonies yet to be written in the key of C Major, but sometimes the composer is more inspired in B flat minor or some other key. That's why professional quality imaging programs offer alternative palettes; the more powerful software programs have quite a few palette options. (For some reason that is probably associated with the uniformity of everything on the Mac, there tends to be a wider variety of alternative palettes in the PC environment than on Macs.)

Look for a box or some other command on the palette that doesn't appear to have any relationship to color picking. In *PhotoStyler*, it's a rectangle with various tools pictured. In *Picture Publisher*, it's a pull-down menu called Edit. You'll find it in *CorelDraw*, in the color dialog as an option button labeled "palette." Regardless of whatever program you are working with (assuming that it provides access to alternative palettes), it will probably have some such place on the palette box or color dialog that doesn't make any sense otherwise. When you click on that box or command, you will be given the option of loading other palettes.

Some of these alternative palettes may be rather exotic (though useful), such as the range of hues that are used in gold and/or other metals. Others are based on famous paintings, such as Cezanne's "Bathers." Still others focus on the colors associated with sample images in the programs' tutorials. A *Pantone* or *Trumatch* palette relates to specific inks used by printers; see Fig. 22-6. (Check with your printer manufacturer and/or your print shop to see what name-brand palette you should use for images destined for print.)

You can add colors to most existing palettes, or you can create and save completely new palettes. The colors may be picked up from your pictures with the eyedropper tool (in paint programs) or you can take advantage of numerous techniques to custom mix new colors. The main caveat is to make certain that whatever color you create can be

Figure 22-6

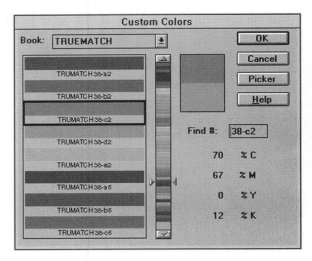

Among many programs' alternative palettes are ones that correspond to printers' swatch books—such as those produced by Trumatch and Pantone. In this dialog, if you click on the down arrow next to Trumatch, you would be able to choose from a number of alternative brand-name palettes.

reproduced on the printer or other output device you will be using. Otherwise, the only time you will get to enjoy that color is when it appears on your monitor.

Mixing your own colors

Daniel enjoys cooking Chinese food. Okay, maybe no Chinese person would recognize his concoctions as such, but that's what we like to call them. The problem is Daniel's sauces. First of all, we don't eat or cook with sugar, so he usually compensates for that with untraditional ingredients. Whatever he does, it's almost always attractive to see and delicious to eat. Unfortunately, it is also very difficult to repeat any of his successes, because he follows his instincts rather than any recipe.

Mixing custom colors for a personal palette is like creative cooking. While there might be tried and true formulas that everyone will recognize, it is usually that little extra, unexpected ingredient that adds that certain flair.

Here are some techniques we use to mix custom colors. Most of these techniques (except the first one) apply only to paint programs not illustration software.

> ➤ In the color dialog of both illustration and paint software, play with the numerical values or scroll bars of the component colors (such as red, green or blue when you are in the RGB color model). Different percentages will create new colors.

> ➤ Using variable transparencies, combine any color with any other on a palette scratchpad or an empty image file. We use a medium to large size paintbrush or airbrush. Paint away, calling up a variety of colors from the existing palette and letting them bleed onto each other. Draw crisscrossing intersections, make

happy faces, pour bucketfuls of transparent shades on top of each other. If the program has a water brush or smear tool, use it to blend the colors. Have fun doodling and exploring possible mixtures. Then use the eyedropper tool to pick up any new colors that you like out of the mishmash you've created.

➤ If you want a color or series of colors that would be made from the combination of two colors, make a gradient between the two colors. Then use the eyedropper to pick up the most pleasing of the results.

➤ Use the eyedropper tool to select colors from an existing picture that might be appropriate for the new palette.

➤ Some programs will make graduations between two colors in a palette. Try that command to see what it offers for your new palette.

When you have made that perfect color from a bit of this and that, you don't want to lose it because you know you'll never be able to repeat it exactly. Luckily, custom-created colors can usually be saved to your hard disk, as an extra color on the default palette or as part of one of your custom palettes. Look in the same box or command that we mention above for loading alternative palettes. That's where you'll find the command for saving new palettes. It's useful to save distinct palettes for each of your pictures, so that when you want to work on a specific image again, all you have to do is call up the palette associated with it to be sure to use the correct colors.

⇨ Color channels as creative canvases

Think of an animation artist at work on the acetate pages that make up a single frame (or cell) of a cartoon. As we have all seen on the Disney documentaries that we grew up watching, he might paint the greens of the background landscape on one sheet. On the next level might be the reds of the foreground flowers. And on a third overlapping sheet might be the black outlines. When all the acetate sheets are put together, one on top of each other, the composite whole looks as though it were painted on a single sheet.

Like animation cells, 24-bit (and 32-bit) digital images are made up of color channels that, when combined, generate the entire picture. These are the channels that are used to prepare color separation files for 4-color press printing. But printing isn't the only purpose for color separations. This ability to split your images into distinct but related channels provides a canvas for a variety of imaging techniques. See Fig. 22-7.

Figure 22-7

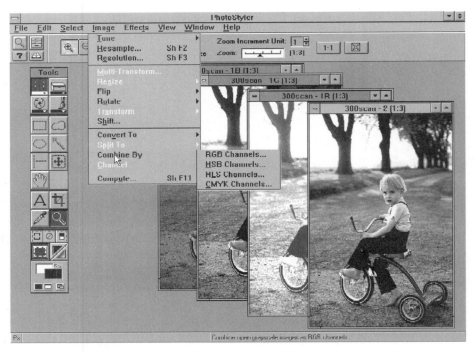

*In PhotoStyler, Sally's photo of an Amish child was split into red, green, and blue channels in preparation for editing. Even if a program doesn't show you the channels in their corresponding colors, you can usually tell from the name on the window, which channel each represents. In this case, the red channel is the one that is called "300scan-1**R**", the blue channel is noted as "300scan-1**B**", where the letter after the number corresponds to the initial of the color channel.* Photo © Sally Wiener Grotta

Color models & color channels

How an image splits into its channels for color separation is dependent upon what color model you are using. For instance, RGB will split into red, green, and blue channels, which represent the image's greyscale values for each of those colors. When you split a picture into red, green, and blue channels, you are creating three new views of the image that determine the color value of each bit of data.

In paint programs, you can edit the individual color channels. For example, you can manipulate the red value of a pixel or group of pixels when working in the red channel without affecting the green or blue. Any editing done on those individual channels will affect only the color component represented by the channel when they are recombined to make the complete image.

HSB and HSL split into channels that are associated with the hue, saturation, and brightness (or lightness) of the image. Edit channels split according to these color models when you don't want to affect

individual color components of the image but do want to alter the way the hues are laid out, their saturation, or their brightness.

When you prepare an image for color separation for printing, you convert it first to CMYK. It's a project that is usually best done in partnership with your service bureau and print shop (see Chapters 30–31), so that you can be sure to set up the ink percentages, dot gain, etc. according to their printing process. Usually, CMYK channels are not used for creative editing processes, but they can be. In fact, it might become increasingly common with the introduction of "smart" monitors that can adjust colors to more closely approximate CMYK color. (See Chapter 28.)

⇨ Editing color channels

Most of the tools that a paint program provides for working on 24-bit images, you can use on color channels. Therefore, you can paint, mask, brighten, darken, smear—or do just about anything. See Fig. 22-8.

Figure 22-8

Some software (such as Photoshop) give you access to color (and mask) channels through a "Show Channels" command from the pull-down menus at the top of your screen. By clicking each channel on or off, the view of the active image is changed to show the channel chosen.

Try using a filter on one channel only and then recombining to the full image. Depending upon the channel and the picture, the effect can be quite surprising. Since you can mask a channel, you can also limit your filter (or any other tool) to a specific area of the channel.

Gradients also can be applied to channels. Try the following for creating an interesting background. Split a blank white image into its RGB channels, and then fill each channel with a different angled linear gradient. For instance, on the red channel, make it progress from the upper right corner to the lower left. On the blue channel, have the gradient from the upper left to the lower right. And on the green channel, create a gradient that goes vertically across the middle. Then use a whirlpool filter on each of the channels set at different degrees of swirl, such as 90, 180, and 250 degrees. When you recombine the channels, you'll have a lovely whirlpool of colors.

Or apply a crystallize filter on one channel of an RGB picture to see how that will affect the composite whole.

If you shift the images slightly to one side or the other in each channel, you'll end up with a visually effective repetition of the image in the various colors when you recombine.

Of course, you can do much more subtle things in individual channels, such as brightening or darkening, increasing or decreasing the contrast, painting outlines, etc.

These techniques represent an area that has not been fully explored by digital artists, which means there's still room for pioneers in it. Have fun experimenting with different possibilities, trying them out first on small, low-resolution files so that you don't waste time waiting at each step. Then, if you like what you did, you can always repeat it on one of your higher resolution images.

Recombining channels: Some unusual possibilities

If all you want to do is put the split channels back together again after you have done whatever editing it was that you did, then recombination should be a simple matter. However, it is possible to use the reconstitution process to produce additional special effects.

Remember, the different channels are just greyscale images. Thus, one can combine any greyscale images of the same size. (You can check an image's size and even recompute it to match another through a command usually called "Resize," "Size," or "Image Size" in the pull-down menus at the top of your monitor.) Why not try replacing the red channel of a picture with a greyscale illustration that you created, and see what happens?

Similarly, you can take three or four greyscale images and combine them as though they were color channels.

Also, there's no law that says that, just because you split an image according to one color model, you can't recombine the channels according to another model. Suppose you split an image into red, green, and blue channels. It is possible to recombine them using the HSL model. This can create interesting color shifts, or it can just make mud. But it's fun finding out.

In addition, some paint programs have merge controls for combining channels that give the artist more options on how they will come together. These are quite similar to the merge controls we discuss in Chapter 24 on "Creative Montaging," in that you can tell the paint software to calculate the relative values of every pixel in each channel and make choices between them based upon the command you

choose. For instance, you can choose to have the lighter pixel be the dominant one in the merge, which would mean that when the channels are combined, the final image would be composed of only the brightest pixels. Play around with the various options for combining (or calculating) channel merges to discover some interesting visual effects.

23

A balancing act
Tools for perfecting your bitmapped image

CHAPTER 23

EVER since the Age of Enlightenment took us out of the Dark Ages, literally and metaphorically, science has tried to explain why we see what we see, what color is, the different properties of light, etc. Over the centuries, technicians have quantified, codified, analyzed, and experimented with light, to the point that we know its composition and behavior, or we can assign it numbers and values like lumens and degrees Kelvin. What has evolved is a highly regarded, well-established library of formulae, graphs, charts, and other scientific representations of what artists call beauty. It does seem a nasty invasion of the aesthetic realm by scientists who seem to have a native need to analyze a sunset to appreciate it. Personally, we feel Rembrandt's, Tintoretto's, and Seurat's experiments are much easier to look at and understand, besides being better explanations of the visual phenomena associated with color and light.

For better or worse, computers have no poetry in their souls when it comes to color and light. They're machines created by engineers and scientists and therefore can function only with absolutes. So it's the scientific theories and literal interpretations of visual perception that digital imagers must adhere to as tools for increasing creativity and mastery, and not the visceral, subjective, aesthetic principles upon which all art is based.

That's why this chapter may have a couple of intimidating, scientific-looking graphs (specifically, histograms and gamma curves). Don't worry about them being incomprehensible or esoteric because they are really straightforward and very easy to understand. Consider these graphs as merely symbolic visual representations of the real world, much as a road map might be. Isn't that what artists are most comfortable with—symbolic visuals? Okay, it's not as simple as that, but it's not so complicated either. All you have to do is take a moment or two to get acquainted with what the symbols are meant to represent. Before you know it, they too will become second-nature tools that are almost transparent to the creative process. What's more, the information that they will provide about your bitmapped images will be useful to you as you edit your pictures.

The good news is that these charts and graphs are used in only a few of the many tools that paint programs offer for fine-tuning your image. The real problem in using all these editing tools is not in deciphering what they are and how they work, but in carefully balancing their effects on your image. Each one must be adjusted to its highest potential, but not so much that it contradicts or interferes with adjustments made with other tools. Tweaking any tool, no matter how beneficial it might be to the final image, involves certain trade-offs. The trick is to understand what each tool and technique actually does to your image, how to control those effects, and when to choose one over another.

NOTE The tools covered in this chapter are among the more sophisticated and most valuable available. Not all paint programs have them; generally, illustration programs do not. If you plan to edit photo images, you will almost certainly need them to produce top quality professional work. In addition, they may be very useful when working primarily with computer-generated art. When you begin shopping for your digital imaging software, make sure that your primary paint program offers a large share of the tools described later in this chapter. Then, when those needs are taken care of, you might (or might not) want to choose other programs for the power of other features that they may offer.

Let's get the explanations of the two most central scientific graphs (histograms and gamma curves) out of the way, so we can go onto the really interesting stuff—how they can be used effectively to fine-tune your images toward perfection, using tonal controls and color correction techniques.

Greyscale values

Throughout this chapter and elsewhere in this book, we talk frequently about greyscales. It is a concept that is so fundamental to imaging and, before that, to photography, that its definition is taken for granted by those who know it. But it is useful to go back to the fundamentals before learning new tools based on them.

In photography, a greyscale is a continuum of tones from pure white to pure black. In digital imaging, it is made up of 256 steps (0 to 255) of graduations between pure white and pure black. A pixel's value in relationship to the greyscale is a measure of its brightness or darkness.

In a greyscale picture, the pixels whose values fall between white and black are varying levels of grey. In an RGB color picture that has been separated into its three channels of red, green, and blue, the pixels whose values fall between 255 and 0 are varying levels of the primary color of its channel (red, green or blue), with 255 being not white but the color of the channel. Thus, when working with a fully combined RGB picture, every pixel has a designation that is described in terms of its greyscale values in all of the primary colors. For instance, a pixel that is said to be R255,G0,B0 is pure red. One that is R255,G255, B255 is pure white. (In the RGB color model, which is based on transmitted light, white is the combination of all colors.) And a pixel that is R187,G143,B159 is a very specific pinkish flesh tone. (You may also designate greyscale values for other color models, such as CMYK, HSB, and HSL.)

Please see the preceding chapter for a fuller description of greyscale pictures, color separations, channels, and color models.

Histograms explained

When working with tonal controls and color corrections, you will often encounter a technical-looking figure called a histogram. A *histogram* is a graph that shows you in a visual manner the distribution of greyscale values among your picture's pixels. See Fig. 23-1 for an example.

Figure 23-1

A histogram.

If you recognize it for what it really is—a tool of the statisticians—then its purpose becomes more apparent. It could just as easily be used to graph the geographical distribution of business properties in a small town. Main Street would certainly have the highest peak, and developers might want to even that out by trying to convince old firms to relocate or new companies to build on other blocks around town. On the other hand, the citizens of that town might prefer to have all the businesses in one area for convenience or to protect the cozy quiet in the residential neighborhoods.

Similarly, an image histogram tells you where within the greyscale range the pixels that make up a picture are distributed—what percentage are light and what percentage are dark, and how dark or light.

Reading a histogram isn't as difficult as it looks. The horizontal axis (known by mathematicians as the x-axis) represents the full range of possible greyscale values from 0 to 255. The vertical scale (known as the y-axis) measures how many pixels fall into each greyscale zone. The number of pixels that make up shadows are measured in the left corner, highlights in the right, and midtone pixels fall in the middle of the graph. Therefore, a dark image will have most of its pixels toward the left side, which would be represented by more and taller peaks in that area of the histogram. A light picture will be more concentrated to the right. An image that is well-balanced between light and dark values will have a rather evenly spaced histogram in which the peaks are approximately the same level throughout the distribution range. (Well-balanced in this context isn't necessarily an ideal, but rather a point of reference. Sometimes, extreme shadows or highlights can be aesthetically pleasing, depending upon the picture's design.)

The reason why there's a histogram—more to the point, why you should know how to read, and then manipulate one—is that you can adjust the greyscale values of an image through various tools. The best way to gauge exactly what effect those tools have on your image is by looking at a histogram. In fact, a number of tools in some programs will actually have you make the adjustments directly on a histogram. Even when the histogram isn't pictured in the tool's dialogue box, it is valuable to view the graph before and after applying the tool to understand what it really did to your image.

⇨ Gamma curves

If you can understand that there is a difference between a "before" version of a picture and an "after" version of the same image when it has been manipulated in some way, then gamma curves will be easy to understand too. Gamma is the word used by mathematicians to indicate change; in geometry, it is represented by a line or curve that graphs that change. (Some programs refer to gamma curves as maps or curves.) See Fig. 23-2 for an example.

Figure 23-2

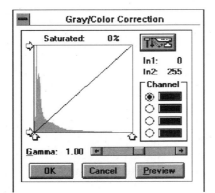

A gamma curve.

In imaging, gamma curves, like histograms, are graphical representations of the balance of shadows, midtones, and highlights. However, the gamma curve works with these values for an original image (x-axis or the horizontal scale) as it relates to those for the manipulated image (y-axis or the vertical scale). Remember, the gamma curve is not the graph but a line drawn on the graph that plots this relationship.

(Depending on your software, the original image might be called the scanned-in image, the input image, or some other name. The manipulated image might be labeled the output or screen image, etc. Remember that the graph isn't actually comparing two images, just two versions of the same image—the before and after versions.)

Initially, the greyscale values are the same for both the input and the output images; they are identical at this point. (No manipulation has occurred, so there have been no changes.) That means the gamma curve that plots their relative greyscale values is a straight 45° line. (A 45° line is one that is equidistant between the horizontal and vertical axis, reflecting an equality of values.) But when you begin to change the greyscale values of the image on the screen, the curve will change. The extent of that change and the shape it makes of the gamma curve becomes important when you want to recognize the nature and strength of a software tool's effect on your picture.

Every time you open a gamma curve dialogue box and bring it up onto the screen, the gamma curve will be at 45°, regardless of how many changes you made to it in earlier sessions. That's because the software measures change for each session in which you work on the curve and considers the original image to be the one with which you start the session.

By adjusting certain segments of the line, you are changing the values of the shadows, highlights, or midtones. The lower portion of the gamma curve controls highlights, while the upper portion refers to the shadows.

If the curve dips down below the 45° line, then that portion of the picture (the highlights, shadows, or midtones) will appear darker and the colors less intense. If it pushes above the 45° line, then that portion of the picture will become lighter and the colors more intense.

HINT Try adjusting gamma curves within color channels to increase or decrease the intensity of the color (such as red, green, blue, cyan, magenta, yellow, or black) or other attributes (such as the saturation or brightness of an HSB color separation). See the previous chapter for more information on color separations.

The usefulness of this graph will become obvious as you become familiar with the various tools and techniques that work with it. Interestingly, imagers quickly learn to identify certain tonal and color effects by the shape of the related gamma curve. But they seldom think about what it means mathematically.

Again, try to keep in mind that a gamma curve is just a visual aid to understanding what is happening to your pictures.

NOTE All the tools and techniques discussed in this chapter are generally accessible in the pull-down menus at the top of your screen, usually under "Image," "Map," "Transform," or "Adjust." Also, please note that while we do our best to mention the various names by which a tool or technique will be known in a variety of software, we cannot list all the names that could possibly be used for them. When we must

make a choice, we use the term that we feel best describes the function of the tool or technique.

Tonal controls

Here is where paint programs shine, as time-saving, convenient, no-nonsense tools for adjusting, fine-tuning or exploiting the greyscale values of any picture. Tonal controls will make your pictures appear more realistic or more surrealistic by using delicate or heavy-handed adjustments. With an ease that is most welcomed by those of us who have spent hour after hour in the darkroom, they will compensate for poor exposure, difficult lighting situations and less than perfect scans. The effects they apply to computer-generated illustrations can be the difference between an average picture and one that lights some sparks. In many cases, the tools will be almost deceptively simple and react quite clearly and directly to what you do, providing immediate feedback and satisfaction.

HINT
Remember to use a mask when you want to limit the area of your picture on which any of the tools in this chapter will apply. (See Chapter 20 on masking.)

⇨ Brightness & contrast

The most basic tonal control in any paint program are two sliding scales that control brightness and contrast. Almost every picture will benefit from a slight boost in both—about a 10% increase in brightness and a 10% increase in contrast. That slight rise (which is generally known as an "S" gamma curve, for its shape) will give just a bit more oomph to most pictures and will make boring exposures pick up some dynamic range. See Fig. 23-3.

Figure 23-3

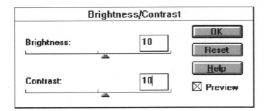

Brightness/Contrast controls.

Like new lovers or an old married couple, contrast and brightness almost always go hand in hand. Rarely would you want to adjust brightness without contrast and vice versa, which is why they are always grouped together under the same command. (However, their controls work independently.) If you increase brightness, it will tend to wash out the shadows and highlights of your picture unless you increase contrast. And if you go the other direction on the sliding scale

and increase darkness, you would want to reduce contrast, or the details in your shadows could be swallowed up by a monochromatic black.

If your initial picture is a poorly exposed or badly lit photograph, these tools might be able to help you salvage it. In extreme cases, you might want to adjust one of these tools more than the other, depending upon the quality of the picture.

Be careful not to add too much contrast to a picture—it might look great on the monitor, but the result when it is printed may be too strong.

HINT When you use the type tool to place letters or numbers on your image, instead of filling them with colors or textures, use the brightness/contrast controls. Adjust them toward a level of darkness that will make the letters distinct from their surroundings. When you remove the mask, you will end up with letters made up of darkened elements of your background. This technique can be quite interesting on weather-beaten wood, giving it the feeling of a faded painted sign.

The brightness and contrast of a picture is such an integral part of effective imaging that other tools and techniques in this chapter will continue to return to these principal factors.

⇨ Equalize

Equalize (which is sometimes called *Quartertone*) is an automatic recalculation of the histogram of an image that redistributes the greyscale values more evenly. It works by seeking out the brightest and the darkest pixels in the picture, setting them at white & black (respectively). Then it attempts to redistribute the greyscale values of all the other pixels in the picture so that they stretch out evenly between the two extremes. This is a useful tool for quickly adding contrast to an image and generally brightening up the shadows, though the effect will vary depending upon the original picture. As with any automatic function that the computer can do, it can often go too far. After all, the computer is just a dumb machine that follows established formulae, which have no relationship to aesthetics. As we stated earlier, a well-balanced, even histogram is not necessarily an ideal objective. For instance, sometimes you want a heavy bit of shadow in an area of your picture.

HINT Before applying a stylizing or artistic filter—such as emboss or graphic pen—to an image that has heavy shadows, consider using the equalize tool on the dark areas. (Be sure to use a mask to protect the rest of your picture.) This will increase the amount of detail in the shadows for the filter to pick up and work on. That was one of the steps that

Sally used before applying Emboss to her lighthouse picture, equalizing the large expanse of rocks in the lower left portion of the image to provide more distinct ridges. (See the color section.)

⇨ White point/Black point

Photographers love the *White Point* and *Black Point* tools (see Fig. 23-4). Like equalize, they redistribute greyscale values across a wider range. However, white point/black point tools do it in stages (concentrating, one at a time, on the light or dark areas of a picture) and with more interactive control from the user.

Figure 23-4

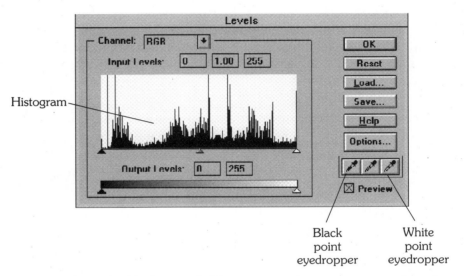

In Photoshop, the black point/white point eyedropper icons are found in the Levels dialog in which the histogram is also displayed. A neutral grey point eyedropper is also provided for removing color casts from the picture.

Each of these tools are represented by an eyedropper icon, which can be found in the dialogue boxes of one of the other tonal controls. Magnify your image until you can distinguish specific color areas. (This might require going to the pixel level, depending upon the amount of differentiation between colors in the image.) Select the brightest, whitest spot you can find and use the white point eyedropper on it. That will set that pixel to a greyscale value of white, and will redistribute other pixels relative to the value. The black point works the same way, setting the darkest pixel in your image to black. You may choose to use only one or the other of these tools, or both.

These tools are very quick and easy redeemers of poorly exposed photographs. Use them if a picture is washed out, with inadequate dynamic range, no true whites anywhere and/or no strong blacks. But don't use them indiscriminately or without thought.

Here are a couple of mistakes to watch out for when using the White Point or Black Point tool:

➤ Make sure that you select the brightest or darkest pixel with the eyedropper. Otherwise, you'll wash out the highlights or deepen the shadows, both of which will result in the loss of detail. For instance, if you choose a pixel as the white point that is not the brightest pixel in the picture, then all other areas that were brighter than that pixel will also be set to white. That means, you will have lost all differentiation among all pixels in the range between the actual brightest pixel and the one that you selected as the white point. Suppose that you select a pixel in a white shirt that should be grey because it's in the shadow of a crease of the material. Then, when you set that pixel to white, all shadows (and all creases in the shirt) will be turned white. The shirt would lose all detail and would look like an albino blob. A similar unsatisfactory result would come out of setting the wrong pixel to the black point.

➤ These tools are very good at making simple color corrections, such as when there is a yellow tint to a photograph because it was shot with daylight film in a fluorescent setting. Because that would make the brightest point in the image yellow, just setting that point to white will remove the yellow tendencies of all the pixels in the picture. (Usually you will also want to set a black point in that situation.) However, many pictures have a tint that is part of the composition. For instance, a sunset is best when it is pinkish. Setting the brightest point in a sunset picture to white would make the whole thing look as though it were shot at midday.

Be sure you really want to use these tools on your picture *before* automatically going at it. They're so easy to use that you can quickly destroy all the ambience that you originally worked so hard to achieve.

HINT Before you apply any tools to your picture, be sure to save your uncorrected, unmanipulated image to a file on your hard disk. Also, always save your manipulated image to another file, before applying additional techniques to it. Many of these commands can actually destroy data that you won't be able to get back without referring to the original or successive files. Also, quickly use the undo command before you proceed further, if you don't like the effect of a tool.

Posterize

As we mentioned in the Filters chapter, the *Posterize* command reduces the number of colors (or greyscale values) in an image. (Because this command may be found either under filters or under tonal controls, depending upon the program, we are dealing with it in both chapters.) Posterize creates a poster-like effect with fewer and

harder transitions between color areas, greater contrast and less detail. (See Fig. 21-8B in Chapter 21.)

When you call up the posterize command, you will be asked to decide how many levels you want per channel. (Levels are not the actual number of colors but are mathematically—exponentially—related to it, since you are dealing with the number of levels per color channel.) The lower the number of levels, the fewer colors you will have and the stronger the effect. Use the preview option, if your software has it, to try out different levels. Sometimes the effect can be very different among levels of consecutive numbers, such as 4, 5, and 6.

 HINT Try any of these commands, tools, and techniques on the individual channels of a picture for some interesting effects. (See Chapter 22 for an explanation of color channels.)

Threshold

Threshold also affects levels but in a very different manner. When it is applied to a greyscale image (which is the only kind of image some programs will allow this command to be used on), it pushes all pixels to black or white. Thus, all the grey pixels with a value below a certain level (or threshold) will be set to black, and all those above that threshold will be set to white. See Fig. 23-5.

Figure 23-5

A threshold of 144 was applied to this photograph to make a black-&-white image with no greys.
© Sally Wiener Grotta

In those programs that will apply threshold to color images, it does the same thing, but the result is much wilder, pushing pixels to colors they were never meant to be. Of course, sometimes, bizarre colors can make for interesting design elements. (However, not all such colors are printable, see Chapter 28.) See Fig. 23-6.

Figure 23-6

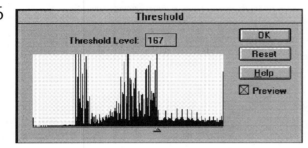

The threshold command works with the histogram. Pushing all pixels to the left of the specific "threshold" or greyscale level all the way to black, while all the pixels to the right of that threshold are pushed to white. This makes a greyscale image into a stark black & white.

In a dialog box, you will set threshold at a specific number, somewhere between 0 and 255. 128 is the halfway point, but it won't necessarily produce an even split between pixels. Remember, depending upon the image, pixels can be distributed quite unevenly in the histogram. In some dialogues, you will be informed what percentage of pixels fall above or below the threshold level chosen, in order to give you a sense of just how much of your picture will go to one side or the other of the histogram (or, to put it more precisely, in greyscale images, what percentage will turn white and what percentage will turn black). Again, do use a preview button (when one is available) to see the effect on your picture and make sure that you will get the result that you want.

Invert or Negative

The *Invert* or *Negative* command does exactly what its name implies. It makes a negative out of your image, transposing the greyscale and color values to the exact opposite on the scale between 0 (black) and 255 (fully bright). (See Fig. 23-7.) This can be useful if, for instance, your service bureau or print shop needs a negative file of your image for printing. (We tend to let them take responsibility for such processes). Or you might want to create an image that gives the visual impression of an exposé, cover up, deep investigation, dark and hidden secrets, or any other subject where things are the opposite of what they seem. Inverting just a portion of an image can have a dramatic effect on a composition.

Solarize

Anyone who has worked in a darkroom will recognize the *Solarize* command. If an only partially developed photographic print is exposed for a moment to light, then some of the areas on that print that would have been light will turn to dark. The computer creates solarization less

Figure 23-7

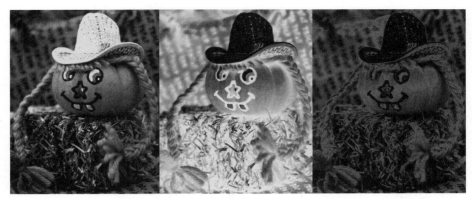

The left image is the original. The middle is the negative or inverted image. The right is the picture solarized. (Some programs allow you to select the threshold at which you want the solarization to take effect.) © Sally Wiener Grotta

haphazardly than traditional photographers, who often discovered the effect by accident. What happens is that some of the brightest pixels are pushed into the dark range of the histogram, while some midtones might be made lighter. The darkest pixels usually remain as they were. So the result is something like a combination of a negative and a positive of the same picture. (See Fig. 23-7.) When a color image is solarized, it can produce some fantastic, almost psychedelic effects.

What you see isn't necessarily what you get

As you work with tonal controls and color corrections on your image, don't forget that your monitor might be deceiving you about the true nature of your picture. This is because computer color (which is created by transmitted light) is different from printed color (which is created by reflected light). This is a complex issue to which we have devoted Chapters 28 and 29. We won't go further into it here, except to offer the following warnings:

- *Don't rely solely on the feedback you are getting from your monitor, unless it has been properly calibrated. Even then, be wary of depending on the visual information.*

- *Whenever you push pixels along the histogram—especially in those commands (such as solarize) that can result in wild shades and combinations—watch out that you aren't creating unprintable colors.*

⇨ Color corrections

As we pointed out in the previous chapter, the most intrinsic aspect of computer art—or any art, for that matter—is color. Paint programs provide a variety of sophisticated and precise tools for balancing and editing color, which can give the artist the best of all worlds within the small confines of the jumble of electronics that is the computer.

⇨ Color balance

In every image, there are several elements you can work on to balance the colors to an optimum level. First, there are the various channels of the image. (As you remember from the previous chapter, channels are the color separated files, such as the red, green, and blue greyscale images that, when combined, make up a 24-bit RGB picture.) Then there are the highlights, midtones and shadows of the image. Each one of these can be manipulated individually or as a whole. That is why many programs will give you the option of working on the gamma curve in the master channel, the red channel, the green channel, or the blue channel. Similarly, you might be asked to indicate if you want your changes to affect the image's highlights, midtones, shadows, or the entire picture.

HINT

When balancing the color of a picture that includes flesh tones, always start with the midtones (to make sure that the skin looks right), and then correct the highlights and shadows. Once that is done, double-check the flesh color in the midtones. Also, when you have to sacrifice detail somewhere in the picture, it is best to do so in shadows rather than in midtones or highlights. Shadows have a tendency to obscure detail anyway.

The simplest form of color balance is a series of sliding scales that gives you immediate control over the color mix of the entire picture. For instance, in *Photoshop*, the "Color Balance" dialog has three scales, along which you slide your cursor to balance your picture between red and cyan, green and magenta, and yellow and blue. By using the preview option, you can immediately see what any change to each of these scales will do to your image. See Fig. 23-8.

Figure 23-8

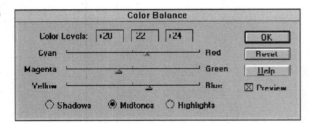

Photoshop's Color Balance dialog.

However, every professional quality paint program (including *Photoshop*) has at least one and as many as several commands that will allow you to adjust the color balance of your image by using a gamma curve. See Fig. 23-9.

To understand how a gamma curve (which is really working with brightness and contrast) affects color balance, remember (as mentioned before) that every pixel in a picture is measured by the greyscale values of its component colors. (It's the greyscale of an

Figure 23-9

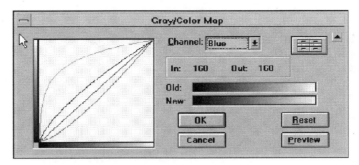

*In this PhotoStyler dialog box, the gamma curves of
each color channel (red, green, and blue), plus of the
master RGB image were manipulated to change the
color balance of an image.*

image that gamma curves and histograms depict.) Therefore, if you are
able to change the greyscale value of one or more component colors,
you will end up with a different composite color.

For instance, a pixel that is designated as R255,G79,B98 is a specific
peach color. But if we adjust the greyscale values of the green and blue
components so that it's composite value is R255,G85,B222, then the
pixel would be a more purplish pink.

To translate this to your image as something that is made up of
millions of pixels, think about adjusting the greyscale values of the
entire picture in each color channel—red, green, and blue. This will
change the color balance of the picture, just as it changed the color of
the individual pixel just described.

A program might have a variety of tools that work with the gamma
curve. One kind will have arrows at either end of both the horizontal
and vertical axes. (See Fig. 23-10.) By moving those arrows, you can
change the curve and actually dispose of greyscale values in the
extreme ranges. This is a drastic effect that should be used only
sparingly and then very carefully, because it destroys current image
data.

In another, you will move your cursor within the graph, pushing the
curve in whatever direction you want it to go. Experiment with this for
some strange and interesting effects, as well as some very subtle color
changes.

The third kind will ask you to input number values that will affect the
gamma curve. (See Fig. 23-10.) Remember, the 45° line of an original
gamma curve is equal to 1.00 because the input and output image are
exactly the same. Thus a gamma value of less than 1.00 would darken
the picture (or the color channel), and a gamma value greater than
1.00 would lighten it.

Figure 23-10

Push these arrows & boxes to change the horizontal & vertical extremes on the gamma curve

Gray Balance

Channel: Blue

Highlight In: 190 Out: 215
Midtone In: 117 Out: 144
Shadow In: 45 Out: 40

1.49

Input gamma numerical values here

OK Cancel Auto Preview

In this dialog box, two different methods were used to change color balance on the gamma curve: by pushing the arrows and boxes that affect the horizontal and vertical extremes of the graph, and by inputting a numerical value for the gamma curve. (Both methods could have been used on each of the color channels.)

When she first started imaging, Sally was uncertain for weeks about using gamma curves. The problem was that the more she read about them, the more difficult and complicated they sounded. Being an artist, she functions better in a hands-on environment. As soon as she just went ahead and started playing with gamma curves, she recognized what all the fuss was about and has been using them freely and creatively ever since. So now we repeat our prime piece of advice—experiment, go ahead and make mistakes, push these tools to their limits and beyond. That's the key to becoming a master imager.

Hue & saturation

You might have noticed that when we talk about computer colors, we have avoided using the word "hue." That's because the word has a very precise meaning in digital imaging. *Hue* is a value along a continuum that is the range of colors of the entire spectrum. That is why a gradient drawn with the HSB or HSL color model will make a rainbow effect. (Please see the previous chapter's discussion of color models.)

Therefore if you want to introduce a color shift into your image or correct one that has been created by improper scanning, use the hue component of the *Hue/Saturation* command. With it, you can create such effects as turning red roses on green stems into blue roses on purple stems.

The saturation control increases or decreases the strength or intensity of the color.

Some programs handle this function a bit differently, providing you with a tool that is called *Color Changes* or *Color Replacement*. Like the Hue/Saturation command, it can alter a specific hue or range of hues to another and/or change the level of saturation of your colors. See Fig. 23-11.

Figure 23-11

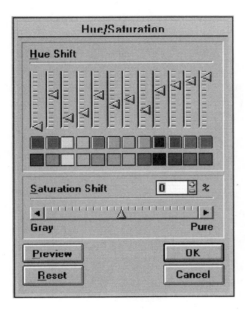

The hue/saturation dialog boxes of different programs may not look alike, but they work on similar principles to this one from Picture Publisher. Here, the bottom row of color boxes represent the current colors in the image. As you adjust the sliding scale, the colors of the top row of boxes are changed, so you can see just what the original color will become. The saturation is adjusted through another sliding scale or by inputting a numerical value.

As with any of the tools in this chapter, use the masking tools to make dramatic changes to a select area of your image.

⇨ Intuitive color & tone editing

What if you just don't want to learn about histograms and gamma curves? What if you prefer to work with color balance, brightness, and contrast more intuitively? Fortunately, you're in luck because there is software that will allow you to do that too.

The original ground breaking program was *Cachet* from EFI. When you edit a picture with *Cachet*, it provides side-by-side sample versions of that image (called thumbnails) at different levels of color, saturation, brightness, contrast, etc. You simply click on the version that you prefer and up pops another set of thumbnails from which to choose—all based upon your first choice. You keep going through the multiple choice process until you are happy with the image. *Cachet* works simply, naturally, grounded on your visual judgment and not on graphs or numbers. Don't worry if your monitor isn't properly calibrated because the software includes reference images (software files of

pictures that have been printed in a wire-bound booklet). That way, you can see what the colors on your monitor would look like if they were printed out onto the same printer as *Cachet* used.

This multiple choice type of color correction works well and quickly. So much so that the *Photoshop* 2.5 update added a similar feature (without the reference images—though you can create your own) in its "Variations" command (see Fig. 23-12). We wouldn't be surprised if other paint programs begin to offer thumbnail multiple choices as a matter of course, because it makes sense for users who are either intimidated by curves or numbers or who just want a direct visual point of reference that aids in making color and balance choices.

Figure 23-12

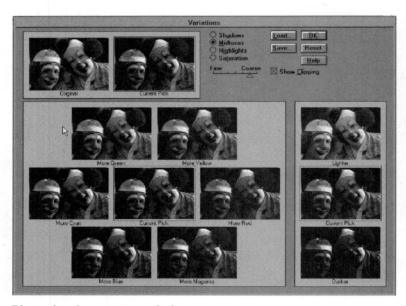

Photoshop's variations dialog.

The difference between thumbnail choices and working directly with editing tools is like the difference between taking a multiple choice test and an essay exam. The latter is more difficult, requiring more from you in terms of control and perception, but it allows a greater portion of your own personality to come through—and shine, when you do it superbly. Multiple choice is more automatic, less creative, quicker, perhaps easier to grade, and suffices when all you want is to measure something quantitatively.

When your objective is simply to perfect a scanned-in photograph, use the thumbnail choice method. When you want to be more creative and explore the many artistic possibilities of what you could do with your picture, go for the more traditional tools.

HINT When you are preparing several elements from a variety of sources to be used in a montage, you will want to color balance them relative to

each other so they look as though they were created under the same lighting conditions. That is an excellent time to use thumbnail choice editing tools, while keeping files of the other elements on the screen, as points of reference.

Sizing & reshaping

When you scan a picture or create a new image file according to the rules of intelligent imaging, the first step is to make certain that the size of the image—both in dimensions (such as 8"×11") and in resolution (pixels per inch)—is correct for the output device for which it is intended. This is a standard operating procedure for quality control. In an ideal world, you will always know in advance what image size you need and will always scan or create an image with that in mind. Resizing would never be necessary in order to make it fit your printer or film recorder.

Because we don't live in an ideal world, and because even the best plans might have to be changed, you might need for some reason to change the size of your image. One common reason is that you might want to change an image's size so that it can be merged with another image. Whether it's done through a color channel combine control, a cut and paste montaging, or some other technique, all image components that are merged must be of the same resolution and appropriate dimensions. So how do you go about resizing an image properly?

Image size controls

When you open up the *Image Size* controls (which may also be called *Resample* or *Resize*), you will be given the current dimensions of the picture and, in most programs that offer this tool, the ability to change them. Before you do anything, you must double-check how the following options are set.

> *Preserve Proportions.* When you change the physical dimensions of a picture, you will want to be careful not to change its proportions. For instance, if you have an 8"×10" image, when you half the 8" side, you will want to half the 10" side to make a 4"×5" picture. It would distort the picture to turn it into a 4"×8" image. Of course, you might want to distort the proportions for design purposes; in that case, make sure that the preserve proportions feature is turned off.

> *Preserve File Size.* As we said in Chapter 10, the size of your image file is based upon the dimensions of your picture and its resolution. If you don't have the preserve file size activated, when you reduce a picture's dimensions or resolution, then you

will lose megabytes of data and the file will become smaller. If you have the preserve file size option activated, then when you decrease resolution, the dimensions will automatically be increased and vice versa. Only some programs have this option available, but it is a valuable one. (In *Picture Publisher*, it is called *Smart Sizing*.)

➤ *Units of Measure*. Be sure you double-check what units of measurement are being used by the numbers involved. Dimensions can be described as inches, centimeters, millimeters or pixels. Obviously, something that is 36mm wide is quite different from something that is 36" wide. It's a simple mistake everyone makes at one time or another.

Actually altering the image size is as simple as typing in the new numbers, then clicking on the "OK" or "Done" box.

Incidentally, those programs that won't allow you to change an image size usually have a "Get Info" or similar command that will at least tell you what the current size of your image is. This is useful when you want to know if the file may be used in conjunction with another, or when you want to create another file to use with it.

If you enlarge your image file, your computer will have to create new data to fill in the spaces. This is done through what is called *interpolation*, in which the software makes a judgment call on what the new data should be, based on the information associated with adjacent pixels and the type of interpolation chosen. Interpolation is an inaccurate process, and the results can sometimes be disappointing. Whenever possible, rescan an image in order to fit the needed size when you require a larger image or greater resolution.

⇨ Canvas size

Sometimes you don't want to change the size of an image but to enlarge the canvas on which it sits. This enables you to make attractive borders or add other elements to the picture. (See Fig. 23-13). When you click on the canvas size command, a dialogue box similar to the image size controls will be placed on your monitor. The dialogue box will give you the current dimensions of your image, which will remain constant. Type into the appropriate boxes the size canvas you want to surround that image. The dialogue also displays a square divided evenly into three rows of three boxes. By clicking on one of those boxes, you tell the computer where on the new, enlarged canvas you want the current image to be placed. For instance, if you click on the middle box—which is the preferred position for adding a traditional border to the picture—then your image will be placed dead center in the new canvas. If you click on the lower left corner, then your image will be tucked into that corner of the canvas. Generally,

Figure 23-13

(A) Photoshop's Canvas Size dialog in which the image is placed in the left center square, as the canvas is increased. (B) The resulting placement of the image, with the increased canvas area filled with black, which was the current background color.
Photo © Sally Wiener Grotta

the area where your image isn't placed will be filled with the current background color.

⇨ Resizing & reshaping tools for masked areas

An area that has been selected by a mask tool may be resized, either by inputting the appropriate numbers into a resize command or by calling up the *free resize* tool. This will place dots on the outline that you can pull with your cursor in order to change the size of the area. Similarly, there's a *skew* command, which will distort the shape of a masked area; *rotate*, which will allow you to turn it in place; and *distort*, which will do just that, according to how you pull it about and others.

24

Creative montaging

BY now, everyone has seen the pictures—the ones that just couldn't conceivably be real—with penguins flying or the Statue of Liberty in the Mojave Desert. Digital imaging makes the impossible possible, if only visually.

The tools and techniques available in imaging programs for cutting and pasting elements from various pictures into a montage can be very sophisticated. Procedures that would have taken a graphic artist or darkroom technician hours or days might be achieved in minutes or hours, and with a more seamless integration.

Montaging begins with selecting an area of a picture with one of the masking or picker tools. Once a selection has been determined, you can cut out the area or copy it. Either command temporarily places that portion of the image into a holding area within your computer's memory that is called a *clipboard*. Then, when you call up the paste command, it will pull that portion of the image out of the clipboard and place it in a different place on the same image or even in another picture entirely. You can move the pasted area anywhere on your image, stretch it—do whatever you want to make it fit perfectly and improve your design—before removing the marquee border (in paint programs) or the bounding squares (in illustration programs) that defines it as a selected area. When the border is gone, the pasted area becomes part of the new image. It will appear on top of whatever was in the background as if it were there from the very beginning.

Cutting and pasting is a very intuitive process that should be familiar to anyone who has ever used scissors and rubber cement on a drafting board. (Or even for everyone who played with construction paper, scissors, and glue in kindergarten.)

Illustration software's montaging is very straightforward, following the described processes. When you use a paint program to cut (or copy) and paste, you have access to a wide range of special effects, the limits of which imagers have yet to discover. (This is another area in which paint programs have far more sophisticated variables than illustration programs.) For that reason, this chapter focuses on the montaging techniques and tools possible with paint (aka photo manipulation) programs. Chapter 22 provides information about illustration software's montage abilities.

HINT

As a general rule, the commands that govern cutting, pasting, montaging, and merging selections are usually found in the pull-down menus at the top of your screen under "Edit." Other commands you will want to access are those that control masks, which may be found under "Select," "Transform," or "Masks."

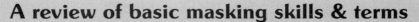
A review of basic masking skills & terms

Accurate and well-controlled masks are vital to montaging, just as using scissors correctly (without hacking off important parts of your composition—or your fingertips) is necessary to real world cut and paste operations. For this reason, let's review some of the terms and skills that we covered in Chapter 20.

First the terms:

- *A mask is a selection tool that defines exactly what area of your bitmapped image will be affected by whatever other commands you use.*

- *The dotted outline that the masking tool draws to designate the limits of the selected area is a* marquee *(also known as* dancing *or* marching ants*).*

- *The names of tools used for drawing masks are* rectangular, circular, freehand *(or* lasso), magic wand, *and* Bezier.

And some masking fundamentals:

- *Be sure to perfect your mask, using whatever techniques are available. You want to include every dot and hairline that belongs inside the selection, without cutting off relevant pixels or bringing into your composition elements that just don't belong there.*

- *When appropriate to the design, use anti-aliasing or feathering commands to make the masked element blend more smoothly with the rest of your picture. But remember to keep a hard edge to objects when it would make design sense.*

- *Before you do anything, check to see if the masked area is a floating selection and/or if the preserve image option is on or off. When the selection is floated, editing the masked area will not affect the underlying pixels, until you remove the mask. If it is not floated, then you are working directly on the pixels that make up the image. For instance, if you cut an unfloated selection from a bitmapped image, you will be left with a hole in the shape of that selection, filled with the current background color.*

- *A mask is a separate file associated with a bitmapped image; it is usually portrayed as a black-&-white silhouette. As such, it may be painted on or otherwise manipulated. This will alter the final result of pasting the mask. One popular and useful effect is to paint a mask file with grey, making it translucent (as opposed to perfectly clear) so that any command you apply to the image through the mask will affect the image only partially. Another technique is to apply a filter to a mask file to change the texture of the merged result.*

- *Some programs allow you to view the mask as a color overlay through which you can see the entire image and through which you may edit by painting with white to add to the mask or with black to remove areas from it. (This is called "Quick Mask" in Photoshop or "rubymask" in PhotoStyler.) Sally uses this facility*

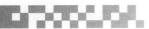

for her final perfecting of her masks, because it can be so precise without requiring that she be able to draw exact lines.

For more detailed information about how to make the best possible masks and how to manipulate them see Chapter 20 on "Conquering Masking."

Pasting controls

When pasting a selection into an image, the *merge controls* (also known as *paste controls* or *composite controls*) of paint software offer a number of options that can dramatically alter the final effect. Many of these options take for granted that you have at least two masks defined:

➢ What we will call the *source selection* is that masked area that will be removed from its original picture (or its original position within the same picture).

➢ What we will call the *destination selection* is a masked area in the new picture that will determine how or where the source selection will be pasted.

These are terms of convenience to help describe how various merge controls work.

Paste into & paste behind

The *paste into* (or *paste inside*) command puts a source selection inside the destination mask. Imagine a picture of a landscape in which you want to change the overcast sky to one with better clouds or a bluer color. Luckily, you happen to have a nice photo of a bright blue sky with billowy clouds in your files. You would mask the area in the picture where you want the new sky to go. Then you would paste the selected portion of the new sky *into* the masked area where the old sky was.

The *paste behind* (or *paste outside*) option places the source selection so that the destination selection covers it in whole or part. For instance, suppose you have a picture of a dog and another picture of an oriental carpet, and you want to have the dog on the carpet. You would paste the carpet *behind* the dog's mask. (Of course, if you moved in the other direction, you would paste the dog *into* the carpet's mask.)

See Fig. 24-1 for another example.

Figure 24-1

The destination mask. © Sally Wiener Grotta

The source mask. © Sally Wiener Grotta

The source (the masked boy's head) pasted into the destination's mask (the flower). © Sally Wiener Grotta

The masked boy's head pasted behind the flower's mask. © Sally Wiener Grotta

 # Translucent pastes

In the example of the dog on the carpet, if the dog's mask were painted a uniform medium grey (as described in Chapter 20), then you would be able to see design elements of the carpet through the dog. In other words, the dog would be somewhat translucent.

As an alternative, some programs have an option in their paste controls that will define the level of opacity or transparency of a selected area. (See Fig. 24-2.) Thus, if you put the source selection's transparency at 50%, then when you paste it into the destination selection, 50% of the resultant image will have elements of the underlying destination selection showing through. (See Fig. 24-3.)

Figure 24-2

PhotoStyler's Composite Controls.

Figure 24-3

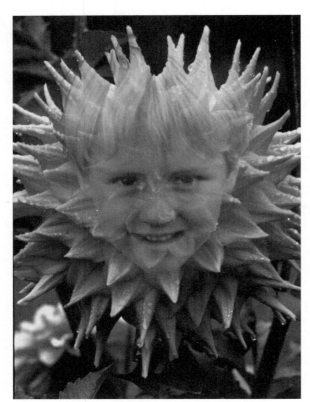

A 50% paste of the boy's head into the flower's mask. © Sally Wiener Grotta

Color & greyscale values as determining pasting factors

The transparency option, or painting grey on a mask file, can determine how much of an original image shows through after a pasting operation. You can get much more precise, actually designating which pixels you want to be used by the resultant image. This is achieved by telling the software to compare the color and greyscale values of the destination and source selections and to choose between them, based upon what command you use. These commands will be very familiar to you if you have experimented with the "Use Foreground Color If . . ." paintbrush options we covered in Chapter 18. (In the following descriptions, we are taking for granted that the mask files have not been painted with grey elements and the transparency option is at 100% opacity.)

➤ The default is *Always* or *Normal*, which indicates you want all the pixels of the underlying image to be replaced by those of the overlay image. In the case of the dog on the carpet, this default would make sure that none of the carpet would show through the dog.

➤ The *if darker* command will choose those pixels from either the destination or the source selection that are the darkest and they would be the ones used in the final composite image. (See Fig. 24-4.) Similarly, the *if lighter* command will choose those pixels that are the lightest. Therefore, if you have a checkerboard of black & white that you are pasting on top of a pattern (such as paisley), then the if darker command will result in a checkerboard of black squares interspersed with paisley squares. The *if lighter* command will create a checkerboard of white squares that alternate with paisley squares.

➤ When you use *color, brightness, saturation, hue, luminosity,* or similar paste options, then the named feature (such as color, luminosity, etc.) of the source selection will be pasted onto the destination selection, with the rest of the destination selection showing through. Try this experiment. Use the emboss filter on an image. Then paste the colors only from the original picture onto the embossed version. The embossed image's texture and distinct contrasts will be tinted over by the original colors.

➤ *Additive* and *subtractive* paste commands will mathematically combine the greyscale values of both selections. In the additive, you will end up with a brighter image, because the command adds the greyscale values together. In the subtractive, the result will be darker. (Remember, in a greyscale, the higher the number, the lighter the pixel, with zero being black.)

(A) A checkerboard pattern. (B) A grey pattern. (C) The checkerboard pattern pasted over the grey pattern using an "If Darker" merge control. (D) The same paste, but with an "If Lighter" command. (E) Use these merge controls to determine just what will happen to your design. By using an "If Darker" merge control to paste the masked boy's head into the flower mask, only the dark eyes, mouth, and the edge of his face are used in the montage, because those are the areas of the boy's head that are darker than the flower's pixels that they replace. © Sally Wiener Grotta

Figure 24-4

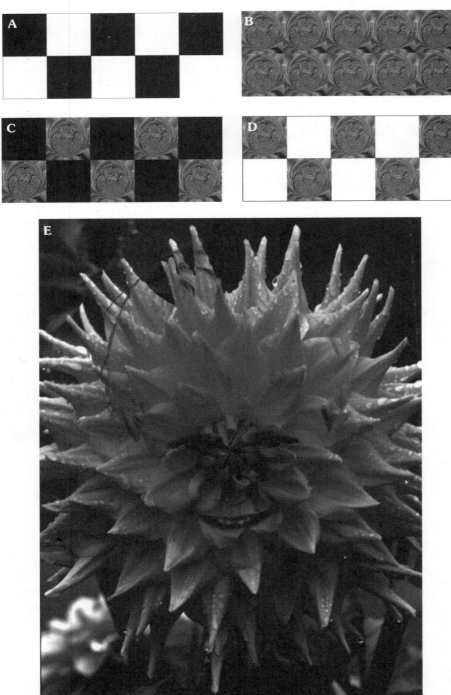

As with the paintbrush options, there are additional color or greyscale related commands (such as *multiply, screen, dissolve,* etc.) that will control the way images will merge when they are pasted. The names (and sometimes the effect) of such commands will change, depending upon the program you are using. We have found the color or greyscale related paste controls of *Photoshop* and *PhotoStyler* to be the most versatile of the paint programs we have tested.

 Try using paste controls on specific color channels, controlling the transparency on each.

⇨ Montaging guidelines

The first rule of montaging is to make sure that the various components can and will fit together, both artistically and physically.

⇨ Physical compatibility

All elements of a montage must be made up of the same kind of data; otherwise your software will simply refuse to paste them together. So they must come from pictures with identical *image types* (such as greyscale or 24-bit true color), *color models* (such as RGB or CMYK) and *file formats* (TIFF, BMP, PCX, PICT, etc.). To review the various image types and color models, go back to Chapter 22. File formats will be explained in Chapter 25.

In addition, all components should have the same *resolution* (dots or pixels per inch).

If any of your components are physically incompatible, use whatever conversion utilities your software might have to translate it to the right kind of data. Or, better yet, plan your composition from the beginning and make sure that all the components you create for it will fit together. At best, conversion is no better than a last ditch option because it can cause degradation or loss of data.

⇨ Artistic compatibility

While it is up to the artist to decide what components will look good together, there are some established rules of thumb.

> ➤ *Color Balance.* Be sure that all elements of a montage are color balanced to each other. Bring them all up onto your screen and edit each one, in relationship to the others, with the various tools we discussed in the previous chapter. Or use *Cachet*, the color editing program. (You'll be able to work on only one picture at a time in *Cachet*, with the others being opened as

reference images.) The trick to color balancing the components is to make them look as though they were created under the same lighting conditions, using the same palette of colors.

➤ *Perspective*. The various elements' perspectives should fit the composite whole. This is a key that some of the early imagers missed, even when producing some very expensive, slick ads. For instance, we remember seeing the cover picture of a catalog for a new cruise ship that was created on a computer by putting the vessel in New York Harbor (where it hadn't sailed yet). The problem was that the water of the harbor was angled in one direction and the ship's alignment simply didn't relate to it. (Essentially, the harbor picture was an aerial shot, while the ship's picture had been taken from the front of the vessel.) No, it didn't quite look as though the ship were about to fly off into space, but it did make the bow (the front) of the vessel look grotesquely large. The skew, distort, and perspective mask transforming controls are very useful for fixing this kind of problem.

➤ *Light Source*. When you are finished with your pasting, the resultant picture should look as though the main light (or the sunlight) is coming from one direction. If you use elements from a variety of pictures that were photographed under different conditions, the angle of light might vary for each component. This can be corrected with some intense editing, or it can be fixed from the start by controlling how the components are first created. Some paint programs have lighting tools that will create needed corrections or adjustments in a picture's light source. (*Fractal Design Painter's* lighting tool is excellent.)

➤ *Quality*. The final determining factor of whether components destined for a composite belong together is hard to define, but it has to do with their quality. Do they have equivalent levels of detail? Are their dynamic ranges (the range of their greyscale histogram) similar? Are they equally sharp or blurred? Are their luminescence, contrast and brilliance analogous? Look closely at the amount of noise or graininess for compatibility.

As we have stated before, the best time to make sure that the various elements will meld well together is when you create the components. Try to plan ahead when you know you will want to make a montage.

Making a composite something more than the sum of its parts

One of the telltale signs of a computer composite are elements that just don't look as though they have settled into the picture. They are

hovering over the ground or unaffected by the rest of the image or otherwise stick out like a sore thumb. Something just doesn't fit.

A variety of techniques may be used to make the composition more than the sum of its individual parts. The result is a finished picture that stands on its own, without any reference to how it was created.

⇨ Blending

As we mentioned in the chapter on masks, the edges around a formerly selected area can be sharp or jittery, making them stand out from the rest of the image. Try using feathering or anti-aliasing on the marquee, while the area is still selected. Or use one of the blur (or smudge) tools, after the marquee has been removed, to make the edges blend into their surroundings. Just don't smudge it so much that the edge loses its distinction, or else the picture looks as though it has been handled by a child with dirty fingers.

⇨ Shadows

Shadows give dimension to a picture, as well as establish a subliminal link between the various elements. Use one of the following techniques to make shadows:

> ➤ Mask the object that will be projecting the shadow. Move the marquee as an empty outline, then distort it so that it falls across the ground and other objects in the right perspective and direction for the shadow. Then, use the brightness/contrast command to darken the area. (You might also want to introduce a slight color shift to give your shadows the appropriate tint.) When you remove the marquee, you'll have a shadow. Use this method for long shadows, such as those made by an early morning or late afternoon sun.

> ➤ If your shadows don't need to be so precise because the main light will be coming from higher up, then just draw a rough, freehand mask over the area where you want the shadow to be cast. Again, use the distort or skew command to make sure it falls just right across the other elements of the picture. Darken it and remove the marquee.

Be sure that all shadows in your picture fall in the same direction, are equally dark, and relate to their shadow casting objects with the same proportional length and same kind of distortion. (See Fig. 24-5.)

Figure 24-5

The first consideration in choosing these two elements was that both had rear lighting—creating similar halos—and the wind was blowing their hair in a similar direction. An important step in making this montage included using the red mask overlay (called Rubymask by PhotoStyler and Quick Mask by Photoshop) to capture the boy's strands of blowing hair. However, the lightness and contrast had to be adjusted on both, and the boy had to be blurred, while the rookerie photo was sharpened to bring them closer in quality and balance. Then the boy's mask was pasted behind the mask of the penguin that is now to the rear of his trike. And another penguin was copied from the background, enlarged, and sunk into the rocks between him and the viewer. Finally, an appropriate shadow was created and some rocks cloned. © Sally Wiener Grotta

 ## Sink the components into their surroundings

When Sally pasted the picture of an Amish child on a tricycle into one of an Antarctic penguin rookerie, it continued to look like two pictures pasted together no matter what she did with shadows and color balancing. But when she put some of the Antarctic rocks in front of the trike and sunk its wheels between other rocks, then all the pieces began to meld together into a image. Most people who view the picture don't even realize that it was the result of a cut and paste. They simply ask how we got a Pennsylvania Dutch kid all the way down to Antarctica.

The various elements of a composite picture shouldn't lay one on top of the other. Instead, have them surround and embrace each other. Here are a few suggestions:

➤ Use the cloning tool to paint from one component onto another.

➤ Pick up the dirt from the ground and throw it onto the ball or the flower.

➤ Make the elements interact as they would if you had seen them together in the real world.

In the final analysis, the best montages are ones that don't scream at the viewer, "Hey, look, someone knows how to use a computer!" Instead, it should be recognized as an effective piece of creativity, regardless of how it was made.

25

File formats &
data management

AS you graduate from learning imaging to working at it, you will discover that some important decisions you'll have to make about your image files will have nothing to do with creativity. This is the nasty business of file management and housekeeping.

Like it or not, you will have to consider several issues frequently as you image. These include:

➤ Determining the appropriate file format in which an image should be saved to the hard disk.

➤ How to transfer files among programs.

➤ Selecting the file format that is preferred by your clients, service bureau and print shop.

➤ Whether or not you should use compression on your image files to save storage space.

➤ How to organize your files on your hard disk logically, so they will be easy to find.

➤ Maintaining a database of your images so you can keep track of them.

File formats, image data types, & color models

In Chapter 22, we discussed image data types and color models. Try to keep the concepts behind them, as well as file formats distinct and clear.

File formats are the way data are organized by programs when they save images to your hard disk. In addition, each piece of software will load from your hard disk only those images that are in the file formats it supports.

Image Data Types relate to the amount of data associated with a bitmapped image, as created by a paint program. (This is also known as image or data depth.) For instance, a greyscale picture is an 8-bit image. A true color RGB picture is 24-bit.

Color Models refer to the rules by which color is mixed and created. The RGB color model (which is the one native to computer monitors) is based on transmitted light, in which white is defined as the sum of all colors. The CMYK model (which is used in printing) is based on reflected light, and white is the absence of all color. HSB stands for hue (the range of the spectrum), saturation (the intensity of color) and brightness (the amount of light), and so forth. For further information on color models see Chapters 22 and 29.

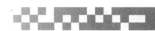

⇨ File formats

When you create an image—either through scanning it into your computer or drawing it from scratch on your monitor—it must be saved to your hard disk. Otherwise, it would become an ethereal artifact that could never again be seen, worked on or printed. Once the computer's power is turned off, it's gone forever—unless it is saved. The method by which the software organizes the data in the saved file is called the file format.

Several dozen different file formats are used by various kinds of software to save graphics files. Each one has its own personality: an individual manner in which it organizes the data, a different perspective on the kind of data that it considers most relevant to defining the image, etc. No file format completely agrees with any other.

Why are there so many different kinds of file formats? Because software development is rooted in anarchy. When a new computer field opens up, every programmer and manufacturer rushes to create what he hopes will become the standards by which others will be guided. But it takes some time for standards to be established and, because having one's own standard adopted can involve millions in royalties, no one is anxious to give their standard up for another's if they can help it. The upshot is there are often so many standards that no one can agree on just one. Computer graphics is no exception to this.

Another reason is need. For example, the file formats developed for black-&-white or greyscale images were fine—until the advent of color graphics and color printers. Suddenly, the existing file formats were entirely inadequate; and rather than rewriting the file formats, it was often easier to simply develop an entirely new file format that would accommodate new advances in technology or programming. This is an ongoing process similar to the theory of evolution, which would rather throw up new species of animals while the older ones continue as they had been.

A hard disk filled with images saved in different formats is something like the United Nations. The delegates need to agree on a common language before they can even begin to communicate, but everyone wants that common language to be his native tongue. Luckily, all professional quality imaging programs will now support (load, work on, and save to) several formats, most of which are more or less standard throughout the industry.

How do you know what format you're working in? On PCs, when you look at the image file names in the directory in which they have been

saved, to the right of the dot will be a three-letter designation of the file format (called the file "extension"). For instance, "clown.*tif*" or "boat.*bmp*." On Macs, when you look at the folder in which your images are saved, the type of file format is often written across or under each image icon. Also, when you go to save or load a file from within an imaging program, the dialog box somewhere usually indicates the file's format.

Here are some of the extensions and names you will see most often:

➤ Tagged Image File Format or TIFF (.TIF)

➤ *Targa* (.TGA)

➤ PICT (.PCT)

➤ *Windows* Bitmap (.BMP)

➤ *Windows* Metafile (.WMF)

➤ *ZSoft* (.PCX)

➤ Encapsulated PostScript (.EPS)

➤ Graphics Interchange Format (.GIF)

➤ Computer Graphics Metafile (.CGM)

➤ Kodak *Photo CD*

➤ Desktop Color Separation (.DCS)

➤ Drawing Interchange Format (.DXF)

There are many others, but they aren't used as frequently by computer artists because they are too limited or too specialized. In addition, several imaging programs have their own proprietary file formats that are the default when a new picture is scanned in or drawn, or when you save a file in that program without indicating a different format. For instance, Adobe has its *Photoshop 2.0* and *Photoshop 2.5* formats. Most illustration programs use their own proprietary formats, which is why many of the formats listed here and described later are bitmapped formats.

We're sure that we have missed someone's favorite format in that list, but our purpose is to focus on the ones we have found most relevant—the ones most frequently referred to among the imaging artists, clients, and programs we know. Quite frankly, we have our personal prejudices toward or against certain formats, which will become evident in the following descriptions. These preferences are based on experience—on judgment calls we have had to make to be sure that our images were safe, the data integrity preserved, our files compatible with the programs in which we want to use them and appropriate to clients' needs.

HINT If all you want to know is which file format is best to use, when you intend working on it in two or more programs, then just keep this one thought in mind. *Save your file in a format that the destination software can load and save.* (This includes making certain that the file is in a format that your output device and its software can use.) However, there is much more to selecting a format than compatibility issues, which is why we are dedicating a good percentage of this chapter to the subject.

⇨ Vector or raster?

A file format will generally use one of two methods to organize the data that makes up an image—*vector* or *raster*.

Vector (which is also known as *object-oriented*) images are formed by mathematical formulae that define the shape and color of their elements, like a line, a circle, etc. This produces sharp delineations between elements, such as you see on poster-like illustrations.

Raster (or *bitmapped*) images are made up of individual dots, each of which have a defined value that identifies its precise color, size and placement within the image. This provides a more natural blend between dots, as in a photographic image.

We tend to use the words object-oriented and bitmapped (rather than raster and vector) because we remember their distinctions more easily. Their names say what they do: *object-oriented* formats define images according to the *objects* that form them, while *bitmapped* formats define images by organizing the many thousands of *bits* that form them. However, it is useful to understand the words vector and raster when talking with other imagers, your service bureau or print shop, and other imaging-savvy individuals. (The language of the game can be an important indicator to others that you know what you are doing, even though it has nothing to do with the quality of your work.)

Illustration programs create object-oriented images, while paint programs work with bitmapped images. Object-oriented files are smaller in size—require less memory—than equivalent bitmapped files. (For further information about the differences between these two kinds of images, see Chapters 17, 18, and 19.)

NOTE When an object-oriented file is converted to bitmapped, there is generally a limit to the resolution that can be specified. Sometimes, the highest resolution available is 300 dpi. When a bitmapped file is converted to object-oriented, it will lose the resolution information, regardless of how high the original resolution was.

Live Picture

As we go to press, a fantastic (and expensive) program called Live Picture has been announced. It's a new software technology that will allow imagers to work in real, immediate time on extraordinarily large size images. When Kai Krause of HSC Software demonstrated it to us, he opened a 500Mb image that came up on the screen within seconds (such a file usually takes many minutes to load in, even on a high-powered system with many megabytes of RAM), immediately rotated it, merged it with another 500Mb image, and performed other usually time-intensive tasks without any appreciable wait. Live Picture uses a brand-new patented file format that may just revolutionize the way we all image—if you can afford the software (which we understand will probably list for about $3,500). At present, it works only on Macintosh machines, though it is being designed to operate on any system using the new PowerPC microprocessor.

Tagged Image File Format (TIFF)

TIFF is probably the most popular full-color bitmapped format around, supported by every PC and Mac paint program we know. TIFF is especially appropriate for images based on scanned photographs.

Sally uses this file format 90% of the time when working on bitmapped images. When she translates object-oriented images to a bitmapped format, she almost always (whenever possible) chooses TIFF. The only reason she will change over to another format for bitmapped images is to output to some other program that needs a special format for compatibility or to comply with a client's wishes.

You might have heard that there are many different versions of TIFF, which can conceivably cause some compatibility problems among programs. True, software developers can create their own proprietary versions of TIFF (under license from Aldus Corporation), and they might or might not be fully compatible with each other, or with the more commonly used form. At the time of this writing, there have been five main revisions of TIFF—Class 1 to Class 5, with 5 being the most recent. But very few TIFF files created by current mainstream paint programs suffer from any incompatibilities. We have experienced no compatibility problems and have used TIFF as our bitmapped format of preference for some time.

Perhaps some of those who have had problems were trying to use a Mac TIFF file in a PC or vice versa. While a direct, unconverted transfer is not possible (unless you are using a PC/Mac hardware or software emulator), it's very easy to translate the PC to the Mac TIFF and vice versa. Some imaging programs offered this feature when you save the file (using "save as" and not simply "save"). Another potential incompatability occurs when one program allows you to save mask

information in the TIFF file, while another doesn't recognize what to do with the extra data.

NOTE We are the first to acknowledge that we are not techies. Nor are we programmers. Therefore, our approach to choosing a file format is a more pragmatic one. Our litmus test is: how well does it work for us in various situations?

Some programs offer a TIFF option called LZW compression. As you will read later in this chapter, we have two different views about whether or not compression is something an imager should do to her pictures. But we agree that the LZW method of compression is well worth avoiding if possible, because it slows everything down to the proverbial crawl. Whenever you want to save or open up a TIFF/LZW compressed image, you might as well go brew a cup of coffee rather than wait at your monitor for the computer to do its job. (Okay, that's an exaggeration, but LZW compression is *slow*.) Another compression method often associated with TIFF is JPEG. We'll talk about JPEG later, since it may be a method that you will elect to use when your files threaten to overwhelm your hard drive.

Uncompressed TIFF images have none of these speed problems. When and where TIFF does slow down has nothing to do with the file format, but its size. Because TIFF is a popular format for high resolution photographic images, you may produce large files—larger possibly than the amount of available RAM in your computer. (When a file is physically larger than the amount of RAM available, anything you ask the computer to do to the file will require using the hard disk, which is much slower than RAM.) This large file slowdown isn't exclusive to TIFF; it's a problem you'll have in any format when you are working with large files.

Targa File Format (TGA)

Originally created for Targa's display boards, it is a bitmapped format that still enjoys widespread support among paint programs and service bureaus. What makes Targa different (some say superior) is that it can save images in 24-bit *or* 32-bit color. Many users swear by Targa's technical superiority. Other experts feel that the Targa format should only be used for multi-media purposes. Our opinion? We don't see any compelling reason to use Targa for typical paint saves when TIFF works as well as it does.

If you use Targa, here's one vital thing to keep in mind. While the Targa format may be used for 24-bit and 32-bit color images, both for the Mac or the PC, remember that saving a file in 32-bit color will increase your file sizes, thereby taking up more storage space on the hard drive and slowing down your paint programs when you work on those images.

PICT File Format

A format native to the Macintosh platform, there are two versions: PICT1, which is a black-&-white format, and PICT2, which can handle color information. Interestingly, PICT can be used for both bitmapped and object-oriented files and may be exported to the PC environment as a file with a .PCT extension. However, PICT does not maintain color data integrity on the level of TIFF. For that reason alone, we have tended to avoid PICT.

On the other hand, Robert Schwarzbach of ArtLab, whose opinion we respect, has told us that PICT is his favorite file format because it retains mask and path information (which includes PostScript data), while TIFF doesn't. He also appreciates PICT's compression algorithms that save him space on his hard disk, and he has seen no image degradation from it. You'll have to make your own decision about which kinds of data are most important to your image, and choose between formats accordingly.

By the way, we heard of one person who had scanned in a 50Mb image and, after editing it, output it to a film recorder as a PICT file. It took nearly 10 hours. After complaining to technical support, he was instructed to convert it to a TIFF file. In the TIFF format, that same 50Mb file took only 13 minutes to record. Apparently, PICT's compound nature can confuse output devices. This is anecdotal information from a technician whose opinion we respect, but we didn't personally confirm it by spending 10 hours trying to output a PICT file to our film recorder. Schwarzbach's reaction to that story is that you can always change over to TIFF before outputting to a film recorder, but he would maintain a copy of the original PICT for any future editing.

Windows Bitmap File Format (BMP)

As its name implies, this is a PC-only format. Its original purpose was to provide some support for Microsoft graphics saves in the Windows environment. (Microsoft is the manufacturer of *Windows*.) It is a weakling of a bitmapped format that Sally uses, rarely, for only two reasons:

> ➤ It is the only bitmapped format that some PC object-oriented (illustration) programs support.

> ➤ A couple of our editors request it as a screen capture to illustrate Windows-based software reviews. (For this particular book, all the screen captures were saved as PCX files.)

Windows Metafile (WMF)

This is the object-oriented format native to *Windows*, which means that it is comparatively stable in that environment when you are cutting and pasting, or importing and exporting, between programs. (See later comments about file and data transfer.) However, we wouldn't change to this format just for that purpose. Seesawing back and forth—changing formats frequently—can increase the possibility of data loss. Because WMF offers no other appreciable advantages, we generally don't bother using it.

ZSoft File Format (PCX)

One of the oldest bitmapped formats, PCX was developed by the ZSoft Corporation for its own PC paint programs. While later and current versions work with 24-bit color, older versions do not. So make certain that you are using a recent version; otherwise, it will save 24-bit color images as 256-color—a degradation in data indeed. Also, if someone gives you an old PCX file, it might show some color shifts because of the differences between the current PCX format and its predecessors. PCX is a good format to work in and is well supported by paint programs. But as a general rule, we prefer the flexibility of TIFF. (However, our publisher requested that screen captures for this book be delivered as PCX files.)

Encapsulated PostScript Format (EPS)

At the heart of EPS is *PostScript*, Adobe's superb page description language that has become the standard for the quality output of digital images. EPS is considered the format of choice by most layout (desktop publishing) programs, because of its reliability and versatility. It is supported on both the Mac and the PC, but some imaging programs will not read EPS files created by other programs. An EPS save might involve choosing between binary or ASCII. Check to see which is required by the program (or the person) to which you are exporting the file. EPS is an object-oriented format, but its data may also include embedded bitmapped images. However, those bitmapped images may not be edited once they are placed in an EPS file.

What is PostScript?

The definition everyone gives to describe PostScript *is that it is a page description language owned by Adobe Systems (which also puts out* Photoshop). *But what does that mean?*

PostScript *was originally conceived and developed as a way of handling type so that it would print out smoothly, with no "jaggies" or ragged edges. It did this by looking at a page as an entirety rather*

than at the individual component letters. In other words, the letters were objects, defined by their shape and their placement within the page. Also, the resolution of the image was determined not by the file but by the output device. You could use the same PostScript file to print out on a 300 dpi black-&-white laser printer or a 2540 dpi color imagesetter.

It was just a small step from that to becoming the de facto standard for printing out any graphics—including object-oriented or bitmapped, or a combination of graphic types.

Your desktop printer will either be licensed to use PostScript or not. The licensing involves a fee that the printer manufacturer pays Adobe for the right to incorporate in their devices the proprietary programming that defines PostScript.

Given our druthers, we would choose a PostScript printer over a non-PostScript one every time, especially for graphics output. (Please see Chapter 14 on Printers.) If your output device doesn't have PostScript, you can buy and use what is called a PostScript emulator (or clone). Emulators are software or firmware (software permanently encoded onto chips or cards) created and marketed by manufacturers other than Adobe. Their purpose is to break the perceived Adobe monopoly on quality output and get a share of the potential profits.

A number of programs (actually, device drivers), such as Freedom of Press and SuperPrint, do in software what PostScript does in hardware. Once installed and configured properly, they work well and transparently. For laser and dot matrix printers, PostScript software emulators sell from a hundred to a few hundred dollars, depending upon the brand and how many fonts are included. However, those same programs designed to be used with film recorders can cost between $1000 and $2000. Why so expensive? Because the volume of sales is much lower—the driver must be customized for each film recorder manufacturer's products—and because digital imaging customers are generally willing to pay much more for software that they must have. We definitely recommend using a PostScript emulator for your film recorder, if you can afford it.

Whether you use genuine PostScript or an emulator, generally speaking, when it is built into the hardware—as part of your printer— the output process will be faster than any software option.

Graphics Interchange Format (GIF)

GIF is a popular bitmapped format for transmitting images over the phone lines, especially through the CompuServe on-line service. GIF is not a format of choice for professional imagers, though. It does not maintain the same kind of data integrity as TIFF; it doesn't even store color or greyscale information. So don't seesaw to and from GIF. If you must transmit a file in this format, hold onto your original full data file in its appropriate file format.

GIF can be used on various computer platforms, including both the Mac and the PC.

Computer Graphics Metafile (CGM)

In the midst of this file format anarchy, CGM is a real PC standard, certified by the American National Standards Committee and the International Standards Organization. If you are working with large monolithic corporations or the government as a client, you might be asked to use this object-oriented format. It is well supported by illustration software and desktop publishing programs. We have found no negatives associated with it. It is especially useful when moving an image among various illustration programs.

Kodak Photo CD Format

This format hasn't been around for long, and some paint and illustration programs haven't been updated to include it along with its other format options. Now that Photo CDs are gaining in importance in the imaging industry, it's only a matter of time before it becomes ubiquitous.

What the Photo CD format does is allow the artist to read photo files off any Kodak Photo CD. (Of course, you have to have a CD-ROM drive attached to your Mac or PC and the proprietary software plug-ins that will translate the information.) It also allows a user to write files in this format, generally to your hard drive, or some sort of removable drive. However, we can think of no reason to want or need to save files to this format, unless you are publishing your own CD-ROMs and have access to a drive that can write to CD-ROMs.

Desktop Color Separation Format (DCS)

DCS is a format that is used only for output to certain printing environments. It allows the picture to be separated into the four process colors (CMYK), and for the file to hold all four separations and a master file (which is in PICT format). Usually, service bureaus and print shops are much more involved with the DCS format than digital artists are. However, Maureen Stuart of Preality (who is a prepress expert) has advised us that it is the format of choice when using QuarkXPress, if you want your color images to separate properly.

⇨ Drawing Interchange Format (DXF)

DXF was created by AutoDesk, the developer of the very expensive but highly sophisticated *AutoCad* and *3-D Studio*. DXF is an object-oriented format that can also support ASCII (the text recognition format). You'll use it only if you get into high-powered 3-D modeling on the PC, in which case it will be an important part of your work.

⇨ Changing file formats

There will come a time when you will probably have to switch from one file format to another. Perhaps it will be so you can continue to work on a particular file in another program, or to be compatible with a specific printer or other output device, or maybe that your client asked you to give him the file in a format you personally never use. Regardless of the reason, you will want to know whether you will have to make some quality compromises in going from one file to another, or if there are any difficulties or problems inherent in the process.

Here's some specific examples of why you might want to change file formats.

No one imaging program will do everything you want, despite what software manufacturers claim. Besides, you'll develop personal preferences for using a particular tool in one program, and another tool in a different program. What's more, those preferences will change as you learn more about a program, as you encounter new challenges, or as the moon becomes full. That's why professional imagers maintain a library of software rather than using just one single paint or illustration program.

In another kind of scenario, you might want to take a piece of an image that you created in one program and paste it into another image that might have been created in an entirely different program. For instance, suppose you created an illustration of a dog in *Adobe Illustrator*. You could take that dog and put it into a farmyard photograph that you scanned in using *Photoshop*.

Once an image is created and perfected, you or your client will probably want to import it into a desktop publishing program, such as *QuarkXpress* or *PageMaker*. Because EPS is generally considered the format of preference for desktop publishing (DTP), you might have to convert to it from the file format you used to create the image. (However, nowadays most DTP programs will support numerous formats.)

Then, there is the question of output. Each device—such as a film recorder or printer—can accept only those images that are in certain formats. Or even if it accepts a certain format and will make a serviceable transparency or print from it, it might produce a cleaner, richer or quicker image using another format.

It's generally an easy matter to work on an image file in almost any program, even if it were created in another program or on a different kind of computer. You just have to be sure that the image is saved in a file format that the destination software or hardware supports.

Each format treats the data associated with an image differently. As a rule, when you don't need a specific format for compatibility reasons, then you should always choose the format that maintains the highest degree of data integrity.

HINT

Be careful when you change file formats. If the new format doesn't support the same kind of data as the original, you will lose some of the original data permanently. For instance, in changing a bitmapped image to an object-oriented format, the computer will automatically discard all data related to resolution. Or, if you change from a Computer Graphics Metafile (CGM) to a Graphics Interchange Format (GIF), you will lose all color information about the original picture.

How to change an image file's format

To change an image file's format, open it up in a program that supports both its current and intended format. Then save it in the new format.

If the program you are working in doesn't save or load a file format that you need, try using the "import" or "export" options under "File" in the pull-down menu at the top of your screen.

Both procedures will do the job equally well. But remember that in doing this, you are changing the inherent structure of the image file and how it organizes the data that defines your picture. Using both the save/load and the import/export dialogs to change file formats is so simple that it is difficult to remember that it is a drastic alteration of the very essence of the image.

To show you how it works, let's suppose you want to change a PICT file to a TIFF file. You would look under "File" in the pull-down menu at the top of your screen and click on "Load" (or "Import"). The dialog that opens shows a list of files in the current subdirectory and a pull-down box that indicates the current default file format. Click on the file format, and a list of formats the program supports will scroll down. Choose PICT from that list, then change to the subdirectory in which

the PICT file is saved. Then double-click on the name of your file. That will open up the PICT file and load it into your program.

Now choose "Save As" (or "Export") under "File," and a similar dialog will open up. Change the file format to TIFF and click on "OK" to save the file in TIFF format. (See Fig. 25-1.)

A

B

(A) Photoshop (for Windows) "Save As" dialog box. (B) The same with the file format pull-down option activated.

It's that simple to change a file format in any of your imaging software. The only practical limitation is the number and type of formats the specific program supports.

There's an alternative method for converting from one file format to another, and that is to use a utility program specifically designed for that purpose. For the PC, we use a program called *HiJaak*, a screen capture program that also has the facility to change a file's format. On the Mac side, we have used a program called *PICTure This*, but are testing others to replace it. Such utilities may support literally dozens of formats, far more than any paint or illustration program.

⇨ Transporting image components

Bits and pieces of images you have created can be incorporated into other images or page layouts. It doesn't matter if you want to work between pictures within a single program, among programs or, even, in different types of programs.

Generally speaking, you will choose between two methods to achieve this:

> ➤ Cutting (or copying) & pasting
> ➤ Linking

Use the cut & paste method when the two image files you are working with are of the same type—object-oriented or bitmapped.

Use the linking method when one image file is object-oriented and the other is bitmapped, and you don't want to change either format.

Cutting, copying, & pasting image data

Both the Mac and the Windows environment use what is called a "Clipboard." The clipboard is a temporary holding area in RAM memory where you can park part of an image. When you select an area in an image and choose "Cut" or "Copy" from the "Edit" pull-down menu, that selected area will be held in the clipboard until you cut or copy something else (because the clipboard can hold only one thing at a time) or until you shut off your machine.

The difference between cutting and copying is very simple and obvious. Cutting will remove the selected area from the original image. Copying will keep the original image intact, as well as put a copy of the selected area into the Clipboard. Then you open up the image file where you want the selected image in the Clipboard to go. Click on "Paste" in the "Edit" pull-down menu, and whatever was in the Clipboard will be pasted into the active image as a selected area.

Move the newly pasted selected area into position. Once done, you may resize, reshape, or skew it as needed. If the destination image is bitmapped, when you remove the mask, the new image data becomes part of the picture. If it is an object-oriented image, it will settle into its layer within the picture.

Further discussion of this method of image data transfer—as it relates to bitmapped images—may be found in Chapter 24. Chapter 19 refers to this method in its relationship to illustration programs.

Linking

Linking is a useful technique whenever you want to use an image that is created in one program within a document or image in another program, especially if the source image is bitmapped and the destination image is object-oriented (or vice versa).

The big difference between linking and cutting/pasting is that, with linking, the selected part of an image to be placed in the new picture or page doesn't really become a part of it. Instead, it continues to live on (so to speak) in its original file. Its location in the new picture or page is more or less something of a window view onto the other image. You can manipulate the outline of the linked piece of image by resizing it, skewing it, etc. You can sometimes even change the view of it, by moving the image within the outline. But, generally speaking, you usually can't edit the piece of image itself. What's required is to go into its original file to edit it (often using the path that the link has created).

On the Mac, this is called *Publishing & Subscribing*. In Windows, it's *Linking & Embedding*. It's an important aspect of desktop publishing, so we will return to this subject in the next chapter. We also discussed it in Chapter 19 in the section about putting bitmapped images into object-oriented pictures.

The compression debate

Some married couples argue about money or sex or who has control over the television clicker. Working together as we do, every hour of every day (which to us is one of the pleasures of life), our arguments take a somewhat strange form. For years, we battled about split infinitives and grammar. Now we occasionally come to loggerheads over data compression, a subject that is almost as controversial to imagers as pro-life or pro-choice is to certain members of our society.

To put our differing stands succinctly: Daniel believes in certain kinds of compression, even on important images. Sally refuses to take a chance with losing any data related to her images. Luckily, we have several computers, and we have divided our responsibilities for them. So Sally controls what kind of compression or other maintenance decisions are to be made on the computers that hold her images.

To help you judge what you should do about compression, you might want to know that Daniel wrote this section on compression, but Sally edited it and added her two cents.

Data compression is by no means a new technology. It's been used successfully on mainframes for many years, where data must be absolutely, completely correct. Now that it's migrated to the micro environment, data compression has become part of the landscape, so to speak. It even has the equivalent of the Good Housekeeping Seal of Approval, since Microsoft includes a data compression option (albeit, not a very good one) with its DOS 6.0.

There are three very distinct and different kinds of data compression. In one you won't lose any data, and that's called lossless compression. The second one will throw away bits of information as it compressed. The third one is also lossless, but it's used primarily to transfer or archive program and non-image data files.

Lossless compression

Lossless data compression, as its name implies, means that not one single bit or byte of data is ever lost. To work its magic, lossless data compression substitutes shorthand bits for longer bits. For instance, suppose the computer sees the words "Daniel Grotta & Sally Wiener Grotta" many times in a file it is saving. If it writes that name out in full, it would take up 35 letters and spaces every time. Instead, it instantly works out a code, such as "DSGrta" (which is only 7 characters long), which it then substitutes wherever Daniel Grotta & Sally Wiener Grotta appears. When the file is being loaded in, wherever the computer sees DSGrta, it realizes that it's a code and then replaces it with the original Daniel Grotta & Sally Wiener Grotta. All this happens automatically, and in real-time—so quickly that there is no appreciable slow-down.

The upshot is that lossless data compression can typically squeeze out 60% to 120% more storage space on a hard drive, depending on the program and type of files. Some types of data—like word processing or spreadsheet files—can be reduced by a quarter, half, or even more, while others—like fonts or digital imaging files—hardly compress at all.

With this kind of utility, every time the computer saves a file, it automatically compresses it according to any parameters that the user pre-sets. For instance, it's possible to specify that compression should be done by the fastest means possible or for maximum compression. Then, when the file is loaded in or copied to a floppy, a removable drive, or a tape drive, it is usually saved uncompressed.

HINT Data compression can be used on media other than the hard drive, something that is often done on SyQuest cartridges or CD discs, to double the data they can hold. But you must be sure that the destination computer (whether it is at a service bureau or at your client's office) has the same data compression program running so that it can decipher the compressed code.

Incidentally, most backup programs offer lossless data compression as an option. It not only saves storage capacity, but it generally helps speed up the backup process. Depending upon the program, a user can select the degree and type of data compression desired.

The $64,000 question is if there is a price to be paid for this seemingly something-for-nothing data compression. Yes, and no,

depending upon to whom you are talking. Data compression is transparent and foolproof, working in the background so efficiently and effectively that you'll never know it's there. There's no speed penalty, the data are safe, and there's absolutely no degradation of image quality. On the flip side, you might not be able to use some utilities (such as a specific optimizer or low level formatter), and if you have problems with the hard drive (such as a corrupted FAT or File Allocation Table), you might not be able to recover any of your data, except from your backups.

There are many lossless compression utilities available for both the Mac and the PC. *Stacker* is the best known, it works with both platforms, and, for our money, it's the one to use. In addition to compressing hard drives, it can also be used on floppies and removable drives, including SyQuest and CD cartridges. Microsoft includes a data compression utility in its DOS 6.0. We have it installed on our Spear 386SX (which we use for reviewing hardware like printers and scanners) and, frankly, we're aren't particularly impressed. It increased storage capacity by a modest 60% and seems to have slowed things down—very slightly to be sure, but it's still not as fast as *Stacker*. Nor does it allow the degree of control and customization that *Stacker* permits. Which one you select is a matter of choice.

Daniel uses *Stacker* on his computer because it stretches the storage space of his hard drive by about 100%. In the past two years, Daniel has had no difficulty whatever with running *Stacker*. He even has a co-processor board that speeds up *Stacker* operations to the point that, with many functions, it runs even faster than an uncompressed hard drive. The only problems Daniel has had is in configuring *Stacker* with other software, such as *Qemm* (a memory management program) and *PCKwik* (a software cache utility), but these conflicts were easily resolved.

On the other hand, Sally used to have *Stacker* on her ComTrade WinStation (for the partition that had her programs, not the one with her images) but permanently removed it after her hard drive crashed. Because of the way *Stacker* does its magic (by combining everything into one huge megafile), Sally was completely unable to recover any of the files on the hard drive. (Fortunately, she had backed up the day before, but, even so, she had lost hours of work.) Sally probably would have lost some or even many files had she not been using data compression, but she would have been able to recover others. That's one of the reasons she refuses to use any kind of data compression on the Micro Express PC. In fact, we do not recommend Stacker for the Mac because it turns off virtual memory.

What we do agree upon is that we both use data compression on our daily DAT tape backups. It saves a little time, it allows us to record more per tape, and, because we're dealing with digital data, everything

is well protected. However, when saving image files, we turn the compression option off. Part of the reason we do this is to ensure maximum backup integrity. But the main reason is that, uncompressed, the data can be read by any other 2.2 gigabyte 4mm DAT drive and backup utility. With data compression, the recipient must also use the same software and compression option to read the tape.

⇨ High compression

The second, more controversial method is called *high data compression*. High compression is what gave data compression its bad name among many imagers. Unlike lossless compression, it almost always involves a degree of data loss. Also, it will slow your computer operations down as it compresses or decompresses the file. Depending upon the program and the degree of compression specified, that time delay can range from negligible (so fast that it appears to be working in real time) to unbelievable (15 minutes or longer just to save or load in a file).

But the gains can be significant as well. A 50Mb image file can be shrunk down to less than 250K. This ability to compress 2:1, 5:1, 10:1, or even up to 200:1 represents an important savings of storage space when your hard drive is nearly full. Extreme data compression also makes computer-to-computer transmissions of data files possible, especially for news organizations covering fast-breaking, deadline-hugging stories with filmless cameras that have to get their images back to the newsroom within minutes. Using a modem, even a high-speed model, would take too long to send uncompressed images. In fact, the best-known image data compression format, JPEG (Joint Photographic Experts Group), is specifically designed to compress photographic images. JPEG is endorsed by most professional paint programs and is often offered as an option under the "save" pull-down menu. In addition, several software manufacturers sell JPEG compression utilities that they claim do a better job (greater compression, faster compress/decompress times, better image integrity) than the ones included in paint programs. When Sally is shooting on location, on a tight deadline, and must transmit an image that will be printed on newsprint or as a small size picture, she will use JPEG for the transmission. But she flatly refuses to use it for high resolution or large files that might be used for high quality output.

JPEG has become the high compression format of choice among digital imagers who regularly compress their image files, not just for transmission, but regular storage and as a portable media to hand to clients or a service bureau. While we know of no one who maxes out compression to a 200:1 ratio, 7:1 and 10:1 ratios are quite common.

The question is, how does high compression affect data image quality? It all depends upon the degree of compression, the brand of JPEG used, and whom you ask. As we mentioned, people tend to be passionate on the subject, either swearing by it or at it. We've seen prints made from JPEG files that are absolutely indistinguishable from uncompressed files. The main reason for this is that the bits that the computer throws away might not be necessary for the print anyway. Remember, many data files include excess bits that cannot be used by printers or film recorders. This is not to say that the computer will necessarily discard unneeded bits and retain vital bits. It's just that you routinely might have too many bits to begin with, so JPEG just takes advantage of your caution and conservatism.

On the other hand, a visual expert often can spot differences in print quality. A printed image that was compressed might have less colors, not be quite as sharp, lack tiny detail, or somehow not quite compare to the uncompressed image. It's up to you or your client to determine whether the compressed images are acceptable for your particular purposes.

An important consideration when thinking about using JPEG or any other high compression is what your final output will be. If your image is intended for a glossy print of considerable size, it would be safer to not take a chance with losing data. If it is going into a newspaper, the quality of the printout will be so minimal that you will probably not notice any data degradation in the final print.

Actually, any file format, and not just JPEG, can be shrunk with high compression utilities. There are many available, and they can usually be found by reading the ads in digital imaging magazines like *Imaging*, *Photo Electronic Imaging* or *High Color*. Having no personal familiarity with any of those utilities, we can't recommend for or against using any of them.

The other important high compression format for photographers is the one Kodak uses on its Photo CDs. In order to squeeze up to 100 low, medium, and high resolution image files on a single 660Mb CD-ROM, Kodak had to develop a tight, efficient compression algorithm that would work fast, almost in real time, shrink a file down to about a 5:1 ratio, and *still* produce a high quality digital image file that could be output to a relatively large file without any noticeable degradation. Most who have seen the results of Kodak's professional CD service agree that the company has done an excellent job with its data compression software.

We suggest not using JPEG or any other high compression format if you have no need to do so. Consider it only if you are running out of hard drive space, have to squeeze an image or images on a removable drive or cartridge in order to transport it to a client or service bureau, or plan to transmit it via a modem. (Of course, be sure that the

recipient has the software necessary for decompressing the image.) Otherwise, why bother risking quality degradation, if you don't have to?

A test for high compression

Here's what we suggest doing in order to determine whether JPEG is for you. Open up a bitmapped file with lots of color and detail, and then save it to the TIFF format. (Bitmapped images have much more data associated with them, so they would provide a better sample for this test.) Then save the same file in the JPEG format. If your program allows, save it three times—at 7:1, 10:1, and 20:1 compression ratios. (Don't try any high compression ratios, unless you really don't care about image quality.) Then print out all those files on your color printer, or have your print shop output them on the device you use for making match prints. Of course, note which print corresponds to what file format or compression ratio, and be sure your prints are at least 8"×10" or more. (The larger the print the easier it will be to discern image degradation.) Then put them side by side and examine them. Also have other experts whose opinion you respect or on whom you depend (such as art directors) examine the prints. Daniel's rule of thumb is to ask yourself these two questions: can you see any differences using only your eye, and do you think the difference to be significant? If the answer is no to both questions, you might want to try JPEG or some other high compression.

⇨ Archival compression

There's one other form of data compression that we'll mention briefly, not because you will ever use it to save or archive images, but because you will probably buy software that uses it.

Floppy diskettes aren't very expensive, unless you're a small software company that has to buy them in lots of 100,000. Then you become very parsimonious and look for ways to cut down on the number of floppies that you must provide in order to hold your program. That's when you would consider using an archival compression utility to reduce the number of floppies needed.

A public domain program called *StuffIt* and a "shareware" program called *PKZip* are used by almost everyone in the industry to save on the number of diskettes needed to hold a large program. They compact all the data down as far as possible, which is then unpacked, or "exploded," when installed on another computer. That's why, when you put a new program on your hard disk, it will sometimes take a while for each floppy to be read and copy its data to your system. While a lossless compression scheme, it works like a high compression utility because it takes some time to compress and decompress the files. Also, these programs aren't very good in handling complex image files.

Organizing your data

Who hasn't known someone with the prototypical college boy's room? It's a disaster area, with clothes thrown in piles here, there, and everywhere other than in drawers and closets. Papers and books are scattered wherever they fit (or, more likely, fall). Yet, he is not only an "A" student, but claims that if his mother ever dared to neaten everything up, he would never be able to find anything again.

While that kind of storage system might work for a college student, it would play havoc with the precious data on your hard disk. How would you find the one image you need among the megabytes or gigabytes that the hard disk might hold? It wouldn't be quite as bad as a needle in a haystack, but looking for it would take away precious seconds or minutes that you could be imaging. Add to that the many gigabytes of storage media you may use in the form of SyQuest cartridges, magneto-optical discs, DAT tapes, etc., and, to paraphrase a famous politician, pretty soon you're talking about real time loss.

We recommend two techniques for gaining control over the mass of data and files with which you will be dealing:

➢ Organize the files logically

➢ Use an image database program

Organizing files logically

If you were ever permitted to help that college boy organize his room, the first thing you would probably tell him to do would be to designate specific drawers and shelves for specific types of articles. For instance, socks belong in a sock drawer, all biology books in the same area of the same shelf, sweaters in a sweater box in the closet, etc. With everything in its place, he would be able to find anything he needs in the shortest time possible. That's sensible advice that translates well to the computer.

NOTE

The Mac and the PC are quite similar in many ways, but they often use different words to describe similar aspects of working with a computer. In the following discussion, we use the word "folder" to describe sections on the hard disk in which data and program files are organized. That's what Apple calls it. Substitute the expressions "directory" and "subdirectory" for "folder," and you will be able to translate what follows to managing your files on the PC.

When you load a program onto your hard disk or save a file, the data will actually be placed wherever there is space on the hard disk. In computerese, this is called random access. Fortunately, the computer remembers exactly where it put the data by maintaining a complete

list, called the File Allocation Tables or FAT for short. Mind you, none of that is visible to the user, and you never have to know about the FAT until and unless it gets corrupted or wiped out.

Instead, what the user sees are lists of names of the files placed into various folders. You might create the folders yourself, or whatever program you're running created them automatically when it was being installed. Similarly, you might deliberately place specific files in a particular folder (because that's where you want to park it), or the program's default values will automatically save any file you create or work on in a particular folder.

Folders are like a collection of wooden Russian dolls, each of which, when opened, has another doll inside her, another inside that one, and so on. Any folder can have several other folders inside it, and like branches on a tree, the further out it goes, the more permutations it can have. The trick to organizing your files so that they are easy to find is to create folders with logical names, such as "Utility Programs," "Imaging Programs," "Business Programs," etc. Then, within each of those folders, put the appropriate program folders.

Data files should be arranged in a similar manner.

For instance, we have a folder called "Books," in which there is a separate folder for each book that we are writing or have written in the past 4 years, plus a folder called "Book Proposals." Whenever we sign a book contract, one of the first things we do is transfer the related proposal to a new book folder. That book folder will be divided into other folders, such as "Notes," "Letters" (related to the research), "Illustrations," "Chapters," etc.

Inside the "Imaging Programs" folder, Sally has a folder for those images on which she is currently working. Each image has its own folder inside that one, which contains various versions and components of that image, related masks, and relevant color palettes. When the image has been completed, she will transfer that specific folder to her archival storage tapes.

The point of all this nesting is to be able to find the file you want as quickly as is humanly possible. The alternative is to go searching through every folder (or every directory and subdirectory) on your hard disk until you find it.

⇨ Naming conventions

One of the main differences between the PC and the Mac (at least until the next generation of DOS is released) is that while the Mac allows a user 32 characters to name a file (such as "GREY HORSE IN EMPTY FIELD"), the PC allows a very parsimonious 8 characters

("GRYHORSE"). Because the Macintosh's name can also be a description of the file or the image, it's a relatively easy task for a user to organize her folders according to what those file names are. For instance, one could have a series of image files, such as GREY HORSE WITH BLUE SKY, GREY HORSE WITH CLOUDY SKY, GREY HORSE PIXELATED, etc. Use your imagination in coming up with descriptive names that will tell you about what's in the file.

Because of the 8-character limitation, it requires a little more effort on the PC. DOS allows a user to add a 3-character extension to any file, by typing in a period and then those 3 characters. Or number, if you desire. Often, you won't have any discretion about putting in those 3 characters, because you will have to use them to designate the file format. So, instead of putting in GRYHORSE.V1 or GRYHORSE.V2 (version 1 or version 2), you must use the .PCX or .TIF extension on all your files. What we do is change the name to incorporate the variation, such as GRYHORS1.PCX or GRYHORS2.TIF.

Also, since each picture Sally is working on is kept in its own subdirectory, she will depend upon the name of the subdirectory to help her identify the files. For instance, on the PC, she might have a subdirectory called GRYHORSE. The file names in that subdirectory might include HEADMASK (for the mask drawn around the horse's head), ORIGINAL (for the original scanned in photo), CORRECT (for the color corrected file), etc.

Thinking logically, come up with shortcuts and substitutions to organize your file names so they make some sense, even on the PC.

Incidentally, there are some utilities like *Sherlock* that work under Windows to allow a user to substitute Macintosh-like descriptive names instead of the 8-character convention. We don't use them because, while this utility works fine with Windows, the *real* file name that DOS sees will be completely cryptic and incomprehensible. We often reference files with a DOS shell called *Norton Commander* to copy, delete, or change file names. (It's much faster than trying to do the same thing in Windows.) That isn't possible with name expanding utilities.

⇨ Image database programs

A productive imaging artist will probably create hundreds of digital pictures over a year's time. Even those who work at it only part time will end up with quite a library of images within a couple of years. She won't keep them all on her hard drive, because that would require much more space than even the largest hard drive has. And it wouldn't be cost effective to get additional hard disks just for the purpose. Instead, she'll archive them in various storage media. (See Chapter 12: "Storage Devices.")

With image files being so large, her archive library of images might eventually fill a bookcase. Now, how is she going to find a specific picture out of all those tapes, disks and/or CDs?

Numerous companies market programs, called image databases, that are designed to handle the problem of archiving images so you can quickly lay your hands on them. For those unfamiliar with this popular category of applications software, a database is a way of organizing, categorizing, and correlating data of any sort. Thus, a business may maintain a database of its clients, another of its employees' personnel records, etc. A visual database does the same thing with image files.

Here's how they work. Each picture, photograph, illustration, etc., is given its own record (which is like a page in a notebook). The record contains all the information about the picture that you feel is important, such as its subject (horse, man eating hot dog, New York street scene, etc.), the type picture it is (head shot, architectural view, pastel sketch, etc.), when it was created, using what software, on which computer, for what project, what client, what other pictures were incorporated into it, how many times it has appeared in print, how much money it has earned, etc. And, of course, exactly where it is stored in your archive library (such as Tape #116 or SyQuest cartridge #313).

Let's suppose that you need to find the illustration of a child with a beach ball that you made sometime between January and April of 1993. You would list those criteria in the database's search function. Perhaps the search turns up five such images including a thumbnail version. A thumbnail is a low resolution representation of an image file, just large enough that you can identify it. Accompanying the thumbnail is whatever text-based information that you entered when you created (or added to) that particular record. Most importantly, it would be able to tell you on which particular tape, cartridge or whatever it could be found.

Beginning imagers won't need an image database—at least, not yet. But once you begin accumulating image files, and you discover the need for accurate, detailed records about the creative, technical, and business data associated with each image, it's time to go shopping for a visual database program. The sooner you begin, the more detailed the data, the easier things will be for you. We recommend not putting it off. If you wait until you absolutely need an image database, it will already be almost too late to create one without a great deal of backtracking. The time to start one is when you have so few images that it would take only an afternoon to input all the information into the database.

Such image database catalogs are invaluable. Take it from an imager who started creating her images before such visual databases were available. We'll discuss them further in Chapter 27.

26

Desktop publishing's layout programs

T wasn't very long ago that whenever we visited a magazine art department or an advertising agency, somewhere in the labyrinthine offices was a highly skilled paste-up artist bent over a large layout table. With pasteboard, Xacto knife, rubber cement, rulers, and a blue pencil, he would meticulously labor at laying out each page of a project, combining pictures and type into a perfectly aligned and designed form, ready for the printer.

But that's a dying art that has all but succumbed to computers. We're certain that somewhere out there are layout artists and designers who still practice the old-fashioned, hands-on method, but they're few and far between. Laying out type and pictures on a computer is so much faster, neater, more efficient, and more cost effective.

The computer layout revolution erupted onto the scene a few years ago, when three factors coalesced: the development of powerful, affordable but relatively simple to use desktop publishing software; the increased availability of comparatively inexpensive desktop laser printers; and the universality of high-quality, high-resolution computer-driven imagesetters at print shops and service bureaus.

NOTE Desktop publishing is such a mouthful that it is often abbreviated to DTP. We will use both expressions, plus "layout programs," to describe this kind of software.

 # DTP: # An imager's competitive edge

While some digital artists will never personally use desktop publishing software—after all, what does page layout have to do with creating art or manipulating a photograph to perfection?—there is considerable incentive for the digital imager to become involved in DTP (or at least learn more about it):

> ➢ The potential for increased profit.

> ➢ To better understand clients' needs.

> ➢ For greater artistic control over the final form of your art or photograph.

> ➢ To create a more professional look for business communications and self-promotion pieces.

If you already have a computer, a SyQuest drive (or other removable data storage device) and a laser printer, you are set up to do desktop publishing. All you need is a DTP program. The three most popular professional-quality desktop publishing programs are *QuarkXPress*, *Aldus PageMaker*, and *Ventura Publisher*.

The software is no harder to learn and use than any paint or illustration program. Because DTP programs are essentially object-oriented software, much of what you learned in Chapter 19 about illustration programs will apply to computerized layouts.

In other words, there are no real hardware or software obstacles to doing DTP and some important reasons to at least understand it.

How you might use DTP

It's a fact of life: the overwhelming majority of print ads, brochures, magazines and newspapers are created and prepared with DTP programs. Therefore, like it or not, your photographs, images, digital art, etc., will probably be desktop published, i.e., laid out onto the page by computer. Somebody will be commissioned and paid to do this. Given that you have the means (a computer and DTP software) and the skill (basics can be quickly acquired, especially if you are already familiar with illustrations programs and can do a good design job), that person could be you. Even if you feel that assuming complete desktop publishing responsibilities is beyond your scope, you may offer to assist or to take over some part of the layout process.

Of course, you might not want to do any of the layout yourself. Or your clients might be reluctant to commission you to take responsibility for this phase of the project. Nevertheless, it will still be well worth your time and effort to learn and understand the basics of DTP. For instance, you can use desktop publishing software to ensure that your art will fit the client's design. By scanning in his drawing or "comp" of his design into your computer, you can then use a DTP program to lay your picture into that drawing and make sure it is precisely the size, shape, perspective, etc., that your client needs. Suppose the design calls for a picture of a child swinging a baseball bat, and the bat must fit exactly between two blocks of type. At the same time, the child's body must curve just so into the right-hand side of the piece, in order to leave the correct amount of room (but not too much) for the company's logo. There's no guesswork involved if you use a DTP program to check to see that your picture is perfect for the client's needs, before you deliver it to him.

On an even more basic level, a commercial imager would want to be conversant in desktop publishing terms and considerations, so that she would come across as a knowledgeable professional who understands a client's particular situation. We're sure that there have been times when a client has started talking about typefaces and point sizes, information boxes and drop leads, assuming that you understood exactly what all those terms mean and how they relate to the project. You have three choices in how to handle that kind of situation. You can reveal your ignorance (and possibly lose the account), fake it (which could make you appear like an absolute fool if you get caught

on a particular detail), or learn the language and the basics of desktop publishing (so that you come across as a knowledgeable professional).

Another aspect in which DTP can give you an edge is in fine-tuning what your stationery and printed material say about you. As a professional, you need to project an image of competence, genius and reliability to your clients. If they think you are anything less than professional in your business dealings, they might question your ability to handle their account. All other things being equal, the artist or the studio that presents the most attractive and professional image will be the one that gets the job.

Once upon a time, it was perfectly acceptable to type a notice or a document and send it to the client, confident that its content would represent your philosophy and professionalism. Those days are quickly fading because most clients and companies with whom you deal have higher expectations. They don't want typewritten copy when computer-generated typeset quality is now the standard. In today's intensely competitive environment, your stationery, public relations releases, invoices, private newsletter, promo pieces, and anything else you send out on paper has to stand out, even if it has little or nothing to do with your work as an artist, photographer, or designer. It's a silly snobbery—one that is probably more subconscious than discerning. However, since anyone—from Fortune 500 companies to the smallest studio—can have access to the same desktop publishing tools, it makes sense to make use of them.

⇨ DTP basics

Desktop publishing is both simple and complex. It is simple in that it takes very little time to understand and use the concepts that control it. And it is complex in that the variety of options available are extensive. This chapter will take the simple approach—exploring the concepts rather than describing the individual desktop publishing commands.

On the most basic level, desktop publishing software takes type and pictures that were created or edited in other programs and pastes them together into a printable form. The source programs may be your word processor, a paint and/or illustration program, a collection of clip art, etc. It may also include a logo or template provided by a client, a scanned-in photo or sketch, a texture from a CD-ROM, etc. As long as the file is in a format that the DTP software supports, it will be able to import it and put it in place within the document. The point is that, generally speaking, the layout program doesn't create these elements, it just uses them.

HINT The two file formats used most frequently for pictures being imported into a desktop publishing layout are EPS and TIFF. (See Chapter 25.)

Any kind of layout that you see in a newsletter, magazine, newspaper, catalog or brochure, you can achieve with a desktop publishing program. First, decide what you want your page or pages to look like, and then look for the commands, tools and techniques that will help you achieve it. In other words, a good design is the basis for every desktop publishing project, as it has always been for any published material. But unlike the traditional method of cutting and pasting, once you have put together a page or an entire document, it isn't frozen into place. You have the freedom to experiment with it—moving elements about, resizing, reshaping, and recoloring them as the whim strikes you, until it is just right.

The electronic pasteboard

When you load in a desktop publishing program, your monitor turns into an electronic pasteboard and layout table, which you can customize as you desire. (See Fig. 26-1 for a PageMaker screen.)

Figure 26-1

PageMaker's screen.

Anyone familiar with illustration programs will recognize the most obvious attributes of a desktop publishing screen:

➤ An empty page is displayed on the work area. You'll organize your layout on that page, but you can use the work area to temporarily hold items you plan to paste onto the page—much as you do on a real world layout table. (If the page is magnified, you will see only a portion of it, and it will fill the entire work area.)

➤ Rulers line the top and left of the work area. If they aren't displayed, choose "Show Rulers" in the pull-down menu at the top of the screen, generally under "Options" or "View." Of course, you can choose whether the unit of measurement is in inches, millimeters or picas.

➤ A rectangular arrangement of icons is displayed either to the side or on the top of the work area. While the icons represent different tools than those associated with illustration software, you will interact with them in a very similar manner.

➤ A pull-down menu at the top of the screen provides access to additional commands and tools.

Rulers & guidelines

A traditional paste-up artist will draw blue pencil (non-printing) lines with the aid of a straight-edged ruler, to mark the layout page and guide him in placing the pictures and type. So, too, you can place non-printing guidelines on the desktop publishing page, just as you would with illustration programs.

Generally, you just click on the ruler and, while holding the mouse button down, drag out toward the image page. As you drag, you'll pull a perfectly vertical or horizontal guideline out onto the layout page. Release the mouse button when the guide lines up with the rulers at the appropriate point. For instance, if you want a horizontal guideline 2" from the top of the page, pull it until it intersects with the vertical ruler at the 2" mark. It's a remarkably easy process that you will use frequently in all desktop publishing programs.

HINT

Use guidelines extensively. Whenever you place any text or type, line it up first with guides. It's a very valuable, easy to use technique that provides a high degree of precision.

Incidentally, if the rulers on your screen don't line up so that the zero point is at the corner of your layout page (or if you want to make the measured zero some other point on your page), it is easy and desirable to fix it. The intersection box where the horizontal and vertical rulers meet in the corner of the work area is sometimes called the "Rulers

Origin Box." Click and drag on that box. When the crosshairs that form as you drag reach the corner of your page (or reach the zero point you wish to define), release your mouse button. That will change the numbers on your rulers to zero at that point.

HINT To make sure that whatever you place on your page lines up exactly with the guides, search out and activate the "snap to grid" or "snap to guidelines" command, which is usually in the pull-down menu under "View" or "Options." That will force any drawn or imported item to connect exactly with the nearest guideline, when it is placed in close proximity to it.

Constraining keys

All imaging programs, including desktop publishing software, make use of what are called constraining keys. *When they are used in conjunction with a drawing command (which is activated by a mouse or stylus button), they will limit the proportions of whatever you are drawing. For instance, if you are using a rectangle drawing tool, a constraining key will force it to draw only perfect squares. It's a useful technique indeed.*

Constraining keys are usually chosen from among the following individual keys or a combination of them: "Shift," "Alt," "Control," "Command," "Apple," or "Option."

When you use a constraining key, remember to release your mouse (or stylus) button before you release the key, in order to maintain the constraint.

Margins & columns

Special guidelines that can affect how your type and pictures will lay out onto the page will include margins and columns. While any type or picture that is on your image page will print out (whether or not it is within the margins), by defining your margins, you will have better control over the placement of the various design elements. They will also assist you in making sure that every page in a document conforms to the same format. (See later comments about Master Pages.)

Columns are usually defined by their number (how many columns you want to fit across the page) and the distance between them. Text inserted into a page with column guidelines will flow through the columns, as it does in a newspaper, from the upper left to the lower right corner of the page. Any spillover from the first column will start at the top of the second one, etc. (See Fig. 26-2.)

Figure 26-2

Text placed in a page will automatically flow according to the columns and margins setup. (The illegibility of the small text is called "greeked." See the explanation of the term later in this chapter.)

The master page or style sheet

As you work with desktop publishing, it becomes obvious that you will want to repeat certain page formats frequently, for two reasons:

➤ You are working on a multi-page document in which you want every page to conform to basically the same layout.

➤ You define a style—such as for letterhead stationary or the first page of a monthly newsletter—that you will want to use over again.

Rather than re-invent the wheel, so to speak, every time you work with a specific page layout, it's possible to define what are called master pages and style sheets.

A *master page* is a non-printing layout that defines the style of a multi-page document, so that the look will be consistent throughout. Some of the defaults the master page will set include:

➤ Paper size, margins and other dimensions

➤ Columns template

➤ Non-printing guidelines (though additional guidelines may be created for each page as you work on it)

➤ Printable borders, frames and other design accents

➤ Page headers and footers

➤ Type fonts

All the defaults that the master page creates can be overridden, if the artist wishes. For instance, the default type might be Baskerville, but you might want to use Ariel for a text box on page 3, to set it apart from the rest of the document.

When you are working with a document that will be printed double-sided, you might want to make a left and right master page. This is especially useful if you have design elements, such as corner page numbers, which should alternate left and right relative to whether they are on an even-numbered page or an odd one. (See Fig. 26-3.)

Figure 26-3

Similar icons are often used by DTP programs to show you which page you are viewing and working on. Here, we read that we are viewing the first page of a three-page document, and that it is a right-side page.

Whenever you are working on a layout, check to see on which page you're working. Somewhere on the monitor (usually in a corner of the work area) will be an indicator that the current page is a master sheet, page 1, page 2, a left or right page, etc. This is especially important when you want to protect the integrity of an established master page. It is possible to rearrange pages if, for instance, you accidentally design on page 2 though you thought you were working on page 3. However, you want to be careful to keep your master page quite clean and separate from any of your document pages. You wouldn't want to layout page 1 or 2 on the master page.

In contrast to master pages, *style sheets* are layouts that relate to a form that you will use frequently, but which might or might not be part of a large document. This might include an invoice, the often repeated design of a certain client's advertising campaign, etc. Most programs also allow you to define and save the styles of individual components of a layout, such as paragraphs, captions, titles, letter salutation, etc. These styles are usually saved in a style library on your hard disk, which probably also holds some default layouts that are supplied with the program. Some programs automatically save these styles to a library that is associated with a specific document. For instance, if you do a regular newsletter that you send out to clients and prospects, the styles that you define for the text, headlines, title page, etc. should be saved in the subdirectory or folder that is dedicated to that newsletter. It can then be loaded in as the default values every time you produce an issue.

⇨ Placing text

While this book is about working with pictures in a computer, the primary purpose of desktop publishing is to place text effectively on a printed page. This is a task that DTP programs do superbly, by treating each block of text both as an object that may be physically manipulated and as a string of letters that may be edited.

HINT

Generally, you treat text as an object when you are positioning it and shaping how the block will lay on the page. To do that, you use the position tools. When you want to edit it or format individual portions of the text (such as headlines or font changes), you use the type options and text tool.

Preparing a page to receive text varies only slightly among the various desktop publishing programs. Some require that you draw a non-printing frame or box in which the text will be put. In others, you simply have to click where you want the text to go. In either case, it will flow according to the columns and margins that you defined when you initially set up the page.

Text is usually imported from a word processing program, though you can always add words, sentences, or even entire paragraphs as needed. Programs differ in how much of the word processing format will be imported. We usually use our word processor's native editing formats for such matters as dividing paragraphs, establishing italics, and other actual editorial matters as we create the text. But tabs, headlines, columns, and other visual formatting we will do in the desktop publishing program. By the time we are finished with creating a document, it is not uncommon for us to have completely changed all word processing formats and commands within the DTP program.

⇨ Importing text

To import text into a desktop publishing document, format the page as described above, and choose where you want the text to go. Then, look under "File" in the pull-down menu at the top of the screen and click on "Place" or "Import." That will bring up what should be, by now, a rather familiar dialog box, in which you choose the file you want. (If it isn't listed, then you're looking in the wrong folder or subdirectory for that specific file. While still in the dialog, change directories or folders to the right one.) Double-click on the file you want. Depending upon the desktop publishing software you're using, you may be required to click on the spot within your image page where you want it to be placed, or the text might just appear there.

The text will flow through the margins and columns that you defined. If you're viewing the entire page, and if the text is dense and small, it

might look like nonsense symbols. (Look back at FIG. 26-2.) This is what is known as "greeked" text. (Monitors have limited resolution and can't accurately display characters below a certain point size.) When you magnify the page, you will be able to read the individual words and letters of the text, but you won't be able to see the entire page.

Viewing your page at different magnifications

At different times, you will want to look at your page from various viewpoints, zooming in to see details or pulling back to get the full picture. The magnification level at which you can display the page is controlled by commands available in the pull-down menus at the top of the screen, usually under "Page" or "View." (There might also be icons somewhere on the edge of the screen which, when you click on them, will change the magnification level of the current page.)

The commands available in the pull-down menu may include:

- *Fit in window. This allows the entire page to be viewed. It's useful for checking the overall look of the page and deciding where in the page you want to place text, images, lines, boxes, columns, etc.*

- *Actual size is supposed to display the page at the size it would be if it were printed out according to its page definition (such as 8½"×11"). The name of the command is something of a misnomer or, at best, only an estimation, because the size will usually be somewhat off from the exact dimensions of the page, depending upon your video board, monitor, and program. But it's still a useful view, because it allows you to judge the approximate size at which readers will be seeing the document when it is printed. Thus, you can make appropriate decisions about font size, picture detail, etc.*

- *25%–400%. You can usually choose a specific magnification of the page, according to percentages in which 100% is the "actual size."*

Get into the habit of switching back and forth among various magnifications, as you make design choices, so that you can have all the information you need to make your decisions.

Text as an object

The block of text that you place on your desktop publishing page takes up space, much as a square, a circle or a polygon drawn in an illustration program does. The outline of that block of text is defined by the mathematical formulae that best describe it. In other words, it is an object. As such, it may be moved about, broken into pieces, reshaped, resized, etc. To manipulate this block, usually all you have to do is select it, by clicking on it with the pick tool active. Once selected, you can push it around with your mouse or stylus, to your heart's

content. This flexibility is what makes desktop publishing software so useful and effective.

⇨ Editing text

Most of the text editing that you will do in DTP programs will have to do with the look (rather than the content) of the word. But there will be occasions when you will need to make last-minute text changes or edits and will want to do it within the desktop publishing software, rather than redo it with your word processor. Fortunately, desktop publishing programs allow the user to create or change words, sentences, paragraphs, charts, and such within the layout software. The commands and functions are similar to many that you are used to working with in your word processor program, often including such options as spell check, search and replace, insert and delete, etc. Whenever possible, we recommend using your word processor for any extensive editing. It will be easier and, in most instances, much faster.

On the other hand, the changes that you will want to make that relate to the how text looks on the page should be done in the desktop publishing program. These include:

- ➤ Font type, size, and style
- ➤ Hyphenation
- ➤ Leading, spacing, and kerning
- ➤ Text justification or alignment
- ➤ Tabs, indents and other positioning commands

⇨ Font type, size, & style

Desktop publishing software will allow you to change the fonts of individual letters, words, phrases, sentences, paragraphs, or an entire text. When you make such changes, the text will reshape itself automatically, according to the established layout. For instance, if you have an article that fills three columns when the type is sized at 12 points, when you change that size to 10.5 points, it will fill less than three columns. Therefore, when text is spilling over the space you have for it or when you have too much open space on a page, altering the font size is a quick and easy method to make the text fit the page.

Whatever typefaces you have loaded on your hard disk or built into your printer can be used by desktop publishing software.

The style of your type relates to whether it is underlined, italics, subscript (below the line of text), superscript (above the line of text), all small capitals, bold, etc. A single font can be made to have a variety of

looks by changing its style. All this can be designed and designated within any DTP program.

 Remember, the basic rule of good type design is "Less is more." There are so many different digital typefaces available that, when DTP first became popular, amateur jobs were marked by their overuse of too many fonts on a single page. If you change typeface, use italics or bolds; or, whatever you do to alter the look of your type, make sure the effect adds to (rather than detracts from) the overall design and its impact.

Varieties of fonts

There are thousands of different fonts available for the computer. Generally, they may be divided into bitmapped and outline fonts. It should come as no surprise that the differences between those two kinds of fonts are similar to the differences between object-oriented and bitmapped images.

A bitmapped font is one that is specifically defined by the dots that form it. For this reason, they tend to have jagged edges. Every character must be stored, fully formed, on the hard drive, which generally means that they take up much more space. For instance, a typeface will have a separate file each for 10 point, 12 point, 24 point, etc. The only marginal advantage of bitmapped fonts is that, being predefined, they generally load and print faster. But because they don't have the same quality and versatility, we don't use them for output. On the other hand, screen fonts (those that are displayed on the monitor) are bitmapped.

An outline font is defined according to its shape, which is stored on the computer's hard disk as a mathematical formula. When you want another size of the same font, the formula is invoked by the software, which reforms the letter. This means that you can specify the exact print size, such as 10.2 or 33.8 points. "Jaggies" (the rough edges typical of a bitmapped font) are less pronounced with outline fonts. Also, one can produce many more special effects, such as rotating, squeezing, or filling in the characters.

Although there are many different brands of type, the two most popular ones used professionally are Adobe's PostScript and Apple's TrueType. PostScript fonts are considered by many to be the best on the market. They are smooth, quick outline typefaces that are supported by just about every program, print shop, and service bureau you will ever need to use. What's more, they take advantage of the superiority of PostScript printers. (See the previous chapter for more information about PostScript and Chapter 14 on printers.) The main problem with these fonts is that they are usually more expensive than others. Also, there are two varieties of PostScript fonts: Type 1 and Type 3. Type 1 are far more common, but Type 3 is gaining in popularity. The main difference is that, while all PostScript-equipped printers and output

devices can handle Type 1 fonts, only newer models can capitalize on some of the more advanced features associated with Type 3.

TrueType fonts are also very good outline typefaces. They are not as ubiquitous as PostScript fonts and tend to be more popular for straight text. Their main advantages over PostScript is that they usually print out faster, and they are often less expensive.

What kind of font should you use?

If all you care about is having an attractive type that will output to your low-resolution laser printer with some efficiency and quality, it doesn't really matter if you go with less expensive outline fonts. Better yet, use the typefaces that came built into your printer or as part of your DTP program. That way, you won't have to bother ever buying additional fonts.

However, if you need to provide a digital file that includes type to a print shop, service bureau or client, you must use a font that they have. That means, they must have the specific brand and style of type that you are using, in order to interpret and create the typeface that your digital file describes. For instance, if you are using Compugraphics' Times Roman as part of your page layout, your service bureau or print shop can't substitute Adobe's Times Roman for it and expect a perfect match. Sometimes the differences are very subtle. If you are using an Adobe font provided by Apple as part of the Macintosh's System 6, it might not be entirely compatible with the newer fonts that are part of System 7. In the Mac world, each specific typeface has a unique identification number. If the font you embedded in your file doesn't exactly match the one that the printer is using, what might happen are infuriating, seemingly unexplainable printing mistakes, like the capital "B" dropping below the level of the other type, or a thin line extending up from the small "p". Or, even more commonly, unplanned fonts will be substituted for yours.

Adobe remains the most commonly supported font vendor, but many print shops and service bureaus maintain a large library of fonts from different vendors to support their various clients' preferences. It is best to check with the recipient of your digital files to find out what brands and kind of fonts they have before you even start to create the files. If you insist on using a particular font that your service bureau doesn't have in its library, they might ask you to purchase a copy of the font software for their use, or they could charge you extra to cover their cost for buying a font that they might use only with your work.

⇨ Leading, spacing, & kerning

The major difference between the look of a typewritten page and one that is done by a professional printer are the physical relationships of the individual letters, words and lines to each other. Most typewriters are monospaced devices, giving equal space to anything, regardless of

how much space it really needed. A small "i" will take up exactly the same amount of space as a large "W". Most computer printers are capable of producing what is known as proportional type, which means that the actual printing space given to each character is proportional to its visual width. For instance, the space given to a capital "M" in a printed word will be as much as 5 times as wide as a small "i". Proportional spacing makes reading easier and more natural, and ever since Gutenberg, printers have used it almost exclusively. (Monospacing was a product of the typewriter, not the printing press.)

Desktop publishing has its roots in printing, which means it uses some sophisticated tools to make the printed word look just that—printed. These tools control type leading, kerning, and spacing.

Leading is a wonderfully old-fashioned word. When type was set by hand, thin pieces of lead were placed to maintain the space between the lines. This is done electronically in desktop publishing programs through a dialog box that sets leading in your preferences file or in some other command area. This might also be called "interline spacing" in some programs.

Kerning refers to the space between specific letters within a word. The shape of certain letters in juxtaposition to certain other letters creates visual ambiguities. For instance, consider a capital "A" followed by a small "v". Without kerning, there appears to be too much space between the two letters. But with kerning, the two letters are moved closer together so the "v" fits neatly next to the backward leaning leg of the "A". Kerning, when it is done correctly, takes all these special combinations into consideration when laying out type. You can have a DTP program do "auto-kerning," or you may overrule the software's choices and set the kerning yourself, determining both the special combinations and the degree of space between the letters.

Other spacing considerations that you may set in DTP programs include those between words, between paragraphs, between headlines and text, etc. Usually, these spaces are inserted automatically by the computer. But if you want to squeeze the text closer together, or spread it out with lots of space in between words (for visual effect, or to change the density of the type to make the text better fit the page), there are tools for adjusting those spaces. Often, the spaces are described in terms of a percentage of the type's size.

Hyphenation

A first cousin to spacing between words is hyphenation. When a word has to be squeezed or stretched in order to fit on the line, it can look artificial. Typographers overcame this visual difficulty by inserting hyphens between the letters of words, so that the first part could be at the end of one line and the rest at the beginning of the next line. Over

the centuries, a set of grammatical rules have evolved regarding proper hyphenation. For instance, hyphens are usually inserted between syllables. Both word processing and desktop publishing software are capable of automatically or manually hyphenating words. If done according to grammatical rules, approximately 95% of the words will hyphenate or break at the proper space. However, about 5% of the words don't follow the rules, either because they are monosyllabic or are exceptions to the rules.

To produce proper hyphenation, many programs have what are called hyphenation dictionaries, which contain the breaks for specific words. Also, the user is allowed to add words to the dictionary so that the word will break at the correct point.

Of course, it's also possible, and often useful, to turn hyphenation off entirely, so that no word will be broken up in mid-letter. If you are preparing text with your word processor for exporting to a desktop publishing program, don't hyphenate. Let the DTP program do the hyphenating for you.

Text justification or alignment

Choosing your text justification (which some programs call alignment) is a simple matter. Do you want the text centered on the page or in the column, or do you want it even on the left margin, the right margin, or both?

When desktop publishing first became available, it was exciting to be able to use the clean look of text that was justified on both the left and the right margin. That made a square box of text that formerly was available only from a printing press. Now that DTP is common, many designers choose what is called a ragged right margin (in which only the left margin is lined up or justified). That allows for more even spacing between words as well as a sense of informality or friendliness. But when you are laying out numerous columns of text for a small newsletter, a ragged right margin can be distracting.

Use varied justifications to set titles, captions, or other special text apart from the body. For example, centered headlines are very effective and the norm, but some designers like to use a left justification for sub-headers.

Tabs, indents, etc.

You will want to set up the tabs and indents so that they are the same number of spaces throughout your document. For instance, if a paragraph indent is five spaces in the first column of the first page, you would want it to be five spaces in the last column of the second

page and anywhere else in that document. Otherwise, you would have an uneven, unprofessional look to everything.

Tabs, indents, and other spacing commands may be set up either in the preferences file, in style sheets, or in some other command that is usually accessible in the pull-down menus at the top of the screen. You may define them differently for every document, if you wish.

 When working with text that you want to line up, such as columns of numbers, use the Tab key, not the space bar, to delineate spacing in DTP.

Other text formatting facilities that might be available in DTP programs are also accessible through the pull-down menus. Try different settings to see how they affect the look of your document.

⇨ Placing pictures

Placing pictures in your desktop published document is very similar to placing text. Usually, the first step is to draw a frame to hold the picture. This might be a rectangle or square (with angled or curved corners), an ellipse or circle, or, in some programs, an irregularly shaped polygon. Once drawn, it may be reshaped, resized, or moved, even after the picture has been placed inside it. In some programs, the frame creates its own printing border; in others, you have the option to make borders or not.

The "Import," "Place," or "Get Picture" command may be found in the "File" pull-down menu at the top of the screen. In the early days of desktop publishing, everyone used EPS (Encapsulated PostScript) as the graphics file format of preference. (See the previous chapter.) Now, although most DTP programs support various formats, we still tend to use EPS and TIFF as our preferred formats. They give us a higher degree of quality, data integrity and compatibility.

Depending upon the particular program and the document, once you import a picture into a DTP document, you might not be able to edit it. If you want to make changes to any of those images, you must go back into a paint or illustration program, bring the file up, edit it, save it, and re-import it into the DTP page. However, in some DTP programs, the image is brought in through linking (see the previous chapter). What that means is that the frame through which the image is viewed in your DTP document is really a window to the imaging program in which the picture really exists. In that case, any changes you make to the image file, when you are in another program, will be viewable in the DTP program (without having to re-import the picture). Think of it as a window through which you see a candy store display. You can't eat the candy while looking at the window from outside (i.e.,

while in the DTP program). But if display is rearranged inside the store (that is, while in the imaging program) you will see the difference from your outside viewpoint.

Though you can't edit the picture in the desktop publishing program, there are various things you can do, which relate to two aspects of the picture:

➤ The frame through which it is viewed

➤ What is viewed through the frame

As we mentioned earlier, the frame may be resized, reshaped, or moved anywhere within your document.

But suppose your image is larger than the frame. Then, what you see in it will be only a portion of that image. You can move the image inside the frame, so that you see another portion. For instance, if your picture is a portrait of a woman, her hair and neck might be cut off from view by the size of the frame. You would want to make sure that her eyes and other important, definitive parts of the portrait are included. This you do by moving the picture within the frame.

Or you might have the option of shrinking the picture itself within the frame, so that the whole portrait can be seen. Conversely, you might want to enlarge a picture to make it fill a frame.

HINT You might want to temporarily hide pictures that have been placed on a page. (If this option is available in your DTP program, it is usually accessed in the pull-down menus at the top of the screen.) That will speed up page redraws and reduce the time it takes to print out proofs. However, be sure to reinstate the pictures before you make your final good print or before you send the file to the print shop or a client.

Wrapping text around illustrations

When you place a picture into a document, the usual default setting in the DTP program will automatically cause the text to wrap around the picture. You can usually set the amount of space you want between the text and the top, bottom, and sides of the picture.

There are various ways the text can wrap:

➤ Stopping just before the picture and starting again just after the picture.

➤ Stopping just before the picture and starting again where the designer places it.

➤ Wrapping around a rectangle, so that text flows around the sides, as well as before and after the picture.

➤ Wrapping around an irregularly shaped polygon, rather than a rectangle.

Sometimes, you won't want text to wrap around the picture. Instead, it can be effective to have the text superimposed over a picture—especially if the picture is a light-colored silhouette. Most DTP programs have an option that allows that, too.

Depending upon the program you are using, you either have to turn on the text wrap option, define it according to your design, or the default will be to wrap. However your program works it, text wrap can be so automatic that it is easy to forget about the options. Eventually, you just take for granted that whenever you insert any element—a picture or a block of text—onto a page, whatever text was there will move over and make room for it. Any excess text will flow onto the next column or the next page. When you delete or resize page elements, text will flow automatically to fill in the holes or to make space. (See Fig. 26-4 for a word wrap example.)

Figure 26-4

Ragged right text wrapped around a picture, with a small margin to offset the image.

Of course, you can take control over the process. It's possible to cut sections of text out to be moved elsewhere, or to resize elements to make them fit together in different ways. The amount of interactive control you exercise over your document is up to you.

⇨ Finishing touches

In addition to placing text and pictures onto your document, you may draw borders, lines, and boxes, as well as introduce color highlights and design elements. Text may be inverted, so that it is white on a black or color background, or rotated so that it climbs vertically along the edge of a document. In fact, desktop publishing software allows you to implement many variations in your documents.

The end result is a document that could just as easily have been created by a professional print shop—if your design is good and the quality of your laser or color printer is high enough. For an even better production run, you could take your DTP file to a print shop for higher quality output on an imagesetter.

The purpose of this chapter was to provide a quick overview of what desktop publishing is. To learn more about what you can do with it, read your program's documentation and other books on the subject. Of course, the best way to learn any of these programs is with hands-on experience: use them, experiment with them, push at their limitations, get into trouble and find ways to extract yourself. Try desktop publishing some personal projects, like designing a new letterhead or business card. Instead of writing a proposal to a potential client as a letter, consider creating a visually stylish newsletter about who you are and what you could do for them. Explore what desktop publishing could do for your ordinary paperwork, such as delivery memos and faxes. Then, after all the experiments are done, develop a uniform look to all your paper—stationary, faxes, invoices, newsletters, etc.—so that it will become recognizable as representing you.

27

Important non-imaging software

WHEN you buy a cookbook to learn how to create a gourmet dinner for four, it will tell you what ingredients you need to buy, how to prepare them, and how to serve them. All cookbooks take for granted that you have a kitchen, with a stove that is connected to either gas or electricity, a sink with running water, a refrigerator to keep the food fresh, and all the utensils, pots and pans, serving dishes, etc. that are necessary for doing the actual cooking and presentation.

In previous chapters, we've covered the general principles and tools that govern how paint, illustration, and desktop publishing programs work. But there's a lot of additional software that you'll need in order to use the imaging programs, keep things running efficiently, create a safety net, make quick fixes in case of trouble, hopefully recover from the brink of catastrophe, or help set up the means to transfer your data to a client's or service bureau's computer system. Without some of them you're just not cooking. Others are not absolutely necessary, but will make things easier, safer, more reliable, or more efficient.

Every user should have six distinct types of software on their Mac or PC, regardless of whatever other application is running:

➢ The operating system/operating environment

➢ Utilities

➢ Device drivers

➢ Font generators

➢ Imaging-related applications

➢ Other applications

Let's look at what these types of software are and what they do.

⇨ The operating system

Quite simply, the operating system is god to your computer. It controls, interfaces, or interacts with absolutely everything, from accessing the disk drives to moving your mouse, changing the display on your monitor to keeping track of all your files. Most of every operating system functions automatically in the background, so you're rarely aware of what it is doing or how it works its magic.

Every computer has an operating system. If it didn't, it wouldn't be able to do anything. You couldn't run any programs or do anything other than look at the machine.

Part of the operating system is built into a ROM (*Read Only Memory*) chip plugged into your computer's motherboard. (It's rarely soldered,

because this particular ROM might be replaced from time to time). It gives the system essential instructions, such as what fundamental devices are attached to the computer (disk drives, type keyboard and screen, etc.). Once it polls the hardware and runs basic internal diagnostics, its next task is to tell the computer to access the hard drive or a floppy drive and load in the software portion of the operating system. This it does *every time* you turn on or reset (reboot) your computer.

NOTE While the operating system of any computer is referred to as DOS— Disk Operating System—DOS is very frequently used to identify the operating system that a company called Microsoft produces for the PC. When we use the expression DOS we will be referring to the Microsoft product, not the category of software.

The overwhelming number of computers sold come with an operating system already installed. Long gone are the days when most users were expected to prep and format their hard drives and then install the disk operating system themselves. Also, most new PCs sold have Windows 3.1 installed. (By the time this book is published, some high-powered systems might have the new Windows NT installed instead of the older 3.1 version.) Most Macs are also sold with the operating system already installed. So all a buyer has to do to get started is hook up the cables and cords and turn it on. Just about the only users who install DOS on their own are those who select bargain-basement no-name clones or buy parts on the component level—motherboard, disk drives, memory, expansion boards, etc.—and assemble their own computers.

Although you might never have to buy and install an operating system on a brand-new computer system, it's likely that at some time in the future you'll want or need to update your current version. So you should know at least a few things about different operating systems.

Getting the newest versions

Software is never quite perfect and never quite complete, which is why companies constantly improve, change, and update their programs. Another reason is that updates are cash cows, because users always want the newest, best, most advanced versions, whether or not they represent real improvements. People update on the premise that they will somehow be better, solve problems, add new functions, eliminate annoying mistakes, etc.

Fortunately, most updates are improvements over earlier versions.

In addition to major updates, software manufacturers frequently release interim versions that usually correct specific bugs or fill conspicuous gaps. Often they are unannounced, and you'll never know they're available unless you ask. Here are a few things that you

can do in order to ensure that you receive notice and information about new releases:

- Send in your registration cards as soon as you have installed the software. Some companies will not give any technical support until you do.

- Whenever you must speak to anyone in technical support, ask if there has been an interim release since the date of your version. Ask him or her to send it to you. (There may be a nominal charge.)

- Learn to use your modem to call the company's bulletin board (most computer companies maintain one for their customers). Usually, there's information about new releases, patches, bug fixes, etc. Often, there are updated, corrected files that you can download to your computer. (See Chapter 33 about bulletin boards.)

- If you subscribe to CompuServe, America On-Line, or other commercial database services, check to see if the software company maintains a Forum in the SIG (Special Interest Group) section. Often there's information on new versions that may not be available to the public anywhere else.

- Subscribe to several computer magazines—at least one general to your platform (PC or Mac), and the other related to graphics/digital imaging. They often carry news and "first look" reviews of updates and improvements.

Reading the version number

How fresh is your software? Are you certain that you have the latest version? Whether it's an operating system, utility, or applications program, the system used to identify the version will always be the same. For instance, suppose you have a program that is titled MegaColor 3.14a. (We made up that name, so don't go looking for it—unless the great god coincidence decides to play a trick on us and have a program come out under that moniker.) Here's what those numbers and letters mean:

- The number to the left of the decimal point always refers to major releases, sometimes so different from the previous version as to represent a virtually new piece of software. Therefore, the 3 of 3.14a tells us that it is the third release of the program.

- The number immediately to the right of the decimal point is a major revision to the current version.

- The next number is a minor revision to the current version.

- Small letters generally refer to unpublicized interim upgrades.

- If you're not certain which set of disks that you have is the latest version, put a diskette in the computer and look at the dates of the files. Use the set with the most recent dates.

⇨ System 7

If you're buying a Mac, that probably means that you will power up and find that System 7 is controlling your computer. At the time of this writing, System 7 is Apple's latest and most powerful operating system yet, and by far its best. It has undergone several revisions since it was first released; we're currently using version 7.1. If your Apple's operating system is an earlier version than 7.1, you should seriously consider upgrading immediately. System 7 software can be purchased for $75–$90 at most outlets that sell Mac products. All it takes to install the new system is to power up, put the first diskette in the drive and follow the very simple instructions.

What distinguishes Macintosh operating systems, including System 7, is its simplicity and ease of use. The Mac was originally designed from the ground up as a GUI (graphical user interface) machine, which is reflected in what its operating system looks like and how it works. This means that most commands and functions that a user gives the computer are done visually rather than verbally. Instead of having to type in commands, the user sees on the screen a series of icons, or miniature pictures, which are activated by moving the mouse so the screen cursor is on top of the icon and then pushing the mouse button. The GUI approach makes using the Mac quite easy. The tradeoff, however, is that it is inherently slower and less powerful than a verbal-based operating system.

The second, even more important advantage of the Macintosh operating system is that every piece of software installed or hardware added to the system conforms to rigid standards Apple has laid down. This eliminates the problem of internal operating system or hardware conflicts (where two or more programs vie for the same memory allocation or device assignment number and cause a system to act erratically, freeze up, or even crash). The user doesn't have to set dipswitches or jumpers on an expansion board, or select various technical parameters in the operating system in order to ensure that the computer recognizes the program or peripheral as unique. (You do have those problems and demands on PCs.)

Last (but certainly not least) is that, because everything on the Mac is standardized, all software use the same set of commands. Unlike DOS, in which the Exit command might be F10 on one program and F4 on another, a Mac user needs to learn but one set of commands and they will be common to all programs. It's a lot easier than having to learn everything all over again every time you buy a new program.

Because no one except a computer reviewer or a hardcore techie is going to pit the Mac and the PC against each other with a stopwatch, the speed differences between the two operating systems are negligible and largely irrelevant. In fact, System 7 is faster for the novice because

he doesn't have to learn and memorize lots of commands, or need to waste time retyping if a mistake is made in inputting the command.

Although System 7 offers significant changes, additions and improvements over System 6 and even earlier Apple operating systems, the one thing that becomes almost mandatory for serious digital imaging is its ability to use virtual memory.

Virtual memory: An operating system's hat trick

Image files tend to be very large. The bigger the final image, the higher the resolution, the more data about color and greyscale, and the larger the file size will swell.

Ideally, one should have at least twice the RAM as the size file commonly worked on. Therefore, if the largest image file size you commonly handle is 42Mb, then you should have at least 84Mb in your computer system. Unfortunately, the Quadra 700 can accommodate a total of 68Mb, though the Quadra 800 and 950 can take up to 256Mb.

So what does one do when the file size is larger than the amount of RAM in your computer or is large enough that your system doesn't have at least double the RAM? For instance, let's suppose that you are creating an image for output to a large format printing device, and it involves working with a 42Mb file. And let's assume that you have a Quadra 700 like ours, with a total of 20Mb of RAM. What virtual memory in an operating system does is appropriate unused hard drive space and use it to extend RAM by treating the two types of memory as if they were the same exact thing. So, instead of our Quadra being limited to 20Mb of RAM, we're able to use the empty spaces on our 400Mb hard drive as virtual memory.

However, the penalty for the use of all this extra memory is speed. Hard drive speeds are measured in milliseconds, or thousandths of a second. But electronic RAM is measured in nanoseconds, or billionths of a second. Ergo, hard drive access is many thousands of times slower than electronic memory access. The alternative is to either work with a smaller file size (which would either reduce the image resolution or its final output dimensions), or add more memory to the Mac (four 16Mb SIMM boards would cost an extra $2000–$2600, depending upon the market price and where they are purchased).

Incidentally, Windows for the PC also uses virtual memory to extend/supplement a computer's RAM. It's called the Swap File, and a user can either make it a temporary file (Windows will make, and then erase the file from unused hard drive space whenever necessary), or a permanent file (a specific, predetermined file) is created and always used as a holding area for virtual data. It takes up more space, but it also works slightly faster.

 # DOS

The most common, widely used operating system in existence is DOS. It's the program that made Microsoft's wunderkind Bill Gates the richest man in America. And it's the operating system that those of us who have been using it for over a decade, in its various incarnations and versions, have learned to both love and hate.

DOS is like the eccentric aunt who hands out presents and pocket change every time she visits, but also plants sloppy wet kisses on your cheeks and has bad breath. Unlike the Mac's GUI-based System 7, DOS is a verbally-based operating system. This makes it fast, direct, and powerful. On the other hand, it has more than its share of maddening limitations, most of which can be traced back to decisions made more than a decade ago, even before the first IBM-PC was sold.

In 1980, Microsoft was a tiny company that developed utilities for the most widely used operating system of the day, CP/M (which has since gone to operating system heaven—or hell, depending on how you liked or loathed it). When IBM launched a Manhattan-Project-like crash program to bring a microcomputer (the IBM-PC) to the market as soon as possible, the computer giant didn't have time to write a new operating system for it. After negotiations with the company that produced CP/M bogged down, they turned in desperation to Microsoft. Bill Gates then bought an off-the-shelf operating system from a still smaller company and worked feverishly to modify it for the new computer. The result was an operating system named PC-DOS. Because IBM was so desperate, Gates managed to negotiate the deal of the century: he retained the right to sell a generic version of the same operating system, named MS-DOS. When the clones and compatibles began flooding the market, they all needed to retain 100% compatibility with the IBM computer, which they were able to do (in no small part) because of MS-DOS.

For better or worse, certain technical design decisions were made in creating the original PC-DOS that persist right through the latest version, DOS 6. Because the hardware on the original IBM-PC allowed for a total of slightly over 1Mb of total system RAM—of which about a third would be reserved for internal functions like the screen, serial and parallel ports, etc.—it was decided that the maximum amount of RAM available to users could safely be put at 640K. Mind you, this was back when the original IBM-PC was released as a 16K machine and could be upgraded only to 64K of RAM. Almost no one ever envisioned that the current generation of PCs would come equipped with a minimum of 4 or 8 megabytes, and that for digital imaging, 64Mb or even 128Mb would be commonplace. Another decision was to place an absolute limit on how large a hard drive the operating system could accommodate. That was when 5Mb hard drives cost 2–4 times more than today's 500Mb drives, and when the original

IBM-PC couldn't even be equipped to run a hard drive (it came with a single 180K floppy drive). So, allowing for the greatest possible expansion, Microsoft generously allotted 32Mb as the largest storage possible for any future hard drive use.

Of course, many of those original limitations and restrictions were eliminated in later versions of DOS. Only, in order to maintain backwards compatibility with all the preexisting PC hardware and software, the 640K ceiling remained. It's still with us in DOS 6.0. That has caused all kinds of problems for software authors and created a cottage industry for companies that produce utilities designed to compensate for DOS' limitations.

Despite its annoying limitations and occasional problems, DOS is still the operating system of preference for digital imagers using the PC platform.

Windows

Windows is a graphical user interface (GUI) that was originally designed to work under DOS on the PC. (Windows NT has now replaced DOS, but Windows 3.1 still works in conjunction with DOS.) The idea behind Windows was to make working with the PC as easy, direct, and graphically oriented as operating the Mac. Well, it doesn't quite work that way because it remains difficult to add peripherals and devices to the PC (while it is almost child's play on the Mac). However, the programs that run under Windows are standardized and use many command functions and have a structure similar to Mac programs.

The great majority of PC imaging software run under Windows, which makes it a necessary operating environment, if you are using a PC. The few imaging programs that continue to run under DOS tend to be faster than comparable applications that use Windows, but don't go out searching for them. Because they can't use Windows drivers—such as for a specific graphics board—they must provide drivers of their own. Often, the number of drivers provided are very limited and might not work with your particular system. On the other hand, some of the most powerful programs (such as HiresQFX) run under DOS. All of the must-have mainstream paint, illustration, or desktop publishing programs work under Windows. That means they can take advantage of Windows technological advances, which include multitasking, linking images between different programs, sharing device drivers like printers, etc.

Multitasking allows the user to run a number of programs at one time. For instance, at this moment, Sally has loaded in *Photoshop*, *CorelDraw*, *WordPerfect*, *Act!* (her contact database), and *OnTime* (her calendar program). She could be working on a chapter of this book, when she suddenly decides to check out a command in *Photoshop*. A quick "hot key" input and she's in *Photoshop*, working

on a picture in it. Then, say, she receives a phone call. Leaving the picture where it is, she can switch into *OnTime* to schedule an appointment with the caller or into *Act!*, to make certain she has his correct phone number, or back into *WordPerfect* in order to take some interview notes. The limits to multitasking are those of your computer memory. Theoretically, you can run as many programs as you want at one time, if your computer were outfitted with enough memory. The most we have had loaded has been 10, but they ran like the proverbial molasses. (The more programs you have loaded, the slower your computer will run.) We usually switch among no more than five programs, as our standard operating procedure.

There's no question that Windows is slow, and earlier versions tended to be unstable no matter what you did or how you tweaked it. (It would freeze up, crash, give you error messages, sometimes eat your files, etc.) It's too soon to tell how fast or how stable Windows NT will be in daily use with imaging programs.

The great advantage of Windows is that once you learn it, you have already mastered 50% of every program you will run under it. Also, once you configure a printer, scanner, etc., it should be accessible from various Windows programs without having to set up and configure every time (although we have had quite a bit of difficulty with attaching devices to Windows).

Windows NT (which is currently the newest version of the program) has finally broken the 640k barrier described earlier. It is a true 32-bit operating system, which means it can take better advantage of the speed and other capabilities of 32-bit CPUs like the 486 and the Pentium. (See Chapter 8.) Unfortunately, there's virtually no 32-bit software, including imaging programs, on the market to take full advantage of it. And all our current Windows programs—which were written for 3.1 and not NT—run very slowly on NT and therefore we use only 3.1 for the present. But that's bound to change quickly as NT grows in acceptance.

Windows NT is a big program, hogging both disk space and memory. You should have at least 16Mb of RAM, 100Mb free on your hard disk, and no slower than a 33MHz 386DX computer to run it. If your PC doesn't have that sort of hardware, and if you don't have NT specific software, stick to Windows 3.1.

OS/2

DOS and Windows aren't the only option for a PC operating system. Until recently, IBM and Microsoft jointly developed and marketed their operating systems. But now they have gone their separate ways— Microsoft with Windows and IBM with their OS/2—becoming bitter rivals for the multi-billion dollar PC operating system market.

At the time of this writing, we would not recommend making the switch to OS/2 for your PC. But it is worthwhile keeping an eye on it as it develops and, hopefully, improves.

The problem with OS/2 is that there aren't many applications being written for it. Remember, an operating system is the software that allows other programs to run on your computer. That means that the programs have to be written according to a code that is compatible with the operating system. The other limitation is in device drivers, those utilities that tell the computer how to react to the hardware that's attached or plugged into your computer system. For instance, there's no device driver for our Matrox Impression 1024 graphics board to allow it to run in the 24-bit mode (though Matrox does provide 24-bit OS/2 drivers for some of its newest graphics boards). Be sure to check whether there is a specific OS/2 driver for all your peripherals before even considering installing that operating system.

One way that IBM is trying to get around this is by writing OS/2 so that it can run any program written to the Windows' code and for DOS-based software. However, Windows-specific programs currently run slower under OS/2 than under Windows for various technological reasons. Unfortunately, none of your Windows-specific drivers will work with OS/2 right now.

It's the uncertainty and the lack of a guarantee that any particular Windows program will run flawlessly under OS/2 that prevents most serious digital imagers from taking the risk. Unless and until OS/2 specific imaging programs are released, or IBM can guarantee complete compatibility with Windows programs and drivers, we suggest not using OS/2.

Personally, we will consider switching to OS/2 when these problems are solved, because it's a built-from-the-ground-up operating system rather than a fixed-up, patched-up one that dates from the early 1980s, which was originally designed for 8-bit computers. OS/2 offers many advanced features, such as a much better GUI, no restrictions on the amount of RAM, true multitasking (where programs can work in the background rather than just be parked there waiting to come up), etc. But until the problems with OS/2 are solved, don't waste your time trying to make it work.

Unix, NextStep, & other operating systems

There are alternative PC operating systems with various strengths and weaknesses that are fighting for their share of the microcomputer market. Some have come out of the minicomputer environment. Others were developed specifically for super micros (workstations).

Generally, these systems are difficult to use because they come from a world in which *engineers and techies rule the roost*—but they *are* very fast and powerful. The software that will run under these operating systems tend to cost 2 to 10 times more than comparable paint and illustration programs that run under Windows or System 7. They require even more memory than Windows NT and won't run well on anything but state-of-the-art machines.

(By the way, the much-raved-about but high-priced Silicon Graphics workstations all run under Unix.)

The makers of these various operating systems are all trying to adapt to the PC market as quickly as possible. So it is very likely that downsized, modified, but powerful new versions will begin appearing even before this book is published, in an attempt to give Windows and System 7 a run for their money.

SUGGESTION For the time being, stick with Windows 3.1 or System 7. They each have a large base of software and are rooted in tried and true technologies.

Is there a single operating system around the corner?

Ideally, there should be but one universal operating system in which all the commands, functions, keystroke combinations, and nomenclature are identical. It shouldn't matter if you had a Macintosh or a PC, just as anyone who can drive a Chevy can get into a Taurus or a BMW and drive away, because the gas pedal, brake, and gearshift are the same in virtually any make or model. In a few years, this might actually come about because Apple, IBM, NeXT, Novell. and other major computer companies are feverishly working on a number of cross-platform operating system prototypes. For instance, Taligent is a system that remains, at this time, a drawing board fantasy devised by Apple and IBM, to someday replace DOS, Windows, and System 7.

These next generation operating systems are being designed to look, feel, and work exactly the same, regardless of whether you have a Mac, PC, workstation, or some other microcomputer. Everything would be simplified, and you will be required to learn only one set of rules in order to master any computer type or brand.

The most important advantage of a universal operating system is that there won't be Mac or PC software anymore. Every program designed to work under this operating system will work on every make and model of computer. That, in turn, will probably drive hardware prices down even further. And since software developers won't have to spend R & D money developing separate versions for different computer platforms, software prices will probably drop dramatically as well.

Two problems still have to be overcome before we have a universal operating system. The first is, whose standard will the computer industry adopt? With billions of dollars riding on the outcome, there will probably be a donnybrook among competing operating systems before one clear winner emerges. The other drawback is that a universal operating system is years away. We're not holding our breath.

Utilities

Like most homeowners and apartment dwellers, we leave major maintenance and repairs to experts. But if a faucet leaks or a floorboard comes loose or a fuse needs replacing, we do it ourselves. What's more, it's necessary to routinely maintain our home—keep the lawn mowed, the weeds pulled, polish the woodwork, vacuum the carpets, etc. For both maintenance and minor repairs, we need basic tools, which is why you'll catch Daniel at the hardware store at least one Saturday morning every month, buying what's interesting, necessary, or on sale.

Similarly, every computer system needs tweaking, fine-tuning, housekeeping, and even fixing on a more or less regular basis. By computer, we generally don't mean the hardware, since about the only thing that a nontechnical person can do to keep things running smoothly is to occasionally vacuum or blow off the dust that accumulates on circuit boards and peripherals. We're talking about utility software, which are those programs that make things easier, faster, safer, or more effective.

Utilities are those programs that do the lion's share of housekeeping and maintenance for your computer. Some of the chores utilities can take care of include:

> Hard disk maintenance

> Hard disk backup

> Shells

> Memory managers

> File management

Hard disk maintenance

The hard disk is the bank vault of your computer. Everything that is valuable to you—all your data, your programs, and your images—are kept there. You want to be sure that it is at its peak efficiency. And when something goes wrong (no, it is not a question of *if*, but a

definite *when*), you need the means to repair or recover your data and your programs.

Hard disk maintenance includes:

➤ Formatting

➤ Surface scanning and fixing

➤ Optimizing

➤ Recovering deleted or corrupted files

➤ Virus scanning

➤ Mirror

✳ **Formatting** When a hard disk (or any storage media for that matter) is first manufactured, it's as blank and innocent as a newborn babe. Before it can be used, it must be taught the basic conventions of where and how to store and retrieve data. This is formatting.

Probably, any hard drive you get will already be formatted. In fact, you should make it a condition of the sale. If they won't prep and format it, you won't buy it. Still, there will be some time in your near future in which you will have to do some formatting—if not of your hard drive, then of your SyQuest cartridges, magneto-optical discs or floppy disks.

Your disk operating system comes with a formatting utility, and it will handle many—if not most—of your needs. However, the operating system's format command might be limited in various ways that third-party formatting utilities are not. For instance, a third-party formatter usually includes greater error checking and can format various media that might not be included with your operating system format.

There are two kinds of formatting: high-level and low-level. The high-level format prepares your hard disk or other storage media to receive and hold data. Low-level formatting revitalizes your hard drive, and it is something that your technician will be more likely to do, though experienced computer users do get into it eventually.

Over months of use, the perfect alignments of your hard drive can begin to slip, and errors can creep in. Also, you will experience micro-crashes, truncated files, and other unavoidable disk errors (such as are created by turning off your computer without properly exiting a program). In addition, parts of the media itself can actually wear out or become unuseable. So, if you store data on that particular worn spot, the data itself can become corrupted. A low-level format will find these areas of weakness, try to recover and move the data to a safer area, and then lock the area out so new data won't ever be written to it. You may lose $\frac{1}{100}$ of 1% of the storage capacity of your hard drive when a few bad sectors are locked out. Rarely do you ever lose more than a half percent of the total storage area over the life of a hard drive.

Low-level formats take time and are best done overnight. They do not destroy any of your data; however, we strongly suggest that you do a complete backup before activating the low-level format. Computers are not perfect, and things can go wrong. It's better to be safe with a full set of backups than sorry.

Be sure you understand the basic difference between a low-level format and a high-level format. A low-level format is a revitalizing tool that should leave all your data intact. A high-level format wipes out all data. (There are utilities for recovering data from a drive that was accidentally formatted, so long as you haven't written anything to the hard disk since the high-level format.)

HINT On the PC, never, ever, ever run the command FORMAT C: unless you mean it. That will destroy all the data on your primary hard drive. And if you really intend to reformat drive C (in order to install everything from scratch), type FORMAT C: /S, which will ensure that you'll be able to automatically boot off your hard drive.

✳ **Surface scans & repairs** A surface scan is a commonly used utility that detects and corrects relatively minor and superficial errors on the hard drive. It will test every single sector on the drive. If any sector fails, the data are transferred, the area on the drive noted and permanently locked out. It's different from a low-level format for two reasons: it's a much more superficial checker, and it works much faster than a low-level format. A surface scan should always be done just before you optimize your drive.

✳ **Optimizing** Optimizing is to hard drives as basic housekeeping is to your closets.

When your computer saves data to the hard disk, it places it wherever there is space. Thus, a file might be spread out among many sectors all over the disk, broken up into bits and pieces that the software must reassemble every time it wants to use it. If you are working with large image files, this problem is magnified considerably and slows down hard disk operations (such as saves) even more.

An optimizing utility organizes the data on your hard disk, so that related data from each file are physically placed in adjacent sectors. That way, the software doesn't have to search the entire drive to find all the components of a single file. The advantage is obvious: greater access speed. If you are imaging frequently and work with large image files, it would be sensible to optimize about once a week (doing a surface scan first).

HINT Be sure to back up your hard disk before you perform a low-level (or high-level) format, surface scan or optimization.

* **Mirror** Because saved data are placed willy nilly anywhere they will fit on the hard drive, the computer must maintain a master list of where everything is located. This is the File Allocation Table (FAT). Without the FAT, a system just can't function, the hard drive can't be accessed, and everything freezes up. In other words, the FAT is crucial to being able to run your computer. Because it is the most frequently accessed area on your hard drive, it is also the area most prone to becoming corrupted.

 On startup or a reboot, a mirror utility takes a snapshot of your FAT and stores it elsewhere on the hard drive. That way, if the original becomes corrupted, you can restore the FAT and get back to work.

 Mirror utilities are not usually sold separately. Instead, they tend to be a component of a larger utility program.

* **Recovering deleted or corrupted files** This is one of those chores that no one wants to do, but everyone is thrilled to realize it is possible—when the horror of lost data hits home. You can lose data in any number of accidents, or catastrophes. Sometimes, you simply hit the wrong key and erase a file. Other times, there's a glitch in the electricity, silicon chips, or electronic circuitry, any of which will give your computer the wrong command or play havoc with the integrity of your files. Whatever the reason, there are utilities that allow you to at least try to recover the data.

 Quite frankly, its a 50/50 proposition whether or not you'll be able to get your files back—whole and usable. You'll increase your chances if you don't do anything—such as save a file—that could possibly write new data onto your hard drive, thereby overwriting the old, lost information. That's because the way these utilities work is to analyze the sectors where the lost data were and attempt to coax the information out of hiding. But if you write anything into those sectors, the old data will become absolutely irretrievable. Given the uncertainty of these utilities, your best data safety net is to back up often. (Please see the section on backup utilities shown later.)

* **Virus scanning** It has become a sad indictment of modern society that we have to protect ourselves from a new breed of impersonal, undirected crime. Whether we are walking down a city boulevard or working at our computer, we must do what we can to avoid becoming the victims of someone else's anger or boredom.

 A computer virus is code that has been engineered for the express purpose of infiltrating as many computer systems as possible (including yours). It attaches itself to certain sectors on your hard drive and, like a time bomb, becomes active when specific conditions are met. Quite frequently, these conditions include when the system clock reaches a predetermined date, or whenever you invoke a little-used command.

Viruses can be innocuous. For instance, the famous IBM *Merry Christmas* virus just flashed a holiday greeting on thousands of computers and then wiped itself out.

But most viruses exist to destroy. The famous Michelangelo virus was projected to be the Armageddon of computers that would trash millions of hard drives on a certain date. Fear was rampant throughout corporate America, and a record number of virus scanning utilities were sold. (We have often wondered if some of the more publicized computer viruses weren't manufactured by individuals or companies who wanted to boost their sales of such utilities.) Fortunately, it fizzled and very few computers were adversely affected.

Almost all computer viruses follow known methods of infiltration, attaching and attacking. So virus scanning utilities are able to check your hard disk for certain telltale signs. If they are found, the utility will look more closely, seek out the virus, and destroy it. Scanning your computers for viruses on a regular basis is like making sure your child receives inoculations for known diseases. The chances are you'll never need it, but if you do, it could be a lifesaver.

If a virus is already doing its nefarious work on your computer, it might already be too late. But there are some anti-virus utilities that can stop the virus in its tracks and, possibly, repair some of the damage.

HINT

We don't download software from public bulletin boards or use any freeware because they are infamous for carrying viruses. Sally runs an anti-virus every time she optimizes her drives, and Daniel set up his AUTOEXEC.BAT file to automatically run an anti-virus scan every time the computer is turned on or rebooted. If you want to use bulletin board software or freeware, scan for viruses first before attempting to run them on your system.

By the way, we were out of the country on an assignment for more than a month when word began to spread about the Michelangelo virus. The first we heard about it was from an American tourist on the African savannah. Of course, we were worried; we wouldn't get home until the day after it was supposed to hit. What did we do? When we powered up our computers, we booted them off of a floppy (that had no date), ran a floppy-based virus scan and, only after we were assured that our systems were clean, did we access our hard drives.

HINT

If you are ever struck by a virus, don't automatically reach for your backups. They might be infected as well. Call a consultant, expert, or the technical support number of your utilities program to see how you can check your backup files before they wipe out your hard drive a second time.

✳ **Recommended hard disk maintenance utilities** There are several utilities packages that do a decent to good job on hard disk maintenance, but two companies lead the pack in versatility, power, and reliability: Symantec (the manufacturers of *The Norton Utilities*) and Central Point Software (which makes *MacTools* and *PCTools*). Both provide support for Macs and PCs, and, frankly, we have *both* installed on all our computers. If you value your data, you'll follow our example.

⇨ Hard disk backup

There is only one way you can guarantee the safety of all the data and programs on your hard disk. That is to always maintain a duplicate set of current data. Backup utilities are very simple; they copy everything that is on your hard disk onto some other redundant storage media. (Please see Chapter 12 for a discussion on storage media.) Then, should anything go wrong—whether it's a single corrupted or accidentally deleted file or a completely trashed hard disk—you'd be able to restore all your data from your backup set.

However, backups are only as good as your most recent save. If you lose data, and the last time you backed up was several days ago or more, then when you restore you will have lost several days (or more) of work. We do full backups every other day. In addition, we copy critical files (such as chapters of this book) to floppies, in between the full backups. That way, when we have difficulties, the most time we will lose is perhaps a few hours—though it is often no more than a few minutes. Images are more difficult to protect because they are so large. But if Sally has just finished an intricate imaging maneuver, she will copy the file onto a magneto-optical disc for safekeeping until the next full backup. (Finished images and related files are saved separately from her backup sets, in two duplicate libraries of archival tapes.)

It is possible to schedule your backups to run automatically in the background at a specific time every day. However, we are concerned that it could mean a sudden drain on RAM just as we are in the middle of some other memory-intensive command, which could very possibly result in a computer freeze. That's why we just learn to depend upon our own discipline to remember to back up. (Our tendency to forget to back up does seem to be in direct proportion to the computer's tendency to mess up vital data.)

✳ **Recommended hard disk backup utilities** For full backups, we use *PCTools* on our PCs and *Retrospect* on the Mac. We have found them not only easy to use when backing up, but, most importantly, very simple and reliable to use when we need to restore data. *The Norton Utilities* also has a very good backup command; in fact, Symantec sells a package that is basically just the backup section of *The Norton Utilities*. Other programs we have tested and found to be very good include *Sytos* and *FastBack*.

Shells

Unlike Apple's System 7 or Microsoft's Windows, DOS is a very unfriendly, cryptic operating system. To use it effectively, you have to type in very precise verbal commands that include colons, commas, and letters accurately spaced and placed. Some of the common commands you might need to use include copying data from one disk to another, moving between directories, organizing files into subdirectories, deleting unwanted files or programs, etc.

Rather than memorize all the possible commands that you might need to invoke in DOS, you can use a shell. A shell is a utility that wraps around DOS and functions symbiotically with it, with the purpose of making it easier to view and organize data as well as to activate numerous commands.

We use *Norton Commander*, which automatically displays all files in any subdirectory and provides us with methods of manipulating them with a click of our mouse or the use of "hot keys." For instance, F5 will copy a highlighted file to whatever subdirectory on whichever disk we indicate. *Norton Commander* is by far the best DOS shell we have encountered, and we put it on every DOS machine we must use, including laptops.

The same developers have *Norton Desktop* for Windows, which Daniel uses but Sally considers unnecessary. Windows is a simple enough program to use and understand. In fact, she feels that *Desktop* complicates matters for her. It also consumes almost 15Mb of hard drive space.

The Apple has no real need for shells, although they exist. We haven't seen anything that they could do that would make an easy system any easier to use, so we wouldn't waste our time seeking them out or buying them.

Memory managers

If your imaging system is Mac-based or if you are running Windows NT, don't bother reading this section on memory managers. It's a PC/DOS issue.

As we mentioned earlier, DOS has a ceiling of 640K of RAM to which it will allow direct access. Yet, modern PCs have much more memory than that—from 4Mb to 256Mb. An imaging system is almost useless without at least 16Mb of RAM, though Sally is chomping at the bit waiting to upgrade within the month from 32Mb to 64Mb or (dream on) 128Mb.

In order to be able to use the memory above 640K, DOS has to be told how to access it. This is the job of a memory manager utility. A particularly problematic area is between 640K and 1024K, which is where your video, device drivers, or TSR software (pop-up programs that can be kept in RAM) can be loaded in. You want to load as much as will fit in that 640–1024K area in order to give you more of your 640K to actually run your software. The 640–1024K area is often crowded and not very well behaved.

What happens to all that RAM above 1024K? Absurd as it might seem, it is used by software, by importing key chunks of the program into the 640K. The design is the craziest inheritance we have from the early days of microcomputers. But at least it all happens so fast as to seem to be instantaneous.

DOS 6.0 has its own memory management utility called MemMaker. It's easy to invoke, but it's not very good. There are other memory managers that make much better use of RAM, such as *QEMM* or *386Max*. (We use and recommend *QEMM*, though some swear by *386Max*.)

Memory managers might be difficult to install and tweak, so you might want to call in a technician to do it. It's an outdated problem that should have gone the way of the dodo years ago. Luckily, it only exists in DOS and in versions of Windows earlier than NT.

⇨ File management

Over the course of time, you will end up with literally hundreds of subdirectories or folders and thousands of files. You won't remember what all or even a small number of them are. And if you happen to write a particular letter or generate a specific image, it could easily be lost among the labyrinth of files. Should you need to locate that file, it could take you considerable time and effort to find it.

File management software will help organize and group your files according to whatever criteria you consider to be convenient or logical, such as by type or subject, alphabetically, by date created, etc. Often, the program will include a means to allow you to search for a particular file and quickly find it, regardless of where it's stored on the hard drive.

Another category of file management software is search utilities that will help you seek out a single word, address, or whatever throughout your storage media. There are two kinds of search utilities: one that indexes everything beforehand, and the other that just goes in and starts looking. The first requires that you scan every file (which can be done automatically), so it can build a master record of where everything is stored. This consumes lots of hard drive space, but it will

work very quickly. The other kind simply scans all your files sequentially, looking for the combination you specified. This can conceivably take hours on a large hard drive.

We don't use any file management software (although we should), so we really don't have any recommendations based upon personal experience. We have heard that *DiskTop* is a useful one for the Mac.

We can also place in this category those utilities that allow a PC to name files more like a Mac. Any PC running under DOS limits file names to a maximum of 8 letters (plus a 3-letter extension). On the other hand, the Mac permits the use of up to 32 characters, which means that file names can be very descriptive. Thus, a letter saved on a Mac might be called "Memo to Dave re 4/23 meeting" but would be saved on a PC as Dave423.

We briefly reviewed a program called *Sherlock*, which allows PC files to use descriptive names. It worked beautifully in Windows and didn't give us a lick of trouble. However, when we were finished writing the review, we removed the program because it interfered with our effective use of *Norton Commander*, the DOS shell that we use (see last section). Our problem was that, when we looked at our files through *Norton Commander*, the 8-letter names that *Sherlock* gave the files were cryptic and incomprehensible.

A number of utilities exist that will allow you to convert a file's format. (Please see Chapter 25 on file formats.) Suppose you have a TIFF image that you want to turn into an encapsulated *PostScript* (EPS) file. It would be possible to open the picture in an imaging program that supports both formats, and then save it under the new format. But a faster method would be to use a format translator. What's more, such utilities support many more formats than any imaging program. Our file format preferences tend to be limited to only a handful of very well supported ones, so we don't really need a translator. On the PC, we sometimes use *HiJaak* for such conversions (mostly because we also use that program for screen captures, so it is often resident in memory). We haven't needed to use a file translator on our Mac, because our Mac imaging programs do the job just fine.

Other utilities

There are literally hundreds of different kinds of utilities on the market. Some are useful, others critical, and many just gimmicks. We use a variety of them (including a few of the gimmicks). Our choices are based not only upon need but also upon how much hard disk space they take up and how much they cost.

For instance, we use screen protection utilities. An imaging system's monitor is a very precious component in that it can be expensive, and

provides the immediate feedback on which you will base design decisions. Unfortunately, if the monitor is kept on continuously, the phosphors can actually burn permanently onto the screen. There's little you can do about keeping the screen turned on when you are working at the computer, but there are many minutes in the day—such as when you answer a phone call or get up from your desk to get a Diet Coke—when you aren't looking at the computer. If, after a specified amount of time (say 5 minutes), you haven't used either your keyboard or pointing device, the screen protection utility will automatically blank out whatever is on your screen and replace it with some animated visual (flying toasters, exploding stars, Star Trek characters, etc.) that will guarantee that no one spot is constantly on. When you touch your mouse or keyboard, whatever was on your screen originally will be instantly restored. There are many pretty, strange, or funny screen protection animations, and each is about as good as the other.

Another useful kind of utility is called a macro program. A *macro* is a software shortcut that will allow you to use one or two keystrokes for executing complicated commands or inserting frequently used words, phrases, or sentences. Most paint and illustration programs come with collections of macros, as well as the ability to create your own macros. But when you want to use a macro outside of your applications programs, such as to execute a sequence of Windows commands, that's when a macro utility comes in handy. Typical macro utilities include *QuicKeys* (for the Mac) or *ProKeys* (for the PC).

Remember: Resist the temptation to load up your machine with utilities. The idea is to have an imaging system that is productive, protected, and comfortable to use, not to evolve into an environment where much of your time is wasted on the tools of the computer rather than the images it helps create.

⇨ Device drivers

Technically, device drivers are utilities. But, for the purpose of dividing this chapter into easy to understand blocks of information, we define utilities as useful—not absolutely necessary—software. True, it would be foolish to use a computer professionally and not back up frequently or perform all the other maintenance and repairs that would keep it at peak efficiency. That just makes them important, but not indispensable. But device drivers are absolutely necessary to doing the specific job that you bought the system for in the first place—imaging. If you want your scanner, film recorder, printer, removable drives, CD-ROM drives, etc. to work, you will have to have the software (device drivers) that will allow your computer to communicate and work with them.

When you buy an input, output, or storage device, the manufacturer usually (but not always) furnishes a software driver. What do you do when the driver isn't included? Or when the driver is too limited or operates the device at the speed of snails? Third-party device drivers are also available, and some of them are so good that they can be preferable to those that are provided with a device. But they can also be very expensive.

The most frequently purchased and used third-party drivers are printer drivers, which may be used for printers, film recorders, or imagesetters. Their purpose is to take a file (which might be an image or a layout) and prep it for actual output. The way the prepping is handled is the key to whether or not you will end up with a superior end result.

Basically, a printer driver has to take a digital file and rasterize it— that's the process of converting it into dots that can be used by the output device to transfer the data to paper or film. Rasterizing is frequently referred to as RIP (Raster Image Processing) or ripping. RIPs can be either hardware or software (hardware RIPs are usually very expensive and used in print shops or service bureaus.) The kind of RIPs the imager will usually be involved with are software solutions, which are slower and less powerful than the more expensive hardware ones, but their bottom line is more accessible to the individual imager or small studio.

PostScript is the most widely respected page description language used to translate files into a printed page on paper or film. Many printers and imagesetters have PostScript built right into them. Other devices, like film recorders, don't. So, if you want to have a PostScript-type clarity and smoothness from a non-PostScript device, you need to use a device driver that provides PostScript emulation or compatibility.

Why would you want PostScript emulation? Because it will give you more precise, more perfect visual output. The type will look better, with less "jaggies." The placement of design elements will be more exact. And, generally, the overall quality will be superior to non-PS output.

A very popular and successful PS device driver that is available for quite a number of printers and film recorders is *Freedom of Press*. Another one is *SuperPrint*. A PS emulator can cost up to a couple of hundred dollars for an ordinary office-type laser printer to thousands of dollars for film recorders.

When choosing which device driver we will use for a piece of equipment, we generally go with the device manufacturer's recommendation as to which driver would be best. But we talk not just

to the salespeople but to the technicians and troubleshooters who have a more day-to-day experience of the situation.

For our SyQuest, CD-ROM, DAT tape, and magneto-optical drives, we use *CorelSCSI* drivers on our PCs. It's a godsend program that provides drivers for scores of SCSI devices, many of which don't come with their own drivers or whose drivers support only the Apple platform. At the time of this writing, Corel was still only in the development stage for CorelSCSI for the Mac.

One of the problems with device drivers is the anarchy among standards or the lack of standards. In fact, driver incompatibilities (and the complexity of connecting devices to our computers) have caused well over three-quarters of the hardware and software difficulties we have experienced.

There's another type of driver being bundled with an increasing number of scanners and other devices, called TWAIN. Essentially, TWAIN is designed to eliminate the babel of standards by using the same plug-in for a variety of paint and desktop publishing programs. Thus, it's not necessary to configure each device individually, and the same plug-ins can be used for any and all TWAIN-compliant devices. The only drawback to TWAIN is that relatively few devices on the market are TWAIN-compliant, though more are added every month.

Our advice is, all other things being equal, always opt for the TWAIN compliant device over the one that does not adhere to TWAIN standards. It will make life easier for you. But don't expect it to solve all your problems.

Font generation

As we have said before, and we will continue to say as long as the moon stays in the sky, computers are dumb machines. They can't do anything unless you tell them not only what you want, but how to do what you want. They can't even form the shape of letters on your screen, in your images, in your word processing documents, or in output to a printer or film recorder without being given instructions of what the letters should look like and how they should be formed. This is the job of a wide range of software called font generators.

Fonts are created one of two ways: as bitmapped typefaces or as outlines. It's not unlike the distinction between paint and illustration files. Bitmapped fonts (like bitmapped digital images) are made up of many dots that are assigned a specific position within the design. Outline fonts (like object-oriented images) are defined by mathematical formulae that describe their shapes.

Outline fonts are smoother and scalable. In other words, once a font has been defined on your hard disk, you can use it at any size you want. Bitmapped fonts have rougher edges, and, though they might be enlarged or made smaller, to avoid degradation of shape, they should be redefined for each size you want to use. The infamous "jaggies"—those step-like ridges where a curve should be—are much more prominent in bitmapped fonts.

Outline fonts are the preferred kind of typefaces for professional imaging output, and the two most popular are PostScript (Type 1 and Type 3) and TrueType. Numerous companies package and sell both PostScript and TrueType font libraries. PostScript rules the roost of high quality output, such as would be used for high-end imaging, whether from a service bureau, print shop or a number of desktop color printers. But TrueType does offer equivalent quality, usually at a lower price.

So why should you use the more expensive PostScript fonts? Remember, computers are dumb machines that must have software tell it how to generate a font. When you use a font in a document or an image and then hand the file over to a client, a service bureau, or anyone else to view it or output it from another computer, the software that generated that font must be installed in the destination computer and/or output device. Otherwise, it will substitute a different font that it does support. Because the great majority of high-end output devices have PostScript capabilities, they will substitute PostScript fonts for TrueType fonts that you use in your designs. Now, you might not mind having a dumb machine making arbitrary changes in your design, but we do—especially because the results are quite unpredictable, and can be disastrous.

On the other hand, many more service bureaus and print shops are now supporting TrueType, as well as many other typeface libraries. So don't just take for granted that you need PostScript. Talk to your service bureau and print shop to find out what fonts they can handle. If the hundreds that they have don't include a special one that you simply must use, you have a number of options:

➤ Provide them with a licensed copy of the software that can generate that typeface. (Respecting copyright is a two-way street—no imager who cares about his own intellectual property should circumvent the rights of others. Please don't copy or pirate software. See Chapter 4.)

➤ Use font software that will allow you to embed the code that will transfer instructions to the destination computer for creating the typeface. This is a function of the licensing agreement of the font software and of the program (such as *QuarkXpress*) in which it is used.

➤ If you are dealing with an image that you created in an illustration program, you can actually convert any type into a curve, much like any other object in the image. Just be sure to do the conversion only after the entire picture is in its truly final state, because you won't be able to edit the letters as type once they are curves. (It's best to save a copy of the image before you convert the letters to curves, so that you can always go back and make changes later if you want.)

By the way, many fonts by different manufacturers look almost identical. So, if there is an off-brand typeface that you really like, there is a high likelihood that something very similar to it may be available as TrueType or PostScript.

Font management & utilities

A friend of ours called us late the other night, frantic because his computer was suddenly acting up. It had slowed to a crawl—even starting it up seemed to take forever, though it never had before—and it froze whenever he tried to do any memory-intensive task. After a long session of talking him through a number of diagnostics, he happened to mention that he had been experimenting with a few new font libraries that day. That's like saying he had decided to play with a few small elephants in a one-bedroom apartment. Fonts take up a considerable share of computer resources. The more you keep active on your system, the more they will bog down whatever you want to do.

 HINT Keep active only those fonts that you are currently using. Print out sheets of typefaces that you own and put them into a notebook so that you can make design decisions about which ones you want for a specific project. Apple computers allow you to maintain separate "suitcases" of font libraries on your hard disk that you can organize according to projects. But we believe in cleaning out our hard disk after every job, putting any font that isn't immediately needed onto magneto-optical discs or SyQuest cartridges. It's a relatively easy matter to reactivate any font you want.

Fonts are the one area in which PCs make life easier than Macs. The problem is that there are thousands of fonts available for Macs, but only a few hundred IDs. (Apple insists that each typeface have a specific identification number, which was a great idea when fonts could be counted by the dozens. But it's now a chronic problem because there are many more fonts than the number of IDs that Apple originally set aside for the Mac.) That's like having hundreds of different companies with their headquarters all in the same skyscraper—and all the companies are called XYZ Widgets, Inc. Naturally, Macs are known for font ID conflicts.

Quite a few third-party utilities are supposed to help with sorting out this problem. Mostly they assist with installing and organizing fonts, and/or recognizing and resolving conflicts. We haven't been doing much font work on our Quadra yet, so we don't have a recommendation as to which ones do the best job. But some of the ones we are currently testing include *Suitcase*, *Font Info*, and *MasterJuggler*.

An important font utility that is now being bundled into many imaging programs (for both the PC and the Mac) is *Adobe Type Manager* (*ATM*). Adobe is the manufacturer of PostScript, so they are *de facto* experts on maintaining control over the fonts on your hard drive. *ATM* works with PostScript Type 1 fonts both on your screen and in output. (Type 2 doesn't exist and Type 3 doesn't print out as well at small sizes, so most people want only Type 1.)

⇨ Imaging-related applications

Elsewhere throughout this book, we mention a variety of programs that are important or useful to doing imaging, though they are not imaging software. These include:

- ➤ Image databases, such as *Image Pals*, help you keep track of the hundreds of pictures you will be creating. (Please see Chapter 25.)

- ➤ Color management programs, such as *Cachet*, *ColorSense*, *Trumatch*, etc. help control color calibration and correlation to input/output devices. (See Chapter 28.)

- ➤ Screen capture programs, such as *HiJaak* (which is mentioned earlier) and *Snappro*, will take snapshots of whatever is on your monitor and turn it into an editable and printable graphics file. That's how we made the illustrations in this book that show software dialogue boxes, commands, etc. After the screens are captured, the files are like any other image file—they may be opened in an imaging program, edited, and output.

⇨ Other applications

When you buy a Mac or a PC for imaging, it almost goes without saying that you can use the computer for other purposes. Similarly, if you have a computer that you use in your business (and if it is powerful and fast enough, has 24-bit color, is loaded with RAM and has enough space on its hard drive), you could use it for imaging.

Therefore, all kinds of applications may be used on your imaging system, including a word processor, business management program,

contact database, calendar program, spreadsheet, money management program, etc. But be sure that you always leave enough room on your hard disk for the primary purpose of the system—imaging is a memory and storage intensive process. That's why we just bought a new 1.7 gigabyte hard drive for one of Sally's machines and are pricing yet another 1.7 gigabyte drive.

Part 4

The difficult
question
of color

28

CMYK or RGB

Why what you see
isn't necessarily
what you will get

A N acquaintance of ours called us the other day, quite confused. He had just finished his first digital job—it was a restoration of an old, faded photograph—but it didn't print out the way he had expected. We aren't talking about someone who is inexperienced with design or composition; he's a well established photographer whose name would be instantly recognizable among professionals. What's more, he'd bought the best imaging equipment he could find, so the hardware and software couldn't be at fault. But when he sent his finished image from his Macintosh Quadra 950 to his Kodak XL7700 dye sublimation printer, the beautiful greens that he saw on his screen were so toned down that it changed the whole mood of the picture.

The mistake he made is a common enough one, even to professionals who should know better. The problem, in a nutshell, is that the color you *see* on your monitor is created by a very different set of scientific principles than the color that is output on any printer. Therefore, no matter what you do, it will always look slightly or significantly different. Nor is that the only problem: computer color in general is a very complex issue that requires a fair degree of knowledge and experience to master properly.

We briefly discussed the various *color models* that are involved in computer art in Chapter 22, but that was in relationship to working with color when you are designing or composing on the monitor. In this chapter and the next, we will go into greater depth about two of those models, CMYK and RGB—exploring the problems inherent in computer color as it relates to the difficulty of making printed images appear as similar as possible to the ones you created on your screen.

⇨ When red isn't red

In our everyday world, the way we describe colors is imprecise. When you tell two friends that you purchased a brown dress, one might envision a khaki brown while the second may picture a chocolate brown.

As visual artists, we recognize that no real object is ever made up of a single color. Even a solid red block has highlights, shadows, and varying shades, depending upon the way the light hits it, the quality of the light, and the angle from which it is being viewed.

The traditional artist working at an easel or a drawing board doesn't have to worry about the lack of color precision. He keeps mixing the colors as he goes until they are what he wants. There is an immediacy of result, a direct line of cause and effect, over which he has complete and explicit control.

Photographers have had a bit more experience with the uncertainty of color produced by technology. Because color dyes are inherently unstable and cannot be reproduced exactly the same every time a new batch of chemicals is mixed up, the qualities associated with color film will change with every production run. A specific kind and brand of color film manufactured in April may render very different colors than the same kind and brand made in May. That's why professional studio photographers routinely test each new emulsion batch of film, to check the color characteristics and adjust the balance when shooting under various lighting conditions.

Both the traditional artist and the photographer, as well as the art director and designer, have known the problems inherent in reproducing colors. When printing an original work of art or a photographic negative onto paper or some other medium, it has always been necessary to provide clear, precise, unambiguous communications with whomever or whatever would be doing the actual printing. Otherwise, the final colors might not be what was intended by the artist. A photo lab making a custom color print needs to know how large to make the print, how much to correct the color balance, whether to concentrate on flesh tones or some other area, etc. Even more precision and interactions are required when the final product isn't a print for display, but a set of color separations to be made into printing plates. To do these sort of critical printing jobs always involves careful consideration, specific instructions, and making match (test) prints at various steps in the process, to provide visual feedback that everything is proceeding correctly, that the printer's interpretation of the picture's colors are the same as the artist's and the client's.

That is how it has always been. Now that computers have come on the scene, the translation of colors between media has become an even more complex issue. It's necessary to relearn the language of precise color description that we studied as art students and to correlate it to the language of computer color. Without a common language with which to communicate, we will never get the colors right.

The sliding scale of perceived color

The human eye is capable of seeing a remarkably wide range of colors. No medium or machine that man has fashioned can come even close to equaling the extraordinary way the eye processes and produces color.

So far, film is the best thing we have, though it doesn't capture the full gamut of colors that we can see.

A computer monitor can display and work with even fewer colors than film. A good monitor may be able to show a grand total of 1.5 million different colors simultaneously.

517

On the lowest end of the scale are printed pictures, which can show only a small fraction of the colors a computer can display. A typical color print uses an average of only about 5000 different colors.

Therefore, when you choose the colors you want to work with, you must realize that you'll see far more colors in the real world than you'll ever be able to capture and display. Similarly, the colors you see on your monitor will far outnumber the actual number of printable colors. If your final output is intended to be print (as opposed to film transparencies), then you must be very careful when picking and working with colors on the computer monitor.

The many languages of color

Color could be said to be the original Tower of Babel. The many attempts to describe and define it have created a wide range of scientifically precise, yet conflicting terms and concepts—all of which are valid under certain circumstances. We will not attempt to cover all the color theories, because that would get overly technical and, by rights, deserves a book of its own. Instead, we will explore only those few theories that directly affect computer art.

Remember high school science, where we learned that color is created by the reflection or absorption of various wavelengths of light? When we looked at a red apple, what we saw was red, our teacher explained, because all other colors but red are absorbed by the apple. The red color was reflected by the apple's surface into our eyes. If all colors had been absorbed, we would have seen black. In a contradictory lesson, when we held a prism up to the light, it split into a rainbow, because white light is made up of all colors.

Then, when we went from science class to art class (or from theory to real world experience) and tried to mix all colors of paint together, we ended up a gooey, muddy mess that was quite dark, but certainly not true black. That was our introduction to our first two theories of color—*additive* and *subtractive*—and their limitations. These are also the theories that are the most relevant to computer art.

According to the *additive* theory (which was demonstrated by the prism), when you add red, green, and blue (*RGB*) together, the result is white, and the absence of color is black.

According to the *subtractive* theory, when you add cyan, magenta, and yellow (*CMY*) together, the result is supposed to be black, and the absence of color is white. (This is the theory that was used to explain the red of the apple.) But there are problems with this theory when printers try to use it. That's why the theoretical CMY model becomes a reality-based CMYK. (See later for an explanation of what the "K" is and why we need it.)

Both of these theories, as conflicting as they might sound, are scientifically correct. The difference is that the additive theory applies to *transmitted light* (such as that which the computer monitor uses) and the subtractive theory refers to *reflected light* (which is the basis for printing pigments).

When you create an image on a computer monitor, the colors that you see (regardless of what color model you use to pick your colors) are governed by the laws of additive color. When you print that image, the colors of the print media will be governed by the laws of subtractive color.

Theory vs. reality:
The colors of a computer screen

Imaging programs will allow a computer artist to work with various color models (such as HSL, CMYK, RGB, etc.) on the computer monitor. These are available as design and editing conveniences and tools. However, whatever theoretical color model you are working with on the monitor, you will always view all the colors on the screen according to the RGB color model.

This sounds confusing but is quite logical. Physically, the screen creates the colors you see with transmitted light, so it is governed by the additive theory. It is not possible to change the laws of physics that determine how you see the colors on the computer monitor. But the software developers can attempt to emulate the color models of other theories.

Hold a printed CMYK color swatch up to a monitor that is supposedly displaying the same CMYK colors. The essential difference between the two is so obvious that it becomes difficult for your eyes to relate the transmitted swatch to the reflective (printed) swatch. Psychological barriers fight the physical contradictions. This is the problem that many have with trying to calibrate their monitors according to printed color guides. (See Chapter 29.)

Why don't the CMYK colors on the monitor look exactly like the printed CMYK colors? Because they are RGB colors being manipulated to approximate CMYK.

⇨ Imperfect translations

If an artist sitting at her easel wanted to make a perfect cyan, all she would have to do is mix equal parts of green and blue on her palette. Magenta would be composed half of red and half of blue. And, according to this theoretical example, yellow should be red combined with green. (Though what artist wouldn't just squeeze some ready-made Chromium Yellow out of a tube rather than try to mix it?)

It would stand to reason, then, that it shouldn't be all that difficult to translate RGB colors into CMY colors. Unfortunately, it is not only difficult, but a most complex operation that can almost never be perfect. (See Fig. 28-1.)

Figure 28-1

A traditional color wheel (such as the one in the color pages), in which the primary colors are shown to be directly related to each other, seems to indicate that it shouldn't be difficult to convert RGB colors to CMY colors. But that just isn't the way it works.

The stumbling blocks are rooted in two technicalities:

➤ The difference in background (transmitted light and printed media) affects the appearance of the colors.

➤ Printers pigments don't perfectly follow the rules of subtractive color.

How an image's background affects its colors

When you view a color on a computer monitor, it is pure transmitted light. The color's luminosity is exaggerated by this fact. Of course, the tendency of the individual monitor toward certain tints (such as blue or green) might affect what you see, but the overall effect is a bright, almost shimmering color.

When you view a printed color, it is set against a piece of paper (or similar media) which absorbs part of the pigment, adds texture to it and, when correctly viewed, has no additional light coming through it. In fact, the printed color is based upon the absorption of light. This reduces the luminance of the original RGB image, before you even begin with the difficulties of approximating the original colors.

The fallacy of the subtractive theory

According to the subtractive theory of color, if you mix all colors together, you will get black. In practice, it doesn't quite work that way. In an earlier section of this chapter, we described what happened in art class, when we mixed all pigments together—we ended up with a

muddy mess. Printers are much more accurate with their mixing than we ever were, but they still can't get a perfect black with any possible combination of cyan, magenta, and yellow. Why not? Because all of the inks used in commercial printing have certain inherent physical limitations (the details of which only a chemist would care to study) that make it impossible to blend colors to make a true black.

That's why CMY must become CMYK when you go to press—where the "K" stands for black. The printer adds an extra pigment, black, to the mixture of inks in order to lend crispness and definition to the picture. Adding black ink is the only practical way to reproduce a level of true black; otherwise, the printed image will show a dark, muddied grey wherever black should be. The introduction of black into the printing process throws a metaphorical monkey wrench into any straightforward conversions and calculations, because a printer's CMYK has no direct correlation, no mathematical relationship to a computer monitor's RGB. That's why the translation of RGB computer images to CMYK printed pictures is never perfect.

NOTE While print jobs are based on the CMYK color model, film transparencies (like the computer monitor) work with the RGB color model. Therefore, the problem of color translation does not exist if your final output is intended to be a slide. Just make sure that the purpose of the transparency is to remain a transparency, such as for use in a slide show. If it is to be printed, then you will face the same problem of going from RGB to CMYK.

⇨ The differences among devices

To compound the difficulties, every monitor has its own individual characteristics. Remember walking into an electronics store and seeing a wall of different television sets, all displaying the same program? No two screens were alike, even among those from the same manufacturer. Some were brighter, others had a certain tint, etc. The same is true with computer monitors. They will all show colors slightly differently.

Similarly, every input and output device will have their own particular color characteristics. When an image is scanned or printed, the individual color tendencies of that particular piece of equipment handling the process can be transferred to the image. This can ultimately lead to color chaos.

For instance, a scanner might add a bluish cast to a file, which, when viewed on a monitor with a tendency toward red, will actually look too magenta. If the computer artist is not aware of the scanner's propensity towards blue, she may believe what her eyes are telling her: namely, that the color balance needs to be adjusted in order to remove

some magenta. But what she really needed to do was to remove some of the blue, because the actual image in the computer (as opposed to what she sees on the monitor) has too much blue, not too much red. Similarly, if the color printer or the film recorder also has a leaning toward a certain hue, such as yellow, the problem is compounded yet again. Added together, it's inevitable that the final picture will be way out of whack, colorwise.

It isn't a completely hopeless situation. As we discuss in the following chapter, it is possible to better gauge, control, or, at least, try to understand the colors on your computer monitor and to coordinate it to input and output colors.

⇨ Bottom line

What we're trying to say in this chapter is very simple but extremely important. Just as you don't believe in Santa Claus or the Easter bunny, don't accept the often-touted concept of WYSIWYG ("wizzi-wig," or "what you see is what you get"). It simply doesn't exist, at least so far as the accurate displaying and reproduction of colors is concerned. Once you recognize and accept the fact that the colors you see on the screen won't be, can't be exactly the same as the colors that will be printed out in a magazine advertisement, a poster or an annual report, the better prepared you are for tackling the methods and processes available to digital imagers to correct and perfect color rendition.

29

Controlling color

CHAPTER 29

AS we discussed in the previous chapter, you can't believe the colors you see on your computer monitor. So, how is an artist, designer, or art director to make intelligent composition decisions when sitting at the computer and viewing a color image?

Various schemes and devices are used to help control, calibrate, and interpret screen color. It's also possible to try to coordinate monitor color to input and output devices, so the correlation between the two is as close as possible. But to ensure quality color results, the artist must learn to choose colors intelligently, according to what he knows rather than what he sees. We'll discuss all these methods in this chapter.

⇨ Calibration

Calibration is a software and/or hardware process that adjusts and fine tunes the colors the monitor produces according to some established standard. Some of the calibration strategies include:

➤ Using so-called smart monitors.

➤ Adjusting the monitor's gamma curve within certain imaging programs.

➤ Calibrating a monitor with a densitometer that reads the screen's colors and feeds that information back into specialized software.

➤ Calibrating of the monitor in relationship to input and output devices.

⇨ Smart monitors

A comparatively new generation of "smart" computer monitors are being marketed as conforming to the CMYK color model. They have built-in microprocessors that allow users to correct colors according to a particular palette or model. When you are done, the changes you make to the settings stay resident in the hardware. Some of these monitors allow you to save more than one color standard, so that you may choose from among a variety of settings, depending upon what program you are running, which devices you are using for input and output, etc. That's useful if you use different printers, service bureaus or print shops for different projects or clients.

Regardless of what a salesperson or ad copy tells you, these are *not* CMYK monitors. That's an oxymoron—a self-contradictory phrase. Monitors' colors are created by transmitted light and can't possibly ever be anything other than RGB devices. The CMYK color model is based on reflected light and can never display the same exact colors as

RGB. The best that a smart monitor can do is more closely emulate CMYK colors than other monitors. (Please see the previous chapter.)

Of the smart monitors we've tested or considered, we have not yet seen exceptional CMYK compatibility. For instance, the NEC F5G and F6G are both superb monitors that feature multisync capabilities, non-interlaced high-resolution displays, and a variety of advantages and advances. However, its touted ability to emulate a CMYK monitor is not one of its strongest technological points. To supposedly produce CMYK compatibility, the user is required to load in a software utility, then to place against the monitor a small swatch of colors printed on a piece of card stock paper and compare them to a similar swatch of colors displayed on the screen. You're supposed to make adjustments until the two swatches look identical to your eyes. The two major fallacies of this system are:

➢ The human eye is not an exact measurer of color similarities. Every individual will see colors slightly differently, so the perception of color will be a variable, not a constant.

➢ The colors on the screen are created by light, while those of the printed swatch are created by reflective media. The screen colors will always be more luminous than the printed colors. And that makes it very difficult to compare them.

We understand that this is just the beginning of what smart monitors will be able to do. First, they had to get them on the market; then, if there is a demand (as there is certain to be), the manufacturers or third-party developers may introduce add-on products that should automate the process of correcting the screen color to better approximate CMYK values.

In the meantime, there is no reason not to buy them. They tend to be of excellent quality, and sell at virtually the same price as other high-resolution monitors. Just don't depend upon them to answer your color coordination problems.

The imaging environment

Regardless of whether or not you calibrate your monitor, it is desirable to be able to count on your screen colors to be the same every time you power up your computer. This depends a great deal on your imaging environment. For consistent and reliable monitor color, the ideal room in which to image is one with neutral-colored flat-painted walls (18% grey is the best). It should have a consistent, low level of ambient color-corrected artificial light with no hot spots and no windows. (The description should sound rather familiar to art directors, photographers, and other visual professionals who must view film, page proofs, or other important color materials. It's been typified as the ideal room for such work for years.) The purpose is to cut down on reflections and color impurities influencing what you see in the monitor. Temperature fluctuations can also affect the stability

of monitor colors, so it is best to keep the room thermostat at a steady level.

Unfortunately, that sounds like a very unfriendly kind of environment in which to work for the long hours that imaging requires. Sally's office was designed years ago, long before she began serious imaging. It has lavender walls, dark woodwork, and white lace curtains that shimmer with light from the large windows. Because it is in an old building, with an unreliable steam heat radiator and a window unit air conditioner, there is no such thing as a steady room temperature. It is a far cry from the ideal that all experts consider necessary, but she feels that it is just as important to be comfortable and happy where she works. Besides, she has the experience to not be influenced by color impurities that have been introduced by outside factors and which will have no effect on the final image. (See later about educated color picking.)

If you are the kind of person who believes in conforming to technical specifications to guarantee your very best results, regardless of human considerations—and if you have the budget and time to redesign an enclosed portion of your studio—it is recommended to stick with the established 18% grey, enclosed, reliable, though boring, room.

Monitor gamma

Technically speaking, calibrating a monitor's colors means changing its gamma curve. Gamma is the term used by mathematicians to denote change, and, when calibrating your monitor, it is represented by a graph in which the horizontal axis refers to data of the image file and the vertical axis refers to the monitor's data. If you have a perfect 45° line, then the monitor and the file will handle the image in the same manner. But, since the monitor may introduce color impurities to the display of the image—each monitor will probably have a tendency toward pinkish, bluish, or greenish tints—this will mean that you won't see the image accurately, according to the specifications embedded in the file.

NOTE The image file is where all the data that defines your picture is placed. Like any other computer file, it's stored on your hard disk or other storage media, to be called up into computer RAM memory when you want to work on it. Regardless of what you see on your monitor, the image file is what determines how your final picture will really look.

Think of the monitor as a window that looks into a room. (The room would be the actual image file.) If that window is made of glass that isn't perfectly clear, has streaks of dirt, or is tinted, then your view of the room will be tinged according to the color of the glass. That doesn't mean that the room's own colors are tinged; only that your view of it is.

So it is with your monitor. When you see the display of your image, the screen's own tint will affect what you see, but that tint is not part of the actual image. That's why when you make editing decisions based upon what you are seeing on the display, you may be making wrong judgment calls that will alter your final pictures in ways you did not want.

In other words, when you look at a monitor gamma curve, it is quite logical to expect that the data that is part of the image file will not be an exact mirror duplicate of the data displayed on the monitor. But that is precisely what a 45° line represents. To make what you see on the monitor appear closer to the reality of the image file as it will print out, it's necessary to alter the way the monitor handles the data. The graphical effect of this is that the values that relate to the gamma's vertical axis will have to be changed, according to the individual characteristics of the specific monitor.

The result is not a straight 45° line but a curve that either dips like a valley or goes up like a hill. A dipping curve decreases the intensity of color on the monitor; a curve that goes up increases the intensity of color.

Some software programs represent the monitor gamma, not by an actual graph but by the numbers associated with the graph. Therefore, an uncorrected gamma would be described as having a value of 1. If the gamma curve dips below the 45° angle, then the numerical value would be less than 1, which would represent a decrease in monitor color intensity. It follows, then, that a gamma value over 1 would represent an increase in monitor color intensity.

The purpose of adjusting the gamma is to bring monitor color intensity closer to the intensity of colors in the actual image file. In other words, it's so that what you see is somewhat closer to what you have in the computer's memory, which is what really counts.

NOTE The gamma curve discussed in Chapter 23 is not quite the same as monitor gamma. Monitor gamma refers to the colors of an image file as they are saved in the file compared to how they are viewed on the monitor. The other gamma curve is used to affect the greyscale values within the highlights, shadows and midtones of a picture. The essential reason they use the same name is that the graph that represents them stems from the same mathematical concept of charting the characteristics of a thing against similar aspects of a related but different thing. (There's more to it than that, but there's no need to go further into the subject unless you are deeply concerned with mathematical and technological semantics.)

Before you calibrate

Because environmental factors affect the colors you view on a monitor, be sure that everything is in its normal state before you begin calibration.

- *Turn on all lights or open up the shades that you would usually have on when working; turn off all the others. Try to regulate your working lights, so that none will create glare on the screen.*

- *Set the brightness and contrast knobs on your monitor and permanently leave them there. If possible, note where their settings are, so that, if they are accidentally moved, you can reinstate your settings at the same level.*

- *If your computer is on a network, try to isolate it for the time you are performing the calibration. Then save the results in a personal file that relates to and affects only that specific monitor.*

- *Close all other programs that may be running on your computer so that they won't affect any of the operation.*

 # Changing monitor gamma within imaging programs

Most of the more powerful imaging programs have built into them some kind of monitor calibration method. These calibration methods tend to follow a universal pattern in which two groups of colors are displayed, and the user adjusts the one set to try to make it match the second set. When the adjustments are made, they are saved so they will take effect whenever you open that program.

Any calibration done within a particular imaging program, such as *PhotoStyler*, will affect only those images that are displayed within that program. That's because the monitor gamma values you save are kept in a file that is opened only by that specific program. Other calibration schemes (which we will cover later) will affect the display regardless of what program you are working in.

 # Densitometer calibration

A much more reliable method for calibrating your monitor is to use a densitometer, a device that reads the actual color values right off your screen. A screen densitometer is a small CCD embedded within a suction cup that is attached directly to your screen and connected by cable to the computer (see Fig. 29-1). Because it gets its readings directly from the front of the screen, it will see the same exact colors that you see. Working in conjunctions with the calibrator is a utility that displays a test chart with colors of known value; the densitometer

Figure 29-1

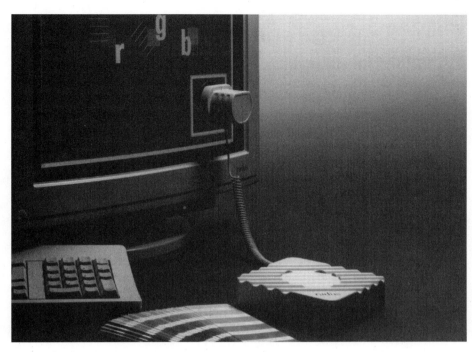

Photo of monitor calibrator.

is placed directly over them. (Most utilities display a round bulls eye or other similar graphic in the middle of the screen where the suction cup is affixed.) The software displays colors, which the densitometer reads, giving instant feedback (instructions) to the computer to adjust the monitor gamma according to an established standard of purity. This will ensure that the colors you see are true and unaffected by any tint of the individual monitor.

By the way, some utilities that are designed to be used with a densitometer also provide a means to manually adjust the colors for those who don't have a calibrator, or wish to fine-tune the calibrator's adjustments. For instance, Matrox's *ConsistentColor* software, which is designed to work with Matrox's 24-bit video boards and a Sequel calibrator, also furnishes a means to manually fine-tune the colors. This particular calibration program is one of the more sophisticated ones that we have seen. It provides 24 greyscale boxes (eight each for highlights, midtones, and shadows), plus 7 graduated strips for greyscale, red, green, blue, cyan, magenta, and yellow, and 2 hue discernability scales. You can make adjustments that relate, not only to these various determinants, but also to any image in your system. In fact, Matrox suggests that, as you calibrate, you keep on hand a printout of the image made by your desktop printer or your print shop. That way, you can color match the picture on the monitor as closely as possible to the printed one. (See the later section on reference images in this chapter.)

 # Coordinating input & output devices to your monitor display

We highly recommend using a densitometer to calibrate your monitor. Unfortunately, a densitometer, no matter how good it is or easy to use, won't solve all your color problems. All it takes care of is the display on your monitor, not how your input or output devices interpret color information. The same is true about the built-in automatic calibration firmware that many scanners and film recorders have; they just don't coordinate with each other, or your display. Just as every monitor has different tendencies and characteristics, no other digital imaging devices, sometimes even among the same brands and models, will treat color in the exact same way.

There are various software and hardware schemes that attempt to solve the problem of this apparent disarray of the various components of your imaging system, by referencing what are called lookup tables— LUTs. (LUTs may also be called DCPs, which stands for Device Color Profiles.) LUTs describe the color tendencies of specific scanners, recorders, and printers; this information is then used to coordinate image data with the monitor display. Using a LUT is an excellent way to match the color of a device to that which you see on the monitor. Unfortunately, the major problem about LUTs is that there aren't enough of them listed in the major imaging or calibration programs. So, it is rare for us to find all the scanners, recorders, and printers we test or own referenced by them, despite the fact that we are working with popular, mainstream products, such as the Leafscan 45 and the Agfa PCR II recorder. (On the other hand, our Tektronix Phaser IISDX dye sublimation printer is listed on almost everyone's LUTs.)

 Before you purchase any calibration product, make sure that it has the specific LUTs for the peripherals you use, and that it will work with your particular configuration.

Another method used to coordinate flatbed scanners to the monitor that some programs use has the user scan the printed greyscale into your computer, which will then be displayed on your monitor. Then you adjust the computer so that the scanned greyscale is displayed according to its true colors. This will work only if the monitor is calibrated before the scanning, to ensure that the color impurities on the display relate only to the scanner's characteristics and not a combination of monitor and scanner inaccuracies. Unfortunately, at the time of this writing, none of the manufacturers who use this technique provide slides for those of us who use film scanners and not flatbed scanners.

Agfa's *Fotoflow* system answers some of these problems by establishing a software link between image files and input and output

devices. *Fotoflow* provides a color test image (slide or paper) which you scan into your system. It then compares the result with the same image within the program to establish the scanner's "profile." After that, whenever you scan anything, the system will automatically make the appropriate color corrections by coordinating the image file to the scanner's profile. *Fotoflow* also includes lookup tables for printers and film recorders. So far, it is the most comprehensive system that has been developed to help with this problem. But, we are certain that others will be coming onto the market, even before this book is published.

How often should you calibrate?

The first rule of thumb is to calibrate your monitor whenever anything changes in either the environment or with your software. This means every time you change monitors, lighting situations, or any settings on the monitor itself. Also, whenever you upgrade any of the software to a new version, remember to recalibrate. The second rule of thumb is to recalibrate at least twice a month or, if you are doing heavy-duty imaging, every time you start a new job.

In contrast, a service bureau or anyone involved in constant work that is very color-intensive should calibrate all equipment with as accurate tools as possible every morning as they start the machines. For added security, these devices should be recalibrated any time a film emulsion is changed or any other conditions are altered, even if such occurs several times a day. Find out how often your service bureau calibrates its equipment to help ascertain how precise their work will be.

By the way, most high-quality film scanners and recorders come equipped with built-in calibrators that operate automatically whenever they are turned on, as well as whenever environmental conditions (or, in the case of recorders, film emulsions) change or any settings are altered. Leaf Systems recommends that a scanner should be recalibrated approximately every two hours (in addition to every time they are turned on) because the brightness of the bulb that provides the light will vary as its temperature changes. We have followed that suggestion with all scanners we have used. We have our film recorder set to automatically recalibrate after every five exposures.

⇨ Educated color picking

While calibration is most valuable, it still doesn't guarantee that your print job will give you the colors you see on your monitor. You must make your color choices, not according to what you see on the computer screen, but according to what colors your output device is capable of reproducing. Many of the colors you see on your monitor cannot be possibly printed with any inks, dyes, or pigments. The trick is to adjust your software so those non-printing colors will either be eliminated or displayed in such a way that it is obvious that they cannot be printed. Barring that, you will have to learn to recognize

which colors are printable and which ones are not, so that you may pick your colors accordingly.

There are several techniques and tools that will help you select printer-capable colors. We recommend the following:

➤ Constrictions within imaging programs

➤ Working with established color systems and swatch books

➤ Creating your own swatch book

➤ Using reference images

Imaging program constrictions

Most sophisticated imaging programs include utilities that will help you work only with printable colors.

For instance, some will give a visual warning, or constriction, if you pick a color that is usually not available in print. In *Photoshop*, you'll see a small exclamation mark in a triangle on the color picker, next to the square in which your selected color is displayed. Always watch out for such warnings.

Cachet has a "gamut alarm," in which you choose a printer from the menu (no not all printers are listed) and then the unprintable colors in your image are highlighted. It's best to replace them with printable colors, rather than take chances.

Other programs will literally stop you from choosing an unprintable color. In *Fractal Design Painter's* color palette, if you check the "printable colors only" option, when you choose an unprintable color, the program will automatically substitute what it considers to be the closest approximation that can be produced by a typical CMYK printer. The only problem with this automatic substitution is that you may end up with colors that you never wanted. But you can easily change that by picking another color.

Whatever constrictions your software provides, be sure to pay attention to them. Break with them only if you know that they are wrong about your specific printer (something you can tell only from previous experience), or if the final output is intended for film transparencies, not print. Otherwise, you might make design decisions that will lead only to disappointment.

HINT

The more intense, bright colors that you see on the computer monitor are specifically the ones that usually can't be printed. If you absolutely must use such a color, ask your printer about the possibility of using fluorescent inks. It will be more expensive and more difficult, but if the job is important enough and the reasons for such bright colors strong

enough, you might want to spend the additional money and put up with the extra inconvenience.

Color systems & swatch books

Many imaging programs and desktop color printers are licensed to offer *Pantone* colors. *Pantone* is a well-established color system that has been used by print shops for three decades. In the software that supports the Pantone system, it's an option of the color palette. *Pantone* colors are identified, not only by visual appearance, but also by specific numbers that correlate to printed swatch books that you can buy and which your print shop will probably have. However, be aware that if you choose your colors based upon the .*Pantone* option in your software, it doesn't necessarily guarantee that your print shop will be able to perfectly duplicate those colors. But there are ways to use the *Pantone* system (or *Trumatch*, *Toyo* or any color swatch system) that will increase the odds in your favor.

> ➤ Check with your print shop to find out which swatch system they support. Ask their advice about how to use it.

> ➤ Probably the most important key to working with this or any color system is to use only "process" colors and not the solid or spot colors. Process colors are produced by the four-color method used by printers, combining cyan, magenta, yellow and black to make all printed colors. Solid (or spot) colors present problems to printers.

> ➤ Know whether the paper you will be using will be coated or uncoated, and choose your colors accordingly. Color will appear differently on different types of paper.

> ➤ Don't depend upon software-based color palettes to visualize what the color will look like once it is printed. Yes, certainly, refer to printed swatch books, but recognize that they aren't necessarily proof that you will get that specific color from your print job.

There are color systems other than *Pantone* that you might want to consider. *Trumatch* is very popular, and it has the added advantage of being an award-winner for the assistance it provides to electronic designers. It was created by computer, specifically for computer-based color work that will be exported to four-color (CMYK) process printers. *Trumatch* swatch books indicate the percentages of CMYK it would take to create a certain color—or at least the percentages that created the color as it is printed in that book, on that kind of paper with that specific ink batch. *Trumatch* also produces software that will allow you to output a personalized color reference book on your own desktop color printer. By printing out the actual colors on your own device (or

your service bureau's printer or print shop's press), you'll have an extremely accurate visual point of reference in determining how an individual printer is going to handle specific colors. *Trumatch* may be the new kid on the block, so to speak, but it is aggressively licensing its color system to many software and hardware manufacturers, and it is rapidly catching up with *Pantone* as the preferred color system for digital imaging.

Be sure to use the right color system for the job. We tend to use *Trumatch* for those images that go out to our print shop, because they have told us they prefer it (as many print shops do). We still use *Pantone* (process colors only) for those we will produce on our PC and print out on our Tektronix dye sublimation printer, because it uses *Pantone*-approved colors. However, any print jobs that we do from our Quadra 700 are based on *Trumatch*, because we used their software to make a very useful color reference book for whatever color printers we happen to be testing that's attached to the system (see Fig. 29-2). This has been so easy and useful that we expect as soon as *Trumatch* releases a PC version of the software, we may switch over entirely from *Pantone* to *Trumatch*. Of course, we could make our own book without their software, but it is more time-consuming.

Figure 29-2

The provided b&w photo of Trumatch ColorFinder.

It's important to remember that using any established color system won't guarantee results that duplicate what's displayed on your monitor. But it will give you some control over the process and allow you to make intelligent choices.

Color: An age-old problem

Time and age (as well as heat, humidity and light) affect color display.

After a while, the phosphors that excite the colors of a monitor will deteriorate and produce different results than they originally did. Film recorders use an ultra-high resolution monitor to project an image, which is then captured onto film. So, they too are affected by age. The jury is out on whether scanner's CCDs and photomultiplier tubes wear out or deteriorate. But it does become apparent that the older your equipment is, the less reliable it becomes as a point of reference for color.

Printed colors, too, such as color swatches or reference images, will age, yellow and change, so that you can't depend upon them as you would have when they were new. Keep them safe, out of direct light and away from heat to help sustain their usefulness. But eventually, no matter how well you protect them, they will no longer provide true color references. You should buy or make new ones about once a year.

Creating your own color book

The best way to determine what your printer will do with a computer-generated color is output that color on your printer.

Create a custom palette and write down, as you go, the percentages of the primary colors that created each color. When you are done, print out the colors on your desktop printer, or send that file to your service bureau to print out on the output device you normally use. (Some shops will print such reference files out at a discount, because they recognize their purpose, which is an advantage to them, too.) Now you will always be able to exactly duplicate those printed colors by calling up the same percentages.

Because it is a mammoth task to make up all possible colors, use this procedure only for palettes that are related to specific jobs or individual images. It is also helpful to show the printed reference to your print shop before you go ahead with creating the image. That way, they can offer you advice about any colors they feel they might have difficulty reproducing.

 The key to intelligent color picking is to know how a specific color will reproduce on your intended printer, before you decide to use it in your design.

Color editing according to printed reference

A variation on the color book theme is to print out some of your images on your printer. Also, keep low-resolution versions of those images on an easily accessible folder or subdirectory on your hard disk. When you are working on another picture, you can call up these low-resolution images and look at their prints as a point of reference of the kinds of colors you are using, and how a finished, final version might print out. You might even want to pick some of the colors from the reference image to use in your current editing job.

It is best to have different kinds of reference images, so that you can compare like with like. In other words, if you are editing a picture of a seascape, it wouldn't help to compare it to an indoor picture of a child's birthday party.

We suggest printing out any image on your desktop printer *before* you do any color editing on it. That way, you can have a very specific reference image for the current job.

 It is most useful to put squares of color from the palette that was used to create the reference image on its border before printing it out. That combines the usefulness of printing personal swatches with the convenience of the monitor/printer reference images.

The future of color control

Obviously, this question of color is a driving force within the imaging industry. It's the number one stumbling block for those who work with computer art and layouts, so developers and manufacturers will continue to come up with products that will hopefully help visual professionals to gain some semblance of control over it.

As new software and hardware solutions enter the market, judge them according to how much information they provide in relationship to what they help you *know* and what they help you *do* about the final output. If all they do is make colors look prettier or duller on your monitor, then they might not be giving you the information or the tools you need. If they help you *recognize* what will happen to colors when they are translated from the monitor to the output device, without confusing the issue even more, then look further into them.

PREPRESS has always been something that someone else has done. Whether you're an illustrator, designer, photographer, art director, or other visual professional, after the design had been determined, the picture created and the layout devised, then it was all sent out to an army of anonymous professionals who handled the color separations, typesetting, stripping, and printing. If they did their magic correctly, we'd end up with a finished print job that we could use. If they didn't get the colors right or otherwise missed the mark, then we would fuss and fume, demanding they do better, belying the fact that they were the ones in control. We were mere supplicants who could only hope that when we sent our all-important jobs out to them, we'd end up with something close to what we envisioned.

No wonder that many of us have always imagined that these prepress experts really live in dark caves. There, they must pull out all the stops, recite the appropriate incantations, stir their cauldrons, like MacBeth's witches, and throw in a pinch of this or that—to taste, of course—like Julia Child.

Until recently, prepress was something that could be done manually or with million-dollar digital imaging systems—only by highly skilled graphics artists. Nowadays, sophisticated and affordable digital imaging technologies provide almost anyone with the tools to tackle most traditional prepress functions. Some visual professionals have taken this to mean that they should do their own prepress, thereby retaining control over creativity and, hopefully, saving both time and money. Others feel that, despite the easy availability of prepress desktop computer tools, it's still preferable to leave the most sensitive and intricate jobs to the experts. Better to concentrate only on what you excel at, rather than trying to do something for which you have scant skills or experience.

Whichever position you end up taking, you should know something about prepress basics and nomenclature, such as trapping, stripping, and ghosting, because that's what your clients will be asking your advice about. It is no longer considered businesslike to remain ignorant of prepress operations.

One way or another, the visual professional is working as a member of a team. The key to successful cooperation is understanding what is expected of you, what you can ask of others and—most important of all—clear communications through all channels. Even if you don't want to be a team player, you should be able to speak the language and understand what will be done to your picture after it leaves your safekeeping.

This chapter is not intended as a how-to manual on prepress. (That is a book length subject on its own.) Instead, we'll explore key issues of electronic prepress that are relevant to digital imagers—specifically,

what you may want to do on your own system to prepare your pictures for output.

The stages of prepress

Traditionally, a design was roughed out on paper by the art director, then cleaned up into a "comp." (A comp is a sketch of the design that provides specifications of angles, orientation, placement of the various elements, etc.) A visual artist or photographer was commissioned to create the picture, which, when finished and approved, was sent off to the color separator. (Color separations are necessary to make the actual plates that are used on the printing press.) In the meantime, a typesetter at some print shop would be creating the necessary type.

All those necessary components—the picture, color "seps," and type—would be returned to the art director, who would either approve the work or send it back out for corrections. Then he'd assign a designer to put it together in a final layout, pasting the type and pictures together exactly as they'd appear in print. After that, the layout would be sent out again to a "prepress shop" for stripping and film preparation. Proofs from these were reviewed by the art director and, hopefully, approved. Finally, a print shop would do the press run, producing the final product.

Digital prepress is not so different, except that much, or even all of the work—the comp, the picture, and the type—can be done on a desktop computer. Even color separations can be set up on a desktop, and some very ambitious electronic design studios are getting into converting the layout directly to film. However, most are happy to leave the color separations and film preparation to service bureaus, because they are quite painstaking, skill-intensive chores. Doing paste-ups by hand is, at this point, almost a lost art; the overwhelming majority of layout work is being composed with the aid of desktop publishing programs. (See Chapter 26.) In the end, it all still has to go to a print shop.

⇨ Prepress experts

The two kinds of outside agencies that all digital imagers and art directors will continue to depend on, at least for the next few years, are the *service bureau* and the *print shop*. These terms are bandied indiscriminately among traditional and digital artists and designers. But exactly what they are and what services they provide is far from precise.

Many different companies call themselves service bureaus, some of which may also offer printing facilities. On the other hand, many print shops now devote a substantial portion of their resources to providing digital imaging and prepress services that are commonly considered within the domain of service bureaus.

For the sake of convenience, we will use the following definitions:

> ➤ A *service bureau* works with digital files: creating them with scanners, providing computer manipulation services, and/or outputting them to film (though some also have printers and imagesetters). The central room or work area of the company has one or several computers that do these digital operations. Some service bureaus were originally photo processing labs, but many others have sprouted full blown out of this digital revolution.

> ➤ A *print shop* uses printing presses (and other printing technologies) to output to paper and other reflective material. They generally don't care if the source of the image is digital or film. Most have been doing the job of printing traditional materials for years. With the advent of digital imaging, they have installed and integrated computers to accommodate their customers' changing needs.

There's quite a bit of crossover between the two categories. In addition, there are many service bureaus whose focus is so narrow, that you'll use them only for very specific kinds of jobs. For instance, some service bureaus specialize only in producing color separation films from a digital file and virtually nothing else.

We will discuss how to determine what a service bureau or print shop can do for you and how to work with them effectively in the next chapter.

Preparing your image for output

If you are a commercially oriented photographer, artist, or illustrator, chances are that most of your images will go through prepress. That's because prepress is the process that prepares images for mass distribution, such as in advertising campaigns, magazines, brochures, posters, corporate annual reports, books, etc. It doesn't matter if you have a top-of-the-line laser printer, recorder, and color printer because, at some point, your images will have to be output to some other mass medium that can be viewed by the public.

The question is where does prepress begin? And, more specifically, how does it affect the way you handle your image?

If you want to be literal about it, prepress is everything that happens to a design before it ends up in its final printed form. So, that would include the period of conception and creation, as well as color separations and all the rest. But by common usage, conception and creation have always been (and continue to be) something that stands apart from prepress.

It's like saying that planning a wedding includes the courtship. Yet, everyone keeps those two stages separate in their minds and hearts. Perhaps it has something to do with the idea that courtship shouldn't be planned. Rather, it should be spontaneous and romantic (although we have known some very successful courtships that were plotted out with the express purpose of winning a heart). On the other hand, wedding plans should be disciplined and well organized.

Being romantics ourselves, we will respect that distinction. So, when we speak of prepress, we are talking about everything that comes after the actual creation of an image, up until the time when it reaches the printing press (which is not unlike a bride and groom standing before the altar). But we also include the decision of what kinds of colors you will use in the creation, because it is a printing concern—even though it must be determined sometime after the conception and before the creation of the image.

Given that definition, every imager is already involved in prepress. If nothing else, he must consult with the print shop and/or service bureau about color palettes. He must also decide what file format to use to save the file when preparing it for delivery to the client. Both of these concerns are part of prepress.

Some digital imagers may want to get more involved in preparing his image files for prepress. The primary motive is increased profits. If you can offer your clients an additional service, then, perhaps, it would deserve additional payment. That leads us to the more subtle motive: competition. If other imagers are providing such services, does it give them a competitive edge over you? Or, will your clients simply learn to expect you to have, at your fingertips, a certain level of knowledge and sophistication about handling digital image files from conception through to production?

How much you get involved in prepress will be an important career decision you will have to make. Sally has chosen to be knowledgeable, to be able to provide information and advice to the client regarding his prepress questions and concerns. Given enough financial or creative motivation, she'll do some desktop typesetting and layout on her images. But, she leaves the heavy-duty prepress responsibilities—color separations, halftone screens, trapping, etc.—to others who want to devote their lives to the subject. That's the dividing line: does she wish to remain a digital artist, or does she want to work as a graphic arts technician? That she chooses not to get heavily involved in doing prepress herself does not preclude learning about the subject, addressing them in her work when appropriate, and asking the necessary questions of others on the design and prepress team, to make sure that the job is being done correctly.

The key issues

Everything that prepress does is for the express purpose of ending up with the best possible print job, so it's useful to recognize where the bottlenecks are. What are the issues that can cause problems and affect quality?

There are five areas of concern on which prepress focuses:

➤ Color

➤ Layout

➤ Ink

➤ Dots

➤ Mechanics

Let's look at each of these issues in more detail.

Color

Color, as we discussed in the previous two chapters, presents problems when you are trying to print the color values that best represent the design. Because many of the colors you can see on your monitor as you create the image are not available in a print, you have to choose design colors intelligently, with the final output constantly in mind. Many paint and illustration programs have some sort of preview feature that allows you to determine which colors will print on the intended device or printing press as you see them (more or less), and which ones exist only on the monitor and cannot be reproduced with the inks or dyes your printer has on hand.

The imager is directly involved in this issue, by virtue of the fact that he is the one who initially chooses the colors with which he will create his picture. Be sure that you determine what are the appropriate colors for the project's intended output. Talk with the printer who will be doing the job and get his recommendations in writing. That way, if anything goes wrong, you can prove to the client that you held up your end of the bargain.

Layout

Personally, we know of no ad agency, magazine, newspaper, company, or individual involved in the production of printed material intended for mass distribution or viewing that doesn't use desktop computers to do the layout. The day of pasteboards, Xacto knives, and

rubber cement is gone. True, there may still be some highly skilled paste-up artists who cling to the hands-on methods, but they aren't competitive. From a commercial perspective, manual layouts aren't cost- or time-effective when compared to a computer.

Layout is the one major area of prepress that is most accessible for imagers. All you need is one more piece of software—usually chosen from among *QuarkXpress*, *Aldus PageMaker*, or *Ventura Publisher*. That software will turn any imaging computer system into a desktop publishing system. The skills you develop for imaging (especially those that you use with illustration software) are closely related to those needed for electronic layout. Besides, it takes advantage of your ability as a designer. For those reasons, it is becoming increasingly common for a computer artist to assist in or to produce the layout of a project. That's when you are no longer only an artist but also running a design studio, which is one rung higher on the responsibility ladder, as well as (hopefully) on the payment schedule.

Desktop publishing (DTP) does not only do the layout, but also produces the type that is used in that layout. This has all but eliminated the dynamic, volatile, and highly respected role of the traditional typesetter who breathed hot lead, molding it into words you could not only read but also feel. DTP can be a creatively satisfying and useful skill that Sally enjoys employing not only on her images, but on her professional stationery, business cards, and other printed material that we use. Please see Chapter 26 for a fuller discussion and explanation of desktop publishing.

Color separations: The business of balancing inks

The question of ink comes into play long before your image reaches the printer. After an image (and its layout) has been approved by the art director, the file is separated into the colors of the inks that will be used to print the picture. For a four-process printing, these are cyan, magenta, yellow, and black (CMYK). This color separation creates four different files of the image, which are ultimately output to film and handed over to the print shop. Each film is used to create a plate that tells the printing press where to lay that color ink. It also determines how much of each color ink is required.

Suppose the picture were of a tent in bright sunlight, with no shadows. The tent is striped in the four primary colors: cyan, magenta, yellow, and black. Each color separated film would show the stripes only of the color it is meant to represent. For instance, the yellow file would show only the yellow stripes, etc. When that film was used on the

printing press, the press would put down yellow ink only at those places where the yellow stripes exist.

But very few pictures are made only of pure solid primary colors. In fact, the idea is to mix those four primary colors according to varying percentages to create all other possible colors. The problem is making sure the percentages are correct. It is in controlling the varying percentages—and the diverse ways different inks respond to them— that the printer becomes an artist (or a failure).

Should an imager get involved in color separations?

It's now possible for the imager to make color separation files on his desktop computer. Instead of delivering a single digital file to the art director, print shop, or service bureau, he could quite easily provide five files: the master image and its four color separations. As the first step after creating the picture, it is almost too obvious a thing to do— just tell the software to break the file up into the four primary colors. But it's not that simple.

If you want to do the color separations yourself, be sure to consult with your print shop about how to determine the correct percentages for each of the primary colors.

HINT If you're a young artist, just starting out in the business, consider taking a year off from your art. Apprentice yourself to a respected print shop—preferably one that still does things in the time-honored, traditional way, as well as digitally. Learn the insides of the business, and you'll be far ahead of your imaging competitors at the end of that year. We wish we had done that twenty years ago. But who knew back then . . .?

The printer's secret recipe

As we discussed in the previous chapter, the black in CMYK gives greater depth and definition to the primary colors of cyan, magenta, and yellow. But when the black is added, it makes the image darker. To make up for this, the printer must decrease the grey components of the picture's colors in direct proportion to the amount of black that is added. It's also important to understand that black is the least expensive of the inks. So, by using more black in the formula, the printer hopes to decrease his costs. He also will need to keep track, not only of ink percentages, but of volume. If he uses too much ink, it won't be absorbed by the paper (in which case it can literally slide off the page in a gooey mess), or it will take too long to dry.

This balancing act of grey components and black ink is referred to as "Undercolor Removal" (UCR) and "Grey Component Replacement" (GCR). If you get involved in doing your own color separations, you should know that individual imaging programs may use different percentages of UCR or GCR to compute color separations. This means that the final printed image can vary considerably, depending upon where and how the separations were defined. Sophisticated color separation software will allow you to set the UCR and GCR; others just take over and do things the way they were programmed.

HINT

Before purchasing a color separation program, talk to your service bureau about which one they use and why.

On top of that, the same UCR or GCR formulas will produce different results, depending upon when and where the file is printed, because printing inks are variables, not constants. It's just not possible to produce, at least on a commercial level, colors that are always consistently identical. Each batch of ink, even from the same manufacturer, will exhibit different color characteristics. When a printer changes ink manufacturers (as they all do), things become even more problematic, and any adjustments and compensations you have made to bring your computer color more in line with actual printing color will have to be recalibrated again. Then, the actual media that the images are printed on also vary considerably in the way they absorb pigments and reflect colors. Even the same type and brand of paper can react differently to the printing process. For instance, older paper or paper stored in a warm area can contain less moisture than a new shipment of paper, and that will affect how the ink absorbs.

Is color forever?

Chemically, color is inherently unstable and, over time, will change and fade, especially the longer it's exposed to light. The colors used by the Egyptians to decorate their mummies' sarcophagi—colors kept in absolute darkness and at stable temperatures for thousands of years—have not stood the test of time. More recently, the colors of a 10-year-old photographic print are probably already shifting, with reds and oranges becoming more prominent as greens and blues start to fade. There's not very much you can do about it (though you can slow down the process by storing color prints and transparencies in cool, dark, dry places).

That means the printer must rethink how to mix his inks to attain a specific color every time he changes inks or media. From experience, he should be able to make rather good educated guesses about what to expect from any given type of ink, paper, and original image. But it's a difficult call that depends on the skill and professional pride of the individual printer.

In addition, if you want to create the color-separated files on your computer, you will have to work closely with the service bureau that actually puts the color-separated files onto film. Film emulsions vary, chemicals degrade, etc., all of which means that you may not be able to use the same computer settings and percentages six months or a year from now, no matter how closely the color matches right now.

That is one reason that some production managers prefer to work with a company that can do the job of both the service bureau and the print shop—so you don't get in between them when they disagree about color separations. However, a good print shop is not necessarily the best company for putting the color separations to film. Another way of handling it is to allow the print shop to broker the color separations to a service bureau whom they trust. That's more costly, but it forces the print shop to take full responsibility for the final result.

If you create your own color separation files, consult often with your print shop and service bureau. The percentages that they advise you to set one week may change the next week.

We don't mean to discourage you about making your own color separation files. Just remember that making good separations is almost an art form that requires skill, precision, and good nerves. It's a lot of responsibility, with so many ways to go wrong. If an image file is incorrectly separated, the entire print job will be a failure.

Dots

Whether you're working digitally or traditionally, if your image is going to an offset press (the most common type of printing press), it will have to be "screened." (Another term frequently used is "halftone screen," which is the actual layout of the dots.) The color separated files will be divided into many thousands of tiny dots, which will, in turn, determine how much of that color ink will be placed on the paper. See Fig. 30-1.

The dots of these screens are made in evenly spaced rows, or lines. That's why printers and imagers refer to screen resolution in *lpi*, or lines per inch. (Remember in Chapter 10, when we explained that the size of the screen of your final print determines what resolution you should scan your picture when you first digitize it? The generally accepted optimum relationship is that the scan's dpi—dots per inch— should be twice the output screen's lpi.)

Some software—such as *Photoshop*—will allow you to set your halftone screens, but you must be careful that your output equipment is properly calibrated. We tend to leave this matter up to our service

Figure 30-1

A halftone screen applied to a greyscale image, which means that there is only one screen (and one color ink) involved.

bureau, because it is such a precise procedure that can cause major problems.

⇨ Moiré

When the four-color halftone screens are compiled to print out the picture, the lines of each screen are *offset* at an angle. The results are different colored dots fitting next to each other. When the dot patterns are magnified, you will see subtle rosettes of the four colors, which when done correctly will blend into what looks like a continuous tone to the naked eye. However, if the screen angles are not quite right, you'll end up with a *moiré* effect—which looks like subtle swirls of color within the image (see Fig. 30-2).

Figure 30-2

Moiré patterns are evident on this image in which the angles of the four halftone screens were set up wrong. They're most prominent in the small circles of dots in the clown's hat and on his nose.

This distorted relationship of the dots will become obvious and distracting in the final printed picture. Moiré is a greater problem with imagesetters than it is with traditional presses. That's why some experts suggest making halftone screens that follow traditional rules regarding the angle of lines. If you do your own halftone screens, get advice from your service bureau and print shop about setting the correct angles. Until you have some control over the process, be sure to follow your software's default settings or, at least, write them down so you can get back to them when moirés start developing.

By the way, some imagers use moiré as a creative design tool. It was one of the definitive aspects of Op Art, which was popular in the 70's. It is very distracting unless it is done very, very well.

Examining the dots on the film

The film should be checked for the quality and the size of the dots that make up the picture. If they blur (are soft) rather than have clear, sharp edges (are hard), the result can be a color shift. In addition, the dots may be smaller on film than on the printed page (which is known as dot gain). It's the dots that determine the amount of ink that's applied and how it is distributed. Conversely, the quality and the gain (enlargement) of dots can be affected by the paper's absorbency, the ink's traits, and the characteristics of the press.

An experienced printer can usually judge the amount of dot gain that can be expected in a given situation. That's why he should be involved in the halftone screening, to try to compensate for potential gain before it happens. While we don't get involved in halftone screens, we know to look out for dot gain when checking proofs. Being able to recognize problems when they occur is an important aspect of professionalism.

We are firm believers in depending upon the experts for direction and suggestions. But we also realize that most printers are more familiar with traditional processes than with digital ones. So take their advice and sift it through the knowledge you develop about your own image files.

Mechanics

Most prepress concerns have remained the same, whether your prepress is being done in the traditional manner or by computer. It doesn't matter if the original is a photograph, a painting, or a digital file. This is most obviously true when you have to deal with the mechanics of actually printing. Two matters that we have inherited

from the traditional printing industry, and which remain paramount in preparing digital files for printing, are trapping and film density.

⇨ Trapping

We have to go back to some basics to understand the concept of trapping. Printing on a press involves a separate run (or station) for each color. Therefore, on a four-color press, each of the color separations are used to guide the placement of ink for each of the primary colors—cyan, magenta, yellow, and black. (There are other presses using a different number of colors. The higher the number, the better quality the image and the higher the cost. Expensive, ultra-high-quality coffee table art books may be printed on an eight-color press.)

Imagine the precision required to ensure that each color fits the paper at exactly the correct registration. If one color is off just a fraction of a millimeter, you could have gaps (called leaks) and overprinting.

For instance, suppose you are printing a picture of a yellow ball on a magenta background (doing two runs for the two colors). Let's say you print the yellow ball first and then the magenta background onto the same paper. If the registration of the two runs is slightly askew, you might have white gaps on one side of the ball (where the magenta was supposed to meet the ball exactly). And on the other side the magenta would overlap onto the yellow, distorting the shape of it. (For another example, see Fig. 30-3.)

Printing presses are mechanical monsters that seldom create perfect registration for every ink pass, so, chances are, you'll have some overlapping and gaps. Major misregistration will require reprinting the job, but, if you are dealing with a quality print shop, that doesn't happen all that often. (In fact, some print shops are now attempting perfect registration, though we remain doubting Thomases on the feasibility of perfection.) It's the minor misregistration that you have to worry about. That's what trapping is all about.

Trapping actually forces slight overprinting of one color onto the adjacent color, to avoid the possibility of white gaps where the paper shows through. The general rule of traps is to print the lighter color over the darker color. That way, when the two inks overlap, the color that is created is halfway between the two colors—a rather natural gradient, which, to the human eye, is almost indiscernible. However, if the dark color were printed on top of the light one, it would make an edge that would be much darker than the light shape and would be disruptive to the composition.

 HINT The ability of two colors to mix to make a third color is one way that printers can help you save money. It allows for a three-color print job using only two inks.

Figure 30-3

A leak (the white area where no ink is placed) occurs due to the misregistration of numerous print runs on the same image. If the picture had been trapped correctly, there would have been no leaks.

Choking & spreading

Trapping is achieved by two methods: choking and spreading. Let's go back to that yellow ball on the magenta background again. *Choking* would have the background color printed into the area reserved for the ball, actually choking or pushing into its area to create the trap. *Spreading* would overprint the ball, so that its colors would spread out from its circumference into the background. (See Fig. 30-4.)

HINT The rule of choking and spreading is that the lighter color should be the one to do the job. If the lighter color is the background, then use choking. If the lighter color is the object, then use spreading.

Some programs, like *QuarkXpress*, come with a built-in trapping function that can be used at an established automatic level or controlled by the user. There are also many third-party programs that are solely devoted to trapping (some of them run into the thousands of dollars).

Figure 30-4

Traditional trapping	**Desktop trapping**
Cyan spreads Magenta chokes	Line overprints Fill knocks out

With conventional film, exposure can be carefully controlled to slightly over- and underexpose different separations. This ensures that areas of different colors which butt up against one another will slightly overlap each other in the final film. This "choking" and "spreading" can be adjusted to accomodate the registration tolerance of different printing presses. It is usually done by a professional camera operator at a separation house just before film is sent to the printer for platemaking.

In a digital image separate elements (usually lines) must be created that will overprint the color under them, creating a trap. For example, a rectangle may have a cyan fill that knocks out of a magenta background. The trap is created by assigning an overprinting line or stroke to the rectangle. If the line is either cyan or magenta only half of its thickness will actually act as a trap (the detail in the circle shows an overprinting cyan line with the white dotted line indicating the center of the line).

Traditional vs. desktop trapping methods.

Should you do it? Yes, no, maybe. It depends upon whether you want to take the responsibility that can save you money if you do it right, or increase costs if the print shop has to correct your mistakes. The consensus we've gotten from experts involved in trapping is—don't bother, unless you're a printing and color expert. But then, all it takes to become an expert is to learn the rules and use them correctly. If you are going to do your own trapping, study the subject carefully. Read up on it and try to get an experienced printer to talk you through your first several attempts.

We haven't gotten involved in this aspect of prepress, because we feel so much depends upon what specific inks are being used and how finely tuned the machinery is on the day that our job is printed. We'd rather the print shop be able to guarantee our job (which they can't do unless they control all the mechanics of it, including setting the traps).

⇨ Density of the film

The screened color separations that tell the printing presses how much ink to lay down are in fact large-sized sheets of film. (Most color separation films are traditional light-sensitive silver halide emulsions that are created in an imagesetter and are then chemically developed.

Some films are really clear acetate sheets generated by desktop computer printers, but they tend to be of much lower quality than true film.)

The density of the film (the amount of light that each allows to come through) must be measured by a densitometer. Depending upon the composition of the image, the general rule of thumb is that the highlights and shadows should be evenly distributed to ensure a proper exposure, when the picture is printed. Even if the creative decision is to allow the density to be somewhat uneven, most printers advise that you should maintain the same level of density for all positives that are supposed to be in the same document, particularly if they are similar types of images.

When you choose your print shop for an important job, you will want to be sure that the printer will double check your films' densities, as well as keep an eye on their presses at all times. While much of the process has been automated and computerized, the quality of your final print job will still depend upon a skilled printing press operator. It is that person who will constantly monitor color quality and adjust ink flow when necessary. The kind of operator you want is one who takes creative pride in a job well done.

⇨ Coming changes

Just as today's prepress is different from the norm of only five years ago, developing and evolving technologies will bring some important changes to the process over the next few years. The software will undoubtedly get more specific and sophisticated, the tools more powerful and easier to use. Desktop printers may evolve into affordable desktop imagesetters. Finally, our expectations and definitions of quality printing and color may change. Not too many years ago, perfectionists demanded that all their work be set in hot type. Laser printers were initially scoffed at because of their low resolution and tendency to produce "jaggies." But because they became so ubiquitous, those who previously demanded resolutions of 2500 dpi or 2700 dpi for their page compositions began to be content with 600 dpi, 400 dpi, and even 300 dpi type. The quality didn't improve—the standards of excellence changed with the times and the technology.

Therefore, prepress may become a common desktop procedure, like desktop publishing and image editing on Macs and PCs is on a par with large systems costing far more. Prepress software will inevitably become easier to use and more reliable. And the prepress process could become more predictable.

At present, we recommend that most visual professionals will want to leave most prepress procedures to the experts, though you should understand and be able to supervise the process. Consider becoming involved in layout (if it interests you or your clients), make sure you have control over output color decisions, but let the service bureau and print shop take the responsibility for color separations, halftone screens, and other such critical stages.

However, in a few years time, clients may expect that the ability to produce accurate, press-ready color separation files and other prepress skills, is part and parcel of the job they're paying you to do. That's one reason we suggest learning the basic terms and concepts—in preparation for the time when our industry changes, again, in response to changing technologies.

31

Working effectively with a service bureau or print shop

THERE'S an old story about a serving boy who is hungry, although there's plenty of food in the manor. When he finally gets up the nerve to ask for a bite to eat, the cook looks at him with surprise and says, "Why didn't you say something before?"

A digital artist, designer, or art director can hunger for appropriate output of images, but, unless he tells his service bureau and his printer what it is he wants, he will never be satisfied. Communication is the key to getting quality services that fit your needs and design. You must thoroughly explain what it is that you want and need, ask questions whose answers will help you make intelligent decisions, and learn how to discern when you are getting the quality of work that you require. It is also necessary to pick the right company for the job, recognize their abilities and deficiencies, understand the limits of the technologies, and, finally, stay within your budget.

⇨ What is a service bureau?

The term service bureau is an amorphous, ever-changing one that refers to a company that provides a variety of services related to processing digital images. There is some distinction between service bureaus and print shops, but nowadays the blurring of services offered by either or both is creating an industry-wide confusion.

Most commonly, service bureaus are said to be involved more directly with digital files and film, while print shops work with printing presses. The problem is that most print shops now have a computerized area set aside for their "service bureau," and some service bureaus are now offering print output. In addition, various service bureaus define themselves quite differently, from narrow focus (a single kind of service, such as producing color separations) to comprehensive (trying to be everything to every client).

When shopping around for the company or companies that will process your digital images, look carefully at the specific services they offer, rather than at the name by which they categorize themselves.

Services that a print shop or service bureau may (or may not) offer include:

➤ Scanning

➤ Image manipulation or correction

➤ Output to slides or negatives

➤ Color separations

➤ Printing

➤ Assistance in streamlining and fine-tuning your imaging process.

Why use a service bureau or print shop?

Suppose you have the budget and can outfit your system with a quality desktop scanner, film recorder, and color printer. You might even be able to afford a top-of-the-line LeafScan45, Agfa PCR II film recorder, and Tektronix Phaser IISDX dye sublimation printer. So why would you want to use a service bureau or print shop?

Because their experience and equipment will be even better, and they can probably achieve more, in output and final image quality.

For those important, big-money jobs that require the highest possible quality of a drum scan, large color separation films, or four-color process prints, your desktop system will most likely not meet the level of production quality or volume output required.

And for those digital imagers who don't want to spend the big bucks just yet in order to buy a scanner and recorder, they can get excellent results from having a service bureau do their scans and output. The service bureau can provide digital files of scanned images compatible to your system on a SyQuest cartridge, magneto-optical disc, or other transportable storage media. After you have manipulated the image to your heart's content, you can then give them the cartridge back for output. It's a very viable alternative to buying or leasing the equipment yourself, if you aren't doing a high volume business and/or require a higher degree of quality than desktop devices can provide.

Service bureau scanning

The best quality scans that only a good service bureau can provide are usually done on a drum scanner. It's axiomatic to say that the scan you would get from a drum scanner will almost always be superior to any desktop scanner.

What makes a service bureau's drum scan so superior? Though price tags are not always a gauge of what a piece of equipment can achieve, a $5000–$10,000 desktop scanner simply does not measure up to a $100,000–$250,000 drum scanner. First and foremost, the drum scanner uses a much more precise technology. (Please see Chapter 10.) Besides, the typical service bureau drum scanner is a heavy monster of a machine that is often bolted to the floor, which gives it greater stability and solidity.

But more than any technological superiority (which will probably be matched in future generations of desktop scanners), what makes a

service bureau scan better is the scanning technician. You may scan in five photographs or pieces of art a week; a service bureau operator may scan in five pieces an hour. That level of experience can add up to a critical margin of expertise.

In addition, a service bureau may have better software for its scanner. This can translate into more detailed control, better color precision and more image depth.

⇨ When do you need a drum scan?

The difference between a good desktop scanner and a drum scanner can be minuscule. Only a visual expert can tell the real difference between the two. If the art or photography scanned in is reproduced at a relatively small size (under 8"×10"), even then he might have difficulty. The important telltale signs become more obvious when the image is blown up to a larger size or printed out with greater resolution. That's when those negligible differences may become apparent and critical to the question of a quality job.

Even when a drum scan isn't needed, it still may be desirable. When Rolls Royce builds a car, they don't spend 25 cents for a cheap fastener to hold a $50,000 engine together. In the same vein, a creative director putting together an expensive ad campaign may not want to take a chance on any element, including a desktop scan.

Some of the situations in which a drum scan should be used include:

➤ If you are scanning film larger than 4"×5".

➤ If the final print will be blown up larger than 1,000% of the original size.

➤ If you are working with a very particular and demanding client, who wants the best, regardless of whether he needs it or not.

➤ For the peace of mind and insurance that somebody else will take the responsibility and guarantee the quality of the scan.

Quite candidly, relatively few visual situations actually require a drum scan. In fact, desktop scanners have improved so much in the past few years that only a handful of experts can really tell the difference. Already, the Leafscan45 is competing directly with drum scans for images up to 4"×5", and a number of service bureaus routinely use Nikon LS-3510AF and Leafscan35 desktop scanners for many of their customers. As quality improves and prices drop, the drum scanner could become less and less important for quality work.

Information you should provide your service bureau

In order to ensure the best possible scans, you will have to tell your service bureau as much as you can about your images:

> ➤ Exactly what will you be doing with the scanned image? What will be the final output in terms of size, media, and color?

> ➤ To help them determine the proper scanning resolution, you must inform them what sort of output device you will be using (printing press, slide presentation, etc.). What is the projected final printing screen lpi (lines per inch) or the type of film you plan to use?

> ➤ Describe your imaging system to them. How much memory does your computer have? What size file can it handle?

> ➤ What storage media (SyQuest cartridge, DAT tape, etc.) should the digital file be saved to, so that you can use it? Will you provide your own storage media or will they (at an extra cost, of course)?

> ➤ What kind of computer will you be using the file on (PC or Mac or whatever)? In which file format (such as TIFF, PICT, etc.) do you want the digital file to be saved? (See Chapter 25.)

> ➤ The degree of prescan correction you expect from them, as opposed to the amount of correction you want to do yourself. (We like to have the scan emulate the original as closely as possible in color, dynamic range, quality of light, etc. All other corrections, we prefer to make ourselves.)

> ➤ What name should they give the file when they save it?

We also strongly recommend that you put a label with your artwork or on your slide that gives your name, address, and phone number, as well as an attributing copyright line.

⇨ Information you need from the service bureau

There are hundreds of firms throughout the country that either call themselves service bureaus or are *de facto* service bureaus by virtue of the services they offer. You can find them in the Yellow Pages, by perusing ads in local professional journals, or through word of mouth recommendations. As with any other product or service, some service bureaus will be better, faster, or less expensive than others. You have to check them out to find the one that matches up with your needs, expectations, and budget.

When you go shopping for your service bureau, you will want to make your choice based upon knowledge about what they offer, what kind of equipment they use, how experienced and knowledgeable they are, and what procedures they use to ensure quality and security. Some of the questions you should ask include:

➢ What kind of scanners do they use? How often do they calibrate the scanner and by what method? (Calibration should be done when the machine is first powered up and checked frequently throughout the day, because it can change. We calibrate our own film scanners once every two hours, when they are on continuously.)

➢ Is the operator someone who works only on scans, day in and day out? What is his experience? Try to talk to him to get a feeling for his attitude about scanning and his depth of understanding.

➢ How many scans do they do in a day? (Too few, and they might not have the experience; too many, and your job may be rushed.)

➢ Is the scan manned continuously (good) or left unattended (not so good)?

➢ If you give them a mounted slide, will it be remounted?

➢ How do they handle your slides or prints? What insurance do they have regarding damage to your originals? What procedures do they implement to protect your originals?

➢ How fast a turn around can they give you? How much extra do they charge for immediate service? Do they pick up and deliver? Use a messenger service?

➢ Do they guarantee a certain level of quality? How do they define quality? Do they guarantee colors that exactly match or closely match the original?

➢ How large will the file be at the specifications that you have requested?

➢ Do they keep archival copies of your scans on file, and if so, how secure are they? How long will they keep it in their records? (Service bureau archiving is not uncommon. Some artists and most service bureaus see it as a convenience. In fact, there may come a time when the service bureaus will charge for storing images. Other artists worry about their images being kept in someone else's library and, perhaps, being used in some unauthorized manner.)

How to judge what you get in a scan

How and when can you tell whether you got an excellent scan or merely an adequate scan? It depends upon your criteria. As a rule, certain aspects of the scan are not discernible until you see the final output of the image. That's because it is a digital file that will be viewed on a monitor. What you see on your monitor doesn't necessarily reflect the resolution, color or sharpness of the actual picture in the file. (See Chapters 28 and 29.) However, you can check its size, resolution, and other aspects by just calling up the "get info" or "image size" command when in an imaging program.

The most important way you can be sure of quality is by developing a relationship with the service bureau. The quality you get is only as good as the service bureau and its people. And the best way to be able to judge the expertise and reliability of the people who are handling your scans (or anything else they may do for you) is through experience—knowing that they did a good job the last time, because it showed in the final output.

Service bureau computer manipulation or correction of images

Strange as it might seem, some of the people who will be reading this book may never actually sit at a computer or do any digital imaging. Instead, they will act as buyers, sellers, or middlemen, who, as part of their services, arrange for the digital handling of images. They may be art directors or designers whose jobs require that they obtain digital services for a project. Or, they may be artists, illustrators, or photographers who sell their work with an added service built into it. After they have created a picture in a very traditional manner, they will take it to a service bureau for scanning, retouching, and other corrections, and, perhaps, even for complete image manipulation. Then the service bureau will output the image to a medium appropriate for delivery to the client.

As a rule, the kind of manipulation or correction that most service bureaus will do relate to improving the quality of your image. It could be said that such companies are now taking the place of traditional retouchers. They generally have high-powered systems on which they can do some basic image manipulation—removing type from an old ad, adding 3-D effects to an important bar chart presentation, merging two or more files, correcting color or tonal balance, etc. Of course, you pay for these added services.

Clients generally don't use the typical service bureau for creative work, but that line too is blurring. For instance, some high-end, elite service bureaus are infringing on the role of digital design studios, and some digital design studios are beginning to offer service bureau kind of work for their clients. But this particular crossover is still relatively uncommon.

When working with a service bureau for image manipulation, be certain to explain clearly, in person, as well as in writing, exactly what you want. Look over their portfolios to see if they have the skill to do the effects you are seeking. Find out what technician will be assigned your job, talk to him, ascertain his experience. Ask him what potential problems he foresees in the project and how he plans to handle them. Make sure you are paying for results and not for a newcomer to learn on your job.

Some service bureaus are excellent retouching shops, but if you are getting into creative work, we recommend using an individual imager or digital design studio.

⇨ Output to slides or negatives

While film has long been an important intermediary stage of most commercial jobs, it is no longer really necessary. We suspect that in the near future most imagers won't bother with outputting their pictures to slides or negatives. But, in the meantime, there are still some important reasons you may want to continue with this practice:

➤ If your image is going to a stock bureau whose files are still geared to handling only slides.

➤ If that is what the client requests as the final product.

➤ If the image is to be used for slide presentations.

➤ If you are uncertain what the ultimate purpose or output will be, then film is the translatable medium.

➤ To show a client who is either not computer literate or doesn't have the equipment to view digital files.

➤ For a slide portfolio.

Besides, there's something very satisfying in holding a film in your hand; it's an emotional thing that clients still respond to viscerally. You just don't get the same feeling (or the same information) by holding a SyQuest cartridge up to daylight.

Information you need to tell the bureau about film output

Digital image files are not like 'chromes and E-6 processing. You can't just drop off digital files at your service bureau counter and expect them to provide you with the slides or negatives you need. They will need specific information in order to do the job right. Be sure to tell the person behind the counter *and* to label your disc, cartridge, or tape with the following information:

➤ The size and type of film you want.

➤ The resolution you require.

➤ Whether you want slides mounted or unmounted.

➤ The name and format of your digital files, and on what kind of computer system they were saved.

➤ Your name, address, phone number, and a copyright line.

Questions to ask the service bureau about their film output

You will want to know as much as possible about how your digital files will be handled, and by whom, before selecting the company and personnel who will be transferring your images to film. Here are some of the questions we suggest asking:

➤ What kind of recorder are they using? Not only the brand, but the number of bits or the depth of the image (such as 24 bits, 33 bits, etc.).

➤ How often do they calibrate the recorder? It should be recalibrated *every* morning and *every* time they change the film. In fact, we programmed our film recorder to automatically recalibrate after shooting five images. If the recorder is on continuously, it should be calibrated at least once every two hours.

➤ How do they determine that the calibration is accurate? Quality service bureaus process film shot on the recorder often and regularly, to check the colors being produced.

➤ What is the experience of the operator, and how many rolls or sheets of film they do in a day?

➤ Do they process the film by machine or provide custom processing?

➤ What is their turn around time? How much extra do they charge for rush service? Do they do pick up and delivery?

> What kind of color and quality guarantees do they offer? (Some service bureaus we have polled will guarantee color only if they did the original scan on which the image was based.)

> How much contrast will the image pick up? An inherent phenomenon in all copy film processes is that contrast will always increase; it's something you have to plan for when creating a digital design. It's useful to have your service bureau help you understand ahead of time how much added contrast you can expect.

How to tell the quality of film recording

This is easy. Put it on a light box, stick it under a 4X or 8X loupe, look for sharpness, color saturation, and most importantly, contrast. If it looks good to you, that's the definitive proof that the image was output to film properly.

The best copy films are Ektachrome 100 and Agfachrome 100, both of which have emulsions that are corrected for copying. They tend to be slightly flatter than films like Fujichrome, but with very good resolution and color saturation. The Ektachrome is somewhat cooler in tone than the Agfachrome, with a tendency towards blue (Agfa tends towards brown). However, with excellent calibration and the use of proper lookup tables, it is extremely difficult, even for an expert, to tell the difference between emulsions. That's because the corrections are so accurate that they compensate for the film's characteristics and tendencies. (For a discussion on the technology of film recorders, please see Chapter 13.)

Color separation

You need color separations if you are planning to output to a printing press. Those color seps are used to create the halftone screens and the plates that determine what inks are used in what manner on your final print. (See Chapter 29.)

For many digital imagers, the color seps are the final product in which they will be involved. They are also a most critical step for ensuring final print quality. Because of their importance, you will want to be sure that the lines of communication are clear, not only between you and the service bureau, but also between the service bureau and the print shop—and, of course, the client.

No further color corrections are possible after the file has been separated. You'll want proofs and match prints to sign off on and to

show your client. (See later in the chapter about proofs.) Don't go any further until you have a client's written approval of the color separations.

There is an advantage to having the color separations prepared by the print shop that will be doing the print job. That way, there will be no disagreements between companies about who is ultimately responsible for the quality of the job. However, not all print shops are as good at doing color separations as they are at printing. If a print shop cannot produce its own superb separations, it might send the job out to a separation specialist with whom they work on a regular basis. Of course, the print shop will add a mark-up on the separation to their bill. The value to you is you still get one-stop responsibility.

 # Information you need to provide the color separator

> ➤ The name and file format of the digital file and the kind of computer you used to create it.

> ➤ What kind of printing press it is going to be printed on.

> ➤ The number of inks—in other words, how it should be separated—though CMYK (cyan, magenta, yellow, and black) is the most common and may be the only method available from some separators.

> ➤ What brand inks will be used.

> ➤ The desired halftone screen resolution.

> ➤ What size will the final print be.

> ➤ Critical colors that must be maintained with absolute fidelity, such as the color of a client's logo.

As with the handing over of any digital files, try to put as much of this information on a label that is fixed to the storage media (such as the SyQuest cartridge). There should also be a label with your name, address, phone number, and copyright line.

Information you need from the service bureau or print shop

> ➤ Again, you need to know about the calibration of their equipment—specifically, the frequency, method, and to what standard.

> ➤ What kind of computers and other equipment do they use?

> ➤ What guarantees do they provide regarding quality and color?

➤ What is the depth of experience of the operator and the company in making color separations? How many do they do in a typical week?

➤ Do they specialize in working with digital files?

➤ What problems do they foresee, and how can they be avoided?

➤ Is the process automated or manned, and to what degree?

⇨ Judging the quality of color separations

Usually only an expert, with a depth of experience in such matters, is qualified to judge the quality of color separations. That's why you need match prints at this stage for you to check and your client to sign off on. (That means that he officially approves the job so far.) Otherwise, you can be in the soup, if, for instance, the print run of 100,000 has to be discarded because something is off, and you didn't catch it.

HINT

When trying to ascertain the experience of a service bureau or print shop, ask to see some samples of their work. Most professionals are thrilled to show off their portfolios. Also ask to see unfinished pieces from current projects. Look for images that are similar to the kind you will be needing them to do. Ask what were the difficulties about specific pieces, and how they overcame them. It's a useful interaction that may provide valuable information about them.

⇨ Printing

Printing covers such a wide variety of services that there can be some confusion about what a service bureau or print shop has to offer, and how they differ. There are both traditional and digitized print services. At present, most computer-driven printing technologies are geared to one-of-a-kind or one-at-a-time output, and they work directly from digital files. The more traditional printing presses are used for medium to large production runs, and they require color separations and printing plates.

The same company may (or may not) provide both kinds of processes.

➤ All print shops have printing presses. (That's why they're called print shops.) They usually also have some digital printers, which they tend to use to make proofs.

➤ Not all service bureaus have digital printers, though some specialize in them.

> Print shops and service bureaus that shoot color separation files usually have imagesetters that are used for that purpose, as well as for output to photosensitive paper.

> Some companies that are neither service bureaus nor traditional print shops will specialize in large format prints (though such large posters, murals, or billboards may also be available from some print shops and service bureaus).

It sounds confusing because service bureaus, print shops, and other companies that handle digital files are not clearly delineated.

The best way to understand what kinds of print jobs you can get from any of them is to determine what kind of equipment they have. Or to put it in other terms: What you want will determine where you will have the work done with what process and what equipment (and at what price).

There are generally three categories of prints that you may order:

> Individual prints

> Print runs

> Proofs

⇨ Individual prints

Individual prints will include those that you have done for exhibition, presentation, or your portfolio. Even if you are having more than one print of the image being made (but generally less than 100 copies), it will fall into this category.

The printing technologies that we discuss in Chapter 14—such as dye sublimation, thermal wax, dot matrix, etc.—may be used for this purpose. But there are certain noteworthy printers that are available only in specialty shops. These include equipment that will output images onto unusual media (including watercolor paper, cloth, vinyl, etc.) and large prints (such as posters, murals, even billboards).

When you order individual prints, be sure to match the process to the image. In fact, Sally will design her images according to the output she intends. Thus, for an upcoming exhibit, she is creating a bright, clear illustration portrait of Daniel and our cat Chocolate for 42"×36" electrostatic paper output on a *Megachrome* printer that was originally used for plotting out large architectural plans. A 16"×24" fantasy landscape piece that she will be finishing up in *Fractal Design Painter* will be output onto textured watercolor paper on a *Stork* printer. And an abstract that is only in the conceptual stage will probably be done as a batik on cloth.

When deciding on your output for these individual (or small run) images, visit various service bureaus and digital print shops. Ask to see finished jobs that came off different pieces of equipment. Find out what kinds of media and what color palettes may be used with each process. Discuss with the personnel what kinds of files do well with each method or style, and try to pick their brains about tips and tricks they might have for designing the image to take advantage of the various technologies.

Print runs

If you want to create a printed piece that would be distributed *en masse*—such as self-promotion sheets, brochures, magazine inserts, flyers, newsletters, newspapers, etc.—then you will have it run off on a printing press. There are numerous kinds of printing presses, most of which are known by their brand names. However, two basic distinctions are made:

> ➤ The paper form
> ➤ The number of colors

Printing presses may use roll or sheet paper. The large rolls of paper are more economical, but create more difficulty with registration (lining up the various colors) and are used for jobs in which quality is not the primary concern. (Newspapers are usually printed on enormous roll presses, which may also be called web presses.) Presses that handle sheets instead of rolls allow for easy changing of media (so you may have a wider selection of paper type) and less difficulty with registration.

A press may handle two, three, four . . . up to eight different colors per run. Each color is printed separately in a section of the press. (You can quickly figure out how many colors a press can print per run by counting the number of sections or humps the machine has.) If a print shop has only a two-color press, they will have to do two runs to do a four color project, changing the inks in between runs.

HINT

Use a print shop that has the right press for your project. If you need a three-color job, it's usually more expensive to use a shop with only a two-color press. Also, the more runs the paper has to make through a press, the greater the chances are that problems could develop. If you are doing a three-color job on a four-color press, consider adding another color. It wouldn't add much to the cost and could enhance the overall impression of the job.

There are two kinds of colors that may be used: spot and process. Process colors take advantage of the ability of inks to mix in order to create a wide array of colors in the print job. Therefore, a four-color press using CMYK inks can produce a picture that has hundreds or

thousands of colors in it. Spot colors are solids that are already mixed, which means that there are thousands of possible spot colors, each of which is laid down separately from all the other colors in the picture. Spot colors are most frequently used in printing pages that have few colors. Process color is more reliable and economical, as well as being the preferred method for outputting digital files. When making your color choices from various palettes in your software, it is best to work from a process palette rather than a spot palette. But talk to your printer about that and any other decisions you must make regarding color.

 Look into whether or not your print job would benefit from having one of the colors be a varnish. That will give it a glossy, richer look.

The value of proofs

With so many steps along the prepress path, each of which is influenced by different choices that you or someone else might make, it's important to visually check what you have at various stages. This is done with proofs. A *proof* is a print created on a desktop printer, imagesetter, or some other output device. It is important to realize that almost no proof will exactly match the final print, because the output process will be different. But some proofs are more accurate than others. (A *press proof* is an exception in that it is created on the printing press that will be doing the final run.) Be sure you (and your client) recognize what kind of information each kind of proof is providing about the job's progress.

For instance, the proofs that you can get from a desktop printer will never match the colors of a four-process press print, but they are useful to check composition, placement, design, etc. The problem with some of them—most specifically, those from dye sublimation printers—is that the proof can look so good that the client will expect the final picture to look exactly the same.

A contract proof is that which a printer agrees to match in the final print job. It tends to be expensive, but it can be an invaluable guarantee of quality and color for that all-important job.

When you or your client is asked to "sign off" on a proof, the signature on the memo indicates complete approval and acceptance of the proof. So it is important to *recognize* what is being said by the specific proof, and to know what to look for to determine if it is what you want.

First of all, read the memo that accompanies the proof. It should explain what is being promised about the job by the proof. Is it just a check on the composition or a verification of colors? Don't sign any memo that doesn't exactly spell out what you are okaying.

Some of the things you should look for when approving a proof (depending upon what kind of proof it is), include:

➤ Overall design. (That should be approved at the very beginning, before anything else is done.)

➤ The meshing of individual design elements back together. (After the file has been color-separated, you want to be sure that the separations will fit correctly and that the registration of the print run will be nearly perfect.)

➤ Look for moiré patterns, those swirling distractions that occur when the color separated halftone screens aren't properly offset to each other.

➤ Trapping. When colors meet on the page, are there open spaces where they shouldn't be? Be sure that the trapping has the lighter color spreading over the darker. Look closely at the shapes of letters that are involved in trapping, to make sure that they aren't distorted by the process.

➤ Color. If it is a contract proof or a page actually pulled from the printing press, are the colors acceptable? Remember, don't sign off on color until you are dealing with a contract proof.

➤ Clarity. Is the printing process smudging elements that were originally sharp?

➤ Excellence. That's something you must judge according to your own criteria.

Proofing is an important part of the prepress process. It allows you to catch problems before they compound and become expensive. Therefore, the more frequently you proof, the safer you are, although it can get expensive to order too many. Think out where the critical points are for your project and where mistakes are most likely to happen. Then order a proof for those stages.

There's another, psychological purpose for proofing that can be useful in doing business with your clients. There's something very satisfying about holding a piece of paper in your hands that represents the progress of a job. Just be sure that the client thoroughly understands the proofing process, or they might be suddenly unhappy with the quality or expect something in the final print that is actually intrinsic in the proof only.

Sally will print out proofs on one of her desktop printers quite frequently, when she is in the middle of designing a picture. The translation of what is on her monitor and created by light into something that is on paper and of a tangible size helps her in refining her images. And, of course, in sticking closer to reality.

Information you need to tell your print shop

➤ The purpose of your print job.

➤ The number of prints.

➤ The media you want it to be printed on.

➤ The size.

➤ Any folding, inserts, or perforations you will need.

➤ The precision of color that you require, especially providing examples of the color of a client's logo or any other that must be matched.

➤ The color palette.

➤ The level quality you require.

HINT Whenever we have a multiple page, double sided, or folded document printed, we make a dummy up by photocopying the various pages, stapling them together, and folding them according to our design. We give the printer the dummy when we place the printing order. That way, when the plates are laid out by the printer, there is no question about orientation. The very few times we haven't done this, we have sometimes ended up with upside down pages or impossible fold lines.

Information you need from your print shop

➤ What percentage of their work originates in digital files? (You want a printer who is familiar with the peculiarities of working digitally.)

➤ Will they guarantee the traps?

➤ Will they make a limited run for actual press proofs?

➤ Will they check the densitometer readings of your film?

➤ How much dot gain do they expect and how will it affect your final quality? (See previous chapter)

Determining the quality of what you will get

Before you decide on which printer you will use, go into the working area of the print shop itself. Look to see how clean everything is, how actively the operators are involved, and how caring they are toward the job. You want operators who are not only highly skilled, but also

who have a great deal of pride in their work. Go in the morning, when print shops tend to be busy. Watch for specific details, such as the operators pulling prints, regulating the inks, etc. There should be a hubbub of activity surrounding any well-run printing press, as the operator makes adjustments, checks for problems, and coaxes the machine to produce the best it can.

Go back during a slow time and have the manager introduce you to a press operator. Ask him what are the pitfalls of printing, and how they are best handled. The good printers are very knowledgeable individuals from whom you can learn a great deal. What's more, you will get a sense of how well they will handle your print job. Ask their advice. Of course, many printers are good bull artists. Hopefully, you will know enough after reading this book and working with images to discern the truly informative from the run-of-the-mill.

Look at some of the jobs they are currently doing, paying particular attention for clean, clear type, good registration, proper colors, and overall excellence of appearance. Then, when they have done your job, check it for the same things. If it looks good, then it's a good job. If it doesn't work as you had expected, then all the other processes that led up to it were for nothing.

When you have the final print of your job, you can best judge the other aspects of the production process. If you used an inexpensive desktop scanner, yet your own color separations and the final product look beautiful, then why bother with the expense and effort of using top-of-the-line equipment? On the other hand, if you skimped at various stages, and it shows on the final print, you will probably want to rethink your priorities.

The print is the final product. You can view it without any equipment and hand it over to your client. Its very tactility is satisfying. Study it carefully to see what could have been done better. Ask your print shop and service bureau what they think about the end result, and what they feel could have been done differently that would have made it a better, more cost-effective, or more creatively satisfying job. That kind of feedback is invaluable for when you plan out the next project.

⇨ Scheduling a print job

Good print shops are almost always busy. The ones where you can walk in and schedule a large job to be done immediately are not busy enough and, perhaps, not good enough. Besides, if it is an important job, you will want to talk to the print shop before deciding that they are the right ones to do it. That's why it's important to work out your printing schedule with the print shop at the very beginning of the project. Of course, important jobs are often rushed, but that means they require even more care with scheduling, not less.

Once the concept for a project has been roughed out, you are ready to start talking to print shops. Discussing the job with them will help you develop a design that can take advantage of the technology available, as well as use the most cost-effective ways of doing things. That's another reason to get the print shop involved early in the game. Besides, it will give you the time to compare what various shops have to offer.

After you have chosen your print shop, talk to them about when you expect to deliver the job to them. Would they have a press available for your work and how long do they expect it to take? Then plan for the inevitable hangups. Suppose, for instance, the color separations aren't done correctly, the client isn't happy with the layout, someone delays signing off on a proof, etc.

A corollary of Murphy's Law states that delays creep into any project in direct proportion to its importance and your proximity to deadline.

Another important thing to find out beforehand is whether or not the printing press you want to run your job on would be available, should you deliver late. Remember, those presses are expensive machines that must be kept running, or the print shop won't stay in business long. Some print shops will bend over backwards to accommodate your delays, while others will shrug and reschedule you when it's convenient to them.

Plan a realistic production schedule that factors in any possible delays, and then try to stick to it. We have never heard of a project being overscheduled and being delivered too early for the print shop. But we have heard many horror stories about rushing through key stages, missing the printing windows, and ending up with a late, unsatisfactory finished product.

⇨ Developing a relationship with your service bureau & print shop

Everyone knows that the time to find a family doctor isn't when you are sick. You want to have a history with that doctor, so that he knows you and your physical condition. You can trust him, because you have spent the time (and money) developing a relationship with him. You also know his limitations and personal quirks, which helps you understand his comments and suggestions.

The service bureau and print shop that you use for your professional projects is as important to its success as a family doctor is to your physical health. The longer history you have with the service bureau or print shop, the better your chances are in getting results you expect. If

they did a good job before, they will probably provide the same level of service the next time you use them. And if they really get to know and like you, they might just put out that little extra that will mean the difference between a good job and a superior one. That level of consistency and predictability can make your life less hectic and your work more secure. Besides, they can provide invaluable advice and assistance that can further your knowledge and ability that will, hopefully, lead to your creating the right kind of digital files for superior end results.

Many service bureaus will work closely with regular customers to help them overcome the difficulties in determining what colors they will get from the imaging they are doing on their studio equipment. (See Chapters 28 and 29.) Some of this help may (or may not) include:

➤ Color swatch books that relate to service bureau (or print shop) output on their specific equipment.

➤ Free or discounted output of test files.

➤ Calibration software that will coordinate your system equipment to their output.

➤ Modem service in which a service bureau operator will connect to your system over the phone lines to help troubleshoot an image file or a color calibration problem.

➤ A company employee that will pick up and deliver your work on short notice or at odd hours.

➤ A company technician that will personally color-calibrate your system.

If you are not a regular customer, why should they spend the extra time talking over important jobs with you or helping you solve problems that are actually none of their concern? After all, the only responsibilities they really have is to provide the input and output for which you pay. However, the smart businessperson recognizes that if he provides those extra services, his company will be able to depend on your business, because you'll learn to rely on him for advice, assistance, and other support that will help you fine-tune your imaging process.

Developing a relationship is a two-way street. When approaching a service bureau or print shop with which you haven't worked before, you are in an uncertain period—much like the first meeting of two people who may or may not become friends and/or lovers.

Recognize that the person with whom you want to speak is busy. Make an appointment rather than just stopping into their offices. Schedule a length of time that you would like to talk to them; make it at least a half-hour for the first meeting, so you can have him show you around the shop or plant.

Get a feeling for the personality of the individuals and of the company. Some printers are very capable but very rough folk—a personality trait with which we personally feel uncomfortable and difficult to work. We prefer straightforward, uncomplaining individuals with no axes to grind, who will do a professional job, according to specs. But you might work better with other personalities. ·

When you have so many questions that it will be obvious that you are a novice, it might be politic to invite the person out to lunch, not only to pick their brains, so to speak, but to encourage him to be generous with his knowledge. You may even consider asking that person, or some other employee of the service bureau or the print shop, to consult with you to plan a specific job. Their advice may or may not be free, but you would probably be able to pass a consultant's fee onto the client. It may save you time and money in the long run. Most times, they will provide information and suggestions as part of the cost of doing business and keeping you—their client—happy.

Be honest about the likelihood of doing a job with their shop. Is it a bid for the job that you are only just submitting to an art director, or do you have a firm contract? Are you talking to other service bureaus or print shops? Are the bids that you are asking from them going to be compared to other bids? How often do you project that you will be needing services such as they provide? Weekly? Monthly? Clients are as important to them as they are to you. Put yourself in their shoes and treat them as you would wish your clients would treat you.

Keep them informed about the progress of a project, but don't waste their valuable time with chit-chat. Always ask questions and give information, but don't make unreasonable or non-negotiated demands (unless you are willing to pay extra for it).

Make your financial arrangements well in advance, and put it in writing. Will you pay on delivery or one-third down at the beginning of a job? Can you establish a regular credit account in which you will be billed and have a certain amount of time to pay? Will the charges and fees be reduced if your volume of business increases? Will they take a personal check or only a company check? Will you give them your tax number for their files, so you won't have to pay state sales tax? What sort of receipts or invoices will they provide, for you, the client, the IRS? Don't assume anything when it comes to what you will be paying, how you will pay it, and what services you will be receiving in exchange.

You will find that a good service bureau or print shop is worth its weight in gold. Take your time choosing the ones you want to use. You won't be married to them. In fact, you will probably maintain relationships with a stable of them and choose the right one for the job at hand. But the more settled you are in these relationships, the

better off you will be when it comes time to finish up an important project.

When you think you have found a good print shop or service bureau, try using them for a small project or a self-promotion piece *before* entrusting them with a major job. Many can talk a good game; go with the ones that can deliver.

⇨ Determining the bottom line

When we first started out in business, we used to pick our printers by one criteria: price. However, when we had an important rush job, we went with a slightly costlier shop that wouldn't ever bend the rules for us or for anyone, because they always delivered according to the contracted schedule and the agreed-upon specs. Time and again, the less expensive print shops would fail us in one way or another—by being late, by not producing top-notch work, or whatever. But that other shop, the one that was pricier and less flexible, almost always gave us what they promised. We no longer shop around for anyone else to do the specific kinds of jobs that are that company's specialty.

The moral is to always keep in mind that there may be a tightrope balance between quality and cost. Don't always go with the lowest bid. Instead, figure into your calculations the level of reliability, quality, and service you require. But don't take for granted that a higher price will necessarily mean that you are dealing with a better service bureau or print shop.

Different kinds of projects require different kinds of print shops and service bureaus. Once you have defined the specifications of a project, take them (in writing) to various service bureaus and print shops. Ask them if they can handle the job and how they would go about it. If their verbal answers seem to fit your needs, ask them to provide you with a written bid, which you will then compare to other competitive bids. Be sure that their bid includes details of just what they will do, how, with what kinds of guarantees.

After you have selected the winning bid, then give the service bureau and/or print shop you have chosen the final specifications of the job so that they can provide you with a final estimate.

There is a difference between a bid and an estimate, other than the obvious one that a bid is competitive. A bid is based upon the description of a theoretical job; an estimate is based upon the exact and final specifications of a very real and thoroughly thought-out (and almost ready to go) job.

When you accept an estimate, ask where the potential bottlenecks may be and what hidden or uncovered costs might evolve as the job is being done.

Be sure everything is in writing before you turn over a job to anybody. That way, you will know exactly what you are paying for, and they can understand precisely what is expected of them. Such estimates are often done on standard forms, but don't accept all the terms as written in stone. Question anything you don't understand or you don't feel comfortable with.

We do have one personal rule of negotiating—leave some meat on the bone. In other words, we try to get the best agreement we can, but we don't try to push anyone so far that they aren't happy with the final result. We don't want to be anybody's fool, but we also aren't vampires. Maintaining a respectful and productive relationship with your service bureau and print shop requires that they are able to make a profit from the work they do for you. Otherwise, they won't stay in business very long. Besides, if they feel cornered, they may also become resentful, which can play havoc with the quality of work you will be able to get from them. The bottom line of a job is much more than price.

I MAGING is not a cheap medium. Though you can get started with a stripped-down, entry-level computer and "lite" digital software for under $2,000, it's not unlike having the corner drug dealer giving you your first fix for free. The imaging habit is something that feeds on your capital.

On the other hand, imaging has never been more affordable. A few years ago, to do the kind of fancy computer magic we've been discussing could cost in the millions of dollars. Even now, if you go the route of a high-end workstation or solution (see Chapter 7), a complete system would be priced from $50,000–$250,000. But, with a well-equipped PC or Mac system, you'll probably be spending between $10,000 and $50,000. (Leasing will be a little less expensive.) And, if you do it right, your digital imaging equipment should more than pay for itself within 12–18 months, or even sooner.

In this chapter, we will try to help you analyze just how much it will cost you to become an imager. This is dangerous ground, because prices will continue to change as new products, improved technology and competition all impact on the market. So, please don't take any of our dollar figures as gospel. Instead, use them as very general points of reference to help you make decisions and work out your budget.

NOTE All the terms we use in this chapter are explained in detail throughout the rest of this book. If there is any definition you don't remember or any concept you don't understand, please look up the word in the Index or the glossary to find the various explanations.

⇨ The imaging computer

A basic 486 PC (without a monitor, pointing device, hard drive or added memory) will cost about $1,000. An equivalent Mac will cost about $2,000. The most powerful basic systems (CPU, memory, monitor, keyboard, hard drive, pointing device, etc.) will cost about $5,000 on the PC side and about $7,500 for the Mac.

HINT Before you buy any equipment, take an imaging class, analyze your market, and make sure you know what you are going to do with the hardware you buy.

RAM memory is wealth to an imager, a better gift than diamonds as far as Sally is concerned. It's now selling for about $35–$45 per megabyte, depending on its speed and density. (16Mb SIMMs actually cost more than 4Mb SIMMs on a per megabyte basis. There's no such thing as a giant economy size.) As a general rule, RAM must be added in increments of 4Mb or 16Mb at a time, though it's possible to mix-or-match 1Mb and 4Mb SIMMs in order to produce an odd-number configuration. Unfortunately, the new 32Mb SIMMs are hideously

expensive, nearly twice the per megabyte cost of 16Mb and 4Mb SIMMs. We've seen them selling between $2,000 and $2,200 each.

HINT Make certain that your computer will be able to accommodate at least 64Mb of RAM. Many PCs' motherboards can be expanded only to 32Mb, which will severely limit their future expandability.

Color monitors range from about $250 for a basic 14" low resolution color screen to about $3,500 for high resolution 21" "smart" monitors. The bigger the monitor and the higher the resolution, the more it will cost. Alas, the increased price is disproportionate and not incremental.

The bigger your hard drive, the less you'll pay per megabyte. But the faster your hard drive, the more it will cost. The absolutely minimum entry level is about 200Mb, which you could double with *Stacker* or similar software to about 400Mb. That would cost $375–$475 for the drive and under $100 for the doubling software. A 1 gigabyte drive (which many consider the necessary minimum for imaging) costs about $1,100–$1,600. A 2-gigabyte drive ranges from about $1,900 to $2,600. Faster drives (SCSI-2 drives, drives that spin at 5,200 rpms, or drives with seek times less than 10ms) will add about 25% to the price of the drive. Also, drives are usually priced as internal devices that will fit inside your computer case; an external drive (with case, power supply and cable) will cost $85–$150 extra.

HINT When you buy your basic computer, make sure that its controller board and ROM will be able to function with a hard drive that's larger than 1 gigabyte, even if your first hard drive is smaller than that.

Keyboards are often included in the PC system price but are extra on a Mac. A basic keyboard will cost $40–$125, depending upon the brand and features. Specialty ergonomic keyboards sell for up to $260, though they're more suited for heavy text users rather than digital imaging.

A drawing tablet or digitizer with a stylus list from about $129 to over $800 for a high end 12"×12" tablet. Sally started with an inexpensive *AceCat* until she needed (and could afford) the pressure sensitivity and greater precision of the more expensive brands (such as *Wacom* or *Kurta*). The street price for a top-of-the-line tablet will be $500–$700.

⇨ Other storage devices

You will choose your storage devices, depending upon your needs and compatibility concerns. Generally speaking a SyQuest drive is used to exchange files with service bureaus, print shops, clients, etc. DAT tape and magneto-optical drives are usually for off-line storage and

archiving, though they may be used for data exchange. CD-ROM drives will allow your computer to read Photo CDs and all the other data (such as fonts and clip art) that are published on CD-ROMs. Writable CD drives are only for those who want to make their own CD-ROMs. (See Chapter 12.) Look at Table 32-1.

Table 32-1

Comparative costs of storage devices

Drive	Price range	Cost of media*
SyQuest	$280–$700	$65–$85 (44Mb cartridge) or $95–$120 (88Mb cartridge)
120/128Mb Magneto-Optical	$900–$1,800	$45–$65
Multisession CD-ROM	$250–$1,500	Reads only prerecorded CD-ROMs
Rewritable 660Mb CD	$3,000–$6,000	$25–$35
DAT tape	$1,000–$3,500	$14–$19 for 1.3Gb, $17–$25 for 2.2Gb, $25–$35 for 4Gb

* Media are the tapes, discs or cartridges used by these drives to save data

While these prices are current, they aren't written in stone. Discounts are often available, and some hardware can be bought at closeout, reconditioned, or even used. While we do not recommend buying a used computer or hard drive, we bought a reconditioned Wangtek DAT tape drive through an established mail-order company for $650, about half what it would have cost new. It has performed quite satisfactorily for many months.

Digital input

Unless all your imaging will be based on computer-generated illustrations, you'll need to get pictures into your computer in some way.

Flatbed scanners cost from $600 to over $20,000. A reasonably good quality 24-bit device is around $3,000. Studio-size desktop film scanners cost $2,000–$22,000. (See Chapter 10.)

However, service bureau scans and Photo CDs are proving to be very satisfactory alternatives to having your own scanner. (Please see Chapter 31 for a discussion of when you'll want to farm out your scans.)

Service bureau scans are as little as $5 for low-resolution automated scans, with no corrections. Custom high-resolution scans and large-format films can run as high as $75–$100 per scan, and up. A good 35mm scan is about $25–$40. If a print is digitized on a drum scanner, the price is about the same. If it is done on a flatbed scanner, then you'll probably pay about $25 for an 8"×10".

NOTE The cost of scanning is directly related to the resolution and file size. High resolution scans require more expensive equipment and are usually more time-consuming.

The cost to scan in an image on Kodak's amateur or professional Photo CDs ranges from about $1 to $25 per image. The amateur system is geared towards 35mm negatives and transparencies only, while the professional CD system can accommodate film media up to 4"×5". (No paper-based art work will currently work with the Photo CD system.) The other difference between the amateur and professional Photo CD systems is that the latter will yield slower, higher quality scans. Both work automatically and do not require an operator to make pre-scan adjustments. As of this writing, there are no labs that feature customized professional Photo CD scans, but we are certain that soon there will be some Photo CD labs that will do more for you and charge accordingly.

⇨ Digital output

The final output of digital images is a complicated subject that depends upon (and determines) what your final product will be. You may choose between film (usually transparencies), digital-based prints or print shop-type press runs.

⇨ Output to film

Film recorders cost $4,000–$50,000. The average, good, studio-size recorder is about $14,000–$50,000. In addition, film, processing, and mounting—whether you do it in your darkroom or send it out to a lab—will run $.25–$.50 per each 35mm frame. In comparison, service bureaus will output to 35mm film for about $10–$35 a slide, depending upon the resolution of the image. Larger format film range $50–$300. Inexpensive, low-resolution slides (suitable for multimedia presentations) cost from $5 per slide, though we've seen ads for slides as low as $2.50 each. (See Chapter 13.)

⇨ Desktop printers

While you can probably function as a professional imager without a desktop color printer, it can provide extremely useful feedback while you work. Printers are also invaluable for "comps" (composition proofs) and FPO (for position only) prints. Depending upon the technology and the particular model, a color printer may also be used to create portfolio and exhibition pictures. Greyscale printers aren't color devices, but they can be used for generating low and medium-resolution camera-ready halftones. Black-&-white laser printers are

well suited for studio and business management, such as word processing, accounts, scheduling, inventory, etc. We strongly recommend making a desktop color printer as part of your digital imaging system. And if you plan to use your computer for normal business purposes, by all means add a laser printer. See Table 32-2.

Table 32-2

Comparative costs of color printers

Type of printer	Estimated cost	Cost of consumables* per page
Dot matrix	$400–$1,000	50–90 cents
Inkjet	$1,000–$11,000	45–$1
Thermal wax	$2,500–$6,000	$1–$2.50
Electrostatic or color laser	$15,00–$22,000	45–75 cents
Dye sublimation	$1,300–$17,000	$2.50–$7

* Consumables are the ribbons, inks, paper and other materials that are used by the printer to output a page.

Printers continue to decline in price, but the specifications may or may not be the same for the less expensive models. (See Chapter 14.)

⇨ Service bureau & print shop printing

Individual digital prints under 11"×14" run about $10–$200. However, many digital print jobs are priced by the linear foot and are dependent upon the type of technology used. When you take the job to a print shop, too many variables are involved for us to be able to reliably quote average prices. However, as a point of reference, Table 32-3 shows some of the prices that Today's Graphics, Inc. of Philadelphia charges.

Table 32-3

Sample service bureau output costs

Current print charges from Today's Graphics of Philadelphia

24"×36" Iris print $250

8.5"×11" Imagesetter print $19

8.5"×11" PostScript off-press color separation proof $60

8.5"×11" 4-color Pantone proof $89

Typography $100 per hour

Electronic mechanicals $120 per hour

* These prices are bound to change with the market and the technology and are provided only as a point of reference.

Same day or priority service will carry a 50%–200% price premium.

Your software budget

Essential software includes not only imaging programs, but also your operating system, utilities, etc. When you buy your computer, the *Windows* or *System 7* is most often included in the price, installed and ready to go. Be sure to get *Norton Utilities* and/or *MacTools* or *PCTools*, which cost about $125 each (See Chapter 27). You'll accumulate other non-imaging software, as the need arises or as you can afford it. We wouldn't be surprised if the typical imager spends about $1,300 per year on utilities and other accessory programs.

Imaging software is another matter entirely. Get one at a time. After you have mastered one, then consider buying another. Take your time selecting each piece of software. Attend trade shows to see demos of various programs, so that you may compare them in action. Eventually, you'll probably want at least one powerful paint program (about $650), one major illustration program (about $600) and one desktop publishing program (about $700). Filters and other specialty software (such as special effects and texture libraries) you'll probably buy as you can afford them, after you have developed the skill to use them and understand the kind of projects they would be useful for. The first such purchase will probably be a package of *Aldus Gallery Effects* for about $100.

Keep an eye on your budget. The add-on software may be inexpensive, at least compared to your main programs, but they mount up. A successful imager could easily spend about $3,500 on imaging software in a year, though you could probably get by with a budget of about $1,200, after your initial investment.

You should also figure in the cost of updates. Software companies often make more money selling the latest versions of their programs to registered users than they do marketing new software. Supposedly, updates contain important improvements, enhancements, and corrections for bugs and other deficiencies in earlier editions. However, some companies seem to issue suspiciously frequent, expensive updates that do not appear to feature enough to justify the price. The general rule of thumb is that software companies issue one major upgrade every 12–15 months, and the price to registered users should be roughly a third of the list price of a new program. We usually update our software with each major revision.

The price of knowledge

Probably the least expensive aspect of getting into imaging will be your very first investment—learning. Half-day introductory seminars can be found for free. To really learn, you'll spend a couple hundred

dollars to about $1,500 (plus room, board and transportation, if necessary) for classes in which you will sit at your own computer and do some actual imaging. (Please see Chapter 18.)

 HINT We repeat: Don't buy any hardware or software until you have taken a class and done some imaging. The reality is worlds apart from any theoretical information you may read or be told.

You'll also want to budget in the subscription of at least two imaging magazines and one general computer magazine, plus the purchase of various reference books. That will probably be about $150–$200 a year.

Can you afford it?

Don't go into sticker shock. It's possible to do things piecemeal, obtaining and upgrading hardware and software as you develop the expertise and the clients that will help you pay for them. Or you can lease or finance your purchases, to take the bite out of spending all your capital at one time. It's not unlike building wings onto your house as your family grows. The trick is to make sure that your basic equipment will be able to accommodate future additions. For instance, you will in the long run save money by getting a computer that can accommodate at least 64Mb of RAM, though you may start out with only 16Mb.

If you want to be completely logical and businesslike, you'll want to buy or lease only that equipment that you know you can afford. The equipment that you need but can't afford to buy or lease, you can usually farm out that work to a service bureau on an as-needed basis. Of course, that doesn't take into account the considerable emotional and creative value of having a piece of equipment always at hand, as opposed to using a service bureau. You'll have to make that kind of judgment call on your own.

The general rule of thumb is if you can't project being able to pay off a piece of equipment or software within 12–18 months, you should get something less expensive, lease rather than buy, or farm the work out to a service bureau.

You'll also want to factor in your projected volume. For instance, suppose you want a $15,000 film recorder, which you project you'll use to output about 36 exposures a month. With that sort of low volume, it would be much more cost-effective (and probably give you better quality output) to use a service bureau, which might charge $15–$25 per 35mm exposure. (Usually, the more work you farm out to a service bureau, the bigger the discount they offer you as a regular customer.)

 HINT Check the prices of your local service bureaus for the quality and type of input or output you would want before getting a scanner or film recorder.

To buy, lease, or rent

Anyone who is in business recognizes that there is more than one way to get equipment onto your premises: buy it outright, lease it, or rent it. You buy if you have the cash flow and want ownership, possession, unrestricted use, and the ability to dispose of the equipment as you see fit. You lease if your accountant feels it would be a financial advantage, or if the market appears to be changing dramatically, and you can get a favorable (though more expensive) short-term contract (such as 6 months or 1 year). You rent if you want to use the equipment for a specific, short-term project (especially if you can pass the cost of the rental onto your client), or if you just want to try it out before committing to it.

Buying equipment

When you buy the equipment, it's yours to do with as you please. In the long run, it's the cheapest alternative. In fact, if you pay on delivery, you may be able to negotiate a discount. There are several options: pay cash, take out a loan, pay on an installment plan, or pay by credit card (which, if you're using a gold card or platinum card, may have the added advantage of possibly extending your warranty).

But there are disadvantages to buying. Unlike cars and houses that have relatively stable and predictable value, the computer market is notoriously volatile. That means that you may not be able to use the equipment as collateral for any loan (though there are exceptions). Also, when you buy, you may spend your entire budget on fewer items, thereby delaying your ability to upgrade your system or add components as soon as you had hoped.

Before you buy, consider the following:

> ➤ Can you afford it? (Including whatever extras are necessary.)

> ➤ Is it what you really want, and do you really need it?

> ➤ Are you getting it for the best price?

> ➤ Does it come with good service and a good warranty? (See later in the chapter)

> ➤ Will you be able to trade it in or sell it at a reasonable price when you want to upgrade?

Leasing equipment

Leasing is an option that is best discussed with your accountant, because the advantages are essentially ones that deal with cash flow and tax considerations. When you lease, you can get much more equipment into your office sooner, because the initial investment (down payment, refundable deposit, first and last month's payment, etc.) is much less than buying the equipment. On the other hand, the total cost of leasing is usually more than buying. But that can be a deceptive measurement, because it doesn't take into account variables such as being able to hold onto your capital for income-earning investments, savings, or to maintain your business. Also, it's possible that the entire lease may be tax deductible, whereas there's a limit of how much purchased equipment you can deduct in a single year. (Currently, purchased equipment over $10,000 must go through a 3- or 5-year depreciation cycle, even though most is paid off and replaced before then. As we write, Congress is debating to raise that limit to $20,500 or $25,000, so the point may be less important if your total investment falls within that range.) Depending upon the contract, your lease can be up in 6, 12, 18 months, 2 years, 3 years or any predetermined period. This gives you more windows of opportunity to upgrade to newer or cheaper equipment.

When you lease, your note becomes an asset of the leasing company, which may be sold or transferred by them to anyone. So, don't take a salesperson's verbal promise about anything to do with leasing. Get absolutely everything he promises you in writing, including offers of extra service, consideration, available accessories, trade-in options, etc.

Your leasing contract remains in force for its full length, regardless of what happens to the equipment. It can be a lemon, destroyed in a fire or stolen . . . whatever happens to it, you (or your insurance company) will be liable for the full cost of the lease contract.

HINT

If you lease, don't tie yourself to a piece of equipment for longer than 2 years. It's not practical, given the rate of innovation and cost reductions in the industry. As an alternative, you can sometimes negotiate a lease in which you may upgrade the equipment at certain intervals (for an extra fee, of course).

Here are a few things that one should consider when negotiating a lease:

> ➢ How long is the lease?

> ➢ Is it an open-end or closed-end lease?

> ➢ Is insurance included or extra? Who is warranting the products?

> ➢ Is there a down payment involved, and, if so, how much?

➤ Is there a security deposit? Is it returnable?

➤ Will you be required to prepay the first and last month?

➤ Will there by a buy-out option at the end of the lease? How much money is it?

➤ Will there be a balloon payment at the end of the lease? How much?

➤ Is there an upgrade or trade-in option? What are the terms?

➤ Can you also put training, service, materials, etc., on the lease?

Renting equipment

Renting is the most viable option for very short-term use of equipment, especially on a per job basis. Conventional wisdom states that you should never rent for periods longer than 4 months, because it will cost more than buying. (The rule of thumb, with rental companies, is that a rental device should pay for itself within 5–7 months.) However, that seems to be too long a rental period to us, given the kind of money it can involve.

HINT Take out your calculator and add up the real costs of such a venture—including shipping, insurance and other expenses—before signing on the dotted line.

We rent filmless cameras and other equipment on a daily or weekly basis for specific jobs and bill the client for the rental. We also recommend renting equipment, if you just want to see how well you would function with it before you go ahead and buy or lease. In fact, renting things like filmless cameras for a personal project is a great way to learn how to use them professionally.

Before renting, check out the following:

➤ Is the equipment you want available when you need it?

➤ Must you positively return it when you have agreed to do so, or may you extend the time until you are done your assignment?

➤ What sort of security deposit, if any, is required?

➤ Will you get a substantial discount the longer you rent?

➤ Can you change the rental into a lease, or even a purchase, and be credited for the amount you have paid already?

➤ Who is insuring the equipment?

⇨ Where to get the best deal

It seems that everybody and his brother is ready and willing to sell you a computer and whatever else you might want to attach to it. You could get your imaging system from the privately owned neighborhood computer shops, franchise computer store, superstores, specialty shops or VARs, or through the direct channel (mail order).

⇨ The neighborhood computer shop

In an ideal world, in which budget isn't a consideration, we'd be happy to recommend getting your imaging hardware and software at the local "mom and pop" computer store. They're convenient, and it would mean supporting what may be a family operation. Unfortunately, most locally owned and operated computer shops tend to be high-priced, with a limited inventory and not much knowledge about digital imaging. Still, we do buy cables, diskettes, and other emergency or small items from our local shop, because they're convenient, and because it makes us feel better.

⇨ Franchise computer stores

Franchises, like ComputerLand and Entre, are more complete business-oriented operations that concentrate on aftersale considerations, such as service and training. However, their primary market is businesspeople (who usually buy office computer equipment), not digital imagers. They also tend to be expensive, because they have fancy showrooms and maintain a relatively large sales and support staff. What's more, their sales staff usually have a limited knowledge, based upon the specifications of the equipment they have in stock, which generally doesn't translate into imaging-specific information.

⇨ Superstores

Large superstores, like CompUSA, tend to have excellent prices on many (but not all) items, a good selection and, usually, an easy-going return policy. However, don't expect to find technical expertise or specialty items, such as a film scanner. While they usually have a service department on site, they are often quite busy, and it can take some days before they get to your equipment. (A few superstores provide loaners while your equipment is in the shop, but the available loaner may not have the same capabilities as your machine.) Also, superstores can be gold mines of misinformation, especially about digital imaging, so know what you want before you walk in the door.

Specialty shops & VARs

When you want to deal with imaging experts, you go to a specialty shop or a VAR (*value added reseller*). These may be a comprehensive imaging department in a well-established professional camera shop or some other company that has chosen to specialize in putting together digital imaging systems. The essential difference between specialty shops and VARs is that a specialty shop usually focuses on imaging and solutions for specific studio needs. A VAR also offers solutions, but focuses on selling systems rather than components. The staff of both kinds of companies know their equipment, tend to have the best available, and are very service-oriented. Their tech support will talk you through anything or even come out to your place to set up the system. Depending on your arrangement with them, they may be able to repair or replace malfunctioning equipment in as little as four hours from the time you call for help.

The primary advantage of working with a specialty shop or VAR is that they make things work—whatever it takes. They consider how *every* specific component or peripheral integrates into your computer system. They'll tell you when a particular hard drive or film scanner is not the best for your needs or configuration. Of course, you will pay at or near full retail prices, which means that this might be the most expensive way to go. But it can also be the cheapest, if you factor in the value of your time and the cost effectiveness of not making an expensive mistake. You'll be up and running sooner, your downtime will be diminished, and you'll have someone to call or complain to when you have problems or something goes wrong or you just need advice about how to proceed with a particular project. Part of what you are paying for are answers and assistance when you need it.

Pick your VAR or specialty shop carefully. Go by their reputation and the length of time they have been in business. For instance, we work with Ken Hansen in New York and Mid-City in Philadelphia, as well as WEB Associates in Norristown, PA. What one of these doesn't have, or can't answer a certain question satisfactorily, another probably will.

Incidentally, if you are going to use a particular VAR or specialty shop for their advice, it's only right to also patronize them. We heard of a woman who spent many hours at Ken Hansen's imaging center getting advice and answers about what she needed. But she eventually purchased her Macintosh system at a discount house, saving about a thousand dollars. When she got into trouble, she thought nothing of calling Ken Hansen for help. They didn't turn their backs on her, but it really wasn't a nice thing for her to do.

HINT Be sure that your imaging specialist is knowledgeable about artistic digital imaging. Corporate imaging—the digitizing of large volumes of files—is another type of specialty and an entirely different animal.

⇨ The direct channel

Mail order (which has become known as the direct channel) is a highly reputable, intensely competitive, multi-billion dollar industry which accounts for a quarter of all the microcomputers and 35% of the software sold in America. Nowhere else will you find better prices or a larger selection. It's the easiest place to comparison shop and the quickest way to get exactly what you want, with no-hassle or overnight delivery available. Even major companies like Compaq and IBM now sell through the direct channel. You'll find dozens of ads in any computer magazine with listings of equipment and software available, usually through a toll-free number. The only other channel that provides better responsiveness and technical support are specialty shops and VARs.

When working with the direct channel, you want to be sure that:

➤ You have a 30 or 60-day, no questions asked return privilege, with no restocking fee.

➤ They have the products you want in stock and can ship them out within 48 hours.

➤ They provide unlimited telephone technical support.

➤ You fully understand who pays for the shipping.

Have them fax you an *exact* specifications list of what you are buying, by brand names as well as description, before you give them the order. If possible, pay by credit card. It gives you more protection and may even extend your warranty period. (You can always persuade the credit card company to withhold payment or lean on the vendor, if you have problems.)

If you deal with really large companies, like Dell or Gateway, chances are you'll have very few problems, often fewer than any other method of buying or leasing (other than VARs or specialty shops). The big companies got as big as they did by giving customers exactly what they want: great prices, excellent service, and quality goods.

SUGGESTION For full service and knowledgeable personal support, spend the money to get your equipment and software through a top-notch imaging specialty shop or VAR. If you know what you want and are not intimidated by technology, you can save money by going through the direct channel. Superstores and neighborhood shops are useful for supplies, such as labels, cables, etc., after you are up and running.

⇨ Warranties

Warranties are usually included in the purchase of equipment. It used to be that 90 days was the industry standard, but the technology has become much more reliable and one-year warranties are almost universal. Many companies offer 2- or 3-year warranties on some products, such as modems and video boards. High-capacity hard drives can even have 5-year warranties.

But there are a few things you should know about your warranty before you assume that you are covered:

➤ There's a difference between vendor-issued warranties and manufacturer's warranties. A vendor will usually repair or replace an item quickly. A manufacturer may take weeks or months.

➤ In many instances when you ask for a warranty repair, your product may be replaced by a used or refurbished product. In the fine print, it frequently states that they don't have to give you a new item in exchange, but one that is equivalent to yours.

➤ Most warranties don't cover you for willful damage or for data loss. If you happen to drop your SyQuest drive, it might not be covered by the warranty (though your insurance may cover it).

➤ Most are parts and labor warranties, which means they don't warrant any other part of your system that may be affected by their product.

➤ If you buy components and peripherals from a number of vendors, each will be covered separately, which may make it harder to get warranty repairs. Each manufacturer or vendor may blame the others.

➤ Software is warranted only to say that the media is not defective. No manufacturer guarantees that their software works, is bug-free, or won't screw up your system. Every time you break open the seal on a software package, that's what you're agreeing to. But as our sister the attorney says, just because they say so, doesn't mean it's so. Complain about problems, and you may get satisfaction.

➤ Don't accept any verbal guarantees. Get everything in writing.

➤ Be sure to send in your warranty cards, because some companies look for reasons not to honor guarantees. Also, it will put you in their database to be kept informed about upgrades and ensure that you have access to technical support.

➤ Always save original cartons, packing materials, etc., in case you must ship a piece of equipment back for repair, exchange, or return.

 # Service contracts

Many computers and systems are sold with service contracts, as part of the deal. Other vendors offer service contracts for an additional fee, often nominal for the first year or even second year, but rising significantly thereafter. There's on-site, walk-in, and return to depot contracts. Most are performed by a national service company that has no ties to the product manufacturer.

The *on-site* contract will get a technician to your office, usually within 24 hours of your call. Depending on the level of service you want (and pay for), that can be reduced to 4-6 hours or be made available in off-hours, like evenings or weekends.

Walk-in service requires that you physically carry your equipment to the nearest authorized repair shop. Repairs are generally made within 48 hours, and you pick it up when it is done.

Return to depot service means packing it up and shipping it back to the manufacturer or vendor, usually at your own expense. They will repair it within a "reasonable" time. (The actual period varies tremendously and depends on such things as how many other repairs are ahead of yours, the availability of parts, and the responsiveness of the company.) Usually, they pay to ship it back to you, by the same means you sent it to them. (If you sent it Federal Express, they will return it Federal Express. If you use UPS Ground, so will they.)

With both walk-in and return to depot service, when you get your equipment back, you are responsible for re-installing it yourself.

Insurance

Computer insurance is cheap. We insure all our imaging equipment with one of the best known and largest brokers specializing in high-tech equipment: Safeware. They've paid up various times, including when we were hit by lightning, which wiped out our laser printer.

The rates vary, depending upon the degree of coverage you require. Some policies cover everything, including data loss and business interruption. Others cover loss or damage to equipment only. We pay about $110 per $10,000 of computer equipment at market replacement value, with a $50 deductible. If something goes down, they pay to have it repaired or replaced with an equivalent piece. Given the reasonable rates, it would be foolish not to be insured, especially since so many things can go wrong.

Your studio, business or camera insurance may or may not cover your imaging equipment. Check with your insurance agent and, if he says you're covered, get it in writing. Also, be sure you have in writing just what the insurance company will do if something happens.

HINT Keep a list of your equipment, including serial numbers, original invoices, and replacement value, in your safe deposit box.

33

Getting help when technology fails, or how to avert & resolve crises

THIS is a good day to write this chapter.

Yesterday, when we were attaching a new CD-ROM drive to our Macintosh Quadra 700, our 400 megabyte hard disk froze up and died. It seems that the software that came with the CD-ROM drive was defective, and it corrupted the program that tells the computer how to get its data from the hard disk.

This morning, when Sally went to power up our Comtrade 486 WinStation, it simply refused to start up. So she moved over to our Micro Express 486, and the mouse wouldn't respond.

And, yet, this afternoon, we are merrily working away at this book and other projects.

Computers are nothing more than dumb machines that can function at incredible speeds. That means that they are able to do remarkably complex tasks, one step at a time, within seconds. The more complex the hardware and the software get, the greater potential for a misstep somewhere along the way. That, in a nutshell, is the main reason why computers sometimes fail.

NOTE One difference between a Mac and a PC is that a Mac user usually needs less technical support. All the accessories, peripherals, and software that work on a Mac are simpler to attach, start, or maintain. The PC system is more complex, which can translate into more time spent troubleshooting.

This is not to say that computers are intrinsically unreliable. Quite the contrary. Considering the amount of data they are asked to process, they are more reliable than just about any other high-tech tools we use in our modern society. The problem is that we have become so dependent on them to get our work done, communicate with the world, create our masterpieces, and file away our important contact lists and documents. Then, when they do fail, the impact on our professional lives and emotional well-being is extreme. The personal sense of betrayal sometimes feels as though it is almost on the same level as finding out that your lover lied to you. No wonder that, when we were in the middle of this morning's crises, we were seriously considering titling this chapter "When All Else Fails, Shoot The Computer." But we'll probably save that title for a murder mystery we're thinking of writing about a computer artist who goes on a rampage.

We're lucky, because we knew what to do to extract ourselves from yesterday's and today's crises. We can even predict what might happen tomorrow and try to prepare ourselves for it, or, possibly, even how to prevent it. No, we are not "tech-heads." We are simply a

writer and an imager who have had our share of crises and have had to learn from our past problems. Given that we write and speak about technology professionally, which means we test quite a bit of hardware and software, changing the configurations of our machines almost on a daily basis, we are much more prone to problems than the typical computer user. But the most valuable resource we have is not our experience or our knowledge, but our ability to reach for the telephone. And that is a resource available to everyone.

NOTE When it comes to computers, the truly intelligent person is not the one who knows all the answers, but the one who knows where to get the answers.

Help! is on the line

When we purchased our second computer (this was back in the dark ages when Radio Shack ruled the industry, and our new machine was a TRS-80 clone called an LNW), it wouldn't start up. The warranty card warned us that opening the case would instantly invalidate the one-year guarantee, so we shipped the machine back to the manufacturer, paying for express delivery both ways. They unfastened the screws that held the case, opened it up, and plugged in a cable that had shaken loose. One week later, some dollars poorer and seven days behind in our work, we were able to start the computer with no problems.

Today, when the mouse failed on our Micro Express, we cavalierly unscrewed the case, yanked a board to make sure it looked okay, plugged it back in, changed our keyboard, and jiggled a few cables. The mouse is working fine now.

What happened to change us? How did we learn what to do when problems arise? Over the past decade, manufacturers of computers, peripherals, accessories, and programs have had to become much more sophisticated, even slick. There are so many competitors out there (a high percentage offering nearly identical products) that service has become one of the pivotal marketing tools they can use. So the really good companies have telephone and fax help (technical support) lines. (Don't use the fax lines, until you feel really comfortable with the machinery.) Technicians man the lines, answering all kinds of questions and instructing the caller, step by step, how to fix a problem. The technicians and the phone lines cost money and eat into profits, so the manufacturers have discovered that it is in their best financial interest to help their customers become self-sufficient.

Service contracts

As we discuss in Chapter 32, service contracts are often included in your equipment purchases. However, even if you have a service contract, you will want to be able to do some basic troubleshooting yourself. Otherwise, you will have to sit and wait, twiddling your thumbs, until help arrives. Besides, unless you have a service contract that covers the entire system, including all components, accessories, and software, it is possible that your problem may not be covered by the contract.

Common sense dictates that most computer users should attempt to solve the easier problems, whenever and however they can. When the difficulty is more severe, such as a hard disk crash, a blown motherboard, an erratic memory chip, or other hardware problems that require physical repairs or swaps, that's when it's time to take advantage of service contract help.

What to expect when you call for help

Automated telephone systems have taken over the corporate world, so it shouldn't be a new experience for you to dial a phone number and have it answered by a recording.

"Hello, welcome to XYZ, Inc., please press '1' for help with widgets on a Mac system, press '2' for assistance with widgets on a PC system, '3' for anyone who doesn't know what kind of widget he has, '4' to buy the new, improved, updated Widget Plus, '5' to speak to Bozo the Clown . . ."

They're predictably irritating, but efficient and cost-effective, so they're here to stay. That means, if you are among the few traditionalists who still have a rotary telephone, one of the first computer accessories you should obtain is a push button, touch tone phone. (If you have a rotary phone, many automated systems will allow you to stay on the line until a live receptionist answers. But that can add even more time to your wait for a technician.)

HINT

When you call for technical help, do so from a phone next to your computer. If you don't have an extension line there, get a portable phone. You must be at your computer to work with an on-line technician.

It's rare to get a technician on the line right away. Usually, you wait, listening to bubble-gum Muzak, advertisements for product upgrades, suggestions that you call the fax line, etc. After you have been waiting a while, many companies give you the opportunity to leave a recorded

message, promising that a technician will call you as soon as one is available. If you are in the middle of an emergency, don't leave a message—stay on the phone. We do trust some companies, such as Symantec, to really call back as soon as they can, but others can take a day or two or longer. Some few still haven't returned our calls.

If it isn't an emergency, try leaving a message, to learn whether you can depend upon the company to return calls quickly during future crises. Daniel often leaves a message, then calls back immediately on one of our other lines so that he can get into the live queue again. Usually, he reaches a technician before one phones him back.

When a technician does get on the line, he may tell you his name. (Ask for it if he doesn't, and write it down.) Then, he'll ask you your name, what product you are calling about, what kind of computer you are using, and, (if the problem is with a piece of software) possibly, what your registration number is. The truly service-oriented companies also have their technicians ask for your phone number, in case you get disconnected. It is a good idea to request his direct phone number for the same reason (though many companies expressly prohibit him from giving it to you).

Then the two of you get down to work. You'll need to describe your problem as clearly and as fully as you can. Explain just what you were doing when it occurred. For instance: "I had *Photoshop*, *WordPerfect*, *Act!* and *CorelDraw* loaded in *Windows 3.1*. I had just applied a *Gallery Effects* graphic pen filter on a 15 megabyte image in *Photoshop* and went to save the file, when an error message came on my screen that said, 'Application Error: Imp800.drv caused an error in module unknown at 0001:3CF3.'" The more specific you are in describing the problem, the sooner you're likely to get to the solution. But if you aren't sure what happened, how or when, don't worry. Explain it as best you can and depend upon the technician to ask you the right questions to extract the answers he will need. Sometimes, the technician will pose a question to which you have no answer. If that happens, ask him where or how you might find that information.

(By the way, for those techies who are reading this, this application error is a hodge-podge of various ones we have seen and never understood. Since the hex numbers—the double group of four digits or letters—meant nothing to us, we haven't bothered to reproduce them here exactly as they were.)

Write down, precisely, any error messages you encounter, with comments on when they occurred and what you were doing at the time. Keep the pieces of paper close to your computer so that you can refer to them when you are on the phone with a technician.

The technician will hand-hold you through diagnosing and, hopefully, correcting your problem. He may ask you to type specific commands into your computer. Be sure to do it exactly as he says, and to describe what you are doing as you do it. Two of the most frequent mistakes made in these circumstances is that the caller is not in the right window or screen, or she has typed the command incorrectly. By describing what you're doing, you can avoid errors.

Sometimes the technician may actually have you open up your computer, pull a board out of the machine and describe it to him. That's how we first learned to not be afraid of violating the inner sanctum of hardware. Don't worry. Be sure he understands that you're new to this kind of procedure. Then, take it step by step, listening carefully to what he is saying and explaining fully what you are doing before you do it and, again, as you do it. (Of course, make certain that your computer is turned off and unplugged whenever you mess around with its innards.)

Be precise and clear about what the results are of your actions. If you don't understand what he wants you to do, it's his responsibility to phrase the instruction so you can understand it. Ask questions about why he is having you try this or that. What exactly is it that you are doing, and why? If something doesn't sound right, express your views. This is how you will learn. Also, jot down what you do at every step of the way, so you can repeat it on your own, if necessary.

HINT

Sometimes a technician will explain his suggestion of how to repair a situation and then try to hang up. Request that he stay on the phone as you do whatever it is he told you to do, explaining that you are new to this and aren't sure how to go about it. We still make that request— and it is usually honored—whenever we are on the phone with a technician, because his first suggestion is not always the best, or even correct answer. We don't want to have to call back and wait in the queue to go through the diagnostics all over again with another technician.

Remember to be patient and gracious. Can you imagine what it must be like to sit in a cubicle all day long, answering the phone, trying to calm down people whose computers have failed them? We wouldn't want that job for any amount of money. Besides, you want the technician to be happy about staying on the phone with you as long as you need him—hopefully, until your problem is solved. (We've had phone calls that lasted an hour or longer, with the technician practically rebuilding our machines or software, using us as his hands. That's a generosity of time that deserves kindness and explains why there's almost always a queue for getting to a technician.) Remember, all he has to do is hang up the phone, and you'd be left high and dry. (Yes, that's happened to us, too. Usually, when he just doesn't know what to do, or it's close to his lunch break, or because he just doesn't want to work on the problem any longer.) It's much easier to be nice

to the technician you have on the phone than to call back to be put on hold and start over from the beginning with another technician. (Unless it's a small company, chances are you won't get the same technician twice.)

On the other hand, there may come a time when you will want to talk to another technician. If your problem is complex or the person you are working with doesn't seem to know how to fix it, he should suggest getting someone else in the company to assist you. If he doesn't, you should ask for another technician—in as diplomatic terms as you can muster.

Try to never hang up in exasperation, as tempting as it might be. It's a waste of time (and money, if it isn't a toll-free call or if you're on a 900 line).

HINT Sometimes (but, in our experience, not often) technicians make mistakes and complicate matters even more. Try to write down what they tell you to do to your computer. That way, if you have to backtrack, you will know just what was done and will be able to restore your computer to the state it was in when you first called.

Of the many scores of times we've called for help, the technician has been able to help us correct our difficulty about 90% of the time. If the solution isn't immediate, then, often, it has to do with a corrupted piece of software or a failed piece of equipment. Replacement parts or program disks have almost always been shipped out to us within 24 hours—sometimes by Federal Express and often at the company's expense.

A few times, the technician has been so perplexed that he couldn't think of what to tell us to do. In those circumstances, it's not uncommon for him to suggest that the problem lies with another piece of equipment or software that was made by a different manufacturer. It has been an even split between discovering that he was right about that—or that he was just passing the buck.

One of the major problems with an imaging system or any other complex computer system is that there are so many different pieces of hardware or software interacting, it isn't always easy to zero in on what's causing the specific problem. (That's the main argument for buying all parts—hardware and software—from one source that will guarantee everything will work well together.) So, if, as occasionally happens, one company's technician is unable to help you, try calling another company whose product is somehow related to the problem at hand. For instance, when we were having difficulties with random applications errors in *Windows 3.1*, Microsoft suggested that we call tech support at Matrox, the manufacturer of our 24-bit color graphics board. Sure enough, the high-resolution video driver had some bug that was tripping over *Windows* when certain commands were

invoked. The problem was solved after Matrox sent out, and we installed, an updated video driver.

If speaking with a technician from the second company doesn't work, call the first company again—maybe another technician will come up with a different, more effective idea.

We have been taking advantage of manufacturers' help lines for as long as they have been available. No wonder we have learned a few things, can sometimes speak the vernacular, and have no fear about juggling a few cables to get a mouse to work. Even Sally, the archetype of the non-technically oriented artist, has been known to throw switches or change jumpers inside a computer. After a few phone calls with these technicians, you begin to feel comfortable with the machinery, can recognize the standard course of action they will take in certain circumstances, and learn that these machines aren't as alien and unapproachable as they first appear.

Manufacturers' bulletin boards & fax help lines

In addition to the technical support that manufacturers offer over the phone, many have fax and/or modem lines that are generally free to all customers.

On some fax help lines, you send a message to the company with as much detail as you can provide about the problem—your equipment, registration number, invoice, and, of course, your return fax number. They will fax back instructions on possible ways to solve the problem.

Another kind of fax service is connected with the automated phone system. Pressing numbers on your push button phone, in response to recorded multiple choice questions, you zero in on the problem that you're having and then order the related printed instructions to be faxed back to you.

The limitation on both kinds of fax help lines is that they deal only with common problems and solutions. If your difficulty is not one that occurs frequently, no preprinted instructions will be relevant to it. Nor do the fax lines provide any interaction with a technician who might be able to diagnose your problem by asking questions whose answers you might not have thought of providing.

Facsimile lines are also very useful if you don't want to be left hanging on the phone for a half hour or longer. Just fax a request to the company to have a technician call you. It's a lot cheaper and, often, faster than trying to get through on a busy line. But, sometimes, you won't hear from a technician for hours or even days. Some companies don't bother responding to such faxed requests for a call back, period.

Bulletin boards are programs that are accessible by calling in on a modem line, using your computer to communicate with the

*manufacturer's computer. Several different kinds of support are
available this way. Two types are similar to the fax help systems just
described. You may either leave a message about your problem and
call in later to see if a technician has responded to it on the bulletin
board. Or, you may look at solutions to common problems that are
already up on the bulletin board.*

*In addition, there may be a forum section in which other users and
technicians leave messages for the general public about problems and
solutions they have encountered. (These are similar to the commercial
bulletin boards we discuss later in this chapter, but they are
intrinsically prejudiced toward the manufacturer's products.)*

*Finally, "patches" may be downloaded from the manufacturer's
computer. A patch is a bit of programming code that supposedly
corrects a bug or weakness in the original software. Like a cloth patch
sewn over a torn sleeve or frayed pocket, a software patch is loaded
on top of the program and replaces the defective code. Sometimes
these flaws relate not to bad design but to a conflict with a specific
piece of equipment or other software that you are using. For instance,
a particular paint program may interface with a Solitaire film
recorder, but not with the company's newer, less expensive Sapphire
film recorder. But they might have a patch that could correct that
deficiency.*

*You may download the patch to your computer (that will require a
certain sophistication with using a modem), and then incorporate it
into the original programming according to the instructions that are
on the bulletin board. The general public—including registered
owners of the product—usually won't be informed about these flaws
and patches unless they call into the company or arrange to purchase
the next upgrade version.*

*We've had limited success downloading patches from bulletin boards
(sometimes they are large files that can take many minutes to transfer,
plus we live in the country and the quality of the phone lines isn't
good), so we always ask to have an upgrade disk shipped to us
instead.*

⇨ When the manufacturer's help line is no help

There's no question that manufacturer help lines are one of the most
useful services in the computer industry. But they don't always have all
the answers, you may not feel comfortable being a technician's remote
control assistant, or you might not have the temperament or time to
sit patiently holding a phone, waiting for someone, even anyone, to
answer. Even more pointedly, what happens if your computer breaks
down on a Saturday evening, and you have a Monday morning project
deadline? (Only some help lines are available on weekends.) Or what

do you do when you seem to have a problem that no manufacturer recognizes or will admit could possibly be caused by their product?

In addition, help lines are expensive to run, so there may come a time when they will no longer be available or affordable. Already, some companies are charging for the service, after your first few calls—over $2.00 a minute. Even WordPerfect, whose 800 line is the best in the industry, is considering downsizing its toll-free support. Today's reality is that there are some companies that have little, no, or very poor quality technical support. So, other sources of help have become important to the computer user.

Manufacturers' help lines

Even before you buy a piece of software or hardware, try to ascertain what level of technical support you are going to receive. A variety of schemes are offered:

- *An increasing number of hardware manufacturers offer lifetime technical telephone support as a way to get you to buy their equipment.*

- *Most telephone support is free, but not toll free. You will have to pay for long distance charges—on calls that can last as long as an hour, or longer.*

- *Many software companies place a time limit on free support, typically one year or 90 days. After that, they charge by either the minute or under a service contract. But others don't bother limiting you, because they recognize that it is usually the new users that have the greatest need for help. Besides, technical support is one of the selling points for trying to discourage pirating of software.*

- *Manufacturers' bulletin boards and fax lines are usually, but not always, free. Typically, they are not toll-free.*

It's not always possible, but, if you can, try to test out the quality of a manufacturer's technical support before you buy or lease. Call their help number and ask questions that relate to your system and how you would be using their product. (When we are reviewing a product, we will often call the support phone number at various times of day or night, just to see how easy or difficult it is to get through, and the quality of advice they give.) If you can't do that, talk to a friend or associate who has purchased the product to find out about their experiences with the tech support.

⇨ Third-party help lines

As can be expected, 900 telephone numbers (in which charges are added to your phone bill) and other kinds of third-party help lines are now proliferating in the computer world. Some companies generalize in all sorts of hardware and software problems. Others specialize in

specific applications, programs, or equipment. Calling them incurs a charge based on time, applied either to your phone bill or credit card. Or, you can establish an account or purchase unlimited support for the length of a contract. (We strongly suggest that you don't buy a contract until you have tried them out with a few problems.)

Why would you use a third-party help line instead of a manufacturer's? First of all, you don't end up sitting on the phone and waiting interminably. Supposedly, the meter starts running from the time you start talking to a real person, not when your call is answered by an automated system and placed in a queue. So, it is in the company's financial interest to get you through to a technician right away. The technicians are said to be better trained and motivated. Not being a manufacturer's employee, they don't have to follow a particular official line. In other words, they can tell you the honest truth about a product and not worry about the reputation or bottom line for their company. Also, they tend to work with more than one product, so if the problem is related to incompatibilities or conflicts rather than something that is integral to an individual program or piece of hardware, they will still be equipped to help you with it. So there should be no buck passing.

On the down side, this kind of support can be very expensive. Most are not proven solution finders. And you are paying for time, not guaranteed results.

Third-party help lines advertise in newspapers, professional journals, computer magazines, or send out direct mail to computer users who are registered buyers of certain manufacturers' products. We have never used one, so we have no suggestions about which companies (if any) are worth your patronage.

Commercial & private bulletin boards

One of the interesting phenomena associated with the general proliferation of microcomputers throughout the world is the growth of dial-up bulletin boards.

Some of these—numbering in the thousands—are small-time private operations run on a shoestring, by a single person or a small group, looking to communicate with like-minded computer users. They leave their computer modem lines open, often 24 hours a day, to provide an electronic forum in which callers may exchange ideas, horror stories, tips, patches, public domain freeware and shareware, as well as give and receive technical assistance and advice. Usually, the only expense is the price of the phone call, though some bulletin board sysops

(systems operators) charge an annual membership fee to help defray their expenses.

Most of these private bulletin boards specialize in a particular type of computer system, peripheral, or application.

Then, there's the commercial bulletin boards (called on-line information services), which are as different from the small private ones as a banquet hall in a four-star resort is from grandma's kitchen. Companies like CompuServe or America On-Line operate huge mainframe computers with many gigabytes of data on virtually every subject under the sun. (Eventually, even the Library of Congress will be on-line.)

All commercial bulletin boards charge a fee. It can be an annual membership, a monthly charge, a per minute use, a per kilobyte of information downloaded, or a combination of all of these. You may already be a member or have a card for a free month of service, if you have recently purchased a modem or communications software. Often, manufacturers bundle in free trial offers to CompuServe, Delphi, Dialog, or America On-Line, as a marketing strategy.

The most relevant features of these dial-up information services (for computer users and imagers having difficulties) are the SIGs or Special Interest Groups. SIGs relate to specific subjects, and members access information on that subject in a subsection called a forum.

The SIG forums that are of particular interest to digital imagers are those involved with digital imaging, graphics, desktop publishing, photography, and consultants. Hundreds of hardware and software companies, such as Adobe and IBM, maintain forum sections that focus on their specific products. By the time this book is published, there may even be a forum or two devoted exclusively to digital imaging. We've found that the computer consultants' forums can be quite valuable, in which you can ask questions and receive answers from some of the most knowledgeable experts in the field. You may also read and join in on dialogues between various consultants and other computer users. These running commentaries can go on for weeks, discussing pet peeves, potential solutions to problems manufacturers don't even acknowledge, suggestions for speeding up your system or getting rid of bugs and viruses, etc.

HINT

Though many users often forget it, these bulletin boards are governed by the same laws of libel and slander as any public communications media. Manufacturers have sued individuals for comments they posted on bulletin boards, claiming that they libeled and defamed their products, even to the point of causing their stock to fall on Wall Street. Be sure that what you say when you leave messages is founded in fact, not in anger or aggravation.

We don't usually access these forums ourselves, not because they aren't useful, but because we live in an area where just connecting to the nearest access number would involve a long distance charge, on top of the connection, membership and monthly fees. However, the few times we have had the opportunity to look these services over, we have found CompuServe to be the easiest and most useful. It has the largest base of users, the most information and the most active forums, some of which focus on digital imaging products. America On-Line (AOL), Delphi, and the other major services appear to be more geared towards the occasional amateur or the hardcore professional in fields other than computing, though AOL has a respected *Photoshop* forum.

Many "name" journalists and other experts are accessible through their private mailboxes on various on-line services. (You can even leave messages for Bill Clinton and Al Gore, both of whom have private mailboxes on several services.) We use our MCI mailbox almost daily, as a means to deliver articles to magazine editors and communicate with clients. In fact, we welcome readers to contact us on MCI at DGROTTA with their questions and comments. We will not always be able to answer all queries personally, especially if we are hit by a deluge. But we will do our best to respond to them either personally or in various articles, columns, or future books.

Connecting to a bulletin board

To connect with a bulletin board, you will need a modem attached to your computer and to an outgoing telephone line, plus a communications program (which is often included in the purchase of your modem). This will allow your computer to dial out to the bulletin board and talk to the computer on the other end of the line.

When you are connected, your screen will be taken over by the "host" computer. It will ask you your name and password and then offer you various multiple choice options or ask you to type in commands that will get you to the forum or other area that you want to access.

Here are some suggestions for functioning efficiently with bulletin boards:

> If you want to leave a message for a technician or other person, compose it on your word processor before calling the bulletin board. Then upload (send) it to the host computer when you're connected. It's more cost-effective and easier.

> Be very wary of downloading (receiving or taking) programs, especially what are called freeware or shareware. While most on-line services do scan such files, viruses can still get through, infecting systems and destroying data. (Freeware are programs

that are free for the taking. Shareware are ones for which the developers will request that you pay a fee if you decide that you want to use it.) If you do download any program, it's safest to save it directly to a floppy, rather than your hard disk, and then scan it with an anti-virus utility.

➤ When you want to read a forum dialogue or other informative material, don't bother trying to read it while you are on line. If it's lengthy, you will be paying for every minute it takes you to read the text. Download text to your computer, so that you can read it at your leisure, even print it out, after you have closed the modem connection. (Viruses are rare with such files, but you can scan anyway.)

➤ Try to schedule your calls to commercial dial-up bulletin boards in the off-peak hours, when the prices are always lower (both phone and any per-minute charges). Check with your on-line service about what their peak and off-peak hours are.

➤ If you have the time, try browsing through any one of the forums related to digital imaging, graphics, desktop publishing, etc. The dialogues can be amusing, as well as informative. Take note of who is writing what. Some participants are very reliable and fair. Others are hot-tempered and given to bad-mouthing a product, service, or individual. If you keep track of the senders' names, you'll soon be able to recognize the ones you want to pay attention to and the ones that are there just for comic relief.

➤ Take advantage of your communication program's macro building ability. Macros can partially or completely automate the dial up, log on, upload, and download processes to save you time, money, and effort.

➤ Keep a log of the times that you are able to get through and the times that the lines are busy. That way, you can determine the best periods for calling in, with a greater assurance of getting through.

➤ Be judicious in your use of bulletin boards. It can be very habit-forming, and the charges can quickly mount up. We've known people who have been hit with $200–300 monthly phone bills, just from heavy on-line use.

HINT If you don't have a modem yet, spend a little more money and buy a good quality high-speed device. The latest generation of top-of-the-line modems are capable of transmitting at 14,400 bps, and up to four times faster with special data compression software. This means that it's fast enough to send and receive large graphics files to or from a service bureau or client. Anything slower would be too slow or expensive. Currently, 14,400 bps modems cost between $300 and $500. Be sure to buy one that can use the MNPS protocols.

NOTE If you use your bulletin board private mailbox for accepting assignments from clients, be sure to follow them up with written

confirmation. (See Chapter 4.) If something goes wrong with the assignment, some companies will not accept records of on-line communications as valid contractual agreements.

➡ Local wizards

Even for those of us who live in the sticks, there are nearby computer experts who delight in sharing their knowledge and providing help in crises.

As we discussed in Chapter 17, our favorite source for finding these individuals is through the local computer users groups. These are clubs of people involved in using computers who get together to exchange information, advice and help. This is a valuable network that costs a minimal membership fee to join. Members have varying levels of knowledge and ability, and have learned to depend upon each other.

Also, users groups are excellent sources to locate tutors and technicians. We found a very intelligent, personable, and capable technician through our local group who charges less than any computer store for house calls and usually comes up with answers more quickly.

You can find out about users groups by asking at your public library, nearby college computer department, computer store, or looking in computer magazines and tabloids.

➡ Things to do before you call in the cavalry

Sally's Quadra was dead last week. No matter how many times we pressed the ON button, the system just wouldn't power up at all. We were about to check the fuse box in the basement when Daniel remembered that he had removed a board the night before and, in accordance with all the recommended safety practices, had first disconnected the power cord from the computer itself. *Voila!* It helps to have electricity feeding into a computer if you want it to work.

Recently, we had a devilishly difficult time initializing a GPIB board (General Purpose Interface Board, made by National Instruments) on a PC, to be used to operate a Leafscan45 film scanner and an Agfa PCR-II film recorder. We followed the directions to the letter. We even spent over an hour on the phone with a National Instruments technician, called a GPIB expert at Agfa, and talked with a local technology expert who installs them daily, but with no success. Sally kept saying that it must be something so simple that no one is even

bothering to mention it. Finally, in the middle of the night, Daniel had a brainstorm, rushed down to Sally's office, and successfully initialized that board within minutes. The problem was a single dipswitch that changed the board from the older to the newer version (both were available for software compatibility), which the documentation mentioned only once in passing, and that the technicians probably thought too obvious to even suggest. It was pushed the wrong way, and, once corrected, the board worked perfectly.

Computers usually conform to the philosophical maxim called Ockham's Razor (William of Ockham was a medieval monk). It states that whenever there is a simple answer and a complicated explanation, usually the simple answer will be the correct one.

In other words, not all computer problems are serious or fatal. Nor do they absolutely, positively need a technician to correct or cure. In fact, the great majority of difficulties are simple to fix. Even a novice can look for the obvious, and those who are a little more experienced can do some serious troubleshooting without having to take a degree in computer science. Yes, certainly, you can leave everything to a technician or a consultant, but that can be both time-consuming and expensive. The expense is unpleasant, but the loss of time is irreplaceable. Besides, if it's a problem you inadvertently created yourself (and many are, especially when you're installing new software or adding a new device to the system), if you don't know what went wrong, you may end up committing it over and over again.

Here are a few things you can look for or do before you pick up the phone and call for help:

> Look for the obvious. Are all cables and connectors properly attached? Is the power on? Have you pressed the Enter key?

> Turn the computer off for at least 30 seconds. Sometimes, freezes and glitches miraculously disappear when the system is powered down and restarted.

> If there is an error message on the screen, read it and write it down. Then do what it tells you to do, or look in the "Troubleshooting" section of the documentation to see what it suggests as a solution to the error message. In fact, even if there is no error message, check the "Troubleshooting" section anyway.

> Look through other books that you may have purchased. (See Chapter 20 about third-party books.) They will often have a clearer perspective on potential problems than the manufacturer's documentation, because they have no vested interest in making sure you believe that the product is the best thing since sliced bread.

> Ask yourself: what is different this time than before? Did you install a program on a PC that changed your CONFIG.SYS or AUTOEXEC.BAT file? Did you plug in a new board or change the configuration on an old one? Are you using a new program for the first time? Sometimes there is a conflict that must be resolved first before the system will work properly.

> Go back to the basics section of your documentation or the section that covers what you were trying to do. Something that seemed logical to you as the next step may be a mistake. Often, following the manufacturer's directions will get it working again.

> Detach external peripherals, such as a scanner or film recorder (after making sure all power to the devices is turned off and power cords are removed). Sometimes the mere presence of a device, even when turned off, will interact badly with a particular program.

> Use a utility program, like *MacTools* or *The Norton Utilities*, to help diagnose, pinpoint, and, very possibly, correct the problem.

Software to save the day

We are not people who believe in keeping up with the Joneses or buying brand name products for the sake of the label. So, it is unusual for us to be completely devoted to a product and say to you that there are two software packages you simply *must* have, available for both the Mac and the PC. *The Norton Utilities* (from Symantec) and *MacTools* or *PCTools* (both from Central Point Software) are absolute required purchases. They have saved the day for us more times than we can count. Okay, if you are on a limited budget, buy just one to begin and save for the other. But don't bring a computer into your studio without also bringing in at least one of these programs.

Why? Because they can recover lost data, restore hard disks even after they have crashed, protect you from known computer viruses, optimize your hard drive, back up all data, and leap tall buildings in a single bound.

Right now, as we write, *PCTools* is (hopefully) repairing a major hard disk crash, which is what kept Sally from working on the Comtrade WinStation earlier today. Yesterday, we used *Norton Utilities* (with the considerable assistance of a Symantec technician on the phone) to diagnose our problem with the Quadra. There have been times when we have accidentally deleted important files; yet, with these programs, we were able to restore them.

There are things that even these two utilities can't fix, but that usually is limited to the kind of problems that require physically repairing or swapping the hardware.

Please see Chapter 27 for a fuller discussion of these programs, as well as others that are useful or necessary for maintaining a healthy and productive computer system.

What is a hard disk crash?

Your hard disk drive is made up of several platters, which are read by magnetic heads that float about ¹⁄₁₀.₀₀₀ of an inch above the surface of the platter. The platters spin 3,600 to 5,400 RPM every second that the computer is turned on. That translates to hundreds of millions or even billions of revolutions during the life of the disk drive. Every single revolution has to be perfect and error free. All it needs to screw up is one single mistake.

Sometimes, the heads literally crash down on to the platters for a fraction of a second, and physical damage can occur, wiping out sectors of data. It's due to fatigue, power surges, software bugs, cycles of the moon, bad karma, or whatever.

Sometimes, all you need to do is re-install the hard disk drivers (software) to get them up and running again. Minor crashes can be repaired with utilities software, such as SpinRite, PCTools, or The Norton Utilities. Major crashes—by that we mean when software is wiped out wholesale or the disk won't even boot—are much more serious and may require remanufacturing (rebuilding) or even replacing the drive.

Minor crashes happen infrequently, but almost every hard disk will experience them over the course of its life. Major crashes are much rarer, but when they happen they are far more traumatic and the data may not be recoverable. Certainly, the user won't be able to resurrect a hard drive that has had a major crash.

When a major crash does happen, it's a catastrophe. That is why you want to be sure to back up all data as often as you can.

 # Redundancy is the best preventive medicine

The first rule of maintaining a healthy computer system is redundancy—the duplication of data, methods, or machinery that protects against complete loss of information, material, or time.

The most effective (and most expensive) kind of redundancy is to have duplicates of your entire system. When Sally couldn't work on the Comtrade this morning, she just moved over to the Micro Express.

The simplest form of redundancy is to keep a separate set of your computer data (backups) on removable storage media. (Please see Chapter 12 on storage media and Chapter 27 on backup utilities.) That way, if there is any loss—catastrophic or minimal—you can

restore your data to the state it was when you last backed up. That is great incentive to back up frequently.

This morning's hard drive crash on our Comtrade WinStation is certainly catastrophic. We'll probably have to ship the drive back to the manufacturer and will ask for a new one, since it has been only a few months since we purchased it. But we are able to keep going on the book and other projects because we have a dual backup system. All the chapters of this book are saved, as we write them, both on our hard drives and on floppy disks. Also, we regularly back up all our hard drives on DAT tapes. Unfortunately, there is some material we may or may not lose—specifically, some entries that we made yesterday in our *ACT!* contact database that contains the names, phone numbers, addresses, and other information about the people in our lives, and the notes for two telephone interviews we did last night. But it could have been worse. This isn't the first time that backups saved our skins, and it won't be the last.

Considering how easy it is to back up hard drives, it's one of the most time-efficient and cost-effective methods available for preventing disaster. In fact, it is generally acknowledged that backing up is the number one essential housekeeping chore of maintaining a useful computer system.

Afterword

Doubtless, over the next months and years, digital imaging equipment and software will continue to evolve. But the real revolution rests in the hands of the people who will use the technology, to create new visual perspectives. It's going to be an exciting, sometimes unsettling, highly creative, and potentially profitable decade, fueled by your imagination, skill, and business sense.

As hard as we tried to fit everything we wanted to tell you about digital imaging into this one volume, the subject is so broad that it simply was not possible. Instead, we concentrated on providing a comprehensive overview of the technology, business strategies, artistic avenues and other professional concerns related to digital imaging.

Even that "abbreviated" perspective mushroomed this project well beyond its original dimensions. According to our contract with Windcrest/McGraw-Hill, we had agreed to deliver a manuscript about digital imaging in four months that would contain approximately 135,000 words and 100 illustrations, or just enough material to fill a 302-page book. It would sell for $29.95. Our publisher arrived at those particular figures from experience with hundreds of other book projects, and by having the corporation's "bean counters" run cost-versus-sales spreadsheets.

But they, like us, badly underestimated the amount of work and the number of words needed to produce the first comprehensive overview of the digital imaging field. The four months stretched into nine, the 135,000 words burgeoned to nearly a third of a million words. And yet, we still had more to say, explain, and explore.

By judicious self-editing before sending it on to our publisher, we managed to pare our original 1,000-plus page manuscript to just over 600 pages, or about twice the specified length. But at that point we hit a brick wall: it was not possible to reduce its size further, and still cover the subject with style and as much detail as readers required. In mid-June, we had a meeting with our editor, publisher, and a number of others who are involved in designing and marketing the book. We asked them to suggest what, if anything, should be cut or condensed.

Whenever one person suggesting editing out something, another would speak up, saying how much a part of the whole it was. Every cut was voted down. It was agreed that if we removed sections or chapters, the book would be perceived as inexplicably incomplete. On the other hand, if we streamlined the copy by cutting out details, examples, and explanations, critics could correctly take us to task for being too simplistic and superficial. After all, digital imaging is a complicated subject with many facets and components, all of which must be raised and discussed in an introductory book.

In the end, our team at Windcrest/McGraw-Hill made what is considered, in this day and age, to be a courageous decision: ignore the bean counters. Everyone unanimously agreed to double the page count, up the price, and reschedule the publication date, so we could include everything that belongs in an introductory book. Even the marketing department, which already had pre-sold thousands of copies, was firmly behind the decision. It's unusual and rewarding to have a publishing house believe in our book to that extent.

But remember all those pages that we cut from our manuscript, before we submitted it to our publisher? Well, they are now squirreled away in our computers, and will form the nucleus for three additional books on digital imaging we'll be writing over the next two years. Each book will approach the subject from a very different perspective, and will provide new kinds of practical information for those of you who pursue imaging as a career.

Our next work, *Digital Imaging Nut n' Bolts*, is a practical, down-to-earth advice-laced book on selecting, buying, installing, and troubleshooting digital imaging hardware, software, and accessories. It is also be a sourcebook of: digital imaging equipment and software manufacturers; dealers and VARs that specialize in selling, leasing, or integrating digital imaging products; important service bureaus; art schools and seminars where digital imaging techniques are being taught; books and magazines dedicated to digital imaging; professional societies and organizations; trade show dates and locations; etc. Of course, it includes lots of tips and tricks to help you avoid the mistakes we've made.

Concurrently, Sally is writing *A Digital Imaging Education*, a step-by-step, reality-based description of how specific images were conceived, created, fine-tuned, and output. Rather than sugarcoating the complicated process of actual imaging, it will candidly discuss the problems, mistakes, and disasters that can (and did) occur, and what can be done to avoid or overcome them. Tips and information are provided to help you translate the solutions that evolved out of each project to your own work.

The last of this series is *The Illustrated Digital Imaging Dictionary*, which is far more extensive and detailed than the glossary in this book.

And so, as the digital imaging revolution continues, we will continue, too, writing books—as well as our Digital Imaging Newsletter, magazine articles, and lectures—to help you remain at the forefront of it. Because your feedback is important to us, we invite your comments, criticisms, questions, and suggestions. How are we doing? What did we leave out? What errors should we correct? Please feel free to contact us c/o Windcrest/McGraw-Hill, or by addressing an electronic letter to our MCI mailbox at DGROTTA.

Thank you for your interest, and best of luck as a digital imager.

Daniel Grotta & Sally Wiener Grotta
Boyertown, PA
October, 1993

Technical information

This book was written using WordPerfect for Windows 5.2 on a Comtrade WinStation 486, a MicroExpress 486, and a no-name 386 clone. The reason why so many PCs were used is because the 486s were review machines that were on editorial loan, and which had to be returned to the manufacturers while the book was being written. Sally's own 386 system was used in between review machines. She is now using a super-fast, high-powered, no-name EISA/ISA/VL-bus 486 system that Daniel just built, which has 64Mb of RAM and a 1.7 gigabyte SCSI hard drive. It is also equipped with a Matrox MGA Impression 24-bit video board, a Wacom SD420E digitizing tablet, and a 20" Mitsubishi color monitor.

All of Sally's original images were created on either the 486s or an Apple Quadra 700, using a variety of imaging software. On the two review 486s, she used a Matrox Impression 1024 video board (with a Sequel calibrator) and a 20" Mitsubishi monitor. On the Quadra, she used the computer's built-in 24-bit video capability, a 16" Apple monitor, and calibration was done with the Kodak Color Sense system.

Her original slides (which are the basis of most of her imaging) were scanned in with a LeafScan 35 or LeafScan 45. A few pictures were originally taken with a Kodak DCS 200 filmless camera and downloaded directly to the computer. She uses no clip art in her original artwork, preferring to create all elements of her montages and illustrations herself. Screen captures (pictures of what is on the monitor) were done with *HiJaak* and *SnapPRO* on the PCs, or with *System 7's* own screen capture hotkeys (Shift + Apple Key + 3) on the Quadra.

Transparencies of color images and one greyscale picture were created on both the PCs and the Quadra, and then output to film with an Agfa PCR II film recorder, using either *Image Assist* for bitmapped or photographic images, or *SuperPrint* for object-oriented illustration images. (Film is still the most reliable medium to communicate with absolute certainty what colors you want.) We used a Lasergraphics LFR Mark II as a backup film recorder, which has its own proprietary software drivers.

Most pictures (other than the few transparencies) were delivered to our publisher on SyQuest cartridges, recorded on a Procom Technology 44/88 megabyte drive or a MicroNet 44 megabyte drive.

Other storage devices that we use include a Procom Technology magneto-optical drive (to hold the overflow of folders and subdirectories of images on which Sally is currently working) and a Wangtek DAT tape drive (for our backups).

Color proofs of images were done primarily on a Tektronix II SDX dye sublimation printer, though some were also output to a Canon CJ10 bubble jet printer or a Hewlett Packard DeskJet 1200C/PS printer.

We are not yet on a network, but that is our next step. At present, we just leave connector cables dangling from each computer, and unconnect and reconnect peripherals as we need them. It's a flawed system that is sure to break down soon, because it accelerates the normal wear and tear on cables and connectors. (Note that we *always* make sure that everything is turned off before connecting or unconnecting anything.) We share text files on floppy diskettes.

Glossary

As with any specialized subject, there's a whole new nomenclature about digital imaging to be learned. We have attempted to define unfamiliar words and terms when we introduce them for the first time in any chapter (most people do not read technical books from cover to cover, like a novel, but will skip around to the chapter that they want information on immediately). That's because understanding something in context is always more useful than simply looking it up in the back of the book. However, there is a place for a glossary, and this is it.

If this glossary seems too limited or incomplete, or lacking in illustrations and examples that's because we had to abridge it for brevity's sake. After all, this book is large and long, and if we added everything that we wanted to or thought should be included, it would probably be bigger than the Manhattan telephone directory. Take heart, because we will shortly begin work on an illustrated digital imaging dictionary. It will include more words and terms, expanded definitions, easily understood examples, drawings, and illustrations. Look for it in your bookstore hopefully sometime in 1994.

Accelerator A device or software designed to speed up operations, usually in screen redraws. Many PC SVGA graphics boards come furnished with accelerator chips, and there are auxiliary boards (commonly called pass-through boards) that will boost the speed of regular VGA boards. The Mac Rocket boards are examples of accelerator boards.

Access code A password that allows a user to get into a computer or particular file.

Access time Also called seek time, it's the speed at which the hard drive or CD-ROM drive skips from track to track as it finds, loads, or saves data. Access time is expressed in milliseconds (ms), and the lower the number, the faster the drive.

Adapter Any device not built into the computer itself that plugs into or adds on to your system in order to increase its capability, speed or capacity. Video and memory boards, mouse and printer ports, and network cards are just a few examples of adapters.

Adaptive compression A type of compression software, usually used for normal backups, that changes the degree and the method of compression according to the type of files being backed up. Although it is a non-destructive method, it's not recommended for photographic quality images.

Additive color theory One of several theories that have been developed to try to describe how color is formed. According to the additive theory, which applies to transmitted light, when you add red, green and blue (*RGB*) together, the result is white, and the absence of color is black. This is the color theory that governs computer monitors and transparency film.

Address One of the most important things that makes the computer work is that it can keep track of everything by assigning a unique position, or address, to every byte of memory, as well as every device attached to the computer system. Addresses become important when two devices or programs try to claim the same address, at which time the user must change one of them to an unused address. Sometimes it's an easy matter of following the installation selections, while other times it requires an expert to get the addresses straight.

Adobe Type Manager (ATM) Adobe is the company that developed and markets PostScript and PostScript typefaces, or fonts, as well as many other related software products. Adobe Type Manager is an important part of what is known as the PostScript interpreter, and its purpose is to help generate on-the-fly (instant) fonts of any size, and in an automatic way that is completely transparent to the user.

Algorithm Also called a routine or even a sub-routine, it's a semi-technical term used to describe a set of software instructions that solves a particular problem.

Alpha The name of a 64-bit CPU made by Digital. It's used in a few high-powered PC compatibles, and, while it may or may not run DOS-type programs, it will operate Windows NT programs.

Alpha channel That portion of an image file in which masking information is saved. Not all software uses this term and not all file formats can save masks with their related images.

Alphanumeric Any character you can type, including letters, numbers, punctuation, and special characters. It's also the combination of letters and numbers often used in the computer field to describe memory addresses, programming code, or certain hardware devices. The i486DX2 CPU by Intel is an example of an alphanumeric.

Analog The term for anything and everything we see in the real, non-computerized world. Technically, it's a continuously variable signal. This is the

direct opposite of *digital* data, which is interpreted as being organized in individual, sharply delineated steps. Computers can't deal with analog signals, so they must be converted to digital.

Anti-aliasing Smoothes out the ``jaggies,'' the step-like rough edges of a line by blending the colors of the pixels that make up that line with the surrounding colors.

AppleTalk Apple's network that links two or more Macintoshes, as well as PCs, together so they may share the same software, files, and devices. Some Apple computers use a faster network format called Ethernet.

Application programs Brand-name commercial software that perform specific tasks, such as imaging, word processing, database, spreadsheet, etc. In other words, a primary program, such as *Photoshop*, *CorelDraw*, *WordPerfect*, etc.

Architecture Refers to the specific design of a computer. You'll also hear it referred to as the type of motherboard in a computer.

Archive A file, image, or text that is permanently stored outside of the computer, such as on a floppy disk or DAT tape. The purpose of archival storage is to keep your data safe in an off-line but quickly accessible record that can be restored and reused whenever needed.

ASCII Stands for American Standard Code for Information Exchange, and is a universal file format, mostly used to send text material between two different kinds of computers, word processors, databases, or other programs.

Aspect ratio Refers to the height verses the width of an image. A picture that is 4"×2" is said to have an aspect ratio of 2:1.

AT bus The 16-bit architecture used in the vast majority of PCs. It's also referred to as the ISA (Industry Standard Architecture) bus.

Attribute A term used to describe the stylistic condition of a font or illustration element. Boldface and italics are just two type attributes.

Authorization code A password put on a file or program. When you install a new program, you often must type in the assigned authorization code (or serial number), which you may find on your registration card, your documentation, or elsewhere in or on the box.

Auxiliary storage Any external storage device that isn't incorporated into the computer, such as a CD-ROM drive or SyQuest drive.

Banding The visible and unwanted break within a gradient of colors. The traditional gradient should be smooth and not show any sudden transitions between shades, though some imagers introduce banding as a design choice.

Baud rate Refers to the speed that data are sent to another computer, either through a network or via a modem. Data moving at 300 baud is very slow, while data zipping at 115,000 baud is relatively fast.

Bernoulli box A type of removable drive used to exchange data on a cartridge. It is far less common than the SyQuest drive and cartridge.

Bezier curve A drawing tool used in both illustration and paint programs to define irregular curves with great precision.

Binary A number system with a base of any combination of zero and one, such as 10011100. Ultimately, all computer code, text, images, etc., are reduced to binary numbers.

Bit The smallest measure of binary information, in which the only options are on or off. The on and off state (or zeros and ones) are actually the only information that a computer can process. But by combining a multitude of bits in a variety of mathematical juxtapositions, complex instructions can be issued to the computer. (See *Byte, Kilobyte, Megabyte, & Gigabyte*.)

Bitmapped Images that are made up of individual dots, each of which have a defined value that precisely identifies its specific color, size, and place within the image. These are also known as *raster* images. A very different kind of image is the *object-oriented* or *vector* image.

Buffer A special memory holding area, in either hardware or software, that is used to speed up operations. Usually, the bigger the buffer, the faster control of the computer is returned to the user.

Bulletin Board Service or **BBS** A dial-up computer service accessible by modem, usually maintained by a manufacturer, distributor, or private company. They're used for 2-way computer-to-computer communications, to download patches and utilities, to allow users to ask questions and access information, to receive company announcements, etc.

Byte A measure of digital information equivalent to eight bits. (See *bit, kilobyte, megabyte, & gigabyte*.)

CAD/CAM Short for Computer Aided Design/Computer Aided Manufacturing. Like digital imaging, it's a graphics-intensive application and often has the same hardware requirements.

Calibration The act of adjusting the color of one device relative to another, such as a monitor to a printer, or a scanner to a film recorder. Or, it may be the process of adjusting the color of one device to some established standard. A *calibrator* is a device that is used to do calibrations.

Capture board An interface card that plugs into the computer motherboard. It can intercept and process standard broadcast signals from a television set, camcorder, VCR, etc.

Cathode Ray Tube or **CRT**　Another name for the computer monitor or screen.

CCD or **Charge Coupled Device**　A photo-sensitive electronic chip that is used in place of film to record an image in tiny pixels, or points. The information captured onto a CCD may then be converted into the digital form that a computer can understand.

CD　Stands for compact disc, a laser-encoded plastic medium that holds a large amount of data. Computers use various kinds of CDs.

CD drive　A device that either records or plays CDs. CD-ROM, MO (magneto-optical), and WORM (Write Once, Read Many) drives are the most common kind of CD drives.

CD-ROM (Compact Disc Read Only Memory)　A compact disc that can hold prodigious amounts of digital information, which may be images, an encyclopedia, or any other kind of file destined for a computer. Identical in appearance to audio CDs, the difference is in the kind of information that they store. CD-ROMs are becoming popular as media for software, clip art, and photo libraries. (See *Photo CD*)

Choking　A printing process that causes the background ink to overlap the area where other colors will be placed, in order to prevent gaps in the ink where the underlying paper will show through. This is part of the issue of *trapping*. The opposite process is *spreading*.

CIE (the Commission Internationale de l'Eclairage)　Attempted to create an internationally accepted standard to describe color in the 1930s. Because it is supposed to be independent of the source of the color (regardless of whether it was created by transmitted or reflected light), it is used by some PostScript printing systems and an increasing number of imaging programs. A color model associated with it is *LAB*, which is a 24-bit image type.

Clipboard　An area of RAM where cut or copied portions of images or other kinds of files are temporarily held. Data will be held in the clipboard until you cut or copy something else (because the clipboard can hold only one thing at a time), or until you shut off your machine.

Clone tool　Used in paint and illustration programs to exactly duplicate all or part of an image somewhere else in the picture, or make a copy of the entire picture. It may also be referred to as a *rubber stamp* tool.

CMYK (Cyan, Magenta, Yellow, & blacK)　The color model that is used in four-color process printing, and that is based upon reflected light. It is the opposite of RGB (red, blue, and green) color produced by a computer monitor. (See *Color models*.)

Color channel　The portion of an image that is associated with a specific primary color. For instance, an RGB image may be divided into three color channels, representing the red, green, and blue data that define that image. It

is possible to separate an image into its color channels, edit them individually, and then recombine them. Images are frequently separated into cyan, magenta, yellow, and black (CMYK) channels to prepare them for output by a printing press.

Color models Refer to the rules by which color is mixed and created. The *RGB* color model (which is the one native to computer monitors) is based on transmitted light, and white is defined as the sum of all colors. The *CMYK* model (which is used in printing) is based on reflected light, and white is the absence of all color. *HSB* stands for hue (the range of the spectrum), saturation (the intensity of color) and brightness (the amount of light). And so forth.

Color separation Refers to the color positives that are used to produce color plates for a printing press. Most often, there are four color separations in a set, each one used to produce the primary colors of cyan, magenta, yellow, and black. Color separations are commonly referred to as color seps, or simply seps.

Constraining keys Used in conjunction with drawing or painting tools to confine shapes to exact dimensions, such as perfect squares, circles, perpendicular lines, etc. Keys used are usually Alternate, Control, Command, Shift, or Option.

Conventional memory The first 640K of RAM on a PC that is accessed by all applications programs. Because most professional-type software requires much more RAM than conventional memory can provide, there are a variety of memory manager programs that manipulate and extend conventional memory so the computer won't freeze up.

Coprocessor A chip or a board designed to perform a single function very rapidly. For instance, a video coprocessor will appreciably speed up how fast things are painted onto the monitor.

CPU (Central Processing Unit) The "brains" of the computer. Intel's i486DX and Motorola's 68040 are specific types of CPUs.

Cropping The process of cutting away the outer edges of an image.

CRT or **Cathode Ray Tube** A computer monitor.

DAT or **Digital Audio Tape** Records computer signals digitally rather than analog, allowing for much higher density and greater accuracy. DAT drives are peripherals that record onto 4mm or 8mm DAT tape cassettes and may be used for archival storage.

DeskTop Publishing or **DTP** The process of designing, creating, and laying out documents that combine type and picture elements.

Digital Refers to the two numbers, zero and one, that a computer can recognize. It also has many sub-meanings, but all of them harp on the fact that

digital data reduces the universe to just two states. Digital is the opposite of analog, which sees the universe in continuous variables.

Digital camera A device that captures an image on a CCD so it can be uploaded to and manipulated by a computer. It might also be called a *filmless camera* or a *still video camera*.

Dipswitch A miniature on/off lever (that looks like a wall light switch) often found on PC peripherals or motherboards. They must be set properly—usually with the tip of a screwdriver or even a paperclip—in order to work correctly. A *jumper* is very similar to a dipswitch in function, but is set either by placing or removing a tiny plastic-covered block over rows of pins, either establishing or breaking an electrical connection.

Disk drive A device that randomly stores digital data so it may be used by the computer. Hard drives and floppy drives are types of disk drives.

DOS (Disk Operating System) The name given to Microsoft's software that is used on most PCs. Also referred to as PC-DOS and MS-DOS, each generation is differentiated by a specific number. At the time of this writing, the most advanced version is DOS 6.0.

Dot matrix printer Uses tiny electrically-driven needles to place individual dots of ink on paper. Low-cost dot matrix printers use 9 needles to form characters and images; better models use 24 or even 48 pins.

Download The process of capturing data from another computer or device. It's the opposite of *upload*, which is transmitting or sending data to another computer or device.

Dpi or **dots per inch** Refers to the number of dots that a device is capable of producing. The higher the number, the greater the resolution, and the finer-looking the image. It's often used interchangeably (but inaccurately) with lpi (lines per inch) and ppi (pixels per inch).

DTP or **DeskTop Publishing** The computerized process of combining type and art into a page layout that is ready for printing.

Driver A software utility specifically designed to make a particular device or program work with another device, program, or computer system. For instance, to attach a film recorder or scanner to your computer will always require some sort of a driver.

Dye sublimation printer or **dye sub printer** The only kind of desktop printer capable of reproducing photo-quality continuous tone color images.

Dynamic range The contrast ratio of highlight to shadow. Film has a much greater dynamic range than anything that can be printed out from a computer.

Equalization Evens out the light and dark elements of a picture, creating a more even *histogram*.

ESDI (Enhanced System Device Interface) A type of hard drive and drive controller used on the PC. It's now considered obsolete, having been eclipsed by *SCSI* devices.

Export The process of sending a file to another computer, program, type of file format, or device (such as a printer or film recorder).

Feathering Makes an edge softer, so that it blends in more with its surroundings.

File The term given to any collection of data—such as a letter, an image, a database record—that is stored on the hard disk or some other media as a separate entity. Files have names and may be saved, loaded in, run, etc., by invoking that name.

File formats Determine the way data are organized by programs when they save images to your hard disk. In addition, each piece of software will load from your hard disk only those images that are in the file formats it supports. Some examples of file formats are TIFF, PICT, and BMP.

Film recorder A device that is used to record a digital image onto photo-sensitive film.

Filter The name given to a single command that applies special effects or certain editing processes (such as sharpening) to images.

Firmware Programming code (or software) that is permanently burned into computer chips or PCMCIA cards. For instance, a lookup table that tells a film recorder how to adjust itself for a specific brand film emulsion may be encoded onto a card that you or a technician would insert into the film recorder.

Flatbed scanner A device used to get drawings, paintings, illustrations, or other 2-dimensional material into the computer.

Floppy disk(ette) A napkin-sized or shirt pocket-sized type of magnetic storage media, used to install new programs onto the computer, or to transfer or back up small files.

Floppy disk drive The device that reads and writes to floppy disks. There are two primary types: 1.2Mb 5.25" (for the PC only) and 1.44Mb 3.5" (for both the Mac and the PC).

Frame grabber Another name for a capture board or grabber board.

Frisket Another word for irregularly shaped masks or selection areas. (See *masks*.)

Gamma curve A graphical representation of the balance of shadows, midtones, and highlights. It plots the change of these greyscale values as a picture is manipulated, with the values of the original image being assigned to the x-axis or the horizontal scale and those of the manipulated image being assigned to the y-axis or the vertical axis. The gamma curve is not the graph, but a line drawn on the graph that plots this relationship. It's used in some of the important fine-tuning tools of paint programs.

Gigabyte Also written Gb, a gigabyte is 1 billion bytes of data, or 1,000 megabytes. Most serious digital imagers have hard drives that store between 1 and 4 gigabytes. (See *kilobytes, bits, bytes* and *gigabytes.*)

Grabber board See *capture board.*

Grey Component Replacement (GCR) A prepress method by which the black ink percentage is increased to replace a portion of the grey components of cyan, magenta, and yellow inks.

Greyscale The range of grey tones between black and white. It may also refer to the level of darkness or lightness in a color image.

Greyscale monitor A monochromatic computer screen that displays between 16 and 256 shades of grey.

Hard drive A computer's primary high-capacity storage device. Modern hard drives range in size from 40 megabytes to 4 gigabytes, though 1 gigabyte and larger drives are most commonly used by serious digital imagers. It's also called a hard disk drive.

Hacker The semi-affectionate term originally given to avid computerists who love playing with the technology. In recent years, it's come to mean malicious high-tech vandals who try to break into secure systems, pirate software, or introduce destructive computer viruses.

Histogram A graph that describes the greyscale distribution among all the pixels of an individual image. Reading the histogram can tell you if there are heavy shadows, bright highlights, equal distribution within the midtones, etc. The histogram is used to assist in some of the methods that paint programs use to adjust the balance of lightness and darkness of a picture.

HSB or HSL Color models in which the components are: hue, saturation, and brightness (or lightness).

Hue A term used to describe the entire range of colors of the spectrum. In HSB and HSL color models, hue is the component that determines just what color you are using. In gradients, when you use a color model in which hue is a component, you can create rainbow effects.

IBM compatible (or PC) A type of computer that will run DOS-type software, and has an ISA, EISA, or PS/2-type architecture. Many PCs work with Windows and OS/2.

Icon An on-screen graphical representation of a software tool or technique.

Image data types Relate to the amount of data (or digital information) associated with the image. (This is also known as image or data depth.) For instance, a data type of a greyscale picture is 8-bit. A true color RGB picture is 24-bit.

Import The process of receiving a file from another computer, program, type of file format, or device (such as a printer or film recorder).

Interpolate The automatic process that a computer uses to add data when an image is resized, scanned in, or printed out at a resolution different than the original resolution.

Jumpers Tiny connectors on a PC peripheral or motherboard that are set by the user so it integrates into his or her particular system.

Kilobyte (K) A measure of digital information equal to 1,024 bytes. (See *kilobytes*, *bits*, *bytes*, and *gigabytes*.)

Laser printer A high-speed electrostatic printing device that uses a laser to "paint" the image onto a photosensitive drum, which is then transferred to paper. Most laser printers are monochromatic or greyscale devices, though a few are capable of printing in four colors.

Lossless data compression Shrinks the size of files by creating something of an internal shorthand that will rebuild the data as it originally were before the compression. Thus, it is said to be non-destructive to image data when used. Many imagers are still wary of it, though some experts believe in using this form of compression.

LPI or **lines per inch** A printing term referring to the resolution of an image.

Luminance A measure of the brightness of an image. It's also used to describe whether an image has a certain indefinable and subjective shining or scintillation that makes it stand out.

LUT or **Look Up tables** Used in software and hardware to coordinate input and output to the individual color characteristics of film, scanners, recorders, and printers.

Macintosh A type of computer manufactured by Apple used by many digital imagers. The Quadra series represents the most powerful kind of Macintosh.

Magneto-Optical drive or **MO drive** A type of compact disc drive that can both read and write to a special CD cartridge. While the technology is quite

different and its operating speed is significantly slower, an MO drive performs the same function as a hard disk drive.

Marching ants or **dancing ants** The outline of dots that selection tools create on a bit-mapped image when the user is drawing a mask. (See *marquee*.)

Marquee The outline of dots that selection tools create on the image when the user is drawing a mask. (See *marching ants*.)

Masks Defines those areas in an image in which the user wants commands to be active and those areas in which the commands will have no effect. Masks are also used to select the portion of the image which will be involved in cutting, copying, and pasting operations. They are created with *selection tools* and are also called selected areas or *friskets*. In some programs, the mask channel (which may also be called the alpha channel) may be directly edited. In others, it appears only as an outline of dots. (See *marquee* and *marching ants*.)

Megabyte (Mb or MB) A measure of digital information equal to 1,024 kilobytes. (See *kilobytes*, *bits*, *bytes*, and *gigabytes*.)

Memory Refers to data storage space, either electronic memory that the computer needs to operate (such as RAM), or permanent storage that remains intact (such as a hard drive) when the computer is turned off.

Menu A list of available functions, tools, or other options that is shown on the screen.

Microcomputer A device that is controlled by a microprocessor, or CPU, which can process information at incredible speeds.

Microprocessor or **CPU (Central Processing Unit)** A chip that acts as the "brains" of a computer. The Intel Pentium and the Motorola 68040 are examples of microprocessor chips.

Modem A board or a stand-alone device designed to translate digital data to and from analog tones that can be transmitted over a telephone line. Modems are used to access bulletin boards and to send image files to clients and service bureaus.

Moiré A mottled pattern that shows through the final printed picture when the four halftone screens (of cyan, magenta, yellow, and black) are not accurately angled in relationship to each other to produce the desired effect of a continuous tone print.

Monitor The screen or CRT that one views to see what is happening in the computer.

Morphing A special effect that merges the attributes of two different images into a single, continuous one. For instance, a wolfman could be created by morphing a picture of a wolf and another of a man.

Mouse A type of pointing device that one pushes on a pad in order to make corresponding moves on the computer monitor. The mouse is not the pointing device of preference for digital imagers because of its low resolution and imprecision.

Multisession CD-ROM drive A device that can read CD-ROM discs in the Photo CD format. It's sometimes referred to as an XA-compatible of multimedia CD-ROM drive. Ordinary, usually older CD-ROM drives cannot read the Photo CD format.

Object-oriented images Are formed by formulae that define the shape and color of their elements, such as a line, a circle, etc. (Also known as *vector images*.) A different kind of image is *bitmapped* or *raster*.

OCR (Optical Character Recognition) Software that will interpret scanned-in text material so that it may be recognized as words and edited by a word processing program. Without OCR software, the letters would be shapes like any other bit of graphics that no word processor could interpret.

OEM (Original Equipment Manufacturer) A vendor who sells equipment under his name that is manufactured by another company.

OS/2 IBM's 32-bit operating system for the PC. The latest version of OS/2 is 2.1, and it may be used to run some PC digital imaging software.

PCMCIA cards Credit-card-sized memory devices that plug into scanners, film recorders, laptop computers, and other devices. They are often used to quickly update internal operating instructions and *Look Up Tables* on digital imaging devices.

Photo CD The Kodak system of storing photographic images that are scanned with Kodak's equipment onto CD-ROMs, which can then be read with a *multisession CD-ROM drive*. Just as the Xerox name should not be used when you are talking about generic photocopies, Kodak is attempting to maintain trademark integrity with their Photo CD name. When it isn't a Kodak product, it's a CD-ROM, not a Photo CD.

Pixels Short for "picture elements," pixels are the dots that make up a bitmapped picture. When the image is magnified so that you can see the individual dots, it is said to be *pixelated*. *Pixelating* filters will create the same effect on a non-magnified image.

Plug-ins Software programs, such as third-party filters or device drivers, that can be made accessible through another program. For instance, if you can scan a picture from *Photoshop*, then the scanner's driver is a plug-in that has been attached to *Photoshop*. *TWAIN* is a popular plug-in for scanners.

Pointing device The name given to a mouse, trackball, digitizing tablet, or any other device manipulated by the user's hand to move the computer cursor.

Posterization Lowers the number of color levels used by a picture, so that transitions between colors are more sudden.

PostScript An Adobe Systems, Inc. trademarked page description language for creating shapes and type on a page. Software and hardware may be described as being PostScript compatible.

Prepress The process by which a design is taken through the various stages from concept up to camera-ready mechanicals or electrostatic separations. Traditionally, this involved an army of experts including the art director, the designer, the visual artist, the typesetting, the color separator, the stripper, and the printer. Digital imaging now allows one person to take responsibility for most (if not all) of those stages by computer. Today's service bureau usually does the film preparation, and the printer continues in his traditional role.

Process color Takes advantage of the ability of process inks to mix in order to create a wide array of colors in the print job. Therefore, a four-color press using CMYK inks can produce a picture that has hundreds or thousands of colors in it. A process color palette is generally the preferred kind for generating images that will be printed. (See *spot color*.)

QEMM or **Quarterdeck Electronic Memory Management** A commercial memory management utility for the PC that allows the user to access RAM above 640K. QEMM is usually more efficient, but harder to set up and configure, than the memory management program (EMM386) that comes with DOS 6.0.

QIC or **Quarter Inch Cartridge** A type of backup tape drive. QIC drives generally have a smaller capacity than *DAT* drives. Because they record analog rather than digitally, they are not considered as accurate or desirable as DAT drives.

RAM or **Random Access Memory** The electronic memory chips or boards that a computer uses to process information.

Raster images are made up of individual dots that each have a defined value that precisely identifies its specific color, size and place within the image. (Also known as *bitmapped* images.)

Rasterization The process by which images and other computer generated information is translated into printable form. The process is also known as *ripping*.

Read only memory or **ROM** The chips in which the memory is permanently etched, and which are used to give specific instructions to either a computer or a peripheral. ROMs are different than RAMs in that they can't be changed by the user, but ROM may be swapped when updating is needed.

Removable mass storage A device that allows a cartridge to be inserted in the drive, and to which data may be saved or imported. The SyQuest cartridge is the most widely used fixed removable disk system in digital imaging.

Resolution A measure of how much data or information is associated with a particular image. The higher the resolution, the sharper, better and more detailed the image.

RGB The additive color model that is native to computer monitors and available on all imaging programs. According to this model, the combination of red, green and blue (RGB primaries) makes white.

RIP or **Raster Image Processor** The hardware and/or software that allows a computer printer to translate a computer-generated image into a printed image. Somewhere along the way, a digital image must be "ripped," if it is to be printed. (See *Rasterization*.)

RISC or **Reduced Instruction Set Computing** A stripped-down type of CPU that sacrifices some convenience for pure speed. RISC machines are fast workstations dedicated to a single function like digital imaging.

Rosette The circular pattern formed by angling the four halftone screens of cyan, magenta, yellow, and black, so that the different color dots are placed adjacent to each other. If the angles of the screens relative to each other are not accurately calibrated, the rosettes will shift, disrupting the continuous tone effect of the picture and creating a *moiré* effect.

Scanners Devices that digitize (or capture) and convert real-world images and objects to digital data that a computer can recognize and manipulate.

Scitex The name of an Israeli company that manufacturers drum scanners and other high-end service bureau and publishing equipment. The word is sometimes misused to refer to any scan done on a high-end drum scanner.

SCSI or **Small Computer Systems Interface** The best-known and widely-used type of interface for attaching digital imaging devices, such as scanners, film recorders, disk and tape drives, etc. SCSI-2 or Fast SCSI is a more advanced type of SCSI that allow for faster data transfer rates between the device and the computer.

Selection tools Those software tools that allow the user to define areas to be masked, so that commands applied to the image will be active only in the selected area and not elsewhere in the image.

Spot color Inks that are already mixed, which means that there are thousands of possible spot (or solid) colors, each of which is laid down separately from all the other colors in the picture. Spot colors are most frequently used in printing pages that have few colors, such as newsletters. (See *process color*).

Spreading A printing process that causes the ink that creates the objects in a picture to spread out into the background ink, in order to prevent gaps in the ink where the underlying paper could show through. This is part of the issue of *trapping*. The opposite process is *choking*.

Still video camera is another name for a filmless or digital camera that uses a CCD instead of film to capture video images.

Stripping A prepress term in which photographic positives—or four individual color separations—are assembled in a flat in order to create a metal printing plate.

Stylus A pen-shaped device that is used by digital imagers instead of a mouse, because it is more precise and feels more natural than a mouse.

Subtractive color theory Governs inks, dyes, pigments, and other physical materials used in the printing process. In it, the absence of color is white and the combination of all colors is black. CMYK (Cyan Magenta Yellow blacK) is the color model associated with this color theory. (See *Color models*.)

SyQuest The trademarked name of a removable drive system for both the PC and the Macintosh, it is universally used throughout the digital imaging community. Syquest cartridges are bathroom tile-sized storage devices that hold either 44 or 88 megabytes of data, and which may be removed for security purposes or to send to a client or a service bureau for prepress processing.

System 7 The name of the current operating system used by Apple computers. The latest version is 7.1.

Thermal wax printer A type of color printer that embosses colors onto paper from rolls of wax-coated cellophane.

Third-party software Programs created and sold by companies that are designed to interact with better-known programs manufactured by another company.

Thumbnail A small, low-resolution version of a larger image file that is used for quick identification or speedy editing choices.

Toner Consists of minuscule iron metal filings that are deposited and affixed to paper by electrostatic (laser) printers. It is most often black, though a few color electrostatic printers use color toner to produce CMYK prints.

Trapping A term that comes from traditional printing. It refers to the ability of an ink to transfer to another layer of color as to blank areas of the paper. Each time a paper is put through a printing press, a new color ink is applied. If an image has colors that should meet at a specific line, then the press must be perfectly adjusted. Otherwise, a white space might appear where the colors were supposed to meet, because the press isn't perfectly calibrated so that every pass is exactly the same as the previous. Trapping is the word used to describe the process that compensates for the stretch and shot of paper as it

runs through a press, so the colors meet more perfectly. This continues to be an important issue in the professional printing of computer images, especially those that involve type or object-oriented drawings.

TrueType The name used to describe font outline technology developed jointly by Apple and Microsoft. It is not as widely used by professionals as are PostScript fonts.

Undercolor Removal or **UCR** A prepress method by which the grey components of cyan, magenta, and yellow inks are decreased and the percentage of black ink is increased.

Undo A command usually found under "Edit" in the pull-down menus at the top of the screen that removes the effect of the last command invoked. Some programs have several layers of "Undo." But most programs will allow you to undo a command only immediately after the command has been used and only if no other command has been used in the interim.

User-friendly A much misused industry buzzword to describe hardware and software that is particularly easy to set up and operate by computer novices and others without a technical background.

Users groups Collections (or clubs) of individuals who use computers, and who freely share advice, tips, and tricks that they have learned, based upon personal and professional experiences. You can usually locate them through the local librarian, computer magazines, nearby universities, etc. A valuable source of help, information, and technical support.

Utility Any software that performs certain technical functions needed for the smooth operation of the computer or hard disk, or to make a particular device work with a specific program or system.

Vector Images formed by formulae that define the shape and color of their elements. (Also known as *object-oriented* images.)

VGA Stands for Video Graphics Array, a medium to high-resolution graphics standard for the PC. Windows requires that a PC has a VGA graphics board and driver installed in order to operate properly. SVGA is a higher resolution VGA.

Video RAM A special type of high-speed memory installed on a video graphics card that allows for higher resolution and faster screen redraws.

Virus A deliberately destructive bit of programming code that can be inadvertently transmitted from one computer to another, and which can corrupt or wipe out files or an entire hard drive. There are many anti-virus programs designed to detect and eliminate computer viruses.

Window A frame on the monitor that shows a view of an image, text file, program, or subdirectory. Depending upon the program, windows may be opened, closed, expanded, shrunk, or moved about at will.

Windows and **Windows NT** The operating environments used on PCs for most imaging programs.

Index

Illustration page numbers are in **boldface**.

Other Bestsellers of Interest

SHOOTING OUTDOOR VIDEOS

Don Steffans

You want to record your special trip for posterity (or at least your family and friends) but your videos suffer from unpredictable conditions. Let Don Steffans, a former co-producer and writer for "Worldwide Sports," show you how to take advantage of today's hand-held cams and make professional-quality outdoor videos—without equipment that costs as much as the rest of your vacation. You'll learn shooting techniques that cover every outdoor setting, from snow skiing to scuba diving.

• 132 pages • 80 illustrations • 4-page full-color insert.

060978-0 **$19.95**

STACKER®: An Illustrated Tutorial

2nd Edition

Dan Gookin

Turn your single hard disk into two with this professional guide. Updated through Stacker 3.0, it contains information not found in the manuals. You'll use such features as Express or Custom Setup for Windows and DOS; Windows Stackometer™—a set of real-time gauges showing hard disk capacity, compression ratio, and fragmentation levels. Plus, you'll use Unstack™, a time-saving utility that decompresses files and automatically returns systems to their original state.

• 208 pages • 50 illustrations.

024010-8 **$19.95**

SUPER VGA GRAPHICS: Programming Secrets
Steve Rimmer

Programming advice isn't generally considered witty, whimsical, or fun—except when it's from Steve Rimmer. In the latest of his computer graphics books, he not only provides the tools you need to make Super VGA graphics modes work for you, he makes them enjoyable, too. With very little math, indirect addressing or exponential notation, the examples Rimmer uses will let you access the Super VGA Graphics modes of most of the popular display cards, display pictures, print graphics, manage a mouse, use clickable buttons, draw graphic primitives, and more.

- 592 pages • 100 illustrations.
- 3.5" disk

052999-X **$49.95**

SAVING WATER IN THE HOME & GARDEN
Jonathan Erickson

Regardless of whether or not your clients live in drought-prone areas, new federal, state, and local restrictions to reduce water consumption will soon make saving water everyone's business. This book shows you many water conserving products you can incorporate in your work, including the use of low-flush toilets and low-flow showerheads, the design of "gray water" systems, the installation of efficient sprinkler systems, and much more.

- 160 pages • 125 illustrations.

019705-9 **$12.95**

BUILD YOUR OWN LOW-COST POSTSCRIPT® PRINTER AND SAVE A BUNDLE
2nd Edition
Horace W. LaBadie, Jr.

LaBadie shows you how to assemble your own inexpensive laser printer, upgrade, or replace a chip. You'll learn how to convert stock Canon CX and SX laser engines to full Post-Script printing capability. Plus, you'll discover how to find, purchase, and assemble components. You'll understand engines, controllers, interfaces, power supplies, cabling lasers, toner cartridges, fuser mechanisms, memory upgrades, and more.

- 232 pages • 130 illustrations.

035887-7 **$19.95**

DYNAMITE CRAFTS FOR SPECIAL OCCASIONS
Jim Lamancusa

Here is a fun, well-illustrated book that will show you and your kids how to assemble beautiful crafts projects for special occasions all year round. Thirteen-year-old author Jim Lamancusa features 30 of his favorite craft activities that are sure to be a hit with kids ages 7–14. Each kid-tested project includes step-by-step instructions and helpful illustrations. Plus, all the inexpensive materials are easy to get.

- 128 pages • 150 illustrations, including a 4-page full-color insert.

036159-2 **$12.95**

DECORATIVE METALWORKING

Charles P. Holtzman

Transform inexpensive scrap metal into beautiful, functional items for around the house. With only a few simple tools and a basic knowledge of metalworking, you can create any of the projects in this book. Step-by-step, illustrated instructions for 20 projects describe how to mold decorative plant stands, hanging lamps, vases, scrolled brackets and hinges, wind vanes, letter racks and openers, and much more.

- 144 pages • 271 illustrations.

005875-X **$9.95**

KID CASH: Creative Money-Making Ideas

Joe Lamancusa

Now kids can enjoy a sense of accomplishment and learn valuable lessons about money and the working world with this unique reference/workbook. In it, 14-year-old entrepreneur and businesskid Joe Lamancusa tells his peers about dozens of money-making enterprises for kids over eight years old. From conventional jobs like babysitting, lawn mowing, and snow shoveling, to more professional jobs like seasonal decorating or computer services, you'll find great ideas for today's young entrepreneurs.

- 160 pages • 50 illustrations.

036158-4 **$9.95**

BUILD YOUR OWN 486/486SX AND SAVE A BUNDLE

2nd Edition

Aubrey Pilgrim

This hands-on guide makes it possible for you to build your own state-of-the-art, 100% IBM-compatible PC for about one-third of the retail cost or less with little more than a few parts, a screwdriver, and a pair of pliers. So don't shell out huge sums of money for a PC at your local retail outlet. This book will allow you to enjoy the speed and power of a 486—and still put food on the table.

- 256 pages • 58 illustrations.

050109-2 **$29.95**

UPGRADE OR REPAIR YOUR PC AND SAVE A BUNDLE

3rd Edition

Aubrey Pilgrim

Why replace an old PC or PS/2 with an expensive new one when a few simple upgrades would do the trick? The third edition of this popular guide covers motherboards, CPUs, floppy and hard disk drives, BIOS and RAM chips, graphics cards, displays, printers, modems and faxes, memory boards, giving you the latest hardware and software options, prices, and sources. You can save from $900 to $1,500 in less than an hour—the amount of time it takes to replace a motherboard.

- 272 pages • 77 illustrations.

050111-4 **$29.95**

WINDOWS® BITMAPPED GRAPHICS

Steve Rimmer

Stocked with ready-to-run source code in C, and illustrated with many fine examples of bitmapped output, this complete programmer's reference gives you all the practical information you need to work effectively with Windows-compatible graphics formats, including Windows BMP, TIFF, PC Paintbrush, GEM/IMG, GIF, Targa, and Mac-Paint. You get a toolbox of portable source code designed to help you integrate these standards into your Windows applications plus a whole lot more.

• 400 pages • 82 illustrations.
052995-7 **$38.95**

Rx PC: The Anti-Virus Handbook

Janet Endrijonas

This timely guide and its companion 3.5" disk are an effective prescription for the prevention of computer viruses. Your lesson in preventive medicine starts with a brief introduction to what computer viruses are, where they come from, and how they can harm your computer. You'll discover how to install the proper virus protection software and how to perform regular system monitoring, maintenance, access control, and file backup—all of which can significantly reduce your risk of losing data to viral infection.

• 208 pages • 100 illustrations.
• 3.5" disk.
019623-0 **$39.95**

OBJECTVISION™ PROGRAMMING FOR WINDOWS

Donald Richard Read

Create your own graphical applications for Windows, or improve old applications in minutes with this easy-to-follow guide—and its 3.5-inch companion disk—to the powerful ObjectVision GUI development package. It will show you how to use ObjectVision's unique "forms" model that makes it easy to adapt dBase Paradox, and a host of other database programs to the Windows environment. Plus, you'll learn how to design your own Windows databases visually, without getting bogged down in complicated source code.

• 208 pages • 380 illustrations.
• 3.5" disk.
051292-2 **$34.95**

ALL THUMBS GUIDE TO COMPACT DISC PLAYERS

Gene B. Williams

Keep your CD player running smoothly and save a bundle of money in the process. This easy-to-understand guide offers clear illustrations and step-by-step instructions for cleaning, lubricating, and repairing virtually any CD player. You'll find extensive sections on how to do maintenance and repairs without harming your CD player, your discs, or yourself.

• 144 pages • 163 illustrations.
070587-9 **$9.95**

BUILDER LITE: Developing Dynamic Batch Files

Ronny Richardson

With this software and Richardson's accompanying user's manual, even beginners will be able to build and test sophisticated batch files in as little as 10 minutes. Richardson's step-by-step tutorial demonstrates how to write batch files that manipulate displays, create menus, make calculations, customize system files, and perform looping operations. This isn't a demo package, either. Builder Lite was developed by Doug Amaral of hyperkinetix, inc., especially for this book.

- 368 pages • 61 illustrations.
- 3.5" disk.

052362-2 **$44.95**

VISUAL BASIC™ ANIMATION PROGRAMMING

Lee Adams

Computer animation is more than entertainment. You can use it to give your applications more pizzazz and make them more marketable. This expert guide shows you how to achieve common effects such as run-cycles, background pans, motion blur, and adjustable timers, and how to use different methods to create and store animated images on the Windows platform. Several complete, working programs demonstrate how to tap into Window's powerful, built-in graphics library, the GDI.

- 656 pages • 216 illustrations.
- 5.25" disk.

000452-8 **$39.95**

Prices Subject to Change Without Notice.

Look for These and Other Windcrest/McGraw-Hill Books at Your Local Bookstore

To Order Call Toll Free 1-800-822-8158
(24-hour telephone service available.)

or write to Windcrest/McGraw-Hill, Blue Ridge Summit, PA 17294-0840.

Title	Product No.	Quantity	Price

☐ Check or money order made payable to Windcrest/McGraw-Hill

Charge my ☐ VISA ☐ MasterCard ☐ American Express

Acct. No. _____ Exp. _____

Signature: _____

Name: _____

Address: _____

City: _____

State: _____ Zip: _____

Subtotal	$ _____
Postage and Handling ($3.00 in U.S., $5.00 outside U.S.)	$ _____
Add applicable state and local sales tax	$ _____
TOTAL	$ _____

Windcrest/McGraw-Hill catalog free with purchase; otherwise send $1.00 in check or money order and receive $1.00 credit on your next purchase.

Orders outside U.S. must pay with international money in U.S. dollars drawn on a U.S. bank.

Windcrest/McGraw-Hill Guarantee: If for any reason you are not satisfied with the book(s) you order, simply return it (them) within 15 days and receive a full refund.

BC

About the authors

Sally Wiener Grotta & Daniel Grotta are a husband/wife photographer/writer team who collaborate professionally in producing books, articles, columns, reviews, and photo essays on a wide variety of subjects. Over the past 16 years, their assignments have taken them to more than 70 countries and all continents, including Antarctica. They frequently write about computers and photography, so it was probably inevitable that the Grottas would become leading experts on the natural synthesis of these two technologies, digital imaging.

Daniel has a lot of Ex's to his credit: ex-war correspondents, ex-investigative reporter, ex-photojournalist, ex-classic music critic, ex-book editor and reviewer. Sally started her career as a model, actress, and singer, and became a successful photographer when she discovered that she preferred being behind the lens of the camera. She has thoroughly embraced digital imaging, combining it with her (film-based and filmless) photography. As she says, "Now that I'm freed up from the limitations of chemistry, physics and optics, I am also no longer pigeonholed professionally or creatively."

The Grottas live in a turn-of-the-century Victorian house in a small Pennsylvania town with their two Hungarian sheepdogs and Burmese cat.